Millais

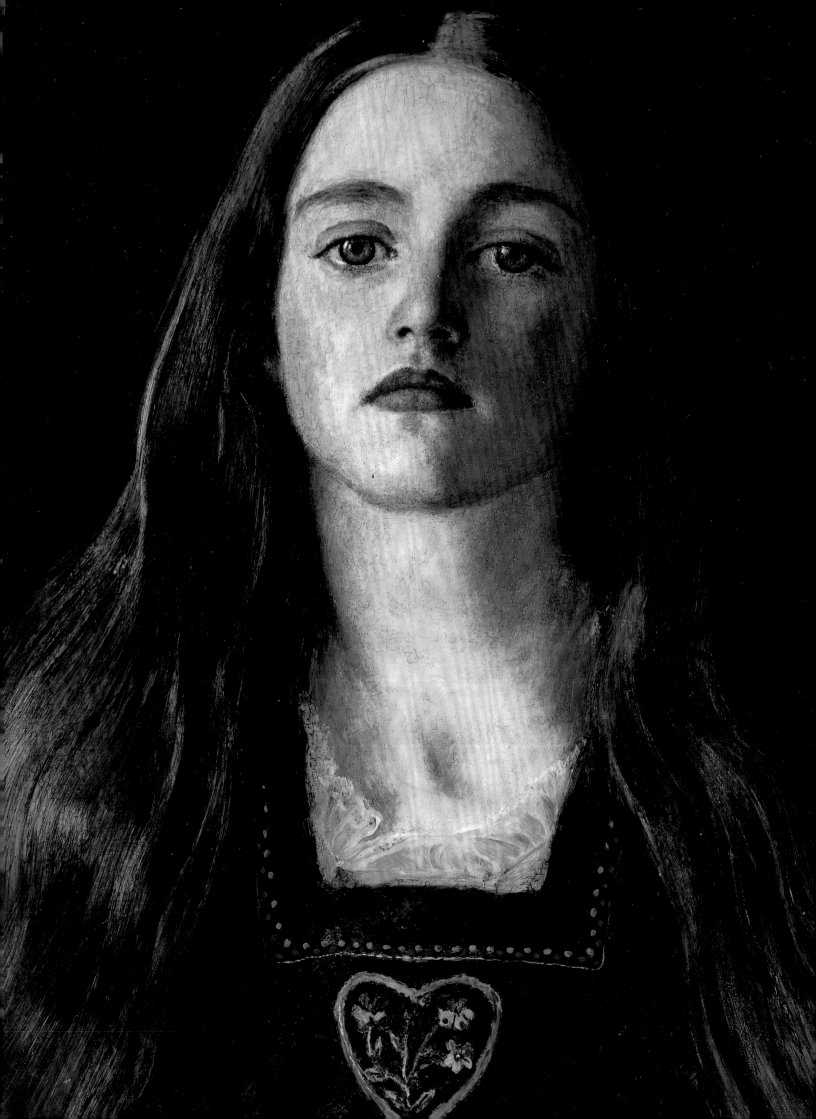

Jason Rosenfeld and Alison Smith

With contributions by Heather Birchall

Millais

Tate Publishing

First published 2007 by order of the Tate Trustees
by Tate Publishing, a division of Tate Enterprises Ltd,
Millbank, London SW1P 4RG
www.tate.org.uk/publishing

on the occasion of the exhibition
Millais

Tate Britain, London
26 September 2007 – 13 January 2008

Van Gogh Museum, Amsterdam
15 February – 18 May 2008

Kitakyushu Municipal Museum of Art, Fukuoka
7 June – 17 August 2008

Bunkamura Museum of Art, Tokyo
30 August – 26 October 2008

© Tate 2007

Reprinted 2007

British Library Cataloguing in Publication Data
A catalogue record for this book is available from
the British Library

ISBN 978-185437-667-1 (pbk)
ISBN 978-185437-746-3 (hbk)

Distributed in the United States and Canada by
Harry N. Abrams, Inc., New York

Library of Congress Cataloging in Publication Data
Library of Congress Control Number: 2006937945

Designed by Matt Brown, DesignBranch
Printed in Italy by Conti Tipocolor, Florence

Front cover: *Ophelia* 1851–2 (no.37, detail)
Back cover: *Bright Eyes* 1877 (no.104)
Frontispiece: *Sophie Gray* 1857 (no.83, detail)
pp.8–9: *The Fringe of the Moor* 1874 (no.129, detail)
pp.244–5: *Millais with Mrs Langtry, Eastwood 1879*,
Geoffroy Richard Everett Millais Collection

Measurements of artworks are given in centimetres,
height before width.

Full details of the exhibitions referred to in abbreviated
form in the captions are given in the list of exhibitions
on pp.259–61.

Initials after entries denote authorship
AS Alison Smith
HB Heather Birchall
JR Jason Rosenfeld

Contents

Sponsor's foreword

Tate Members are delighted to support *Millais*, a fascinating survey of the career of an artist whose interest extended beyond Realism and Aestheticism and was as much engaged with modern developments in art as with the Old Masters. A founding member of the Pre-Raphaelite Brotherhood, Millais spearheaded the most radical artistic group in the history of English art. In the second half of the nineteenth century he was the most successful painter in Britain, with a reputation across Europe and America.

The charity Tate Members was founded in 1958 specifically to support the work of Tate; it has proved one of the most successful schemes of its kind. Last financial year Members gave nearly £4 million in direct funding to Tate. This included £500,000 towards start-up costs for Tate Modern 2 and £250,000 for the fund to save Turner's watercolour *The Blue Rigi* for the nation.

Tate Members are central to the success of all four galleries. They help build and care for the Collection and extend exhibition, educational and outreach programmes. Members also play an important role in helping Tate fulfil its duty to increase public knowledge, understanding and enjoyment of art. We hope that many of you who view the exhibition and read this catalogue will join us and help support Tate's vision.

Francine Stock
Chair, Tate Members

Acknowledgements

Many people have been involved in the realisation of this exhibition. In addition to the acknowledgments made by Stephen Deuchar in his preface, we would like to thank the many individuals and institutions that have helped make this exhibition possible. Within Tate Britain we would like to thank Stephen Deuchar and Judith Nesbitt for guiding the project through various stages of development. Heather Birchall and Tim Batchelor handled the complex administration of the show with great enthusiasm and expertise, and we would especially like to thank Heather for the time she dedicated to *Millais* before she left to become curator at the Whitworth in Manchester. Kiko Noda coordinated transportation for the exhibition and tour. Nicola Bion was in charge of the catalogue, which was edited by Mary Scott and designed by Matt Brown at DesignBranch. The exhibition was designed by Alan Farlie of RFK Architects, and the graphics by David Ellis of whynotassociates. Funding for restoring paintings by Millais in the Tate Collection was generously provided by the Vandervell Foundation, the Charlotte Bonham-Carter Charitable Trust and an anonymous charity. Within the conservation department we would particularly like to thank Helen Brett, Natasha Duff, Rica Jones. Leslie Carlyle and Jacqueline Ridge (before she left in 2006) for their knowledge and patience. Valuable work on restoring frames for the show was done by Gerry Alabone, Stephen Huxley, Alastair Johnson and Adrian Moore, and conservation of works on paper by Piers Townshend, Rachel Crome and Charoulla Salt. We would also like to thank Rodney Tidnam, Sarah Tucker, Anne Low, Katherine Moulds, Jennifer Batchelor, Louise Butler, Andy Shiel, Hattie Spires, Geoff Hoskins and the art installation team.

Many people have offered advice and information. In particular we would like to thank Nicholas Tromans who made valuable comments on the text, and Tim Barringer who also read sections of the catalogue. Charlotte Gere shared her deep knowledge on the art and costume of the period and Rupert Maas was generous in allowing us to consult documents in his archive. In developing the show we are much indebted to the support of Martin Beisly at Christie's, Peter Funnell at the National Portrait Gallery, and Peter Nahum. Thanks also to Marymount Manhattan College for giving Jason time off from teaching to work on the catalogue. We would also like to acknowledge the help of the following individuals: Daniele Archamgault, Seth Armitage, Richard Ashrowan, Sir Jack Baer, Robin de Beaumont, Edwin Becker, Alex Bialy, Natalie Bondil, Judith Bronkhurst, Peter Brown, Sally Burgess, Stephen Calloway, Phyllis Connors, Mary Cowling, Lucy Cullen, Maria Devenay, Louise Downie, Inge Dupont, Peter Freeman, David Glass, Ted Gott, Karen Gottlieb, Christopher Gridley, Cheryl Hartup, Alex Hamilton, Colin Harrison, Ben Hay, Nahoko Hirano, Emily Hope, David Howarth, Simon Houfe, Carol Jacobi, Vivien Knight, Colin Lees-Millais, Lionel Lambourne, Wendy Makins, David McNeff, Jennifer Melville, Clare Meredith, Catherine Messum, Jane Munro, Christopher Newall, Patrick Noon, Charles Nugent, Yoko Obuchi, Fiona Salvesen, Desmond Shawe-Taylor, Tessa Sidey, Robin Simon, Fiona Slattery, MaryAnne Stevens, Ann Sumner, Simon Toll, Julian Treuherz, Andrew Visnevski, Stephen Waterhouse, Annette Wickham, Scott Wilcox, Mary Jane Wilkinson, Andrew Wilton, Barry Windsor-Smith, and Kirche Zeile.

Millais was proud of himself as a family man and had eight children. Although neither of us intend on having the same, we dedicate this catalogue to Martha and Iris, and Hayden and Ethan, who have enhanced our understanding of the painter and most things of import in our lives.

Alison Smith
Jason Rosenfeld

Foreword

In his day, Sir John Everett Millais, Bt (1829–96) was regarded as the greatest of British artists, internationally renowned. His works were always widely shown, both within the UK (particularly at the Tate) and abroad. However, there has been no full-scale survey of his work in the past forty years (the centenary of his death passed almost unnoticed) and even the 1967 exhibition at the Walker Art Gallery, Liverpool, and the Royal Academy of Arts, London, did not examine the entirety of his career. The present exhibition is, in fact, the first since the Royal Academy retrospective of 1898 to attempt such an overview. I believe it offers many new insights to his work, not least through bringing together a magnificent group of the late landscapes which argue his case as a worthy successor, at one level, to Constable and Turner. Certainly he was very much more than a dazzling and prosperous painter of portraits and subject pictures. The exhibition reveals him as a painter of great emotional power and psychological acuity.

Millais looms large in Tate history. He was our founder Henry Tate's friend and favourite painter, active in his support for the establishment of the national gallery of British art at Millbank, and the subject of Thomas Brock's statue of 1904 that stands beside the building. And whatever the vagaries of taste and fashion, his *Ophelia*, part of Tate's founding gift, has remained one of the best-known and most popular of all individual works in the Collection. His output has been explored and contextualised in three recent exhibitions here: *The Pre-Raphaelites* in 1984, *Ruskin, Turner and the Pre-Raphaelites* in 2000, and *Pre-Raphaelite Vision* in 2004. The present project extends our understanding of him in further ways, revealing him as a complex figure, engaged with Realism and Aestheticism, and with surprising links to so-called progressive artists like Whistler, Manet and Sargent. A more international figure than is often assumed, his stature and influence have been somewhat overlooked in a climate of modernism, consigned to faint praise only for his undoubted technical brilliance. While it is not the particular aim of Tate Britain's exhibitions to upgrade critical reputations – rather, we aim to please the eye, illuminate the nature of accomplishment, and explore the texture of art history – there is every reason to believe that the twenty-first century may celebrate Millais as warmly as did the nineteenth. It is appropriate

and promising that the exhibition will be touring internationally, first to the Van Gogh Museum in Amsterdam, with whom we are delighted to be collaborating, and thence to the Kitakyushu Municipal Museum of Art and the Bunkamura Museum of Art in Japan, where Millais is already much admired.

The exhibition was proposed by and has been curated by Alison Smith, Head of Acquisitions, British Art to 1900, at Tate Britain, and Jason Rosenfeld, Associate Professor of Art History at Marymount Manhattan College, New York City. They have worked closely and productively together from the outset, and I want to thank them for their dedication to the idea of casting strong and fresh light on the familiar, as well as introducing to the public many lesser-known works in Millais's intriguing and varied oeuvre. Whilst charting a new course of analysis and interpretation, I know they wish to express their gratitude and admiration for the scholarship of Malcolm Warner and Mary Bennett. Warner's PhD thesis of 1985 and Bennett's 1967 Royal Academy exhibition catalogue provided the foundation for the provenance and exhibition history given in the catalogue and many other insights besides. Dr Warner, whose catalogue raisonné on the artist is in preparation, has been a most generous resource, patiently answering questions throughout. We should also like to acknowledge the important input of Paul Goldman, who acted as consultant to the show, advising on the selection of Millais's graphic works, including his designs for book illustration.

Our greatest thanks are due to the lenders of works of art, whose cooperation and kindness underpin the whole exhibition. I would like to make special mention of Sir Geoffroy Richard Everett Millais, for us a truly model descendant – generous with loans, visual and literary materials and copyright. Alison and Jason's acknowledgements make clear their additional debts on many fronts, especially to their colleagues across Tate, whose dedication to creating exhibitions of extraordinary quality is the bedrock of so much of Tate Britain's continuing success. And, as so often, the support of Tate Members has been crucial. It is much appreciated.

Stephen Deuchar
Director, Tate Britain

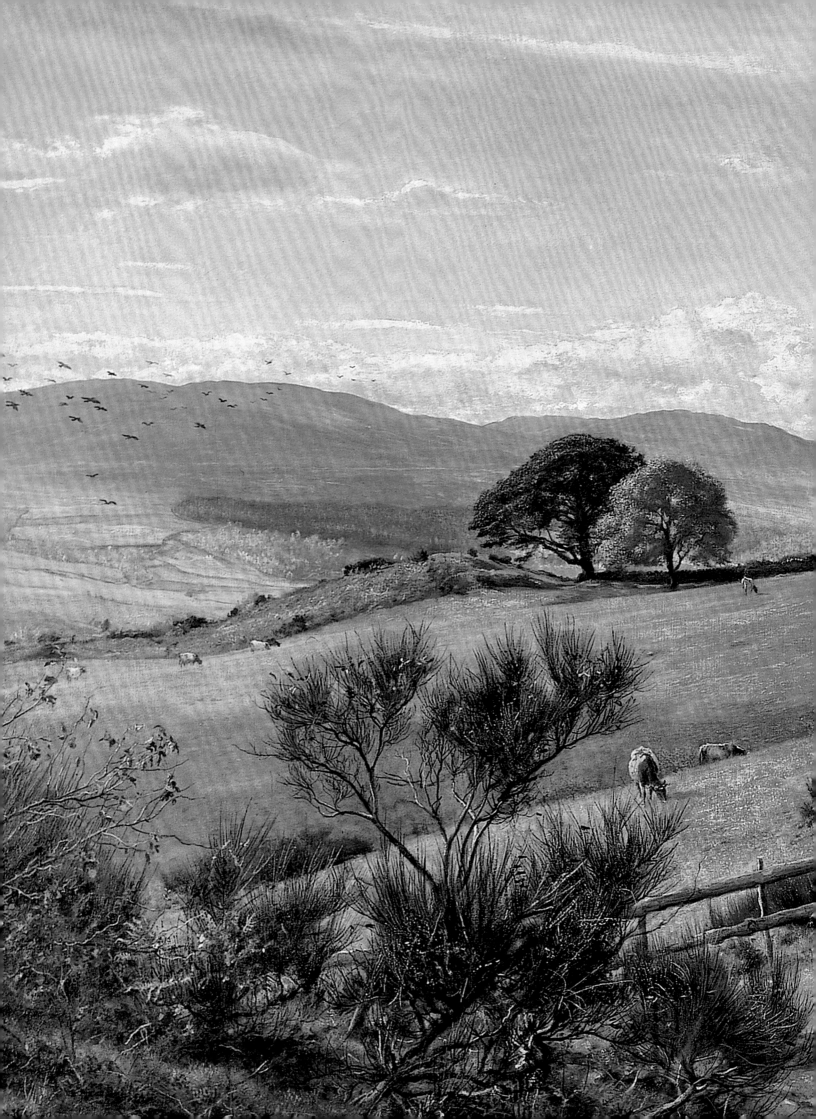

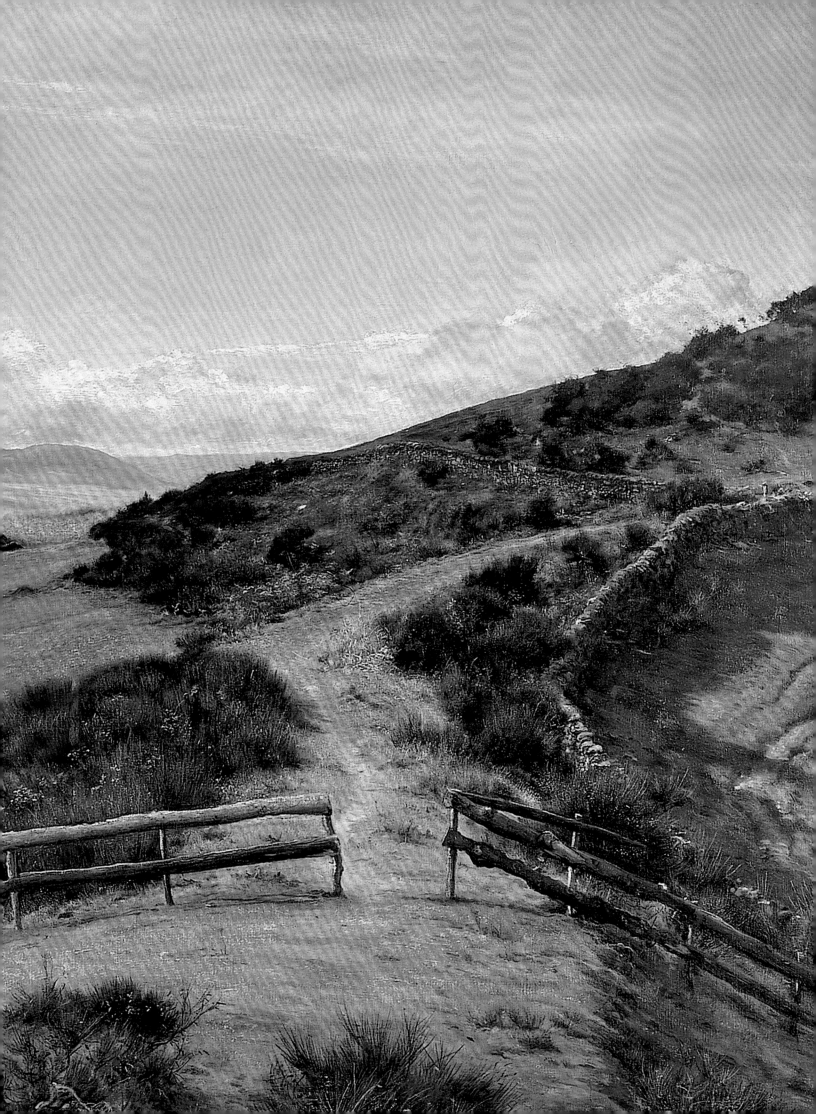

Millais in His Time and Ours
Jason Rosenfeld

The perception that the art of John Everett Millais (1829–96) was particularly English was a source of pride and pleasure to the artist himself, as well as to his critics and biographers in the nineteenth century. The same perception, however, which persists to the present day, hindered his reputation in the twentieth century, and his art has suffered from this provincial construction. It has proved difficult to overcome the image of the artist as deerstalker-clad sportsman, country gentleman and baronet seen in photographs, the affable man recorded in memoirs, and the fabricator of populist icons for an imperial age – constructions that later saw him fall in esteem as hard as any Victorian artist in the early twentieth century.[1] But Millais's works must be seen in a broader context than the nationalism of the Victorian era or the subsequent modernist desire for vengeance against its predecessors. Millais's works can now be seen to function powerfully in the cultural diversity of the modern Europe of the second half of the nineteenth century; he is an international figure, part of a more far-reaching and dynamic story of the arts of the period. It is certainly important to consider Millais's career in the small context of England, but it is also time to think of his work, in Milan Kundera's productive phrase, in the supranational history, the large context.[2] This has already been accomplished in terms of the various artists who have influenced his style over the course of his career: Hans Holbein and Lorenzo Monaco, Thomas Gainsborough and Joshua Reynolds, Diego Velázquez and Bartolomé Esteban Murillo, Rembrandt and Frans Hals. But what of his own impact, his reputation and effect on an international stage? This essay proposes some ways of inserting him into the broader currents of cultural production in the late nineteenth and early twentieth centuries, into what might be called a borderless art history, and of providing inspiration to artists in the wider strands of visual culture into the present time.[3]

On 17 March 1873, before departing in mid-May for London to work for the Goupil firm, the twenty-year-old Vincent van Gogh wrote from the Hague to his brother Theo: 'I am […] curious to see the English painters; we see so little of them because almost everything remains in England.'[4] Such was the result of economic success: one of the few products unavailable for export from England was contemporary art, for there were sufficient buyers in the country with enough means to support a robust market. By 1873, Millais certainly had little reason to seek clients abroad: he had a network of dealers in England eager for his pictures; he faced a long list of people keen to commission their own or family portraits; he had recently begun painting large-scale landscapes in order to give himself a reprieve from portraiture and expand his market; he received a significant income from the reproduction of his works in various print media; and his reputation was continually growing. And yet he constantly cultivated a broader presence and publicity through exhibiting in world's fairs throughout his life, and through engravings after his works that proliferated in foreign nations. Millais had an obvious and enduring effect on art in his country, but it is his influence beyond the provincial world of England, the demonstrable effect beyond the nation's borders, that reveals his larger importance in the period.

Van Gogh's taste was both catholic and conservative at this stage in his career, but his interest in Millais extended long after his later embrace of Impressionism, and then the evolution of his unique style in Arles.[5] It is worth considering what the artist saw in Millais's landscapes (and those of John Constable who made a similar impact),[6] and the possible effect on his style, especially as this exhibition will be shown in the museum that bears his name in Amsterdam, and in a country whose artistic traditions had, in turn, such an impact on Millais. The influence appears most evident in the dramatic, sweeping perspective of Millais's later pictures, their headlong rush into space, the collapsing of distance and foreground, the open brushwork pursued largely in front of the motif, and the elevated claims to intimacy and poetry within the landscapes. While in London, van Gogh saw many of Millais's oils, and also became familiar with his art through prints. He did not know the older artist personally, yet wrote to his brother Theo, 'Once I met the painter Millais on the street in London, just after I had been lucky enough to see several of his pictures'.[7] Their conversation is not recorded, but works such as *Chill October* 1870 (no.125) and *'Over the Hills and Far Away'* 1875 (fig.26, p.219) had a marked effect on his art, for at the time few artists other than Millais were painting such expansive and broad landscapes, remarkable for dispensing with traditional framing elements and notable instead for their trademark plunge into the distance. The sentiment of such scenes, the pathetic quality discussed in Alison Smith's essay, appealed to van Gogh, who maintained an affection for empathetic and literary art from Britain throughout his life, most tangibly in large binders filled with illustrations cut out from British periodicals, and most evocatively in his exceptional visual memory. He was perceptive about the poetic aspirations of Millais's landscapes:

> Personally, I find in many modern pictures a peculiar charm which the old masters do not have.
>
> For me one of the highest and noblest expressions of art is always that of the English, for instance, Millais and Herkomer and Frank Holl. What I mean about the difference between the old masters and the modern ones is this – perhaps the modern ones are deeper thinkers.
>
> There is a great difference in sentiment between 'Chill October' by Millais and 'Bleaching Ground at Overveen' by Ruysdael; and also between 'Irish Emigrants' by Holl and 'The Bible Reading' by Rembrandt. Rembrandt and Ruysdael are sublime, for us as well as for their contemporaries; but there is something in the modern painters that appeals to us more personally and intimately.[8]

In connecting Millais with the social realists Hubert von Herkomer and Frank Holl, whose illustrations in *The Graphic* and other publications van Gogh knew well, he united the three in terms of observational veracity and poetic appeal, as well as perpetuating the perspective of seeing Millais in terms of Englishness. For van Gogh, Millais conveyed the experience of being of the landscape, of immersion, not just seeing nature as a remote and awesome vista, as in the divinely illuminated but nonetheless prosaic panoramas of Jacob van Ruisdael and the seventeenth-century Dutch school. The communicative quality of these English pictures was an inspiration to the young Dutch artist, as he wrote from Etten to the painter Anton van Rappard:

> It is a pity that the artists here know so little of the English. [Anton] Mauve, for instance, was quite thrilled when he saw Millais's landscape 'Chill October', but for all that they do not believe in English art, and they judge of it in too superficial a manner, I think. Over and over Mauve says, 'This is literary art', but all the while he forgets that English writers like Dickens and Eliot and Currer Bell [Charlotte Brontë], and of the French, for instance, Balzac, are so astonishingly '*plastic*', if I may use the expression, that their work is just as powerful as, for instance, a drawing by Herkomer or Fildes or [Jozef] Israëls.[9]

Figure 1
The article by Salvador Dalí
(1904–89) featuring
Millais's *Ophelia*, *Minotaure*,
no.8, 15 June 1936, p.46
TATE

In his own landscape art, van Gogh would emulate the actual, the powerful and the poetic as conveyed in Millais's work. There is one further reference to Millais's Scottish landscapes in his letters, from 1883, again to Rappard: 'Adieu – may your work prosper – don't you think the weather glorious these days – a real 'chill October'? How beautiful the mud is, and the withering grass!'[10] Written early in the year, it is not a literal reference to the autumn month, but a connection with Millais's picture, remembered one decade later. Characteristically, van Gogh properly reads its sentiment, one of bleak beauty, a landscape of vast space and particular climate, bracing rather than wistful, a celebration of natural beauty rather than an expression of personal melancholy. It is a concrete yet poetic image of particularity, a modern mode of vision.

The history of modern art tends to make heroes of artists neglected in their own day who influenced later avant-garde developments; artistic predecessors gain a credibility often denied them by their contemporaries. In most tellings, Paul Cézanne is seen as the key figure for Modernism, due largely to his influence on Pablo Picasso, Georges Braque and Henri Matisse, the acknowledged leading lights of the early twentieth century. While Picasso acknowledged an early admiration for the work of Edward Burne-Jones, Millais lacked such champions at the key moment of modernist inception, and even early twentieth-century British artists turned to the Continent for inspiration. But it was a similarly eclectic symbolic realist, Salvador Dalí who, in the Surrealist magazine *Minotaur*, offered *Ophelia* 1851–2 (no.37) as a positive example of rejection, a credible and critical alternative to the Olympian order of Modernism, as already well established in 1936 (fig.1).[11] Dalí was entranced by Millais's depiction of the 'eternal feminine', and so linked his work to late nineteenth-century Symbolism in Europe, a movement now recognised as important to understanding modern culture, but then often seen as degenerate and degraded, fussy and sentimental, and not of sufficient formal interest as a path to formal abstraction. Dalí precisely intuited that the broadly popular *Ophelia*, with its gorgeous surface and mosaic-like coloration, a lush and hyper-real veneer, in conjunction with its disturbing exploration of mortality and sexuality, should be seen as anticipating the most trenchant psychological interests of the end of the nineteenth century.

For Dalí, the picture was not sentimental or mawkishly Victorian. The Catalan artist thus cut through the prevailing misapprehension about Millais. Millais pursued symbolic realism in an unflinching manner, whether in depicting people or landscapes. He eschewed the conventionally beautiful and the traditionally idealised, and often rejected the insistence of his contemporaries on a pre-existing idea of beauty. Such an approach drew both criticism and praise in his day.

Millais should also be seen in the context of modern practices in the making and promotion of art. Later in life, he substituted the Pre-Raphaelite insistence on present acuity of vision – such as the need to go to a carpenter's shop in Oxford Street in the late 1840s in order to paint accurate details of a carpenter's shop of the Augustan era in the Roman Empire – for the fixity of vision afforded by photography. He used photographic prints of both his portrait subjects and his portraits in progress, often marking these up before turning back to the canvas. His son Geoffroy helped him with his large-scale Scottish landscapes by supplying photographs of possible sites.[12] These, ultimately, do not betray the obviously collaged effects of the productions of P.-A.-J. Dagnan-Bouveret in France and the Newlyn School in England, whose landscape scenes and images of people in nature bear an inherent artificiality, interesting as a

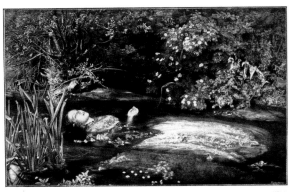

LE SURRÉALISME SPECTRAL DE L'ÉTERNEL FÉMININ PRÉRAPHAÉLITE

par SALVADOR DALI

L'histoire de l'art est à refaire d'après la méthode paranoïaque-critique. DALI.

La lenteur caractéristique de l'esprit moderne est une des causes de l'heureuse incompréhension du surréalisme de la part de tous ceux qui, au prix d'un véritable effort intellectuel, se bouchant les narines et fermant les yeux, essayèrent de mordre dans la pomme par excellence incomestible de Cézanne, se contentant par la suite de la regarder en purs « spectateurs » et de l'aimer platoniquement, puisque la structure et le sex-appeal du fruit en question ne permettaient pas d'aller plus loin. Ces gens sans appétit crurent que, précisément, c'était dans la simplicité de cette attitude anti-épicurienne que résidaient tout le mérite et toute la santé esthétique de l'esprit. Ils crurent aussi que la pomme de Cézanne avait le même poids que la pomme de Newton et encore une fois ils se trompèrent lourdement, car, en réalité, la gravité de la pomme de Newton réside par excellence dans le poids des pommes d'Adam des cous courbes, physiques et moraux, du préraphaélisme. C'est pourquoi, si l'on crut à tort que l'aspect cubique de Cézanne représentait une tendance matérialiste consistant en quelque sorte à faire toucher du pied ferme l'inspiration et le lyrisme, nous voyons maintenant qu'il ne fit que le contraire : accentuer l'élan vers l'idéa-

lisme absolu du lyrisme formel qui, loin de toucher terre, s'envola vers les nuages ce qui approcha Cézanne est, comme vous pouvez le comprendre, bien plutôt Le Greco que son prétendu et chimérique « Poussin d'après nature ». Par contre, ceux qui commencèrent à faire toucher véritablement des pied ferme l'inspiration furent précisément les languissants et soi-disant immatériels préraphaélites, lesquels, comme je le montrerai plus loin, érigèrent la véritable structure matérialiste du lyrisme en utilisant la « chaînette » et les « lignes géodésiques » de la légende structurale d'Europe.

Il est donc naturel que, lorsque Salvador Dali parle de ses découvertes paranoïaques critiques au sujet du phénomène pictural, les contemplateurs platoniciens de l'éternelle pomme de Cézanne ne veuillent pas prendre trop au sérieux cette espèce de frénésie qui consiste à vouloir tout toucher avec les mains (même l'immaculée conception de leur pomme), pis encore, à tout vouloir réellement manger et mastiquer d'une façon ou d'une autre. Mais Salvador Dali n'a pas fini d'insister sur ce côté hypermatérialiste, primordial à tout procès de la connaissance, de la biologie liée à la chair et aux os de l'esthétique — sur ce côté immensément solitaire,

46

modern practice in its own right. Nor do they resemble the recently discovered use of projected photographs of figures in the contemporary landscapes of Thomas Eakins in the United States. Rather, Millais used landscape photography to assist in broadening his vision, and in selecting anti-picturesque unobtrusive motifs. Harry Quilter castigated the artist for precisely this in 1888, describing *Murthly Moss, Perthshire* 1887 (unlocated) as:

a beautiful landscape *study*; *not a picture*. It is not a picture, because it shows us the sum of one impression of nature only, not the result of many; because its beauty is motiveless, as if the painting had been done by a camera instead of a human hand; because there is no evidence of selection of arrangement; because there is no personal note, no completed (or even incomplete) idea.

Here is a very simple proof of the truth of these objections. Look at the work for a short time carefully and a strange sense of incompletion – a deficiency of which we do not at first perceive the reason – comes over us. What is it that we lack? After a moment the answer comes clearly; what this study wants, is – *the rest of the landscape*! What does this mean? That the work has neither beginning nor end; that it is a piece snatched out of the middle of Nature's storehouse.[13]

Quilter touches on many such elements of Millais's late landscapes, which seem to reflect advanced tendencies in international art of the late nineteenth century, precisely what might have appealed to an open-minded young artist such as van Gogh: the unfinished and non-subjective view of a seemingly haphazard selection of natural elements; the lack of studied arrangement and composition; the objectification of the motif; and, crucially, its incompleteness, its fracturing of vision. Quilter did not know that Millais was using photography, and it is precisely the elements that the critic mentions, and criticises, that seem most interesting now.

With the exception of Dalí's paean to the artist, written evidence of Millais's artistic influence in the twentieth century is difficult to quantify. But Millais sought to disseminate his art and ideas widely from early on using the latest technologies, and refashioned his own professional image and activities, presciently constructing an artistic identity that gestures towards the era of Andy Warhol and Damien Hirst. He had a pragmatic, unromantic view of patronage, and although he exhibited regularly at the Royal Academy, he also eagerly endeavoured to sell his works through dealers, with or without copyright, and at times even before formally exhibiting them. In his maturity he would show simultaneously at multiple venues, whether at the traditionalist Academy, the more radical Grosvenor Gallery and its later rival the New Gallery, or at Thomas McLean's populist-inclined commercial gallery on the Haymarket. His embrace of the print market through reproduction in journals, and large-scale reproductive engravings and chromolithographs, was unprecedented in scale and thus extremely lucrative. His small watercolour variants and countless designs for illustration – the latter well represented in this exhibition – show his willingness to move across media in order to develop his aesthetic and simultaneously to secure his market. He also went to great lengths to persuade patrons to lend to the proliferating domestic and international loan exhibitions. This tapped into a growing publicity-seeking trend in contemporary art, one that came to full flower in illustrated publications, which ran lengthy articles on private collections in the late Victorian era. Millais's career parallels the growth at that time of the international celebrity culture of the art market, one that matches the dizzying profusion of contemporary art fairs in the early twenty-first century. Millais's international stature, unrivalled by any other British artist of the period, is too little remembered today. He won numerous prizes at a number of international exhibitions, orders of merit from academies across Europe, and was featured at the first Venice Biennale in 1895, one year before his death. His fame was substantial and international: *The New York Times* even included a note regarding the burning of Millais's rented house in Perthshire on 11 January 1892, a fairly minor incident.

Response to Millais on the Continent was largely enthusiastic, if not within traditionally avant-garde circles. The *Paris Daily Messenger* pondered questions of Millais's reputation in its obituary of the artist:

May not 'Dew-drenched Furze' and 'Chill October' have some merits which another age will discover, and to which we are merely blinded by the glare of neo-impressionist novelties? Is the taste for the 'North-West Passage' and 'Little Miss Muffat' [*sic*] hopelessly irreconcilable with art and Degas' 'Absinthe Drinker'?[14]

Walter Sickert, however, made light of Millais in 1917 in recalling an exchange with Degas:

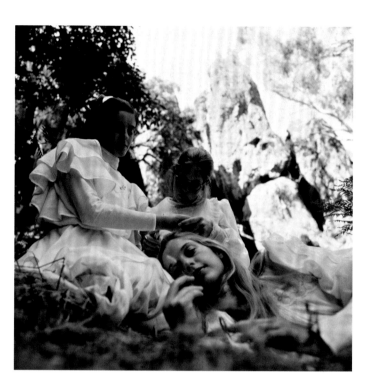

We were walking one morning down from Montmartre to go to Durand-Ruel's. Degas was dressed in a grey flannel shirt, a muffler and a suit that might almost have been ready-made. '*Ce n'est pas*,' I said, stopping as one does on the Continent [...] 'Sir John Millais would never show himself at Agnew's in that get-up.' He pulled up with mock indignation. 'Sir,' he said, 'when an Englishman wants to write a letter, he puts on a special costume, made to write letters in, and when it's finished, he changes back again! To look like a ragman, and be the great Condé; that's the way. Now isn't it?'[15]

Degas's opinion of Millais's pictures is not recorded. Other French artists were less circumspect. M.H. Spielmann wrote of *A Yeoman of the Guard* 1876 (fig.4, p.17): 'It was this picture which caused the French artists to exclaim at the Paris Exhibition of 1878, and opened Meissonier's eyes, as he himself said, to the fact that England had a great school and a great painter.'[16] Meissonier knew a thing or two about painting men in uniform, and was only one of a number of Continental and American artists who were moved by Millais's work and who corresponded with him, including Jules Bastien-Lepage, Albert Bierstadt, Benjamin Constant and the Spaniard Mariano Fortuny, the latter of whom Millais met in Paris in 1867 and who visited his studio many times.[17] Millais's influence on James McNeill Whistler and John Singer Sargent, those two most international of late nineteenth-century painters, has been well documented. It is important to reach a position in the comprehension of art of the late nineteenth and early twentieth centuries that values such interconnections, despite the lack of an obvious effect of Millais's work on the likes of Paul Gauguin, Henri Matisse or André Derain in Paris. Other avenues have been too little explored, such as possible connections to Gustav Klimt, Adolph Menzel, Alphonse Mucha or Gustave Moreau.

It is the parallels with such figures, themselves until recently

Figure 3
Barry Windsor-Smith
(b.1949)
Fallen Icarus
1980
BARRY WINDSOR-SMITH

overshadowed by a history of art dazzled by Impressionism, which might allow for a more nuanced understanding of Millais's later works – such as the portraits of Louise Jopling (no.118) and Kate Perugini (no.119), landscapes such as *'The Sound of Many Waters'* (no.130) and *Dew-Drenched Furze* (no.135), grand subjects like *Jephthah* (no.93), and Aestheticist works such as *Sisters* (no.90) and *Esther* (no.92). Here one sees the broad talents and vision of one of the most poetic and gifted artists of the period.

More recently, Millais and the Pre-Raphaelites have had a strong effect on visual culture, a rehabilitation emerging out of the same milieu that supported the grandiose Millais exhibition at both the Walker Art Gallery, Liverpool, and the Royal Academy in London in 1967, as well as major exhibitions on Dante Gabriel Rossetti, William Holman Hunt and Ford Madox Brown at around the same time. With this general resuscitation of Victorian art in the 1960s and the concurrent rise in prices, artists as diverse as Peter Blake, Graham Ovenden, a graduate of the Royal College of Art in 1968 and a founder of the Brotherhood of Ruralists in 1975, Gilbert & George, whose early work was inspired by the 'crazy colours' of Millais's and Pre-Raphaelite works,[18] and Lucian Freud in the same period, freed from the oppressive need to pursue only pure abstraction, welcomed the heightened vision and naturalist ethic of Pre-Raphaelitism in their painting. It is perhaps in film, and in the larger popular culture of the period that the influence was most tangible and effective. Peter Weir's film *Picnic at Hanging Rock* (1975) bore evident Pre-Raphaelite and Aestheticist intimations of adolescent female indolence, innocence lost and implied mortality (fig.2). Its complicated and radiant view of late Victorian sexuality leans heavily on paintings such as Millais's *Spring* (no.84) and features a montage at the end of the film with a shot of a reproduction of Frederic Leighton's *Flaming June* c.1895 that elucidates the film's coming-of-age at the turn-of-the-century theme. Wide-ranging films such as Jonathan Miller's *Alice in Wonderland* (1966), Michael Reeves's *The Witchfinder General* (1968) and Hollywood director Tony Scott's exceptional American Civil War short, *One of the Missing* (1971), made while at the Royal College of Art, treat landscape in a vivid and magnified Pre-Raphaelite manner initially established by Millais, and connect it symbolically with human passage and mortality. Similarly, the effect on popular music was trenchant, in both the content and visual accompaniment of bands such as Led Zeppelin, in their films (*The Song Remains the Same*, 1976) and album art (*Houses of the Holy*, 1973). Millais also had a significant effect in the realm of comic-book illustration in the period, inspiring the work of significant artists such as P. Craig Russell and East Ham Technical College graduate Barry Windsor-Smith, whose *Conan the Barbarian* (1970–4) and subsequent work established a new aesthetic benchmark for mainstream comic-book imagery (fig.3).

It is this Millais, the most culturally engaged artist of his time, the continually innovative painter, the canny self-promoter, the unrepentantly bourgeois yet non-aesthete Academician, the former enfant terrible and latter international celebrity, and the keen sportsman, that emerges when taking a wider view of his art. Neither a paragon of modernist alienation, a solitary genius seeking remove from urbanity, nor a recorder of modern life in the byways of London and its suburbs, Millais instead painted portraits of the city's most eminent participants, and developed his own concept of pathos and sentiment, one that appealed to people across a broad spectrum, from prime ministers of both parties to young and impressionable Dutch prospective artists.

The prevailing history of late nineteenth- and early twentieth-century artistic Modernism is marked by a focus on artists who initially operated at the margins, in tension with a perceived conservative/academic centre. The nineteenth-century's rich and diverse aesthetic mainstream was too easily disparaged by its inheritors, the angry young artists of the 1900s, and consigned to an obsolescence, both critical and cultural, from which it has never returned. Millais's career and the quality of his body of work give reason to reject this judgement, a century after it was formulated, as being too limiting, and now too dated a criterion for art-historical evaluation. A radical in his youth through his association with the ideas of Pre-Raphaelitism, a persistently innovative and creative artist in his middle period, producing works often incomprehensible to his peers and ahead of their time, and a strikingly successful Academician in his later career, Millais represents not the bland mainstream of British aesthetics in his lifetime, but its most challenging aspect. He was Britain's most connected practitioner in the full pageant of nineteenth-century art and society, the equal of literary figures such as Charles Dickens, George Eliot and Thomas Hardy. It is this Millais that emerges here, and it is this Millais who will continue to challenge the public and scholars in future.

'The Poetic Image': The Art of John Everett Millais
Alison Smith

John Everett Millais was the presiding artistic genius of his age, a painter who won widespread popularity through the sheer force and variety of his productions. As a eulogy published shortly after the artist's death in August 1896 proclaimed:

> The great characteristic of his whole life was an extraordinary activity, a constant striving to produce great results, and to strike out for himself new directions in which to exercise his exceptional powers.[1]

Pursuing a path that uncannily mirrors the artist's own body shape, Millais's art developed from the lean spiky formations of his Pre-Raphaelite youth, as seen in works such as *Isabella* 1848–9 (no.9) and *Christ in the House of His Parents* 1849–50 (no.20), to the robust manifestations of his corpulent maturity, typified by his candid yet penetrating society portraits, and stirring patriotic works like *The North-West Passage* 1874 (no.96) and *The Boyhood of Raleigh* 1869–70 (no.94). The dynamics of change that propelled Millais's art also made it resistant to classification, with the result that it has been variously identified as romantic, realist, aesthetic, Impressionist and symbolist, even though it is difficult and not very productive to place him securely in any one of these categories. If Millais can best be described as a symbolist of a realist nature, it was because of the unique way he focused on the ordinary particulars of existence as a means of investigating meaning beyond the viewer's apprehension of material reality. His refusal to engage with any transcendent Platonic visualisation of the Ideal, not only explains his omission from surveys of Symbolist art, but has encouraged the crude misunderstanding that in Millais's art what you see is all you get.[2]

Imagining the Artist: Millais in Literature

Millais's extraordinary success during his lifetime – the vast income he accrued through the sale of pictures and copyrights, his being the first ever native British artist to be awarded a hereditary title – invited criticism that, the more successful he became, the more his art began to compromise genius for material gain. This criticism was first articulated in 1882 when Emilie Barrington's polemic 'Why is Mr Millais our Popular Painter?' appeared in the *Fortnightly Review*, and became more controversial when Marie Corelli condemned Millais for sanctioning Pears' Soap's use of *Bubbles* 1886 (no.107) for advertising purposes in her novel *The Sorrows of Satan* (1895). It was not so much Millais's painting that was seen to be at fault (Corelli herself thought *Bubbles* worthy of 'the veneration that befits all great art') as the way he conducted his career.[3] Following Millais's death, the accusation became central to the ideology of the avant garde, for which honorary titles and commercial success were anathema to its notion of genius, which was increasingly defined in terms of a bohemian lifestyle, disdain of bourgeois values and an aesthetic born of a retreat from reality. Quality in art was thus measurable primarily in terms of integrity of existence, worldly success being a sign of insincerity, populism, and mere facility of technique. In his obituary of Millais, the editor of the decadent *Savoy* magazine, Arthur Symons, condemned the artist's mature output for sacrificing authenticity and integrity in order to serve the commodity culture of the day:

> he painted whatever would bring him ready money and immediate fame; and he deliberately abandoned a career which, with labour, might easily have made him the greatest painter of his age, in order to become with ease, the richest and most popular.[4]

The contrasting idea that art should serve a cultural elite rather than appease a mass audience formed the leitmotif of Olivia Shakespear's *roman-à-clef*, *Rupert Armstrong* (1898). This carefully researched novel drew on the writings of dissenters such as Symons to juxtapose the successful but popular Armstrong (the alter ego of Millais) with the 'unhonoured [...] genius of the pavement', Isaac Isaacson, an artist who a 'clued-in' reader would have recognised as Simeon Solomon, a painter also associated with Pre-Raphaelitism but whose career pursued an opposing trajectory to that of Millais.[5] In the novel, Armstrong's wife Eve is construed as a *femme fatale* – the instrument of her husband's downfall – who encourages the artist to 'sell his genius for a mess of pottage' in order to fulfil her insatiable appetite for luxurious living.[6] Such condign accusations, whether fictitious or biographical, became the norm during the twentieth century, with Millais's wife Effie held accountable for his supposed betrayal of his early aesthetic ideals.[7]

The moral aspersions cast on Millais's later productions, or the conflation between domesticity and prosperity on the one hand, and aesthetic lack on the other, had the long-term effect of severing his Pre-Raphaelite creations from his subsequent painterly works, thereby fragmenting the artist's identity into what the painter Walter Sickert described as a 'terribly fluctuating line' of hits and misses.[8] The myth that developed around Millais in the wake of his marriage, parenthood and move to the palatial house in Palace Gate, had the negative effect of divesting his work of any integral artistic merit, despite the influence of the artist's son John Guille Millais's hagiographic biography of 1899 in projecting the opposite view, that his father's greatest achievements paralleled the financial success of his maturity.[9] Family and friends apart, the fact that Millais was without a consistent literary champion from the time he broke with Ruskin made him susceptible to critical opprobrium. However, it was the compelling beauty of the key works that punctuated the painter's career which disturbed the tendency of his critics to equate the circumstances of the artist's life with the quality of his art. In *Rupert Armstrong* Shakespear describes a number of Armstrong's works through the character of the painter's daughter Agatha. These would have been recognised as verbal evocations both of works by Millais and descriptions of his pictures by art critics. The elegiac character of the artist's late Scottish landscapes is a theme that hallmarks his obituary notices, and this is something Shakespear tunes into with Agatha's description of Armstrong's *Lonely Moor*:

> But there was one landscape I liked: a lonely moor, stretching to a belt of trees, and a gray sky, such a scene was common enough; but some sadness in the painter's soul had expressed itself in the picture, and I felt moved by it, almost to tears, as in my childhood days.[10]

Shakespear's fictitious painting *The Reapers*, in front of which Agatha experiences a moment of aesthetic epiphany, can be read as a homage to *The Blind Girl* 1854–6 (no.62) and, more particularly, *Autumn Leaves* 1855–6 (no.82):

> I had left the world outside splendid and in colour; I found it here again glorious in yellow-corn, and purple distance, and perfect, delicately vivid flowers among the wheat [...] in the midst was a young girl; her hands were idle; she looked at me with my own eyes, gray, wide open; she had my ruddy health, and red-brown hair; like mine, her harvest was not sown.[11]

In the novel Agatha's encounter with *The Reapers* stirs intense feelings of pleasure mingled with pain, inviting her to fathom the deeper meaning of beauty and its relation to the idea of life lived as art.

Another instance of a painting by Millais infusing the pages of literature is the emblematic role ascribed to *Ophelia* 1851–2 (no.37) in Natsume Soseki's *The Three-Cornered World* (1906). Soseki, one of the first Japanese writers to be influenced by Western culture, saw the painting at the Tate Gallery on his visit to London in 1901. His novel is about a painter who seeks to immerse himself in nature in order to escape emotional entanglement, but finds himself fascinated by the alluring mistress at an inn. Inspired by thoughts of Millais's *Ophelia*, he imagines painting the mysterious woman he has encountered:

> I believe it was Swinburne who, in one or other of his poems, described a drowning woman's feeling of joy at having attained eternal peace. Looked at in this light, Millais' 'Ophelia', which has always had a disturbing effect on me, becomes a thing of considerable beauty. It had been a constant puzzle to me why he had chosen to paint such an unhappy scene, but I now realised that it was after all a good subject for a picture. There is certainly something aesthetic in the sight of a figure being carried along by the current free from all pain, whether it be floating, beneath the surface, or rising and sinking by turns. Moreover, it will undoubtedly make an excellent picture if both banks are decked with many kinds of flowers whose colours blend unobtrusively with those of the water, the person's clothes and her complexion. If the facial expression is perfectly peaceful the picture becomes almost mythical or allegorical. A look of convulsive agony will destroy the whole mood, while one which is absolutely composed and devoid of all passion will fail to convey any of the girl's emotions. What expression ought one portray to be successful? It may well be that Millais' 'Ophelia' is a success, but I doubt whether he and I are of the same mind. Still, Millais is Millais, and I am myself; and I wanted to express the aesthetic quality of drowning according to my own convictions.[12]

The passage is worth quoting at length because, like Shakespear's allusion to *Autumn Leaves*, it underlines Millais's skill in discovering the aesthetic means of expressing the ineffable, and how he was capable of using recognisable external form to mirror the viewer's inner experience.

New for Old
Millais's paintings typify the historicist yet eclectic culture of his day in that they display a keen awareness of the art of the past as well as revealing a strong sense of responsibility for those traditions he acknowledged in his work. 'Pre-Raphaelite', for example, was chosen as a label for the movement Millais helped establish because it referenced a particular style within art history. However, in an age acutely aware of patterns of artistic inheritance and legacy, it is significant that Millais established no school or group of followers. It is because he was such a constant innovator that one can only talk about the impact of particular works rather than his style as a whole. *Ophelia* is probably the artist's most influential painting in this respect, inspiring a succession of images of fey women transported down river to a premature death, such as John William Waterhouse's *Lady of Shalott* 1888, in which the clump of reeds, similarly placed in the bottom left corner, evoke a parallel mood of mutability. By refusing to adhere to any single tradition Millais could be characterised as an eclectic, an exponent of a *juste milieu* tendency in nineteenth-century art in his

assimilation of a sequence of prototypes ranging from Jan van Eyck to Diego Velázquez. 'Painting is quite hard enough,' he was quoted as saying, 'without narrowing one's vision or focusing one's idolatry.'[13] Despite the range of influences on Millais's vision, it is nevertheless difficult to pinpoint precise sources. His works certainly reverberate with echoes of past masters, but the influences are so subtle and masked that they elude definition. Thus while many of Millais's Pre-Raphaelite associates latched on to the convex mirror in the celebrated van Eyck *Arnolfini Portrait* 1434 as a device for exploring the boundary between illusion and fantasy, Millais rejected such overt quotation, preferring to acknowledge the signifying power of the motif in a more oblique way as in, for example, *Mariana* 1850–1 (no.22) and *The Bridesmaid* 1851 (no.27), both of which use body language and expression to dramatise the idea of an inward gaze.[14] Although paintings such as *Hearts Are Trumps* 1872 (no.110) and *Cherry Ripe* 1879 (no.106) can be seen as more performative re-inventions of particular works by Joshua Reynolds, the relationship between the two artists is less concerned with emulation than with updating, parody and the projection of difference. Millais maintained an essentially ambivalent relationship with tradition in that, while he recognised the Reynoldsian idea of quotation, he ventured beyond assimilation by using the past as a testing ground against which he could assert his own self-determination as an artist.

Pre-Raphaelitism was crucial to Millais's development because it was his involvement with the movement that identified him as the avant-garde rebel against whom his later works had to be measured. Although it is possible to argue that Pre-Raphaelitism was only of passing significance for Millais who, as a child prodigy, seemed inevitably destined for greatness, it must have been an all-consuming passion for him to so wholeheartedly reject the trappings of his early precocity and so openly risk the vitriol of critics and the art establishment. Pre-Raphaelitism was an avant-garde movement in that it heralded a break with precedent and was orientated towards the future development of art. The idea of striking out in a different direction can only take place in a culture with a strong sense of history and one that construes the chronology of art along both temporal axes. To be avant garde thus presupposes a belief in the evolution of art, an awareness that was acute during an age when museums and galleries were being established in Britain for the first time. Where Millais's early work was so outlandish was in its acknowledgement of the past in order to deny 'art' as it was understood in the culture of his day. Thus *Isabella* is laden with visual allusions to the past from Hans Memling to Paolo Veronese, but such hints are overwhelmed by the symbolic white leg that slashes across the composition. This was a device that shocked Millais's audience into recognising that here was an artist who wanted to start afresh in rejecting established convention. A key reason why Millais and his colleagues referenced medieval art as a more authentic model for innovation was because they believed it to be less governed by formula and more receptive to empirical formation than the styles that had predominated since the Renaissance. Paintings such as *Isabella* and *Ophelia* were revolutionary in that they were constructed on principles diametrically opposed to academic rules of picture making. Thus Millais's gesture in painting *Ophelia* of 'applying a magnifying glass to the branch of a tree he was painting, in order to study closely the veins of the leaves', was in effect a repudiation of the abstraction from nature deemed necessary for a finished painting.[15] The Pre-Raphaelite principle of looking inwards was conducted with the intention of relaying the sentience and morphology of forms, and it was this concern to illuminate the vitality and

complexity of phenomena that remained with Millais throughout his career, as borne out by the emphasis he placed on psychological truth in both his portraits and subject pictures. His quest for authenticity of experience further explains his continued aversion to classicism as a style, as he set down in an address to art students in 1875: 'no man is a really fine draughtsman who cannot disentangle himself from classical regularity [and represent, ...] when called upon, the eccentricities and infinite variety of nature.'[16]

Psychology

Pre-Raphaelitism can also be said to have established Millais as a pioneer of modern psychology, particularly in the way he focused on physical appearance to probe unconscious desires and impulses, or to underscore what Sigmund Freud later termed the 'psychic energy' within human personality. For Millais and his Pre-Raphaelite brethren, the expression of character in painting depended upon the direct observation of life. Rejecting the academic principle of idealising appearance, they upheld individuation as the key to disclosing inner spiritual and emotional experiences. Michael Fried's concept of 'absorption', which he applied to French eighteenth-century painting, is relevant here, in the way Millais focused attention on a person engrossed in a particular activity as if unaware of an audience.[17] A key example of absorption in Pre-Raphaelitism would be the diagonal line of faces in *Isabella* and the study for *A Baron Numbering His Vassals* 1850 (no.18), in which each figure is engaged in some prosaic activity, either a reflex action, such as the fief nervously biting the feather in his cap in no.18, or more conscious gestures like the figure carefully wiping his mouth in *Isabella*. What is significant about these compositions, especially regarding their projected scale, is that both can be described as non-events in that they deliberately eschew a dramatic focus. Instead, Millais uses expression to point to a hidden agenda as well as the emotion that belies the surface of ordinary appearances.

Despite plans for other multi-figure compositions, it is significant that Millais produced only two large-scale group paintings during his Pre-Raphaelite period. After *Christ in the House of His Parents* he increasingly turned to couples or single figures in order to focus more intensely on intimate representations of private moments. Eroticism forms the leitmotif of several of these paintings, for example the longing for consummation in *The Bridesmaid*, frustrated desire in *Mariana*, and embryonic sexuality in *The Woodman's Daughter* 1850–1 (no.23), and this is something Millais projects through the adoption of close-up perspectives or by obliterating the boundary between participant and viewer. The intensity of feeling relayed in these compositions through rich colour, claustrophobic setting and bodily expression, finds a parallel in the poetry of romantics like John Keats and Alfred, Lord Tennyson who, in works like *St Agnes' Eve* and *Mariana*, employ sensual imagery and elaborate language to project similarly heightened subjective states of mind. In his interest in portraying emotional physicality, Millais was certainly in advance of Dante Gabriel Rossetti, who did not adopt similar formats until the late 1850s. Rossetti's iconic heads also project a more essentialist idea of female sexuality, while Millais's unidealised figures offer a more nuanced view of how feeling manifests itself through external appearance. And whereas Rossetti employs symbols to offer multiple associations, Millais represents objects in a more material way to reinforce the emotional charge of an image. Thus a sugar caster features significantly in a number of early compositions and is used by Millais to

signal the boundary between the physical world and experience that transcends bodily existence, such as mortality in *The Death of Romeo and Juliet* c.1848 (no.7), religious exultation in *St Agnes' Eve* 1854 (no.28) and sexual initiation in *The Bridesmaid*. The repeated use of this motif forms part of a vivid and highly inventive iconography of feeling, an iconography that complicates rather than merely embellishes the hidden dynamics of a subject.

Around the time of his marriage to Effie, when Millais was spending prolonged periods of time in the company of her adolescent sisters, Millais pioneered a type of female portrait in which the burden of feeling was concentrated in the face, but in which the figure's expression appeared blank, as if denying access to the inner recesses of the mind. Like photography, this was a type of portraiture made more expressive by virtue of being enigmatic. While such images encouraged the viewer to draw psychological meaning from costume and surrounding environment, as in *Wandering Thoughts* c.1855 (no.64), in which the black dress prompts the association of death and memory, or *Autumn Leaves*, where the autumnal setting evokes a sense of transience, the power of such images ultimately depends on the projection of the viewer's experience on the interiority of the model, whose abstracted expression invites the imposition of sentiment. Indeed, the perceived vulgarity of Millais's female types of the mid-1850s is testimony to their power of communicating on an immediate physical and emotional level, beyond the trappings of dress or accoutrement. Millais abandoned such heads in his later work as he developed the genre into a more lucrative kind of 'fancy picture', and as he focused the psychic energy within individuals more on representations of old age. Inspired in part by the portraiture of Rembrandt, Millais sought to relay individual experience by attending to the concentrated energies arising from a face. Rejecting the Reynoldsian approach of conveying personality through appropriate Old Master models, with Millais's aged heroes, feeling is concealed within a prescribed social role. The defiant veteran mariner in *The North-West Passage* is one instance of this tendency, but probably the most famous example of existential isolation within a role was the *A Yeoman of the Guard* (fig.4), exhibited at the Royal Academy in 1877. On one level this is a portrait of a recognisable individual, John Charles Montague, a Corporal in the 16th Lancers who had served for more than twenty years in India and who, following his retirement in 1847, had been appointed to the Yeoman of the Guard (a veteran company of picked soldiers, distinguished by their original costume, employed on special occasions as the sovereign's bodyguard). With his upright posture, competent gaze, fixed jaw and raised eyebrows he is shown suffused with a sense of duty. However, as a fancy picture of an old man holding his papers as he waits at his post for the roll-call that will dismiss him from his position, his lack of resignation adds pathos to the image. For William Michael Rossetti it was the contrast between the intimations of the gaudy red uniform and extreme age that infused the image with 'genuine pathos', making it, perhaps surprisingly, Millais's 'singular masterpiece'.[18] Increasingly in his later work Millais would cast an individualised 'real' head into an easily legible, standardised plot, in the case of the *Yeoman* into the archetypal myth of the humility that comes with extreme age. With his new psychological realism it became Millais's mission to revivify the popular category of 'literary' painting by imbuing it with a depth of feeling unprecedented for his time.

Pathos and Poetry

The viewer's awareness of feeling in Millais's work owes much to him being a painter-poet, in the tradition of William Blake, J.M.W. Turner and Rossetti,

Figure 4
A Yeoman of the Guard
1876
TATE

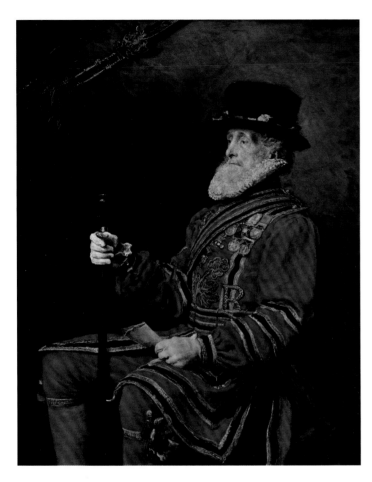

with the difference that Millais's writings are not well known and had an
ancillary relationship to his art. Much of his poetry dates from the later
part of his career and, although not directly related to specific pictures,
connects with them in terms of feeling and humour, particularly themes
of memory, loss and the struggle to discern meaning in an alien
environment. Just one example from a cluster of poems among the Millais
papers in the Pierpont Morgan Library, New York, is the selected verse
from a long poem he wrote, perhaps as an articulation of the inner
paralysis he experienced when struck dumb in the final stages of illness:

I had a dream that I was walking
By moonlight down a country road.
And heard a hum of voices talking
Far off from any fixed abode.

And coming to an open space,
I looked upon a mighty field,
And saw a strange thing for the place
A curious unexpected yield.

At first I took the crop for wheat,
And then for poppy as the ear
Was round and larger than is meet
For any common grain to wear [...]

And as I looked I clearly saw,
What filled me with a sudden dread,
That every individual straw
Upheld a living human head [...]

Then as I turned to leave the ground
To leave the grim uncanny plot
I felt that I myself was bound
And rooted to the very spot

Surprised, I thought it was a spell,
I laughed a little laugh of scorn
But at a glance I saw too well
Below I was a stem of corn

And agonised I fell a sobbing
Alas I had no heart to break,
I felt my brain as usual throbbing
But nothing downwards left to ache

Quite powerless I knew my fate
Another skull upon a stalk
Still able to communicate
Although prohibited to walk [...][19]

What linked poetry and painting for Millais was the artist's ability to stir
a mutual feeling within the spectator and to communicate emotions that
resided at a primal level of consciousness. His long-standing love of music
is also central to our understanding of his work, not in the Whistlerian
sense of the abstract disposition of forms within a composition, but in his
concern to strike sympathy within the beholder. As Millais set down in an
undated private note:

> In a room where there are many pianofortes together, strike the keys of
> one of them, and all the surrounding instruments will give a faint echo
> of the dying accents. In like manner the Poet springs the Chord, and
> we all partake of the vibration he has set in motion. [He] has created
> nothing in us, he has only awakened what was dormant, reminding
> us that if we possess an analogous system of sensibility, wires and
> sounding board as well as he, they are mute.[20]

Here Millais seems to be referencing the sympathy-based moral
sentimentalism of the Enlightenment philosophers David Hume and
Adam Smith, in enunciating a similar belief that human communication
is dependent upon empathy between individuals and that the purpose of
art is to stir mutual feeling within the spectator.[21] However, it was Millais's
aim to redirect what was formerly an elite and rare quality into something
more widely accessible, a bold manoeuvre in a culture that was widely
perceived to have commodified, even degraded, sentiment through the
mass dissemination of sentimental imagery, ranging from Keepsake
Beauty prints to Academy oil paintings.[22] By positioning himself as the
painter of meaningful feeling, Millais was in effect modernising the
Enlightenment concept of sentiment by imbuing it with a tension, and
seeking to make it relevant to the more populist age in which he lived.

The power of Millais's works to stir emotion in the spectator probably
explains why, more than any other painter of the period, his pictures
invited ekphrastic interpretation. This is testified by the sheer number
of poems composed in response to particular paintings, notably the late
landscapes, many of which were published in the immediate aftermath
of the artist's death and which can be seen as elegies for the passing of
the creative energy that brought such deeply felt imagery into being.
Millais's paintings are in essence poetic images. A poetic image, according
to the poet and literary scholar C. Day Lewis in his magisterial book
of that title,

> is a more or less sensuous picture in words, to some degree
> metaphorical, with an undernote of some human emotion in its context,
> but also charged with and releasing into the reader a special poetic
> emotion or passion.[23]

This definition is applicable to Millais's art in that it was similarly
concerned with relaying to the viewer something more than an accurate
reflection of external reality; in other words, it appealed to forms of
expression other than the purely visual, such as poetry and music.

One of the reasons why Millais's late landscapes elicited ekphrasis
was because his recreations of observed scenes communicated sensations

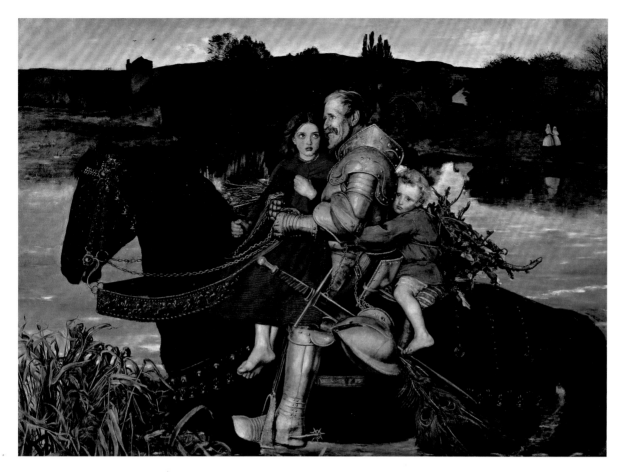

associated with the experience of looking. His predilection for divesting nature of human beings and of giving poetic titles rather than referring to specific locations, allowed him to play down topographical interest in order to intensify the spectator's empathetic engagement in terms of the feelings his works conveyed. As *The Times* noted with reference to the artist's landscape exhibits of 1875:

> his landscapes are empty; his desolation is not abominable, since it is peerlessly beautiful, but it is not the less desolate, and produces dejection; and, moreover, he refuses to give his roomy bird's eye view a local habitation and a name [...] Turner was vague in his nomenclature when he grew old, but not so vague as this.[24]

By withholding information, even though his landscapes were based on particular sites, Millais used pictorial qualities to orchestrate emotion in the beholder, without resorting to decorative effect. His exuberant calligraphic brushwork thus conveys the dynamic of natural phenomena, as with the tangled timbers in the foreground of *Winter Fuel* 1873 (no.128), while the sweeping impression of space in a work like *The Fringe of the Moor* 1874 (no.129) is imparted by the high suspended viewpoint. Tonal modulations of sombre colour enlivened by bright touches reify and unite disparate elements within a composition, reinforcing the physical sensation of being immersed in a particular environment, as in *Christmas Eve* 1887 (no.133), where the alienating cold of the winter twilight is conveyed by the mottled hues of snow and blinding light of the setting sun that illuminates the windows of Murthly Castle, making it unclear whether the building is inhabited or not. It is the human element in Millais's landscapes (whether peopled or not) that invites sympathy or a sense of longing for what is lost or absent, and here lies the sense of nostalgia his scenes impart to the viewer.

Millais's art is both realist and symbolic, not only in its freshness and evocativeness of imagery, but by virtue of its preoccupation with the sense that a person's apprehension of mundane reality opens up a perspective of uncertainty on existence. This awareness, expressed in Millais's art through the relation of the natural world to human experience, relates to both Keats's theory of Negative Capability and the 'honest doubt' that permeates Tennyson's poetry, especially *In Memoriam*. The romantic awareness that a close inspection of nature intensifies mystery first manifests itself within Pre-Raphaelitism, in the complex micro-systems that counterpart the predicaments of his human protagonists, for example, the sprouting forest in *The Woodman's Daughter* that foreshadows the budding sexuality of the children, or the intricate patterns of undergrowth in *Ferdinand Lured by Ariel* 1849–50 (no.15), which connects more with the grotesque world of faery than the urbane courtly society represented by the prince. However, while the precise itemisation of Millais's Pre-Raphaelite manner establishes the unique character of each object with the effect of estranging figures from the environments in which they are set, the broader style he adopted in his maturity endows the represented scene with the feelings and sensations of the onlooker rather than asserting the separate identity of both. It is significant that, following a Ruskinian phase of development in the early 1850s, Millais's work starts to be characterised as 'pathetic'. This term was not intended to be in any way derogatory, but refers to the way he endowed inanimate natural objects and prospects with human emotions and associations. Spielmann was thus inspired to write of *Chill October* 1870 (no.125): 'There is pathetic desolation throughout the whole marshy expanse, and the reeds whistle sadly as though Syrinx herself were among them'; while the *Athenaeum* said of *Lingering Autumn*:

> The charm the poet found in fair but fading human life the painter has recognised in the beginning of the year's decay [...] Its subject is the serene charm, the tender pathos of incipient decline, more beautiful because more touching than the earlier splendours of the year.[25]

The Ruskinian concept of the 'pathetic fallacy', 'a falseness in all our impressions of external things', coined in relation to literary criticism in

Modern Painters III (1856), could be applied to Millais's work of the same period and thereafter, in the sense that what he depicts does not just exist as a truthful representation of the world as it appears to the senses, but partakes an extra psychological dimension.[26] Thus the objects that fill the room in *The North-West Passage* increase our sympathy for the old man's immobility in light of his former adventurous existence, while the penumbral spiky terrain that forms the setting for *St Stephen* 1894–5 (no.99) creates a harsh location in order to accentuate our awareness of the release from pain that marks the martyr's death. By embedding features within the fabric of the canvas through dense gestural brushwork, Millais could further be seen as seeking a fitting 'objective correlative' for the emotion he wished to express. This was a term employed by Washington Allston in the 1840s to describe the way an artist uses objects or a situation to evoke a desired emotion. However, for Ruskin, the 'pathetic fallacy' was a scientific failing in that it appealed primarily to the imagination rather than presenting an accurate depiction of nature. His intense dislike of Millais's *Sir Isumbras (A Dream of the Past)* (fig.5) was because he felt the artist was moving away from the loving depictions of nature he so admired in works like *The Return of the Dove to the Ark* 1851 (no.25), towards an exaggerated theatricality, an effect he ascribed to the illogical spatial relationships between the figures and setting and a perceived inconsistency in lighting. The liberties Millais took with this design certainly influence our response to what might otherwise be appreciated as a contemplative autumnal scene. The severity of features, such as the silhouette of the horse and armour of the knight,

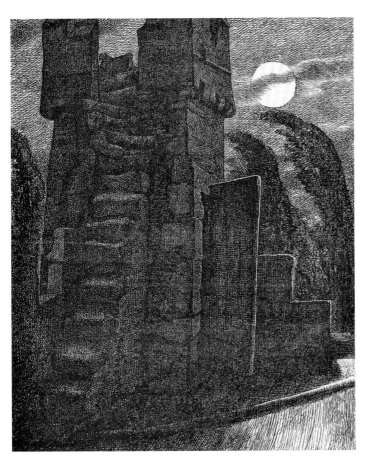

jars with the tender bare limbs and anxious expressions of the children accentuating their vulnerability, while the mysterious nuns in the distance, in keeping with the painter's earlier use of these figures in his art, alludes to a longing for the afterlife, thereby increasing awareness that the children hover on a precarious boundary separating life from death.

Millais embraced the pathetic as he increasingly advanced a manner that projected his subjectivity as an artist, hence the concomitant development in his art of a looser, more assertive technique in contrast to the minute finish of his Pre-Raphaelite works, which signals the submergence of his identity within a style. The 'pathetic' also relates to his work as an illustrator, which got underway from 1852 and continued throughout his career. What is distinct about Millais's designs for wood engravings is the way he employed physical objects to create an atmosphere that parallels the mood of a poem even if it does not fully respect the imagery of the text itself. A key example of this is his extraordinary design for Tennyson's *The Sisters* (fig.6). The poem concerns the sexual conquest and murder of an Earl 'fair to see' by one sister, in revenge for his seduction and the subsequent death of her sibling, but Millais relays the macabre nature of the subject not by representing actual persons, but by suggesting the motivation of the unseen narrator through sinister tomb-like towers whose illuminated monolithic forms stand firm against the wind that blows the surrounding trees. Likewise, in his Anthony Trollope illustrations, Millais utilises the mechanics of modern costume to tease out social and sexual tensions between characters in a way that enhances the reader's appreciation of a situation.

Millais's late subject pictures have been dismissed as 'illustrative', but this is a misunderstanding of how he redefined the very concept of illustration in relation to his art. Educated in a system that prized the text above the visual image, Millais strove to reverse that relationship or to posit a synergetic dialogue between the arts, both through his strategy of illustrating non-existent texts, as in *Sir Isumbras*, or by uncoupling an illustration from its source to offer his own psychological interpretation of a chosen theme, as instanced by *The Sisters*. It is this latter approach that unites an etching such as *The Border Witch* 1862 (no.78) with a history painting like *Esther* 1863–5 (no.92), the overriding aim being to allow pictorial elements to trigger narrative in the mind of the viewer, who becomes a proactive agent in the creation of meaning rather than a passive recipient of received information. The key to Millais's art is thus the relationship he invites between the subjectivity of the beholder and the subject of representation. It is not conventionally illustrative in that it ranges beyond replication, yet it is too embedded in material reality to justify the appellation 'aesthetic'. Millais's art has many affinities with Aestheticism, namely its appeal to musicality, and sense of design and colour, but unlike painters such as Frederic Leighton, James McNeill Whistler and Rossetti, it is too rooted in empirical sensory experience to aspire to a transformed ideal of reality. It is nevertheless possible to contend that Millais was in essence a symbolist, seeking through his struggle to capture the fleeting world of appearances a subjective awareness of the impact of time and memory on human psychology. His final paintings express a keen awareness of the liminality of existence in probing the polarities of youth and age, and the boundaries separating temporal experience from uncertainties beyond consciousness. In his quest to probe the sensibilities of modern life Millais assumed the role of a poet in paint, and in so doing he occupied a unique position in the visual culture of the nineteenth century.

1
Pre-Raphaelitism

Pre-Raphaelitism

In the three years that separate *Pizarro* (no.5), the picture with which Millais made his debut at the Royal Academy in 1846, from *Isabella* (no.9), one of the works that launched the Pre-Raphaelite Brotherhood, Millais's art underwent a dramatic transformation. *Pizarro* is couched in the bombastic language of the Baroque, with its incisive diagonal rhythms and emphatic three-dimensional construction of form. In rejecting this style Millais was in effect denouncing the associations that underpinned the Grand Manner of the European Baroque and British academic painting. *Pizarro* represents a momentous event in world history and accordingly arranges form in a hierarchical manner so as to present a legible drama in which all the main characters have their allotted place. Questions such as whether the brutality of the conquistadors was inspired by God or gold are not addressed: the public language of the Baroque was a crude tool for exploring the subtleties of human motivation, and Millais's main concern here is how to present the climactic moment of a well-known narrative. He rejected such operatic illusionism in *Isabella* and *Christ in the House of His Parents* 1849–50 (no.20), ultimately because he wanted to probe the psychology of human relationships. These paintings are not only signature announcements for the radical Pre-Raphaelite style, but also expressions of Millais's frustration with Old Master conventions. Thus both of these works are deliberately conceived as non-compositions, with features laid out almost like a child's drawing in denial of the sophisticated patterns that comprised the academic tradition of history painting. In so doing Millais was seeking to re-orientate the viewer's attention towards an understanding of how the quirks and specifics of physiognomy and objects could open up more profound insights into a particular situation. His principle of leaving the drama in suspension, or unfinished, is further evidence of his disavowal of conclusive devices and of his preoccupation with the indeterminate nature of human expression. Moreover, with Pre-Raphaelitism Millais's art

projected a rhetoric of humility. Rejecting the absolute political statements of the Grand Manner, his art drew on a romantic reverence for nature in assuming an organic interrelationship between human beings and the environments they inhabit, but with the aim of expressing doubt or incompleteness. Paradoxically the movement's respect for the 'primitive' art of the early Renaissance period was based on what they saw as its visual and psychological complexity in contrast to the perceived superficiality of the art that followed in the wake of the Renaissance.

Whereas Millais's first Pre-Raphaelite paintings can be seen as an abrupt volte-face in his style, his drawings reveal a more even line of development. As a young artist Millais was attracted to the cleanness of outline associated with Neo-Classicism, particularly the engravings of John Flaxman. Flaxman's manner was also influenced by the German linear graphic style exemplified by Moritz Retzsch (1779–1857) and promoted by the subscribing organisation the Art-Union. The Pre-Raphaelite Brotherhood grew out of the Cyclographic Society, the sketching organisation to which all the painter members of the movement belonged. At meetings each participant would be asked to make a drawing, often on a set subject, which was circulated for written comment by other members. The roots of Pre-Raphaelitism as a shared ethos can thus be found in graphic art, which further explains the group's antipathy towards what they disparaged as the mucky medium of oil paint. The importance of draughtsmanship in establishing the group's identity helps explain why their early paintings have the appearance of drawings worked up into paint, all being executed with small strokes in a similar piecemeal fashion.

Although it is not entirely clear if the various artistic personalities connected with the Pre-Raphaelite group came together deliberately in order to direct a revolution in style, or

whether vice versa, it was their bonding as a group that was the catalyst for such a change, the individuals involved certainly felt braver as a cohort. The vexed question of how art should proceed following a perceived crisis in history painting was an issue Millais debated with his colleagues, and it took a team effort to suggest solutions. Just as most of the key developments in Modernism from Impressionism to Pop art were group efforts, so Millais, William Holman Hunt and their coevals were all united in their conviction that the conventions which had dominated European art since the Renaissance were redundant, and that it was their mission to revitalise art by a return to first principles. For such a daring challenge it is significant that the group initially avoided contemporary-life subject matter, such as the themes adopted by painters like Richard Redgrave and G.F. Watts around 1848, instead choosing to place their heroes in literary and historical contexts in order to create a poetic intensity of vision. The theme of persecution, or of individuals set at odds against social norms, which runs through early Pre-Raphaelitism, was projected on to a historical stage as part of the group's agenda to make the past relevant to the present day. With this aim the group succeeded in shocking the public.

Within Pre-Raphaelitism Millais certainly had a potent role, bearing the brunt of early criticisms levelled against the movement. His paintings were the most controversial in terms of their religious iconography, inviting the criticism that he was playing fast and loose with sacred history. Although Millais shared with his fellow artists a relentless pursuit of objectivity, it was the technical mastery with which he rendered surface detail that made his paintings appear most compelling and audacious. Above all, it was perhaps as a painter of women that Millais made his mark. Women in Millais's pictures have been regarded not only as ciphers for the projection of male fantasy, but as real individuals experiencing complex palpable feelings. AS

Self-Portrait 1847
Oil on millboard
27.3 × 22.2
Signed and dated on verso
National Museums Liverpool, Walker Art
Gallery. Presented by Miss Eleanor Prior, 1977

Provenance John Kennedy, from the artist, and thence by
descent to Mrs Eleanor Prior, who presented it to the Walker Art
Gallery, 1977

Exhibited RA and Liverpool 1967 (7); Jersey 1979 (18);
Liverpool 1994–5 (49)

Millais painted this first self-portrait when he
was still a student at the Royal Academy. Known
there as 'the Child', he was noted for his delicate
appearance, as recorded in contemporary
portraits such as an oil study of c.1841 by the
Scottish painter John Phillip.[1] Millais presents
himself at his easel, holding a palette in his left
hand as well as an array of brushes, turning
towards the viewer as if engaged in a portrait.
Another canvas leans against the wall behind
him, further testimony to his productivity. He
is styled as a young gentleman in what appears
to be the distinctive black velvet painting coat
he is often shown wearing at the time.[2]

Millais was fêted as a child prodigy and
presents himself as such rather than as a manly
eighteen-year-old. By 1847 he had already
gained a reputation at the Royal Academy as a
prizewinner in competitions organised by the
Society of Arts (see no.2), and was also tackling
ambitious themes from the Bible, literature and
history. That year his *Elgiva* was exhibited at
the Royal Academy, and Millais had also been
awarded a gold medal by the institution for
*The Tribe of Benjamin Seizing the Daughters of
Shiloh in the Vineyard*. A sketch of two full-length
oriental figures on the reverse of the self-portrait
has putatively been identified with figures on the
right of *The Widow's Mite*, Millais's abortive
submission to the 1847 Palace of Westminster
competition, which may have been composed
around the time he painted this work.

Millais's technique at this stage of his career
was very much influenced by Romantic painters
such as William Etty, whom he would have
encountered at the Royal Academy schools.
Areas of damage in the coat and background
have been caused by bitumen liable to shrinking
and cracking. The revolutionary techniques of
the Pre-Raphaelites were partly intended as a
corrective to what the group came to deride as
slovenly Baroque practice. Millais later avowed
that he had never witnessed any cracking in his
work, 'except in the case of some of my boyish
efforts, which were painted into asphaltum, a
colour then in general use which has long been
abandoned'.[3] AS

2

Bust of a Greek Warrior c.1838–9
Black chalk with touches of white
56 × 40
Inscribed 'Presented by his Royal High[ness]
Duke of Su[ssex]'
Geoffroy Richard Everett Millais Collection

Provenance By descent from the artist

Exhibited University of London 1981–2 (20);
Southampton 1996 (48)

In 1838 Millais's family moved from Jersey to
London in order to encourage his precocious
talent in drawing. He first studied Classical
sculpture at the British Museum, and in 1838
enrolled at Henry Sass's art academy in
Charlotte Street, where he copied engravings
and drew from the Antique in preparation for
admission to the Royal Academy schools. At
Sass's Millais would have followed the
standard system of drawing 'from the flat',
copying examples in outline until he was
considered proficient enough to study forms in
light and shade 'in the round'. This study in the
round (of what could be a pastiche of the Ares
Borghese in the Louvre), is a meticulous
exercise in tonal contrast in which gradations
are dramatically explored through fine
hatching and rubbing. The drawing was
awarded a silver medal in the Society of Arts
competition for young artists in 1839 under the
category 'Chalk Drawing from the Antique'.[1]
The prize was awarded to Millais by the Duke
of Sussex, President of the Society.

In 1840 Millais entered the Royal Academy
schools, their youngest ever student.[2] Here he
produced fine, if conventional, drawings
honouring the Academic precept that study
from the Antique fostered idealism in art,
correcting the imperfections in actual human
figures. Years later Millais was to disparage this
system for the inordinate time students had to
spend copying from casts (the recommended
course in the Antique school being three
years):

> We find students straight from the Antique
> school, who have drawn the Gladiator and
> Apollo most correctly and admirably, quite
> incapable of drawing the living model,
> because they cannot draw well enough, yet
> it is only too common to find modest
> faithfulness to nature ignored for the work
> which seems to say – 'see how well I am
> drawn, and how much learning there is in
> me'.[3]

AS

The Danes Committing Barbarous Ravages on the Coast of England 1843

Pen and brown ink

20.2 × 30.4

Signed and dated lower left. Inscribed on mount with title (below), AD 832 (upper left) and Egbert (upper right)

Charles Nugent, Esq.

Provenance D.T. White; Christie's, 20 April 1868 (355), bt G. Smith; anon. sale Christie's, 7 Dec. 1945 (31–3), bt Milling; anon. sale, Christie's, 4 Feb. 1986 (244), bt present owner

In 1843 Millais entered a competition launched the previous year by the Art-Union of London for a set of ten outline drawings. The specification was to illustrate a work of national literature or a single scene from English history, and the drawings were to measure 8 by 12 inches. The winning designs were published and distributed in folios by the Art-Union, a subscribing organisation dedicated to the patronage of art in Britain. Millais's set of ten drawings were on the theme of *The Rise and Progress of Religion in England*.[1] Focusing on Anglo-Saxon history, Millais's source was probably David Hume's classic *The History of England* (1754–62), and perhaps Sharon Turner's *History of the Anglo-Saxons* (1799–1805).[2] Work on the series gave the young Millais some experience – which he was not obtaining at the Academy – in composing historical subjects; his large-scale *Elgiva* (exh. RA 1847) being directly based on his competition drawing of the same subject. Millais's penchant for violent action, apparent in his ambitious history paintings of the 1840s, also characterises the *Danes* drawing, which dramatises the confrontation between Anglo-Saxons and pagan invaders. Confining the main action to the foreground, two Danes are shown attacking an Anglo-Saxon who is about to be stabbed through the throat, while soldiers and the slain are compressed around this central group.

The Art-Union advertisement for the competition stated that the judges were looking for 'severe beauty of form, and pure, correct drawing', as if they had the linear manner of John Flaxman in mind as an exemplar.[3] Millais's drawing respects this style by varying the strength of line employed, suggesting both the simple compositions and low undulations of bas-relief. He also seems to have been influenced by the linear technique popularised by German illustrators, notably Moritz Retzsch, whose *Outlines to Shakespeare* was available with English text by the late 1830s. Retzsch was himself a key influence on Henry Courtenay Selous, who won the Society of Arts competition in 1843 with his illustrations for John Bunyan's *Pilgrim's Progress*.[4] Selous, who also originated from Jersey, appears to have been personally acquainted with Millais at this time, which may explain similarities in the graphic style of both artists.[5] AS

Study for 'Sketches of Arms and Armour from the time of Elizabeth I' 1844
Pen and sepia ink on paper
26.3 × 31.6
Inscribed 'Elizabeth's Reign'
Birmingham Museums and Art Gallery

Provenance Charles Fairfax Murray. Presented to Birmingham by subscribers 1906

This is one of a group of five studies of armour (all at Birmingham) made at the Tower of London, which, together with a design for a frontispiece, may have been conceived as a book. The other drawings in the series are almost identical in size and illustrate armour from the reigns of Henry VIII, James I and Charles I. A sketchbook relating to the project exists at the Victoria and Albert Museum.

In his youth Millais showed a strong interest in depicting scenes with Roundheads and Cavaliers, as popularised by historical novelists such as Walter Scott (1771–1832). This study not only demonstrates Millais's skill in outline drawing but also his fascination with different parts of armour, all of which are numbered and itemised on the right-hand side. The depth of research shown in the series enabled Millais to demonstrate his understanding of the mechanics and function of weaponry, lending a degree of veracity to his more ambitious compositions. Breast plates, rapiers and swords thus feature prominently in *Pizarro* 1846 (no.5). AS

5

Pizarro Seizing the Inca of Peru 1846
*'Pizarro himself advanced towards the emperor,
whom he took prisoner; while his soldiers, incited
by Vincent de Valverde, massacred all that
surrounded the Monarch.' Vide Luffman's
Chronology*
Oil on canvas
128.3 × 172.1
Signed and dated in monogram lower right
Victoria and Albert Museum, London

Provenance Henry Hodgkinson, half-brother of the artist,
who presented it to the South Kensington Museum, 1897

Exhibited RA 1846 (594); Liverpool 1846 (96); Society of
Arts 1847; London 1872 (130); RA and Liverpool 1967 (4);
US and Paris 1975–7 (281); Tate 1984 (1)

At the age of sixteen Millais launched his career
at the Royal Academy's public exhibition with
this picture, for which he was awarded a gold
medal a year later, in 1847, by the Society of Arts.
The painting represents the seizure of the Inca
king Atahuallpa by the conquistador Francisco
Pizarro at the Peruvian highland town of
Cajamarca in 1532, an event accompanied by
the slaughter of around 7000 Indians by
Spanish forces. In representing such a
portentous moment in world history, Millais
utilises the language and rhetoric of academic
history painting to dramatise the clash of
cultures and the eclipse of one civilisation by
another, while also attending to historical
authenticity. The tropical fruit and vegetation in
the foreground establish a sense of the exotic,
together with the ornaments and garments,
which, according to William Holman Hunt,
were lent to Millais by the artist Edward Goodall
who had recently visited South America.[1] The
quotation in the painting's title, from John
Luffman's *The Pocket Chronologist* (1806),
reinforces the actuality of the moment, as
recorded in the eyewitness accounts set down
in Bartolomé de las Casas's *A Short Account of
the Destruction of the Indies* (1552), the primary
source of information concerning the incident
depicted, which also influenced subsequent
accounts in presenting Pizarro as a villain.

In keeping with the traditions of history
painting, Millais does not allow archaeological
and environmental details to overwhelm the
narrative legibility of the scene. The figures
are hierarchically lit and disposed so as to
distinguish key and subsidiary players in the
drama. Atahuallpa thus forms the apex of
a compositional pyramid, and is further
emphasised by the empty foreground and
thrusting diagonal movements from the left
that culminate in Pizarro's talismanic touch of
his shoulder as he turns to witness the crucifix
wielded by the friar Valverde above the setting
sun, symbolic of the capitulation of the Inca
religion and empire to Catholic Spain. The
Raphaelesque grouping of a woman clutching
her child on the right deliberately recalls
the subject of the Massacre of the Innocents,
placing the event in a broader framework
of human cruelty and persecution, while also
perhaps referencing Eugène Delacroix's *Medea*
1838. The classically posed emperor possibly
alludes to the idea of the 'noble savage' as
presented in Benjamin West's *Death of General
Wolfe* 1770, which Millais probably saw when it
was exhibited at the British Institution in 1843.
Another possible source might have been
David Wilkie's *Defence of Saragossa* 1828,
shown at the British Institution in 1842, with
its dynamic diagonal movement, and also an
image of Catholics inspired by their faith into
militant action. More immediately Millais
was likely to have been influenced by Henry
Perronet Briggs' *The First Interview between
the Spaniards and the Peruvians* (exh. 1827) in
the Vernon collection at the National Gallery,
London, which depicts the scene immediately
prior to that shown by Millais.[2]

Pizarro has recently been interpreted as an
'anti-imperialist inflection' during a period of
British expansionism and colonial defence.[3]
Although there is a case for arguing that Millais
followed historians like Washington Irving
and later William Prescott in presenting the
Spanish conquest of the New World as an act
of hubris, it is unlikely that he intended any
political reading at such a youthful stage in
his career. If anything, the painting fulfils
his predilection for scenes of combat and the
paraphernalia of war. Moreover, Millais's debt
to the generalising language of traditional
history painting could be seen to universalise
and therefore normalise the idea of
expansionism, the language of the Baroque
being better suited to presenting a clear-cut
confrontation than probing the motivations
of the individuals involved.

On a more visceral level, it was probably the
experience of watching the revival of Richard
Brinsley Sheridan's play *Pizarro* (an adaptation
of A.F. von Kotzebue's *Die Spanier in Peru*),
at the Princess's Theatre in Oxford Street early
in 1846, that prompted Millais to paint the
subject. Millais was known to be a frequent
visitor to the Princess's and may have borrowed
props and rhetorical gestures from this
production for his tableau. He was also
acquainted with the leading actor in the play,
James William Wallack (whose son Lester was
to become the artist's brother-in-law), recasting
him as Pizarro in his painting. Millais worked
on the picture at his family home in Gower
Street where he erected a large platform at
an angle to serve as a palanquin, and used his
father as a stock model for the priest and some
of the other figures.[4] Although Millais was to
continue using his family and acquaintances as
models during his subsequent Pre-Raphaelite
phase, he was to predicate his paintings on
principles diametrically opposed to those used
in *Pizarro*. AS

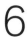
The Death of Romeo and Juliet 1848
Pen and black ink
21.4 × 36.1
Signed and dated in monogram in black ink
bottom left
Birmingham Museums and Art Gallery

Provenance G.R. Burnett sale, Christie's, 4 March 1864 (33), bt in; his sale again, Christie's, 16 March 1872 (72), bt Polak; A. Mackinlay sale, Christie's, 29 May 1875 (85), bt J.R. Clayton and still his 1901; Charles Fairfax Murray by 1905; presented to Birmingham by subscribers, 1906

Exhibited GG 1886 (136); RA 1898 (188); FAS 1901 (29A); Whitechapel 1905 (166); Tate 1911–12 (70); Birmingham 1913 (494); Roland, Browse & Delbanco 1945 (51); Arts Council 1953 (32); RA and Liverpool 1967 (228); Paris 1972 (186); Whitechapel 1972 (35); Portsmouth 1976 (25); Hong Kong 1984 (32); Paris 1993 (96); USA and Birmingham 1995–6 (11)

This is one of Millais's earliest drawings in the Pre-Raphaelite style, which, like the study for *Isabella* of the same date (no.10), represents the topic of doomed young love. The design was probably influenced by Carlo Lasinio's engravings after Benozzo Gozzoli's frescoes in the Campo Santo at Pisa, with its 'primitivising' emphasis on line, empirical perspective and medieval costume. It also acknowledges Millais's Art-Union competition drawings in its bold presentation of human drama in a shallow Romanesque architectural setting, as well as referencing antiquarian details from Millais's studies of armour series of the mid-1840s (see

no.4). More specifically, the composition appears to appropriate Moritz Retzsch's illustration of the same moment from Act 5, Scene 3 of Shakespeare's *Romeo and Juliet* (fig.7), particularly the staging of the event in a vault and the massing of figures around centrally entangled lovers.[1] Hunt recalls the Pre-Raphaelite admiration for the outline manner of Retzsch at the formative meeting of the Brotherhood, a style that can be clearly seen in the fine wiry line of Millais's drawing, indicating how deliberately he had rejected the dense shading and subtle blending of his academic training.[2]

If Millais's drawing was indeed based on Retzsch's, then it could be seen as a deliberate critique of the conventions that govern the latter's design. Retzsch uses classical gestures and expressions to explicate the emotion of the scene, and his composition is ordered around a central pyramid that extends downwards from the crucifix on the wall to encompass the two fathers, thereby rationalising the tragedy within a Christian framework of forgiveness and atonement. By contrast, Millais places a capital decorated with two embracing angels above the bodies of the lovers, but undermines any suggestion of reunion in the afterlife by setting it against two grotesque skull corbels on the rear wall. Millais's prime objective is to

dramatise the human response to the tragedy through an understanding of the dynamics of the characters in the play itself. Thus the fathers have been deliberately moved to the left of the composition and, instead of being shown shaking hands as if settling a deal as in Retzsch's outline, the rapprochement of the Montagues and Capulets is emphasised by their tender embrace and the attention of the Duke of Verona. In the centre Friar Lawrence and the nurse, crouching, gaze in horror at the corpses, while Juliet's mother cradles her daughter. To the right Romeo's friend Balthasar examines the phial of poison as Paris's page holds back the crowd. The other participants are shown to be not so directly involved, either pruriently curious or merely indifferent to the deaths, a realistic, even cynical, view of human nature that epitomises Millais's quest for realism through a wilful naivety of expression. It is this combination of astute observation and antiquarian influence that marks the composition as original and daring for its time. The drama and pathos of the scene is further offset by expressions that are both comic – the camp youth straining to view the phial – and incidental displacement activities, such as the guard extinguishing a candle or the man who holds Romeo's mattock and sucks his hand. AS

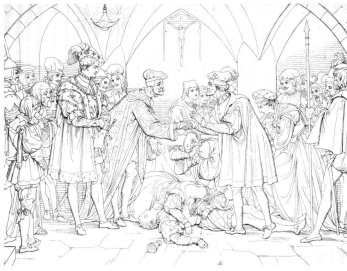

Figure 7
Moritz Retzsch (1779–1857)
Act V, Scene 3, Plate 13, Romeo and Juliet (Leipzig 1836)
THE BRITISH LIBRARY, LONDON

The Death of Romeo and Juliet c.1848
Oil on millboard
16.1 × 26.9
Signed in monogram
Manchester City Galleries. George Beaston
Blair bequest

Provenance James Wyatt, sold Christie's, 6 July 1853 (555), bt Gambart; Francis MacCracken, sold Christie's, 17 June 1854 (89); Joseph Arden, sold Christie's, 26 April 1879 (27), bt Tooth; bt Agnew's from W. Ellis, 28 April 1880, for Dr Aspland; A. Campbell Blair by 1899; by descent to G. Beaston Blair, who bequeathed it to Manchester, 1941

Exhibited NLSDM 1850–1; Manchester 1911 (232); Bath 1913 (32); Tate 1913 (24); Whitechapel 1920 (166); Whitworth 1961 (5); RA and Liverpool 1967 (17); Agnew's 1974; Japan 1992–3 (66); Japan 2000 (14)

It is not altogether clear whether this oil sketch is a preliminary study for a larger painting or a study for no.6. The oil is a smaller, simplified version of the drawing, containing fewer figures, and lacks the incisive detail and expression of the latter. Instead the drama and tragedy of the moment is relayed through sharp chiaroscuro punctuated by patches of strong colour.

Shakespearean subjects were favoured by the Romantics for testing the limits of human experience, and the Pre-Raphaelites honoured this tradition by elevating the writer to a position just below Jesus Christ in their list of immortals.[1] Representations from Shakespeare in Millais's work date from around 1848. Contemporary with this study is the small sketch of *Lear and Cordelia* c.1848 (Private Collection), followed by *Ferdinand Lured by Ariel* 1849–50 (no.15).[2] The violence and morbid passion of *Romeo and Juliet* would have appealed to Millais's youthful imagination. According to his son, it was around this time that the artist conceived of a story for the Pre-Raphaelite magazine *The Germ*, concerning a fatal attraction between a knight and a lady. Millais writes that both were drowned attempting to escape the wrath of the young man's father, and when their skeletons were eventually exhumed they were found locked together, 'the water-worn muslin of the lady's dress still clinging to the points of the knight's armour'.[3]

In 1852 Millais embarked on the balcony scene from *Romeo and Juliet* as a private commission but, as with this design, the composition did not develop beyond a couple of preliminary studies.[4] AS

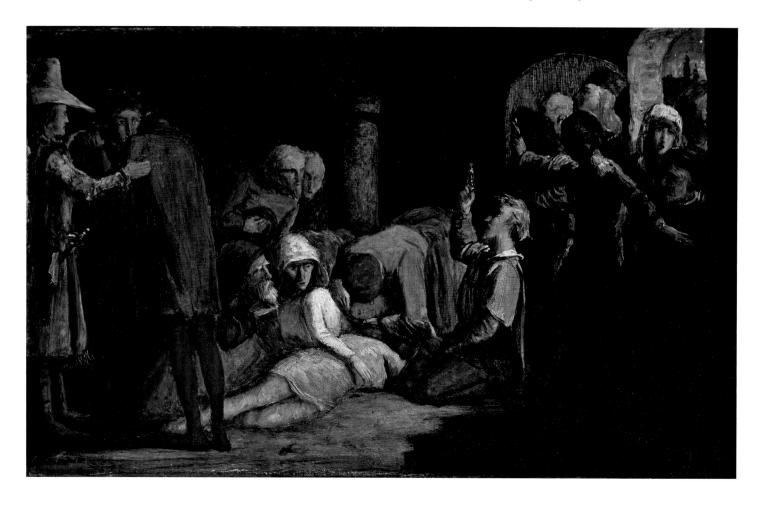

8

The Artist Attending the Mourning of a Young Girl c.1847

Oil on board
18.7 × 25.7
Tate. Purchased 1996

Provenance Given by Millais to Charles Collins; given by his widow Kate Perugini, c.1918, to Millais's daughter Alice Stuart Wortley; by descent to Sir Ralph Millais; his sale, Christie's, 3 Feb. 1976 (66), bt Maas Gallery; anon. sale, Christie's, 13 Oct. 1978 (73), bt FAS; John Gere, from whom purchased by the Tate Gallery 1996

Exhibited Maas 1977 (26)

Although it is not clear exactly when Millais painted this sketch, it was probably executed around the time he had completed his training at the Royal Academy schools in 1847. An unsigned inscription on the original backing to the picture described the occasion depicted as follows:

The painting represents an incident in Millais's own life when he was sent for by people unknown to him, but who knew him to be a young artist, to draw a portrait of a girl in her coffin before her burial. The scene moved him so much that when he got home he made this sketch showing himself being asked to draw the girl's portrait.

The whereabouts of the portrait Millais was asked to produce (presumably by the mother of the girl standing next to the artist in this painting) remains unknown, but this sketch was probably intended as a private memento. The recollected scene is deliberately bleak, as if to dramatise the stark reality of modern death, the only hint of colour being the green eyeshade worn by the weeping woman to conceal her eyes.

Millais presents himself from behind, nervously smoothing the nap of his top hat. The white cloth covering the coffin connotes innocence, being the colour traditionally used for the burial of children.

A preoccupation with mortality, especially premature death, was to become an important leitmotif in Pre-Raphaelitism, especially for Millais, whose work often engages with the idea of human transience, albeit not in such a confrontational way as here. The etching he produced in relation to Dante Gabriel Rossetti's story *St Agnes of Intercession* (1850, no.17), in which the painter Bucciuolo paints a portrait of his lover Blanzifiore as she expires, is a literary variation on the theme, as is *Ophelia* (no.37), with its similarly disengaged head and body displayed obliquely across the composition. AS

Isabella 1848–9

'Fair Isabel, poor simple Isabel!
Lorenzo, a young palmer in Love's eye!
They could not long in the self same
 mansion dwell
Without some stir of heart, some malady;
They could not sit at meals but felt how well
It soothed each to be the other by.

[…]

'These brethren having found by many signs
What love Lorenzo for their sister had,
And how she loved him too, each unconfines
His bitter thoughts to other, well-nigh mad
That he, the servant of their trade designs,
Should in their sister's love be blithe and glad,
When 'twas their plan to coax her by degrees
To some high noble, and his olive trees.' – Keats

Oil on canvas
102.9 × 142.9
Signed with initials in monogram and dated
lower right 'J.E. Millais 1849 PRB'; the initials
'PRB' also appear on Isabella's stool
National Museums Liverpool, Walker Art Gallery

Provenance R. Colls, W. Wethered and C.W. Wass, 1849; B.G. Windus by the end of 1849; sold Christie's, 19 July 1862 (53), bt White; sold Christie's, 14 Feb. 1868 (322), bt Gambart; Thomas Woolner; sold Christie's, 12 June 1875 (73), bt Willis; on sale at FAS, 1881, bt C.A. Ionides; sold Christie's, 5 May 1883 (131); Holland, bt Boussod, Valadon & Co., from whom purchased by the Walker, July 1884

Exhibited RA 1849 (311); Manchester 1878 (223); FAS 1881 (3); Liverpool 1884 (189); Manchester 1885; GG 1886 (120); Conway 1888; Guildhall 1894 (114); RA 1898 (23); Glasgow 1901 (319); Liverpool 1922 (27); Manchester 1929; RA 1934 (545); Birmingham 1947 (48); Whitechapel 1948 (43); Tate 1948 (14); RA 1951–2 (279); Sheffield 1952; Wales 1955 (34); Nottingham 1959 (45); RA and Liverpool 1967 (18); RA 1968–9 (377); Tate 1984 (18); Washington 1997 (6); V&A 2003 (loan)

This was the first painting Millais exhibited following the formation of the Pre-Raphaelite Brotherhood – his allegiance to the group is signalled by the group's initials, which appear twice in the picture. The painting was given a prominent position in the Middle Room of the Royal Academy, hung just above the line with Hunt's *Rienzi* and James Collinson's *Italian Image – Boys at a Roadside Ale-house*.[1] Of these three works it was Millais's that had the greatest impact, being widely recognised as a manifesto for the radical aims of the movement. Indeed, with its bright colour and audacious combination of realism and abstract design, signalled by the white leg that slices with Vorticist violence across the composition, the work stands out as one of the masterpieces of the early years of the movement.

The painting was exhibited accompanied by stanzas 1 and 21 of Keats's *Isabella; or, The Pot of Basil* 1820, which together relay the main themes in the poem that Millais sought to explore: the infatuation of Lorenzo for Isabella, his servitude to her brothers as an assistant in their firm, and the brothers' determination to destroy the lovers'

relationship. Compressing the entire narrative into a single moment, Millais uses inanimate objects, such as the majolica plate decorated with a beheading scene in front of the lovers, to allude to future events in the tragedy in an approach approximating that of Eyckian natural symbolism, while the expressions and gestures of humans and animals infuse the scene with a psychological tension that is both insightful and disturbing.[2]

As with *Romeo and Juliet* (nos.6, 7), it is the interpenetration of quirky observation and defiant archaism that makes the work so outlandish. The picture's debt to 'primitive' or early Renaissance styles was acknowledged in initial reviews. Subsequent accounts have illuminated particular sources, for example, a copy of the figure of Beatrix d'Este from Camille Bonnard's *Costumes Historiques* (1829) for the figure and headdress of Isabella, and the side panels of Lorenzo Monaco's *Coronation of the Virgin* (acquired by the National Gallery in 1848) for the steep perspective and figures of the lovers.[3] For M.H. Spielmann the ingenuity of the composition owed something to Paolo Veronese's *Feasts* (the same artist's *Marriage at Cana* 1562–3 also perhaps suggesting the dog and wallpaper). More immediately, William Hogarth's *Marriage-à-la-Mode* 1743–5 has been put forward as influencing the concealed action of the drama, while the kick might have been prompted by the prominent leg of Hortensio in Augustus Egg's *Scene from 'The Taming of the Shrew'* (RA 1847, no.392), although presented by Millais at a more obtuse angle.[4] It is also likely that the juxtaposition of figures along a table was suggested by the first plate of Selous's *Seven Events in the Life of Robert the Bruce* 1847, itself influenced by plate 16 of Retzsch's *Outlines to Faust* (1820).[5]

Such varied sources have been assimilated to create an image that looked in the words of one critic as if it had been 'passed through a mangle'.[6] Drawing on the tradition of the Last Supper, twelve figures are squeezed around a table that cuts diagonally across the picture surface, a daring reversal of the centralising symmetrical arrangement of several of Millais's earlier paintings. The deliberate perspective distortion, with four figures on the left side of the table and eight on the other, has the effect of destabilising the composition, pushing the interaction between the lovers to the right and establishing competing areas of focus. The kick of the brother in the foreground is a provocative gesture that emphasises the abrupt linear alignments of the design and also serves as a link in the composition. But the *Athenaeum* complained:

the picture is injured by the utter want of rationality in the action of a prominent figure,

– carried almost to the verge of caricature. This figure extends his unwieldy leg in the immediate front of the picture so as not merely to divide attention but to appropriate all the interest from the love-sick Lorenzo and the fair Isabel.[7]

Probably the most deliberately discordant feature, however, is the tension between the formality of the design and the insistent individuality of each figure, a feature characteristic of early Netherlandish painting. In defiance of his earlier practice, and following the tenets of Pre-Raphaelitism, Millais incorporated the physiognomies of actual persons rather than selecting and adapting his models to the characters he intended them to portray. Thus most of the sitters have been identified as relatives, fellow artists or acquaintances, albeit with certain modifications, such as the decision to cast Lorenzo with blond hair rather than the black locks of William Michael Rossetti, the sitter in this case, so as to suggest the character's tender nature.[8] Although Millais did not aspire to literal portraiture, the element of realism is marked enough to create a disjuncture between the modern individuality of each sitter and their imagined role. This produces an unsettling effect in a composition that charts motive and plot through gesture and expression. Both the art of Hogarth and the science of phrenology have been put forward as key influences on the making of *Isabella*, which would suggest that it was via discernable traits of character that Millais sought to hint at the narrative's inevitable grisly conclusion with the death of the lovers.[9] Yet the element of portraiture can be seen as an interposition in this aim, asserting the individuality of the model alongside the character he or she is meant to impersonate. While some of the figures certainly do betray the inner nature of the persons they represent – the rapaciousness of the kicking brother, for example, is suggested by his prominent cheek and jaw – the features of other characters relate more ambiguously to the inner workings of the mind. Some repress emotion or appear distracted, so it is not quite clear if it is the character or model that is being represented. Millais's fixation both with his figures' engagement in the plot and their absorption in their own thoughts, thus works to reinforce the psychological complexity of the narrative and its own self-enclosed logic.

Even by the turn of the century the painting had not lost its power to shock and disorientate the viewer. The leading German critic Julius Meier-Graefe, for one, found it 'unpleasant to the point of indecency, for it is impossible to say whether it is intended for a masquerade or whether these pompous persons are really meant for Florentines'.[10] As

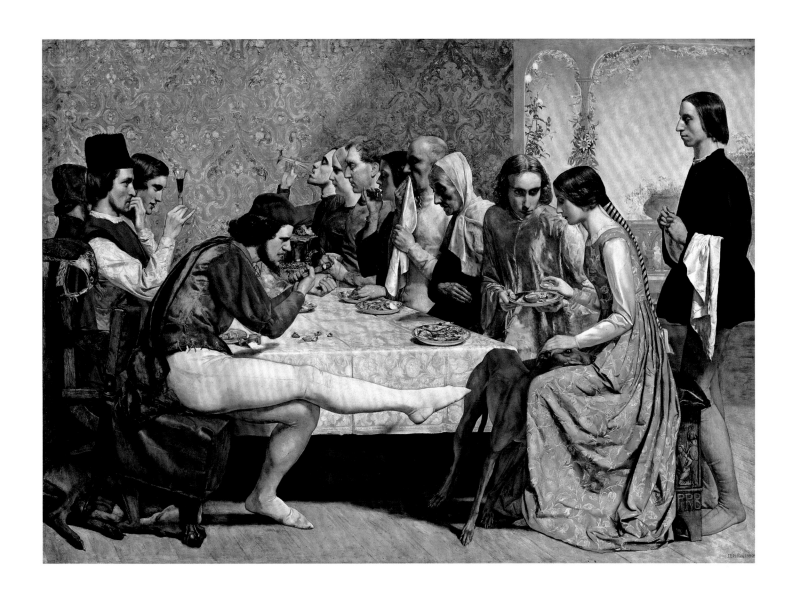

35

10 Isabella 1848
Pen and ink
20.3 × 29.4 (sheet size)
Signed and dated in monogram
Inscribed 'They could not sit at meals but feel
how well/ It soothed each to be the other by'
(Keats)
The Fitzwilliam Museum, Cambridge

Provenance H. Quilter, sold Christie's, 9 April 1906 (190),
bt J.R. Holliday, who bequeathed it to the Fitzwilliam, 1927

Exhibited Manchester 1911 (185); Tate 1911–12 (74); Tate
1923 (216); RA 1934 (1237); Birmingham 1947 (162);
Whitechapel 1948 (50); Arts Council 1953 (33); RA and
Liverpool 1967 (230); RA 1968–9 (593); Paris 1972 (187);
Whitechapel 1972 (36); Baden-Baden 1973–4 (50);
Portsmouth 1976 (26); Munich 1979–80 (313)

**11 Study for 'Isabella': 'Isabella and
her brother with caricature'** 1848
Verso: study of old woman at table
and sleeping dog
Pencil on toned paper
35.4 × 25.1
Birmingham Museums and Art Gallery.
Purchased by subscribers, 1906

Provenance C.F. Murray; presented to Birmingham
by subscribers, 1906

Exhibited RA and Liverpool 1967 (231)

12 Study for 'Isabella': 'Head of the Youth'
1848
Pencil on paper, laid on card
25.6 × 20
Signed and dated bottom right
Birmingham Musuems and Art Gallery.
Purchased by subscribers, 1906

Provenance Probably 1 of 6 studies in D.T. White sale,
Christie's, 21 April 1868 (459 and 459A), bt Ellis; C.F. Murray
by 1899; presented to Birmingham by subscribers, 1906

Exhibited Tate 1911–12 (77); Brussels 1929 (115); RA 1934
(1267); Europe 1935–6; RBA 1937 (123); RA 1956–7 (741);
Midland Federation 1958 (26); RA and Liverpool 1967 (234)

According to Hunt, he and Millais decided in 1848 to illustrate Keats's poem *Isabella; or, The Pot of Basil* (1820) with a series of outlines, which they hoped to publish as a book of etchings.[1] Retzsch's volumes and the Art-Union competition drawings would have provided an appropriate model for such a project. The designs were based on the first stanza of the poem, which sets out the subordinate position of Lorenzo in the brothers' household. Hunt's *Lorenzo at His Desk in the Warehouse* 1848–50 (fig.8) has much in common with Millais's drawing (no.10): the shy exchange between the lovers, the dog scenting their attraction and the greedy mercantile nature of the brothers, expressed by Hunt through the harsh treatment of their employees. Although such features indicate the shared vision of the two artists, Millais's drawing was completed some time before Hunt's, and unlike his is not initialled 'PRB'. The manner of execution also differs. Whereas Hunt's outline possesses the stiff angularity and sharp linear alignments of Millais's painting (no.9), the forms of the latter's drawing are more rounded and the use of line less brittle. As has been suggested, it may have originated in a project initiated by the Cyclographic Society before the formation of the Brotherhood.[2] The fine brushwork also stems from the influence of Flaxman and Selous, and further relates to a series of outline designs for architectural lunettes that Millais was commissioned to produce for the home of John Atkinson of Leeds. The motif of figures around a table not only has a precedent in Millais's illustration for *Hospitality* in this series, but also in Lasinio's engraving of Gozzoli's *Marriage of Rebecca and Isaac* and Retzsch's *Macbeth*.[3]

The drawing was developed from a sketch in the British Museum, which loosely positions eight figures around the table and establishes the motif of the kick. No.10 was subsequently worked up to include twelve figures, and details that place the scene in a particular location as well as hinting at the future deaths of the lovers. However, the feature of the Duomo of Florence Cathedral and the animal trophy on the wall were expunged in the final painting so as to concentrate the viewer's attention exclusively on the family eating their meal.[4]

The detailed head studies relate more specifically to the finished composition and emphasise Millais's concern for verisimilitude. The isolation of each head from the body enhances his scrutiny of the model, while the profile format allows him to accentuate telling physiognomic details such as the mouth. The caricature in no.11 may relate to Rossetti's drawing *A Parable of Love* c.1850, yet further testimony to the close working relationship between the artists of the Brotherhood at this time.[5] AS

Figure 8
William Holman Hunt
(1827–1910)
*Lorenzo at His Desk in the
Warehouse*
1848–50
LOUVRE, CABINET DES DESSINS, PARIS

They could not sit at meals but feel how well
It soothed each to be the other by; Keats

11

12

Garden Scene 1849
Pen and Indian ink on paper
28 × 20.5
Signed and dated in monogram
Private Collection

Provenance Given by the artist to John Hungerford Pollen; his daughter-in-law, Mrs Arthur Pollen, who gave it to the present owner, c.1955

Exhibited RA 1898 (230); Whitechapel 1948 (55); RA and Liverpool 1967 (244)

This drawing was probably produced as a headpiece and decorative border for the page of a book. It shows seven girls under a rose pergola in a garden engaged in the polite arts. To the right five maidens are absorbed in music, literature, sewing and drawing; the girl studying a lily is reminiscent of the Virgin embroidering the flower in Rossetti's *The Girlhood of Mary Virgin* of the same date. The two figures on the left arrange wild and cultivated blooms respectively. It is likely that Millais intended the flowers to carry symbolic significance, the daisy chain around the border connoting innocence and beauty, the lily purity, the lotus silence and the iris a message, perhaps one sent via the robin, a friend of humankind. Millais's sharp eye for botanical detail is also relayed in the drawing, the bulb of the lily being correctly exposed. The barrel-shaped object behind the girls is an unusual feature of the composition and could be a Chinese or Japanese seat or garden monument.

Millais produced a number of headpieces in his youth, one of which is reproduced in his son's biography.[1] The subject of girls in a domestic Eden also appears in a drawing of the same date of a girl cutting a rose, identified as an illustration to Tennyson's *The Gardener's Daughter; or, the Pictures*, and in 1850 Millais presented the Countess of Abingdon with a pen and ink drawing of two girls walking under a bower as a token of gratitude for allowing him to work on *The Woodman's Daughter* (no.23) on the family estate.[2]

Garden Scene has been tentatively related by Ironside and Gere to Tennyson's *The Princess*, published in 1847 and a work that enjoyed great popularity amongst the Pre-Raphaelite Brotherhood.[3] Although both works emphasise feminine accomplishments, the correspondence is not strong enough to confirm the link. However, as a paean to the transience of female beauty it anticipates Millais's *Spring* 1859 (no.84). AS

14

The Disentombment of Queen Matilda
1849
Pen and ink
22.9 × 42.9
Signed and dated with PRB monogram
Tate. Purchased 1945

Provenance T. Morson Jr. sale, Christie's, 24 March 1865 (25), bt Reid; A. Darbyshire; William Brockbank by 1885; bt by the Tate from his son, Oliver Brockbank, 1945

Exhibited Manchester 1885 (727); GG 1886 (140); RA 1898 (219); Arts Council 1953 (38); RA and Liverpool 1967 (243); Detroit and Philadelphia 1968 (223); Paris 1972 (189); Whitechapel 1972 (38); Baden-Baden 1973–4 (53); Arts Council 1979 (13); Tate 1984 (165); Australia and USA 2003–4 (3)

The subject of this drawing derives from the first biography in Agnes Strickland's *Lives of the Queens of England* (1840). Matilda was the wife of William the Conqueror, both of whom were buried in the Church of the Holy Trinity at Caen in Normandy. In 1562, during the religious wars that ravaged France, the Calvinists took Caen and desecrated the royal tombs. According to Strickland, the entreaties and tears of the abbess, Madame Anna de Montmorenci, and her nuns were lost on the iconoclasts,

who considered the destruction of church ornaments and monumental sculpture a service to God quite sufficient to atone for the sacrilegious violence of defacing a temple consecrated to his worship and rifling the sepulchres of the dead.[1]

Strickland also describes the gruesome moment when the queen's tomb is broken into and one of the grave robbers, taking the gold ring set with a sapphire from her finger, gallantly presents it to the abbess. This scene forms the central dramatic incident of Millais's extraordinary composition, which revels in the Gothic details associated with Catholic ceremonial practice. The previous year Millais had treated another subject from Strickland's text, *Queen Matilda of Scotland Washing the Feet of Pilgrims* (National Trust, Wightwick Manor, West Midlands), but the *Disentombment* is a more sophisticated drawing, with its dense areas of shading within a firm outline and knotted overlapping figures that reinforce the pandemonium of the assault.[2]

The *PRB Journal* describes Millais working on the drawing on 15 and 17 May 1849, adding that 'he has put in some fat men, finding his general tendency to be towards thin ones'.[3] The fact there are no figures that match this description in the final design would seem to indicate that he must have deleted them from the final composition. The attenuated forms of the martyrs on the wall hangings being stripped from the wall replicate the brittle foreground figures, thereby extending the iconography of torture and sufferance into the present. As well as satisfying Millais's appetite for morbid subjects, the drawing also continues his youthful penchant for scenes of violent seizure. It can further be seen as an antiquarian exercise; the wide format and intricate composition is reminiscent of Lasinio's engravings, while the ecclesiastical effigies, decorations and missal demonstrate Millais's keen interest in medieval art, and by implication Catholic ritual. His fascination for celibate females also comes to the fore in this work, and in setting the serried ranks of distraught nuns against the chaotic jumble of Protestant looters Millais could be seen to condemn the sacrilegious behaviour of the latter. This would have been a controversial stance at the time, given the bitter debate that ensued within Anglicanism over how far the Church should revive pre-Reformation ritual. However, Millais's delight in the grotesque, which encompasses the nuns as well as their abusers, mitigates any polarised declaration of sympathy.

An early owner of the work was an architect, Alfred Darbyshire of Manchester, who wrote to Millais in March 1869, stating that he had purchased the sheet for a large sum 'as a wonderful pen and ink drawing', and was seeking confirmation that it was a drawing and not an etching as an engraver had suggested.[4] AS

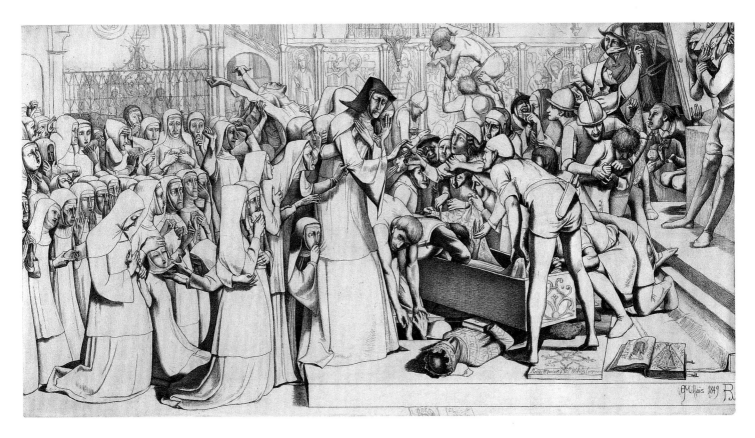

Ferdinand Lured by Ariel 1849–50

'Ferdinand. "Where should this music be?
i'the air or the earth?"
[...]
Ariel. "Full fathom five thy father lies;
Of his bones are coral made;
Those are pearls, that were his eyes:
Nothing of him that doth fade
But doth suffer a sea-change
Into something rich and strange.
Sea nymphs hourly ring his knell.
[Burthen, ding-dong.]
Hark! now I hear them, –
Ding-dong, bell." ' – The Tempest, Act I, Scene 2.

Oil on panel, arched top
64.8 × 50.8
Signed and dated in monogram lower left
The Makins Collection

Provenance Bt by Richard Ellison; James Wyatt; Thomas Woolner, sold Christie's, 12 June 1875 (72), bt J.H. Allen; A.C. Allen; Henry Makins by 1897; his son Brigadier-General Sir Ernest Makins, MP; his son Sir Roger Makins (later Lord Sherfield); his son Christopher Makins, and by descent

Exhibited RA 1850 (504); RSA 1854 (322); FAS 1881 (2); GG 1886 (78); Guildhall 1897 (131); RA 1898 (58); Carfax 1911 (48); Tate 1911–12 (14); Tate 1923 (86); RA 1934 (566); Birmingham 1947 (51); Whitechapel 1948 (44); RA and Liverpool 1967 (23); King's Lynn 1971 (54); Tate 1984 (24); New York 1998–9 (ex-cat); BAC and Huntington 2001–2 (57); Ferrara and London 2003 (82)

This painting offers a novel treatment of Shakespeare's *The Tempest*. Ferdinand has been shipwrecked on Prospero's enchanted island and is lured by Ariel, the magician's servant, towards his master by whispering the false news that the prince's father has perished in the storm. Millais focuses on Ferdinand's struggle to respond to what he cannot comprehend with his senses but which is made vivid to the spectator. Ariel flies so close that he lifts the prince's cap and whispers in his ear, while the sprite's bat-like companions mimic Ferdinand's confusion in discerning the source of the song that taunts him.

The Tempest was very popular with fairy painters and outline illustrators, and Millais's initial design for the subject (Walker Art Gallery, Liverpool) has affinities with both in the linearity of the design and grotesque treatment of the elves. The finished painting ventures beyond these conventions by bringing the real mundane world into direct collision with the supernatural. The dream-like logic of the image is created by what one critic of the 1960s termed its 'extraordinary mescaline-like detail'.[1] In order to create the effect of hyper-reality, Millais executed the background outdoors during the summer of 1849 at the garden of a friend who lived at Shotover Park near Oxford, making the picture his first attempt at painting landscape in a revolutionary Pre-Raphaelite manner. The treatment was, as Millais confessed, 'ridiculously elaborate', allowing one critic to count over twenty types of grass in the composition.[2] Such intensity of observation, accentuated by the shallow setting and minimal shadow, draws attention to the myriad of micro-environments that comprise the background and which threaten to overwhelm the rational space of the garden. The profusion of growth, seen, for example, in the moss-covered fungi sprouting from the decaying stump in the foreground, communicates a pattern of maturation and decay, anticipating the depiction of similar natural cycles in *The Woodman's Daughter* (no.23) and *Ophelia* (no.37).

The figures of Ferdinand and Ariel were added later in the year in Millais's studio, with F.G. Stephens as model for the prince, and the costume was based on a plate from Camille Bonnard's *Costumes Historiques* (1829). The green tones of Ariel and the elves blend with the surrounding flora, and contrast sharply with the brightly coloured figure of Ferdinand who appears superimposed on the design, a disjuncture that accentuates the viewer's perception of his disorientation. The artificiality of his clothing further accentuates the clash between the urbane civilisation he represents and the natural realm from which the supernatural beings emanate. In imagining what these fairy beings would have looked like, Millais extrapolates from nature to create forms of natural ornament, William Michael Rossetti describing the elves as 'vegetable bats'.[3] The lurid green wings appear to have been adapted from greenfly, while the elves' puny limbs and bulging eyes are suggestive of creatures accustomed to the dark and here exposed to direct light. Hunt later recalled how outlandish Millais's image looked when the work was first shown at the Royal Academy:

> The exhibition world was full of pictures of fairies and attendant spirits, these, without exception, were conceived as trivial human pigmies. Millais, at one burst, treated them as elfin creatures, strange shapes such as might lurk away in the shady groves and be blown about over the surface of a mere, making the wanderer wonder whether the sounds they made were anything more than the figments of his own brain.[4]

Millais's radical rejection of both the erotic and whimsical conventions of fairy painters led to difficulty in selling the work. A dealer, William Wethered, had reserved it in advance but withdrew his offer, deterred by the greenness of the fairies and wishing them to be 'more sylph-like'.[5] Even so, Millais was successful in finding a purchaser before sending the picture to the Academy, selling it to the collector Richard Ellison for £150. AS

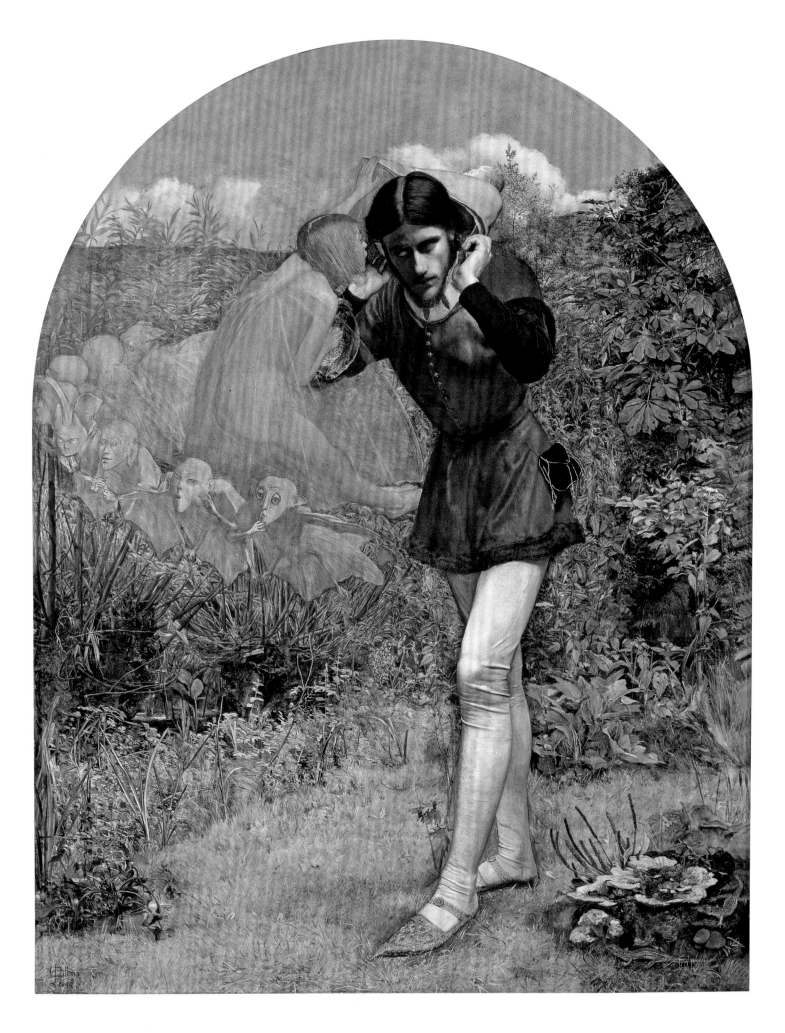

The Eve of St Agnes 1850
Oil on millboard
18.4 × 17
Signed and dated in monogram
The Maas Gallery, London

Provenance Given by Ernest Gambart to Thomas Combe by 19 Sept. 1862; his widow's sale, J.R. Mallam & Son, Oxford, 23 Feb. 1894 (103), bt in; by descent to Mr E.S.T. and Miss I.B.M. Marshall; their sale, Bruton, Knowles & Co., 27 Nov. 1975 (682), bt Maas Gallery

Exhibited Maas 1976; Brighton 1985 (128)

The collector Thomas Combe notes on the back of this painting: 'Hunt tells me today Friday, 19th September 1862, that it was one of his [Millais's] first things after taking to Pre-Raphaelitism.' It is possible Millais made this oil sketch with the idea of following *Isabella* (no.9) with another subject from Keats. The painting illustrates stanza 26 of Keats's poem *The Eve of St Agnes* (1820), which describes Madeline disrobing, her dress 'rustling to her knees [...] like a mermaid in sea-weed', unaware that her lover Porphyro is observing her. Respecting Keats's mermaid simile, Millais paints her body tapering at the knees, while also evoking the form of a bud about to bloom. The liquid application of paint reinforces the mood of private reverie. Although the sketch did not immediately form the basis for a large composition, the motif of a woman alone in a chamber glimpsed in an attitude of erotic longing, was developed in other compositions on the theme of the eve of St Agnes: *The Eve of St Agnes* (no.88), *Mariana* (no.24) and *The Bridesmaid* (no.27).

By 1862 the sketch was in the possession of Combe, who had been given the picture by the dealer Ernest Gambart as an inducement to allow him to engrave Hunt's *The Light of the World*, which Combe owned.[1] Hunt's correspondence with Combe reveals that the collector had reservations about Gambart, so this additional gift was doubtless expedient. It was either the experience of seeing the oil sketch again in 1862 at Combe's house, or being reminded of it by Hunt or Combe, that prompted Millais to take up the theme again with his large-scale version of 1862–3 (no.88). AS

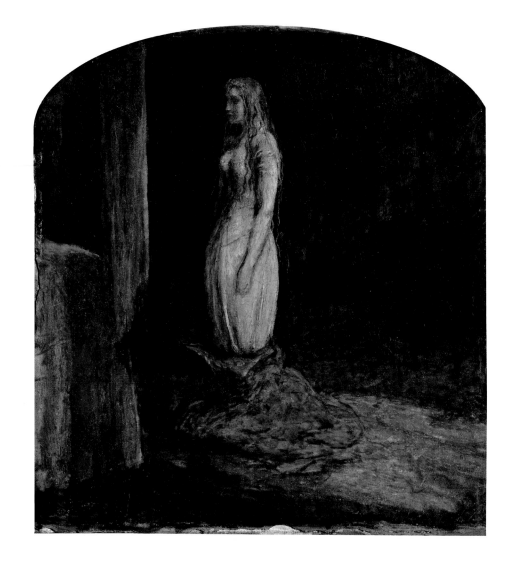

St Agnes of Intercession 1850
Drawing:
Pencil on buff paper
10.9 × 17.5
Birmingham Museums and Art Gallery.
Presented by subscribers, 1904
Etching:
11.7 × 18.8
Birmingham Museums and Art Gallery.
Presented by Charles Fairfax Murray, 1906

Provenance Given by the artist to William Bell Scott; C.F.
Murray; presented to Birmingham by subscribers, 1906

Exhibited Whitechapel 1948 (52); Wales 1955 (41);
Arts Council 1979 (67); Birmingham and London
2004–5 (1)

St Agnes of Intercession, Millais's first attempt
with the etching needle, was made to
accompany the partly autobiographical story
written by Dante Gabriel Rossetti for the fifth
issue of *The Germ*.[1] The invented Florentine
artist, Bucciuolo Angiolieri, is shown in the
act of painting his wife Blanzifiore, who dies
tragically during the portrait-painting session.
Blanzifiore's feeble condition is illustrated by
her wan expression and the support provided
by the two women by her side. The restless
Bucciuolo sits up from his stool, intent on
capturing his lover's likeness. His urgency
echoes a moment in the story when Blanzifiore
remarks on her husband's intention to paint
her portrait in order that 'there should still
remain something to him [Bucciuolo] whereby
to have her in memory.'[2] In the drawing (top),
Millais works out the positioning of the figures
and the interlinking arms of the three women.
The intensity of the detail is taken to a further
extreme where Millais scratched the design
on to the copper plate, notably for the floral
pattern in Blanzifiore's dress and the medieval
pointed shoes worn by the artist.[3]

Rossetti intended to illustrate the story
himself but, finding the precision of the etching
technique almost impossible to master,
irreparably damaged the surface of the copper
plate and asked Millais to take over. The
morbid subject matter relates to a drawing
in Rossetti's possession by Hunt, *One Step to
the Death-bed* 1848. Based on Percy Bysshe
Shelley's poem *Ginevra* (published
posthumously in 1824), Hunt's illustration
shows Ginevra being assisted to her final
resting place.[4]

St Agnes of Intercession was never published
owing to the collapse of *The Germ* after the
fourth issue, a result of an apathetic response
from the critics and disappointing sales. HB

17a

17b

Study for 'A Baron Numbering His Vassals'
1850
Pencil in parts finished with pen
and ink on paper
24.2 × 34.4
Birmingham Museums and Art Gallery.
Presented by subscribers, 1906

Provenance C.F. Murray, presented to Birmingham
by subscribers, 1906

Exhibited Tate 1911–12 (73); Tate 1923 (218);
RA 1934 (1255); Birmingham 1947 (165); Leicester
Galleries 1969 (31)

This study is a preparatory drawing for a
painting that was never executed. A larger pen,
ink and watercolour sketch (fig.9) shows a more
advanced composition, with a long line of
figures set against a background that includes a
castle, buildings, trees and river. An inscription
on the lower right margin of the Tate drawing
indicates that the proposed size for the painting
was 5ft by 3ft 6 inches (152.4 × 106.7cm), a scale
similar to that of *Isabella* and *Christ in the House
of His Parents*, Millais's major Academy exhibits
of 1849 and 1850 (nos.9, 20). Although Millais's
commitment to *The Woodman's Daughter* 1851

(no.23) was probably the main reason why the
project developed no further than the surviving
studies, Millais may also have become put off
the idea because of its strong compositional
similarities with *Isabella*. Not only is it a
medieval subject (in this instance partly based
on an engraving by Carlo Lasinio after a fresco
by Giuseppe Rossi in the Camposanto at Pisa),
but also the elongated line of figures recalls the
diagonal family group on the left side of the
table in the earlier painting.[1] The sub-theme
of class conflict inherent in a feudalistic caste
system is another shared aspect, as is Millais's
focus on expression and gesture to
communicate a range of psychological
responses to the counting. The vassals thus
appear variously apprehensive, passive and
hostile. A young man on the extreme right
nervously bites the feather of his cap and
fiddles with his fingernails, while his wife sucks
the fingers of her baby in order to stop
it fidgeting. A boy to her right insolently blows
his nose but is restrained by the guarding
hands of his father. The man to the right of the
figure being questioned stares defiantly past

the clerk, whilst the woman to his side
arranges her hair. The corpulent bodies of the
lord and lady of the estate counterpoint their
lean dependents, heightening the social
tension between the two groups.

Although the Tate drawing is inscribed
with the title, it is not clear if this work was
based on a specific literary or historical source
as was typical of Millais's practice at the time.
Unaware of the drawing now in the Tate
Collection, J.G. Millais titled no.18 *Canterbury
Pilgrims*, maybe thinking of Ford Madox
Brown's *Chaucer at the Court of Edward III*
(1856–68). However, soon after acquiring
the Tate drawing in 1906, the solicitor J.R.
Holliday canvassed opinion from Millais's
former associates as to its source, and received
an array of conjectural responses. F.G.
Stephens thought the work represented the
Penance of Jane Shore, Hunt suggested
it was an illustration to Patmore's poem
The Falcon (after Boccaccio), while William
Michael Rossetti speculated that it might be
an illustration to his brother's poem *Dante
at Verona*.[2] AS

Figure 9
A Baron Numbering His Vassals
1850
TATE

19

Study for 'Christ in the House of His Parents'

c.1849

Pencil, pen, ink and wash on paper

19 × 33.7

Tate. Bequeathed by H.F. Stephens, 1932

Provenance F.G. Stephens; Lt.-Col. H.F. Stephens, who bequeathed it to the Tate Gallery, 1932

Exhibited RA and Liverpool 1967 (254); Paris 1972 (190); Whitechapel 1972 (40); Baden-Baden 1973–4 (57); Phoenix and Indianapolis 1993; Australia and USA 2003–4 (4)

In 1849 Millais embarked on an original composition that presented the young Jesus in his father's workshop, having stabbed his hand on a nail, attended to by his parents. All aspects of the design were intended to develop the idea of the moment's prophetic significance. Preparatory studies show how Millais experimented with the balance of figures in his *Sacra Conversazione* in relation to surrounding details. A slight sketch in the Victoria and Albert Museum shows just four figures around the table and a small window to the left. A more detailed study at the Fitzwilliam Museum, Cambridge, introduces the mysterious woman folding a cloth on the right, who also appears in a number of other studies relating to

an unidentified subject, and to *Mariana* (no.24), indicating how Millais thought laterally across different projects in refining his ideas.[1] The study illustrated here may be the drawing D.G. Rossetti saw at Millais's studio on 1 November 1849.[2] It shows Christ turning away from his father to kiss his mother as she bites a thread from a cloth she tears with her hands, which she has taken from a basket to bind the wound. St Anne first appears here behind the table and, as in the earlier studies, the apprentice holds his right ear as if straining to hear the exchange between mother and son, a gesture that was rejected in a subsequent drawing (also Tate) as perhaps too obscure to be significant. The woman using her mouth to fold a cloth complements the action of the Virgin, but was also dropped in the finished painting in favour of the young John the Baptist and his greater prophetic relevance to the action.

According to Millais's cousin Edward Benest, both the design and intellectual content were discussed by Millais and his parents before he commenced painting. By 7 December 1849 Millais was reported to have redesigned parts of

the composition, and by 29 December he was at work on the canvas. However, some features were only resolved in the course of painting, particularly the interchange between mother and son and the figure of John the Baptist.[3]

This drawing is self-consciously naive in its spatial ambiguity and schematic treatment of form. Millais's use of line is pronouncedly diagrammatic and he may have used a ruler to accentuate the main perpendicular, horizontal and diagonal axes of the design. This architectural approach is offset by perspective alignments that do not quite converge, and an extreme delicacy of line and brushwork for shaded areas, the effect being that some figures appear violated by the furniture, such as the apprentice hemmed in by the aggressive sharp edges of a stool and window bench. The finished painting eliminates both the window to the left and foreground elements to focus attention on the movement of hands around the wound.

According to an inscription on the back of the card on which the design was mounted, Millais gave the drawing to F.G. Stephens shortly after he completed the painting. AS

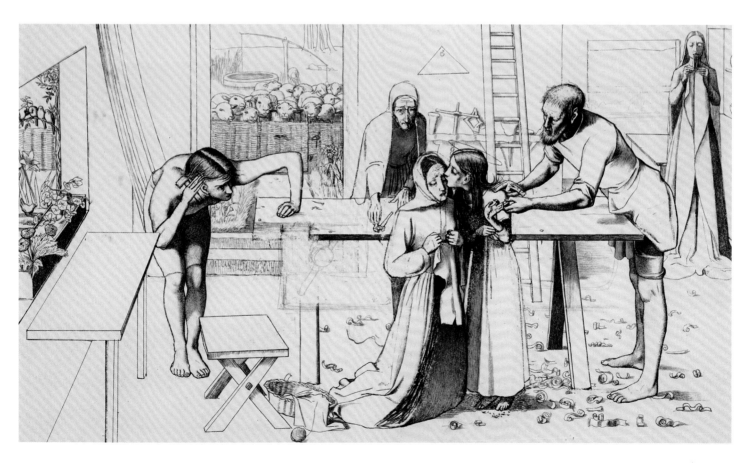

'Christ in the House of His Parents' or 'The Carpenter's Shop' 1849–50

And one shall say unto him, 'What are these wounds in thine hands'? Then he shall answer, 'Those with which I was wounded in the house of my friends.'– Zechariah xiii, 6
Signed and dated 1850 in monogram lower left
Oil on canvas
86.4 × 139.7
Tate. Purchased with assistance from The Art Fund and various subscribers, 1921

Provenance Bt Henry Farrer, dealer, 1850; T.E. Plint, sold Christie's, 8 March 1862 (328), bt Moore; Albert Grant by 1865, sold Christie's, 20 June 1868 (119), bt Moore; John Heugh, sold Christie's, 10 May 1878 (207), bt Bonner; F.A. Beer, Christie's, 8 May 1886 (95), bt in; purchased from Mrs Beer with the aid of the NACF, and presented to the Tate Gallery, 1921

Exhibited RA 1850 (518); RSA 1852 (93); Moore, McQueen, and Co., 25 Berners St, London, May 1862; Ryman's, Oxford, June 1862; Birmingham 1865 (71); FAS 1881 (5); GG 1886 (4); Whitechapel 1894 (112); RA 1898 (7); Glasgow 1901 (157); Whitechapel 1901 (301); NGL 1917; Paris 1938 (91); Birmingham 1947 (52); Tate 1948 (15); Manchester 1948 (16); USA 1956–7 (56); Ottawa 1965 (90); RA and Liverpool 1967 (26); RA 1968–9 (377); V&A 1977–8 (114); Tate 1984 (26); Washington 1997 (7); Tate 2000 (5); Hayward 2003–4 (19)

This was the first important religious work Millais exhibited in public and probably the most notorious image produced by a member of the Brotherhood. The picture aroused such widespread comment that it was removed from exhibition and brought to Queen Victoria for a special viewing.[1] Following the lead taken by Rossetti with *The Girlhood of Mary Virgin* 1848–9, Millais fabricated a story concerning the youth of a sacred figure for the purpose of pictorial experimentation, but was more audacious both in the scale and realism of his conception. The depicted scene shows an incident in Joseph's workshop. The child Jesus has pierced his hand on a nail and is seen attended to by his father and St Anne, while the youthful John the Baptist brings water and an assistant observes from the other side of the table. The dramatic focus of the composition is the encounter between the Virgin and her son. She kneels in front of him in an agonised attitude that betrays her apprehension of the portent of the incident as he raises his hand in benediction.

In order to emphasise the religious significance of the scene, Millais deliberately evoked the manner of early Renaissance painters. The composition was drawn directly on to the white priming (pencil marks can be clearly seen through the paint layers), and was then executed in distinct 'giornata' patches approximating to the fresco and tempera techniques of early Renaissance masters. The hieratic composition is a further acknowledgement of both medieval and revivalist art, and in its symmetrical disposition of figures, as well as subject matter, Millais may have been influenced by Xaver Steifensand's engraving after Friedrich Overbeck's *The Boy Jesus in Joseph's Workshop* 1847, available in print shops from 1848.[2]

However, the archaisms of design are offset by a relentless insistence on particular details that threaten to fragment the ordered arrangement of the composition. To establish authenticity Millais arranged to work in a real carpenter's workshop, where he installed a bed, and got friends and relatives to model for the figures.[3] The artist's sister-in-law Mary Hodgkinson (who had also posed as Isabella in no.9) sat for the Virgin Mary, while the figure of Joseph was based on a grocer from Holborn in order to render 'authentic' working man's musculature in the arms. The face, suggesting intelligence with its pronounced forehead, was based on that of the artist's father. Millais's insistence on physicality was carried to Caravaggesque extremes, as evinced by the two sheep heads he obtained from a butcher's shop to paint the flock, and the blood he squeezed from his own finger and placed on the palm of the young Noël Humphreys to obtain the exact colour for the wound of Christ.[4] Such myopic attention to detail forces the eye to focus on peculiarities such as the dirty toenails of the journeyman on the left, and the red swollen hands of St Anne. Millais's figures appear to be as precisely defined at the extremities as they are in the face, rather than tapering elegantly to fine points as was typical of early Victorian art, and this lends his characters a corporeality he himself found astonishing. Hunt recalls Millais saying that the body of John the Baptist appeared so thoroughly in relief 'that on looking again to the model I could not at the moment tell which was which'.[5] The blend of archaism and realism also serves to accentuate anachronistic aspects of the design, which destroys the illusion of historical authenticity. The scene suggests rural and urban England while also evoking Palestine, and the costume is both biblical and contemporary. In representing Christ with red hair Millais may have intended to bestow Jesus with what he believed to be the racial characteristics of European Ashkenazi Jews, but in so doing risked censure given the negative connotations of red hair in contemporary culture.[6]

The picture was exhibited without a title but instead accompanied by an epigraph from one of the Hebrew prophecies from the Old Testament, which functioned as a sort of analogy, the words from Zechariah given fresh meaning in a context that prefigures the Passion of Christ. The typological relationship between text and image is developed within the composition by associative symbols and ominously significant objects, which collectively remind the viewer of the Crucifixion and the Anglican Church's only two sacraments of Baptism and Communion.[7] Some thought the epigraph from Zechariah inappropriate because the wounded man referred to was conventionally acknowledged to be a false prophet and not the Messiah.[8] However, the text had been evoked in relation to the Passion by the Oxford Movement theologian Edward Pusey and, according to Hunt, the idea for the painting was prompted by a sermon on the passage by Pusey that Millais heard in Oxford during the summer of 1849.[9] One of the reasons why the picture became so controversial was because of its perceived link with the Tractarian or Anglo-Catholic movement within the Church of England. The outburst of anti-Papist feeling in 1850 following Pius IX's restoration of a Catholic ecclesiastical administration in England that had not existed in the country since the Reformation certainly fuelled the charges of retrogression levelled at Millais's painting. Not only was his symbolic scheme considered High Church or Catholic in emphasis, but the hieratic positioning of figures around the bench suggested clergy at an altar, thereby foregrounding the ritualistic celebration of the sacrament of Communion. The fence in the distance is further suggestive of the chancel screen used in Catholic churches to separate clergy from laity. Of particular affront to Protestants was the literal depiction of Christ's wound, suggesting affirmation of the Catholic doctrine of transubstantiation in Mass.

The picture was thus doubly offensive because of its Roman Catholic liturgical references and the fact that it appeared too realistic. Most shocking of all was Millais's representation of the Virgin Mary. Far from inviting Mariolatry, the agony of prescience implied by her haggard expression was interpreted as evidence of her degeneracy. The writer Charles Dickens was particularly offended by this figure and, in an attack on the picture, wrote that she appeared 'so horrible in her ugliness that (supposing it were possible for any human creature to exist for a moment with that dislocated throat) she would stand out from the rest of the company as a monster in [...] the lowest gin shop in England'.[10] The extent to which Millais departed from the serene manner adopted by revivalist artists for holy figures would have been underlined by the appearance of W.C.T. Dobson's *The Virgin Mary and Child Jesus* at the same exhibition, praised by the *Art Journal* for being cast in the pure manner of the early schools.[11]

In the final chapter of his *Modern Painters II*, the critic John Ruskin contended that

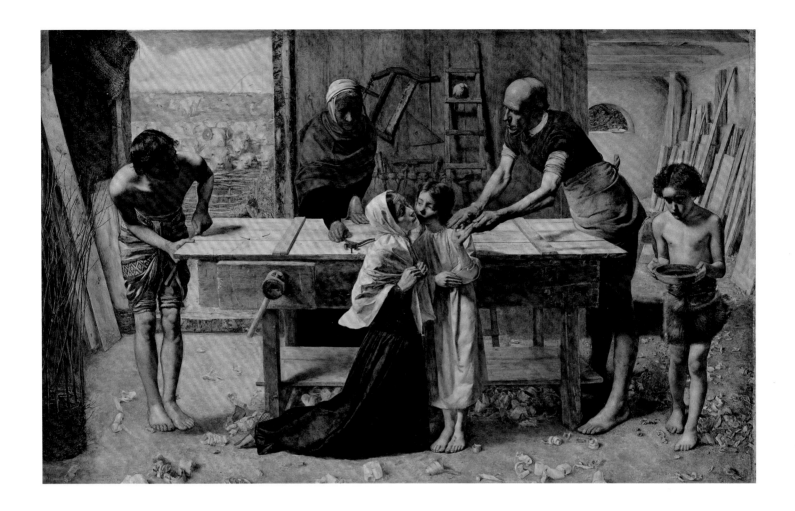

idealisation was the proper way to treat sacred personages, finding an excessive physicality unspiritual and undignified.[12] Idealisation was in fact the conventional way of treating spiritual beings in Britain, as testified by the works of religious painters like J.R. Herbert, Charles Eastlake and William Dyce. As advances in the science of anatomy encouraged artists towards a more scientific understanding of the figure in order to comprehend how complex internal functions influenced external appearance, the Academy retaliated with the claim that the fine arts aspired beyond mechanical replication towards a higher ideal of beauty. What were condemned as the intentional deformities of Millais's figures – the frost-bitten toes of Joseph or the rickety limbs of John the Baptist – were seen by some critics to be symptomatic of the encroachment of pathological anatomy into the realm of art.[13]

Millais's concern to present biblical figures in modern guise, by emphasising the particular and mundane, caused a furore at the time, but paved the way for a humanist religious art later exemplified by the art of James Tissot and Fritz von Uhde.[14] AS

Study for 'The Woodman's Daughter' 1849
Pencil, pen and wash
Signed and dated in monogram lower right
17.8 × 12.5
Yale Center for British Art, Paul Mellon Fund

Provenance Probably B.G. Windus; sold Christie's, 19 July 1862 (3), bt Dr Black; Miss Edith Garrod; anon. sale, sold Christie's, 19 June 1979 (192), bt J.S. Maas & Co, from whom bt by Yale

Exhibited Tate 1923 (214); BAC 1981; BAC 1986–7 (106)

This drawing is a study for no.23. The *PRB Journal* records Millais reading Coventry Patmore's *The Woodman's Daughter* on 23 March 1849. On 7 December Millais showed his friends a design, apparently the second, for the line 'He sometimes, in a sullen tone, would offer fruits', which he subsequently used as a basis for the painting.[1] The reference was probably to this study, which places the figures in the composition with the background sketched in. Gerald is shown disproportionately large observing the children, while the young squire offers cherries and Maud is presented with long hair as she was in the painting before the alterations of 1886.

Two studies relating to the work exist: a drawing at Princeton University Art Museum, which is probably not by Millais but a copy of the finished painting made by another artist before the repaints; and a study with watercolour washes in a private collection, tentatively attributed to Millais, which closely resembles the work under discussion, and may possibly be a preliminary study.[2] AS

22

Study for 'Mariana' 1850
Pen and black ink and wash
21.4 × 13.7
Signed in monogram lower right
Victoria and Albert Museum, London

Provenance Probably T.E. Plint, sold Christie's, 7 March 1862 (88), bt Crofts; Miss M. Adams sold to V&A, 14 Jan. 1931

Exhibited Birmingham 1947 (169); RA and Liverpool 1967 (263); Paris 1972 (191); Whitechapel 1972 (41); Baden-Baden 1973–4 (60)

This is an early design for *Mariana* (no.24), and shows the composition without the concrete natural details that Millais inserted following his visit to Oxford in June 1850. At this stage the drawing can also be seen as more of a response to Tennyson's *Mariana* than his poem *Mariana in the South*, with its distinctive Marian imagery. Mariana is represented with eyes closed as if focused on the fantasy of receiving Angelo; and the passing of time is indicated by the spider's web on the window pane, while the mouse, which also appears in the finished painting, suggests stillness and silence. The outline of a mirror behind Mariana's head would suggest that Millais was thinking of painting her reflected loosened hair. As Alastair Grieve has noted, the drawing is very different from the sharpness of Millais's earlier graphic style, although the sense of weight and volume accords with the sensuousness of the subject.[1] AS

The Woodman's Daughter 1850–1

'She went merely to think she helped;
And, whilst he hack'd and saw'd,
The rich squire's son, a young boy then,
For whole days, as if awed,
Stood by, and gazed alternately
At Gerald, and at Maud.
He sometimes, in a sullen tone,
Would offer fruits, and she
Always received his gifts with an air
So unreserved and free,
That half-feign'd distance soon became
Familiarity.' – Coventry Patmore

Oil on canvas
88.9 × 64.8
Signed and dated in monogram lower right
Guildhall Art Gallery, City of London

Provenance Bt by Henry Hodgkinson; Lady Millais, 1898; Christie's, Millais sale, 2 July 1898 (24), bt Lord Bearstead, who presented it to the Corporation of London, 1921

Exhibited RA 1851 (799); FAS 1881 (6); GG 1886 (115); RA 1898 (33); FAS 1901 (81); Manchester 1911 (264); Liverpool 1921 (975); Tate 1923 (214); RA 1934 (570); Birmingham 1947 (56); Port Sunlight 1948 (130); Bournemouth 1951 (7); RA 1951–2 (277); Sheffield 1952; Arts Council 1962 (45); RA and Liverpool 1967 (29); SLAG 1971 (22); Whitechapel 1972 (30); Baden-Baden 1973–4 (62); Mitsukoshi 1975 (V78); Jersey 1979 (28); Tate 1984 (32); Barbican 1984 (18); Japan 1985; Barbican 1988; Fitzwilliam 1989 (60); Colnaghi 1990 (77); Phoenix and Indianapolis 1993; NGL 1995

The poet Coventry Patmore (1823–96) became known to the Brotherhood when the sculptor Thomas Woolner wrote to him asking for a copy of *The Woodman's Daughter* (1844), a poem widely acclaimed by the group.[1] The *PRB Journal* entry for 22 November 1849 states that a long argument about poetry had ensued at a meeting at Woolner's attended by Patmore, Millais, John Cross and the Rossetti brothers. Here Patmore pronounced the present generation of poets to be highly self-conscious in contrast to their predecessors, 'but not yet sufficiently so for the only system now possible – the psychological'.[2] In selecting the tenth and eleventh stanzas from *The Woodman's Daughter*, Millais was furthering his exploration of the theme of fatal attraction set out in *Isabella* (no.9), a picture Patmore considered 'far better than anything Keats ever did'.[3] The poem addresses the tragic relationship between Maud, the woodman's daughter, and the petulant son of a squire. A childhood acquaintance later blossoms into an affair, which cannot be fulfilled through marriage because of differences in social rank. Maud gives birth to an illegitimate child but after drowning it descends into madness. In keeping with Pre-Raphaelite practice, Millais uses various elements within the composition to draw out distinctions of character and class and to hint at the consequences of action. The oak leaves in the left corner thus suggest the integrity of Gerald, Maud's father, in contrast to the lust of the young squire symbolised by his red hair and tunic, the switch of wood in his hand and two ominous bird feathers at his feet. Maud is significantly positioned between the axe wielded by her father and the strawberries proffered by the boy, while the sexual nature of the children's later history is relayed by the intensity of their gaze and the dynamic thrust of the boy's arm (a gesture perhaps influenced by the kick in *Isabella*), although such candid and awkward posturing is also an original observation of a characteristic of children their age.[4]

Infra-red examination of the painting reveals that Millais plotted the position of the figures before he commenced painting. During the summer of 1850 he took lodgings at Botley near Oxford in order to paint the scenery directly from nature at Wytham Wood. Very little under drawing exists for the vegetation, evidence of this *plein-air* approach to the landscape, although it has been suggested that the patterned structure of the background was prompted by Paolo Uccello's *The Hunt in the Forest* c.1470, presented to the University Gallery, Oxford, in 1850.[5] In contrast to the looser brushwork of the distance, the foreground of *The Woodman's Daughter* is an astonishing feat of mimetic observation, the profusion of natural detail overriding rational space and the masking of each tree trunk with undergrowth, such as the coppice at the bottom right, increasing the piled-up effect. Rejecting conventional methods of drawing the eye into the composition through tonal modulation, the dazzling patterns of shimmering greens add to the overall spatial dislocation.

The figures were only completed following Millais's return to London in November 1850, thereby increasing the tension between figure and ground. Millais paid close attention to the specifics of costume, such as the creases and dart in the boy's stockings, and in January 1851 he wrote to Mrs Combe in Oxford about obtaining some old boots from a cottage child on the estate where he had been working. He added: 'If you see a country-child with a bright lilac pinafore on, lay strong hands on the same, and send it with the boots.'[6]

In his autobiography Hunt mentions that it was with *The Woodman's Daughter* that Millais first experimented with the wet-ground technique, and certainly the naked eye can detect traces of drawing through the painting in the area of the boy's head that Hunt had singled out as an example.[7] The picture was hung on the line in the old architectural room at the Academy, and made enough of an impact to influence subsequent Pre-Raphaelite productions such as John Brett's *The Hedger* 1860.[8] However, the work proved difficult to sell, probably because the face of the girl did not conform to expectations of rustic simplicity; as the *Guardian* put it:

> The figure of the girl is strictly true to nature and fact, but will, no doubt, be a scandal to lovers of picturesque costume, who object to the appearance of female rustics in pictures otherwise than in fancy dresses and with fair skins.

Patmore himself later described the girl as 'a vulgar little slut'.[9] The painting was eventually bought by Millais's half-brother Henry Hodgkinson, at whose request Millais repainted the offending face and other parts of the work in 1886. The discoloration of the alterations in contrast to the stability of Millais's earlier technique has affected the stylistic coherence of the work. AS

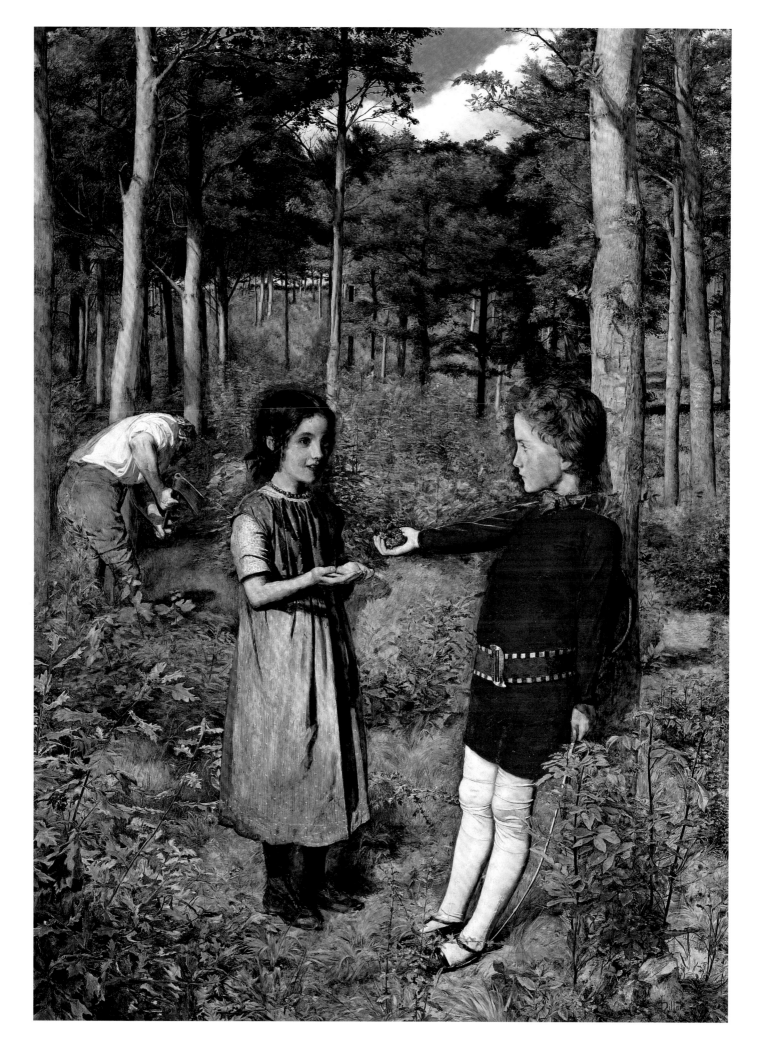

24

Mariana 1850–1
'She only said, "My life is dreary –
He cometh not!" she said;
She said, "I am aweary, aweary –
I would that I were dead!"' – Tennyson
Oil on mahogany
Signed in monogram lower right
59.7 × 49.5
Tate. Accepted by H.M. Government in lieu of
tax and allocated to the Tate Gallery 1999

Provenance Bt Henry Farrer, 1851; B.G. Windus, sold
Christie's, 19 July 1862 (54), bt in; J.M. Dunlop, sold Christie's,
5 May 1883 (60), bt Agnew's; H.F. Makins and thence by
descent; accepted by H.M. Government in lieu of tax and
allocated to the Tate Gallery, 1999

Exhibited RA 1851 (561); RSA 1852 (9); GG 1886 (79);
Birmingham 1891–2 (192); RA 1898 (62); BFAC 1906 (48);
Tate 1911–12 (20); Tate 1923 (7); RA 1934 (564); Birmingham
1947 (55); Whitechapel 1948 (45); Agnew's 1961 (57); RA
and Liverpool 1967 (30); RA 1968–9 (379); King's Lynn 1971
(55); Munich 1979–80 (319); Tate 1984 (35); Washington
1997 (8); Berlin 1998 (51); Tate 2000 (6); Australia and USA
2003–4 (7)

Around the time he was made Poet Laureate, Alfred, Lord Tennyson (1809–92) heard that Millais was painting *The Woodman's Daughter* for Patmore, and reputedly said: 'I wish he'd do something from me.'[1] Tennyson was probably unaware that Millais was already at work on *Mariana* from his poem of the same title of 1830, which was itself derived from Shakespeare's *Measure for Measure*. Mariana is a character who leads a solitary existence in a moated grange after being rejected by her fiancé Angelo when her dowry is lost in a shipwreck. She still yearns for him (Millais represents her wearing an engagement ring), but neither the painting nor poem give any indication of Shakespeare's happy ending. The private altar by Mariana's bed in the background, adorned with a portable triptych and sacred vessels illuminated by the glow of a red oratory light, suggests that Millais was also referencing Tennyson's other poem on the same theme, *Mariana in the South* (1832), which presents her desperately moaning to the Virgin Mary. The silver caster on the altar also appears in the painter's *The Bridesmaid* (no.27) and *St Agnes' Eve* (no.28), the latter an illustration to Tennyson's eponymous poem and also concerned with erotic longing. The snowdrop in the heraldic stained glass represents consolation in the language of flowers and is significantly the flower of St

Agnes, on whose feast day maidens dream of their lovers.

This layering of literary allusions deepens Millais's exploration of the tension Mariana experiences between her spiritual and physical desires. In this sense the painting can be seen as a complement to Hunt's *Claudio and Isabella*, begun in 1850 and also from *Measure for Measure*, where the integrity of Isabella is relayed by her rigid white figure in contrast to the contorted, troubled poses of Claudio and Mariana. Millais's painting also bears comparison with Rossetti's *Girlhood of Mary Virgin* 1848–9, with its image of the Virgin at her embroidery table, and especially with Collins's *Convent Thoughts* 1850–1, which was executed at Thomas Combe's residence in Oxford while Millais was working there in June 1850 on *Mariana*.[2] The Marian overtones of both paintings (the *hortus conclusus* imagery and the ultramarine robe of Mariana) may have been encouraged by the high-church Combes, while the body-effacing drapery of Collins's nun echoes the flat, self-contained stained-glass Virgin in Millais's picture – an ironic counterpart to the sensuous but unfulfilled Mariana.

Millais shares with Tennyson an extraordinary eye for detail, which serves to heighten the psychological intensity of his scene. Objects thus conspire to form an iconography that communicates spiritual seclusion and a yearning for sexual consummation. The atemporal nature of the spiritual life vies with the temporal cycles that govern existence; and the ambiguity of Mariana's gaze, whether it is unfocused or she is looking at the stained glass or the natural world beyond the window, increases the conflict between her seclusion and the feeling of ennui generated by the slow but inexorable passage of time indicated by the wilting leaves scattered across the chamber. Her desolation is further suggested by the penumbral shadows that dissolve form altogether in the far recesses of the room and beneath the embroidery table. The two white tablecloths thus appear suspended, offering a visual equivalent to Mariana's inertia as she waits for Angelo, while also showing how Millais sought to relieve potentially overwhelming surface detail with passages of impressionistic handling.

The pose of Mariana is the single most startling feature in the painting and the key to its interpretation. The attitude was adapted from the stretching figure by a window in a sketch for an unidentified subject (possibly relating to *The Eve of the Deluge*, no.26, or the subject of the youth of the Virgin) in Birmingham, together with a number of related studies.[3] The real yet unusual posture admits an element of voyeurism as the woman is viewed from behind, and this, together with her hands grasping her back, accentuates the fulsome curves of her breast, hips and buttocks. The voluptuousness of the figure, heightened by the brilliant blue of her dress, contrasts with the pallor of her face and what contemporaries considered to be the plain features of the model ('ill-complexioned', according to the *Art Journal*), reinforcing the dichotomy between the self-negation of Mariana's nun-like existence and her sexual languor and frustration.[4] As well as communicating weariness the pose also connotes the backache of pregnancy, but the conception symbolised by Gabriel's salute to Mary is denied Mariana, exacerbating her internal torment.

As was the case with the *Dove* (no.25), Millais sold *Mariana* before it was exhibited at the Royal Academy, in this instance to the dealer Henry Farrer. The painting was hung just below the line in the West Room where, according to William Michael Rossetti, it was a great favourite with women visitors. Overlooking the obvious theme of confinement, it was probably the fact that the picture was a rare example of a work that focused specifically on the subjectivity of what appeared to be an ordinary woman that appealed, as the *Guardian* put it:

> This is the poetry of painting; the effect produced being the exact opposite of that which we experience in so many pictures, when a passionate conception is so often reduced to a mere prosaic stage-like reality.[5]

In 1864 Millais returned to the theme of a woman gazing introspectively at a window with *Swallow! Swallow!* 1864 (Private Collection), from Tennyson's *The Princess* 1847. Despite similarities in colour and design, this was less radical in terms of its symbolic range and psychology.[6] AS

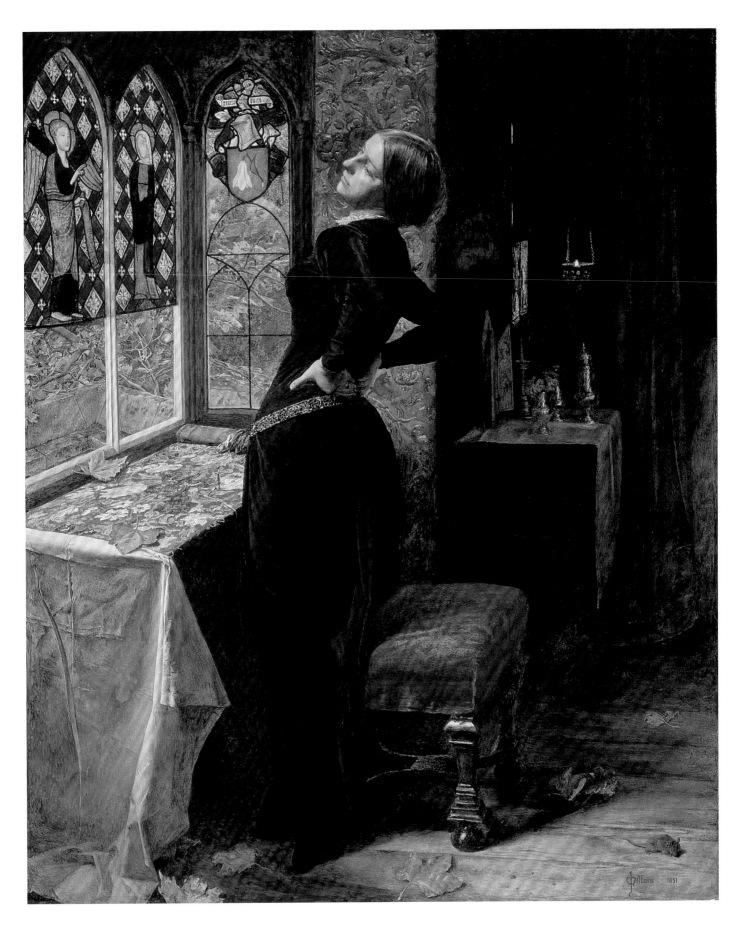

The Return of the Dove to the Ark 1851

Oil on canvas, arched top
88.2 × 54.9
Signed and dated in monogram lower right
The Ashmolean Museum, Oxford. Bequeathed
by Mrs Thomas Combe, 1893

Provenance Bt by Thomas Combe, 1851; Combe Bequest
to The Ashmolean Museum, 1893

Exhibited RA 1851 (651); Oxford Town Hall, 22–24 June
1854; RSA 1854 (437); Paris 1855 (887); London 1862
(650); GG 1886 (88); Liverpool 1933 (59); Birmingham
1947 (54); Manchester 1948 (17); RA 1951–2 (275);
Indianapolis 1965 (54); RA and Liverpool 1967 (32);
RA 1968–9 (376); V&A 1977–8 (115); Tate 1984 (34);
Japan 1987 (21); Tate 2000 (8)

This painting is an imaginary interpretation of
Genesis 8:8–11, and presents the wives of the
sons of Noah tending the dove that was released
from the ark and which returned with an olive
branch showing that the flood waters were
receding. Millais initially planned to include
Noah praying, with the olive branch in his hand,
alongside the girls with the dove against a
background comprising several birds and
animals. On 10 February 1851 he informed Mrs
Combe that he was about to start painting, but
because this did not leave sufficient time for
completion before submission to the Academy
in April, it seems that he decided to reduce the
composition to just two figures set against a
dark background.[1] Technical examination of the
work reveals no drawing for the elements first
proposed, and the existence of a full-scale nude
study for the two figures at the Royal Academy
would further indicate that he had revised his
plans before commencing painting.[2] The

finished picture focuses on the body language
of the girls as they attend to the bird, their
gauche postures and complex hand
movements reinforcing the intimacy of the
encounter.

The painting was purchased by the
Tractarian Thomas Combe before it was
exhibited and, as Malcolm Warner has
suggested, may have been intended as a
pendant to Charles Collins's *Convent Thoughts*
1850–1, also in Combe's collection, the theme
of hope and salvation in Millais's painting
complementing Collins's message of suffering
and resignation. The idea of a pair is
encouraged by the fact that Millais designed a
frame for *Convent Thoughts*, and planned one
for the *Dove* with 'olive leaves, and a dove at
each corner holding the branch in its
mouth'.[3] At the time of his friendship with the
Combes Millais was intrigued by Catholic
doctrine and ritual. The girl on the right thus
wears a white chasuble, her companion a
garment resembling a dalmatic, while the dove
is open to interpretation as a typological
symbol of the Holy Spirit. According to the
artist's brother William, the painting was
viewed by one scholar as emblematic of the
return of Protestant Christians (Millais
included) to the Catholic fold.[4]

The *Dove* was exhibited together with *The
Woodman's Daughter* and *Mariana*, and hung
in the West Room of the Royal Academy. On
hearing that John Ruskin was interested in
purchasing the work, the Brotherhood felt
emboldened to appeal to the critic for support,

which resulted in Ruskin's defence of their
aims in letters published in *The Times* on
13 and 30 May 1851. Here the writer
countered accusations that the movement's
programme was Tractarian and that it
indulged in distortion, contending that its
real dialogue with the past resided in its
emphasis on truth-to-nature. He thus praised
the fidelity with which Millais treated the
ruffled feathers of the wearied dove, the
strands of hay, and the drapery of the
stooping girl on the right, although he did
privately question the accuracy of the olive
branch.[5] Such sentiments were echoed by
William Michael Rossetti writing
anonymously in the *Spectator*, who
commended Millais's truthful depiction of the
figures as lending conviction to the Bible.
Apropos the foremost girl in green he noted:
'she has a large human sincerity of character,
and healthful freshness, primal if not
primaeval, which is far above affected
prettiness as it is unlike stilted convention.'[6]
In contrast to his earlier predilection for
representing thin gaunt females, with the
Dove Millais offered, Rossetti suggested, a
more robust conception of womanhood.
However, many critics found his types
unattractive and distinctly working class.
One writer described the figures as a literal
transcription of the 'laundry maids' Millais
had employed as models; while another
thought his disregard for the waist signalled
a shift towards 'dumpiness' in his
representations of women.[7] AS

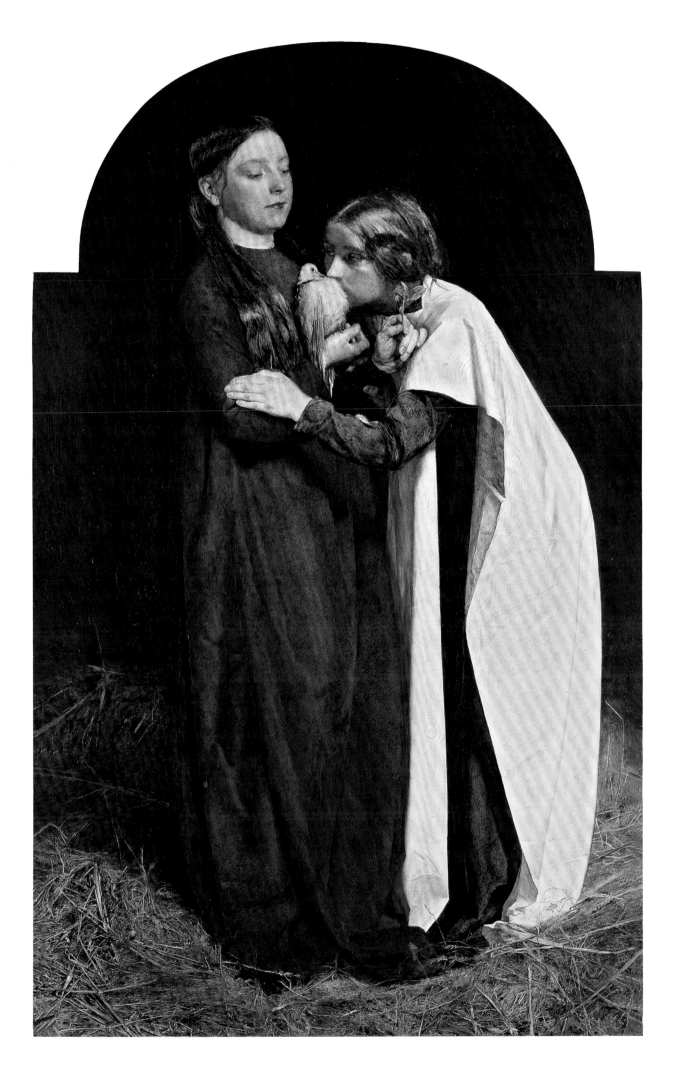

The Eve of the Deluge 1850
Pen and ink, with some grey wash, over pencil
24 × 41.3
The British Museum, London

Provenance J.G. Millais, son of the artist; bt by the British Museum from the FAS 1901

Exhibited FAS 1901 (46); Birmingham 1947 (167); RA and Liverpool 1967 (257); RA 1968–9 (600); Baden-Baden 1973–4 (59); Arts Council 1979 (47); Tate 1984 (171); BM 1994–5 (39); Valencia 2002–3

The subject of this drawing is taken from the Gospel of St Matthew, 24:38–9:

> In the days before the flood they ate and drank and married, until the day that Noah went into the ark, and they knew nothing until the flood came and swept them all away. That is how it will be when the Son of Man comes.

In using a New Testament text to comment on the Flood from Genesis, Millais was reversing the typological procedure he had adopted in *Christ in the House of His Parents* (no.20), in which he used an Old Testament passage to presage the Crucifixion. It is possible, therefore, that the *Deluge* was conceived as a pendant to the former, the grim theme of sinners encountering the end of the world counterpointing the promise of salvation through Christ's sacrifice. Describing the subject to Mrs Combe in 1851, Millais argued that the one advantage a painting had over a sermon was its ability to present every element before the spectator 'without that trouble of realisation often lost in the effort of reading or listening'.[1] The repetition of features from one composition to another was thus a key means of communicating meaning; and so the table central to both works serves to unite the Holy Family in ritual communion in *Christ in the House of His Parents*, but isolates each family member in his or her own selfish desire in the *Deluge*.

This drawing is probably the design Millais showed D.G. Rossetti on 10 December 1850, and which he mentioned he was working on to Mrs Combe in a letter of 2 December. The drawing is squared up for transfer, which would indicate that Millais had settled the composition in his mind. However, on 28 January 1851 he reported to Mrs Combe that he had temporarily abandoned the subject in favour of a smaller painting, the *Dove* (no.25).[2] Later in 1851, however, Millais was working on it again, sending Mrs Combe a detailed description of what he now intended for the design. While this account matches no.26 in certain features, such as the bride showing her ring to the young girl plighting her troth to the man about to kiss her, some of the other figures described, like the 'drunkard railing boisterously at another', 'the glutton quietly indulging his weakness' or the woman vainly withholding her robes from a dripping dog, either do not appear in the drawing or, if they do, are not as fully developed as allegorical figures.[4] This would suggest that Millais had amplified the composition in his mind, adding to his litany of types, perhaps with the aim of embodying the Christian deadly sins. But this ambitious and possibly unmarketable project again stalled.

However, the subject's significance for Millais is indicated by the ideas it generated; not only simpler compositions like the *Dove* and *The Bridesmaid* 1851 (no.27), but also a number of paintings and drawings that employ liminal devices such as the ring, table and window to explore the boundaries separating the sacred from the secular. Millais had still not given up on the undertaking. In 1852 he mentioned the 'Flood' in correspondence with Mr Combe, and in 1853 discussed the subject with Ruskin, who informed his father that the artist envisaged it would take three to four years to complete. Millais's final recorded reference to the painting was a letter to Hunt of 7 February 1854: 'I shall *certainly* join you next Autumn [in the Holy Land]. I shall there begin the Flood.' In the event, Millais's marriage to Effie on 3 July 1855 put an end to the project once and for all.[4] AS

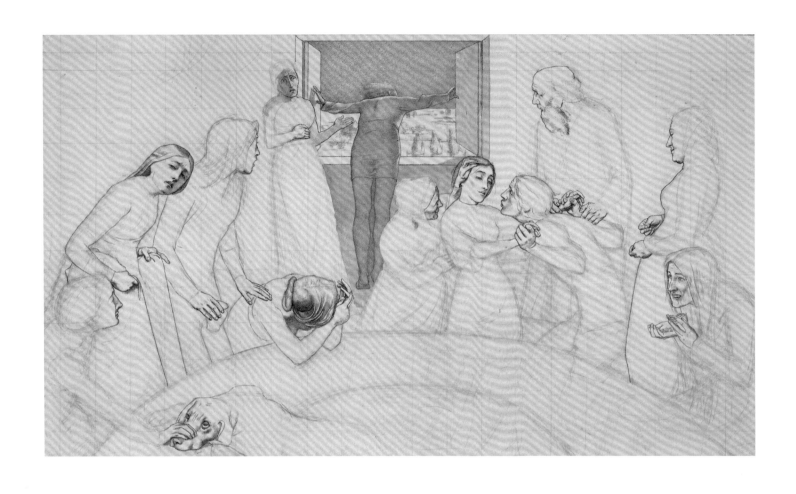

The Bridesmaid 1851
Oil on panel
27.9 × 20.3
Signed and dated in monogram upper left
The Fitzwilliam Museum, Cambridge

Provenance B.G. Windus by 6 March 1855; sold Christie's, 19 July 1862 (46) and 14 Feb. 1868 (314), bt Gambart; anon. sale (likely to be J.M. Wright of Liverpool) Christie's, 4 Feb. 1888 (143), bt Shepperd; by descent to T.W. Harding; presented by T.R. Harding to the Fitzwilliam Museum, 1889

Exhibited Leeds 1888 (264); Whitechapel 1905 (381); Manchester 1911 (272); Tate 1923 (79); Bournemouth 1951 (34); RA and Liverpool 1967 (33); Toronto 1969 (29); Turin 1969 (36); Tate 1984 (37); Fitzwilliam 1989 (62)

The small experimental painting of *The Bridesmaid* was executed while Millais was working on his 1851 Academy submissions. The sketchy lines of under drawing that can be detected through the translucent layers of paint would seem to indicate that he painted the subject direct from the model, in this instance a professional known as Miss McDowall.[1] In its bold iconic presentation of a figure pressed tight against a ledge, the work respects the format used in early Renaissance portraiture, while the hypnotic expression of the woman is intensified by the juxtaposition of dazzling colours, elements that foreshow Millais's later close-ups of entranced young women (see *Sophie Gray*, no.83), as well as Rossetti's sensuous half-lengths of the late 1850s.

In a letter to Mrs Combe of 15 January 1851, Millais mentioned that he had just completed a very small picture of a bridesmaid 'who is passing the wedding-cake through the ring nine times' in the hope of being granted a vision of her future husband. He was referring to the custom of the 'dumb cake' often enacted upon St Agnes' Eve, when a girl would pass nine pieces of cake she had baked in silence three times through a ring borrowed from a married woman.[2] Apart from folklore, the subject may also have been suggested by Tennyson's *The Bridesmaid*, or even *Mariana in the South*, with its rapt description of a woman parting her locks and gazing intently in a mirror.[3] Visually it relates to the marriage scene and the figure of the bride showing off her wedding ring in *The Eve of the Deluge* (no.26). The theme of exaltation anticipates the ecstasy of the nun in *St Agnes' Eve* (no.28), while also developing the idea of longing and frustration explored in *Mariana* (no.24). The scene can thus be described as an erotic liturgy in which Millais interweaves sacred and profane meaning. The baldachin of golden hair recalls the extravagant tresses of the Magdalene while also suggesting the cowl and habit worn by a nun to disguise the body. The sugar caster or condiment vase is more prominently positioned than in *Mariana* or *St Agnes' Eve*, and carries both sexual and spiritual overtones, while the orange blossom, a traditional symbol of chastity, also signifies marriage, the novelist W.M. Thackeray sardonically describing the flower as a touching emblem 'of female purity imported by us from France, where people's daughters are universally sold in marriage'.[4] The placement of the corsage on the girl's chest suggests that she is imbibing its powerful scent, adding to her state of reverie, while at the same time Millais plays on the senses of the viewer in appreciating the work. AS

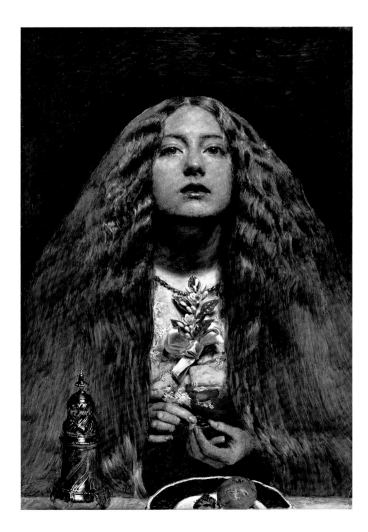

St Agnes' Eve 1854
Pen and sepia ink, with green wash
24.8 × 21
Private Collection

Provenance Given by the artist to Effie Ruskin by late
Feb. 1854; bequest to her brother, George Gray, 1897;
Melville Gray; Admiral Sir William James, G.C.B. grandson
of the artist; by descent to Miss A.D. Dolphin, by 1970s
to present owner

Exhibited RA 1898 (223); FAS 1901 (86); Whitechapel
1948 (59); Arts Council 1964 (239); RA and Liverpool
1967 (338); Portsmouth 1976 (33); Arts Council 1979 (30);
Tate 1984 (200)

This drawing was given to Effie Ruskin by
Millais in 1854 at the same time as he was
making the finishing touches to the portrait
of her husband, which he had begun at
Glenfinlas the year before (no.38). The
composition was based on a sketch Millais
made for the proposed, but unrealised, portrait
of Effie standing by a window in Doune Castle,
which was planned as its pendant.[1] Millais had
fallen in love with Effie during their time in
Scotland, and she must have suspected his
growing affection towards her when she
realised that the pining nun was in fact a
self-portrait. She wrote to her mother on 2
March:

> The Saint's face looking out on the snow
> with the mouth opened and dying-looking
> is exactly like Millais' – which however,
> fortunately, has not struck John who said
> the only part of the picture he didn't like was
> the face which was ugly but that Millais had
> touched it and it was better, but it strikes me
> very much.[2]

Here Millais relates his desire to be attached to
Effie with the nun's longing for the
consummation of her spiritual marriage with
Christ following her death.

Taking his inspiration from Tennyson's
eponymous poem of 1837, Millais presents the
nun looking rapturously on to the snow-laden
roof of the convent. A snowdrop, the birthday
flower for St Agnes, can be seen both in the
leading of the window and on the nun's breast.
The silver caster resting on the altar, an object
that also appears in *The Bridesmaid* (no.27),
and *Mariana* (no.24), here may refer to the
tradition on St Agnes' Eve of eating the shell
of a hard-boiled egg filled with salt and the
multivalent symbolism prevalent in Pre-
Raphaelitism.

The design was engraved as a frontispiece
to Henry Leslie's *Leslie's Songs for Little Folks*
(1883), for which Millais was the sole illustrator.
Leslie's Songs was a reprint of an earlier book,
Little Songs for Me to Sing (1865).[3] HB

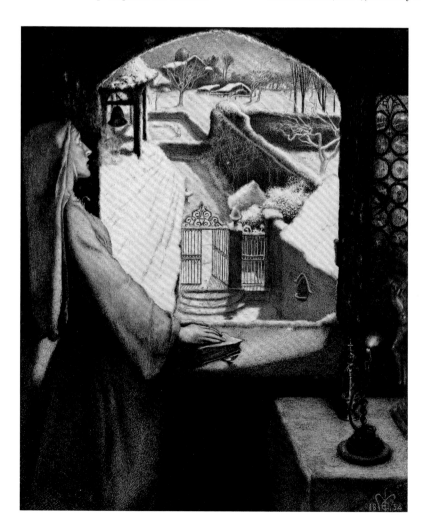

**Portrait of a Gentleman and his Grandchild
(James Wyatt and his Granddaughter,
Mary Wyatt)** 1849
Oil on wood
35.5 × 45
Signed and dated in monogram lower right
The Lord Lloyd Webber

Provenance Commissioned by James Wyatt, and given to
Mary Wyatt (later Mrs Standen); by descent until sold
Sotheby's, 8 June 1999 (27); the Lord Lloyd Webber

Exhibited RA 1850 (429); Oxford Town Hall 1854; GG 1886
(2); RA 1898 (32); Birmingham 1847 (46); Whitechapel 1948
(41); RA 1956–7 (443); Ottawa 1965 (89); RA and Liverpool
1967 (20); Tate 1984 (28); NPG 1999 (4); RA 2003 (20)

This painting is one of several portraits
commissioned from Millais by the sitter, James
Wyatt (1774–1853), a frame-maker, print seller
and art dealer who lived above his shop James
Wyatt & Son at 115 High Street, Oxford. Wyatt
was curator of the Duke of Marlborough's
collection at Blenheim Palace, and from 1842–3
served as Mayor of Oxford. Millais first met
Wyatt during the summer of 1846 when he was
staying with his half-brother Henry Hodgkinson
in Oxford, and Wyatt soon became an important
patron of the artist's work. In 1849 he purchased
Millais's large *Cymon and Iphigenia* (National
Museums Liverpool, Lady Lever Art Gallery),
and later the oil sketch *The Death of Romeo and
Juliet* (no.7).

This portrait was painted in September and
October 1849, when Millais stayed with Wyatt
after completing the background to *Ferdinand
Lured by Ariel* (no.15) at Shotover Park. It
shows Wyatt sitting with his four-year-old
granddaughter Mary, daughter of his son James
and wife Eliza, in the first floor sitting room
overlooking a sun-filled back garden. The room
is filled with paintings and objets d'art that
testify to Wyatt's profession, such as a carved
Chinese goddess and an early Renaissance
tondo, while the inclusion of family portraits
asserts the lineage that binds the two living
figures together. (The small picture to the right
of the window is a portrait of Wyatt's father,
the one above his chair represents Mary's mother
Eliza).[1] The informality

Millais's fresh approach to the generational
family portrait can largely be put down to the
contrast between the generalised Old Master
representations of Wyatt family members on the
wall and what Spielmann termed the 'pitiless
and remorseless solicitude' with which he
rendered the doll-like delicacy of Mary's form
in the embrace of her gruff yet kindly grandfather
propped up in his armchair.[2] The informality
of their grouping reinforces the viewer's
awareness of intruding on the private life of an
individual who was important to the artist.

According to William Michael Rossetti, Millais
submitted the portrait to the British Institution
as a genre picture (portraits were not normally
accepted there), and persuaded Rossetti to write
an accompanying sonnet.[3] Although Millais
was unsuccessful in this ploy the portrait was
subsequently accepted by the Royal Academy. AS

Mrs James Wyatt Jr and her Daughter Sarah
1850
Oil on mahogany
35.3 × 45.7
Signed 'JEM' in monogram, lower right
Tate. Purchased (Grant-in-Aid) 1984

Provenance Commissioned by James Wyatt; by descent to
Mrs B. House, from whom bt by the Tate Gallery 1984

Exhibited Birmingham 1947 (47); Whitechapel 1948 (42);
RA 1956–7 (439); SPP 1960 (3); RA and Liverpool 1967 (21);
Tate 1984 (29); Japan 1998 (60); NPG 1999 (5)

Millais's portrait of the daughter-in-law and
the granddaughter of James Wyatt was
commissioned by the dealer as a pendant to
no.29. Eliza Wyatt, née Moorman, was the wife
of Wyatt's son James who helped run his father's
business; their daughter Sarah (born January
1849) later became Mrs Thomas. She looks
around two years of age in the picture, so it is
likely that the portrait was painted in the autumn
of 1850, when Millais was again staying with
the Combes.[1]

The rectilinear arrangement of the design
recalls Millais's *Christ in the House of His Parents*
(no.20), as do the statically placed mother and
child. Millais uses the sharp edges of the
furniture and picture frames to counterpoint the
graceful interweaving curves of the Old Master
prints on the wall. From left to right these are
after Raphael's *Madonna della Sedia*, Leonardo's
Last Supper and Raphael's *Alba Madonna*. The
conceit of using pictures within a picture was
used by artists as a form of ironic commentary,
as was the case with William Hogarth, or as a
sophisticated play on pictorial artifice, as
instanced by Edgar Degas. Millais uses the
famous exemplars as a foil to assert the real
presence and individuality of the modern
mother and child group, and uses the contrast
to suggest that the High Renaissance style of
Raphael and Leonardo is not only more facile
(being based on contrivance above direct
observation), but less applicable to exploring
the intricacies of modern relationships than
the 'primitive' style that preceded it. Millais's
disdain for the Raphaelesque is shown in a
number of parodies he produced of Old Masters
in the early 1850s, and Combe recalled Millais's
cursory comment on seeing the Ashmolean
Museum's collection of Raphael drawings, that
they 'might be worth a shilling apiece […] who
would give more for such things as these?'[2]
When hung next to the companion portrait of
James Wyatt and his granddaughter, the picture
would also have invited comparison between
Millais's scrutiny of Eliza Wyatt and the
romantic portrayal of her by William Boxall
on the wall behind Wyatt's chair. With its tondo
format and elegant flowing forms the Boxall
in the background of the one harmonises with the
Madonna della Sedia in the background of the
other, a further example of Millais's contempt
for the Raphaelesque and all it spawned.[3]

In eschewing this style Millais was intent
upon making his image appear naive despite
the sophistry used in the quotations. His
sitters thus bear closer comparison to the
dolls and illustrations in the book on the
sofa than to the idealised figures in the
prints. Sarah in particular seems to hover
precariously on her mother's lap, mimicking
the toys strewn across the composition.
The way she clutches her doll echoes the
protective gesture of Eliza but also serves
to establish her own separateness and unique
identity. As well as acknowledging Pre-
Raphaelite art, the stiffness of the
composition also references the formality of
portrait photography, which required sitters
to hold a still pose during an exposure.
Photography introduced a new psychological
dimension to portraiture, which Millais
recognised as significant in undermining
the grace and natural affection displayed in
painted depictions of parents and their
offspring. By equating the modern
technology of photography with early
Renaissance portraiture and religious art,
Millais's painting can be seen as a manifesto
for their shared authenticity. AS

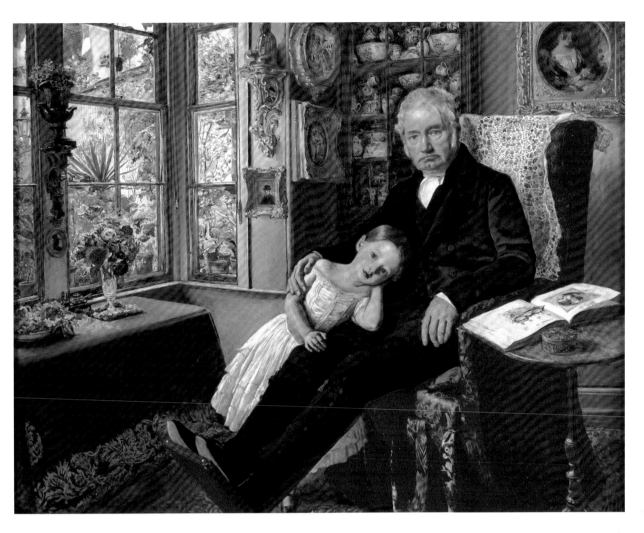

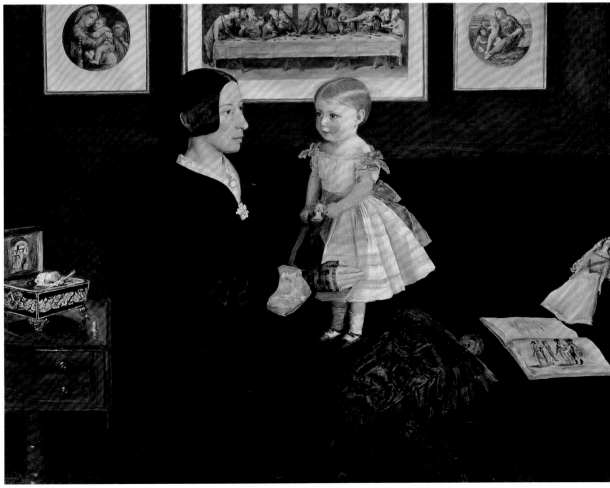

Wilkie Collins 1850
Oil on panel
26.7 × 17.8
Signed and dated in monogram lower right
National Portrait Gallery, London

Provenance The collection of the sitter; Christie's, 22 Feb. 1890 (46), bt H.P. Bartley; bt from him by the National Portrait Gallery, 1894

Exhibited Russell Place 1857 (51); Birmingham 1947 (53); RA and Liverpool 1967 (27); Jersey 1979 (29); NPG 1999 (9); Palace Theatre 2004

Millais knew the novelist Wilkie Collins (1824–89) through his brother Charles, who was one of the artist's closest friends at the time. When the portrait was painted Wilkie and Charles were living with their widowed mother at 17 Hanover Terrace, Regent's Park, where Millais was a frequent visitor. The portrait was probably given to the family as a gesture of friendship for the hospitality he received. At this time Wilkie had just started his career as a novelist, having recently published his historical novel *Antonina* (1850), and was currently engaged in writing *Mr Wray's Cash-box* (1852), for which Millais was to etch the frontispiece, his first published design.[1]

The format of this small portrait respects fifteenth-century Flemish donor portraiture in the position of the hands and face of the sitter illuminated against a dark green background. The family coat of arms in the upper left corner is a further acknowledgement of this tradition and may have been suggested by Thomas Combe, who had an interest in heraldry and whose own portrait includes arms set against a similar backing (no.32). Millais may have also been thinking of Joshua Reynolds's portrait of *Giuseppe Baretti* c.1773, which presents the writer engrossed in his reading. Collins's concentrated gaze, coupled with the precise gesture of his hands, likewise conveys a sense of self-enclosed contemplation as if he were seated in a library or at a fireside. The portrait also attests to Millais's interest in physiognomy, as indicated by the prominent bump on the right side of Wilkie's cranium, a feature Millais noted in a letter to George Scharf, Director of the National Portrait Gallery in 1894, and further recorded by Hunt, who thought it gave an impression of intellectual power. Hunt further recalled the distinctive way Wilkie would look at his friends through his spectacles, and his mannerism of stretching his hands forward inside the front of his knees.[2] Millais's focus on the singularity and self-absorption of his sitter is entirely in accord with the writer's belief that artists should address the complexities of modern life in their art. AS

Thomas Combe 1850
Oil on panel
33 × 27
Signed and dated in monogram lower right
The Ashmolean Museum, Oxford. Bequeathed
by Mrs Thomas Combe, 1893

Provenance Bequeathed by Mrs Thomas Combe in 1893

Exhibited GG 1886 (77); RA and Liverpool 1967 (28);
NPG 1999 (6)

Thomas Combe (1797–1872) was Printer to the
University of Oxford. He was a devout member
of the Anglican High Church and a generous
benefactor, funding the building of the chapel
of the Redcliffe Infirmary in 1864.[1] Millais was
probably first introduced to him by James Wyatt
during one of his summer visits to Oxford in
1848 and 1849, and subsequently stayed with
him and his wife Martha (1806–93) at their
house in the quadrangle of the Clarendon Press.
Many of Millais's letters to the Combes appear
in his son's biography where they are referred
to fondly as 'the Early Christian', 'the Patriarch'
and 'Mrs Pat'. Combe showed great enthusiasm
for the Pre-Raphaelite style, probably because
of its medievalism and ritualistic aspects,
which accorded with his nostalgia for the art of
pre-Reformation England. Combe owned
Millais's *Return of the Dove to the Ark* (no.25),
and it was through the artist that he came to
purchase works by Collins, Hunt and Rossetti.

A note on the back of the portrait states:

This portrait of myself was painted by
J.E. Millais in the autumn of 1850 while he
was residing in my house […] For my
portrait I sat four times or about eight
hours. It is admired for the brilliancy of his
colours – he has not produced anything
brighter. The likeness at the time was
excellent. [The original peacock blue of the
background has since darkened.]

With this portrait Millais deliberately set out to
recapture the strangeness of medieval and
Tudor portraiture, and by combining primitive
with objective analysis created an image
distinct from contemporary portraiture with all
its residual trappings of a Georgian aesthetic.
Moreover, by attending to areas usually edited
out, such as Combe's blotchy cheeks and wavy
hair, Millais emphasises his individuality so
that he comes across as a middle-class
eccentric or man of genius. Combe's fondness
for animals and heraldry is indicated by the
tabby on his lap and the shield in the upper left
corner. The arms are those granted in 1584 to
John Combe(s), a friend of Shakespeare, and
were also used by a Combe family based at
Cobham Park in Surrey. Although it was not
certain if Combe was descended from the
Elizabethans, he probably enjoyed speculating
about his pedigree. Collins's companion
portrait of Mrs Combe's uncle William Bennett
also features an escutcheon, which was
probably imaginative conjecture on Combe's
part.[2] Millais and Collins presented their two
portraits to the Combes as an expression of
friendship and gratitude for their support. AS

Charles Allston Collins 1850
Graphite on discoloured cream paper
16.6 × 12.5
Signed and dated 'John E. Millais PRB/ 1850'
The Ashmolean Museum, Oxford

Provenance Thomas Combe; Mrs Combe's sale, 23 Feb. 1894 (20); purchased by the Ashmolean Museum

Exhibited RA and Liverpool 1967 (266); Japan 1987 (10); NPG 1999 (8)

Charles Collins (1828–73) was the son of the landscape painter William Collins and the younger brother of the novelist Wilkie Collins (see no.31). Both were named after famous Romantic painters, David Wilkie and Washington Allston. As a student at the Royal Academy he befriended Millais and subsequently the Pre-Raphaelite Brotherhood but, despite Millais's proposal that he be elected a member he never was. Collins was with Millais in Oxford from September to November 1850 staying at the home of Thomas Combe, where Collins worked on his most famous painting, *Convent Thoughts*. Collins shared the High Church inclination of Combe, and must also have been a key influence in encouraging the ritualistic aspects of Millais's art around this time. Hunt remembered Collins to have been a striking youth with strong blue eyes and vivid red hair, a conventionally negative feature that embarrassed the artist. Collins appears as the solemn young man Millais described to Mrs Combe as 'devotedly directed to the one thought of some day [...] turning the minds of men to good reflections and so heightening the [artistic] profession as one of unworldly usefulness to mankind'.[1] Hunt also recalled Wilkie Collins's concern about his brother's asceticism, which he feared might impair his health and stamina as a painter.[2] However, while acknowledging the sensitivity of the sitter through a delicate use of pencil and wash, Millais is also concerned to present him as a professional artist – not a holy fool – as signified by his respectable attire. The portrait was presented as a gift to Thomas Combe during the painters' stay and provides a testimony to the earnestness of their endeavour as brothers in art.

In the late 1850s Collins abandoned painting for literature, and in 1860 married Kate, the youngest daughter of the novelist Charles Dickens who, following Collins's death in 1873, married the painter Charles Perugini (see no.119). AS

Emily Patmore 1851
Oil on panel
19.7 × 20.3
The Fitzwilliam Museum, Cambridge

Provenance Given by Millais to Coventry Patmore; by descent to Edward Andrews, brother of the subject in the portrait; Milnes Patmore, son of the subject of the portrait; Mrs Harriet Coventry Patmore (Patmore's third wife) in 1899; Serendipity Shop, London, sold to the Friends of the Fitzwilliam and presented to the Museum in 1920

Exhibited RA 1852 (156); GG 1886 (78a); Tate 1923 (75); RA 1951–2 (654); RA and Liverpool 1967 (37); NPG 1999 (10)

Emily Augusta Andrews (1824–62) was the daughter of a well-known Congregational minister who preached at the Beresford Chapel in Walworth, south London, where the Ruskin family worshipped. In 1847 she married the poet Coventry Patmore and became a kind of poetic muse to his literary friends. She inspired portraits by Millais, John Brett and Thomas Woolner, and a eulogistic verse by Robert Browning. Patmore himself dedicated his most famous poem, *The Angel in the House* (1854–62) to her with the words, 'To the memory of her by whom and for whom I became a poet'.[1] Although there are clear parallels between Emily and the Honoria of Patmore's verse, he deliberately avoided characterisation in order to communicate a spiritualised ideal of marriage. It was only after Emily's death from consumption aged thirty-eight that he finally completed this four-book,

two-volume poem.

Emily herself was known to be a strong-minded intellectual woman, a poet and writer in her own right as well as a critic of her husband's work. Millais's portrait respects her individuality for, despite her reputed good looks, she is not presented as a typical Victorian beauty. The dark colour of the dress and background follows that of his male portraits of the same period and serves to illuminate her determined steady gaze and distinct oval face, not to mention the madder flash of her embroidered bow. The frozen features and frontal presentation of the figure is entirely in keeping with Millais's quest for objectivity at this stage in his career, and invited comparison with the daguerreotype. However, Millais's intense scrutiny also lends a visionary quality to the image reminiscent of *The Bridesmaid* (no.27). The iconic format and halo-like disposition of the hair accentuate the sitter's impassive spiritualised expression, while the nosegay is comprised of blooms that speak in the language of flowers of marital devotion. The iris symbolises a message which the carnation and lily of the valley respectively communicate to be that of woman's love and the return of happiness. It would thus appear that, like Patmore, Millais was seeking to honour Emily's ethereal qualities but in addition sought to assert her presence as a palpable human being.

Millais initially undertook the portrait as a gesture of gratitude to Patmore for introducing the Pre-Raphaelites to Ruskin and for encouraging the writer to pen his controversial letters to *The Times* in 1851. Millais may also have offered it in the hope of promoting himself as a portraitist amongst a literary elite. Emily Patmore was a close friend of Mrs Tennyson, and after completing the portrait Millais was anxious that Tennyson should see it 'that he may give me leave to paint his wife'.[2] The fact this never eventuated may owe something to the strained circumstances surrounding the execution of the portrait. It would seem that Millais was summoned back to London from Surrey, where he was working on *Ophelia* (no.37), to complete the portrait, an interruption that annoyed him and caused him to be negligent with his technique, thereby risking cracking in the background.[3] Patmore himself disliked the image, thinking that it possessed the 'truth and untruth of a hard photograph. I keep it locked up as I do not like the children to think it like their mother'.[4] Contemporary descriptions reveal that the portrait originally included Emily's hands arranging flowers, but at some point Patmore had the panel cut at the bottom for display in a circular mount. It was framed as such, inside a window 6 inches (15cm) in diameter, when he lent it to the Grosvenor Gallery's *Millais* exhibition in 1886. AS

William Holman Hunt (1827–1910)

John Everett Millais 1853
Pencil
25.4 × 17.8
Signed and dated in monogram
Private Collection

Provenance William Henry Millais in 1882; William
Holman Hunt by 1896; Mrs Michael Joseph; by descent to
Mrs Elizabeth Burt; bt Agnew's 12 Jan. 1970, from whom bt by
the present owner, 5 Feb. 1970

Exhibited Leicester Galleries 1906 (43); Manchester 1906–7
(75); Liverpool 1907 (78); Glasgow 1907 (35); Tate 1923
(221); RSBA 1943–4 (612); Birmingham 1947 (155); RA
1956–7 (742); Liverpool and V&A 1969 (128); King's Lynn
1971 (43); Park Lane Hotel, London, 1990

As a young man Millais was known for his
striking appearance, tall with a 'cockatoo tuft'
and fine chiselled features. Hunt remembered
that 'his bronze-coloured locks stood up,
twisting and curling so thickly that the parting
itself was lost; he dressed with exact
conventionality so as to avoid in any degree
courting attention as a genius'.[1] Although
Millais was said to be vain about his
appearance and had no qualms in posing
for other artists, he was also, as Leonee
Ormond has pointed out, capable of self-
mockery (see *My Feet Ought to be Against the
Wall*, no.45).

Around the time Hunt drew this portrait he
and Millais were exceptionally close. Hunt's
departure for the Middle East in January 1854
marked a watershed in their relationship, and
so the portrait was possibly executed by Hunt
as a memento of his friend. Millais himself was
despondent about the impending departure,
and wrote to Hunt, 'scarcely a night passes but
what I cry like an infant over the thought that
I may never see you again – I wish I had
something to remember you by, and I desire
that you go to Hunt and Roskell and get
yourself a signet ring which you must always
wear'. Hunt bought such a ring, which he wore
until his death. This he had engraved with
his initials combined into a monogram with
the letter M.[2]

This drawing shows Millais respectably
dressed wearing the golden goose stick-pin
that he designed and had made up by the same
specialists in novelty jewellery from whom
Hunt obtained his ring. Millais is depicted
wearing a similar suit and the same pin in both
C.R. Leslie's portrait of him of 1852 and Hunt's
pastel and chalk drawing of 12 April 1853. The
latter was one of a group of portraits the Pre-
Raphaelite Brotherhood made of each other at
D.G. Rossetti's instigation to send to Thomas
Woolner in Australia. AS

William Holman Hunt 1854
Black chalk with brown wash on cream paper
22 × 17.5
Signed and dated in monogram
The Ashmolean Museum, Oxford. Bequeathed
by Mrs Thomas Combe, 1893

Provenance Combe Bequest to the Ashmolean
Museum, 1893

Exhibited RA and Liverpool 1967 (339); Turin 1969 (38);
Bucharest and Budapest 1972–3; Tokyo 1975 (147); Jersey
1979 (33); Tate 1984 (199); Japan 1987 (10); NPG 1999 (27)

Millais and Hunt became close friends as
students at the Royal Academy. Together with
Dante Gabriel Rossetti, who was also a student
there, they formed the Pre-Raphaelite
Brotherhood in September 1848. Hunt and
Millais had a profound influence on each
others' art, but their relationship lost its
intensity following Hunt's departure for the
Middle East in early 1854 and Millais's
marriage in 1855.

Prior to Hunt's departure on 13 January,
Millais drew this portrait as a souvenir,
together with another drawing now in the
National Portrait Gallery. The latter, executed in
December 1853, was originally intended as a
souvenir for the Combes but, upon realising
that he could not part with it, Millais undertook
to make a replica. The substitute he provided
turned out to be no copy but an independent
design, which Millais dispatched to Combe
after having it framed.[1] Like Hunt's portrait
of Millais (no.35), Hunt is presented in
professional dress, although he appears older
with moustachios and whiskers. In contrast
to the National Portrait Gallery drawing, this
work presents Hunt from the side and is swiftly
executed in pencil and wash. AS

Ophelia 1851–2

'There on the pendant boughs her coronet weeds
Clamb'ring to hang, an envious sliver broke;
When down her weedy trophies and herself
Fell in the weeping brook. Her clothes spread
wide;
And mermaid like, awhile they bore her up;
Which time she chanted snatches of old tunes,
As one incapable of her own distress,
Or like a creature native and indued
Unto that element; but long it could not be,
Till that her garments, heavy with their drink,
Pull'd the poor wretch from her melodious lay
To muddy death.' – Hamlet, Act 4.

Oil on canvas, arched top
Arched top, 76.2 × 111.8
Signed and dated in monogram lower right
Tate. Presented by Sir Henry Tate 1894

Provenance bt Henry Farrer, 10 Dec. 1851; B.G. Windus;
Christie's, 19 July 1862 (55), bt Graves; Gambart 1864 or
1866; W. Fuller Maitland by 1872; Mrs Fuller-Maitland in
1886; Henry Tate 1892, who presented it to the National
Gallery, 1894

Exhibited RA 1852 (556); Birmingham 1852 (100);
RSA 1853 (188); Paris 1855 (888); Manchester 1864a (717);
London 1872 (450); GG 1886 (117); Guildhall 1892 (149);
Edinburgh 1897 (355); RA 1898 (11); NGL 1917;
Birmingham 1947 (57); Tate 1948 (17); Manchester 1948
(18); RA and Liverpool 1967 (34); Paris 1972 (182);
Whitechapel 1972 (31); Tate 1973–4 (320); Munich 1979–80
(368); Tate 1984 (40); on loan to National Gallery,
London, 1987; Norwich 1996 (24); Tate 1997;
Washington 1997 (9); Japan 1998 (61); Tate, Berlin,
Madrid 2004–5 (2)

Ophelia marks a transition in Millais's style
from the medievalism of his early Pre-
Raphaelite productions to a more poetic
conception of nature and female beauty.
Despite its complex detail the painting's
composition is simple, with the floating and
fragmented head and hands of Ophelia
brought into focus by the shallow setting. As
Théophile Gautier noted, from a distance it
appeared wooden, suggesting a doll in a
cuvette, but on close inspection it became alive,
'evolving and moving before the viewer's eyes'.[1]
Between July and November 1851 Millais and

Hunt worked together at Ewell near Kingston
upon Thames in Surrey, painting landscape
backgrounds for their Academy submissions
of the following year. Millais selected a spot
beside the Hogsmill River at Malden, looking
towards the river bank at the bottom of the
Manor House garden.[2] The figure, painted from
Elizabeth Siddal, was added following Millais's
return to London in December, as was the silver
dress embroidered with flowers, which subtly
blend with the natural plants scattered across
the surface of the water.

Millais took his subject from Queen
Gertrude's poignant description of Ophelia's
madness and death in Shakespeare's *Hamlet*.
The pathetic character of Ophelia appealed
to the Romantics, as testified by the various
representations of her poised above the brook
that appeared at public exhibition in the early
nineteenth century. Millais's rendition of her
drowning was itself novel and demonstrates an
extraordinary understanding both of Ophelia's
elusive mental condition and a pose difficult to
observe from a living model, although Siddal's
ability to hold a touching expression would
have helped in this endeavour.[3] The painting
follows on in Millais's work from a succession
of images of alienated and in some cases
subsequently deranged women, and shares
with *The Bridesmaid* (no.27) a sense of
religious exultation in its presentation of a
single female staring inwardly with glazed eyes
and parted lips. The submerged vivid green
algae in the foreground mimics the shape of
Ophelia's dress, adding to the impression
of her body literally dissolving as the weight
of her garments sucks her under the water.

The faithfully observed flowers within the
picture not only refer to the plants listed in
Gertrude's speech but are further intended to
be read symbolically, developing the theme of
Ophelia's plight and character. They also show
how Millais was concerned to draw attention
to botanical accuracy in order to enhance the

physicality of the scene. Indeed, a number of
the plants were indigenous to the site at Ewell,
such as the purple loosestrife, dog rose and
meadowsweet, as Millais noted in his
correspondence with Mrs Combe.[4] Although
the painting's inordinate concentration on
natural features could be seen as a gesture
towards natural history and its overriding
message of wonderment and interconnection
between all living phenomena, Millais also uses
botanical detail to neutralise any feeling for
tragedy so the depicted cycles of growth,
maturation and decay doubly absorb Ophelia
into a natural process, and render her
insignificant. The flow of her body downstream
or towards the left, respects Millais's vantage
point on the west bank of the river, but
compositionally signals a reversal of the
standard orientation of the gaze from left
to right in painting. Such a device assists in
making human rationality subordinate to
the autonomous logic of nature.

Together with *A Huguenot* (no.57), *Ophelia*
signalled a watershed in Millais's reputation,
converting several reviewers formerly
antagonistic to his work by the pathos and
sentiment of the subject. Tom Taylor thus
declared:

> I see only that face of poor drowning
> Ophelia. My eye goes to that, and rests on
> that, and sees nothing else, till [...] the tears
> blind me, and I am fain to turn from the face
> of the mad girl to the natural loveliness that
> makes her dying beautiful.[5]

The dealer Henry Farrer, who first owned
the work, used *Ophelia* to promote Millais's
reputation by lending it to a number of
exhibitions between 1852 and 1855. The
picture's appearance at the Exposition
Universelle at Paris in 1855 led to the
recognition of Millais as a painter of
international stature. AS

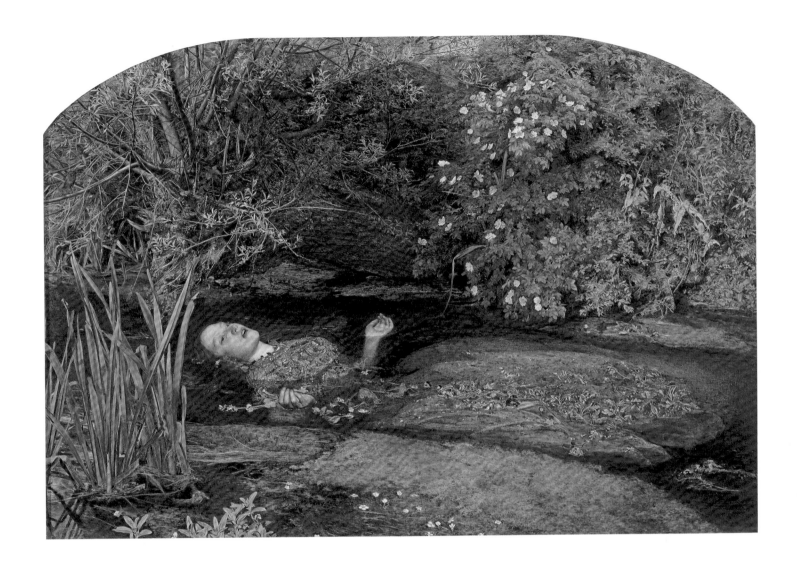

2
Romance and Modern Genre

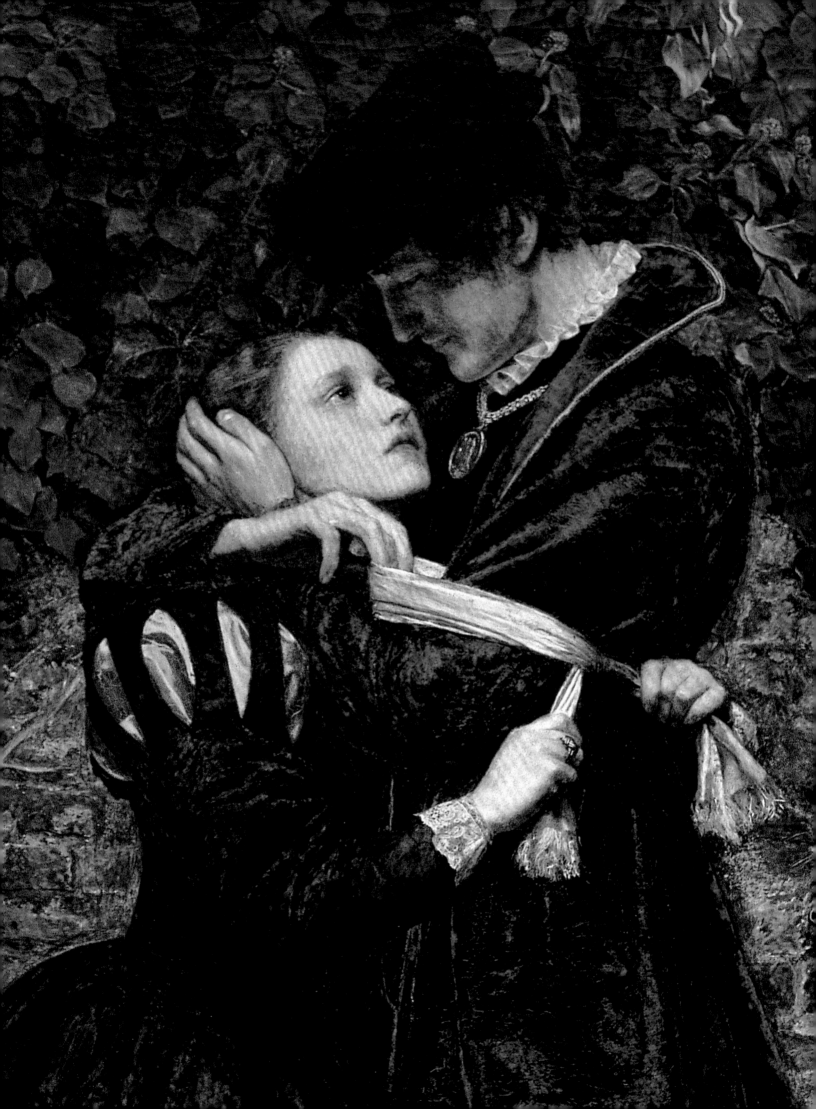

Romance and Modern Genre

From around 1852 Millais's art struck out in a new direction, entering its mature Pre-Raphaelite phase. Medievalism and wilful distortions of form and expression gave way to a broader range of subjects which, while continuing to aim at psychological complexity, were more open-ended in meaning and invited the viewer to respond in an emotive way to the painting. Millais developed the idea of conceiving his works as pendants, therefore expanding the narrative potential of a work rather than compressing meaning into a single image. While he continued to aim at precision, he began to experiment with looser brushwork as well as varying the degree of finish within a picture. Although he continued to work out compositional motifs in the form of sketches, he evolved a more spontaneous manner of drawing in contrast to the linear angularity of his early Pre-Raphaelite studies.

As Millais ceased to be identified with the Pre-Raphaelite Brotherhood and increasingly stood alone as an artist, he inclined towards scenes of romance and modern genre. During the 1850s he pioneered a new type of historical anecdotal painting that focused on ordinary people caught in situations of conflict. Conceived as imaginary episodes, rather than as illustrations to pre-existing texts, these scenes harmonised with popular values especially in the way they used women to promote the stability of the home at times of national crisis or, as J.G. Millais put it, these were unfinished stories of 'unselfish love, in which the sweetness of woman shines conspicuous'.[1] At the same time as Ford Madox Brown and Millais's Pre-Raphaelite colleagues Dante Gabriel Rossetti and William Holman Hunt were experimenting with modern-life subjects, Millais also branched out in representing scenes from contemporary life. Influenced by a new set of associates such as the illustrator John Leech (1817–64), and the novelists William Makepeace Thackerary and Charles Dickens, Millais embarked on a series of drawings and paintings that presented a defining moment in modern life. Wilkie Collins's theory of 'the actual', put forward in the preface to his novel *Basil*

(1852), which was known to Millais, was relevant here in asserting the importance of detailing specific background elements when portraying events of psychological intensity.[2]

While the change in Millais's subject matter can be seen as evidence of his concern to accommodate his art to the prevailing sentiments and values of his day, his figure types were by no means defined by conventional notions of the pretty or beautiful. Complaints about his 'plain people in red hair' peaked in 1856 when Millais exhibited four paintings at the Royal Academy, *Peace Concluded, 1856* (no.66), *The Blind Girl* (no.62), *Autumn Leaves* (no.82) and *L'Enfant du Régiment* (no.61), and this sort of comment was accompanied by criticisms of coarse drawing, treacly colour and heavy shadows.[3] Thus, despite the popular drift of Millais's art, his style was occasionally viewed by critics as defiantly eccentric, placing him at odds with the Academic status quo. It is significant that Millais faced his greatest period of financial insecurity in the years immediately following the break-up of the Pre-Raphaelite Brotherhood in 1853. Although the artist's election to the position of Associate of the Royal Academy in 1853 has been regarded an important factor in the collapse of the movement, Millais initially maintained an uneasy, sometimes hostile, relationship with the institution, as evinced by his fury over the hanging committee's placement of *The Rescue* (no.63) in the 1855 exhibition.[4] The generally poor critical reception of his works affected sales, exacerbating Millais's self-consciousness of his isolation and awareness that his art, for all its powerful emotive appeal, required a specialist appreciation and was therefore uncommercial.

There are a number of factors that explain the dichotomy between Millais's need to accommodate himself with his public and his desire to push out in new directions. First, he had to work through the influence of John Ruskin, who had alighted upon the painter as his first protégé, singling out Millais's work for discussion in his influential pamphlet *Pre-Raphaelitism* (1851). Comparing Millais and J.M.W. Turner, Ruskin set the former's

literalness and acuity of vision against Turner's incredible memory, range of imagination and near-sighted vision.[5] While Millais's 'Natural Ornament' drawings (no.42) are certainly indicative of the intricate relationship between nature and art as theorised by Ruskin, they also display powers of invention that refute the writer's evaluation of Millais as an obstinately factual painter. The drawings he produced around the same time of emotionally fraught couples similarly reveal narrative ingenuity, as well as disclosing his prescience of the strain in the Ruskins' relationship, not to mention his own growing attachment to Effie Ruskin.

Following the annulment of Effie's marriage to Ruskin in 1854, Millais moved away from representing troubled relationships to focus on children and scenes of family life. Millais's interest in domesticity that followed in the wake of his marriage to Effie in July 1855 and the birth of his first son Everett the following year, can partly be seen in terms of his concern to normalise an unconventional union (in order to maintain a low profile the couple lived mainly in Perth until 1861, when they settled at 7 Cromwell Place in London). Effie became a key force in promoting Millais's career, designing and fabricating costumes for his productions, researching subjects and assisting with correspondence. Both had high aspirations for the new direction his art was taking. However, what Millais achieved in extending the emotional range of his work was sometimes perceived to be at the expense of narrative and stylistic coherence. Although, with hindsight, we might view such developments in terms of a nascent aestheticism, more immediately Millais risked placing himself at odds with the demands of the marketplace. His letters to Effie from London reveal an awareness of a number of miscalculations on his part, namely the risk involved in producing large pictures given the demand of middle-class collectors for cabinet-sized works, and his error in believing he could sell direct to collectors rather than depending on the intermediary of a dealer. *The Order of Release 1746* 1852–3 (no.39) was the first painting for which Millais

received a substantial fee in copyright, but despite expectations that he would command even higher prices for ensuing productions, his failure to sell copyrights was the cause of repeated disappointments during the 1850s. The problem stemmed partly from inadequate copyright laws, which were not clarified until the passing of the Copyright Act in 1862, and partly from critical disapproval of works such as *Peace Concluded, 1856* of 1856 (no.66), which deterred publishers like Henry Graves from issuing prints after his pictures. With a growing family to support and determined to mark his success in financial terms, Millais resorted to other strategies such as repeating a design in the form of a reduced version. It was also around this time that he began to supplement his income by taking on commissions as an illustrator, a development that encouraged the freer style of his draughtsmanship as well as his skills at narration. AS

Millais in Scotland

At the end of June 1853, with *The Order of Release, 1746* (no.39) having been on the walls of the Royal Academy for nearly two months, Millais set off for Scotland with a group that included his brother William Henry, and John and Effie Ruskin. Ruskin had instigated the trip and desired three results from their northern travels: to finish the index of *The Stones of Venice*, to prepare his lectures to the Edinburgh Philosophical Institution for November, and to have Millais paint his formal portrait. The Millais brothers intended to produce some art, but also to enjoy a respite from London life and the endless social engagements of bachelors living in the city or in Oxford, where they often spent their summers. Millais did not go to Scotland with designs on Ruskin's wife, and Ruskin did not bring the young painter along to tempt her – only to provide her with company her own age, in her native environment where she felt comfortable, so that he could pursue his work uninterrupted. But Millais and Effie did fall in love. Ruskin, who was observant enough to keep a notebook of Effie's ticks and imperfections he found deplorable, was curiously oblivious to the developing amorous connection between his wife and his disciple. In retrospect, while Millais and Effie would endure two years of agony as a result of this trip, Ruskin would find himself rising to the eventual level of his fame in maturity, and would seem little affected by what he had inadvertently set in motion, although he was ashamed for himself and his family by the entire episode, especially as the marriage was annulled on the grounds of non-consummation.

The main artistic product of this sojourn was Millais's oil portrait of Ruskin (no.38). It came at no small cost to Millais, who painted its background in unremittingly harsh conditions and was made to return unwillingly to Scotland to finish it the next year. He had to endure the presence in his studio of the sitter, whom he found increasingly repulsive as progress on the picture progressed, and had to put aside all other work in order to complete it. For Ruskin, Millais was the inheritor of J.M.W. Turner's position as the most advanced British artist. The experience of sitting for his portrait he thought would give him a chance to oversee Millais's development more closely, in a mountainous location suited to

his aesthetic interests. But he soon found Millais to be formidable in artistic matters, not as easily moulded as were later, more impressionable Ruskin disciples, such as J.W. Inchbold and John Brett.

The group settled in Brig o'Turk in the Trossachs on 2 July, and would remain in the region until having to decamp to Edinburgh in late October. The painting of the portrait did not commence until 27 July. This followed days of rain and the task of locating the necessary spot, a dank gully in Glenfinlas with a series of imposing glacial boulders just above a deafening natural sluice.[1] It was a challenge to work in, demanding a platform to be built for Millais's easel, and with the threat of flooding always present. In the story of the Ruskin portrait lie many traits that Millais would reprise once he began painting natural scenery in Scotland in earnest in 1870 with *Chill October* (no.125). Pre-Raphaelite practice dictated that backgrounds must be done out of doors, with sitters posed later in the studio. The challenge of the elements in Scotland, including the weather and midges, would be met head-on, and would be worn as a mark of manliness by the artist and his biographers. In Scotland, Millais found release from family obligations, critical approbation, urban squalor. He was also able to pursue his love of sport and, after the 1850s, when his finances settled, he went there each autumn for pleasure, eventually producing landscapes related to the hunting and fishing he never tired of. For that he had John Ruskin to thank, and the Scottish ancestry of Effie. JR

Figure 10
Waterfall at Glenfinlas
1853
DELAWARE ART
MUSEUM. SAMUEL AND
MARY BANCROFT
MEMORIAL, 1935
(1935–53)

Figure 11
John Ruskin
1854
PIERPONT MORGAN
LIBRARY, NEW YORK.
BEQUEST OF PROFESSOR
HELEN GILL VILJOEN

John Ruskin 1853–4
Oil on canvas, arched top
78.7 × 68
Signed and dated in monogram lower left
Private Collection

Provenance Commissioned by John James Ruskin; given by John Ruskin to Henry Wentworth Acland, 1871; Sir William Alison Dyke Acland; Sir William Henry Dyke Acland; his sale, Christie's, 16 July 1965 (96), bt Agnew's and to the present owner

Exhibited FAS 1884; GG 1886 (12); Birmingham 1891–2 (231); RA 1898 (55); Glasgow 1901 (327); Whitechapel 1901 (15); RA 1919–20 (144); RA 1934 (551); Venice 1934 (sala 3, 19); Birmingham 1947 (59); Whitechapel 1948 (46); Arts Council 1950 (4); ICA 1951 (16); Wales 1955 (36); RA 1956–7 (440); Nottingham 1959 (47); Australia 1962 (47); Arts Council 1964 (29); Tate Gallery 1964–5 (on loan); RA and Liverpool 1967 (42); Paris 1972 (183); Whitechapel 1972 (32); Tate 1984 (56); Tate 2000 (1); Tate, Berlin, Madrid 2004–5 (79)

This formal portrait of the critic and writer shows him in a three-quarter profile view wearing a frock coat with velvet collar and Oxford-blue stock, and was a collaborative effort between Ruskin and Millais.[1] It was begun in Glenfinlas in the summer of 1853 and was the result of a great deal of tedious work on the part of Millais, who had to sit on a platform constructed on rocks and cope with bad weather and swarms of midges. The portrait combines radical Pre-Raphaelite sharp focus and comprehensive detail of landscape and likeness with an intense connection made between sitter and surroundings. It transforms this Scottish glen into a proprietary aspect of Ruskin's artistic theory. For Millais, the labour was arduous, and he faced the prospect in 1854 of returning to the Trossachs to complete the background, and spending long hours with Ruskin in his Gower Street studio to complete the image, an interaction increasingly odious to Millais.

In the portrait Millais depicts Ruskin looking 'sweet and benign standing calmly looking into the turbulent sluice beneath';[2] in this and other depictions of him, Millais brings out the pensive and self-absorbed aspect of the man. In a similar drawing of only one year earlier, Ruskin has a slight smile and his head inclines towards the viewer.[3] But in a pencil and watercolour image of Ruskin's head, made in early 1854 (fig.11), that approachability has left both his drawn visage and his relationship with Millais. By this time the artist could portray, perhaps better than anyone, Ruskin's likeness, but no longer could he present his likeability.[4] All hint of a smile is gone, the critic is heavy-lidded and seems mentally removed. Two months later, in a letter to Effie's mother, Millais referred to the completion of the oil portrait begun in Glenfinlas as 'the most hateful task I ever had to perform'.[5] He would not see it concluded until that December, seventeen months after commencing it.

Such images presage the stately likenesses of Millais's maturity, when he painted Gladstone and Disraeli with equal reserve (nos.121, 122), but eloquently managed to imbue them with a firmer sense of purpose, concentrated gaze and public presence. The impassive expression of Ruskin in what is the finest British oil portrait of the century is a key facet in its enduring brilliance, and hints at a subjectivity towards the sitter on the part of the artist that is absent from the painstakingly portrayed objectivity in the surrounding gneiss rocks and flowing waters of the River Turk.

Originally intended as a pendant to an eventually unexecuted portrait of Effie at Doune Castle, Ruskin had commissioned his own image on behalf of his father, John James, who refused to lend it once Effie had left his son. It was first publicly exhibited thirty years after its completion. In 1871 Ruskin gave it to his life-long friend Henry Wentworth Acland. Acland hung it in his drawing-room in his house in Oxford. JR

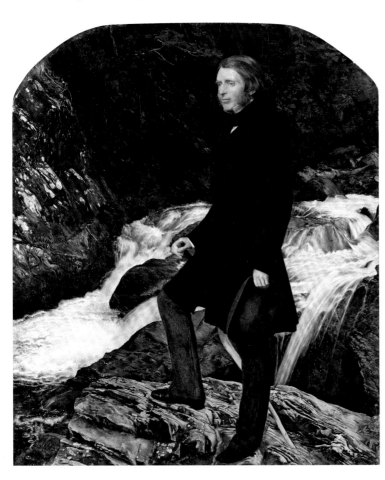

The Order of Release, 1746 1852–3

Oil on canvas, arched top
102.9 × 73.7
Signed and dated in monogram lower right
Tate. Presented by Sir Henry Tate, 1898

Provenance Joseph Arden; his sale, Christie's, 24 April 1879 (67), bt Agnew's; James Hall Renton, sold Christie's, 30 April 1898 (89), bt Agnew's for Sir Henry Tate, who presented it to the Tate Gallery, 1898

Exhibited RA 1853 (265); Paris 1855 (886); FAS 1881 (4); RA 1898 (25); NGL 1917; Liverpool 1922 (43); Arts Council 1964 (238); RA and Liverpool 1967 (38); Tate 1984 (49); Tate 2000 (190)

Painted in London, this picture was exhibited at the Royal Academy of 1853 with its pendant of the same size, *The Proscribed Royalist, 1651* (no.58). Both continue the theme of loves in dire predicaments successfully inaugurated the previous year with *A Huguenot* (no.57). However, here conflict has subsided. A barefooted woman carries in her left arm a slumbering young boy dressed in Drummond plaid, while with her right hand she offers to an English jailer the written order of the title to free her husband, a Jacobite prisoner. The Scot wears a Gordon tartan kilt and his arm is in a sling from a wound. A dog interjects its body between the reunited couple, licking its master's limp hand. With his good arm the man tightly embraces his wife. The jailer stares at the order intently, his face in one-quarter view.

Only the woman's face is fully visible, and it bears an expression far more complex than was typical in mid-nineteenth-century Victorian painting. There is neither evidence for nor merit in the contention of later writers that her expression reveals that she has given her body to free her husband. The defiance that has made a drained mask of her features can be seen as the resignation of a woman who has succeeded in securing the freedom of a man who has failed to release his people from English tyranny. She bears the proud subjugation of Scotland. Her strength radiates from her eyes, and the men on the left form a line of downcast heads leading to her face, as do the turned head of the child and the directional thrust of the dog's snout. The picture is a marvel of design and tenebrism, with the spotlit bodies thrust forward from the inky blackness of the prison. The lack of a release of emotion in the male figures' obscured faces steers the picture away from the sentimental and into the pathetic – emotions not of untempered glee at the family's reunion, but deep sadness and exhaustion. This picture demonstrates the advanced nature of Millais's contribution to historical genre.

The Jacobite Rebellion commenced in August 1745, and the crushing and final Scottish defeat at Culloden was on 16 April 1746. A few months later the Dress Act made wearing Highland clothing, including tartan kilts, illegal, a clearance of symbols soon to be followed by a clearance of bodies through forced mass emigration. When Millais began this picture the Highlands had been suffering from a potato famine for six years, and clearances had recently increased. The painting unintentionally provided a parallel between the image of a defeat of Scottish culture in the eighteenth century and its daily continuation in what was referred to in London as North Britain in the nineteenth century.

The Order of Release, 1746 introduces two elements into Millais's art and life that would occupy him until his death: the woman who would become his wife, and the region that would become his second home, whose history and literature would form the subject of many of his pictures.[1] Effie Ruskin from Perth, aged twenty-four, sat for the picture in early 1853, the first time Millais painted her.[2] She is immediately recognisable by her long, pointed nose, narrow eyes, and centre-parted hair, given an inkier shade than her true colour (see no.41). She evidently enjoyed the resulting celebrity. Once the exhibition opened she wrote to her mother in Perth that she was thrilled that 'Millais' picture is talked of in a way to make every other Academician frantic – it is hardly possible to appreciate it for the rows of bonnets'.[3] The mob of people wishing to see the picture impelled the Academy to erect a barrier before it, a practical measure viewed as an honour previously only granted to David Wilkie's *Chelsea Pensioners*, in 1822.[4]

Stylistically, *The Order of Release, 1746* continues Millais's exploration of the limits of painterly fidelity to actuality. According to Pre-Raphaelite practice he used Effie, a specifically Scottish sitter, for a model. He researched tartans (Drummond plaid was that of a clan associated with Effie's home town of Perth), and he used an actual order of release signed by Sir Hilgrove Turner, Governor of Elizabeth Castle in Jersey.[5] From the gleaming shoes of the jailer, to the Highlander's of dull leather, the splay of bristles of the dog's tail, the extraordinary rendering of textures in the prisoner's heather and purple socks, the jangling iron keys, and the creased and pudgy hands of the child, the details bear close attention. But the overall design is so sharp and balanced, without being stilted, the particular elements so natural in aggregation, that the picture's gravity and purpose is readily revealed. This was the experience of the French romantic painter Eugène Delacroix, who saw the works of the Pre-Raphaelites at the Exposition Universelle in Paris in 1855 and was moved by their sincerity, writing in his journal,

> compare the 'Order of Release', by Hunt or Millais (I've forgotten which), with our primitives and Byzantines, who are so obstinately engrossed by questions of style that they keep their eyes rigidly fixed on the images of another age and extract from them nothing but their stiffness, without adding new qualities of their own. The crowd of hopeless mediocrities is enormous. There is not one who shows a vestige of truth, the truth that comes from the heart, not one painting like this child asleep in its mother's arms, whose silky baby hair and sleeping state are so truthful (in every particular, even down to the redness of the legs and feet), and are expressed with such remarkable observation and above all, with feeling.[6]

Delacroix recognised the innate modernity of Pre-Raphaelite art, as Ruskin had in his letters to *The Times* of 1851 – the combination of a revivalist style with a contemporary approach to materials and methods and unstinting emotional content. In Paris, this picture was accompanied by *The Return of the Dove to the Ark* (no. 25), which it resembles in terms of format and dark setting, and *Ophelia* (no. 37). It was singled out for a second-class medal.[7]

The lawyer Joseph Arden commissioned this picture for £400. Subsequently, the publisher Henry Graves paid 300 guineas for the copyright and Samuel Cousins produced a mixed-method engraving of it in 1856 for him, the first large popular print produced from one of Millais's paintings.[8] There are numerous pencil and pen and ink studies for the picture, a smaller oil version or study in the Makins Collection, and a reduced watercolour in a private collection.[9] JR

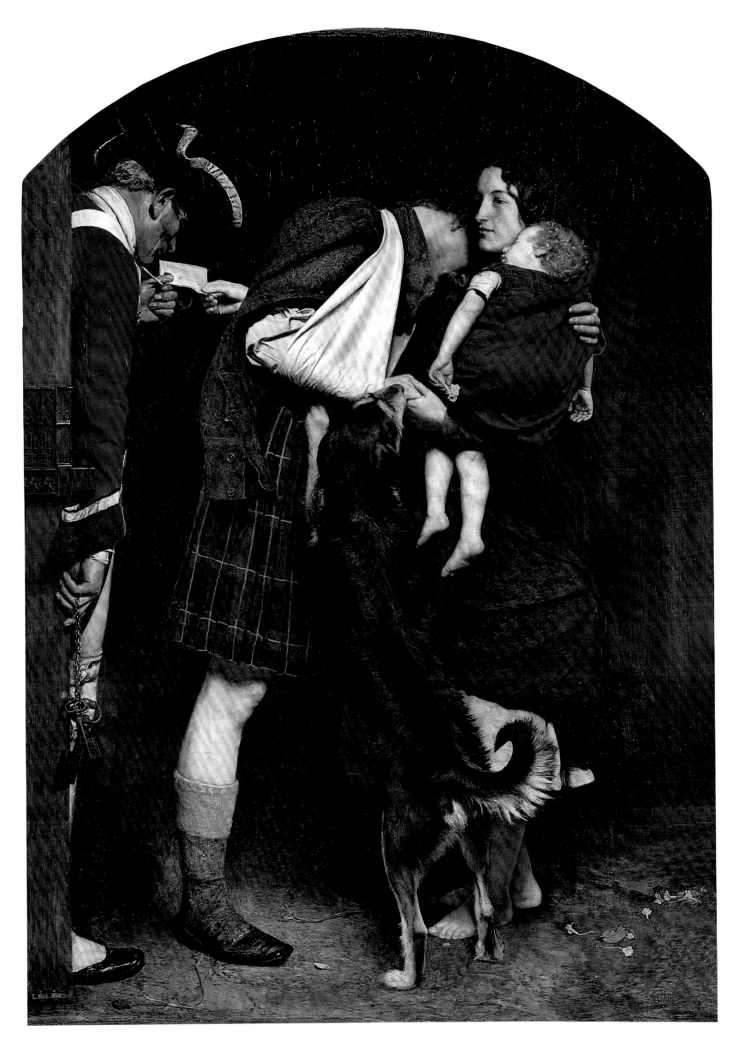

40

William Henry Millais (1828–99)

Glenfinlas 1853
Oil on wood
45 × 64.5
The Makins Collection

Provenance Bt Agnew's at Christie's, 6 Feb. 1948 (127) on behalf of General Ernest Makins, CB, DSO; Lady Ernest Makins and by descent

Exhibited Agnew's 1961 (50); King's Lynn 1971 (78)

A placid view of a fisherman casting on the River Turk, this picture is representative of the Millais brothers' response to the splendid scenery of the Trossachs and their mutual interest in sport. William Henry and John Everett Millais were avid fishermen from a

young age, the latter when he was around ten writing to the Duke of Sussex for permission to fish the Serpentine and Round Pond in London's Kensington Gardens.[1] The quietude of fishing is reflected in the expansive view of the upland landscape and the glassy surface of the water. In Scotland, William Henry often rose quite early to catch trout or perch, to be eaten for breakfast and over the course of the day, and the brothers sometimes fished with spears in the afternoon. Poor weather was frequently employed as a convenient excuse to put off work – painting – in order to fish.

Here the figure, possibly painted by John Everett and perhaps depicting the local

schoolmaster Alexander Stewart in whose cottage they were staying, wears a jacket and a plain tam-o'-shanter, and casts over a deep pool in an area upriver from the site of the Ruskin portrait. The composition is traditionally picturesque, with *repoussoir* framing elements, such as the rocks in the right foreground that lead the eye gently to the figure on the left in the middleground and the outcrop he stands on, which leads back into the distance. But the intense clarity of detail is not. This type of finished predominantly landscape-orientated picture with 'minute imitations' would form the bulk of William Henry's work over his long career as a watercolourist.[2] JR

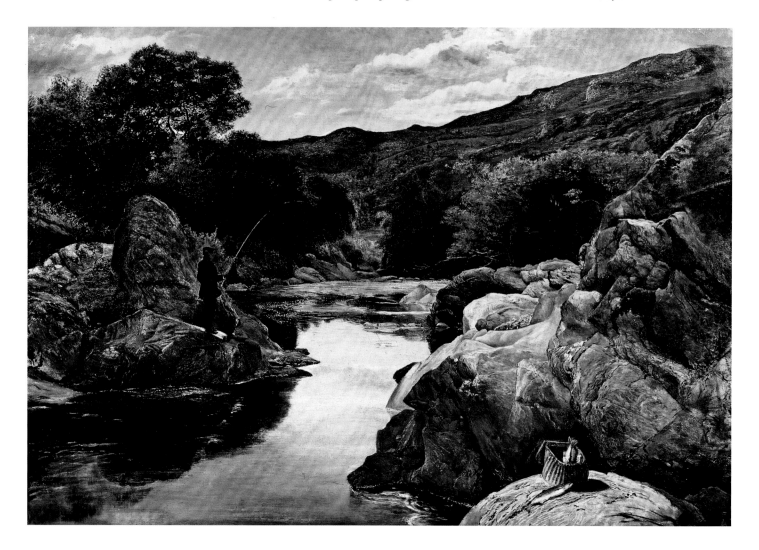

Effie Ruskin 1853
Oil on board
24.1 × 21.3
Signed and dated in monogram lower left
Wightwick Manor, The Mander Collection
(The National Trust)

Provenance By descent to Sir Ralph Millais to 1949;
bt by Lady Mander for the National Trust and
Wightwick Manor

Exhibited Russell Place 1857 (50); Arts Council 1964 (276);
RA and Liverpool 1967 (40); NPG 1999 (18)

Painted in Glenfinlas for John Ruskin, this
small-scale and jewel-like image of Effie intent
on her stitching, very intimate in its close focus,
reflects both Millais's careful and precise style in
the early 1850s and his increasingly frequent
and intense attention to Mrs Ruskin. During
this trip to Scotland, ostensibly to paint the
portrait of her husband, Effie became Millais's
favourite subject. Due to Ruskin's frequent
unavailability and the vagaries of the weather,
he turned to sketching her on rocks and
painting her indoors (fig.10, p.74). She was a
willing and ideal subject, often consumed by the
inordinately still activity of stitching. She was
also his pupil, taking lessons from him and
making a pencil copy of this very picture.[1]
In the end, Millais kept the original.[2]

The hard glassy surface is characteristic of
Pre-Raphaelite paintings in the period. In
conscious emulation of predecessors such as
Hans Holbein and Jan van Eyck, its subtle hues
and modulations of dark tones relate it to
Millais's more formal portraits of *Emily Patmore*
1851 (no.34) and *Thomas Combe* 1850 (no.32).
But the casual angle from slightly below and to
the side, and the subject's concentration on her
work, recall *Wilkie Collins* 1850 (no.31), in which
the writer's gaze appears distant but his mind
active, an energy reflected in his fingers pressed
tightly together. Noteworthy are the treatment
of Effie's fingers working away, and her rough
outfit of a brown linsey-wolsey (wool and linen)
dress with a green jabot that she wore that
autumn. The green of the flat bands and the
maroon of the cloth that she sews are repeated
in the foliage and foxgloves in her hair. The
most delicate touches Millais reserves for the
face, which dissolves in a modern sfumato.
Often read as a symbol of insincerity, the
garland of foxgloves in her hair functions here
as a splash of Scottish colour. JR

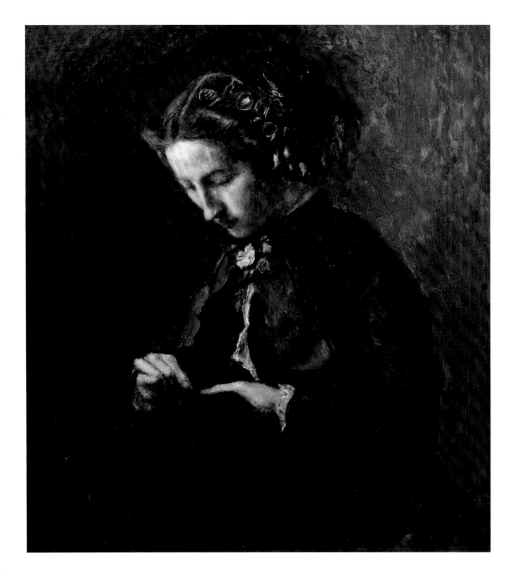

Sketches of 'Natural Ornament' 1853
Pen and ink
18.8 × 22.8
Inscribed on sheet 'finish of the dress',
'chestnut'
Private Collection

Provenance Lady Millais; J.G. Millais, who gave it to Major and Mrs Herbert Pullar, who gave it to Melville Gray; bt by the present owner, c.1950.

Exhibited RA and Liverpool 1967 (315)

J.G. Millais notes on the back of the frame of this picture that it was executed at Callander in August 1853. Ruskin was at that time preparing his lectures on Architecture and Painting which he delivered at Edinburgh in November. Inspired by Ruskin's ideas concerning the adaptation of natural phenomena for decorative purposes, Millais produced a number of sketches of 'Natural Ornament'.[1] The drawings may also have developed from discussions on natural science with Ruskin's friend, the physician and amateur geologist Dr Henry Acland, who would be a key player in the establishment of the Museum of Natural History in Oxford, who joined the party at Glenfinlas from 25 July to 1 August 1853.

As well as testifying to the influence of Ruskin on Millais, studies like this can also be seen as a riposte to the characteristically brunt criticism Ruskin had made in his pamphlet *Pre-Raphaelitism* published in August 1851 that Millais had a 'feeble memory, no invention.'[2] In a letter to Hunt of 17 August 1853 Millais writes: 'He [Ruskin] is quite delighted and astonished at my designs, he thought that we were simply capable of copying nature, and that we had no invention. Now he admits that he was awfully mistaken.' Ruskin himself describes Millais working with feverish intensity, 'chattering at such a rate – designing costumes – helmets with crests of animals and necklaces of flowers'.[3]

In the centre of this drawing Effie models a Renaissance-style dress that flows in continuous channels right down to the hem, yet is exaggerated at the back to suggest a crinoline. On her head she displays a fuchsia earring and a head-dress comprised of horse-chestnut leaves and blossom – a visual pun on the chestnut colour of her hair. In the sketch to the right she wears a heart-shaped tendril crown with a star at its centre, an anchor earring and a necklace fashioned from dead birds. As Charlotte Gere has noted, the border between fancy dress and costume is very fine in this sketch, especially as Ruskin was known to have encouraged Effie in having her dresses made up from Old Master portraits.[4] The drawing also owes something to the animal fashions of the era, particularly the trend for adorning bonnets with real birds, reptiles and insects. Such concoctions were later to be targeted for condemnation by animal rights movements, and in the 1870s Edward Linley Sambourne satirised the exploitation of natural species for female costume in his surreal *Mr Punch's Designs after Nature* cartoons. However, the intricate objectivity of Millais's drawing suggests no repulsion on his part, but rather hints at his enthralment with Effie who is presented as a queen presiding over the unruly realm of nature.

The sheet also includes three designs for parade helmets featuring, from left to right: a swan, a lioness and a vulture consuming an antelope. At the bottom right an otter devours a fish. Millais's delight in hybridising form may further have been prompted by Ruskin's fascination for medieval illuminated manuscripts, as Millais described to Hunt in a letter of 29 August: 'dragons passionately biting their own persons, and bodiless fiddleplayers, and hodded jesters terminating into supple macaroni.'[5] The juxtaposition of humans posed in harmony with natural species against images of predatory beasts characterises a number of related drawings of the same date, notably a study in Birmingham (fig.12), which presents Effie adorned with convolvulus, cowrie shell and lizard jewellery on the same page as a design for a cabinet with a bracket decorated at each end with bats and an owl in the centre holding a dead mouse in its beak. The interweaving of motifs that express both the organic integrity of the natural world and the struggle for existence also underpins Millais's designs for Gothic windows of the same period.[6] While these elucidate Ruskin's belief in the supremacy of naturalistic Gothic form over classical stylisation, the 'Effie' drawings introduce a more personal dimension to this contest, alluding to Millais's competition with Ruskin over the possession of his wife. AS

Figure 12
*Effie Ruskin Wearing a Dress
Decorated with Natural Ornament*
1853
BIRMINGHAM MUSEUMS
AND ART GALLERY

43

Tear Him to Pieces (Foxhunting) 1854
Pen and ink
23.2 × 19.5
Signed and dated in monogram. Verso
inscribed 'The same, Foxhunting – 1920 A.D.'
Geoffroy Richard Everett Millais Collection

Provenance By descent from the artist

Exhibited Southampton 1996 (185)

John Guille Millais recalls that, as a young man,
his father had been adverse to foxhunting
insisting that, unlike shooting or fishing, the
sport was ' "barbarous and uncivilised" [...]
and as such he would have nothing to do with
it'.[1] He was converted from this view by the
Punch cartoonist John Leech, whom Millais
met in 1853. Despite a twelve-year age
difference, the two men possessed a similar tall
athletic physique and soon discovered a mutual
love of country sports. Millais introduced his
friend to salmon-fishing and stalking while
Leech convinced Millais of the physical and
mental benefits of foxhunting. Citing the words
of a fictitious ostler from the pages of *Punch*,
Leech argued: 'The 'orses love it, the 'ounds like
it, the men like it, and even the fox likes it; and
as to health [...] it was only at the tail of the
hounds that an artist could do justice to

himself after the enervating influence of the
studio.'[2] Foxhunting soon became the antidote
to the headaches Millais suffered from when
painting, as he affirmed in a letter to Charles
Collins of late 1853: 'I never felt so jolly in my
life, all the troublesome thoughts of Art were all
shaken out of my head [...] By George there is
nothing like the sensation of riding "over the
hills and far away".'[3] Leech was to become
Millais's companion in such sporting activities
until his untimely death in 1864.

Millais was also a great admirer of Leech's
draughtsmanship, and during his sojourn in
Scotland with the Ruskins feasted on the
cartoons that adorned the pages of the copies of
Punch sent up to amuse the group from London.[4]
As a sign of the deep respect he felt for Leech's
art, the painter made a number of humorous
sketches, which he sent to the illustrator for
inclusion in the magazine, albeit with the
caution that his name should not be published,
as this would 'never go with the serious position
I occupy in regard to Art'.[5]

Leech's influence can be seen in this picture,
with its exuberant subject matter and ironic
caption. Although the date on the drawing would
suggest that it was made during the two weeks
Millais spent with Leech and his wife at Baslow

in Derbyshire during July 1854, there is also the
possibility it was executed earlier, around the
time when the two men met. In a letter to Leech
of 2 September 1855, congratulating him on
the birth of his son, Millais reminded his friend
of a sketch he had made 'two years back of you,
and your son at a meet of hounds'.[6] Here Millais
was probably alluding to the sketch on the
verso of this drawing (below right), which
depicts a similar hunting scene but projected
forward in time to the year 1920, showing
'John Leech aged 100' with 'master John Leech'
holding the tail of a fox in his hand. 'Miss
Leech' appears on horseback while 'Johannes E
Millais' cavorts with wild abandon around the
hounds as they tear at their catch. The Bacchic
revelry of this figure echoes Millais's depiction
of the huntsman in the main drawing, who
could represent either Leech or Millais urging
the dogs on in devouring the fox. The power
of this sketch resides in the delight with which
Millais captures the different reactions to the
kill: the bloodlust of the huntsman, the young
man raising his hands in horror and the
nonchalance of the aristocrat in the distance.
The drawing focuses so intensely on the
ferocity of the sport that it appears more of
a satire than a celebration. AS

43a

43b

Awful Protection Against Midges 1853
Pen and brown ink on laid paper
16.5 × 11
Signed and dated in monogram lower right
and inscribed with title lower left
Yale Center for British Art, Paul Mellon Fund

Provenance John Leech; given to Henry Silver of *Punch*;
Sir Ralph Millais; sold at Christie's, 11 June 1968 (149); Spink,
London; Martin Whiteley; bt from Peter Nahum at the
Leicester Galleries

Exhibited RA and Liverpool 1967 (307); FAS 1983 (41);
BAC 2000

This is one of the many humorous images
made while in Scotland and shows Millais and
Michael Frederick Halliday hooded and
sketching on the banks of an offshoot of the
River Turk.[1] Halliday was an artist who studied
under and was close to Millais.[2] He first
exhibited at the Royal Academy earlier in 1853.
In the late 1850s he would share a studio with
Millais at Langham Chambers. He was
diminutive with a bawdy sense of humour, and
owned a pet monkey. Effie later described him
as 'agreeable [...] but he is not higher than your
elbow I should think[,] bright yellow hair
beard & moustache, an extraordinary laugh

and very like a Dwarf – attired in a Kilt &
Braces of the most perfect description'.[3]
He insisted on wearing plaid while in the
Highlands, and frequently sported a pipe.
Millais, on the right, joins him in smoking in
an effort to fend off the midges.

Humour aside, this work usefully shows
how the artists worked out of doors. Halliday
props his board on his lap to see better both
it and the subject of his painting, his pipe in
his left hand and brush in his right. A box
of colours lies open at his side, indicative
of the new ease of working outdoors with
commercially packaged paints. He expels
smoke from a hole in his sackcloth hood.
Millais sits on a rock and holds a cheroot in
his left hand, while the board rests on his lap.
He draws intently. Every inch of his flesh is
covered. In the right background, a horrified
family is shocked by the sight of these odd and
alien artists. The father grasps his daughter
and thrusts an arm protectively across his
wife, while the family dog howls.

A visit to the Trossachs today will confirm
the presence of an inordinate amount of
midges. Millais quickly grew to regret this

choice of spot for the tedious labour of painting
the Ruskin portrait, as it is in a narrow gully
and the biting gnat-like insects dramatically
increase in number as one enters the area.
Millais first complained about them in a letter
to Charles Collins in London from Jedburgh,
writing that he and his brother William 'have
had some good fishing in Northumberland,
stream, and lake, both. and have been very
happy although much tormented by midge
bites.'[4] Little did he know what awaited him in
the Trossachs, as engagingly detailed in a later
letter, also to Collins:

> I have just attempted to paint on the picture
> of that renowned brother of self defence
> [Ruskin] but have found myself incapable of
> standing the amount of punishment which
> the Caledonian midge hath it in his power
> to inflict, like the Ancient Champions of the
> Ring I anointed myself with oil, in the hopes
> that the vile insect might be scared, but
> found that I was subjected to another almost
> greater annoyance, a sensation of minute
> writhing bodies on the surface of my skin.[5]

JR

Awful protection against midges

My Feet Ought to be Against the Wall 1853
Pen and brown ink
22.5 × 17.5
Inscribed with title lower left
Geoffroy Richard Everett Millais Collection

Provenance Geoffroy Richard Everett Millais by descent

Exhibited RA and Liverpool 1967 (297); FAS 1983 (11); Southampton 1996 (87); NPG 1999 (26)

In another humorous sketch from the Trossachs expedition, Millais portrays himself, as Malcolm Warner has pointed out,[1] as a modern Vitruvian Man, but here Leonardo's ideal nudity is replaced by practical braces and cuffed trousers. Millais's splayed appendages and characteristically ruffled mop of hair are reminiscent of that drawing in the Accademia in Venice. The directness of expression in the face, however, is arresting, and plays off the inspired and wild gazes familiar in Romantic self-portraiture by artists such as Francisco Goya, Henry Fuseli and John Hamilton Mortimer.

Millais did not romanticise his lodgings. He described the daily routine and the pictured room he was renting in a cottage owned by Alexander Stewart, the schoolteacher at Brig o'Turk, in a letter to Harriet Collins, mother of Charles and Wilkie:

> Our cottage is […] built of sand stones. Every day that it is fair we go to paint at a rocky waterfall and take our dinner with us. Mrs Ruskin brings her work and her husband draws with us, nothing can be more delightful. In the evening we catch small trout for the morrows breakfast which we enjoy immensely, they are so sweet. This new residence is the funniest place you ever saw, my bedroom is not much larger than a snuff box[.] I can open the window shut the door and *shave* all without getting out of bed.[2]

Effie, more practically, wrote that same day to her mother:

> John Millais and I have each two little dens where we have room to sleep and turn in but *no* place whatever to put anything in there being no drawers but I have established a file of nails from which my clothes hang and John sleeps on the sofa in the parlour[.] at the other end is the day school and at the kitchen end a nice large room where the clergyman lives an excellent Preacher.[3]

The close surroundings, and possibly the adjacent preacher, drove Millais mad once he fell for Effie. For parts of August he moved to the nearby New Trossachs Hotel to escape the proximity to her. Millais's drawing gives a good sense of his gangly frame when he was in his twenties, and his long face. He often said that he most resembled a 'lamp-post' around this time, when he was 6 feet (1.82m) tall and 9 stone (57kg).[4] The title of this work also refers to the limitations of a two-dimensional medium. To have drawn his feet against the near wall would have meant excluding the viewer from witnessing this humorous act of bodily extension and environmental compression. JR

Seven out of Millais's eleven known scenes from contemporary life directly concern the subject of marriage, particularly unions made under false pretences. Although Millais's romantic obsession with the flawed nature of bourgeois marriage relates to his desire to rescue Effie Ruskin from an unconsummated relationship with her husband (significantly Effie herself made copies of *Married for Money*, no.47, and *Married for Love*, no.48), it was also a preoccupation he shared with contemporaries like Hunt and Wilkie Collins.

The drawings are important for showing the extent to which Millais was prepared to experiment with narrative as he developed as an illustrator. What is particularly distinctive about the following sequence of images is that they appear to be illustrations without actually illustrating a particular text, as if the artist were exploring the idea of the 'illustrative' independently of any literary source. (The titles of most of the drawings are not recorded before 1898.)[1] With these experimental works Millais was inviting the viewer to construct the story, thereby offering a more proactive role for his audience in the appreciation of his art.

46 Married for Rank 1853
Pen and black and sepia inks
24.7 × 17.8
Inscribed 'JEM 1853' (initials in monogram)
Nicolette Wernick

Provenance William Reed in 1898; by descent to Richard Palmer; Christie's, 12 Dec. 1972; Maas Gallery, from whom bt by the present owners

Exhibited RA 1898 (235); Maas 1973 (58); Baden-Baden 1973–4 (65); Maas 1974 (72); Arts Council 1979 (20); Tate 1984 (187)

47 Married for Money 1853
Pen and black and sepia inks
22.9 × 17.2
Inscribed 'John Everett Millais'
Private Collection

Provenance William Reed in 1898; by descent to Richard Palmer; Christie's, 12 Dec. 1972 (47); Maas Gallery, from whom bt by the present owner

Exhibited RA 1898 (235); Maas 1973 (59); Baden-Baden 1973–4 (66); Arts Council 1979 (21); Tate 1984 (188)

48 Married for Love 1853
Pen and black and brown inks
24.7 × 17.5
Inscribed 'JEM 1853' (initials in monogram)
The British Museum, London

Provenance William Reed in 1898; by descent to Richard Palmer; Christie's, 12 Dec. 1972 (46); bt Colnaghi, from whom bt by the British Museum in 1976

Exhibited RA 1898 (235): Colnaghi 1973 (5); Colnaghi 1976 (49); Arts Council 1979 (19); Tate 1984 (189); BM 1994–5 (43)

These three drawings form a triptych on the theme of matrimony – the misery caused individuals by the public pursuit of status and wealth in *Married for Rank* (no.46) and *Married for Money* (no.47), countered by the joys of domestic love in *Married for Love* (no.48). In representing the pitfalls of romance in a society driven by class and commerce, Millais may have been thinking of William Hogarth's satirical *Marriage-à-la-Mode* 1743–5 in the National Gallery, although he was also likely to have been influenced by the works of writers he associated with such as Thackeray, Wilkie Collins and Coventry Patmore, all of whom explored the material realities that underpinned modern relationships.

Married for Rank presents a beautiful but arrogant young woman sweeping into a room at a social gathering in the arm of her elderly husband, who is decorated with the Order of the Garter. She taunts the wounded young officer on the right by flaunting her wedding ring, indicative of her passing him over for the man of senior status obsequiously attended to by the gentlemen on the left. In *Married for Money* the shadowy figure of a woman secretly observes from the gallery of a church a newly wedded couple greeting their guests. Her grief at their union is indicated by her handkerchief, and the precariousness of her social position by her dour dress and the ominous shadow she casts that bisects the design. The tension of the moment is further dramatised by the sharp contrast of light and shade and the abrupt intersection of perpendicular and orthogonal alignments that intensify the gulf that isolates her from the celebrations below. In stark contrast to the cynical view of marriage presented in these two drawings, *Married for Love* commemorates the intimate happiness and social benefits that stem from authentic love. A young curate gazes adoringly at his wife as she kisses him tenderly on the brow. Their reciprocal gaze and touching heads contrast with the other scenes where husband and wife look away from each other trapped in their own selfish desires. The curate is shown writing a sermon marked 'Trinity Sunday'. In the Church calendar this is the Sunday after Pentecost, and in 1853 fell on 22 May, which could either relate to the date of the work or allude to the 'trinity' or fulfilment of husband, wife and child.[1] The map of Britain on the wall, together with the globe in the foreground and books on the shelf, point to the world beyond the domestic sphere as if to suggest that private happiness begets social harmony rather than division. The view of the church through the window reinforces the idea that true religion stems from home, in contrast to *Married for Money*, in which the church authorises an unnatural union.

Married for Money was subsequently engraved by Thomas Oldham Barlow as an illustration to the Longmans edition of Thomas Moore's *Irish Melodies* (1856). AS

46

47

48

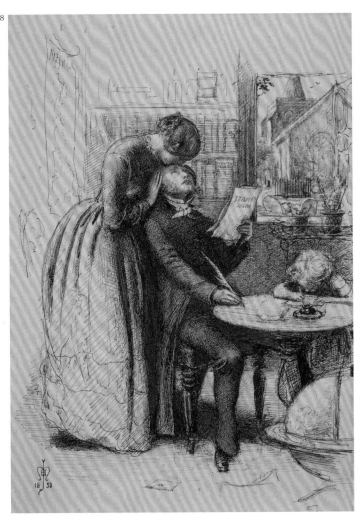

Accepted 1853
Pen and sepia ink
25.1 × 17.5
Inscribed 'To be painted moonlight/ Accepted/
John Everett Millais/ 1853'
Yale Center for British Art, Paul Mellon
Collection

Provenance Lady Millais, who gave it to her brother George
Gray; Melville Gray, by descent to Sir Ralph Millais, sold
Christie's, 4 July 1967 (119), bt P & D Colnaghi; bt Paul Mellon,
1967

Exhibited FAS 1901 (55); RA and Liverpool 1967 (328);
BAC 1977 (45); BAC 1982 (59); Tate 1984 (185)

The inscription 'To be painted […]' on *Accepted*
would suggest that it was Millais's intention to
develop the idea into a painting following the
initiative taken by Hunt and Rossetti with their
modern-life subjects *The Awakening Conscience*
1853–4 and *Found* 1854–c.1859. Millais may
also have been inspired by Hunt's work on
The Light of the World 1853–4 to attempt a
nocturnal subject. If, as has been suggested,
the drawing dates from the spring of 1853, it
is likely that Millais abandoned the project
following his decision to go to Scotland with
the Ruskins.[1]

The dance in the distance may be based
on the many sketches of party scenes Millais
executed between 1850 and 1851, but in this
instance functions as a foil for the foreground
tryst. A young couple have retreated from the
dance into the gloom of the night, indicated by
the dense shadows and bats flickering across
the sky. The man kneels in submission before
the woman and clasps her hands in rapture at
her acceptance of his proposal of marriage,
while she gazes back at the revelry they have
left to be alone. However, were it not for the
inscribed title, the ambivalence of the woman's
gaze and the intensity of her partner's
supplication could be seen to open up other
narrative possibilities. Maybe he is shown
begging for forgiveness or she has accepted his
offer out of pique for being rejected by another
suitor at the dance. AS

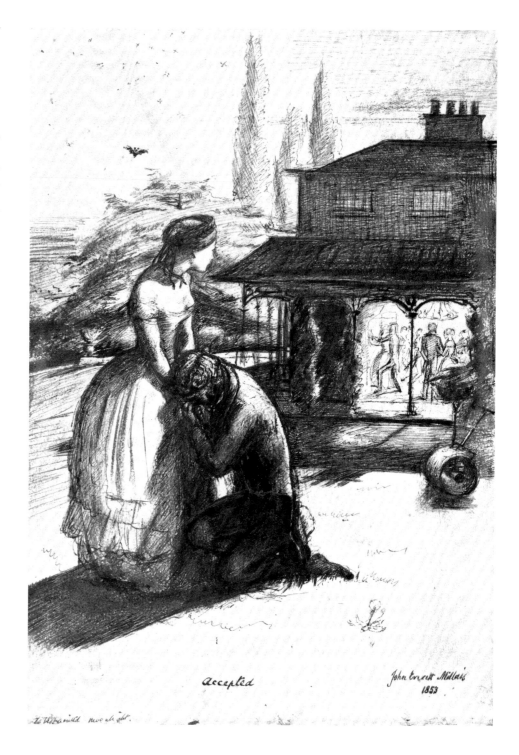

Goodbye, I Shall See You Tomorrow 1853
Pen and sepia ink
24.9 × 17.5
Signed and dated in monogram lower right
Yale Center for British Art, Paul Mellon
Collection

Provenance Lady Millais, who gave it to her brother George
Gray; Melville Gray, and thence by descent to Sir Ralph
Millais; sold Christie's, 4 July 1967 (120), bt P & D Colnaghi; bt
Paul Mellon, 1967

Exhibited FAS 1901 (58); RA and Liverpool 1967 (329);
BAC 1977 (46); BAC 1982 (60); Tate 1984 (186)

This drawing, also known as *Rejected*, may
have been conceived as a pendant to *Accepted*
(no.49), being of similar scale and executed in
the same technique. It was possibly intended
as the daytime counterpart to *Accepted*, the
path of the birds in the sky balancing the
flitting bats in the other drawing. Both works
focus on the tribulations of courtship in formal
social situations. A couple shake hands as they
part after a ride, the silent embarrassment of
their leave-taking heightened by the restless
movements of surrounding animals. The
scene possibly alludes to the tension preceding
the proposal in *Accepted*, or it could be an
independent courtship scene. AS

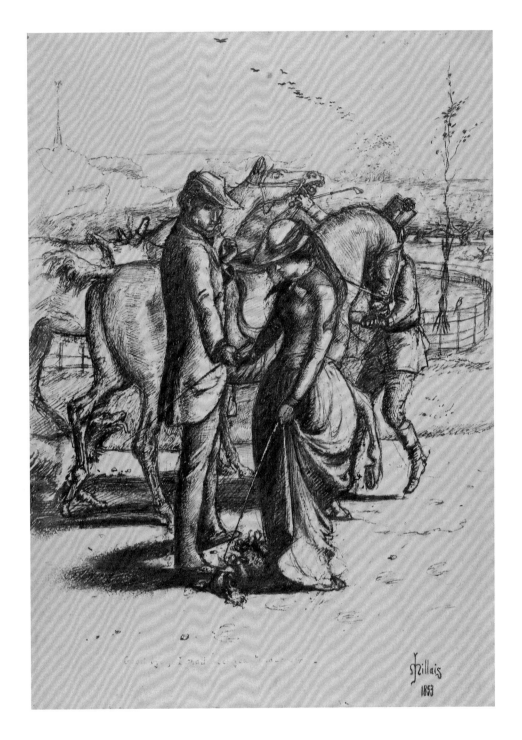

The Blind Man 1853
Pen and sepia ink, within a drawn border
25.4 × 35.6
Signed and dated in monogram lower right
Verso: pencil study of a soldier on horseback
Yale Center for British Art, Paul Mellon Fund

Provenance Effie, Lady Millais; Lady Stuart (née Millais) of Wortley; George Gray and by descent; bt by David & Long, New York, from whom bt by Yale

Exhibited FAS 1901 (79); BAC 1981; Tate 1984 (191); Davis & Langdale 1985 (53); BAC 1986–7 (108); Manchester, Amsterdam and BAC 1987–8 (15)

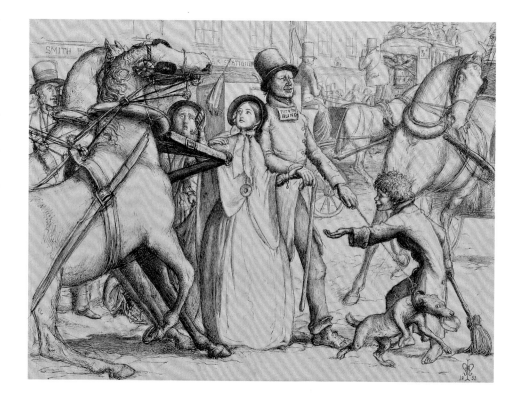

The subject of this drawing was probably influenced by cartoons addressing topical issues that appeared in *Punch*, as well as paintings addressing the subject of female charity by Richard Redgrave and other painters of the Victorian social scene. The drawing shows a blind man being guided across a congested street by a responsible young woman, taking their time as they are tugged along by the man's skinny dog holding a begging bowl in its mouth. The horses rearing up in front of the group, halted by the blind man's companion wielding her parasol, wear blinkers, emphasising their partial blindness, while the crossing-sweeper who puts out his hand to the lady is shown to be morally oblivious to the man's disability.

It has recently been suggested that the drawing was made in response to F.G. Stephens's demand that artists should tackle distasteful subjects from modern life in his article 'Modern Giants', published in *The Germ* in May 1850.[1] Taking the theme of charity as a case in point Stephens suggested that, rather than illustrating noble actions from the past, artists should seek modern equivalents and instanced the action of a friend of his who, putting aside feelings of repugnance, helped a dirty old lady across a crowded thoroughfare. For Stephens this subject was as poetical as the actions of St Elizabeth of Hungary or any other virtuous figure from history. The charitable intervention of the woman in Millais's drawing certainly lends a miraculous element to the image, and invites comparison with Christian iconography of a virgin saint repudiating the advances of a dangerous beast.

Millais was to take up the theme of blindness again in *The Blind Girl* 1854–6 (no.62), a work that includes the same 'Pity the Blind' sign, but which deliberately disavows the satirical edge of this drawing. AS

The Dying Man 1853–4
Pen and sepia ink with wash
19.7 × 24.4
Yale Center for British Art, Paul Mellon Fund

Provenance Lady Millais; George Gray; Melville Gray;
Mrs Sophie McEwen; Miss Veronica McEwen; E.G. Millais,
sold Christie's, 20 March 1979, bt J.S. Maas, from whom bt by
Yale, 1979

Exhibited FAS 1901 (64); RA and Liverpool 1967 (336);
BAC 1981; Tate 1984 (192); BAC 1986–7 (107)

This drawing has been related to a letter Millais
wrote to his wife on 13 April 1859:

> Yesterday I met in the Burlington Arcade an
> old friend from India, the brother of our old
> friend Grant who died. (I drew him in pen-
> and-ink, dying, surrounded by his family.)[1]

The subject may also have been a response to
the 'melancholy illness' of Millais's friend and
Pre-Raphaelite associate, Walter Deverell, who
died of consumption early in 1854. Having lost
both parents and with siblings to support,
Deverell gradually wasted away in conditions
of poverty and neglect that appalled Millais.
In a letter to Mrs Combe asking if she could
recommend 'a good, kind person who would
read to him, and see to his taking his meals
punctually', Millais noted the apathy of
Deverell's servant and his sister: 'There was no
fire in the room, and the invalid was hanging
partly out of his bed, with his hands as cold as
ice.'[2] Although the dying man in this drawing
similarly looks as if he is expiring from
consumption, he is shown to be well cared for
in the bosom of his family, the glowing fire and
warm blanket around his legs evidence of their
sensitivity to his needs. The man appears deaf
to the words being read out to him by the
woman by his side, an observation that may
have been prompted by Millais's recollection
that in the final stages of his illness Deverell
'would not, or rather could not, listen to what
was said to him'.[3] AS

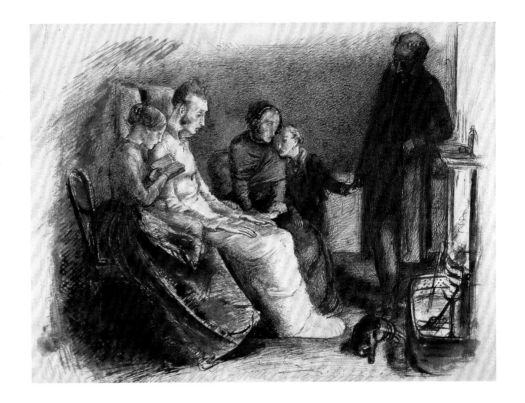

The Race Meeting 1853
Pen and sepia ink
25.4 × 17.8
Signed and dated: 'JEM [monogram] 1853'
The Ashmolean Museum, Oxford

Provenance George Gray; Melville Gray; Colnaghi from whom bt by the Ashmolean, 1947

Exhibited FAS 1901 (48); Whitechapel 1948 (61); Arts Council 1953 (37); RA and Liverpool 1967, (330); Paris 1972 (192); Whitechapel 1972 (39); Baden-Baden 1973–4 (68); Portsmouth 1976 (36); RA 1979 (13.8); Tate 1984 (190); Japan 1987 (55); Nottingham and Exeter 1997–8 (30)

Millais's choice of the Epsom Derby as the subject for this drawing owed much to his friendship with John Leech, the *Punch* illustrator of modern life, who shared with the artist a passion for country sports. Between 1850 and 1853 Leech contributed some sketches to *Punch* on the theme of the Derby, which became influential in establishing the standard iconography of the race meeting by focusing on the gregarious aspects of the gathering and the intermingling of different social classes, as well as creating stock characters such as the reckless swell, the gullible dupe and the gypsy beggar woman.[1] Both Millais and William Powell Frith drew on this rich vocabulary of types in their respective depictions of the Derby, the latter's very large and complex painting of *The Derby Day* being the sensation of the 1858 Royal Academy. But in contrast to the convivial humour of Leech and Frith, Millais's drawing strikes a more sombre note, characteristic of the revival of interest in the Hogarthian modern moral subject that developed among the Pre-Raphaelites in the 1850s.

More immediately the drawing was inspired by Millais's visit to Epsom on 25 May 1853 when the race was won by the horse West Australian. Describing the occasion in a letter to Charles Collins, Millais wrote:

Such tragic scenes I saw on the course. One mustachioed guardsman was hanging over the side of a carriage guilty of a performance only excusable on board a ship in a state of abject intoxication, while with a white aristocratic hand dangling, as dead a lump, as the plaster casts of hands in painters studios, in the same carriage seated beside him endeavouring to look as though she was not cognisant of the beastly reality; his mistress.[2]

The Race Meeting is one such 'tragic scene'. A swell has gambled away a vast sum on the horses. Sated with food and drink he nonchalantly spreads himself out in his landau in a martyr-like pose, while his mistress weeps with shame at his loss. In an image that resembles the mocking of Christ he is shown surrounded by guileful creditors and boon-companions who urge him on to ruin, with the obsequious beggar woman and gypsy girl sucking a chicken leg in the corner underlining the theme of greed and gluttony. The satire on drunkenness and gambling is subtly reinforced by the two 'Derby Dolls' (wooden articulated figures displayed in hats during the races), which mock the decadent toff. The one displayed in the band of his top hat echoes his crucified pose, while the other, merrily perched in an eau-de-vie glass, mimics the swell's inebriated condition. AS

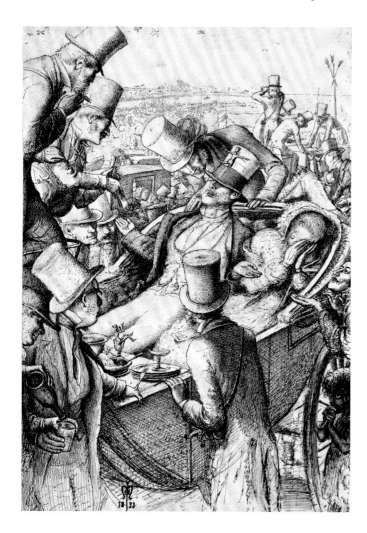

54

Sketch for 'The Prisoner's Wife': 'Wife Confronting Judge' c.1853–4
Pen and ink over pencil with touches
of bodycolour
11.3 × 11.2
Birmingham Museums and Art Gallery

Provenance J.G. Millais; C.F. Murray; presented to
Birmingham by subscribers, 1906

Exhibited FAS 1901 (73); RA and Liverpool 1967 (208);
Birmingham 1997 (42)

J.G. Millais titled this work *The Judge and the Prisoner's Wife*, dating it to 1847 even though he placed it in the 1854 chapter of his father's biography.[1] The sketch most likely dates from 1853–4 and was probably an idea for an illustration or a finished drawing. An elderly judge, shadowed by a circuit judge, is shown trying to make his way into a court building. The distraught wife of the accused reaches out to catch his attention while a soldier and other officials press her back into the throng. In her desperation to grab his attention she lets her baby slip into the arms of her young daughter. With its emphasis on female powerlessness in the face of the law the sketch can be seen as a modern-day counterpart to *The Order of Release, 1746* (no.39), the interlocking bodies and accompanying dog offering further points of comparison. Another sketch in Birmingham for *The Prisoner's Wife*, showing the woman kneeling in front of the judge, with a related drawing on the verso of two figures with arms locked, is inscribed by J.G. Millais 'The Law Courts/ design for illustration'.[2] Although this could be an alternative sketch for the subject, it is possible that Millais conceived of the two drawings as pendants, no.54 being the prelude to the drama enacted inside the court, anticipating Abraham Solomon's popular *Waiting for the Verdict* 1857 and *Not Guilty* 1859. AS

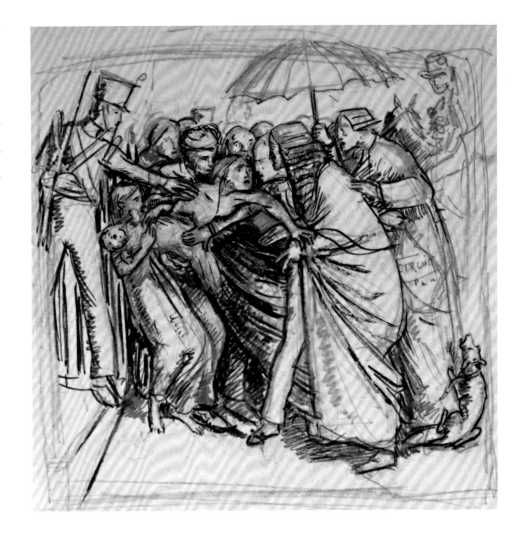

**A Ghost Appearing at a Wedding
Ceremony** 1853–4
Pencil, pen and black and sepia inks
31.1 × 26
Inscribed 'I don't, I don't'
Victoria and Albert Museum, London

Provenance Lady Effie Millais, who gave it to her brother
George Gray; Melville Gray; bt by the V&A in 1947

Exhibited FAS 1901 (71); Arts Council 1953 (36); RA and
Liverpool 1967 (331); Brighton 1970 (91); Arts Council 1979
(29); Tate 1984 (193)

Although this sheet is not dated, it most likely
belongs to the group of modern-life drawings
Millais produced in 1853–4. It shows a bride at
the altar, on the brink of declaring her marriage
vows and accepting the ring offered by the
groom, collapsing in shock as she alone sees
the apparition of her former lover. Millais
captures the trauma of the moment by
contrasting the catatonic rigidity of her face
and arms with her lower limbs, which cave in
as she sinks into the arms of the woman behind
her. The inscription 'I don't, I don't' probably
refers to the bride's refusal in her distress to
take the marriage vow, while the words on the
screen from the Apostles Creed 'I believe in
God the Father' establish a doctrinal
framework for the sacrament she recoils from
in her plight.[1]

The use of the wedding ring as a trigger
for dramatising a state of trance may have
been suggested by *The Bridesmaid* 1851
(no.27), while Millais's interest in supernatural
vision expressed in this drawing anticipates
his later productions *The Grey Lady* 1883
(Private Collection) and *Speak! Speak!* 1894–5
(no.100). AS

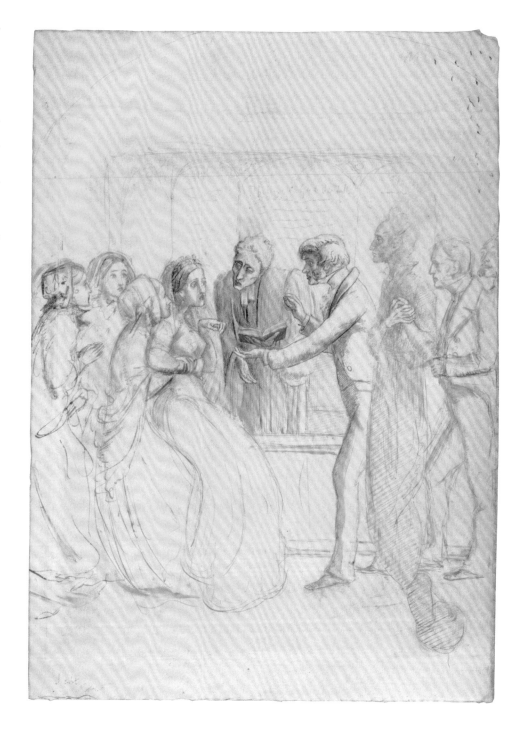

56

Retribution 1854
Pen and brown ink
21.4 × 27.5 (sheet)
Signed and dated in monogram
The British Museum, London

Provenance Lady Effie Millais; her brother, George Gray; Melville Gray; Mrs Sophie McEwen; Veronica McEwen; Eric George Millais; Christie's, 20 March 1979 (208); J.S. Maas, from whom bt by the British Museum, 1982

Exhibited FAS 1901 (77); RA and Liverpool 1967 (334); Detroit and Philadelphia 1968 (226); Jersey 1979 (34); BM 1984 (191); Tate 1984 (194); BM 1994–5 (44)

In this drawing Millais presents a climactic moment in a narrative, and invites the viewer to tease out the cause and consequence of the encounter by studying the gestures and expressions of the protagonists. A couple are just about to leave an apartment to be married but are unexpectedly interrupted by the groom's first wife, who exposes the profligacy of her husband to avoid having to do so in church. In her desperation to prove her identity, the wife shows her wedding ring to the bride, who stares aghast at the guilty bigamist as he ignominiously averts his gaze and hides his hands in his pockets, like the shame-faced Mark Robarts in Millais's illustration *'Mark', she said, 'The men are here'* for Anthony Trollope's *Framley Parsonage* (1861).[1] The pathos of the abandoned wife's situation is underscored by her children's gendered responses to their father's desertion: the daughter's emotional plea contrasting with the son's defiant posture and accusatory stare.

The *mise-en-scène* is carefully constructed to heighten the tension of the moment, with the main action confined to the foreground. The maid entering the room mirrors the viewer's position as an intruder upon such a dramatic moment, while the picture of the ballet dancer on the wall adds a note of ambiguity. It could indicate the profession and, by inference, the morality of the bride, although such a supposition is contradicted by her horrified expression. The more likely explanation is that, like the print of the dancer in Emily Mary Osborn's *Nameless and Friendless* 1857, it functions as a sign of predatory male desire. As

A Huguenot, on St Bartholomew's Day, refusing to shield himself from danger by wearing the Roman Catholic badge 1851–2
'When the clock of the Palais de Justice shall sound upon the great bell, at daybreak, then each good Catholic must bind a strip of white linen round his arm, and place a fair white cross in his cap.' – The order of the Duke of Guise. (See the Protestant Reformation in France, vol.ii., p.352)
Oil on canvas, arched top
92.7 × 62.2
Signed and dated in monogram lower left
The Makins Collection

Provenance bt David Thomas White; B.G. Windus, bt Thomas Miller; by descent to Mrs Thomas Miller, Thomas Horrocks Miller, Mrs T.H. Miller, Thomas Pitt Miller, sold Christie's, 26 April 1946 (88), bt Agnew's; Huntington Hartford, New York by 1954, his sale Christie's, 14 July 1972 (80), bt Agnew's; bt Christopher Makins and by descent

Exhibited RA 1852 (478); Liverpool 1852 (49); GG 1886 (6); Guildhall 1892 (168); Guildhall 1897 (133); RA 1898 (61); London 1908 (101); Kansas 1958; Indianapolis and New York 1964 (49); RA and Liverpool 1967 (35); Detroit and Philadelphia 1968 (225); Peoria 1971 (51); Miami 1972 (64); Tate 1984 (41); London 1985 (467); Washington 1997 (10); Berlin 1998 (52); BAC and Huntington 2001–2 (58 BAC only); Kimbell Art Museum 2005, 'Guest of Honor' painting

A Huguenot was the first of a series of highly successful paintings that focus on the constraints placed on lovers in situations of civil conflict. The accompanying quotation refers to the St Bartholomew's Day Massacre that took place in August 1572, when French Catholics, under the leadership of the Duke of Guise, slaughtered thousands of Protestants, or Huguenots, in Paris. Millais's painting shows a Catholic woman entreating her Huguenot lover to escape the massacre by binding a white cloth around his arm to identify him as a Catholic. The tenderness with which he resists her plea indicates that he would rather die than renounce his faith.

The painting originated as a study of a 'secret-looking garden wall' at the bottom of the garden of Worcester Park Farm near Cheam, where Millais was staying with Hunt during the late summer of 1851.[1] He sat painting this throughout the autumn months with such fidelity to the moss-and-lichen covered brickwork that the painting can indeed be described as a portrait of a wall.[2] However, it was Millais's intention to develop the picture into an illustration of the scene of lovers whispering by a garden wall from Tennyson's poem *Circumstance*, and he accordingly left a blank space for the addition of figures at a later stage. Apparently Hunt found the sentiment of Millais's idea too maudlin and urged him to adopt a subject of greater moral and dramatic significance. Millais eventually concurred and, after toying with a theme from the Wars of the Roses, he recalled the motif of the white armband from Giacomo Meyerbeer's opera *Les Huguenots* (first performed in London in 1842).[3] This scene occurs in Act 5, when the Catholic Valentine tries to tie the cloth around the arm of her Huguenot lover Raoul de Nangis. Millais's painting is not so much an illustration but a crystallisation of the pathos of the scene. The five sketches for the composition reproduced in J.G. Millais's *Life and Letters* show how he refined the idea by excluding the priests and other distracting features to concentrate solely on the psychological interchange between the lovers.[4] Using his friend Arthur Lemprière as model for the Huguenot and the professional Anne Ryan for the woman, Millais attended to the body language and expression of the couple to dramatise their conflicting feelings of devotion,

desperation and duty. The tension of the moment is captured in the play of the Huguenot's hands around his lover's face. One hand gently caresses her while the other tautly draws back the cloth, a gesture that encapsulates both the intimacy of the moment and the external pressures that will lead the Huguenot to his fate.

Rather than being subsidiary elements, the wall and flowers partake of the drama, the former alluding to privacy and entrapment, the latter reiterating in the language of flowers the competing demands of the situation. The ivy that surrounds them both thus symbolises dependence, the Canterbury bell on the side of the woman, constancy, the nettles in the right and left foregrounds, pain, and the nasturtiums by the Huguenot, patriotism. The bright pink rose petals scattered at the foot of the man can be seen as a visualisation of torn feelings as well as an allusion to the blood about to be spilt as a result of the Huguenot's stance. The natural process through which organic forms fuse with and stand out against the brickwork creates a visual tension that subtly echoes the theme of human misalliance, while also connoting the fragility of existence in the remorseless framework of time.

The painting was bought just before it was submitted to the Academy by the dealer D. White for £250, who gave the artist another £50 after publishing the mezzotint by Thomas Oldham Barlow in 1856. Millais also exhibited *A Huguenot* at the Liverpool Academy in 1852 where it was awarded a £50 prize. Capitalising on the success of the image, he produced a smaller replica in oil and three further versions in watercolour. AS

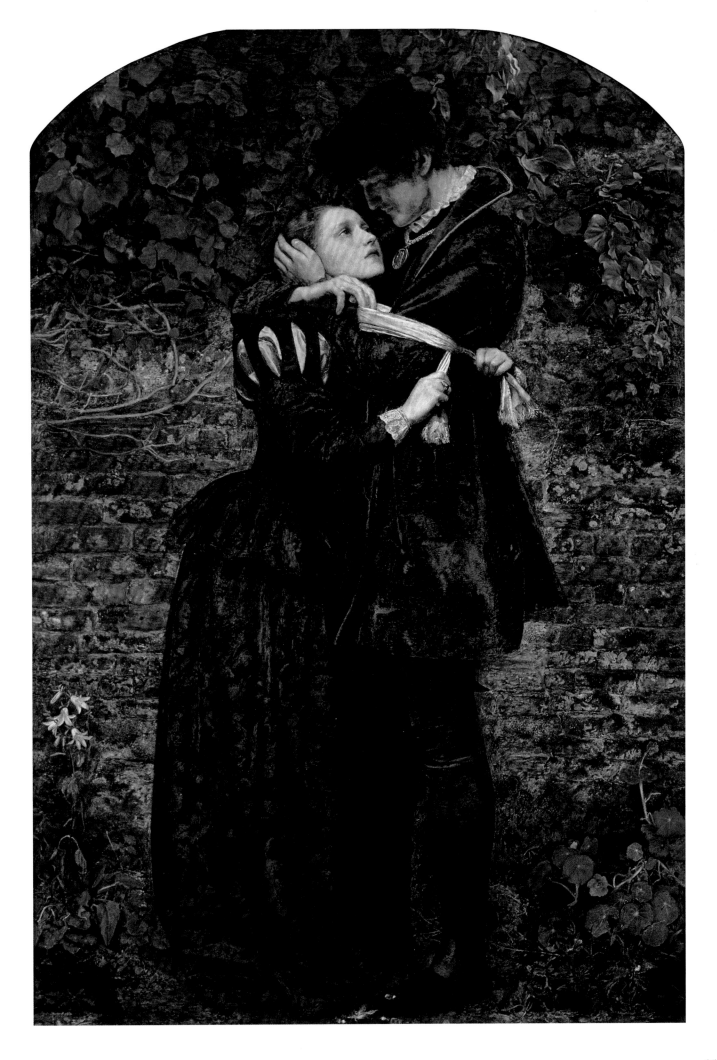

The Proscribed Royalist, 1651 1852–3

Oil on canvas

102.9 × 73.6

Signed and dated in monogram lower right

The Lord Lloyd Webber

Provenance Commissioned by Lewis Pocock, May 1852; Foster's, 18 March 1857 (83); Gambart 1858; Thomas Plint by 1861; his sale, Christie's, 8 March 1862 (330), bt Agnew's; Sir John Pender; his sale, Christie's, 29 May 1897 (54); James Ogsten; his niece Mrs Marjorie Mary Yates; her sale, Christie's, 25 Nov. 1983 (100); the Lord Lloyd Webber

Exhibited RA 1853 (520); French Gallery 1858–9; GG 1886 (125); Birmingham 1891 (193); Guildhall 1894 (106); RA 1898 (45); Wolverhampton and Sheffield 1978–9 (8); National Gallery of Scotland, Edinburgh, 1980–3 (on loan); Tate 1984 (46); RA 2003 (24)

With *The Proscribed Royalist, 1651*, Millais built on the success of *A Huguenot* (no.57), which similarly focuses on lovers in tense historical circumstances, and *Ophelia* (no.37), with its intricate profusion of natural detail. *The Proscribed Royalist* is set during the English Civil War (1642–51), and shows a Cavalier, who has been proscribed or condemned to death, intently kissing the hand of a Puritan woman, presumably his lover, who hands him bread as she furtively glances around, anxious that she may have been followed. As with *A Huguenot*, the subject was loosely based on an operatic plot, in this case Vicenzo Bellini's *I Puritani*, which also concerns lovers

belonging to different political factions and which Millais may have seen performed at Covent Garden during the early 1850s. The date in the title of Millais's painting refers to the Battle of Worcester and the incident when Charles II hid in an oak, which the artist alludes to in representing the Cavalier encased in the womb-like cavity of a massive tree.

Civil War subjects were very popular during the 1850s and early 1860s, dramatising the moral conflicts and dilemmas facing Puritans and Royalists alike. The suspense of Millais's scene is enhanced by the minute precision of natural detail. Many features, such as the pine cones in the foreground and red admiral butterfly on the oak, are camouflaged within the composition, increasing the viewer's awareness of the heightened senses of the woman and her disorientation. She looks away from the man as if disturbed by some rustling sound in the undergrowth. The background was painted at a wooded location near Hayes in Kent during the summer and autumn of 1852. The oak, which subsequently inspired a tourist site known as the 'Millais Oak' on West Wickham Common and is reproduced in J.G. Millais's biography, has survived to the present day.[1] Millais added the figures during the winter in his London studio, using Anne Ryan,

who also posed for *A Huguenot*, and the young artist Arthur Hughes, whose own *Ophelia* shown at the Royal Academy of 1852 had won Millais's praise.

In order to capture the dazzling effect of sunlight on the woman's orange copper-coloured satin dress, Millais arranged a garment around a lay figure, which he positioned next to Hughes in a small sun-lit back room at his residence in Gower Street, and he later returned to Hayes with the draped contraption to paint from it on site. Viewing the picture in Sir John Pender's collection in 1892, J.F. Boyes noted the preservation of 'the brilliant colouring that was universally admired when first seen in 1853, and is now as remarkable as ever'.[2] The sober costume, offset by the sensuous surface of the dress, helps encapsulate the dichotomy of duty and pleasure, while the split oak and detail of the woman's hand in her pocket hint at sexual intimacy and her betrayal of her community.

As with *A Huguenot*, the painting was engraved in steel to take advantage of the burgeoning market for prints, and produced in the same size so that collectors could hang them together.[3] Millais also painted a watercolour version for Agnew's in 1864 and a finished sketch in oil. AS

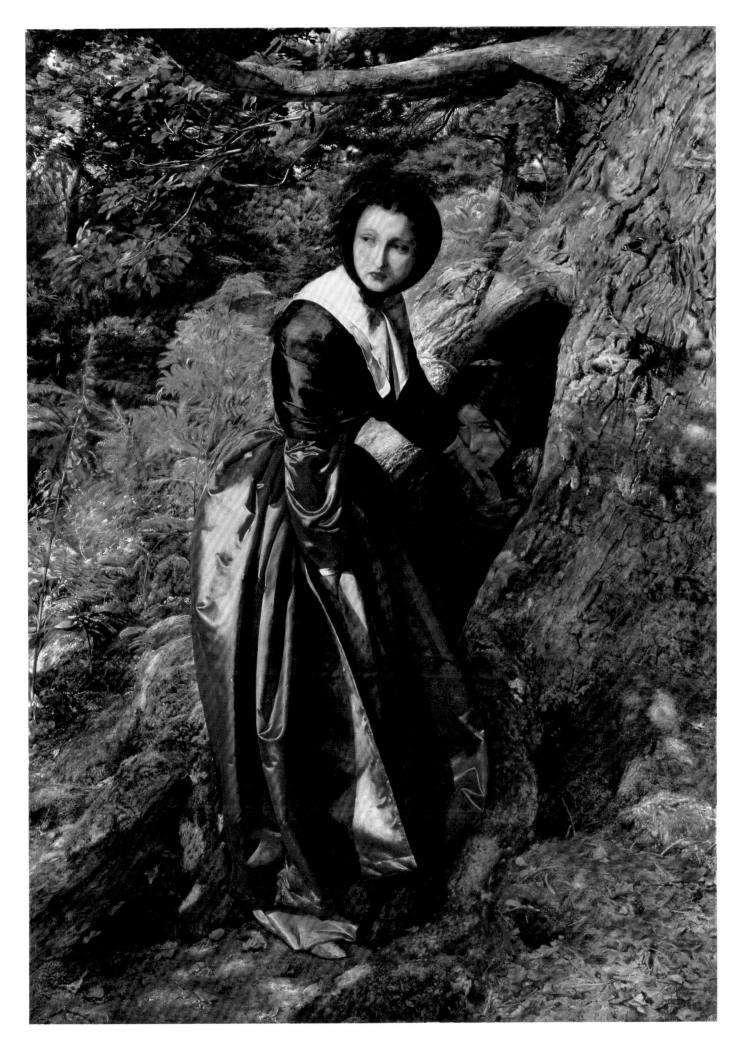

Waiting 1854
Oil on canvas, arched top
32.4 × 24.8
Signed and dated in monogram lower right
Birmingham Museums and Art Gallery

Provenance Joseph Arden; his sale, Christie's, 24 April 1879
(29), bt Tooth; Edward Nettlefold, whose wife presented it to
Birmingham, 1909

Exhibited Glasgow 1901 (204); Manchester 1911 (235);
Tate 1911–12 (15); RBA 1937 (246); Birmingham 1947 (60);
ICA 1951 (17); Wales 1955 (50); RA 1962 (193); Ottawa 1965
(93); Lyon 1966 (79); RA and Liverpool 1967 (43); Tate 1984
(59); USA and Birmingham 1995–6 (31); Berlin 1998 (56)

The year 1854 brought something of a hiatus
for Millais. On 7 November 1853 he was elected
Associate of the Royal Academy, a move that
began his retreat from Pre-Raphaelite circles as
he was drawn into the orbit of the Academy.
However, he chose not to submit to the annual
Royal Academy exhibition in 1854, preferring
to maintain a low profile. This decision not only
relates to his continued work on the Ruskin
portrait, which obliged him to return to
Glenfinlas in May 1854, but to his circum-
spection around the time of the divorce
proceedings filed by Effie against Ruskin.

Waiting is one of a group of small cabinet
pictures Millais produced in 1854 of women
shown absorbed in thought or captured at a
moment of suspense (see no.60). It was painted
either in the spring, prior to his departure for
Scotland, or in July, when he stayed at Baslow
near Chatsworth, shortly after he had received
the news that the decree of nullity had been
granted. In a letter to Charles Collins of 24 July
Millais wrote that he was working on two
sketches '*entirely* painted *without any medium*
[...] the surface looks pearly and delicate not
horny'.[1] It is possible that one of the sketches
referred to could be *Waiting*, the stone wall
being characteristic of the Derbyshire region.
The picture shows a woman huddled in a shawl
gazing out of the scene towards her left.
Whether her expression is one of apprehension,
expectation or furtiveness is unclear, adding to
the uncertainty of whether the person she is
waiting for will appear. The painting was first
known as *The Stile*, a title that neutralises any
suggestion of narrative, although it could
suggest a boundary that the woman has
perhaps transgressed. The identity of the model
is unknown, but one inevitable conjecture has
been that the figure represents Effie anxiously
awaiting the outcome of the suit of nullity or
anticipating the arrival of Millais. It was M.H.
Spielmann who, with hindsight, first
interpreted the image in biographical terms,
retitling it *Waiting* and noting that it resembled
'Lady Millais in a bonnet'.[2] On this line of
inquiry it is equally possible to argue that the
figure personifies Millais's frustration in having
to respect Effie's wish that he refrain from
visiting her until she felt that the time was
appropriate (they were reunited that winter).[3]

The lack of specificity regarding situation or
narrative points to a significant shift in the
artist's style. Although the brilliant greens and
madder touches are reminiscent of some of his
earlier works (see *Ophelia*, no.37, and *Emily
Patmore*, no.34), the painting lacks the precise
detailing that lends itself to narrative and
symbolic decoding. Despite the small scale
of the work, paint is applied in a more
impressionistic way to suggest rather than
describe form. Instead of picking out individual
blades of grass, the dappled shades of the
foreground and distance are indicated by broad
masses of colour enlivened by dashes of blue
and white, an approach that anticipates the
manipulation of paint in the artist's *Vale of
Rest* 1858 (no.85) and *Spring* 1859 (no.84).
What Millais gained through this transition
in technique was the ability to evoke mood
through atmospheric effect. Here the
tranquillity of the setting relates ambiguously
to the subject, harmonising with, yet
counterpointing, the woman's state of
mind. AS

The Violet's Message 1854
Oil on panel
25.4 × 19.7
Signed and dated in monogram lower left
Private Collection c/o Christie's, London

Provenance Joseph Arden by Oct. 1857; his sale Christie's, 26 April 1879 (29), bt Tooth; J. Orrock by 1896; bt from him by Lord Leverhulme, 1898; sold from Lady Lever Art Gallery, Christie's, 6 June 1958 (138); bt Agnew's, from whom bt by Sir Colin Anderson, thence by descent.

Exhibited SPP 1897 (20); Glasgow 1898 (522); Port Sunlight 1902a (74); Port Sunlight 1948 (134); Hampstead 1959 (24); Agnew's 1961 (48); Ottawa 1965 (92); RA and Liverpool 1967 (47)

The Violet's Message is one of a group of small cabinet pictures of female heads that Millais painted in 1854. On 23 March Effie wrote to her mother saying that she had heard from Millais's friend Michael Halliday that the artist was 'working very hard at some heads'.[1] For these Millais used models familiar to his circle, with this picture being based on Annie Miller, who was also the subject of a portrait Millais executed around the same time (Private Collection) in which she wears the same earring, bow and ribbon.[2] Miller, a working-class girl, had been discovered by Hunt, who set out to make her his protégé and wife (he posed her as the fallen woman realising the folly of her ways in his *Awakening Conscience* 1853–4). On his departure for Palestine Hunt entrusted F.G. Stephens with a list of artists for whom she was allowed to model. The list included Millais, who reported back to Hunt that he was painting two heads from her and that she behaved 'very properly'.[3]

The painting shows a woman carefully opening a billet-doux filled with violets, a potent love token she would most likely have kept and pressed. In the demotic language of flowers violets would have been recognised as a symbol of deep affection or fidelity, and so here the flower can be seen as a narrative key, prompting association in the mind of the viewer and allowing for the projection of meaning. The reflected colour of the brilliant madder bow on the woman's lips hints at the emotion she feels within, which her downward expression hides from the viewer. The work can further be seen as a sort of proto 'problem picture' (a term that became common later in the nineteenth century), being neither a portrait nor a genre painting, its nuanced observation of gesture and expression inviting the spectator's empathy with the feelings experienced by the woman as she receives the message. AS

L'Enfant du Régiment 1854–5
Oil on prepared paper, laid on canvas, mounted on board
46 × 62.2
Signed and dated in monogram lower right
Yale Center for British Art, Paul Mellon Fund

Provenance B.G. Windus; T. Horrocks Miller; Thomas Pitt Miller, sold Christie's, 26 April 1946 (89), bt Agnew's; Sir Ernest Makins, and thence by descent; bt by Yale, 1980

Exhibited RA 1856 (553); GG 1886 (65); RA 1898 (59); Glasgow 1901 (243); Bournemouth 1951 (64); ICA 1951 (18) RA 1951–2 (289); RA and Liverpool 1967 (52); King's Lynn 1971 (66); Tate 1984 (70); BAC 1986–7 (70); Australia 1998 (63)

From late August to 22 November 1854 Millais stayed in Winchelsea in East Sussex, where he commenced two paintings, *The Blind Girl* (no.62) and *L'Enfant du Régiment*. As was typical of his practice at this time, he executed the setting on location and added the figures later: the girl in *L'Enfant* was painted from the child model Isabella Nicol in Perth the following year. During an earlier visit to Winchelsea Millais had been struck by the medieval tombs of Caen limestone in the parish church and on his return started this picture, painting a fourteenth-century effigy believed to be of Gervase Alard, Admiral of the Western Fleet under Edward I. Millais's fixation with this particular tomb probably stemmed from his fascination with the picturesque decay and organicism of Gothic forms, which he had shared with Ruskin in Scotland and expressed in his 'Natural Ornament' and architectural studies (see no.42). As Paul Barlow has recently demonstrated, Millais would have been familiar with Ruskin's watercolours and daguerreotypes of medieval tombs in Verona, as well as his thinking regarding the moral lessons to be gleaned from geology, which the writer set down in his *Stones of Venice* of 1851–3, a work greatly admired by Millais.[1]

In this painting the inert stone of the tomb is given meaning by the narrative Millais imposes on the scene. The picture was inspired by Gaetano Donizetti's popular *opéra comique La Fille du Régiment* (1840), which Millais could have seen performed at Her Majesty's Theatre in London in 1847–8 or 1850–1. The opera is set during the Napoleonic Wars and concerns a romantic episode in the life of the orphan Marie who has been brought up by soldiers. Imagining a scene from her childhood, Millais shows her to have been wounded in crossfire during a skirmish either in the French Revolution or under Napoleon, and placed to rest with a grenadier's jacket as a blanket on a medieval tomb. Although Millais could be seen to be offering a more humane view of the French army than was typical of the time, the painting does not require an understanding of historical circumstances or the opera to be accessible. Some critics thus mistook the child for a boy, and the picture was also known as *A Random Shot*, a title appropriated from Edwin Landseer's popular Royal Academy exhibit of 1848 depicting a mortally wounded deer, which was published as an engraving in 1851.[2] The success of Millais's painting was thus partly dependent on his interpellation of his sources, as the *Athenaeum* declared:

> How cleverly this sets the imagination working. What kind-hearted, rough, black-handed soldier, grimy with powder, laid the child here in safety tenderly as a mother? What will be his [the child's] fate? – will he be butchered by a rush of savages, or be led off in triumph to turn drummer at Marengo, or, to plod through ice and sand, to the Pyramids or Moscow?[3]

Seen in relation to Millais's exhibition strategy of the period, the painting continues the winning theme of the plight of the individual in historical situations. In *L'Enfant*, conflict is presented as an invariant of existence, as expressed by the contrast between the pale armoured effigy and the brilliantly coloured grenadier's jacket, not to mention the musketry of the soldiers in the distance. Both the girl and the knight are presented as broken figures; the tomb damaged by the iconoclasm of earlier religious wars, the girl by the struggle enacted in the present. They are united in sleep, and the relaxation of the girl's body on to the monument creates a sort of landscape reminiscent of the integration of living and dead form in Millais's 'Natural Ornament' drawings. At the same time the juxtaposition of the child's ruddy soft flesh against the cold rigidity of the stone emphasises the gulf that separates the living from the dead, while also underscoring the insignificance of life in the broader framework of time. AS

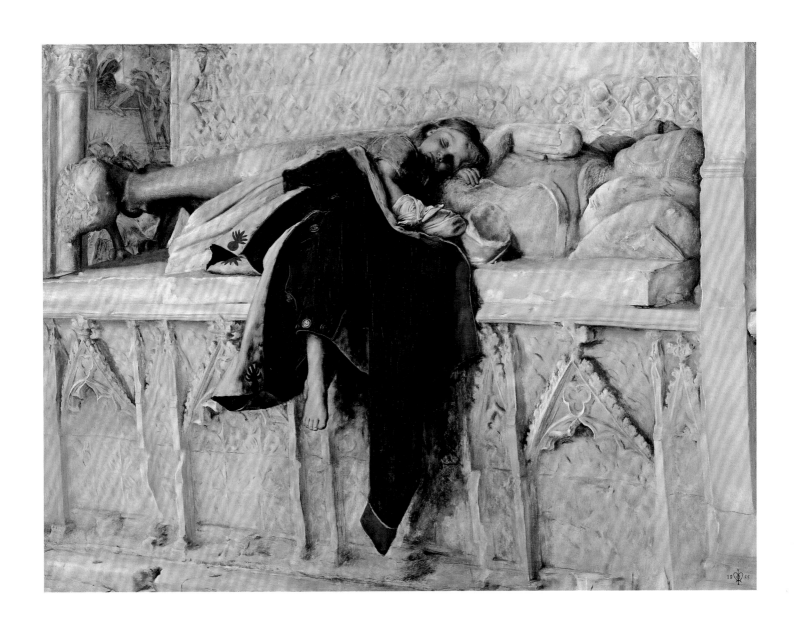

The Blind Girl 1854–6
Oil on canvas
82.6 × 62.2
Signed and dated in monogram lower right
Birmingham Museums and Art Gallery.
Presented by the Rt Hon William Kendrick, 1892

Provenance Bt Ernest Gambart, 1856; John Miller by 1857; his sale, Christie's, 21 May 1858 (171); bt Robertson; David Currie by 1861; William Graham; his sale Christie's, 2 April 1886 (89); bt Agnew's; Albert Wood by 1891; bt William Kenrick, MP, and presented by him to Birmingham, 1892

Exhibited RA 1856 (586); Birmingham 1856 (113); RSA 1856 (89); Liverpool 1857 (124); Liverpool 1861 (15); Birmingham 1891–2 (189); Guildhall 1897 (139); RA 1898 (56); Manchester 1911 (262); Tate 1911–12 (16); RA 1934 (568); Amsterdam 1936 (10); Paris 1938 (92); Birmingham 1947 (61); Whitechapel 1948 (48); Manchester 1948 (19); RA 1951–2 (281); USA 1956–7 (57); Moscow, Leningrad 1960 (82); Lyon 1966 (77); RA and Liverpool 1967 (51); Paris 1972 (184); Whitechapel 1972 (33); Tate 1984 (69); USA and Birmingham 1995–6 (38); Washington 1997 (11); RA 1998 (132); Tokyo 2003; Tate, Berlin, Madrid 2004–5 (105)

In mid-September 1852 Millais visited Winchelsea in East Sussex with Hunt and Edward Lear, who were both working near Hastings, and all declared their enchantment with the place.[1] Hunt was the first who returned to make a study of the city gate and hillside, followed by Millais in the autumn of 1854, who took up a slightly different position to paint the distant background for his projected painting of *The Blind Girl*. The figures for this composition were added in Perth in 1855 – from Matilda Proudfoot, who replaced Effie as model for the blind girl, and Isabella Nicol as her sister – together with the middle ground, which helps explain the spatial ambiguity of the landscape. Significantly *The Blind Girl* was the first composition in which Millais set out to create an uninterrupted illusion of distance: the hill rises up behind the figures with little tonal modulation, leaving the diminishing scale of the rooks and grazing animals scattered across the meadow to establish a sense of recession.

Although the theme of a blind vagrant relates to the social themes Millais had explored in his modern-life drawings of 1853–4 (see *The Blind Man*, no.51), there is no suggestion of satire or social critique. Rather the poignancy of the subject comes from the viewer's apprehension that the beauty of the natural world, disclosed by the burst of intense sunlight that follows a storm, is a sight denied to the blind girl who can only feel the vitality of her surrounds, as J.E. Phythian later explained:

> the blind girl is drawing through her fingers the delicate stem of a harebell; she is finding through the sense of touch something of the beauty that she cannot see. At once there rushes upon us a sense of the great disinheritance of the blind; and inevitably, with our sorrow for them, comes a joyous recognition of all that sight means to us.[2]

The painting also explores how other senses compensate for blindness. Smell is relayed by the blind girl's inhalation of the fresh scent of the meadow after rainfall, and hearing by the concertina and movements of animals in the background.

In capturing the dazzling colours created by a fleeting meteorological effect, Millais may have been inspired by Hunt's *Our English Coasts, 1852* ('*Strayed Sheep*'), painted in 1852 outside Hastings, which also dramatises a seized moment and may further relate with its obscure sub-theme of 'the blind leading the blind'. However, with *The Blind Girl* Millais varies the degree of finish in order to illuminate selected details, rather than embedding them within the composition; the tortoise-shell butterfly, for instance, stands out against the sketchy brushwork of the girl's shawl, in contrast to the red admiral Hunt camouflages within his painting. Despite Ford Madox Brown's claim that Millais had 'scamped the execution', Millais was exploring new ways of orientating the viewer's gaze while maintaining the illusion of high finish, which probably explains his disappointment that the picture was hung higher at the Academy than he would have liked 'as the finish is out of the reach of short people'.[3] The sensitive isolation of natural details also invites symbolic interpretation, the double rainbow being emblematic of God's mercy, the butterfly connoting the human soul, while the crow, rooks and harebell may symbolise respectively hidden knowledge, death and submission.[4]

The Blind Girl was the first of Millais's paintings to be widely described as 'pathetic', a term that might equally be applied to Millais's *Autumn Leaves* (no.82) of the same year, which can also be described as religious without being doctrinaire.[5] Upon selling the painting to the dealer Ernest Gambart, Millais was aware of the marketability of this new class of 'pathetic' subject, as he relayed in a letter to Effie: 'Arden [a lawyer] of course wanted what he couldn't have, finding the Blind Girl too touching a subject. I can't tell you how fresh commissions have accrued from this.'[6] By virtue of the intensity of its observation and understated emotion *The Blind Girl* has justly been regarded as one of Millais's greatest works and, in the words of Walter Sickert, 'one of the masterpieces of the world'. In a letter to Millais after he had seen the painting on display in Birmingham, Hubert Herkomer made a touching tribute: 'I am no longer a youngster, but I assure you that the work so fired me, so enchanted, and so altogether astonished me, that I am prepared to begin Art all over again.'[7] AS

The Rescue 1855
Oil on canvas, arched top
121.5 × 83.6
Signed and dated in monogram lower left
National Gallery of Victoria, Melbourne. Felton
Bequest, 1924

Provenance Bt in 1855 by Joseph Arden; Christie's, 26 April
1879 (68) with copyright, bt Agnew's; Holbrook Gaskell;
Christie's, 24–5 June 1909 (67); Agnew's; Charles Fairfax
Murray, 1917; Christie's, 14 Dec. 1917 (59); Eugene Cremetti
(McLean Galleries); Christie's, 1 June 1923 (149); W.W.
Sampson; bt Felton Bequest for Victoria, 1923

Exhibited RA 1855 (282); Liverpool 1855 (224); RSA 1859
(29); Liverpool 1879 (163); GG 1886 (92); Glasgow 1888
(164); RA 1898 (10); London 1903; Newcastle 1904 (95);
Dublin 1907 (60); Australia 1962 (50); Detroit and
Philadelphia 1968 (227); RA 1968–9 (334); Baden-Baden
1973–4 (72); Melbourne 1978 (1); Tate 1984 (67); Berlin 1998
(53); USA 2000–2 (63)

In 1855 Millais made the gambit of exhibiting a subject from contemporary urban life at public exhibition. *The Rescue* shows a fireman carrying three small children he has saved from a blaze, the youngest of which he delivers into the embrace of their anxious mother. The varying accounts of the picture's genesis all testify that Millais had been inspired by the actual sight of a raging fire to paint the subject.[1] In casting the fireman as a hero he may have been prompted by Ford Madox Brown's celebration of the working man in *Work* (begun 1852), which bestows the modern labourer with the dignity typically reserved for heroes in history painting. The modernity of the subject also owes much to the interest in the everyday that Millais shared with his Garrick Club friends John Leech, William Makepeace Thackeray and Wilkie Collins. It was the latter who early in 1855 introduced the artist to Charles Dickens, who welcomed the opportunity to discuss the subject as one being worthy of representation. Dickens subsequently sent Millais a copy of his own dramatic description of a fire, coincidentally published in the same edition of *Household Words* in which the writer had condemned Millais's *Christ in the House of His Parents* (no.20).[2]

Since the foundation of the London Fire Engine Establishment in 1833, the heroism of fire fighters under the command of James Braidwood had featured regularly in press notices and, as Robyn Cooper has demonstrated, the role of the fireman was often compared to that of the soldier. 'Soldiers and sailors have been praised on canvas a thousand times. My next picture shall be of the fireman,' Millais is recalled as saying. In taking up the topic it would thus seem that he deliberately set out to honour the protectors of civilian life at a time when the army was defending the nation abroad in the Crimea.[3] William Michael Rossetti's observation that 'the whole battle of Inkerman' was captured in the face of the fireman would further suggest that Millais was concerned to encourage such an association in the minds of both his male audience (those excluded from the war) and among women awaiting news of their loved ones overseas.[4] This supposition would support the case that Millais conceived *The Rescue* as a pendant to *The Order of Release, 1746* (no.39), the theme of deliverance and family reunion in both works serving to link intimate moments from the past with the present as expressed in the stoicism of civilians.[5]

The challenge of painting a convincing representation of a rescue from a burning house presented the inevitable logistical problem of how to capture the scramble of bodies escaping the fire together with dramatic pyrotechnic effects. Two studies in the Courtauld Institute of Art Gallery show how Millais experimented with the poses and expressions of the interlocking bodies, and how he changed the children's garments from day to night clothes. He also produced a full-scale cartoon (Birmingham City Art Gallery), a rare example in his practice, and further indication of the struggle he had in lending credibility to the action. According to his son, Millais worked on the picture in the studio of his friend F.B. Barwell, who described how Millais recreated the light and smoke effects by using a sheet of coloured glass and by burning planks on an iron sheet laid on the floor. The picture was painted piecemeal: 'White, mixed with copal, was generally laid on where he intended to work for the day, and was painted into and finished whilst wet, the whole drying together', an indication of the extent to which Millais had relinquished the minute precision of his earlier technique in rendering the dramatic action appropriate for the subject.[6] The excitement of the rescue as the baby sinks into its mother's arms is relayed through the abrupt shift in colour from orange red on the left to cool grey-blue on the right – the most marked point of transition being the sleeve of the mother – a bold device that symbolically suggests that the danger of burning will fade as the children melt into the bosom of their mother. Gender differences are more clearly signalled in this composition than any of Millais's paintings to date, and it is significant that he sought appropriate models to bring out such a distinction. The fireman was thus based on 'a stalwart model' called Baker and the mother on Jane Nassau Senior, whom Millais approached via Tom Taylor, writing: 'I am so struck with Mrs Senior's beauty [...] Although I have not the reputation for painting beauty yet I think I can appreciate it in Nature, and I am very anxious to get a beautiful face for what I am painting this year'.[7]

Despite Millais's hopes for the painting (he considered it his best work), the picture was badly hung at the 1855 RA, being skied and placed 'against the door of the middle room'.[8] Millais remonstrated and insisted that it be lowered three inches and titled forwards to allow for better viewing, but lost his temper when the hangers proposed to restore the picture to its original position. No doubt his anger was exacerbated by the Queen's purchase of Frederic Leighton's *Cimabue's Madonna* 1853–5, the sensation of the Academy that year, and a work considered by one critic at least to be superior to Millais's picture 'as the best quality of historical Art is to tolerable *genre*'. Given Millais's sensitivity over the reception of this work, even Ruskin's praise did not detract from niggling criticisms of 'fantastic exaggeration', and the accusation that it was chromatically incorrect, as flames in a burning dwelling would be yellow and green not crimson.[9] To Millais's chagrin no engraving was ever issued of the painting, even though Gambart offered Joseph Arden £2,000 for the picture and the copyright in 1860. AS

Wandering Thoughts c.1855
Oil on canvas
35.2 × 24.9
Signed lower right
Manchester City Galleries

Provenance Francis MacCracken, sold Christie's, 17 June 1854 (94), bt in, and probably the picture soon afterwards exchanged with White the dealer; B.G. Windus, sold Christie's, 19 July 1862 (34), bt in, and 15 Feb. 1868 (320), bt Gambart; Charles Jackson (dealer), Manchester, from whom bt by Manchester City Art Gallery in 1913 and then identified as a portrait of Mrs Charles Freeman, an error due to confusion with a picture shown at the RA in 1862

Exhibited Tate 1923 (74); RP 1926 (173); Brussels 1929 (113); Jacksonville 1965 (34); RA and Liverpool 1967 (46); Japan 2000 (42)

This intimate scene, like *The Violet's Message* (no.60), is another of the 'problem pictures' Millais first experimented with in 1854. It shows a woman dressed in black and seated in a chair deep in reverie after reading a letter, the thick black border of which indicates a death. Her corsage adds a touch of colour to the composition, while the flower amplifies the theme of bereavement, the scarlet scented-leaf geranium connoting comfort. While the letter functions as a narrative trigger, the woman is presented so lost in thought that her expression is difficult to interpret. She could either be seen as musing over a lost one or distracted by something she has read in the letter to which we are not privy. Unlike Richard Redgrave's *The Governess* 1843, which may have prompted the motif of a woman staring dejectedly after reading a letter announcing a death, Millais is more interested in exploring mood and expression than in inviting the sympathy of the spectator or offering social comment.

Ford Madox Brown saw the painting at B.G. Windus's residence in Tottenham, north London, describing it ambivalently as 'a noble study of [...] an ugly woman in black receiving bad news'.[1] AS

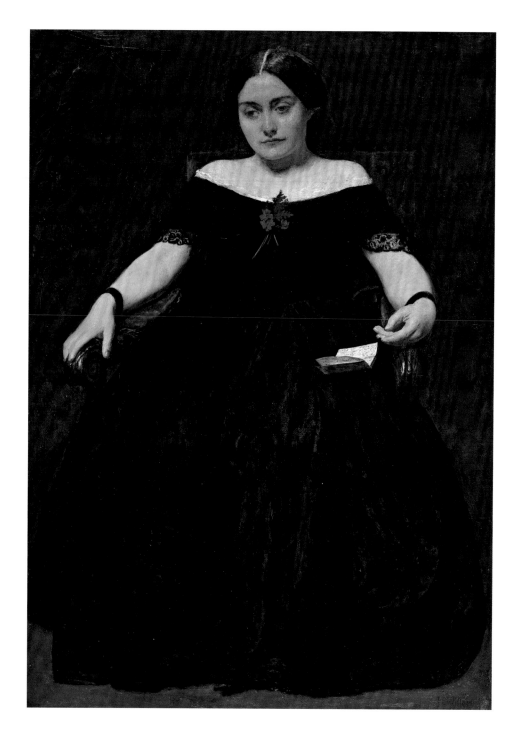

Only a Lock of Hair c.1857–8
Oil on wood
35.3 × 25
Signed in monogram lower left
Manchester City Galleries. Gift of Mr James
Gresham

Provenance B.G. Windus; his sale Christie's, 26 March 1859
(33), bt Gambart; his sale Christie's, 3 May 1861 (118), bt Hart;
H.J. Turner by 1871; his sale Christie's, 4 April 1903 (99), bt
Agnew's, from whom bt by James Gresham, 4 March 1904, his
bequest to Manchester, 1917

Exhibited New York 1859 (149); RA 1900–1 (1); Agnew's
Manchester 1904a (27); Manchester 1904b (200);
Manchester 1911 (271); Tate 1913 (32); Bath 1913 (43); Tate
1923 (69); Jacksonville 1965 (35); Baden-Baden 1973–4 (76);
Berlin 1998 (57); Japan 2000 (45)

Slightly later in date than *Waiting* (no.59)
and *The Violet's Message* (no.60), this small
painting shows a woman wearing a
fashionable day dress, with separate broderie
anglaise collar, cutting a lock of her hair.
Although her motive in cutting the lock is
presented as a mystery, the general assumption
at the time would have been that it was
intended for a lover, who would then have had
it made into a souvenir for a locket. The motif
is similar to that of the pressed flower in *The
Violet's Message*.

 Writers of the period often employed the
token of a lock of hair as a device to connote
love or infidelity. In Wilkie Collins's novel *Basil*
(1852), for instance, a locket containing some
of the hair of the protagonist's fiancée falls
from his waistcoat causing his sister Clara to
understand that his recent secretiveness has
been because he has fallen in love.[1] AS

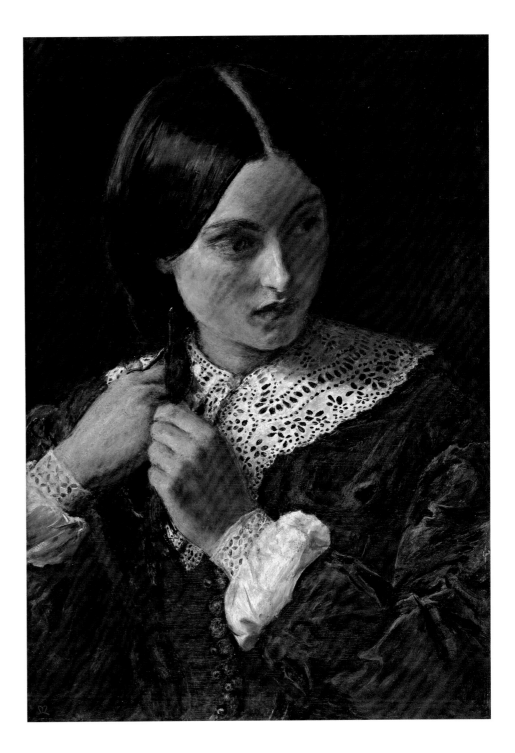

Peace Concluded, 1856 1856

Oil on canvas, arched top

116.8 × 91.4

Signed and dated in monogram lower left

The Minneapolis Institute of Arts, the Putnam
Dana McMillan Fund

Provenance Thomas Miller; Thomas Horrocks
Miller; by family descent to Thomas Pitt Miller; his sale,
Christie's, 26 April 1946 (87); bt Mitchell; Sir John C.
George; his sale, Sotheby's, 3 April 1968 (105), bt Leger
Galleries; bt for Minneapolis through the P.D. McMillan
Fund, 1969

Exhibited RA 1856 (200); RA 1898 (8); Bradford 1904;
Leger 1968 (33); Minneapolis 1972,; Wilmington 1976
(2–7); Minneapolis 1987–8; Phoenix and Indianapolis 1993

The date on this painting forms part of the full
title, as it did with Millais's 1853 Royal
Academy exhibits *The Proscribed Royalist, 1651*
(no.58) and *The Order of Release, 1746* (no.39),
works that similarly explore the theme of male
vulnerability and the stoicism of women.
However, the date in *Peace Concluded* asserts
the immediate currency of the subject, and this
is reiterated in the painting itself by the
accurate depictions of *The Times* for 31 March
1856 and the recent instalment of Thackeray's
serialised novel *The Newcomes*, the last part of
which was issued in 1855.

The painting presents a wounded officer
who has returned from the Crimea and is
reading the announcement of the Treaty of
Paris, which formally brought the 1854–6 war
against Russia to an end, as he reclines on a
couch and is embraced by his wife.[1] The
grouping of these two figures suggests a *pietà*,
which may explain the elongation of the
woman that perturbed a number of critics. The
couple are flanked by two children. The girl on
the left formally faces the spectator, like a saint
in a *sacra conversazione*, as she holds up a
wooden dove of peace, while her more casually
posed sister gazes up at her father and clutches
in her right hand the secular attribute of a
campaign medal. On the mother's lap rest toy
animals emblematic of the conflict: the bear,
cockerel, turkey and lion standing for Russia,
France, Turkey and Britain respectively. Above
the dog, which was painted from Effie's Irish
wolf-hound Roswell, the viewer can just
discern a print of John Singleton Copley's
Death of Major Peirson, 6 January 1781 of 1783,
representing a young officer who was shot
dead defending St Helier in Jersey (where
Millais spent part of his youth) from French
invasion.[2] The theme of patriotic sacrifice
embodied in the print is partly obscured by
the myrtle in the background, a token of Venus
and an emblem of erotic love, which, seen in
conjunction with the print, would suggest the
triumph of love and domesticity over conflict
and public duty. Behind the cushion lies the
copy of Thackeray's *Newcomes*, subtitled
'Memoirs of a Most Respectable Family', which
dramatises the conflict between status and
romance in human relationships, reinforcing
the overall idea of the redemptive power of love.[3]

Two sketches in the British Museum show
that Millais had decided upon the theme of the
announcement of peace and had settled his
composition on paper before he commenced
painting in the spring of 1856. At this time he
shared a studio with an army officer turned
artist, John Luard, who went to Sebastopol in
1855 in search of subjects to paint.[4] Millais's
interest in the Crimea came at a point in his
career when he was determined to paint topical
but marketable subjects. The officer was thus
based on a man who had served in the Crimea,
Colonel Robert Malcolm, the successful likeness
of whom was attested to by Malcolm's father,
who later wrote to Millais asking for a
photograph of the head as a memento of his son
who was away on active service.[5] In locating the
subject of the Crimea in a domestic space,
Millais might well have been influenced by Ford
Madox Brown's *Waiting*, an image of a woman
and child at a fireside, which was started in 1851,
but reworked between 1854 and 1855 to indicate
the absence of the paterfamilias in the Crimea.[6]
He would also have been aware of F.G.
Stephens's *Mother and Child* c.1854, which
shows a woman receiving bad news that her
child's toy lion and soldier would indicate to be
that her husband has been killed in the Crimea.
However the prominence accorded *The Times*'s
announcement of the Treaty of Paris makes the
allusion to the war more specific in Millais's
painting, and was probably suggested by the
illuminated copy of the *London Gazette* in David
Wilkie's *Chelsea Pensioners* 1822 that relayed
Wellington's famous despatch from Waterloo.
The proximity in time between the date given
on *The Times* in *Peace Concluded, 1856* and the
submission of the painting to the Royal
Academy in April, shows Millais's conceit in
inviting comparison between the speed and
virtuosity with which he produced his scene
and the efficiency that went with newspaper
production.

According to Brown and Hunt, Millais had
originally set out to make a satirical image
concerning the custom some officers adopted
of unjustifiably claiming home leave while on
active service, but had decided against this
following the declaration of peace, hence his
insertion of the announcement in *The Times*.[7]
Conflicting interpretations of the picture's
genesis must surely relate to the rather
melancholy mood it generates. It is not clear
whether the officer's experience of reading the
announcement elicits feelings of pride and
consummation or shame at having missed the
final stages of action as he lies supine in a realm
of female comfort and adornment. The
deliberate understatement also underscores the
idea of a female perspective on the price of peace
and, in this respect, it is significant that Millais
used Effie as a model for the wife. Her plaited
hair forms a halo-like circle around her head
and lends her a timeless spiritual quality.[8] Just
as the painting marries the personal with the
clubbable side of Millais's life, so the picture
explores how individual lives are circumscribed
by volatile political forces, symbolically
suggested by the children's game with the toy
animals.

Millais clearly had high aspirations for the
painting and, through the intermediary of
Augustus Egg, sold it to John Miller before the
Academy exhibition for the very high sum of
900 guineas. His hopes of separately selling the
copyright to Henry Graves were expressed in a
letter to Effie of 8 May 1856:

> Well I have seen Graves and the criticisms
> *don't make the SLIGHTEST difference*, but
> I shall not get nearly so much for the
> copyright *OWING* to the *UNPOPULARITY
> OF THE PEACE* which is every day more
> apparent, and there is no enthusiasm in the
> matter to make the engraving the speculation
> it might have been. Anyhow I think I am
> certain to get *500* for it which is not to be
> sneezed at.[9]

In the event the painting was not engraved,
partly due to complications in copyright law,
partly due to the adverse criticisms in the press
referred to by Millais in the above-noted letter,
but also, as Graves implied, due to the mood
of disillusionment that came in the wake of
the Treaty of Paris. The Crimea had exposed
inefficiencies at the highest level in the British
military system, and criticisms of misconduct
continued long after hostilities had ceased.
While Millais's painting certainly taps into
prevailing sentiments of the day, with the
exception of Ruskin it did not inspire
widespread approbation. Wilkie's *Chelsea
Pensioners* had been exhibited seven years after
Wellington's victory at Waterloo, allowing for
the public projection of nostalgia, whereas
Millais's picture probably came across as too
political and opportunistic a statement for the
time. AS

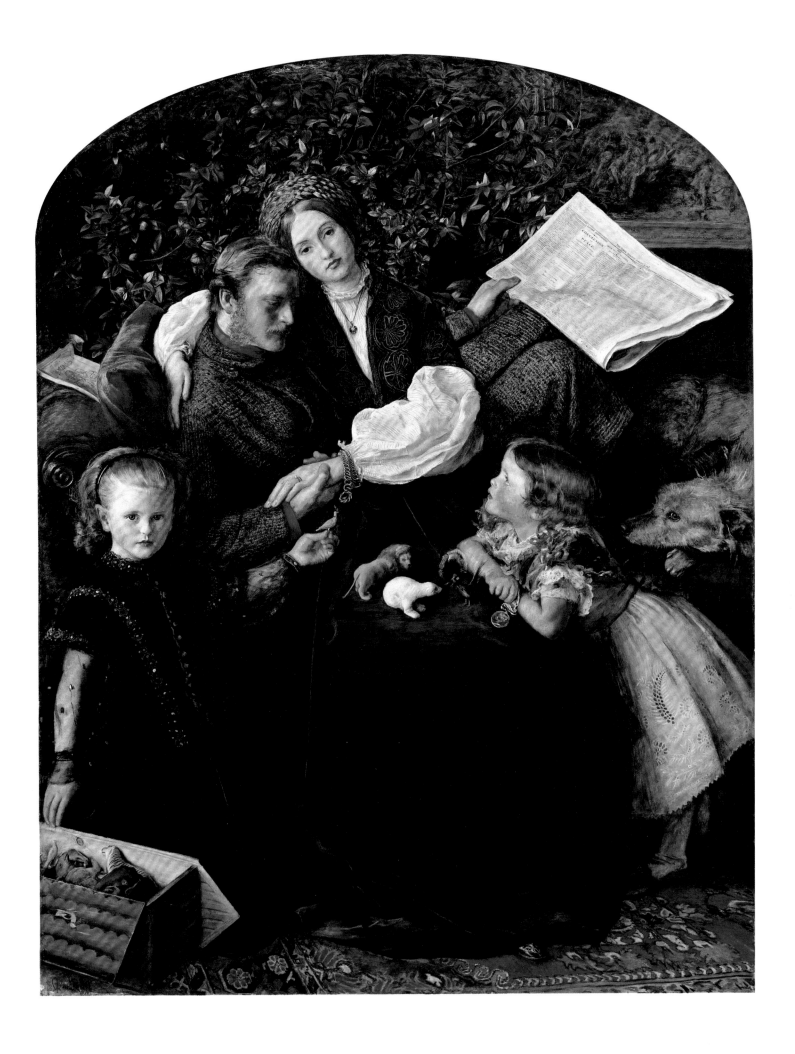

The Escape of a Heretic, 1559 1857

'At Valladolid, this Friday before Good Friday,
A.D. 1584, before the Licentiate Cristoval
Rodrigues, Commissary of the Holy Inquisition,
appears Fray Juan Romero, monk of the Order of
Saint Dominic, in the convent of the said Order in
the said city, familiar of the said Holy Inquisition,
and having sworn to speak the truth, saith – 'That,
having been assigned, together with Fray Diego
Nuño, familiar of the said Holy Inquisition, as
confessor to Maria Juana de Acuna y Villajos, late
in close prison of the said Holy Inquisitor, convict,
as an obstinate heretic, and left to be delivered to
the secular arm at the Act of Faith appointed to be
held in the said city, before His Most Catholic
Majesty, our Lord the King, this day, he was
yesterday at noon in the prison of the said prisoner,
together with a person unknown, whom he
supposed to be the said Fray Diego, but saw not his
face by reason of his wearing his hood drawn
forward, when he was of sudden set upon, gagged
and bound by the said person unknown, and his
habit stripped off and put upon the said prisoner,
who so passed out of the said prison with the said
person unknown, nor hath since been discovered by
the deponent or the other familiars
of the said Holy Inquisition in the said city'. –
From 'Documentos relativos á los procesos por la
Inquisicion de Valladolid'.

Oil on canvas, arched top
106.2 × 76.2
Signed and dated in monogram lower left
Museo de Arte de Ponce, Puerto Rico, The Luis
A. Ferré Foundation, Inc.

Provenance Sir Henry Houldsworth; by descent to Sir
Reginald Houldsworth; his sale, Sotheby's, 7 July 1965 (115),
bt by Luis Ferré for the Museo de Arte de Ponce

Exhibited Langham Chambers 1857–9; RA 1857 (408);
Manchester 1878 (232); Manchester 1885 (379); Manchester
1887 (404); Guildhall 1894 (121); RA 1898 (49); Whitechapel
1898 (131); Glasgow 1901 (305); Bradford 1904 (120);
Whitechapel 1905 (380); Manchester 1911 (242); Glasgow 1913
(345); Liverpool 1922 (49); Cambridge and New York 1974;
Phoenix and Indianapolis 1993; Oklahoma City 2005 (67)

In paintings such as *A Huguenot* (no.57) and
The Order of Release (no.39), Millais developed
the tradition within British history painting of
presenting imaginary anecdotes from the past
in order to universalise the emotions
experienced by individuals trapped in situations
beyond their control. Whereas *A Huguenot*
relied on an accompanying historical text to
contextualise the depicted incident, *The Order of*
Release depended upon viewers' knowledge of
the Jacobite Rebellion to assist in their
comprehension of the subject. In 1857 Millais
made the bold step of exhibiting two paintings
accompanied by spurious historical texts: one
penned by Tom Taylor for a picture celebrating
medieval chivalry, *Sir Isumbras (A Dream of the*
Past) (fig.5, p.18); the other for a scene
denouncing Roman Catholic persecution
entitled *The Escape of a Heretic, 1559*. He had by
this time established a reputation as the most
controversial of the Pre-Raphaelite artists, and
in satirising the custom of appending primary
sources to establish meaning, Millais was in
effect questioning history painting's traditional
subservience to the written text.

The lengthy quotation appended to the
Heretic purports to come from *Documentos*
relativos á los procesos por la Inquisicion de
Valladolid, apparently a first-hand account
of the depicted scene, that of the bound priest.
Viewed in conjunction with the statement,
the image represents a dramatic incident
concerning the escape of a young woman
condemned as a heretic by the Spanish
Inquisition, and forced to wear the sambenito
or penitential garment for her auto-da-fé.
According to the purported testimony of the
bound priest, an unidentified man (perhaps the
woman's lover) had masqueraded as her
confessor and then gagged the priest and
stripped him of his habit, hurriedly placing it
over the heretic as a disguise to facilitate her
escape. The embroidered sleeve that peeps out
from under the rescuer's disguise indicates his
noble status, while the Sambenito, crudely
adorned with cavorting demons and disclosed
to the viewer by the friar frantically attempting
to remove the woman's disguise, flaunts the
perverse ideology that has condemned her
to death.

According to Effie Millais, the painting
was originally conceived as a pendant to
A Huguenot and was prompted by the couple's
visit to the home of the historian of Spanish
culture Sir William Stirling of Keir in the
autumn of 1855. The subject was apparently
suggested by woodcuts in Stirling's possession
dating from the mid-sixteenth century, several
of which represented burnings in Spain, 'the
women and men being habited in the hideous
dress of the "San Benito"'.[1] Stirling, a prolific
collector, also owned etchings from Francisco
Goya's satirical series *Los Caprichos* 1799,
which may have influenced the exaggerated
elements of Millais's design. Given Stirling's
knowledge of Spanish history it is likely that
Millais had him invent the text for the painting.

The setting was based on the staircase at
Dalhousie Castle near Edinburgh, and the
model for the nobleman was the gamekeeper of
a Mr Condie. It is likely that Sophie Gray posed
for the heretic. Effie describes the difficulties
Millais encountered in fixing the expressions of
the two protagonists, the cracked surface of the
faces providing evidence of multiple revisions.
Like the gagged priest, the woman is presented
wide-eyed and taut with shock and fear, the
glint of her teeth reminiscent of Ford Madox
Brown's grimacing figures. The lover's
demeanour also captures the intensity of the
moment and, with an expression reminiscent
of the kiss of Judas in Giotto di Bondone's
Betrayal of Judas c.1305, his lips are pursed as
if soliciting her silence and calm. The clenched
fists, precariously positioned dagger and
splayed feet of the hero add to the contortion
and violence of the composition, while spatial
ambiguities (the tilt of the floor and hovering
patch of landscape glimpsed through the
window) enhance the overall sense of
confusion and disorientation. Accepting the
authenticity of the accompanying text, most
commentators were offended by the
mannerisms of style and coarse features that
Millais had felt were necessary for the scene,
contending that these rendered the subject
illegible, the *Athenaeum* concluding:

> At first we see a death struggle, then an
> escape intercepted, then a monk clothing
> a boy or girl for *auto da fé*, then a martyrdom
> – so on till, our conceit baffled and our
> curiosity nettled, we spell out the true story
> by the help of the real document.[2]

To the annoyance of the painting's first owner,
Millais produced a smaller version of the
subject for the dealer Ernest Gambart,
who commissioned two small replicas of
A Huguenot in the same year.[3] The reuse of
compositions was to become typical of the
artist's practice in ensuing years and developed
in tandem with his drive for productivity. AS

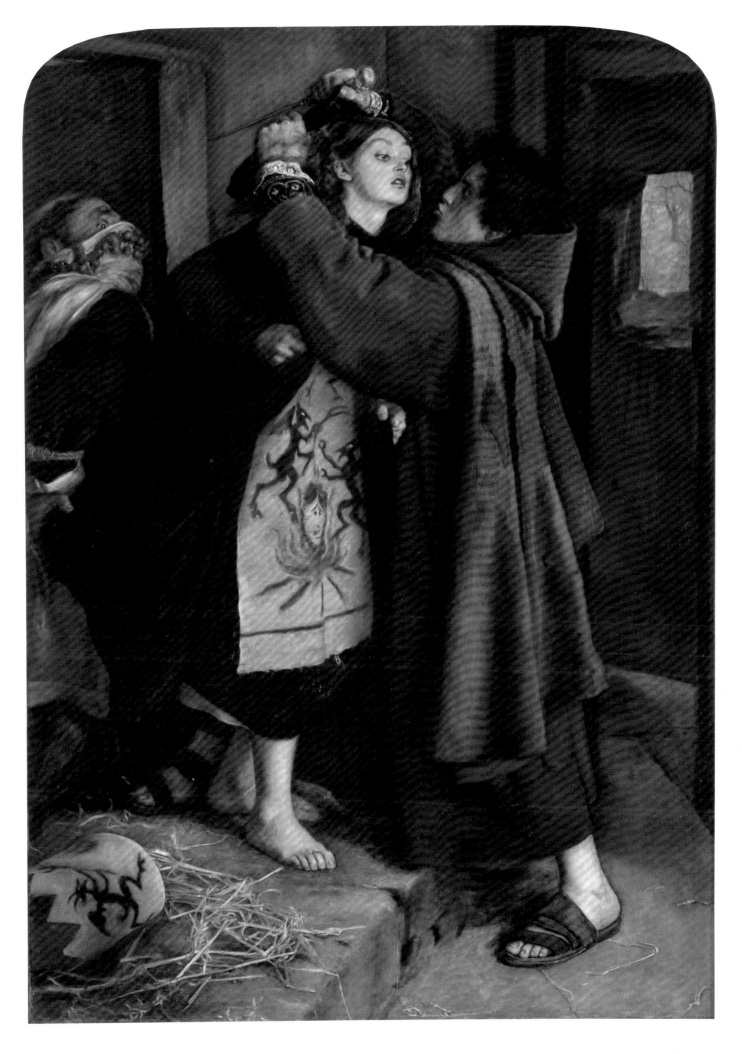

The Black Brunswicker 1859–60
Oil on canvas
104 × 68.5
Signed and dated in monogram lower left
National Museums Liverpool, Lady Lever
Art Gallery

Provenance Bt from the artist in 1860 by Ernest Gambart; T.E. Plint; Christie's, 8 March 1862 (331), bt Graves; Albert Grant, sold Christie's, 20 June 1868 (120), bt Moore; Agnew's, who sold it to James Price, 27 Aug. 1868; bt back from Price by Agnew's, 27 April 1887 and sold to James Hall Renton, 24 May 1887; sold Christie's, 30 April 1898 (90), bt Agnew's for W.H. Lever, and thence to the Lady Lever Art Gallery

Exhibited RA 1860 (29); GG 1886 (123); RA 1898 (21); Glasgow 1901 (230); Port Sunlight 1902a (146) and 1902b (166); London 1908 (105); Rome 1911 (60); Birkenhead 1912; Liverpool 1922 (36); Birkenhead 1929; Toronto 1936 (148); Port Sunlight 1948 (143); RA and Liverpool 1967 (59); Sheffield 1968 (40); Baden-Baden 1973–4 (77); Tate 1984 (108); RA 1998 (143); Berlin 1998 (58)

Millais's difficulty in selling his large poetic pictures *Spring* (no.84) and *The Vale of Rest* (no.85) may explain his reversion to the smaller type of narrative picture that had won him popularity in the early 1850s. Writing to Effie in May 1859 he lamented: 'Whatever I do, no matter how successful, it will always be the same story, "Why don't you give us the Huguenot again?"'[1] His attempt to pair *The Escape of a Heretic, 1559* (no.67) with *A Huguenot* had not been a success, the former providing too histrionic a counterpoint to the mood of understated resignation of the earlier painting. Thus, in embarking on *The Black Brunswicker* as an alternative to *A Huguenot*, Millais decided to play safe. Not only is the plot identical in both works, but the crisply delineated detail of the new production signalled a momentary return to the artist's earlier Pre-Raphaelite manner, the treatment of the white satin being regarded by some as equal to that of the Dutch master of bourgeois interiors, Gerard Terborch. Since the appearance of *A Huguenot*, Millais's work as an illustrator for magazines such as the *Cornhill* and *Once a Week* had extended his skill in selecting defining narrative moments for depiction, and in using his understanding of psychology as indicated by dress and deportment to bring out nuances of character and situation.

The Black Brunswicker is an imaginary scene set on the eve of Waterloo and, according to J.G. Millais, shows a young Prussian Brunswicker or cavalry officer taking leave of his English lover to withstand Napoleon's initial advance at Quatre-Bras.[2] The evening dress worn by the woman (modelled by Dickens's daughter Kate) probably refers to the famous ball given at Brussels by the Duchess of Richmond on the night before the battle, which reinforces the theme of duty resisting pleasure. On the wall of the drawing room hangs an engraving after Jacques-Louis David's portrait *Napoleon Crossing the Alps* 1800, which sets the historical context for the scene, and can be seen as both an exhortation to battle (a symbol of the Brunswickers' hatred for Napoleonic France) and a rhetorical device that underscores the restrained heroism of the officer. Millais was determined to triumph with this painting and, having alighted on a theme that had contemporary resonance in light of Napoleon III's intervention in Italy (as in the print), he set about researching the detail, seeking the assistance of the pioneering war correspondent William Russell. Millais originally intended to show the lady sewing black crepe around the arm of the officer as a token of mourning, but abandoned the idea as it approximated too closely to the motif of the Catholic woman tightening the white band around the arm of the Huguenot.[3] He also reversed the position of the figures as well as presenting the woman looking down at her lap dog, who pathetically echoes her silent plea. The viewer's apprehension that the Brunswicker's mission will be fatal is suggested by the death's-head insignia (later appropriated by Himmler's SS) on his helmet, from which his lover averts her gaze, as well as by the vermilion ribbons on her dress. The crinkled paper that connotes damp on the wall and the heavy creases of the woman's dress are more subtle touches that allude to the vulnerability of tangible surfaces (and by implication feelings) to external pressures.

The *Art Journal* pluralised the title and in so doing noted that Millais was inviting the viewer to speculate beyond the frame of the picture so the image became 'the frontispiece of a history'. Comparing the painting to *A Huguenot*, the critic noted that the singular title of the latter focused attention on a particular predicament, whereas this one was about a corporate identity.[4] Keenly attuned to the public's appetite for narrative complexity, Millais was aware that an image's ambiguity encouraged prolonged inspection even if it resulted in some taking against a work.

Although *The Black Brunswicker* is not nearly as laden with clues as some of the artist's earlier productions, the painting belies the clear narrative reading promised by the choice disposition of elements within the composition. 'So many of our so-called dramatic pictures [...] are so transparently intelligible, they ram their moral and their meaning so remorselessly home,' declared Tom Taylor in *The Times*, discovering in Millais's painting a welcome engagement of the spectator's attention in probing the inner feelings of the protagonists.[5] The crowds of people clustered around the work at the RA certainly testified to the enigma it posed, and this is further evinced by the sheer variety of critical opinion offered as to the painting's meaning. The *Art Journal* thus described the work to be an agonising parting scene between husband and wife, whereas J.B. Atkinson suspected that the Brunswicker was trying to escape the attention of the lady. The *Illustrated London News* read the subject as the officer's recognition of the woman's infatuation with him, while Taylor thought he had just detected her secret passion for Napoleon.[6] The engraving on the wall proved to be the most perplexing device, and was interpreted as a reminder of the Brunswickers' oath of vengeance against Napoleon or as a clue to the cross-purposes and rival jealousies within the picture. The fact the critics did not in this instance regard the work as a failure in narrative coherence but as a fascinating mystery to be deciphered shows how successful Millais had been in extending rather than frustrating interpretation.[7] The subtlety with which he conveyed the internalised emotions of the moment helped guarantee the work its broad appeal. This was later borne out by a report describing the Zulu prince Shingana's compassionate involvement with the predicament of the couple upon seeing a reproduction of the painting at Bishopstowe in Natal.[8]

The Black Brunswicker marked a watershed in Millais's reputation and his emergence as the nation's most popular painter. The picture was sold to Gambart for 1,000 guineas, the highest price a work of his had yet commanded, and Millais later made watercolour copies for the dealer. The engraving published by Henry Graves and Co. in 1864 proved so successful that a second edition was issued three years later.[9] AS

The Ransom 1860–2

Oil on canvas

129.5 × 114.3

Signed and dated in monogram lower right

The J. Paul Getty Museum, Los Angeles

Provenance E. Gambart in 1862; Charles P. Matthews by 1886; sold Christie's, 6 June 1891 (90), bt Agnew's; William Kenrick, 1891, by inheritance to W. Byng Kenrick, still his in 1947; anon. sale Christie's, 15 Feb. 1963 (108), bt Leger Galleries; James Graham Gallery, New York, 1964–7; Victor D. Spark, New York; bt Getty, 1972

Exhibited RA 1862 (198); GG 1886 (116); RA 1898 (30); Birmingham 1947 (63); Indianapolis and New York 1964 (51); Jacksonville 1965 (36); RA and Liverpool 1967 (61); Peoria 1971 (53); Miami 1972 (65); Berkeley, University Art Museum 1989–90 (long-term loan)

Millais expended considerable time over *The Ransom*, embarking on the painting in the autumn of 1860 and completing it around the time the painter Elizabeth Butler saw it, still wet, on the easel in Millais's studio in Cromwell Place on 16 March 1862.[1] A study for the principal figures now in the collection of the Royal Academy (including the father in contemporary dress) appears on the same sheet as a sketch for *The Order of Release*. While this might suggest that Millais had conceived of the idea in the early 1850s, the similarity of subject matter may have prompted him to return to an earlier study to avoid repetition in the poses. The composition compresses seven figures into a tight space and involved meticulous research in the design and fabrication of the dress. According to Millais's son most of the costumes were made by Effie from a book of designs lent by Lady Eastlake. The historian Sir William Stirling may also have supplied images.[2] Millais employed a variety of models for his cast of characters: acquaintances, non-professionals and a lay-figure. The head of the knight was modelled both by Millais's friend Major Boothby and a Mr Miller, while his body was studied from a large railway guard nicknamed 'Strong'. The page was drawn from a handsome youth called Reid and both girls were painted from Helen Petrie. Major McBean of the 92nd Highlanders and a labourer sat for the guards. The tapestry was the last object to be inserted – a reversal of Millais's earlier Pre-Raphaelite practice – and was based on *La Main Chaude*, an early sixteenth-century Flemish tapestry that Millais arranged to paint in the unfinished part of the South Kensington Museum near where he lived.

The picture shows a nobleman reluctantly handing over precious jewels to secure the release of his two daughters from kidnappers who have held them for ransom (Millais's first title for the work was 'The Hostages'). The setting is ambiguous: the tapestry indicative of a rich interior, the straw-covered floor and mud-splattered stockings of the page on the left, suggestive of an entrance to a castle. The confrontation between aristocrats and kidnappers is brought out by the contrast between the rich decorative costumes of the former and the more roughly dressed men on the right accompanied by a bloodhound. Millais's approach to the subject relates to both his historical and contemporary works and fuses his realist and decorative interests. The motif of release from a claustrophobic setting is reminiscent of *The Escape of a Heretic, 1559* (no.67), while the elaborate dress and chivalric theme of an armoured knight rescuing children relates to *Sir Isumbras (A Dream of the Past)* (fig.5, p.18). Significantly the picture was started at the same time as *Trust Me* (fig.13) and shares key characteristics: the theme of surrender, the shallow setting and stiffly posed page and nobleman echoing the stance of the father in the modern-life work. The atmosphere of distrust that permeates the two compositions is brought out by the complicated play of glances and hand movements in both, while narrative ambiguity is reinforced by the unspecific context (*The Ransom* is unusual in Millais's historical oeuvre to date in not relating to any text or episode). Although *Trust Me* was intended as a 'problem picture', its affinity with Millais's illustrations for Anthony Trollope's *Orley Farm* (see no. 80) enabled viewers to discern meaning, whereas *The Ransom* appeared unintelligible. The *Art Journal* was thus baffled why the family who appeared to be in the stronger bargaining position should be offering such wealth, and confused by the kidnappers' reluctance to relinquish the girls.[3]

In terms of style the painting is indicative of Millais's quest to broaden his range of references. His debt here to Diego Velázquez, especially the painter's *Surrender of Breda* (1634–5), has recently been demonstrated by Paul Barlow, and Millais's attention to the great Spaniard's work may also have been encouraged through his friendship with Stirling, whose *Velazquez and his Works* was published in 1855.[4] More immediately the

sophisticated pattern-making and play on surface and depth points to Millais's awareness of the work of Henri Leys as well as aesthetes like Rossetti and Frederic Leighton, the latter of whom Millais was keenly aware as a rival at this time.[5] Although Millais never went so far as to eliminate narrative altogether in seeking to gratify the eye with sensuous colour and ornamentation, *The Ransom* does share the sense of hermetic self-containment that characterises similar progressive art of the period, and in the elegant disposition of the limbs appears almost like a dance.

At the time of its production Millais considered *The Ransom* to be an important work, as evinced by the high price of £1,000 he placed on it.[6] The picture was much admired while in process, the poet and politician Richard Monckton Milnes hinting that their mutual friend Stirling should have it; and in a letter to Effie of 28 May 1861, Millais describes how Sir Coutts Lindsay, Lady Somers and Mrs Dalrymple had been in ecstasies over the picture, convincing him that he could sell direct to a noble patron without accepting a lower price from a middleman.[7] Despite such optimism the painting did not immediately find a buyer. It was eventually bought by Gambart, probably just before the Royal Academy exhibition opened in 1862. AS

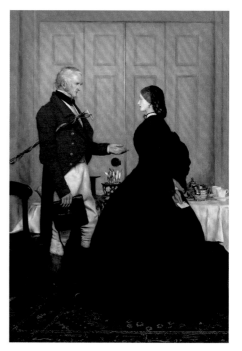

Figure 13
Trust Me
1862
FORBES COLLECTION,
NEW YORK

The Young Mother 1856
Etching on paper
Published in *Etchings for the Art-Union
of London by the Etching Club*, London 1857
Geoffroy Richard Everett Millais Collection

Provenance By descent from the artist

Exhibited Southampton 1996 (108); Rye 1996 (18)

The models in *The Young Mother* may be
Millais's twenty-eight-year-old wife, Effie, and
their first child Everett,[1] who was born on 30
May 1856 at their home, Annat Lodge in Perth.[2]
Millais delighted in the arrival of his son and
wrote to his cousin, Emily Hodgkinson,
following the birth: 'I am the distinguished
owner of a little gentleman [...] The nurse of
course says it is like me, further, adding that it is
an extremely handsome production!'[3] In this
imagined scene Millais sets the nursing mother
and her new-born against the thatched cottages
and rugged hills of the Perthshire landscape.

Two children are shown playing in the
background, while in the foreground rowing
boats rest on the bank of a body of water. The
densely worked detail of the mother and child
in the foreground and the cottages in the
middle distance contrasts with the delicate
sinuous lines used to create the outline of the
distant hills. *The Young Mother* is an early
example of Millais's fascination with the
landscape of this region, which would later
flourish in his large-scale oils from the 1870s
to the 1890s.

In 1862 the French writer and critic
Charles Baudelaire described the 'British
craze for etching'. The 'etching revival' came
about in part due to the efforts of the Etching
Club.[4] Founded in 1838, the Club became the
first professional group of artists in the
country to promote the art of etching. Millais
was unanimously elected into the Club in
November 1856, and regularly attended

meetings until the late 1870s. With an ever-
growing family, Millais may have welcomed the
social occasion the meetings provided, the
artists taking it in turns to host the meeting in
their homes. Although members were
encouraged to discuss their current projects, it
was recorded on 4 February 1868 that 'The Club
had no business before it and Etching was
hardly a subject of discussion'.[5]

Millais contributed to five of the communal
albums published by the Club, with all expenses
borne and profits shared among the members.
Shortly after attending his first meeting, *The
Young Mother* was recorded in the minutes as
one of a number of etchings to be sent to the
Art-Union for publication.[6] Millais's etching was
one of the largest in the volume (some were no
bigger than thumbnails), which included a
variety of primarily historical, genre and literary
subjects by Richard Ansdell, William Holman
Hunt, James Clarke Hook and others.[7] HB

The Moxon Tennyson 1855–6
Point of the brush with wash and penwork in
Indian ink with some scratching out
Five works in one mount, pen and black ink
The Ashmolean Museum, Oxford

Mariana
9.6 × 7.9

Provenance Henry F. Makins, Esq. by 1898; bt from auction,
London, 1958, by Alister Mathews (Bournemouth); from A.
Mathews to Ashmolean 1958

Exhibited RA 1898 (62); RA and Liverpool 1967 (351);
Portsmouth 1976 (33); Jersey 1979 (37); Japan 1987 (35);
Colnaghi 1990 (84); Birmingham and London 2004–5 (5)

The Day-Dream; The Sleeping Palace
(illustrated below)
8.3 × 9.6

Provenance The Reitlinger Collection, bt Ashmolean 1954

The Death of the Old Year
9.7 × 8.4

St Agnes' Eve
9.7 × 7.2

The Lord of Burleigh
8.3 × 9.6

Provenance (for the 3 works above) Bt from auction, London,
spring 1958, by Alister Mathews; then to Ashmolean 1958

Exhibited (for the 4 works above) RA and Liverpool 1967
(352–5); Portsmouth 1976 (33); Jersey 1979 (39); Japan
1987 (35); Colnaghi 1990 (84); Birmingham and London
2004–5 (5)

When Edward Moxon died in 1858, just over
three-quarters of the 10,000 copies of his
published collection of Tennyson's works,
Poems by Alfred Tennyson (1857), known as the
Moxon Tennyson (printed by Bradbury and
Evans) remained unsold. The disappointing
sales were in part due to poor reviews, the
critics finding it difficult to correlate the
engravings by more established artists, such as
Daniel Maclise and William Mulready, with
those of the younger and more rebellious Pre-
Raphaelite artists. Although Ruskin had
criticised the Moxon Tennyson in his popular
drawing manual, *Elements of Drawing* (1857),
remarking that the woodcuts were 'terribly
spoiled in the cutting',[1] he had initially been
responsible for persuading Alfred, Lord
Tennyson to allow the young artists to
contribute to the volume. Tennyson was
generally averse to the work of illustrators,
remarking on one occasion that they 'never
seem to illustrate my own ideas'.[2] However,
persuaded by Ruskin, and aware that sales
would be enhanced by the association with the
Pre-Raphaelite artists, Tennyson invited
Millais to his home in Freshwater Bay on the
Isle of Wight in 1852. Millais subsequently
wrote to Rossetti, informing him that the poet
'intended to give the great part of the work for
the volume to the Pre-Raphaelites.'[3]

Although initial sales had been
disappointing, in particular for Moxon who
had previously reaped profits from anthologies
of Tennyson's poetry, following the purchase of
the excess stock by the publisher, Routledge,
and a reduction in price, the book sold out
immediately. The Moxon Tennyson set the
standard for the next decade of book and
magazine illustration, appearing at the dawn
of what is now considered to be the golden age
of English illustration. Millais benefited
greatly from this surge in demand, which was
in part sparked by a general increase in
literacy, and it is possible that during the
1860s his name was popularised more
through engravings in magazines and novels
than by works he submitted to Royal Academy
exhibitions.

It is not clear whether these highly finished
designs for the Moxon Tennyson were used
by the engravers to prepare their blocks, or
if they were later copied from the wood
engravings for a future sale. From 1861, when
Millais had been commissioned by Thomas
Plint to produce watercolours of each of the
illustrations he had made for Anthony
Trollope's *Framley Parsonage*, he had begun
to produce small watercolour versions of his
designs, which had previously appeared as
illustrations. It is likely that, given the careful
application of colour and presentation of these
drawings, this was his intention here. Original
reproductions proved a profitable venture, and
watercolour versions could fetch between
fifteen and twenty guineas, and painted
duplicates as much as fifty guineas.[4] HB

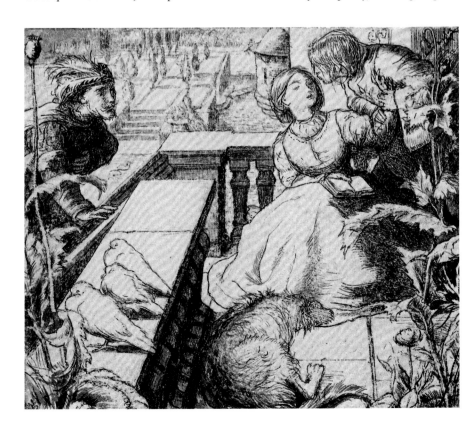

A Dream of Fair Women: Cleopatra 1857
Pen and India ink with scratching out,
mounted with a proof wood engraving
by William James Linton
Published in *Poems by Alfred Tennyson*,
Edward Moxon, London 1857
Victoria and Albert Museum, London

Provenance (Drawing) Bt from Christie's, 5 May 1903
(Proof) Bt from J. Rimmel & Sons 1914

Exhibited (Proof): RA and Liverpool 1967 (356); Wordsworth
1992 (270); Birmingham and London 2004–5 (12)

This is one of two illustrations Millais made for
Tennyson's poem *A Dream of Fair Women*,
included in the Moxon Tennyson, published in
1857 (see also no.71).[1] First published in 1833, it
describes a poet's experience after reading
Geoffrey Chaucer's *The Legend of Good Women*
(1385–6). The poet imagines that he is living in
the past, and is transported into a wood where
he meets many 'Fair Women' including
Jephthah's daughter, 'Fair Rosamund' and
Cleopatra. They each recount the story of their

lives to him, including their respective joys and
adversities. Millais illustrates Cleopatra far
from her native Egypt and sitting within a
dense wood, her raven hair loose beneath her
throne. She reveals to the poet the deadly
snakebite, which she had wilfully incurred in
order to escape being taken to Rome:

> With that she tore her robe apart, and half
> The polish'd argent of her breast to sight
> Laid bare. Thereto she pointed with a laugh,
> Showing the aspick's bite

The engraver, William James Linton, sent
Millais proofs on India paper, which Millais
corrected with Chinese white (a white pigment
made from zinc oxide), and to which he added
notations and sketches in the margins. In
November 1856 Millais wrote to Linton,
delighting in his care in engraving the proofs,
but remarking that some retouching was
required to improve the composition,
particularly to the gradations of shadow

surrounding the face and bosom. Through the
technique of wood engraving, which allows light
to be carved into the block, Linton was able to
reproduce the effect of the moonlight reflecting
on to the darkened face of Cleopatra, and
accurately emulate the shading, texture and
outline of Millais's drawing for the final
engraving (below, right).

Millais produced eighteen illustrations for
the Moxon Tennyson, and for each he adopted
a pictorial convention to correspond with the
theme of the poem he was illustrating. The dark
hatching Millais employed for *Cleopatra*
contrasts with the linear style and extensive
negative space of the *Locksley Hall* images,
expressive of the latter's modern subject matter
(no.73).[2] HB

72a

72b

Locksley Hall 1857
Proof engraving and corrected proof engraving
by the Dalziel Brothers
Published in *Poems by Alfred Tennyson*,
Edward Moxon, London 1857
Victoria and Albert Museum, London

Provenance Bt by the V&A from the Dalziel Brothers in 1901

This is one of two engravings Millais made to
illustrate Tennyson's *Locksley Hall*. The poem
first appeared with others by Tennyson in 1842.
The collection, containing *Morte d'Arthur* and
Ulysses, established Tennyson's position as the
foremost poet of his day, and in 1850 he was
appointed Poet Laureate. *Locksley Hall* is a
stream-of-consciousness poem about the pain
of lost love, set at the eponymously named
home of the narrator's former sweetheart, Amy.
Throughout the soliloquy the narrator's only
consolation is that Amy will be burdened with
an unhappy future, and he paints her as
constrained by a faithless husband and a
resentful child. At the end of the narrative he
hopes for the destruction of Locksley Hall,
whether by 'rain or hail, fire or snow', as
compensation for his despair. Although it is not
clear exactly which episode in the lengthy
poem this design relates to, it is possible that he
has selected a moment from Amy's future
where, as a jealous, elderly woman, she
castigates her daughter for receiving an
unsolicited letter, possibly from a lover:

> O, I see thee old and formal, fitted to thy
> petty part,
> With a little hoard of maxims preaching
> down a daughter's heart.

In the illustration the young woman, with one
hand placed near to her heart, is interrupted in
the act of penning a note. She cowers from the
older woman who appears to threaten her with
the letter, which has presumably just arrived.
The actions of the letter's intended recipient
clearly transgresses the family's rules of
conduct, their privileged situation evident from
the ornamented piano to the right of the
illustration and the formal day dress worn by
the two women.

The work of the Pre-Raphaelite illustrators,
and in particular Millais, is characterised by an
insistence on facsimile reproduction. The proof
with Millais's corrections (below left) reveals his
extraordinary attention to each line scratched
into the wood.[1] Using microscopic touches of
Chinese white he corrects the inaccuracies,
explaining each with annotations around the
page giving instructions to the engravers. For
example, in the top left he writes: 'cutaway that
line under the eye, and make the space clear as I
have done with white paint on the imperfection.'
Millais returned the proof engraving of *Locksley
Hall* with a letter to the Dalziel Brothers
annotated with detailed sketches, particularly
of the chin and eyes of the older woman.[2]

Three pencil studies exist for this illustration
in Birmingham Museum and Art Gallery, one in
reverse and another showing the mother and
daughter embracing. HB

73a

73b

The Bridge of Sighs 1858

'Where the lamps quiver
So far in the river,
With many a light
From window and casement,
From garret to basement,
She stood, with amazement,
Houseless by night.'

Etching on paper
17.7 × 12.5
Published in *Passages from the Poems of Thomas
Hood Illustrated by the Junior Etching Club*,
London 1858
Geoffroy Richard Everett Millais Collection

Provenance By descent from the artist

Exhibited Southampton 1996 (114); Rye 1996 (19)

In *The Bridge of Sighs*, the most densely worked of his etchings, Millais illustrates a young woman standing on the banks of the Thames at night, the lights of the bridge reflecting into the water and illuminating her face, which is turned away from the towering dome of St Paul's Cathedral. Her thick hooded cloak masks a child which, presumably born through an adulterous relationship, is the cause of her despair. Suicides, especially among women, were a cause of great concern to Victorian society and, due to the popularity of its 54-foot (16.5m) drop with those seeking to take their own lives, John Rennie's original Waterloo Bridge became known as the 'Bridge of Sighs' or 'The Arch of Suicide'.[1] The poem by Thomas Hood (1798–1845), *The Bridge of Sighs*, first published in 1844, caused a sensation, appearing just two weeks before the heavily publicised attempted suicide of the seamstress Mary Furley in London's Regent's Canal.[2] Many illustrators and artists seized the morbid theme, including Gustave Doré and Augustus Egg, the latter producing his triptych on the consequences of adultery, *Past and Present*, in the same year as the publication of Millais's etching.

The career of Hood, who died in 1845, was celebrated in November 1857 when the Junior Etching Club chose a selection of his poetry for its next publication. Each member of the Club had two weeks to produce an etching of his choice. Millais in particular dragged his heels and, anxious not to delay publication, it was agreed that etchings that were delivered late would be relegated to 'head and tail' pieces. By 3 November 1858 Millais's etching was still not ready and he became noticeably absent from the Club's meetings.[3] However he finally produced two etchings for the volume (the other illustrating Hood's love poem, 'Ruth') out of a total of thirty-four by more than twenty artists, including John Tenniel, Charles Keene and Arthur Severn.

Millais rarely attempted subjects of deep social significance and, unlike Dante Gabriel Rossetti who devoted a number of poems and pictorial works to the subject of the fallen woman, *The Bridge of Sighs* was unique in his oeuvre. Millais's illustration responds to Hood's plea for a greater understanding of prostitutes. However, contrary to Hood's poem, which does not mention a child being with the woman, and echoing the final part of Egg's *Past and Present* trilogy where the woman's desperation is indicated by the tiny feet of a child protruding from her cloak, Millais suggests that a bastard child is the cause for her rejection. HB

Iphis and Anaxarete c.1861
Watercolour and bodycolour
8.1 × 13.3
The Ashmolean Museum, Oxford

Provenance Sydney Morse; Mary Munster;
bt Christie's, 19 March 1937 (146); F.R. Meatyard;
A.P. Oppe, bt Ashmolean, 1940

Exhibited Birmingham and London 2004–5 (31)

This watercolour relates to an engraving after Millais, published in *Once a Week* on 19 January 1861 to accompany Mary Munster's lengthy poem of the same name. The poem corresponds to Ovid's Greek myth in which Iphis, a Cypriot shepherd, commits suicide after being shunned by Anaxarete whom he loves. In anger the goddess of love, Aphrodite, turns Anaxarete to stone as a punishment. Millais illustrates the penultimate scene in Munster's harrowing poem, when Anaxarete discovers the dead body of Iphis on her wedding day (the poem does not indicate whom she is to marry):

> But she whose pride had brought him to
> his doom.
> Smiled coldly on the rigid upturned face.

Surrounded by the wedding guests, Iphis still holds the instrument he has used to stab himself, the red swell on his torso revealing the location of the fatal wound. Anaxarete is shown in the distance wearing her wedding veil, her haughty posture contrasting with the young women who recoil in horror at Iphis's untimely death and offer comfort to one other. In the background a girl, unaware of the horror in the foreground, drops a wreath in Anaxarete's path.

The ornate urn in the foreground and the outline of a Doric temple demonstrate Millais's awareness of the classical source of the poem. In addition several women hold wreaths, which, according to the Greco-Roman tradition, are symbolic of the beginning of a new life for a betrothed couple. However the dress of the women contravenes that of ancient Greece and, instead of clinging draperies, the women wear the flounced skirts that fashion decreed in Victorian England.

Millais contributed a total of sixty-nine designs to *Once a Week* between 1859, when the journal was set up by publishers Bradbury and Evans under the editorship of Samuel Lucas, and 1863, at which stage sales had already begun to decline owing to production costs and increased competition. This watercolour was probably produced for private sale after the engraving's publication. HB

A Lost Love c.1860
Watercolour on paper
10.3 × 8.5
The British Museum, London

Provenance Sydney Morse, Christie's, 19 March 1937 (124); presented by L.G. Esmond Morse in memory of his father to the British Museum

Exhibited BM 1994–5 (47); Birmingham and London 2004–5 (23)

This delicate watercolour was made after an engraving produced to accompany the anonymous poem *Lost Love*, published in *Once a Week* on 3 December 1859. The short poem describes a woman who seeks comfort in clinging on to a 'faded floweret in her hand' (possibly a gift from her lover), while she looks 'upon the night'. Seated beside a window, she appears absorbed in the moonlight, which reflects on to her face and skirt and casts shadows behind her. The petals from the posy she is holding form a pool on the floor beneath her billowing skirt (characteristically in Millais's illustrations this consumes a large part of the composition). It has been suggested that the model was Effie's sister, Alice Gray, who would have been around fourteen years old and who also posed for *Autumn Leaves* (no.82) and *Spring* (no.84) in this period.[1] The solitary woman, often awaiting the arrival of a lover or despairing at their departure, was a favoured subject in Victorian painting and poetry, and appealed both to the crowds visiting painting exhibitions and to the readers of popular periodicals, who took pleasure in fabricating narratives.

In 1859 Millais had been approached by the publishers Bradbury and Evans to provide illustrations for their new threepenny journal, *Once a Week*, which had been set up under the editorship of Samuel Lucas partly in opposition to Charles Dickens's new weekly periodical *All the Year Round*. Promising both serialised popular fiction and illustrations by John Leech, John Tenniel and George du Maurier, *Once a Week* was an immediate success and sold a total of one million copies in its first year. Between 1859 and 1863 the periodical provided Millais with a timely source of income, and he wrote to William Holman Hunt: 'I have more than one mouth to fill now, and I work, when otherwise (as a bachelor) I should never have thought of it.[2] Over the next four years Millais produced illustrations for approximately thirty poems for *Once a Week* (see *Iphis and Anaxerete*, no.75), and also illustrated four novels serialised for the periodical by the English novelist and journalist Harriet Martineau.

From the 1850s Millais had begun the lucrative practice of selling watercolour copies of his engravings and, although the date of this work is not clear, it is likely that Millais made the print after the serial had been published, possibly for a future sale. HB

Love c.1862

'Her bosom heaved – she stepped aside,
As conscious of my look she stept –
Then suddenly, with timorous eye,
She fled to me and wept.'
Pen and ink and blue watercolour wash
12.8 × 9.6
Victoria and Albert Museum, London

Provenance Myles Birket Foster sale, 28 April 1894 (31);
Agnew's sale; bt by Agnew's for the V&A, 1894

Exhibited RA and Liverpool 1967 (358); Arts Council 1979 (70)

This watercolour relates to Millais's illustration for Samuel Taylor Coleridge's poem *Love* (1799), engraved by the Dalziel Brothers for the Revd Robert Aris Willmott's *Poets of the Nineteenth Century* (1857).[1] Published by Routledge, the luxury volume, with gilt decoration on the front and the spine, contained a selection of poetry covering eighty-five years, by Samuel Rodgers, William Wordsworth, Robert Browning and others, and accompanied by one hundred engravings by celebrated illustrators including John Gilbert and John Tenniel. Willmott praised the achievement of the Dalziel Brothers in the volume's preface and remarked that with 'the grace and beauty of the pencil' they had successfully translated the poems into the 'popular language of their own Art'.

Coleridge's poem describes a man recounting a 'doleful tale' in order to seduce his lover, Guinevere. The woman is enchanted by his tragic story of a knight who dies in an attempt to rescue his lover, and is unable to resist falling into his arms. Millais's design shows the two lovers intertwined; the man embraces her with one hand while the other rests on the medieval stringed instrument he has played to accompany his 'soft and doleful air'. The lovers are consumed by moonlight blue-greens in the dense forest setting, a rabbit being the only witness to their embrace. Although the final illustration published in Willmott's volume was praised by Millais's colleagues and friends, in particular by Dante Gabriel Rossetti,[2] the shortcomings of Millais's illustration were noted by one reviewer for *Blackwood's Edinburgh Magazine*:

> Mr Millais has a special gift for the expression of *extreme* emotion; but it is not, perhaps, within the reach of 'black and white' to express that tenderest blending of impulses, or to come up to the description of this unrivalled poem.[3]

Perhaps bearing in mind the reviewers' criticisms, Millais later made this pen and ink drawing, which reproduces the meticulous detail of the engraving. Millais chose not to date his reproductive watercolours and, as a result, only an approximate date has been given to *Love*. In addition, and to maintain its rarity, each copy was given a unique character.[4]

Millais's engravings were occasionally reprinted, and *Love* was later used to accompany the lines of a melancholy poem by the English Renaissance poet Michael Drayton, published in *Dawn to Daylight* (1874).[5] In contrast to Coleridge's *Love*, Drayton's poem describes the parting of lovers. HB

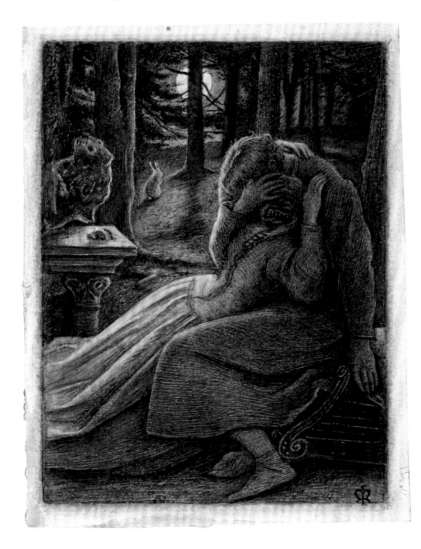

The Border Witch 1862

'Ah me! she was a winsome maid,
Ye couldna fand her marrow
Had ye sought through a' Scotland braid,
Frae John o'Groats to Yarrow.'

Proof engraving by the Brothers Dalziel
Touched proof on India paper
Published in *London Society*, August 1862
Victoria and Albert Museum, London

Provenance Bt by the V&A from the Dalziel Brothers in 1901

This design was used to illustrate the lines of the poem *The Border Witch* by the anonymous author 'T.W.', which appeared in the August 1862 issue of *London Society*. This monthly journal, which continued until 1898, described itself as 'An Illustrated Magazine of Light Amusing Literature for the Hours of Relaxation'. It provided its readers with a mixture of exhibition reviews, short fiction (with titles such as 'A Romance at the Brompton Exhibition'), society news and serialised novels by Arthur Conan Doyle and others. Millais provided three illustrations for the magazine between 1862 and 1864.

The lengthy and, contrary to the magazine's remit, frightening poem describes the adventures of the king and laird, 'Wild Steenie Johnston'. With four of his companions he attempts to overthrow the witch Eppy Watt who, according to the narrator, terrified even the 'boldest huntsman'. Despite being accompanied by the famed 'Red Clavers' hound, the men are unable to overcome the witch and, in the poem's final stanza, she curses Johnston and ruins his livelihood by causing the death of his sheep and cattle. Millais chose to illustrate a circumstantial moment, when the author describes Johnston's daughter May as 'a winsome maid', beloved of all the men in the country. Her artificial pose and fashionable outfit diverts the reader's attention from the poem's harrowing subject matter and May's untimely death at the hands of the witch.[1] Here she is shown holding a riding crop in one hand and, presumably, walking the hounds that will accompany the hunting expedition. Millais's concentration on the fabric and design of the model's outfit relates the illustration to nineteenth-century fashion plates. In addition the posture and averted gaze of the woman, both characteristics of the fashion plate in contemporary periodicals such as *Lady's Pictorial* and *The Queen: The Lady's Newspaper*, demonstrates Millais's awareness of these sources and the burgeoning interest in fashionable dress in Victorian society.

The poem may have appealed to Millais, who spent extended periods in Scotland from the late 1850s, and often chose Highland themes for his painted work. In 1861 he visited Sutherlandshire in northern Scotland, where he indulged in salmon fishing and shooting with his friend, Michael Halliday. He may have been inspired by the historic buildings in the area to create the romantic castle in the background, with its typical round stone turrets and defensive walls. May wears a three-cornered cap, or a kertch, then fashionably worn by Highlanders.

The proof engraving contains annotations around the edges provided by Millais to aid the engravers when cutting the design on to the block. He also includes outlines of the model's profile and the back of the head to indicate where alterations needed to be made. Millais promised that he would 'finish [...] & mail tomorrow for next week'. HB

Orley Farm
Engraving by the Brothers Dalziel
Illustrations for Anthony Trollope's *Orley Farm*,
published by Chapman and Hall, London
March 1862 (Part 1); April 1863 (Part 14)
The Trollope Society

Provenance Bt by the V&A from the Dalziel Brothers in 1901

The collaboration of Trollope as novelist and Millais as illustrator lasted for ten years, and Millais produced eighty-seven designs for six of his novels during this period. Nearly half of these illustrations were made for *Orley Farm*,[1] a lengthy novel with a characteristically subtle plot revolving around a baffling court case concerning the handwritten will of the fictional London merchant and former mayor, Sir Joseph Mason. The novel originally came out in twenty monthly shilling parts under the imprint of Chapman and Hall between March 1862 and October 1863 (Chapman and Hall issued the novel in two volumes in 1863). Two illustrations appeared in each part. Trollope responded to the episodic format by creating numerous subplots and teems of incidental details and characters, as the periodical public demanded continuous 'variety and sectional

incident.'[2] The advertisements for perambulators and christening robes on the front and endpapers indicate that the publication was intended for, and consumed primarily by, a female audience. Millais responded by dressing his female heroines in the most fashionable crinolines, to the occasional irritation of Trollope.[3]

Trollope delighted at the choice of illustrator (the novel's association with Millais could only encourage sales) and later remarked specifically of *Orley Farm*: 'I have never known a set of illustrations so carefully true, as are these, to the conception of the writer of the book illustrated. I say that as a writer. As a lover of Art I will add that I know no book graced with more exquisite pictures.' Millais thrived on Trollope's vivid descriptions and, immersing himself in the text, produced some of his most powerful designs. His exacting style was maintained as he illustrated the events at Orley Farm and, in particular, the tortured struggles and confessions of Lady Mason. Trollope gave Millais some guidance, referring him to descriptions on which to portray his characters and, on one occasion, providing him with a photograph, which Millais probably used to

copy the features of Trollope's childhood home, Julian Hill near Harrow,[5] for the frontispiece.[6] The rural surroundings of the fictional farm are conveyed by a scene in the foreground, of a young girl milking a cow beside a stream (below left). The spatial recession created by the steep slope leads the eye towards the farmhouse in which the complex plot unwinds. Millais's idealised vision of the English countryside echoes illustrative material by engravers associated with the Idyllic school, including Frederick Walker and George John Pinwell.

Millais and Trollope were to remain intimates until Trollope's death in 1882. A letter Trollope sent him on 8 February 1880 indicates the strength of their friendship: 'I am very sorry but I have to dine with another artist on Saturday, – very inferior, – and no whist! I doubt the claret too!!'[7] A near incessant demand for portraits prevented Millais from contributing extensively to any further novels following *Phineas Finn* (1867–9),[8] and the task of illustration would fall to others, notably Mary Ellen Edwards and Marcus Stone. HB

79a

ORLEY FARM.

79b

'Guilty', Orley Farm 1862–3
Corrected proof engraving by the
Brothers Dalziel
Illustration for Anthony Trollope's *Orley Farm*,
published by Chapman and Hall, London
1862–3
Victoria and Albert Museum, London

Millais made a total of thirty-nine engravings
for Trollope's *Orley Farm*, originally published
in serial form 1862–3 and then in two volumes
by Chapman and Hall in 1863. Illustrations
were an integral component of the nineteenth-
century novel and, for Trollope in particular,
Millais was unrivalled in his ability to portray
through the medium of wood engraving a
novel's main protagonists and dramatic
moments. Although Trollope occasionally
offered him some guidance, the author
generally trusted Millais to choose the most
dramatic points, as well as highlight the inner

selves of his novels' key protagonists.

This illustration describes a climactic
moment halfway through the novel, when Lady
Mason confesses to Sir Peregrine Orme that,
out of love for her son Lucius, she has forged
the will that bequeathed to him Orley Farm.
The regret she feels for her misconduct is
displayed through her melodramatic gesture
and crouching position, which contrasts with
that of her lover, whose restrained composure
masks his despair at her behaviour. In
particular, her unwieldy skirt reinforces the
confused emotional drama of the scene. While
displaying his love for Lady Mason (indicated
by his hand resting on his heart), Orme's
outstretched arm presupposes his subsequent
rejection of her and the abandonment of their
marriage.

Millais paid equal attention to Trollope's
descriptions as he did to the cutting of his
designs on the woodblock by the engravers

and, in order to guarantee accuracy to his
original drawing, he often transferred his
drawing on to the wood block itself using a
mixture of lavender and potash.[1] The annotated
proofs and long, illustrated accompanying
letters demonstrate the particular attention he
paid to facial expressions. In this corrected
proof Millais annotated around the impression,
making subtle changes to the engraved lines
using Chinese white. At the bottom of the page
he wrote: 'Be careful with her head correction as
above.' Millais was, however, generally satisfied
with the Dalziels, and while he was working on
the designs for *Orley Farm*, he wrote that, aside
from an eyelid that required 'shortening a trifle',
two of the proofs they had returned to him were
'*very satisfactory*'.[2] The ability of the Dalziels to
translate effectively artists' designs guaranteed
the success of their wood-engraving firm until
the encroachment of photography into book
and magazine illustration from the 1870s. HB

81

Parables of Our Lord 1864
Issued in 1863, dated 1864
a. *The Lost Sheep*
b. *The Prodigal Son*
c. *The Sower*
d. *The Hidden Treasure*
Wood engravings by the Brothers Dalziel
Illustrations from *Parables of Our Lord*,
published by Routledge, London 1864
Tate. Presented by Gilbert Dalziel 1924

By the mid-1850s Millais's reputation for illustrating books and magazines was unrivalled, and in 1857 he agreed to produce thirty illustrations for a new history of the Bible to be published by Routledge. Millais was receiving a continuous stream of commissions for illustrative work at this time, and it would take him six years to complete the project; the number of designs dwindled from thirty to twenty during this period. Millais explained the slow progress of his first solo venture: 'I can do ordinary illustrations as quickly as most men, but these designs can scarcely be regarded in this same light – each Parable I illustrate perhaps a dozen times before I fix, and the hidden Treasure I have altered upon the wood at least *six* times.'[1] Millais was paid £20 for what he would describe as his 'labour of love.'[2]

Religious subjects had been absent from Millais's painted work since the early 1850s, and he was probably guided by the Dalziels in the choice of parables recorded in the four Gospels. Unlike Hunt, who navigated his way through the Middle East and recorded in painstaking detail the sites and people of the Holy Land, Millais did not venture any further than the home of his wife's family at Bowerswell near Perth for his models and landscape backgrounds. Although the *Athenaeum's* reviewer subsequently castigated Millais for mixing up the 'ancient with the recent',[3] there were few criticisms of his draughtsmanship or the accomplishment of the Dalziel Brothers in reproducing his every line and contour for the volume's illustrations. Although the amount of detail varies between engravings – for example in *The Hidden Treasure* the sky remains completely white, whereas in *The Sower* he introduces fowls aiming for stray seed – Millais relentlessly tested the patience of the engravers. On 13 January 1858 he wrote to Dalziel regarding the fingernails of the father and son in *The Prodigal Son*, which he desired to be rendered 'with greater delicacy [*sic*]'.[4] The landscape formation of *The Lost Sheep*, with a shepherd carrying one of the flock over his shoulders

beside a perilous cliff top, imitates Hunt's *Our English Coasts, 1852 ('Strayed Sheep')*, and is Millais's most accomplished outdoor subject for the *Parables*.

Finally in 1863 the *Parables* was advertised in the *Bookseller* as 'Dalziels' Christmas Book' with a quotation from the *Reader*: 'In these designs we have much of Mr Millais' finest work, while Messrs. Dalziel have raised the character of Wood Engraving by their exact and most admirable translation.'[5] Despite mainly positive reviews, book sales remained stubbornly low, and the price of one guinea (not unreasonable bearing in mind the costs involved for the artist, engravers, printers,

cover designers and blockmakers) prohibited sales of the 10,000 print-run. The book was only reissued once, in 1885.

Millais later produced watercolour versions of the *Parables*, several of which are in the collections of the Whitworth Art Gallery in Manchester, the Manchester Art Gallery and Aberdeen Art Gallery. In addition, two engravings were worked up as oil paintings, *The Lost Piece of Silver* exh.RA 1862 (destroyed) and *The Parable of the Tares* (no.91). Finally, replicas of fourteen of the *Parables* were made for a window that was presented to Kinnoull New Church in Perth by Millais's father-in-law, George Gray, in 1870. HB

81a

81b

81c

81d

3
Aestheticism

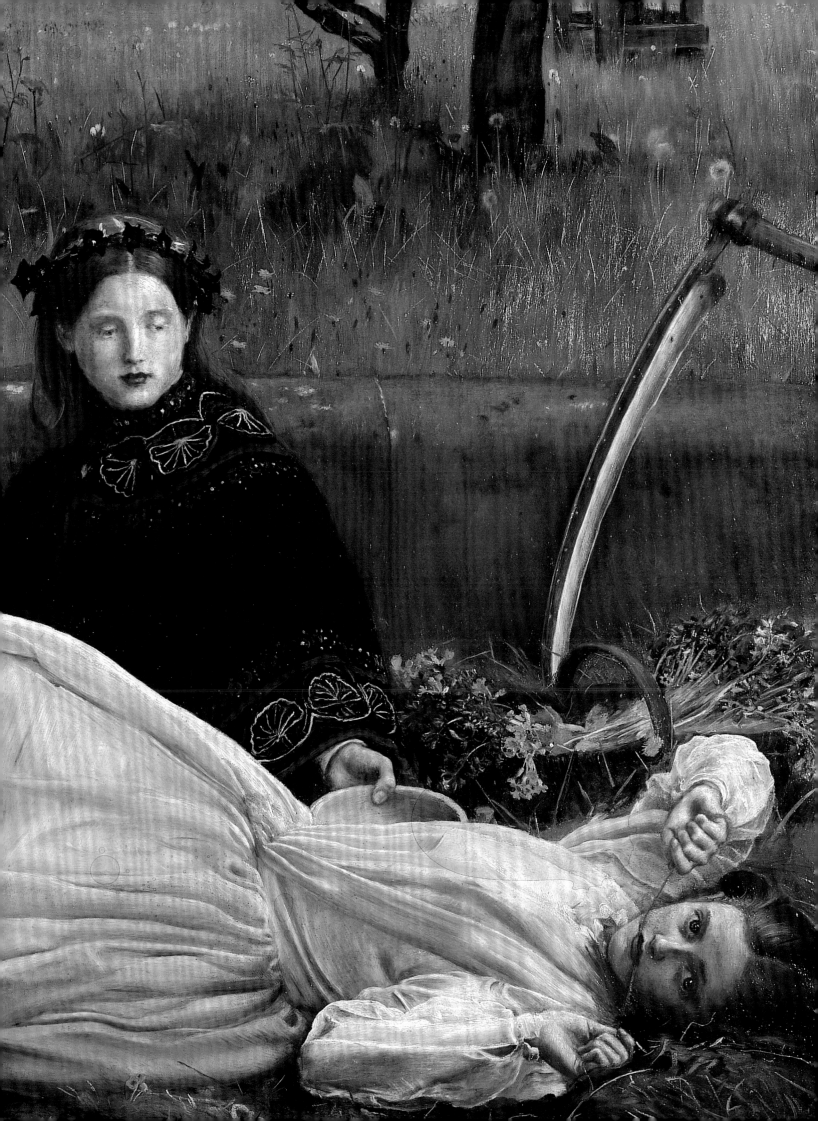

Aestheticism

Few artists of the 1850s can rival Millais in terms of inventiveness and range, both stylistically and thematically. No other artist produced so many high-quality works that have become so recognisable. The early years of the decade were marked by his continued refinement of Pre-Raphaelitism. He began to cultivate his international reputation with his success and exposure at the Paris Exposition Universelle of 1855. Most remarkable is that, following his struggles with and the eventual acceptance of his Pre-Raphaelitism, he shifted gear dramatically in the mid-1850s and began to pursue a new manner, one without precedent and for a time without adherents. This was inaugurated in the Royal Academy of 1856 with *Autumn Leaves* (no.82), perhaps his greatest achievement and most evocative picture. It presented a challenge to the Academy as well as Pre-Raphaelitism, which had by then been taken up by a second generation of artists. Ambitious and elusive, the picture left critics simultaneously unsettled and in awe. With a background begun in Scotland in the autumn of 1855 and completed just before the exhibition opened, *Autumn Leaves* was Millais's first Scottish landscape since the Ruskin portrait, his first large twilight scene, and a radical attempt to refigure the image of female beauty in Victorian art. It rejected the need for literal subjects in Academic pictures and Pre-Raphaelitism, and the overall clarity and precision of Pre-Raphaelite landscape painting, and established themes that would concern Millais in his art for the remainder of his career. Retrospectively, it appears to have heralded the inception of Aestheticism in British art.

In that same year he showed the opaline historical drama *L'Enfant du Régiment* (no.61), the lavish social protest picture *The Blind Girl* (no.62), and the topical family drama *Peace Concluded, 1856* (no.66), all intensely worked and original. But *Autumn Leaves* signalled different concerns from romantic history and modern genre. Its themes continued through the end of the decade on both the small (*Sophie Gray*, no.83) and the grand scale (*Spring*, no.84, and *The Vale of Rest*, no.85). Art historians have recently sensed in these images early signs of the Aesthetic movement, in advance of Walter Pater's landmark essays that would be published in 1873 as *Studies in the History of the Renaissance*. This was perhaps better recognised at the time by the likes of Henri Fantin-Latour, James McNeill Whistler and Théophile Gautier, than in the twentieth century, when Impressionism and Post-Impressionism blocked out the lights of concurrent artistic concerns. Among the groups and movements after Pre-Raphaelitism, Millais was without a consistent literary champion once he split from Ruskin, although he is nonetheless inceptive in the dialogue regarding Art for Art's sake in Europe in this period, as evidenced in two pictures that have emerged only recently, *Sophie Gray* and *Sisters* (no.90).

In Millais's oeuvre, Aestheticism forms a theme and a style that he employs throughout the rest of his career. By 1865, with *Esther* (no.92), his subject matter altered again. But simultaneously with these developments, he was pursuing

a quite different approach in his graphic work (nos.70–80), which is better seen as an evolution in terms of mastery of narrative and brevity. Aesthetic pictures often absolved subject completely, either functioning as portraits or remaining, like *Autumn Leaves*, stubbornly ambiguous to viewers accustomed to decoding references to divine a pat tale. A generally sensuous, opulent and sometimes historically ambiguous style associated with Aestheticism finds its way into many of Millais's portraits, such as *Miss Eveleen Tennant* 1874 (Tate), *Sisters*, '*Leisure Hours*' (no.89), and the portrait-like subject picture '*Oh! that a dream so sweet [...]*' (no.87). Elements of the style appear in Millais's later Scottish landscapes, such as *Flowing to the River* (no.126) and *Dew-Drenched Furze* (no.135). Subject pictures such as *The Eve of St Agnes* (no.88) also remain notable examples of Millais's brand of Aestheticism, one less concerned with a cultish concept of androgynous beauty, and trends in furnishings or crockery, than with evocation in meaning and pictorial effects.

The late 1850s and 1860s was also a period of commercial ascension for the artist, of increased interaction with a variety of London dealers. There were growing demands on him: for more illustrative work, which paid well but filled his hours not spent painting; from an enlarged family; and from his increased international profile, exhibiting four oils and three prints after his works at the London International Exhibition of 1862, and then three oils and five prints at the Paris Exposition Universelle of 1867.[1] JR

Autumn Leaves 1855–6

Oil on canvas

104.3 × 74

Signed and dated in monogram lower right

Manchester City Galleries

Provenance Bt James Eden; traded to John Miller, late 1856, for three pictures; his sale, Christie's 21 May 1858 (168), bt Gambart; James Leathart by 1862; bt from him by the Manchester City Art Gallery, 1892

Exhibited RA 1856 (448); Manchester 1857 (543); Liverpool 1858 (77); RSA 1858 (289); London 1862 (698); Leeds 1868 (1459); FAS 1881 (8); GG 1886 (121); Guildhall 1892 (147a); RA 1898 (38); Glasgow 1901 (312); Manchester 1904 (194); London 1908 (99); Manchester 1911 (244); Tate 1913 (21); Brussels 1929 (110); RA 1934 (539); Amsterdam 1936 (96); Paris 1938 (93); Manchester 1948 (20); Tate 1957 (short loan); Nottingham 1959 (48); Liverpool 1960 (68); Indianapolis 1965 (53); RA and Liverpool 1967 (53); Paris 1972 (165); Whitechapel 1972 (34); Tate 1973–4 (321); Tate 1984 (69); Manchester *et al.* 1992–3 (58); Berlin 1998 (54)

In early August 1855, following a month-long Scottish honeymoon, Effie and John Millais moved into Annat Lodge, a rented Regency period house on a rise above Effie's family home of Bowerswell, Perth. They would live there only two years. Its large garden, with its plentiful trees and remarkable view of the Arrochar Alps, would provide the setting for this picture and initially for *Spring* (no.84). In *Autumn Leaves*, four girls gather around a smouldering pile of leaves. The two on the left have long straight hair and wear matching green dresses. One bears a wicker basket and the other drops leaves on to the mound. On the right a red-headed girl with downcast eyes holds a rake, and before her a smaller girl holds an apple and gentian flowers and stares mesmerised at the pyre. In the background the sun has set and emits an orange haze rising to yellow above the deep blue hills. The spire of the medieval St John's Church is visible on the far left, although the rest of the Perth skyline is obscured in a pointed denial of the urban. Immediately below this are remnants of a fifth figure, a man seen from behind with a hooded cloak and holding a scythe, barely visible through the smoke and paint layers.[1] The models, from left to right, were Effie's sisters, Alice and Sophie, and two locals, Matilda Proudfoot and Isabella Nicol. Effie in her journal wrote that Matilda came from the School of Industry, where 'the girls were all so ugly that [she] was the only one that was drawable', while Isabella Nicol was a sufficiently pretty daughter of a maid.[2] All were under thirteen. In Effie's and Millais's search for attractive girls they were seeking a ruddy blend of the refined and the common, with a certain attractiveness and immaturity.

In this period Millais sought a religiosity that was not dogmatic (as in *The Blind Girl*, no.62), yet he wrote to F.G. Stephens of *Autumn Leaves* that he 'intended the picture to awaken by its solemnity the deepest religious reflection'.[3] He had originally considered including a line from the Psalms in the Academy catalogue, but decided against it, 'from a fear that it would be considered an affectation and obscure'.[4] The poses reminiscent of a *sacra conversazione* altarpiece (without the Holy Family),[5] the shadowy reaper, and the solitary church tower would seem to belie this aim. Yet the symbolic elements in the picture add up to a mood, not a narrative, and critics found the picture obscure anyway. Their problem did not lie with the symbolic content, but with the perceived aesthetic failure of the work, in terms of the faces of the four young girls and the uneven natural scenery, as noted in the *Athenaeum*:

> Of course there is some deep meaning in the season, moment, and even in the red hair, but we do not see it. The way the blue smoke oozes and strains through the sappy and half-withered leaves is well remembered; the evening sky and the dark columns of the trees are poetical and natural; and the leaves are of very varied color, but are painted in a tinted manner not very pleasing.[6]

Ultimately, the idea of an emblematic picture based not on a concise story, but on colour, mood, atmosphere and aesthetics, or the pursuit of beauty, depended on viewers connecting with the figures, just as an altarpiece needs focalisers in the form of saints, who look out at the viewer and serve as intercessors for the faithful. This work, along with *Sophie Gray* (no.83), *Spring* and *The Vale of Rest* (no.85), forms Millais's proto-Aestheticist work of the late 1850s.

Effie described the picture as fulfilling Millais's goal of a work 'full of beauty and without subject', and that is true in terms of it lacking a specific narrative. *Autumn Leaves* has been read in modern times as a melancholy rumination on the transience of life, a reinterpretation bolstered by the autumnal setting, the dead leaves, the setting sun, the half-seen reaper, and the apple as a symbol of temptation and the loss of innocence. But it was also Millais's initial foray into conceptualising modern beauty. He wrote as much to Charles Collins that same autumn:

> nature is too variable in itself to give more than a transient feeling of pleasure. Aspect, is the great secret. *The prospect of the* aspect.

> I have never seen any beauty yet but what looked at times nearly altogether 'ugly' without it. The *only* head you could paint to be considered beautiful by *EVERYBODY* would be the face of a little girl about eight years old, before humanity is subject to such change [...] A child represents beauty more in the abstract, and when a peculiar expression shows itself in the face, there comes the occasion of difference between people, as to whether it increases, or injures its beauty. Now this is evidently the game the Greeks played in Art, they avoided *all* expression, feeling that it was detrimental to beauty according to the capacity of understanding in the mass. I believe that perfect beauty and *tender* expression *alone* are compatible and this is undoubtedly the greatest achievement if successful [...] That very lovely expression in little Alice's eyes which you know, would be the very point which thousands would object to. They would say, 'there is such an odd miserable look about her, I don't like that for a child &c &c'. You will think with all this, that I have been offered the place of lecturer on painting at the RA. The fact is I have been going through a kind of cross examination within myself lately as to a manner of producing beauty, when I desire it to be the chief impression.[7]

Many writers on the picture have convincingly connected this work to Millais's interest in Tennyson's poetry, his experience of raking and burning leaves on the Poet Laureate's Isle of Wight property, and William Holman Hunt's reminiscence, fifty years on, of Millais saying:

> Is there any sensation more delicious than that awakened by the odour of burning leaves? To me nothing brings back sweeter memories of the days that are gone; it is the incense offered by departing summer to the sky, and it brings one a happy conviction that Time puts a peaceful seal on all that has gone.[8]

Stephens's recognition at the time of the 'strange impassivity upon [the girls], as if they knew not what they did, senseless instruments of fate, not foolish, but awfully still and composed; – they gather the leaves and cast them upon the pile, half unconscious of the awful threat',[9] is persuasive, and Millais appreciated it. The critics, however, read their situation as dire: the girls face night, symbolising mortality. As with *Ophelia* (no.37), 'incapable of her own distress', the approaching

shift in the girls' lives is momentous. Stephens makes loose reference to the Parable of the Ten Virgins, often called the Wise and Foolish Virgins, with the girls in *Autumn Leaves* absolved, facing something for which they cannot adequately prepare. In the faces of the Gray sisters, Millais presented to his mid-nineteenth-century audience girls on the cusp of change, not of death but of maturity, significantly unaware of its imminent onset.[10] Consequently, for the viewer the picture is nostalgic, and this is dependent on one's own experience, as well as the abstract expression of the girls, their directness of gaze, their lack of introspection. The sentimentality associated with the picture lies in the viewer, not literally in the oil itself, and this is the key to its suggestiveness.[11]

Other critics recognised that this picture marked a shift in manner, as in an article in *The Times*, which noted

> the advance made in [Millais's] style. Compare the leaves with the straw in the Ark [no.25] of several years ago. There every straw was painted with a minuteness which it was painful to follow; here the leaves are given with great truth and force, but the treatment is much more general and the work more rapid. Throughout all his works the same increased rapidity of touch may be seen; but in all of them will not be seen colour so good as in this work or expression so true.[12]

In his *Academy Notes* (1856), Ruskin hyperbolically wrote that *Peace Concluded, 1856* (no.66) and this picture 'will rank in future among the world's best masterpieces; and I see no limit to what the painter may hope in future to achieve'.[13]

Autumn Leaves was commissioned for £700 by the collector James Eden, but he attempted to renege once he knew of the poor response to the work. Millais refused to break the contract, and Eden traded it to John Miller of Liverpool for three unknown paintings.[14] Later it was owned by the Newcastle shipping magnate James Leathart, a collector who supported James McNeill Whistler, Albert Moore and Dante Gabriel Rossetti. In 1862 Rossetti, who was astonished by *Autumn Leaves*, painted a portrait of Leathart's wife Maria that seems to draw from the painting's tonality and colour scheme.[15] At almost exactly the same size as *The Order of Release, 1746* (no.39), Millais may have hoped to have this picture engraved, but no commercial print was ever produced. JR

Sophie Gray 1857
Oil on paper laid on wood
30 × 23
Signed and dated in monogram lower left
Private Collection, courtesy of Peter Nahum
at The Leicester Galleries, London

Provenance George Price Boyce, his sale Christie's, 2 July 1897 (208); bt in by his daughter Mrs Ernest Charrington, later Mrs Wilfred Hadley; by descent to 2000

Exhibited Possibly Liverpool 1858 (600); RA 1898 (28); Whitechapel 1898 (133); Whitechapel 1905 (403); Tate 1923 (84); Nahum 2001 (5)

Effie's sibling, Sophie Gray, would have been around twelve when Millais painted her in the centre of *Autumn Leaves* (no.82), and fourteen in this image.[1] There is a similarly sized image of Alice Gray (c.1857–8, Private Collection), but it depicts a girl who is still a child. Sophie's image is of another order entirely and is the most sensational recently rediscovered work by Millais.

The picture's direct appeal to emotion and desire is reflected in the ruby red full lips, slightly lifted chin, and intense gaze, hardly that of a naïve young teenager. By contrast, the stitched flowers in a heart on her dress are a more conventional emblem of desire.[2] It is an hypnotic image of the onset of maturity, of sexual awakening and power, a knowing sequel to the deadpan expression in *Autumn Leaves* and its high-collared girlish propriety. *Sophie Gray* is devoid of connotations of mortality and nostalgia. In its resolute likeness, careful drawing and paint application and subtle tones, this intimate picture is one of the finest realist portraits of the nineteenth century. It also conveys a deep sense of connection between artist and subject. Sophie was Millais's favourite in Effie's family, as well as being close to her older sister. She was with Effie in London during the fraught time before she left Ruskin. Millais had first sketched her in 1854 and they would be close all their lives; she and Alice would regularly come to visit Millais and Effie in London. In 1857, Millais also painted her in *Spring* (no.84). In 1873 Sophie married James Key Caird, a wealthy Dundee jute manufacturer, and in 1879 Millais painted a portrait of her five-year-old daughter, Beatrix Ada.[3] He then painted an engaging formal three-quarter-length portrait of Sophie in 1880, but she died after frequent confinements for hysteria in March 1882.[4]

The painting in its format and theme anticipates subsequent works by Millais such as *Only a Lock of Hair* (no.65) and *Meditation* (no.86). It also presages the immediacy and languid sensuality of Rossetti's *Bocca Baciata* 1859 (fig.14), now seen as a signal work of the Aesthetic Movement.[5] Rossetti's close-cropped single female heads often have literary references (here a Boccaccio sonnet), but are evasive in both theme, bearing multiple symbols and extravagant clothing and fussy accoutrements, and gaze, with figures often looking off to the side. In *Sophie Gray*, Millais opted for directness, modern dress and casual hairstyle, all of which give the picture its compelling and enduring power; by comparison Rossetti's works remain distinctly Victorian. As *Sophie Gray* was not exhibited in London until after the artist's death, awareness of it was limited. The watercolourist and Pre-Raphaelite member George Price Boyce bought the picture from Millais in November 1857 for £63, and for the same price the following February purchased the portrait of Alice.[6] He then commissioned *Bocca Baciata* in 1859. Boyce first met Millais in 1852 and was close to Rossetti, moving into his rooms at Chatham Place in Blackfriars in 1862 when the older artist moved out, and then to Rossetti's neighbourhood in Chelsea at West House, Glebe Place, from 1871. Sophie's portrait hung there until his death in 1897. JR

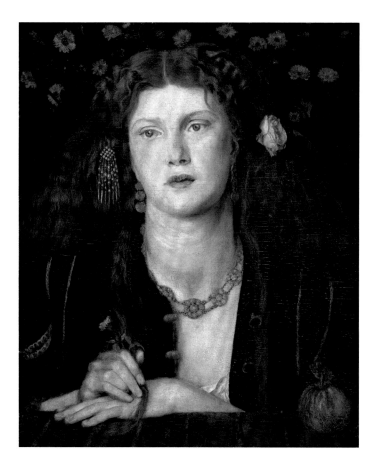

Figure 14
Dante Gabriel Rossetti (1828–82)
Bocca Baciata
1859
MUSEUM OF FINE ARTS, BOSTON, GIFT OF JAMES LAWRENCE

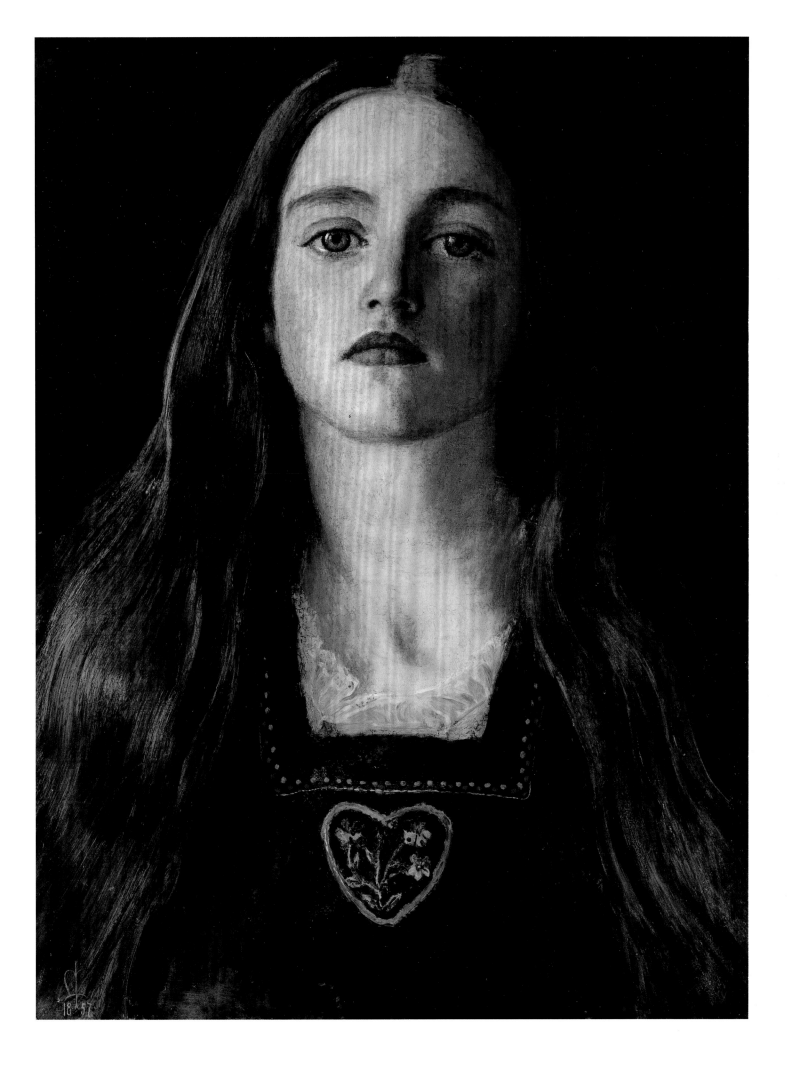

Spring 1856–9
Oil on canvas
110.5 × 172.7
National Museums Liverpool,
Lady Lever Art Gallery

Provenance Bt Gambart, c.6 May 1860; his sale, Christie's, 4 May 1861 (298); bt Crofts; Jacob Burnett by June 1861; Christie's, 25 March 1876 (101), bt Watkins; bt Agnew's from Lefevre, 1 Dec. 1881; sold to William Graham, 16 June 1882; his sale, Christie's, 2 April 1886 (88); bt E.F. White; David Price, sold Christie's, 2 April 1892 (90), bt Thomas Clarke; Christie's, 27 Feb. 1920 (153); bt Goodne & Fox for W.H. Lever (1st Viscount Leverhulme); by descent to the 3rd Viscount, from whom bt 1986

Exhibited RA 1859 (298); Liverpool 1859 (180); London 1862 (699); Cork 1902 (101); Brussels 1929; Bradford 1930 (76); Birmingham 1947 (62); Port Sunlight 1948 (140); RA 1951–2 (294); RA and Liverpool 1967 (58); Tate 1984 (96); BM 1988–9 (44)

Spring was begun at Annat Lodge in the autumn of 1856, painted in various orchards near Bowerswell, and finally completed in early 1859, by which time Millais had also finished *The Vale of Rest* (no.85). They were shown as pendants in the Royal Academy of that year.[1] They continue the theme of *Autumn Leaves* (no.82), equating new ideas of female beauty with natural and human mortality. Low and wide, they are landscape format, on a large scale Millais had not worked with since *Ophelia* (no.37),[2] but *Spring* truncates deep focus with its bank of trees in the middle ground that dramatically block all vision in a decorative and compressing effect similar to that later explored in the radical art-nouveau landscapes of Gustav Klimt.

Begun as a medieval image of a lady under an apple tree and a knight, possibly as a pendant to the similarly sized *Sir Isumbras (A Dream of the Past)* (fig.5, p.18), *Spring* eventually became an image of eight contemporary young girls dressed up as milkmaids and eating curds, milk and cream.[3] The title signals Millais's interest in seasons as conveyors of mood and meaning. *Autumn Leaves* commences this theme, and it is promulgated in later less populated landscapes, *Winter Fuel* 1873 (no.128), *St Martin's Summer* 1878 (no.131), and *Lingering Autumn* 1890 (no.134). The girls pose on a lawn, with a low stone wall separating them from a verdant landscape filled with blooming apple trees. The resulting design is claustrophobic, similar to that of *Ophelia*, and the frieze of colourfully clad girls pushes out of the composition.

Ruskin castigated the natural elements in the picture, in particular 'this fierce and rigid orchard – this angry blooming (petals, as it were, of japanned brass)'.[4] The reference to the artificiality of the petals' hard and glossy finish contrasts with the *Athenaeum*'s review, in which the critic wrote of the grass being 'rather too soft and vapoury'.[5] The foreground grasses are exceedingly sketchy, reflecting what the same journal called Millais's 'careless slap-dash style'.[6] There is very little attention to the detail in the middle ground, as Millais was developing a looser manner. The girls have collected two basketfuls of flowers, which are painted in a free style, especially the one on the right filled with purple and yellow violets, lilacs and gentians.

As in *Autumn Leaves*, some of the figures are more plain than idealised, especially the non-descript girl in the blue dress sitting on the left, likely posed by Alice Gray. But most are very attractive. Georgina Elisabeth Moncreiffe, later Lady Dudley, posed for the somewhat stiff girl kneeling in the middle. Her sister Helen, later Lady Forbes, is the second from right with blue flowers in her hair. Most lovely is the girl next to her in red, a paragon of the beautiful waif-child, with a serenity belied by Millais referring to the model, Agnes Stewart, as 'that little humbug', for being difficult while modelling.[7] The girl in yellow on the far right, also posed by Alice Gray, lounges on her back, a blade of grass between her lips, and looks out of the canvas in a come-hither pose.[8] Her hypnotic stare resembles Millais's portrait of *Sophie Gray* (no.83), who is at the left edge of *Spring*, in right profile, pulling back her long dark hair. Alice again posed for the more innocent girl in green in the centre, who rests her head on her hand, and wears her hair as her sister Effie frequently did, braided and in a top knot (see *Peace Concluded, 1856*, no.66). Only the recumbent girl on the far right looks out at the viewer; she is in a prone position and directly engages the deeper theme of the picture, hence the scythe above her. This traditional memento mori, or symbol of mortality, makes plain the meaning of the picture, that human and natural beauty will fade. The scythe is the farming implement the girls have used to cut their flowers, and also alludes to seasonal transitions, as the blossoms of the trees will ripen into fruit to be harvested.[9]

In *Spring*, the garden wall keeps out the wider world, but only for so long; in this season sexuality comes earlier to some than others, and along with it an awareness of its power. The girl in yellow is 'blooming', a term Millais used in his correspondence of this period to refer to young girls in maturation. The *Spectator* critic agreed: 'It appears [...] that the painter, was challenged by Mr Ruskin to paint "apple bloom", and here is the result; the painter having humanized the scene by painting human bloom as well.'[10] Ultimately this figure is risqué, even if *The Times* referred to her 'perfect girlish grace', while others perceptively noted the intense power of her gaze.[11] In its 'relaxed moody dreaminess',[12] *Spring* anticipates work of the broad Aesthetic movement, for which so many of Millais's pictures of this period seem precursors, such as James Tissot's *Le Printemps* 1865 and John Singer Sargent's *Carnation, Lily, Lily, Rose* 1885–6.[13]

Effie called *Spring* 'the most unfortunate of Millais' pictures'[14] because it took so long to finish – nearly four years – and ultimately was troublesome to sell. The dealer Ernest Gambart took possession of it after the Academy, although he did not like it. Millais wrote to his wife of the lukewarm reaction to his work in 1859 that

the prospect [of wealth] is further away than ever just now. There seems to be no knowing what is to happen. I have no faith myself in anything connected with art & at this moment wd sell my pictures for anything.[15]

Gambart still had not paid for it in the early autumn. Jacob Burnett of Newcastle bought it in 1861 for £650, and later it was purchased by a patron of Rossetti and Edward Burne-Jones, William Graham, who already owned *The Vale of Rest*. The picture was exhibited at the London International Exhibition of 1862 in South Kensington as *Apple Blossoms*, an innocuous title that deflected its deeper meaning. It was accompanied by *Autumn Leaves*, *The Vale of Rest* and, in an acknowledgement of his earlier Pre-Raphaelitism, *The Return of the Dove to the Ark* (no.25), giving visitors a good chance to see the recent shift in Millais's style and concerns. JR

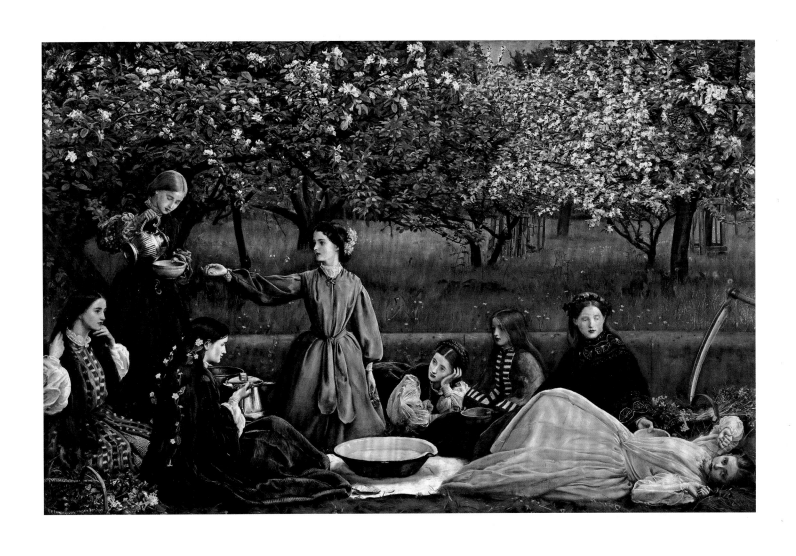

The Vale of Rest
'Where the weary find repose' 1858
Oil on canvas
102.9 × 172.7
Signed and dated in monogram lower left
Tate. Presented by Sir Henry Tate, 1894

Provenance Bt David Thomas White, sold to Benjamin Godfrey Windus; William Graham by 1881, his sale, Christie's, 2 April 1886 (87), bt Dechamps for Sir Henry Tate, who presented it to the Tate Gallery 1894

Exhibited Langham Chambers 1859; RA 1859 (15); London 1862 (649); Dublin 1865; Manchester 1887 (478); Birmingham 1891 (187); RA 1898 (9); NGL 1917; Wales 1955 (37); RA and Liverpool 1967 (57); New York and Philadelphia 1971 (103); Rotterdam 1975–6 (128); RA 1977 (151); Tate 1984 (100); Washington 1997 (13); Berlin 1998 (55)

The Vale of Rest was begun in October 1858 at Bowerswell.[1] Effie Millais wrote of her husband being again inspired by the richness of a Perthshire sunset and at once commencing painting while looking towards the garden wall at her family home, incorporating the tall oaks and poplar trees behind, framed by a purple and gold sky. Millais placed two nuns in the foreground, the one on the left actively digging a grave, the one on the right sitting contemplatively on the waiting headstone with her hands clasped and turning to face the viewer. A rosary with a cross at the end and a skull in the beads hangs by her side. Directly above the head of the labouring nun is a bell tower, and framing the scene on the extreme left a high wall thickly covered with ivy. Below is a pick, or mattock; on the far right twin wreaths lie in the same plane, possibly symbolic but also visually linked to the baskets of flowers and the scythe that border the figures in *Spring* (no.84). The picture is composed of parallel bands moving back into space, forming a one-point perspectival system wholly missing from the comparatively flattened-out *Spring*. The dirt pile between the figures, the stone steps, the line of the nun's heads, the hedges beyond, the wall and low roof of the church behind it, and a curiously level cloud on the left, all serve to organise the picture. Thickly set cypress trees and poplars

rise against the luminous evening sky, trees frequently found in graveyards and associated, respectively, with mourning and endurance since at least the classical era.

A sexton dug a grave for Millais to paint from in the churchyard of the ruined sixteenth-century Kinnoull Parish Church near Bowerswell.[2] Millais struggled with the face of the nun on the left and, after the Academy, repainted that of the right nun twice. The symbolism of the image is both explicit, in the twilight scene of a grave's preparation, and subtle, in the idea of the nun's marriage to Christ occurring at death. Consequently, Malcolm Warner has seen a visual allusion to wedding rings in the yellow funerary wreaths.[3] Millais's fellow Academicians felt that the picture would have been better if he had not included the nun on the right, seen as particularly ugly.[4] But without that figure, who seems disturbed and looks out towards the viewer, much of the depth of the scene would have been lost, as well the direct connection to the girl in yellow on the right in *Spring*. The pose of the left nun is complex and tense. She has removed her gown and focuses on her work, veins bulging in her arms, about to fling dirt on to the pile on her left. It is a rare image of figural action from an artist who specialised in statuesque postures of narrative tension.

Ruskin felt the picture lacked 'convent sentiment', that it was 'repulsive and ignoble', especially in the faces. For him, the picture was macabre in using beauty to occlude death. But he saw it as powerful, while alluding to the lack of labour in its execution, signifying Millais's downhill painterly route marked by flourish and expediency as opposed to careful and sober application and reflection.[5] For his part, Millais felt that Ruskin no longer understood his work or change in style, and that his influence had crested.[6]

According to the artist, the title and its attendant line, 'Where the weary find repose', derived from an English version of the Felix Mendelssohn part-song *Ruhetal*, which he had

heard his brother William sing:

> When in the last rays of evening
> golden hills of clouds ascend,
> manifesting themselves like the alps,
> I often ask tearfully:
> between them, where lies
> my longed-for vale of rest?[7]

The lines also recall Job 3:17 and, especially, Matthew 11:28–30, in which such repose is the gift of faith. And the connection made above between the nuns and Christ is evident in the first stanza of Hymn 114 in John Wesley's *Collection of Hymns, for the Use of the People Called Methodists* (1780):

> JESU, in whom the weary find
> Their late, but permanent repose,
> Physician of the sin-sick mind,
> Relieve my wants, assuage my woes;
> And let my soul on thee be cast,
> Till life's fierce tyranny be past.

James McNeill Whistler and Henri Fantin-Latour, on a visit from Paris, appreciated this picture, along with *Spring*, when they saw them at the Academy.[8] It is possible that they saw in *The Vale of Rest* a link to Gustave Courbet's earlier *Burial at Ornans* (1849), a far less poetic French Realist image of a countryside grave scene. But Millais's modernity was concerned with a new definition of beauty in these pictures, not an explication in a wilfully crude style of the lives of the various social classes of country folk as in Courbet: a definition of beauty that did not always square with public taste in the late 1850s. In 1898, M.H. Spielmann wrote of it as the artist's 'favourite picture – that by which, he said, he set most store'. He described it as a picture 'in which the sentiment is not mawkish nor the tragedy melodramatic – a picture, indeed, to look at with hushed voice and bowed head',[9] a clear assessment of the work's essential qualities. JR

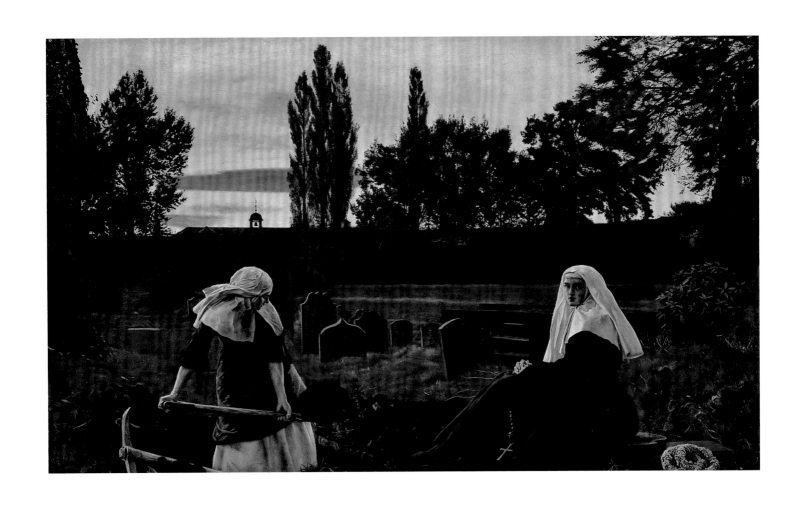

Meditation 1859
Oil on wood
30.3 × 25.3
Signed in monogram lower right
The Provost and Scholars of King's College,
Cambridge

Provenance George Frederick Samuel Robinson,
1st Marquess of Ripon by 1898; Mrs G.E.M. Lewis;
bequeathed 1985

Exhibited French Gallery 1859 (121), RA 1898 (1)

In November 1859 Millais exhibited this close-up image of a woman's head and bust at Ernest Gambart's French Gallery, 120 Pall Mall. It depicts Mary Eyres, a family friend from Kingston-upon-Thames.[1] Shown in left profile, she wears a luminous silk dress with a vivid purple belt and gleaming brass buckle. The picture has a striking and jarring colour scheme, notable in the blue and white striped pillow, the passionflowers and bright aquamarine earrings, and the black choker with onyx and inlaid pendant. The deep turquoise background makes this a study in varieties of blue. This presages colour contrasts that Millais would use in subsequent works such as *Sisters* (no.90). There are two burgeoning passionflowers and a band of

spiky green leaves in her hair, as well as a corsage of hot-house fuchsias, anemones and carnations on her chest; in this sense it resembles, in pose and flora, the earlier image of *Effie Ruskin* (no.41). The shading on her left shoulder and arm and below her head, as well as the lively highlights on her eyes and earrings, give the picture an impressive feeling of actuality and solidity.

Millais wrote to his wife:

Did you see [Tom] Taylor's criticism in the 'Times' on the passion flower head which they call '*Meditation*'. He says the face is '*incontestably lovely*' which is something but of course says it is '*slight*' wants finishing.[2]

Millais was aiming for beauty and an evocative sketchiness in this picture. The intensely delicate painting of the flesh areas, executed with small brushes, is set off by the broad treatment of her garment. The title *Meditation* is somewhat inappropriate, as Mary Eyres is instead rather fixedly watching something outside the frame of the canvas, perhaps even with a slight apprehension. Nonetheless, Millais was pleased with the work, writing that 'she makes a most lovely picture, and it is

admired more than anything I have ever done of the kind'.[3]

Intimate female heads, representing neither straight portraiture nor narrative, became prevalent around this period in the art of the Pre-Raphaelites and their followers. The introspection and expectant gazes in *Meditation* or *Only a Lock of Hair* (no.65) anticipate more theatrical poses of women in Anthony Frederick Sandys's *Mary Magdalene* of the same period or his petulant *Love's Shadow* (1867), and Rossetti's *Bocca Baciata* (fig.14, p.134).[4] These are early examples of this trend, although they are more subject-based than Millais's pictures of Mary Eyres and the Gray sisters.[5] But a religious work like Sandys's *Mary Magdalene* seems much in debt as well to other pictures by Millais, such as *The Bridesmaid* 1851 (no.27), with its sense of intense religious or mystical reverie and luscious cascade of hair.

Millais quickly gave up such heads, taking up the more lucrative practice of full- and half-length figures, as Sargent would do in the decades to come, in Aestheticist works that loosely travel in the field of history such as *Esther* 1863–5 (no.92) or the later orientalist *The Captive* c.1881–2 (no.105). JR

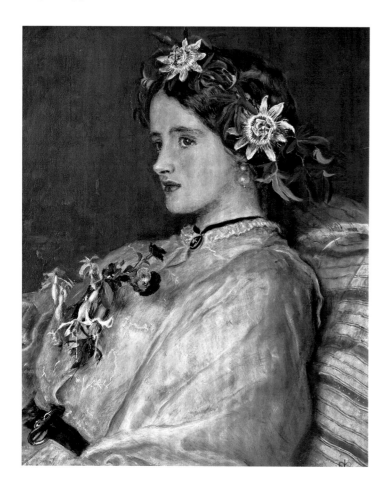

'Oh! that a dream so sweet, so long enjoy'd, Should be so sadly, cruelly destroy'd' – Moore's 'Lalla Rookh' 1872
Oil on canvas
127 × 83.9
Signed and dated in monogram lower left
Private Collection, courtesy of Peter Nahum at The Leicester Galleries, London

Provenance Agnew's; Christie's, 13 Nov. 1992 (111); Peter Nahum at The Leicester Galleries; Private Collection

Exhibited RA 1873 (1005); Nahum 2005 (16)

Painted shortly after *Hearts are Trumps* (no.110), this picture continues Millais's interest in female beauty, fashion, and floral accessories captured with active brushwork, but it is a rare attempt at an orientalist subject, anticipating *The Captive* of the next decade (no.105).[1]

The narrative is understated; it is an emblematic picture rather than an illustrative one. It does not represent a scene from the Irish poet Thomas Moore's orientalist romance *Lalla Rookh* (1817), as the title suggests. This story of lives and loves in ancient India had been popular in art and music since the Romantic period.[2] Analogies to music were common in Aestheticism, and the continued popularity of *Lalla Rookh* in so many different media in the 1860s and 1870s rendered Millais's reference highly topical.[3]

The identity of the sitter is not known, but she is striking with her iridescent green eyes. She stands before precisely the type of effusive floriated background that Millais had used earlier in the year in *Hearts are Trumps* and would later employ in his similarly toned portrait of *Miss Eveleen Tennant* 1874 (Tate). The exotic elements give her an ambiguous ethnicity, and this would reflect the setting of the poem. The combination of decorative elements such as her filigree earring and black velvet robe, with its multicoloured embroidery of 'Indian-pattern silk' trim patterned with white Greek anthemia,[4] and sense of a stilled, unexplained narrative, positions the woman in the broad realm of British Aestheticist style and beauty. This is characteristic of Millais in the period: a combination of ideas of the 'fancy picture' with Reynoldsian concepts of the grand manner along with a bravura brushstroke emblematic of Velázquez, and here an appropriate coloration combed from strands in Venetian and Romantic art. The vacant gaze of the woman, the way she absently fiddles with the damaged white orange blossoms between her fingers, engage the languid and slightly sinister sentiment of the lines quoted, creating a generic image of exotic melancholy difficult to place temporally, one as removed from Thomas Moore's imagined East (the poet had never travelled to India) as it is from the present day, and thus a play on artificiality and painterly performance. Spielmann aptly described it as a portrait of awakening disillusionment, and that symbolism is readily conveyed without any literal reference to Moore's lengthy fantasy.[5]

On the back of the picture is an Agnew's label and a sticker reading 'John Hay & Sons, 30 Grainger Street, Newcastle-upon-Tyne'. This was a firm of carvers and gilders, and it is possible that at one point the picture entered one of the famous Tyneside collections. JR

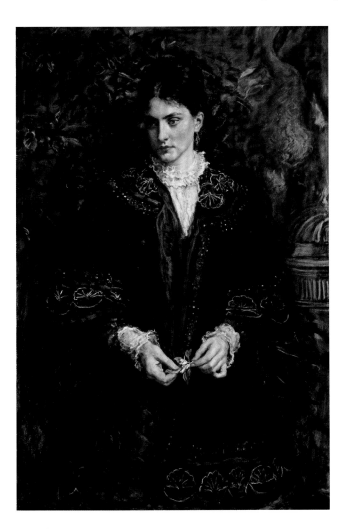

The Eve of St Agnes 1862–3

'Full on this casement shone the wintry moon,
* * * * * *

* * * *her vespers done,*
Of all its wreathed pearls her hair she frees;
Unclasps her warmed jewels one by one;
Loosens her fragrant bodice; by degrees
Her rich attire creeps rustling to her knees:
Half-hidden, like a mermaid in sea-weed,
Pensive awhile she dreams awake, and sees,
In fancy, fair St Agnes in her bed,
But dares not look behind, or all the charm
is fled.' – Vide Keats.
Oil on canvas
118.1 × 154.9
Signed and dated in monogram lower right
Her Majesty The Queen

Provenance Bt from the artist, possibly by Gambart; Charles Lucas by 1865; F.R. Leyland by c.1868; his sale, Christie's, 28 May 1892 (61), bt by his son-in-law, Val Prinsep; sold by his son Anthony Prinsep, Christie's, 22 June 1923 (125), bt Sir Edmund Davis; sold Christie's, 15 May 1942 (128), bt Smith, from whom acquired by H.M. Queen Elizabeth the Queen Mother and by descent

Exhibited RA 1863 (287); Paris 1867 (80); GG 1886 (29); RA 1898 (132); RA 1951–2 (305); Ottawa 1965 (94); RA and Liverpool 1967 (63); New York and Philadelphia 1971 (104); Tate 1984 (122)

Thirteen years after painting a small oil sketch of a woman disrobing in a chamber as an illustration to Keats's poem (*The Eve of St Agnes*, no.16), Millais returned to the theme and composition in a large-scale picture that is one of the high points of the artist's Aestheticist works. It is somewhat surprising how closely he followed the original conception, considering how far this picture is from his Pre-Raphaelite phase in terms of atmosphere and handling, but it was a poem that he clearly appreciated, and a composition that effectively caught its mood. In November and December 1862 Millais and Effie stayed at Knole in Sevenoaks, Kent, to paint this work in the King's Room. For a sufficiently spectral effect he painted her for a few hours around midnight on three consecutive nights in December 1862, Effie supposedly suffering in paltry garments that did little to assuage the chill in the unheated room.[1] The face was finished in London from Miss Ford, a professional model, and ultimately the resemblance to Effie is slight. Millais was still at work on it in March 1863 in preparation for the Academy exhibition. Effie wrote to her mother on 11 March that he was not

> getting on fast at all just now although he works very hard. I wish he would not put off his time painting Susan Anne [Mackenzie, in *Esther* 1863–5, no.92] just now, as he is so far behind with St. Agnes' Eve & it is quite impossible how I think he can do either and a pity to send only 2 Pictures of children however he may do wonders yet.[2]

Apparently he did, for Effie later wrote that it was completed in three and a half days at Knole and two days in the studio; if she is to be believed it is a remarkably short period of time for a large picture.[3]

The above lines from the poem that dramatise the protagonist Madeline's condition accompanied the picture at the Academy: she is in her 'maiden's chamber, silken, hush'd, and chaste', not knowing that her lover Porphyro watches from the closet. Awash in glittering silver-blue moonlight, she has undressed to her petticoat, corset and chemise, and stands in the centre of the room staring absently at the bed, anticipating the fulfilment of the prophecy that young virgins on St Agnes' Eve would receive visions of their lovers. Here Millais continues his interest in female psychology, imaging women in out-of-body states, as in *Mariana* (no.24) and *Ophelia* (no.37). The picture seems connected with the Pre-Raphaelite ideal of seeing the modern world through the Gothic past, literally accomplished here, and in Keats's poem in the lunar light streaming through the old glass of the sculpted 'casement high and triple-arch'd' on to the body of Madeline. The moonlight from the south window of the Knole apartment did not sufficiently illuminate the room or figure, so Millais had to use a bull's-eye lantern to light his canvas at night in his studio. This appears to be a continuation of Pre-Raphaelite claims of naturalism, yet of course Millais does not depict Madeline's spectral vision. However, as against Pre-Raphaelite specificity, the surroundings are not properly medieval; the so-called King's Bed at Knole visible on the left dates to the late seventeenth century. As in the earlier sketch, Madeline stands in undergarments, her blue bodice down at her legs. The treatment is broad on the left side, washed with vertical strokes as opposed to the openness of space and the translucent effects on the right. The head resembles contemporary works by Rossetti or Sandys, with an expression of longing, and a direct sensuality more mature than the girlish face in the earlier sketch.

The Eve of St Agnes was one of three pictures Millais sent to the Exposition Universelle in Paris in 1867. Years later, French critics acknowledged the effect it had on them. Joris-Karl Huysmans in *À rebours* (1884) described its ghostly aspect, with its thin finish and the spectral quality of the figure, along with its anti-Pre-Raphaelite colour, as a 'lunar clear green',[4] giving it a more poetic than naturalistic air, in keeping with the descriptions of Madeline and Porphyro as 'pallid', 'ethereal' and 'phantoms' in Keats's poem. Ernest Chesneau, in his survey of English painting, singled out this work as remarkably illustrative of the exact words in the poem, and consequently 'almost unintelligible to any one' who did not know Keats's lines.[5] The *Art Journal* was less enthusiastic at the time, writing that

> twelve years ago, in the last Universal Exposition, Mr Millais created a sensation by the drowning 'Ophelia:' surprise is now equally on every countenance at the sight of an ugly woman, distempered in aspect, under the title, 'the Eve of St Agnes'.[6]

In Paris, his pictures shared space with Frederic Leighton's massive classicising *Syracusan Bride* 1865–6 and *Golden Hours* 1864, the latter a romantic and musical tone picture not unlike the present picture.

The Aestheticist credentials of Millais's picture were recognised by its first owner, the shipping magnate Frederick Richard Leyland, whose collection was rich in works by Rossetti, Whistler and Albert Moore, and who commissioned from Whistler the famous *Peacock Room* in 1876 for his house at 49 Princes Gate. In the 1890s the picture was owned by the painter Val Prinsep, who described it aptly as 'a painter's picture',[7] and during the Second World War it was bought at the bargain price of £630 by a dealer on behalf of Her Majesty the Queen Mother.[8] JR

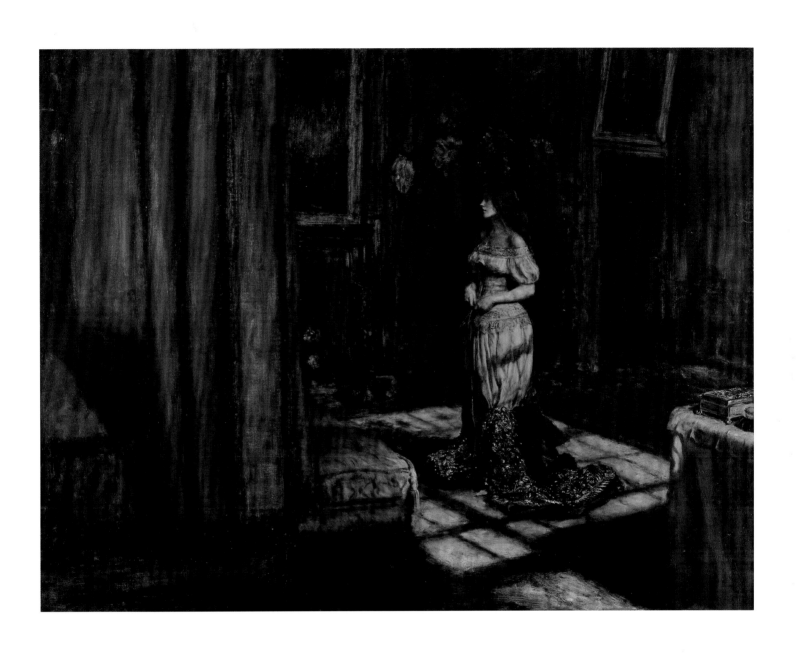

'Leisure Hours' 1864
Oil on canvas
88.9 × 118.1
Signed and dated in monogram lower left
The Detroit Institute of Arts. Founders
Society Purchase, Robert H. Tannahill
Foundation Fund

Provenance Sir John Pender; by descent to Marion, Lady
Des Voeux (née Pender) and by descent; Camilla, Lady Pender
in 1967; Roy Miles 1978; Founders Society Purchase, Robert
H. Tannahill Foundation Fund, Detroit Institute of Arts, 1978

Exhibited RA 1864 (289); Manchester 1864 (702); FAS 1881
(15); GG 1886 (8); RA 1898 (7); Manchester 1911 (245); RA
and Liverpool 1967 (66); FAS 1977 (35); Roy Miles 1978 (14);
Tate 1984 (126); Brown University 1985 (31); NPG 1999 (33)

The sitters for this portrait were Marion
Denison Pender, future wife of the British
colonial governor Sir George William des
Voeux and, on the right, Anne Denison Pender.[1]
Their parents were John Pender and his second
wife Emma, née Denison. He was a Scottish-
born businessman in textiles and submarine
telegraphy.[2]

Millais exhibited this work at the Royal
Academy along with three other child subjects.
Considering the expansion of his illustrative
work at the time, he appears to have been
trying to enter more fully the portrait market
and prove himself as a transcriber of modern
life and dress.[3] Ten-year-old Anne looks to the
left with a resigned and mature expression, one
that shows a mild haughtiness and which
rejects conceptions of the Romantic child of
innocence popular since the Enlightenment.
Marion, only seven, with her blue hair bow
and blank stare, better links with that
tradition, her innocence playfully reflected in
the uncomprehending gazes of the goldfish in
the bowl below her. In showing this duality in
girlhood, Millais created a picture that is both
portrait and a continuation of his concerns
from the late 1850s, as begun in *Autumn
Leaves* (no.82). And in formal terms the girls
are distributed in the composition as things
that exist to be exquisite, as Malcolm Warner
has written: their stillness increases their
objectness.[4] The three captive fish have been
read as reflective of the strictures of life for
girls of this class in the period, but can also
be seen as indicative of natural idleness.

The title of the picture implies such
sustained inactivity, and Millais put it in
quotation marks to preserve it as a phrase.
The concept of leisure and leisure time
developed as a by-product of mechanisation,
and was very topical in economic thought in
the 1860s. For these young girls, products
of the upper-middle class and the direct
beneficiaries of capitalism, there was little
alternative to leisure hours; work was not in
their present or future. The fish in the bowl
can represent the restrictions of everyday life
for these pre-teens, but also the static quality
of their lives. It would be difficult to imagine
Millais posing boys of the same age in the
same way (see *The Boyhood of Raleigh*
1869–70, no.94) without attributes of
imagination or future endeavour. But the
phrase 'Leisure Hours' was also frequently
employed in the title of collections of poems
and hymns, specifically as 'Lays of Leisure
Hours', by various authors through the
nineteenth century, providing a musical
connection so prevalent in the titles of works
of the Aesthetic movement.[5] Formal elements
such as the opulent screen, the vertical slats
of which frame the girls' heads, the delight
in flowers and elements of fashion[6] are also
typical of Aestheticist works, and presage
such elements in Millais's later multi-figure
compositions such as *Hearts are Trumps* 1872
(no.110).

The picture was displayed over the fireplace
in the dining room of Pender's London home
at 18 Arlington Street, Piccadilly. His collection
included a few Old Masters but was strongest
in mid-nineteenth-century British painters.[7]
A generous lender to exhibitions, he owned
The Proscribed Royalist, 1651 1852–3 (no.58),
and later acquired *The Parable of the Tares*
1865 (no.91). JR

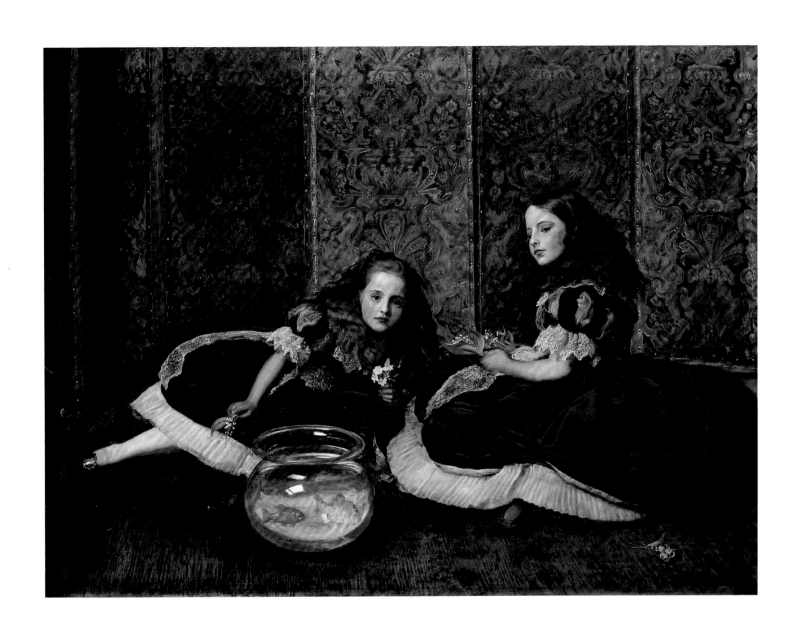

Sisters 1868
Oil on canvas
106.7 × 106.7
Signed and dated in monogram lower left
Private Collection c/o Christie's, London

Provenance C.P. Matthews by 1878; Mrs C.E. Lees by 1898; bt Brett at Christie's, 2 July 1971 (190)

Exhibited RA 1868 (6); London 1871 (323); Paris 1878 (179); GG 1886 (71); Guildhall 1897 (148); RA 1898 (142); Whitechapel 1901 (13); Glasgow 1901 (261)

A picture not seen in public since 1971, *Sisters* is Millais's masterpiece of ascendant Aestheticism, as the artist worked to stay on top of modern trends in art to follow up the largely positive response to his work at the Paris Exposition Universelle the year before. Subsequently, *Sisters* was one of ten pictures shown by Millais at the British section of the Paris Exposition of 1878, where Millais won a gold medal for his work in general, and was created Officer of the Légion d'Honneur, and where it appears to have influenced a new generation of artists.

This painting reflects an ability to deal with the complexities of unifying colour, abstract surface and formal design, resulting in a non-narrative image that anticipates and rivals similar works by contemporaries Whistler, Sargent and Albert Moore. The exactly square picture is inherently artificial in the way that the girls are so obviously posed, and this connects it firmly, along with its colour scheme, to the Aesthetic Movement. The writer and poet Algernon Swinburne, in a review of the Royal Academy of 1868, called for a 'beauty pure and simple'[1] in art, as encapsulated in his two favourite works in the exhibition, G.F. Watts's classicising *Wife of Pygmalion: A Translation from the Greek* and Albert Moore's *Azaleas*. He could not perceive how Millais's works might mirror this trend. Swinburne saw Watts's and Moore's pictures as remote from Millais's, whose works he found wanting in beauty and unworthy of his talent. In seeking beauty, *Sisters* renounces the ideal; it is grounded in Millais's realism, it insists on contemporaneity. But it is no straightforward realist portrait. It was an attempt at multiple likenesses, and its artificiality, as noted above, contributes to a compelling sense of strangeness. Hunt would later call it 'transcendent' and this is closer to the mark.[2] For Swinburne, and for the writer and critic Walter Pater, contemporary subjects were anathema to their ideology of beauty, and erudite artistic mannerisms drawn from past

art, as in Leighton's work, also had no place and diluted the artificiality they sought. But Aestheticism was broader than such a definition, and not always solely dependent on the atemporal or the past.

The models for *Sisters* were, from left to right, Millais's daughters Mary, Effie and Alice Caroline (Carrie) Millais, then around aged eight, ten and five respectively. They have flowing chestnut hair and are dressed in identical white muslin dresses and crossed fichus of a lighter tint, all trimmed with mildly discordant blue ribbons. A riot of crimson-pink, vermilion-pink and white azaleas along with green foliage fills the very near background,[3] those above Mary's head cresting to a brilliant flame. Swinburne was harsh in his assessment:

There is nothing here to recall the painter of past years. There is no significance or depth, no subtlety of beauty; there is the fit and equal ability of an able craftsman. The group of three sisters is a sample of this excellent ability; no man needs to be told that. There is no lack of graceful expressive composition; there is no stint of ribbons and trimmings. There is a bitter want of beauty, of sweetness, of the harmony which should hang about the memories of men after seeing it as an odour or cadence about their senses: and this beauty, this sweetness, this harmony, all great and all genuine pictures leave with us for an after-guest, not soon to pass or perish.[4]

In painting a picture of his daughters Millais had put himself in a bind. He could no longer easily access the poetics of nostalgia and eroticism that enhanced *Autumn Leaves* (no.82) and *Spring* (no.84), or the portrait of *Sophie Gray* (no.83). He was no longer painting the maturing sisters of his wife. It would have been unseemly to load these themes on his pre-teen daughters. Consequently he could hardly paint a picture that would prove erotic. Yet in this personalised reworking of Whistler's *Symphony in White, No. 1: The White Girl* 1862 (fig.16, p.159), Millais moved closer to that painter's monochromatic palette, and also traded the nascent self-awareness of the Gray sisters in *Autumn Leaves* for something approximating the uncertainty on the face of Whistler's lover Joanna Hiffernan in the later picture. He had created something new, a picture both personal and beautiful. And he

provided a further exploration of a contemporary conception of female beauty, one unrelated to past art. Such works, in addition to the many subject pictures for which his children posed, constitute a resolutely modern approach to domesticity from the perspective of a successful male artist, who could hardly be expected to show his affection for his family in any other way. Few male painters were so penetratingly intent on documenting their children in paint.[5]

The role of *Sisters* in the developing Aesthetic Movement can be seen in comparison to the work of John Singer Sargent, such as his masterpiece of children's portraiture, *The Daughters of Edward Darley Boit* 1882. The expressions of the four girls are remarkably similar in Sargent's painting to those in *Sisters*, with a range of facial views and levels of engagement. In both paintings, the youngest sitter is on the right and most directly addresses the viewer. In Millais's image, the emphasis is on immediacy in the claustrophobic floral background and patterning, while Sargent leaves space around his subjects, with evocative depth. The blank expressions of all seven girls thus encourage psychological readings that derive from their surroundings. Works such as *Sisters*, which Sargent would have seen in Paris in 1878, along with *Hearts are Trumps* 1872 (no.110) and *Mrs Bischoffsheim* 1872–3 (no.111), with their concentration on the wealthy upper-middle classes, rich surfaces and broad technique, suggestive reconceptualisation of Old Master painting, and intense interest in modern fashion, would stimulate Sargent to depict cosmopolitan life in Paris and London in a manner that reflected his age.[6] It is possible, if not very productive, to see in Sargent's *Carnation, Lily, Lily, Rose* 1885–6 the influence of Impressionism, due to the ostensibly out-of-doors subject, but here, where pretence of subject, of theme, indeed of sentiment has given way to a pure pleasure in colour, light, tone and texture, the influence is more properly Aestheticism. In this sense, it was perhaps Swinburne who misunderstood Millais's aims, for *Sisters* and Millais's subsequent Aestheticist child portraits did not make possible the airy fantasies of Moore's languid and loosely classical ladies, nor Whistler's women clad in Far East fashions but, rather, the ravishing portraiture of Sargent's mature style, and the atmospherics of John Lavery and the Glasgow Boys. JR

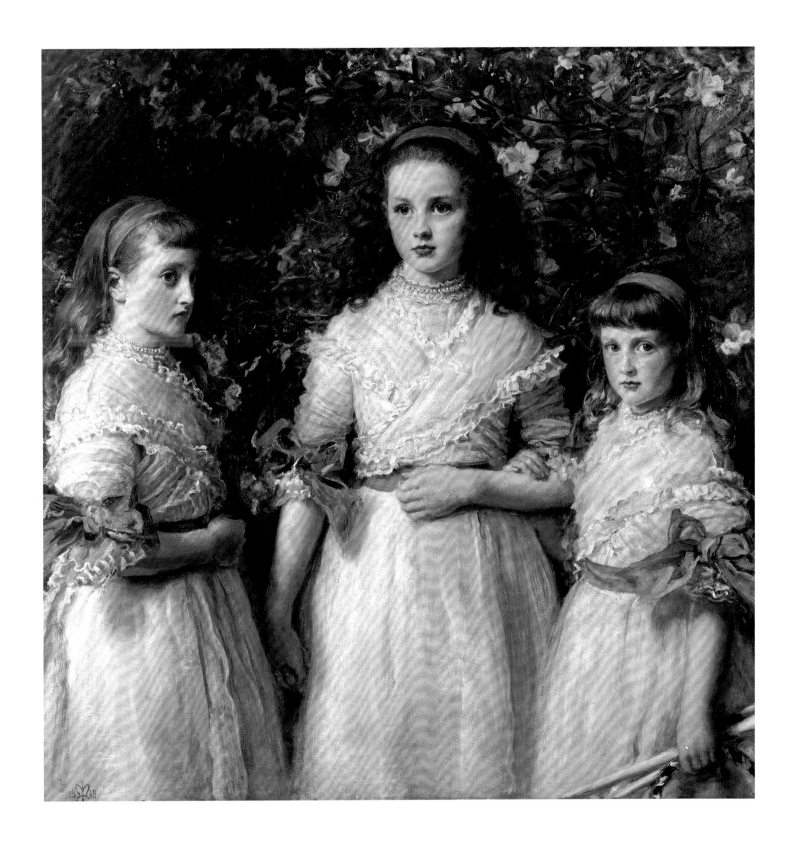

4
The Grand Tradition

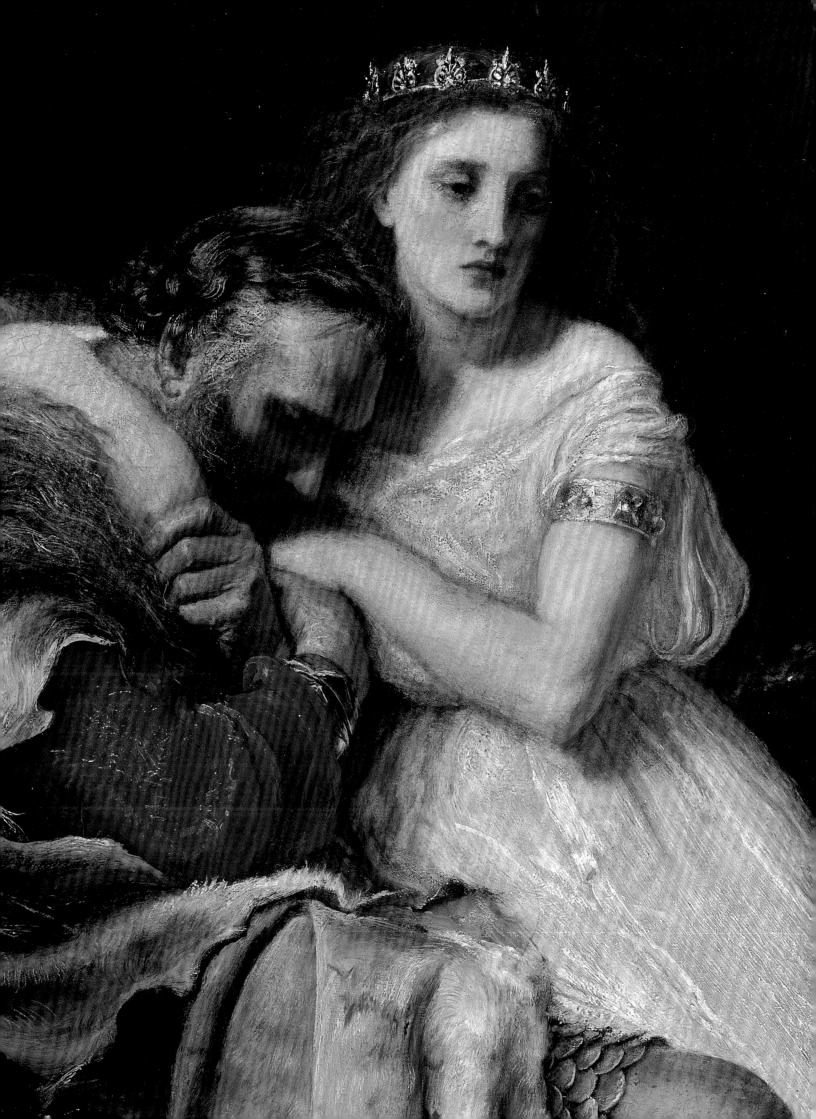

The Grand Tradition

From around 1870 Millais developed a manner of working that was peculiar to him and which endured right up to the end of his career. In terms of iconography, the historical subjects he became renowned for differed little from his mature Pre-Raphaelite works, being rooted in a Romantic tradition that assumed an organic perspective on human existence in maintaining that the past was indistinguishable in essentials from the present. Subjects continued to focus on the predicaments of ordinary individuals in historical circumstances, often in a dialectical relationship with one another, and figures were often composed in pairs to allow for the full engagement of the viewer's empathy. Rather than selecting a moment of climax Millais abided by his former principle of leaving the drama suspended so the ultimate conclusion became a matter of speculation in the audience's mind. However, the painter's later 'subject pictures' can also be seen as a reaction against his early productions in terms of their scale and robustness of execution. Writing as early as 1864, P.G. Hamerton defined the change as a shift from analysis and thought to synthesis and manual power.[1] While the perceived manliness of Millais's later technique certainly matches the theme of imperial ambition and struggle that characterises works such as *The Boyhood of Raleigh* (no.94) and *The North-West Passage* (no.96), the emphasis on fluid brushwork also relates to developments in his public persona as well as his concern to keep pace with the latest trends in modern art.

In contrast to his early manner, which signalled the submergence of his artistic identity within the Pre-Raphaelite Brotherhood, the broad technique Millais adopted after 1870 demanded recognition as a signature style that represented both the mind and body of the painter. As well as expressing the persona of the artist, gestural brushwork also communicated his identification with an egotistical masculine tradition epitomised by the painters Titian, Velázquez and Rembrandt, whose work similarly projects a manly existential stoicism. This style was crucial in conveying Millais's distance from both the 'fleshly' manner of Dante Gabriel Rossetti and the transparency of vision maintained by William Holman Hunt. Millais's advocation of studio production (in contrast to the Pre-Raphaelite principle of painting on location) not only explains the increased scale of his works but the physicality involved in their execution. It became his method to place the canvas side by side with the subject he was painting, so he could pace the length of the studio between each stroke of the brush with the aim of making the painted figure approximate to the appearance of the model. He worked with energy and vitality, as the art critic Sir John Forbes-Robertson later recalled:

> While painting he was on springs all the time. He literally rushed at the canvas, made some correction, then back again several yards from the easel. He seemed longer from the picture than at it, but the work was not slow in growing.[2]

The stamina involved in this kind of production became more pronounced following the move of the Millais family to the grand studio-house at 2 Palace Gate, Kensington, in 1877, which was dominated by the commodious studio on the first floor. This space was generally kept free of clutter, allowing Millais to give full vent to the execution of each work. Comparing the artist's studio with that of Frederic Leighton's, 'cumbered with bric-a-brac' and preparatory sketches, one commentator contrasted the fastidiousness and secrecy surrounding Leighton's creative process with the expansive honesty that characterised Millais's approach to his subject.[3]

Although as an artist Millais preferred to act rather than theorise, he did nevertheless engage in debates about art in defence of his own practice. In his later years he became

particularly preoccupied by what he termed 'the fascination of decay', the belief put forward in his article 'Thoughts on Our Art of Today', that the great works of the past were originally brilliantly coloured but had mellowed with the effects of 'time and varnish'.[4] In a published riposte to the artist, G.F. Watts argued the opposite, contending that the present colour and surface of Old Master works formed part of their original conception.[5] Both artists were in effect using the art of the past to defend their own practice, in Millais's case the high-pitched tonality of many of his canvases, which several critics found audacious, including J.B. Atkinson, who noted:

> It is perilous in the extreme thus to play with tones forced up to a pitch seldom permitted to nature herself. On the whole, since the time of the Venetians there has existed no colourist more highly wrought than Millais at this moment, except perhaps the late M. Delacroix of Paris.[6]

Although the vivid hues of works such as *The Boyhood of Raleigh* can be seen as an extension of the forceful colour of Millais's earlier Pre-Raphaelite productions, in his later works he became more concerned with blending tones rather than placing colours in start juxtaposition, as if signalling a shift in allegiance from pre-Renaissance to post-Renaissance art.

Millais's Old Master loyalties find a parallel in the modern painters with whom he aligned. Although he associated with no identifiable school following his Pre-Raphaelite phase, his art certainly connects with a number of painterly tendencies in modern British art. He shared with Scottish painters such as John Phillip, William Yeames and John Pettie an interest in historical genre as expressed through loose sketchy brushwork. The art of James McNeill Whistler finds an echo in the spatial ambiguities of *Esther* (no.92), while the aesthetically orientated biblical art of painters such as Edward Poynter, Albert Moore and Simeon Solomon influenced the ahistoricity of the costume in *Jephthah* (no.93). The classical dress of the women in the distance of this painting is the closest gesture Millais ever made towards Leightonesque classicism, a style he otherwise rejected as too idealising and design-based for the bravura illusionism he now espoused.

The synthesis Millais aimed for between past and present was undertaken with the interest of embracing a broad audience, not only connoisseurs sensitive to the issue of stylistic influence, but non-specialists eager for drama, characterisation and narrative. Millais was a great champion of the art of illustration, and there are clear parallels between his subject pictures and the designs he produced for the 'historettes' of writers like Harriet Martineau. Literary illustration occupied a low position in the academic hierarchy due to its perceived subservience to written narrative rather than the liberal arts Joshua Reynolds had promoted as the proper models for fine art. Due to the persistence of this line of thinking Millais's work was frequently accused of being exoteric in dealing with facts rather than abstract ideas, a criticism that has persisted right up to the present day.[7] However, seen in relation to his practice as a whole, the later subject pictures continue his earlier interrogation of the relationship between image and text, and the question of which was the most effective vehicle for exploring events unfolding in time. The great achievement of Millais in this field was his placing of the viewer in an Olympian position in using the image to extrapolate meaning beyond the frame itself. This approach not only allowed Millais to offer complex readings of historical and religious subjects, but also encouraged the production of 'enigma pictures' like *Speak! Speak!* (no.100), which have no basis in a particular history or text, and were concerned with probing meaning beyond the image itself. AS

The Parable of the Tares 1865
'But while men slept his enemy came, and sowed tares among the wheat.'
Oil on canvas
111.8 × 86
Signed and dated in monogram lower right
Birmingham Museums and Art Gallery

Provenance Sir John Pender, sold Christie's, 29 May 1897 (55); E.M. Denny, sold Christie's, 8 May 1925 (146); presented to Birmingham by Trustees of the Public Picture Gallery Fund 1925

Exhibited RA 1865 (528); Paris 1867 (80A); GG 1886 (3); Melbourne 1888–9 (186); Guildhall 1892 (151); Bristol 1893; RA 1898 (14)

The subject of this painting is taken from the Gospel of St Matthew 13:25, and is an uncharacteristically grotesque work in Millais's oeuvre. It illustrates the part of Jesus's parable that describes an enemy sowing tares (weeds or darnel) in the field of a farmer at night in order to choke the good seed he has sown. The painting is also unusual in that it was based on an earlier engraving of the same subject from Millais's illustrations for the Dalziel Brothers' *The Parables of Our Lord* (fig.15).[1] In producing this larger oil version Millais aspired beyond illustration towards allegory in offering a symbolist portrayal of the subject. The heavy dark tonality of the composition combined with pronounced caricature in the figure – the lurid break in the sky also suggesting the wings of Lucifer – can be seen as deliberate devices that give full impact to the message of evil. (G.F. Watts was to devise similar emblematic grotesque figures in allegorical works such as *Mammon* and *The Minotaur* during the 1880s). While some critics thought Millais's forcible use of effect and elimination of detail matched the metaphorical nature of the parable itself by suggesting rather than literally attempting to embody the fiend, others found the figure too literal and ridiculous, an embodiment of 'a rascally old Fagan.'[2] Here the reference back to illustration, to George Cruikshank's drawings of Fagin for Charles Dickens's *Oliver Twist* in 1838–41, was to suggest that Millais's personification of Satan was still embedded in the visual language of illustration, and that in failing to transcend the mundane earlier conception, the painting did not succeed in illuminating the moral significance of the text. Moreover, the simplicity of Millais's conception encouraged viewers to read the image purely in terms of the figure's physiognomy and racial features, thereby inviting association with crude anti-Semitic stereotypes.

The painting is significant regarding Millais's relationship with the Royal Academy at this stage in his career. Upon his election to the position of full Royal Academician in December 1863 he was required to submit a Diploma work as a specimen of his skill within six months. However, it was not until November 1864 that he presented *The Parable of the Tares* as a temporary deposit with the intention of gaining extra time to produce a finished piece. Although this was a common enough practice at the time, Millais was somewhat cavalier in his approach to the task, and in March 1865 informed the Council that he would submit *The Parable of the Tares* as his Diploma work after all.[3] Although the Council's subsequent rejection of the *Tares* surely relates to the painter's non-compliance with the rules of the institution, it can also be taken as a sign that the strained relations that had festered between the two parties since the 1850s were not entirely mitigated by his election as an Academician. The Council may also have felt it was bad taste on Millais's part to base his Diploma work on an illustration. One anecdotal explanation of the picture's rejection was that the face of the devil was intended as a caricature of one of the Academy councillors, leading Walter Sickert to speculate the model must have been the 'handsome old Jewish RA' Solomon Hart.[4] AS

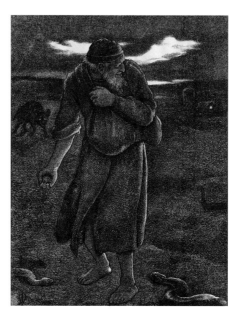

Figure 15
The Tares, from *The Parables of Our Lord*
Published by the Dalziel Brothers, 1864
TATE

Esther 1863–5

'Now it came to pass on the third day, that Esther put on her royal apparel, and stood in the inner court of the king's house.'– The Book of Esther, chap.v., ver.1

Oil on canvas

105.5 × 75

Signed in monogram lower left

Collection of Robert and Ann Wiggins, USA

Provenance Bt from JEM by Gambart, c.7 Feb. 1865; Thomas Eustace Smith by 1873; Alexander Henderson, 1st Lord Faringdon by 1887, his sale Sotheby's, 13 June 1934 (122); Sotheby's Belgravia, 19 March 1979 (26); sold by the British Rail Pension Fund, Sotheby's, 19 June 1990 (36); Sotheby's New York, 20 April 2005 (77)

Exhibited RA 1865 (522); Liverpool 1867 (51); GG 1886 (118); RA 1898 (35); Manchester 1911 (239); BFAC 1912 (3); Vienna 1927 (102)

Esther began as a New Testament subject, with Millais's 1864 Account Book stating that he was painting Susan Anne Mackenzie – the model recorded as posing for *Esther* – as Mary of Bethany.[1] According to the Gospel of John 12:3, Mary was the woman who anointed Jesus with ointment and wiped his feet with her hair. Mackenzie, the daughter of a baronet from Perthshire, was a close friend of the garden designer Gertrude Jekyll and known for being 'brilliant, musical and artistic'.[2] In selecting her as model Millais may have thought her dramatic skills appropriate for the sensuous and emotive subject he had in mind. Although it is not clear exactly when he changed the figure to represent the Jewish queen Esther, the decision may have been prompted by the opportunity to borrow the splendid yellow jacket given to the national hero General

Gordon by the Chinese government. Val Prinsep painted the same Mandarin uniform in his full-length portrait of Gordon exhibited at the Royal Academy in 1866, but with his picture Millais boldly turned the jacket inside out to accentuate the brilliant abstract colour of his design. Presumably he felt such a sumptuous costume was inappropriate for Mary of Bethany and more suited to conveying the opulence of the Persian king Ahasuerus's court.

Esther was one of the Old Testament subjects beloved by seventeenth-century Dutch painters. She was the Jewish bride of the Persian king, and the painting shows her psyching herself up to enter Ahasuerus's chamber in order to save her people from Haman's plot to murder the Jews. By defying the decree that denied a queen access to the king without being summoned, Esther was risking her own life, and Millais accordingly demonstrates the queen's bravery and guile by her resolute demeanour and gesture of releasing her hair to entice the king (a feature probably adapted from the earlier Mary of Bethany idea). While her flowing auburn tresses can be seen as a Rossettian device that emphasises Esther's sensuality, the lack of idealisation in her face draws attention to the fact that it is a real woman who is steeling herself to make the appeal, and it is this element of portraiture that lends integrity to the subject. The tension between the psychological import of the moment and the rich setting is dramatised by the startling bold masses of blue, white and yellow, which, like

Rossetti's *Ecce Ancilla Domini* 1849–50 (which might have influenced the colour scheme), has the visual effect of reinforcing the flatness and spatial ambiguities of the composition.

Millais was likely to have been inspired by the recent work of Whistler, particularly his *Symphony in White, No. 1: The White Girl* 1862 (fig.16, p.159). This similarly presents a full-length figure in a shallow setting and uses a limited colour range to emphasise the artificial nature of the pictorial surface. In his review for the 1865 Academy exhibition, William Michael Rossetti compared *Esther* with another picture of Whistler's, *The Little White Girl* 1864 (Tate) and set the 'exquisiteness' and 'delicious harmonies' of Whistler's design against the 'flashing whites' and 'daring tones' of Millais's production.[3] Later in the century Marion Spielmann described *Esther* as 'The most modernly treated of Millais's early works', a painting that anticipated in its forceful leaps of colour the 'audacious brilliancy' of the Post-Impressionists.[4] *Esther* can thus be seen as a work that shares many characteristics with the progressive Aestheticist art of the 1860s: the decorative colour, striking use of anachronisms, understated mood and conceit of depicting a British model with markedly non-Semitic features in antique dress.[5] Significantly the painting soon entered the collection of one of the most prominent patrons of the Aesthetic school, that of Thomas and Martha Eustace Smith. They may have been attracted to the work by its affinities with Watts's *Choosing* 1864, one of the couple's first purchases. AS

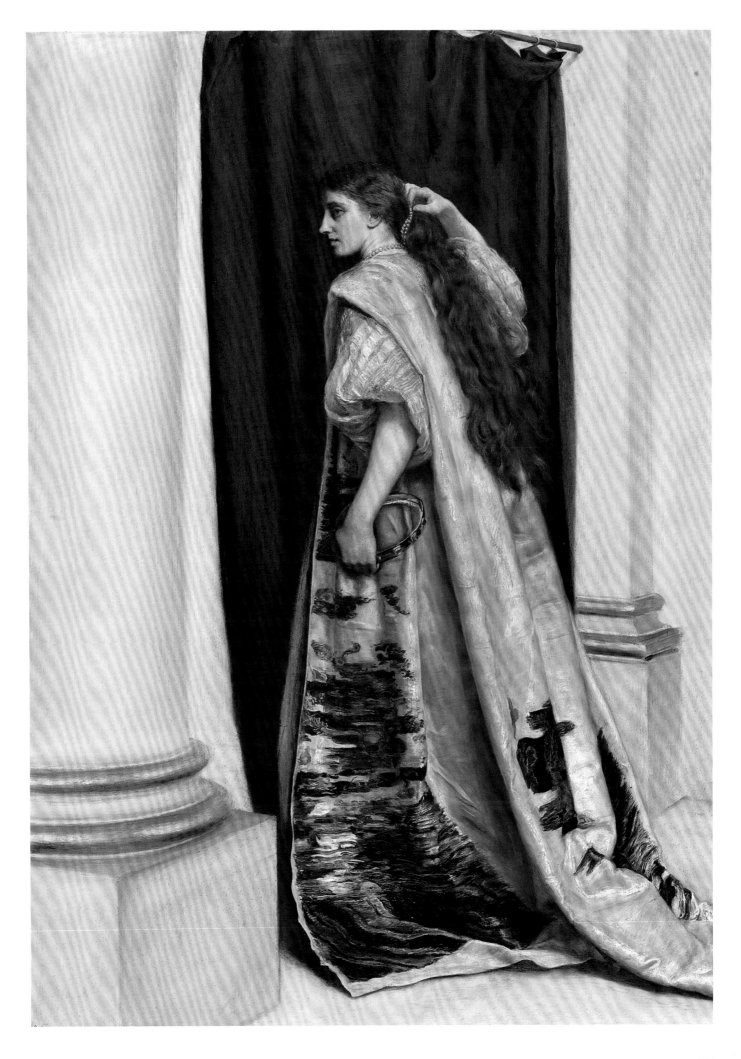

93

Jephthah 1867
*'Alas, my daughter, thou hast brought me very
low, and thou art one of them that trouble me,
for I have opened my mouth unto the Lord,
and I cannot go back.'*
Oil on canvas
127 × 162.7
Signed and dated in monogram lower left
National Museum of Wales, Cardiff

Provenance Samuel Mendel; Christie's, 24 April 1875 (421);
bt Agnew's; Albert Grant; William Armstrong by 1886;
Christie's, 24 June 1910 (77); bt Agnew's; Charles Fairfax
Murray; Christie's, 14 Dec. 1917 (60), bt William Walker
Sampson for Charles Stone; by descent to Isadore Stone, who
bequeathed it in 1964

Exhibited RA 1867 (289); GG 1886 (86); Guildhall 1895
(22); RA 1898 (98); RA and Liverpool 1967 (71); Manchester
and Birmingham 2005 (71)

Jephthah is Millais's greatest history painting
of the 1860s. In it he channelled his decade of
experience working in the field of illustration,
his consistent interest in biblical imagery,
especially Old Testament stories that presage
the New Testament, and a continuing
fascination with family dynamics in his art.
As with much of the artist's production in this
period, there is an overlap between Millais's
painted and printed work. *Jephthah* bears a
resemblance to *The Unjust Judge*, engraved
by the Dalziel Brothers for *The Parables*, in
its biblical subject, central image of a woman
and an authority figure, and ethnic types
with exotic accessories. Despite its Baroque
movement of figures and draped stage-like
setting, and return to the Neo-Classical theme
of *exemplum virtutis*, in interpreting a scene
from the Book of Judges, Millais radically
transformed the way that such tales were
told in paint, employing a number of written
sources while imaginatively reworking
this gripping tale of morality, responsibility
and sacrifice.

Jephthah was a judge in Gilead in
contemporary north-west Jordan, the outcast
offspring of a man also called Gilead and a
prostitute. He led the besieged Israelites into
battle against Ammon to the south-east
(Judges 10:6–12:7). He vowed to God that,
if successful in battle, on returning home
to Mizpah in the contemporary West Bank,
he would sacrifice the first creature he
encountered. Ammon was routed. Jephthah
returned home in triumph. Most artists
depicted the next moment in the narrative
(Judges 11:34–5):

> his daughter came out to meet him with
> timbrels and with dances [...] And it came
> to pass, when he saw her, that he rent his
> clothes, and said, Alas, my daughter! thou
> hast brought me very low, and thou art one

of them that trouble me: for I have opened
my mouth unto the LORD, and I cannot go
back.

Accepting her fate and not wishing to
compromise her father's religiosity, Jephthah's
daughter went to the mountains for two
months with her maidens to bewail her
virginity, to commiserate that she will die
childless, and then dutifully returned to be
sacrificed as a burnt offering. A devastated
Jephthah outlived her by only six years.

Millais imagines the scene after the horrific
meeting of conquering father and doomed
daughter. They sit embracing in his tent, the
full repercussions of his precipitate vow
weighing on their features, their attendants
either in shock, in prayer, or exiting mournfully.
Critic Sidney Colvin was not impressed. It is, he
wrote, 'a study, however perfect, of a life-
guardsman embracing an English girl in a ball-
dress, two negroes,and more English girls in
opera-cloaks in the background'.[1] Colvin could
not move beyond the realistic perfection of
figural types that Millais cannily employed in
his staging of a moment of grave psychological
tension. This had been a common complaint
regarding his art since *Christ in the House of His
Parents* 1850 (no.20), and it reveals Millais's
steadfast commitment to realist portraiture as
the basis for his symbolic modern style, despite
almost two decades of criticism. Colvin's
references to a soldier dedicated to guarding
the monarchy, dandied-up English girls, and
stereotypical racial types revealed *Jephthah* to
be an outré cross-cultural hotchpotch; it struck
him as vulgar and artificial.

In his diary Charles Dodgson (Lewis
Carroll) described the work as 'great' and
'noble', and identified Miss Ward, sister of Lady
Hunt, as the daughter, although J.G. Millais
maintained she sat for the woman turning back
to the main scene in the background. Dodgson
concluded: 'the other figures are a curious
nondescript lot, two Hottentots, an Egyptian
woman, an Italian girl (very like Miss Lydia
Foote), and an Arab boy etc.'[2] The Jamaican-
born Londoner Fanny Eaton, a charwoman
married to a cabman, sat for the tall Middle
Eastern woman in orange with her eyes shut
on the right.[3] Colonel Charles Hugh Lindsay,
third son of the Earl of Crawford, posed for
Jephthah.[4] Hardly nondescript, such figures
represent one of Millais's few attempts to
engage in the kind of variety of picturesque
humanity familiar in Orientalism, the exotic
imagery of North African or Middle Eastern
subjects popular in European art since the
Romantic period. On the other side of the
father and daughter kneels a black woman

with a decorative white veil over her head,
perhaps the daughter's former nurse, who
holds her hands over her heart penitently, and
who looks up, not to the protagonists, but to
heaven. She was described as 'Ethiopian'.[5] She
is the only person who continues to pray on
behalf of the young daughter, while the maids
and attendants all exit, resigned to her fate.
The young black man on the far left sits on a
pillow with his legs crossed, and is framed by
the massive porphyry pillar and the brilliant
blue cloak thrown over the chair. He looks up
at the central scene with a sparkling sense of
inquisitiveness and empathy.[6] These two
figures bracket the main personages with an
intense spirituality befitting the story. Their
expressive faces grip the spectator, and with
them the viewer forms an expansive triangle
around the father-daughter group. The
otherness of these figures is played up,
especially in the female's facial physiognomy,
such as the nostril size and lips, qualities that
contrast the markers of ethnicity of the black
model with the virginal purity of the idealised,
almost featureless daughter.

Wrapped in a superbly rendered animal
hide, Jephthah is a Lear-like figure with
unseen and thus unseeing eyes, very similar to
James Barry's or Benjamin West's conceptions
of that deranged ancient king of the Britons.[7]
In this reworking and updating of historical
imagery from late eighteenth-century British
painting, Millais accentuates Jephthah's full
brow, as does Barry in his *King Lear Weeping
Over the Body of Cordelia* 1786–7, and the
flapping tufts of animal fur on his cloak
stand in for the sublime locks of the mad
British monarch, who lost not one but three
daughters due to his rash decisions.[8]
Jephthah's heavy hands grasp both the frail
right hand of his child and his fulsome cloak.
The spiral vortex pattern of the hide below
his arm sucks in the viewer's attention,
illuminating the whirlpooling depths of
his despair.

In attempting to do something new with
this tale Millais appears to have drawn on
two sources, neither visual. The first is George
Frideric Handel's final finished composition,
an oratorio entitled *Jephtha* of 1751 with
libretto by Thomas Morell. For the middle
classes, the oratorio was popular for the
emotionality inspired through its sacred
music, with tales clearly and repetitively told.
The connections with history painting are
relevant, and point to the particular audience
Millais was targeting in his work. The second
is a now-obscure poem by the Yorkshire-born
Charles Heavysege (1816–76), who spent
most of his life in Montreal, and who

published his lengthy poem, *Jephthah's Daughter*, in 1865.

There are many exquisitely rendered still-life elements in this picture. On the leopard-skin rug in the right corner lie cymbals and a music box, the peaceful instruments of the daughter's and her attendants' welcome to her father, and across in the left foreground are a scimitar and a shield that reflect Jephthah's mournful rumination from lines 17 to 25 of Heavysege's poem:

Strip me of all, now that my child is gone;
Sword, shield, and judge's staff, all emblems take
That may betoken proud authority:
Take Gilead's chair, take all you promised me –

Alas! not Gilead's chair, with present power,
Nor future fame from this proud feat of arms,
Nor all the fulness of these fertile hills,
Were an equivalent for yon lone lamb,
That hither came, gay skipping from the fold.

Gilead's chair, not mentioned in other versions of the story, is here imaged in an Egyptian style. Richard Ormond has pointed out that Millais copied this from a chair designed by Hunt after his first trip to the Middle East in the 1850s.[9] The battle-nicked repoussé shield of gold and metal appears to be an agglomeration of Turkish and Celtic forms, and it is clear that Millais has here strayed far from the rigorous object research of his Pre-Raphaelite works.

Nonetheless, the aggregate is appealingly effective, the peacock-feather fan held by the attendant in the far left background exacerbating the exotic milieu. The scimitar blade is pristinely clean, but alludes to the daughter's eventual death by her father's hand, the chilled and violent antipathy to the warm brass celebratory cymbals spread across the floor.

The Jewish Manchester cotton and shipping merchant Samuel Mendel purchased *Jephthah*. He would also own *Chill October* (no.125). These works later entered the collection of the armaments manufacturer and shipbuilder William George Armstrong at Cragside in Northumberland, built by Richard Norman Shaw. There is a wash study of the two main figures at the British Museum. JR

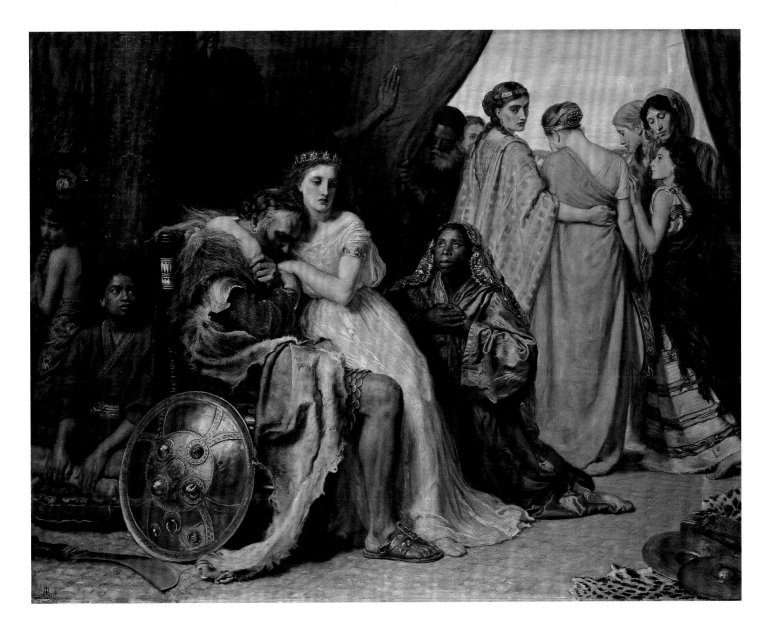

The Boyhood of Raleigh 1869–70
Oil on canvas
120.6 × 142.2
Signed and dated in monogram lower left
Tate. Presented by Amy, Lady Tate in memory
of Sir Henry Tate, 1900

Provenance James Reiss, sold Christie's, 12 May 1900 (43),
bt Agnew's; Sir Henry Tate, presented to the Tate Gallery by
his widow 1900

Exhibited RA 1870 (334); FAS 1881 (11); GG 1886 (96);
Manchester 1887 (474); RA 1898 (126); RA and Liverpool
1967 (75); Devon 1969, 2000–1 (loan)

The Boyhood of Raleigh was one of Millais's
best-known paintings, the theme of youth
anticipating adventure balancing that of
impotent old age reflecting on experience in
the artist's other famous image addressing the
limitations of imperial endeavour, *The North-
West Passage* (no.96). Walter Raleigh was one
of the most celebrated explorers of the
Elizabethan age, as commemorated in
accounts such as J.A. Froude's *England's
Foreign Worthies* 1852, which reputedly
inspired this picture.[1] Millais presents Raleigh
as a young lad mesmerised by the exploits
relayed by a swarthy sailor, whose dynamic
gesture, together with the toy boat and exotic
birds at the periphery of the image, portend
the boy's future destiny. According to J.G.
Millais the background was painted near
Bicton House, the home of Lady Rolles on the
Devonshire coast. Millais stayed at the
Octagon in Budleigh Salterton while painting
the setting. A professional model posed for
the sailor while Millais's eldest son, Everett
(1856–97) sat for the figure of Raleigh, and
his second son George (1857–78; no.115)
for the other boy.[2] The latter died young,
which, with hindsight, adds to the sense
of vulnerability about the children as they
huddle behind the protective edge of the
sea wall.

The understatement of the image is
characteristic of Millais, and the idea of
showing two boys absorbed in the sailor's
story may have been suggested by the artist's
1862 illustration *Sorting the Prey*, from Harriet
Martineau's *The Anglers of the Dove*, which
shows two gentlemen in Elizabethan dress
crouching as they string a batch of fish.[3] In the
detail of the costume and thick application of
rich colour, *Raleigh* references the style of
Titian as being appropriate for a subject of the
same period, Titian being the favourite
painter of the Spanish king Philip II,
England's arch enemy during the sixteenth
century. The drama of the painting centres
on the contrast between the two boys' emotive
responses to the sailor's tale. Walter's gaze
is transfixed on the seaman suggesting the
impact of what he hears on his imagination,
while the other boy looks up quizzically as
if merely interested. The drawing for the
composition reproduced in J.G. Millais's
biography emphasises the importance of
the horizon line in establishing the body
language, and by extension the import of
the narrative. In the finished picture Millais
tightens the eye contact between Raleigh
and the sailor, but projects the significance
of their rapport beyond the frame via the
man's expansive gesture.

Despite the obvious patriotic sentiment
of the picture, Millais also plays on the
viewer's prescience of Raleigh's fate, the fact
he was later imprisoned for treason and
subsequently executed. Behind the seaman's
back, hidden from the boys' view, lie a couple
of dead exotic birds, one of which can be
identified as a toucan. These are positioned
as if about to be decapitated by an anchor that
cuts a swathe into the composition, a feature
reminiscent of the scythe that prompts the
idea of youthful mortality in *Spring* (no.84).
Millais also includes a wicker basket
decorated on the exterior with the yellow and
red plumes of an exotic bird. From a distance
this could easily be mistaken for a sunflower,
an allusion perhaps to the lure of El Dorado
and the hubris of adventure. AS

A Somnambulist c.1871
Oil on canvas
151.8 × 90.9
Signed and dated in monogram lower left
Bolton Museums & Art Gallery

Provenance Mrs Richard Johnson; anon. sale Sotheby's,
19 Nov. 1969 (166), bt by Bolton Museum and Art Gallery

Exhibited RA 1871 (313); Manchester 1887 (470)

A Somnambulist ranks as one of the strangest
works in Millais's oeuvre. It is a nocturnal
subject that shows a woman in a white
nightgown, holding a brass candlestick,
sleepwalking along a coastal path perilously
close to the edge of a cliff. The tip of the candle
wick is a barely lit ember indicating that it
has just been extinguished by the sea breeze.
Behind the path in the distance is a building
with a burning hearth visible through the
window, and beyond that a row of gas jets
suggesting a promenade or railway track.
The fixed, blank expression of the woman,
her ungainly hands and feet, and the
disappearance of her body under the heavy
folds of her gown reinforce the ethereality
of the moment while denying eroticism.

The title of the painting was adapted from
Vincenzo Bellini's opera *La Sonnambula*
(1831), which Millais might have seen
performed at Sydenham, south-east London, in
April 1871.[1] The moment depicted by the artist
possibly relates to the opening scene of the
opera, in which the villagers tell the sceptical
Count Rodolfo of a spectre, a woman dressed
in white with her hair undone, who appears
on dark, misty nights, although it is equally
possible that the figure represents the heroine
Amina in the act of sleepwalking. However,
the modernity of the setting, suggested by the
distant building and lights, which one reviewer
at least took for a coastguard station and a
row of marine-parade gas-jets, also prompts
association with Wilkie Collins's sensational
thriller *The Woman in White*, first issued as a
book in 1860.[2] According to Millais's son, the
dramatic origins of this novel lay in an incident
that occurred when the Collins brothers were
accompanying Millais home after dinner at
their house. At one point they heard a scream
from the garden of a nearby villa, and a
beautiful young woman rushed out dressed
in a flowing white robe that shone in the
moonlight.[3] The woman was Caroline Graves,
subsequently Wilkie Collins's mistress, who
had been kept prisoner by a man in the villa
under mesmeric influence.

If Bellini and Collins provided the narrative
foundation for the painting, it was Whistler's
picture *Symphony in White, No. 1: The White
Girl*, exhibited in London in 1862 as *The
Woman in White* (fig.16), that gave visual
inspiration.[4] Millais's painting follows
Whistler's composition in presenting a full-
length female in white with unbound hair
staring vacantly ahead, her arms hanging
by her sides, and the bottom of her garment
tapering to the right. While the heavy
brushwork of the nightgown in Millais's
composition echoes the thick impasto on the
dress in Whistler's painting, the dark blue-grey
background enlivened by dots for the stars and
street lights resembles Whistler's controversial
London *Nocturnes*, the first of which was
exhibited at the Dudley Gallery in London
in 1871. Millais's painting can thus be seen
as an experiment that combines Whistlerian
landscape and figurative art with the English
tradition of narrative painting. The
extraordinary appearance and narrative
ingenuity of this work is evidence of its
adventurousness. AS

95

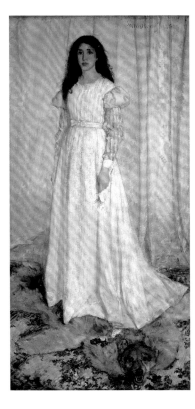

Figure 16
James McNeill Whistler
(1834–1903)
*Symphony in White,
No. 1: The White Girl*
1862
NATIONAL GALLERY OF ART,
WASHINGTON, HARRIS
WHITTLEMORE COLLECTION

The North-West Passage 1874
'It might be done, and England should do it'.
Oil on canvas
176.5 × 222.2
Signed and dated in monogram lower right
Tate. Presented by Sir Henry Tate 1894

Provenance H.W. Bolckow in 1874, by descent to C.F.H. Bolckow, family sale Christie's, 5 May 1888 (53), bt Agnew's; Sir Henry Tate, presented to the Tate Gallery in 1894

Exhibited RA 1874 (320); Paris 1878 (175); FAS 1881 (9); GG 1886 (60); Manchester 1887 (476); RA 1898 (129); RA and Liverpool 1967 (84); Barbican 1992 (77); Tate 1997

The North-West Passage was one of Millais's most popular works, an image that focuses on a moment of private epiphany to inspire patriotic sentiment. The North-west Passage was the name given to the treacherous sea route from the Atlantic to the Pacific round the North American continent. Since the sixteenth century several Arctic expeditions had attempted and failed to discover the passage, defeated by the dangerous terrain and dense network of islands that are indicated on the map, which forms a halo around the young woman's head in Millais's painting. The Elizabethan voyager Henry Hudson had expired on his voyage to the polar seas when his crew mutinied, as commemorated in John Collier's painting *The Last Voyage of Henry Hudson* 1881. Millais's audience would have been more familiar with the fate that befell Sir John Franklin's mission of 1847, the disastrous consequences of which only fully emerged in 1857 when the remains of the expedition, including human skeletons, were discovered. This tragedy inspired Edwin Landseer's monumental *Man Proposes, God Disposes* 1863–4, which shows two polar bears ravaging the remains of a shipwreck.

Millais's painting arose from a renewed interest in Arctic exploration encouraged by the progress made by foreign scientific expeditions. In 1872 a deputation to the Chancellor of the Exchequer requesting Government assistance for Arctic research led to heated correspondence in the press, which in turn encouraged the despatch of Sir George Nares's expedition to the polar seas in the spring of 1875.[1] Millais's picture played a key role in swaying public opinion in favour of this voyage, as one commentator noted:

> Captain Nares has confessed to the strong influence which the work had on himself, and there can be no doubt that *Punch's* imitation of the work – in which Mr Disraeli was represented as an old sailor – did much to popularise the effect.

Indeed, shortly before it left, Millais was invited to dine with the captains of the polar expedition.[2]

The North-West Passage stands apart from a succession of representations on the theme of Arctic exploration by being set in a modest domestic interior, and in this Millais may have been influenced by James Tissot's nautical paintings of 1873, particularly *The Captain's Daughter*, which communicates a similar sense of frustration with the confines of home, as well as setting the aspirations of youth against the experience of old age (an idea Millais inverts in his painting). By departing from convention, Millais was acknowledging the topicality of the subject in assuming that his audience would be able to comprehend the depicted situation. The French were apparently nonplussed by the picture when it was exhibited in Paris in 1878, lacking the wealth of associations conjured up in the English mind by the title.[3]

The painting shows an aged mariner (modelled from Captain Edward John Trelawny, a friend of the poets Lord Byron and Percy Bysshe Shelley), staring out at the viewer with both fists clenched as the thought enunciated in the title of the picture comes to his mind. His daughter sits on a stool by his side and gently holds his hand as she reads to him the pages of a log book. Scattered around the room are maps, charts, flags and a telescope. On the wall hangs an engraving by William Bromley after Robert Boyer's painting of Nelson, published in 1809 on the anniversary of Trafalgar.[4] Another picture shows a ship dwarfed by ice floes. These features supplement the theme of manly endeavour but appear shabby and worn like the weather-beaten mariner's face, and like him they are tempered by a feminine touch, with the flowers that enliven the room. Several studies for the composition show that at one point Millais thought of including two children looking at a globe to enhance the idea of imperial ambition across the generations, but eliminated this detail as being too distracting from the sentiment conveyed by the old man's demeanour of defiance and helplessness. This part of the picture was cut away and a new piece inserted in its place.[5]

The pride of the mariner indicated by his resolute expression and untouched glass of rum punch, is used by Millais to foreground the pathos of his situation. By acknowledging the late portraiture of Titian and Rembrandt in the expressive treatment of the face Millais was encouraging empathy, but he also uses the paraphernalia scattered around the room, rather than an empty backdrop, to accentuate the man's frustration at not being at sea. The view through the window to a seascape reminiscent of Whistler's *Nocturnes*, not only demonstrates Millais's skill in using multiple styles to portray dimensionality without linear perspective, but also his concern to harness style with meaning. The emptiness suggested by the *Nocturne* thus contrasts with the rage and vulnerability exposed in the rugged features of the old man.[6] AS

The Princes in the Tower 1878
Oil on canvas
147.2 × 91.4
Signed and dated in monogram lower left
Royal Holloway College, University of
London, Egham

Provenance Bt from Millais, 27 March 1878, by FAS; sold
Christie's, 28 May 1881 (86), bt Thomas for Thomas Holloway

Exhibited RA 1878 (21); Agnew's 1879; FAS 1881 (14);
Manchester 1885 (392); GG 1886 (63); RA 1898 (150); RA
and Liverpool 1967 (93); Brighton 1977 (d3); Jersey 1979
(56); Hammersmith 1981 (33); Agnew's 1981 (29); Japan
1992–3 (69)

The Princes in the Tower is one of two historical
works Millais produced on the theme of the
persecution of innocent royal children. The
other, *Princess Elizabeth in the Prison at St
James's* (also Royal Holloway College), was
exhibited the year after *The Princes* as a
pendant, and shows the guileless daughter
of Charles I who perished shortly after being
transferred from captivity in London to the
Isle of Wight.

The Princes illustrates a more familiar
episode from British history and represents
the sons of Edward IV, the princes Edward and
Richard, anxiously anticipating the arrival of
the assassins sent by the usurper Richard III.
Although the subject had been treated before
by a number of British artists, Millais's main
source of reference would have been Paul

Delaroche's famous *Edward V and the Duke of
York in the Tower* 1831, a reduced version of
which was on exhibition from the collection
of Sir Richard Wallace at the Bethnal Green
Museum, London from 1872–5, and
subsequently at Hertford House, later the
Wallace Collection (fig.17).[1] While Millais
follows Delaroche in the style of costume
depicted (particularly the boots and Order
of the Garter worn by Edward), as well as
in the idea of the boys huddling together in
apprehension, he decided to present them
against a staircase instead of on a bed. In this
Millais was aiming at historical accuracy,
alluding to the discovery by workmen in
1674 of the skeletons of two children under a
staircase in the Tower of London. Initially he
painted the staircase from the one in St Mary's
Tower at Birnam, but to establish authenticity
sent his son John Guille to make sketches from
the Bloody Tower in London. Finding that he
had positioned the staircase the wrong way
round, as well as making it too small, he
embarked on a new canvas, utilising the
discarded picture for *The Grey Lady* 1883
(Private Collection).[2]

The power of *The Princes* lies in the bold
idea of isolating the boys against the staircase,
the descending line of which visually threatens
to sever their symbiotic form. Rejecting the
smooth brushwork and elaborate setting of

Delaroche's picture, Millais uses a limited
palette, suggestive directional light and broad
washes for the background to elicit feelings of
suspense and dread. The boys' angelic faces
and vulnerable suspended hands stand out
illuminated against the rich black of their attire
and the murky background, while the shadows
they cast on the stairs are echoed by the sinister
shape of a figure descending from above. The
projection of a single strand of straw into the
spectator's space adds to the tension of the
narrative and invites association with blood.
The pathos of Millais's subject resides in the
beauty of the youths, and in introducing an
element of androgyny he may have employed
child models of both sexes.[3] The elegant
contraposto of the boys' postures is reminiscent
of fifteenth-century Italian bronze statuary
(the period referred to in the painting), making
The Princes one of the few pictures in which
Millais consciously acknowledged a tradition
of canonical poses to establish authenticity.
Contraposto also indicates the princes' noble
breeding and how they remain poised in the
direst of circumstances.

The painting was purchased before the
Royal Academy exhibition by the Fine Art
Society, which commissioned the first
engraving of the subject by Samuel Cousins,
and it soon became one of the most popular of
Millais's works. AS

Figure 17
Paul Delaroche
(1797–1856)
*Edward V and the Duke
of York in the Tower*
1831
WALLACE COLLECTION,
LONDON

The Ruling Passion 1885
Oil on canvas
160.6 × 215.9
Signed and dated in monogram lower right
Glasgow City Council (Museums)

Provenance Millais Sale, Christie's, 1 May 1897 (110); Artist's Executors' sale, Christie's, 2 July 1898 (23), bt Marshall; bt by Glasgow Art Gallery, 1907

Exhibited RA 1885 (212); GG 1886 (91); Chicago 1893 (331); Venice 1895 (220); RA 1898 (163); Glasgow 1903 (102); RA and Liverpool 1967 (108)

The Ruling Passion, originally known as *The Ornithologist*, was Millais's most ambitious painting of his later years. The revised title was taken from Alexander Pope's *Epistle to Bathurst* (1733), which addresses the dominant emotional impulses that govern the cycles of human existence, and was probably adopted by Millais as more revealing of the work's real meaning.[1] Although this title may be ironic in the tradition of artists' epigraphs, what could be taken as self-depreciation ultimately serves to illuminate what is profound about the work. In an interview given in 1884 Millais is recorded as saying: 'It is the difficulty of giving agreeable reality to sacred subjects which daunts the modern artist, living in a critical age and sensitive to criticism.' He went on to relate that it had been his ambition to paint a large-scale picture illustrating Jesus's declaration 'Suffer little children to come unto me' and, confronting the question of how best to characterise the children, concluded 'Why, our own fair English children of course – not the brown, bead-eyed, simious-looking children of Syria.'[2]

The Ruling Passion can be seen as a modern secular interpretation of the theme of Christian humility, as expressed in the Christ-like figure of the old man holding what could be recognised as an emblem of love and sacrifice. The painting represents the infirm ornithologist, seated in his invalid's couch, showing some stuffed exotic birds to a group of children tended by their mother, whose protective gesture embraces the youngest but isolates the eldest at the periphery of the composition. According to Walter Armstrong, Millais deliberately set out to fill the

background with 'ugly accessories', wishing to be true to the facts of a 'decidedly middle-class home'. The large Sheraton bookcase was copied from one Effie owned, and the birds that enliven the drab interior were taken from the collection of Millais's son John Guille, himself an ornithologist.[3] In his hand the old man holds a red Bird of Paradise, while on the blanket lie the corpses of a Scarlet Ibis, a Great Bird of Paradise, a Blue-Backed Fairy Bluebird, and lower down, a Regent Bowerbird and a Magnificent Bird of Paradise. A heron pokes out from the drawer of a cabinet in the lower right-hand corner, and on the far table stand a kingfisher, a grey goose and a barn owl in a bell jar. The seated girl on the left holds a Resplendent Quetzal in her lap.[4]

In his biography John Guille Millais writes that the subject was inspired by a visit Millais made to the famous ornithologist John Gould (1804–81), who owned an important collection of birds of paradise.[5] John Ruskin, who greatly admired Millais's painting, was a champion of Gould's work and stood side by side with the naturalist in opposing Charles Darwin's theory of natural selection, seeing the beauty of bird plumage as a manifestation of divine creation. However, in *The Ruling Passion* the birds convey contradictory meanings. On the one hand, they are presented as stuffed specimens, but on the other, signify the transformative power of nature. The red bird isolated against the black of the woman's dress, towards which all the characters turn their gaze, is the symbolic heart of the composition and offers an array of possible meanings: it could be a symbol of transcendence, or of Christian sacrifice, or perhaps it signals the fleeting nature of beauty.

The overriding themes of youth, mortality and the limitations of experience find an echo in Millais's earlier historical compositions, *The Boyhood of Raleigh* (no.94) and *The North-West Passage* (no.96) – the former of which also includes dead exotic birds – as well as anticipating his 'fancy picture' *Bubbles* (no.107) of the following year. Millais's grandson Willie James appears in both this and *The Ruling Passion* as one of the boys leaning over the couch on the right. Millais's friend the engraver

Thomas Oldham Barlow, who was dying at the time, sat for the figure of the ornithologist, thus adding to the poignancy of the subject. Millais's portrait of Barlow (Oldham Art Gallery) also appeared the following year. Millais's combination of the Ages of Man motif with natural history to address the idea of the transience of existence must surely have been made with reference to Joseph Wright of Derby's *An Experiment on a Bird in the Air Pump* of 1768 in the National Gallery. The meditative girl isolated on the left of Millais's painting similarly echoes the figures of melancholy contemplative youths who often appear in Wright of Derby's paintings, for example, his *Edwin* and *Maria*, both of which were included in the widely reviewed exhibition of the artist's works in Derby in 1883. Together with the ornithologist, the figure of the girl was singled out by Ruskin as the noblest figure in the composition, probably because she offered a detached perspective on the cycles governing life. For Ruskin, *The Ruling Passion* was 'the most pathetic painting of modern times', a work that confronted the struggle to discern beauty and significance in the banality of modern existence.[6] Millais himself regarded it as one of his best works and was disappointed that it did not sell. According to his son it was started as a commission but the prospective owner backed down as it reminded him of the sick chamber in which one of his relatives had died after a long illness. In a letter to Kate Perugini Millais wrote:

Both Sir A. B– and Mr. C– declined to have 'The Ruling Passion'. I don't think, therefore, I will trouble the critics and public any more with what is called 'an important picture.'[7]

Millais sent the painting to the Chicago World's Fair in 1893, insisting that the work be glazed, and with an insurance premium of £7,000. Despite the efforts of J.W. Beck, Secretary of the Fine Arts Committee for the exhibition, to find an overseas buyer for the work, it remained unsold until after the artist's death.[8] AS

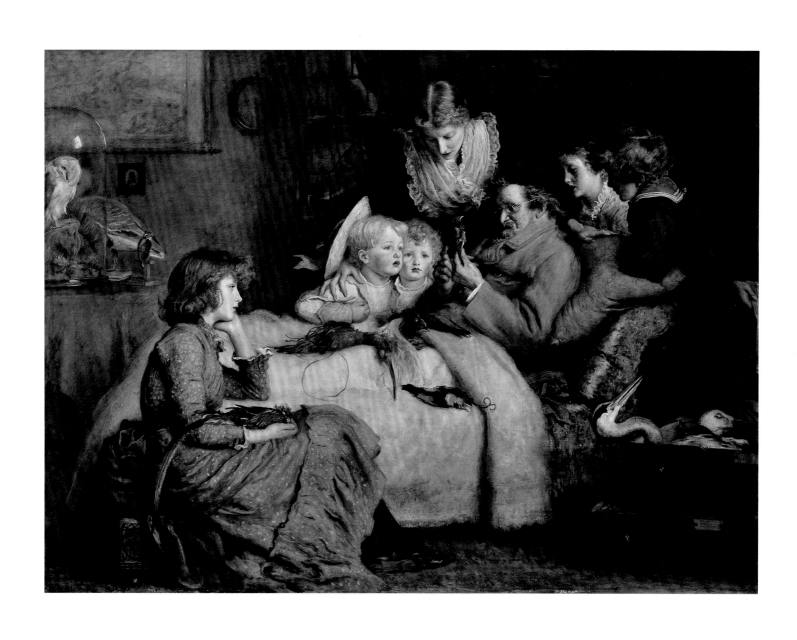

St Stephen 1894–5
'He fell asleep.' – Acts vii 60
Oil on canvas
152.4 × 114.3
Signed and dated in monogram lower right
Tate. Presented by Sir Henry Tate 1894

Exhibited RA 1895 (18); RA 1898 (176); Tate 1997

St Stephen is one of a small group of sombre paintings Millais produced around the time of his final illness, the other works being *'Speak! Speak!'* (no.100), *Time, the Reaper* c.1895 (location unknown), *A Disciple* 1894–5 (Tate) and *A Forerunner* 1895–6 (Glasgow Art Gallery and Museum). Despite their dark tonality and despondent mood these pictures can also be seen as meditations on the afterlife. The artist's son recalled that in his last years Millais was touched by a sense of the divine, which led him to return to the solemn subjects of his youth. It was in conversations with the Revd Armstrong Hall, minister of St John's Church, Perth, that he debated the artistic capabilities of various New Testament subjects:

> In the autumn of 1893, when 'St Stephen' was in his mind as the next subject to be taken up, they discussed together the age of the deceased martyr, as to which there seemed to be some doubt; and finally coming to the conclusion that he was but a youth when he met with his tragic end, Millais so represented him.[1]

The painting shows the lithe body of Stephen, the first Christian martyr, resting upon a bank, his eyes closed and mouth open as if asleep. The violence of his death is indicated by the rocks in the foreground and stains on his robe, while his sainthood is signalled by a halo, the only example of such a traditional device in a work by the artist. The spectral figures that lurk in the shadows are Stephen's disciples waiting to claim the body for burial. Millais painted the background first from a disused stone quarry on Kinnoull Hill, close to the setting of *'Blow, Blow, Thou Winter Wind'* (no.139). The painting is so dark that it is difficult to make out the background, although this is discernible in a photograph taken by Rupert Potter of the work in progress (fig.18).[2] The spiky furze that surrounds the saint's body is a piece of natural observation that accentuates the theme of martyrdom. Otherwise the intense darkness of the background serves as a foil for the illuminated saint in keeping with conventions of Baroque masters such as Anthony van Dyck, whose own violent representation of the subject, with bravura Rubensian landscape, may have been known to Millais.

However, despite his debt to Old Master techniques and mannerisms in the elegant rippling disposition of the body, Millais rejected the conventions both of a multi-figured composition and of showing Stephen bludgeoned to death. By isolating the saint in a stark Scottish landscape, rather than placing him in an idealised setting, he was following the precedent he established in *The Parable of the Tares* (no.91), as well as acknowledging the Netherlandish tradition of locating religious scenes in localised environments. Millais was probably also aware of the 'Scottish' religious paintings of the Pre-Raphaelite associate William Dyce. This approach stands in opposition to that adopted by Hunt, who made a point of painting religious scenes in authentic settings. In representing Stephen as a beautiful youth Millais may have been aware of the painter Edward Armitage's recommendation that the action of a figure in history painting should be sufficient to explain the subject. Taking the subject of St Stephen as an example Armitage argued:

> We read that his face was as that of an angel, and he ought to be surrounded by an angelic halo of light, and this treatment need not be dictated by the text. We should come to the same conclusion simply on the grounds of pictorial fitness.[3]

Millais's treatment of his subject follows on from this idea in rejecting the context of Stephen's death. By focusing on the beauty of a murdered youth he offers a symbolist interpretation of the subject, which may further explain the androgyny of the martyr. Although J.G. Millais wrote that Millais used a male model for the composition, he also mentioned that he worked from imagination and from a professional model whose gender is not specified. This seems to have been a young woman Mary Lloyd, who also posed for *'Speak! Speak!'* and *A Disciple*, and who in an interview given later in her life claimed to have sat for the face of St Stephen.[4] Millais probably conceived of *St Stephen* as a pendant to *A Disciple*, both works focusing on faith as a means of confronting death with equanimity and as a source of inspiration.

According to a memorandum of purchase Millais agreed to sell *St Stephen* and *A Disciple* before they were finished to Henry Tate for £2,500, with the understanding that both would be included in Tate's gift to the National Gallery of British Art.[5] AS

Figure 18
Rupert Potter (1832–1914)
Photograph showing Millais's
St Stephen in progress
c.1894
NATIONAL PORTRAIT
GALLERY, LONDON

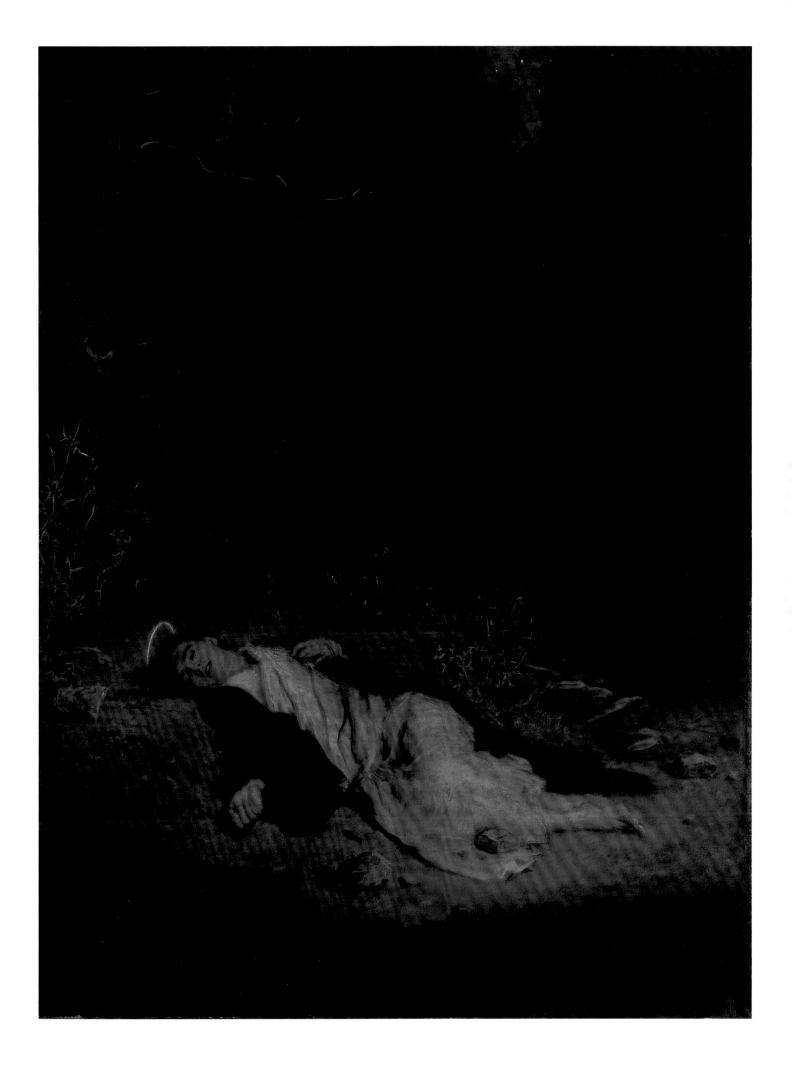

'Speak! Speak!' 1894–5
Oil on canvas
167.6 × 210.8
Signed and dated in monogram lower left
Tate. Presented by the Trustees of the Chantrey
Bequest 1895

Exhibited RA 1895 (251); RA 1898 (110)

'Speak! Speak!' was Millais's last large-scale
narrative picture and a work that encapsulates
his long-term interest in the supernatural.
According to Spielmann, the subject had been
with Millais for twenty-five years, which would
mean that he was thinking about it around the
time he painted the ghostly subject of *A
Somnambulist* (no.95). J.G. Millais, however,
places the idea even earlier in his father's mind,
in the mid-1850s, the period when he produced
A Ghost Appearing at a Wedding Ceremony
(no.55).[1] The painting also shares affinities
with *The Eve of St Agnes* (no.88) in the broad
monochromatic palette and motif of the bed,
and *The Grey Lady* (also known as *The Ghost
Chamber*; Private Collection), with the feature
of the distant staircase.

The picture is an imaginary subject set
in an indeterminate period, even though
J.G. Millais described it as being of the Roman
era. A man starts up in his bed, which is
covered with the pelt of an animal. On the
candlelit table by his side lie the letters of his
lost love whom he suddenly beholds as an
apparition standing at the foot of his bed in her
bridal attire. As he stretches out his arm only
his shadow seems to touch her as she pulls

back the drapes of the bed.

In this work Millais was clearly probing
the boundary between reality and delusion,
between what Hubert Herkomer later
distinguished as voluntary vision – where the
mind conjures up a scene – and involuntary
unsolicited images.[2] The hallucination
experienced by the man in Millais's painting
would seem to be of the latter type, and this is
borne out by the artist's realist interpretation
of a supernatural theme. In order to ground
the apparition in material reality he based
the background on a particular location –
the turret room at Murthly Castle, Perthshire
– and copied the four-poster bed from one
purchased expressly for the purpose. The light
was likewise painted from a specially made
copy of a lamp he had seen and studied in the
South Kensington Museum.[3] Regarding the
psychic side of the picture, Millais was
presumably aware of the Society of Psychical
Research, founded by Frederick Myers in
1882 with the purpose of subjecting ghosts
to the principles of modern scientific
enquiry. Myers was the husband of Eveleen
Myers, whom Millais had painted as *Miss
Eveleen Tennant* in 1874 (Tate). Spielmann
recorded that:

When I remarked that I could not tell
whether the luminous apparition were a
spirit or a woman he was pleased: 'That's
just what I want', he said; 'I don't know
either, nor', he added, pointing to the
picture, 'does he.'

Indeed, while the dazzling effect of the
woman's tiara, necklace, bracelet and belt
enhances her evanescent presence, she appears
more solid than the phantom in *The Grey
Lady*, where the background is more densely
worked than the face, which literally sinks
into the canvas. 'Speak! Speak!' thus resonated
for the feeling of doubt it engendered, or what
W.B. Richmond termed its 'depth of modern
thought'.[4]

In 1895 'Speak! Speak!' was hung in the
same room in the Royal Academy as Leighton's
Flaming June, where both stood out as
epitomising respectively the melodramatic
and late Aesthetic tendencies of two giants of
the British school who were both to pass away
the following year. Comparing the two works
Val Prinsep observed:

The one [Leighton's] seemed to me like
music – the harmonies all thought out, the
lines artfully and carefully composed, self-
contained, melodious, and monumental [...]
like a great sonata. The other like the drama
– full of humanity and feeling, stirring a
different set of nerves, striking a more
human chord, enchanting us by its surprise
and its wisdom.[5]

Following its exhibition at the Royal Academy,
'Speak! Speak!' was bought for the nation
under the terms of the Chantrey Bequest for
£2,000, an enormous sum that marked the
esteem in which Millais was held at the end
of his career.[6] AS

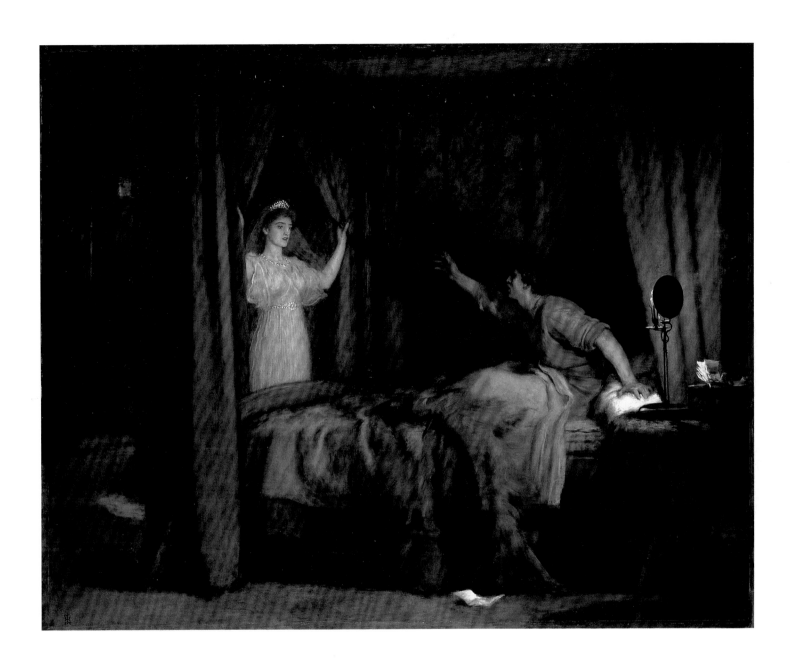

5
Fancy Pictures

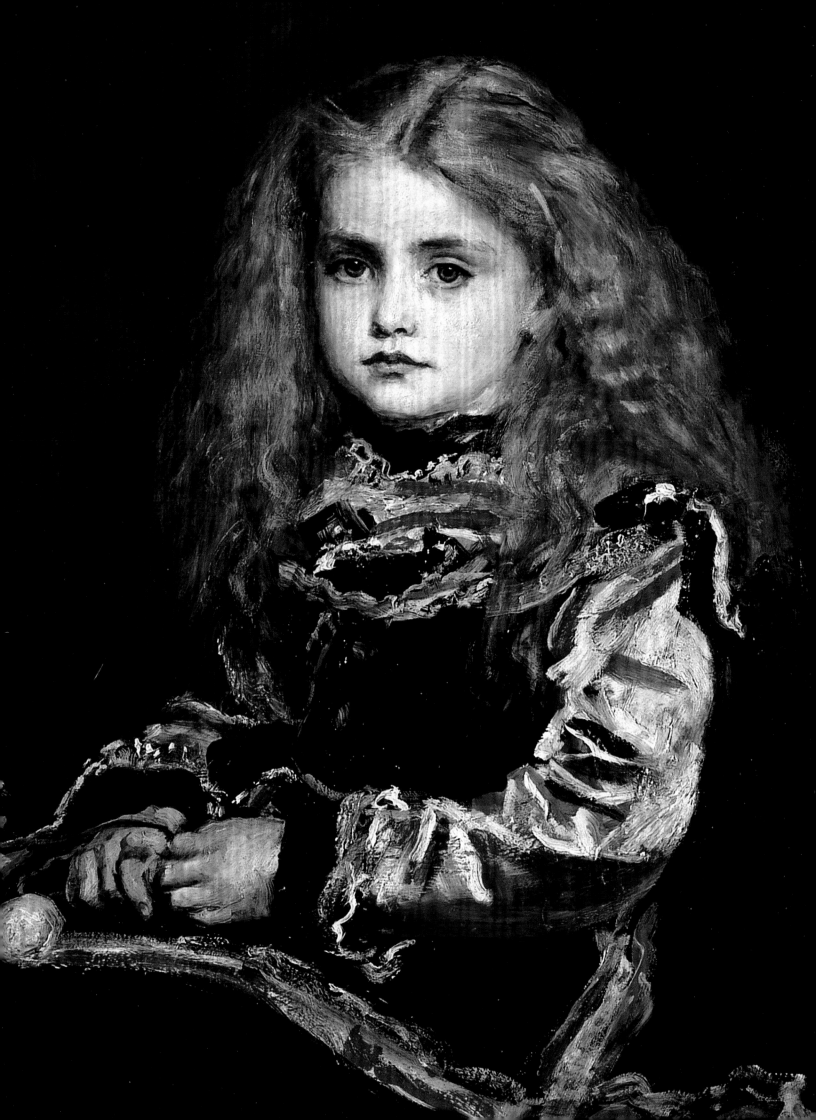

Fancy Pictures

A 'fancy picture' can be described as a genre painting where the sentiment takes precedence over evolved narrative. This type of emotive domestic art came into existence during the eighteenth century around the time the modern idea of childhood was being formulated by Enlightenment philosophers such as Jean-Jacques Rousseau and John Locke, who saw the child as a distilled form of humanity, a view that accorded with their belief that children were innately innocent, replacing a predominantly Catholic perception that infants were born into sin and could only be improved through education. It was through the work of painters such as Jean-Baptiste Greuze, Joshua Reynolds and Joseph Wright of Derby that the fancy picture became intellectually respectable, because at that time the emotional thrill of dwelling on a picture of a child was new and uplifting. However, the repetition of the same glib formulae in the nineteenth century meant that, by Millais's day, what was previously an elite art form had become a more popular type of consumption. Moreover, it was during the Victorian era that Enlightenment notions of the optimism and beauty surrounding childhood were compromised by a more stark awareness of the degrading effects of child labour and sexual exploitation. The fancy picture thus came to encapsulate a contradiction in that, while it continued to convey grace and sentiment, it was also expressive of an anxiety about what society had done to innocence. It was this sense of fragility that gave the genre a new tragic dimension.

Millais had long been fascinated by the idea of the separateness of childhood from adult life, and children had occupied a significant place in his exhibits of the 1850s. However, it was as a father that he first began to experiment with the fancy picture as a genre, particularly following the births of his daughters Effie (1858), Mary (1860) and Alice (1862), who were all pressed into service as sitters. Effie posed first for *My First Sermon* exh.1863 and *My Second Sermon* exh.1864 (both Guildhall Art Gallery, London), and then for *The Minuet* (no.102), followed by Mary with *Waking* (no.101) and Alice with *Sleeping* (fig.20, p.174). Millais's sons Everett and George also sat together with Effie and Mary for the now untraced *The Wolf's Den* 1862–3. With child models readily available Millais was able to give free expression to feelings of parental pride and joy, as well as offer comment on the growth of his offspring, with an eye on the market for endearing images of children. In 1863 the *Illustrated London News* sold a vast number of copies of the large chromotype it published based on James Sant's 1860 exhibit *Little Red Riding Hood*, no doubt making Millais aware that his more astute observations of real children had even greater commercial potential. However, rather than just being a vehicle of sentiment and an expression of financial expediency, Millais's repeated use of his many children in his pictures bears comparison with the intimate depictions of offspring in the 'modernist' paintings of Mary Cassatt and Berthe Morisot.[1] The variety of ways in which Millais represented his children can be seen both as an intervention into a sphere of domestic art commonly perceived as 'feminine', and as a means of asserting his own fertility and experience of fatherhood.

Millais's revival of the fancy picture also relates to his consciousness of his position within the British school. It is significant that he took to the subject at a time when he was developing a more painterly style in emulation of past masters such as Reynolds and Thomas Gainsborough. Edward Armitage was later to claim that the eighteenth century was important for Millais because it represented the start of an identifiable English tradition in art, a tradition to which Millais was keen to present himself as the natural successor.[2] His engagement with the Old Masters was undoubtedly encouraged by events such as the three London exhibitions in the 1860s of historical British portraits, which were important in establishing a canon of past masters and a sense of pride in the British school. The growth in publications on the work of British painters, such as F.G. Stephens's popular essay *English Children as painted by Sir Joshua Reynolds* (1867), were influential in establishing the idea of 'naturalism' as a key trait in British art. Millais was, in fact, a pioneer in re-inventing the eighteenth century, and his fancy pictures played a key role in revising popular perceptions of the previous century as a time of lax morals and frivolity by reaffirming qualities of charm and natural beauty. His engagement with this mode intensified after 1870 (the year when the Royal Academy inaugurated its annual winter Old Master exhibitions), as his brushwork became more self-consciously free and expressive, and as his child pictures became more overtly nostalgic with sitters dressed in mob caps, velvet suits and other trappings of a pre-industrial age. Parody became a key means of acknowledging lineage with the past as Millais began to quote from painters who themselves parodied older masters. The costume in *Bubbles* (no.107) is thus based on the suits worn by boys in portraits by Gainsborough and Thomas Lawrence, who themselves acknowledged the elegant attire of the portraiture of Anthony van Dyck. A photograph taken by Rupert Potter in 1887 of Millais's studio in Palace Gate (National Portrait Gallery, London) shows an easel crammed with small framed reproductions of Old Masters. Millais used these as visual aids when painting from his subject, balancing observation from the model with reference to past masters in evoking the spirit of a lost golden age.

In taking on a genre widely considered to have degenerated into something trite and feminine, Millais sought to aggrandise it by imbuing his child subjects with a prescience of mortality, but with the aim of giving visual pleasure rather than preaching a moral lesson. Emblems connoting the fragility of existence such as flowers, birds and bubbles were common to these works, and it is significant that, following his acquisition of Anthony van Dyck's *Chronos Clipping the Wings of Love* (fig.19) in 1886, Millais hung it opposite the dais on which he posed models in his studio, thereby inviting the association in the adult mind between youth and the inexorable passage of time. The seriousness with which he approached his fancy pictures was reinforced by the introspective demeanour of his subjects, who are rarely shown to be mischievous, smiling or pouting, but are rather posed as philosophers lost in thought or contemplating the beauty of the natural world. While Millais concurred with contemporary painters of the Aesthetic

movement in believing that impassivity was integral to beauty, he stood apart in affirming that this quality was best appreciated in children whose features were not yet marked by experience and character. This idea he put forward as early as 1856 in a letter to Charles Collins:

> A child represents beauty more in the abstract, and when a peculiar expression shows itself in the face, then comes the occasion of difference between people as to whether it increases or injures the beauty.[3]

The wistful expressions of Millais's children were crucial in establishing this mood while avoiding explicit meaning. Millais's fancy pictures can thus be seen as an alternative to the classical aesthetic promoted by painters such as Frederic Leighton and Albert Moore in the 1860s in that, rather than using abstract elements of design to appeal to specially cultivated taste, he set out to embrace the broadest possible audience in offering a more accessible version of the art for art's sake aesthetic.

The success of Millais's fancy pictures was in the fine line he established between re-inventing the romantic idea of natural childhood and in projecting the presence of a real child. Beatrix Potter (the photographer Rupert Potter's daughter) was of the opinion that, of all the modern painters of children, Millais was best able to intuit the expression on a child's face without influencing it through the imposition of his own style.[4] In an interview on his studio practice Millais himself described child portraiture as the most trying branch of the genre:

> It puts me in a perfect fever. They are the very worst sitters in creation. It is so unnatural to a child to keep quiet and they can't do it; they are so full of life and spirits. They drive me perfectly wild. Dear little things, it isn't their fault, but when I hear their merry pattering footsteps outside I get in a fidget all over, and there is nothing for it but to take my pipe well between my teeth and keep my mouth shut or I should go frantic.[5]

According to J.G. Millais, his father became adept in negotiating the disruptive nature of children by surreptitiously noting their attitudes and behaviour in public, and in developing an empathy with his sitters by putting them at their ease when they came into his studio with a 'variety-entertainment' of dolls, books and chocolates.[6] Millais also employed Rupert Potter to photograph children in the pose he had selected for a work, and this became a vital aid in negotiating the transition from studio to imagined setting. A number of these photographs betray the actual mechanics of portraiture, the effects of which were not altogether subsumed in the finished image. Potter's photograph of *Lady Elizabeth Manners* model for *The Young Mother* (see List of Exhibited Works), for example, shows her posed rather precariously on a contraption the artist had devised to elevate the child to a higher position on his sitter's chair. The tentativeness with which the infant holds her pose while offering maternal

protection to her doll is carried over to the final image, adding to its poignancy and charm.

Millais's skill and humour in comprehending both the ease and lack of confidence with which his child models assumed their role was an essential part of the appeal such works made to adults conscious of the otherness of childhood. The Archbishop of Canterbury recognised this attraction when *My First Sermon* was launched on the exhibition scene in 1863, as the *Art Journal* recorded:

> Pointing to this picture, the Archbishop of Canterbury, in his speech at the Academy dinner said, that the hearts of all of us should grow enlarged and we should feel the happier 'by the touching representations of the playfulness, the innocence, and might he not add, [...] the piety of childhood'.[7]

The dealer William Agnew was quick to realise the commercial potential of this new kind of fancy picture when he bought the painting immediately from Ernest Gambart after the latter had purchased it for £420, paying Millais an additional £200 for the copyright. The stream of reproductions that ensued from Millais's fancy pictures culminated in the large chromolithographs that appeared in the holiday supplements of magazines such as the *Illustrated London News* and *The Graphic* during the 1870s and 1880s. It was these reproductions that led both to Millais's fame and to his being recognised as a key contributor to a 'baby disease' in British art, as exhibitions were flooded with images of infants, many of which lacked the robust technique and nuanced observations that distinguished his fancy pictures.[8] AS

Figure 19
Anthony van Dyck
(1599–1641)
Chronos Clipping the Wings of Love c.1630–2
MUSÉE JACQUEMART-ANDRÉ, PARIS

Waking 1865
Oil on canvas
99 × 84
Signed and dated in monogram lower left
Perth Museums & Art Gallery, Perth & Kinross
Council, Scotland

Provenance Moore, McQueen & Co., 28 Sept. 1865;
Agnew's, 4 Dec. 1865; John Hargreaves, sold Christie's,
7 June 1873 (314); Holbrook Gaskell, sold Christie's, 24 June
1909 (68), bt Agnew's; C.F. Murray, sold Christie's, 14 Dec.
1917 (62), bt Cremetti; Cremetti, McLean Galleries, sold
Christie's, 1 June 1923 (150), bt W.W. Sampson & Son;
Sidney Morse, sold Christie's, 26 July 1929 (43), bt Grey;
Melville Gray, who donated it to Perth Museums & Art
Gallery in 1935

Exhibited RA 1867 (74); GG 1886 (114); Manchester 1887
(471); Glasgow 1888 (65); Guildhall 1897 (94); RA 1898 (24);
Newcastle 1904; RA and Liverpool 1967 (69)

Millais's second daughter Mary posed for the
wide-eyed girl in *Waking*, and his youngest
daughter Alice, also known as Carrie, for
the child in *Sleeping* (fig.20). According to
J.G. Millais, *Sleeping* was suggested by the sight
of Carrie fast asleep the morning after a
children's party: 'Millais went into the nursery
to look for the child, and found the French
maid, Berthe, sewing beside the bed, waiting
for her charge to wake up.'[1]

As well as reflecting Millais's paternal
devotion, this pair of paintings was an astute
marketing strategy on his part, and followed
on from the success of *My First Sermon* exh.RA
1863 and *My Second Sermon* exh.RA 1864 (both
Guildhall Art Gallery, London) with a similar
pendant formula, although this time he
exhibited the two works together rather than in
consecutive years. *Waking* was commenced
first, in July 1865, and was bought unfinished
by the dealers Moore, McQueen & Co. on 28
September that year for 1,000 guineas. The

following day Millais informed Effie that he
had promised Moore a complementary picture
of a child asleep for the same price. By
December the dealers had sold *Waking* to
Agnew's, which also took over the commission
for *Sleeping*.[2] The paintings were hung together
in the East Room of the Royal Academy to great
acclaim, Tom Taylor describing *Sleeping* as one
of the most beautiful pictures Millais had ever
painted and 'one of the *chef d'oeuvres*, indeed,
of the English school'.[3] The picture not only
appealed with the winning theme of childhood
innocence, but by virtue of the technical
mastery with which Millais rendered the tone
and texture of the bed linen. Critics were
particularly struck by the quilted satin *couvre-
pied* in *Sleeping* and the heavy knitted blanket
in *Waking*, the detail of the tasselled edge
bunched around the bed frame in the latter
proving that the artist's powers of observation
had not waned since his Pre-Raphaelite days.

Despite the residual influence of Pre-
Raphaelitism in the precise treatment of the
accessories, the decorative bands of colour and
abrupt cropping in both designs are indicative
of Millais's aesthetic interests. The most defiant
gesture was the crimson ribbon that intrudes
into *Sleeping* from the left, which, according
to the *Art Journal*, was one of the 'daring
eccentricities which a man conscious of his
power is apt to indulge in'.[4] The spatial
ambiguity of both pictures invites comparison
with James McNeill Whistler's work of the early
1860s, particularly *The Music Room* 1860–1,
with its complex juxtaposition of textures and
compression of the maid into a corner of the
composition. (Significantly a print after
Waking hung in Whistler's drawing room at

2 Lindsey Row in Chelsea.)[5] However, the formal
elements of Millais's designs help reinforce the
symbolic qualities suggested by details such as
the plants and birdcage. The flowers in both
pictures are wild species that according to the
language of flowers connote natural beauty, the
bluebells and cowslips in *Sleeping* signalling
constancy, devotion and grace. F.G. Stephens
thought the cut stems of the flowers in this work
introduced a melancholy note, reminding the
viewer that, just as the child will awake, so the
plants will die if they are not already dead.[6] The
caged bird hidden from the viewer but to which
the girl awakes in *Waking* is another reminder
of the transience of youth despite its protective
trappings. Millais also uses the doppelgänger
effect of the two girls to subtly communicate the
precariousness of the boundary separating
consciousness from sleep and by implication
death, a theme pursued in a contemporary poem
inspired by *Sleeping*:

> O, how amid our struggles, noise, and strife,
> This face of sleeping child breathes perfect
> peace;
> Looks towards the day when our work
> must cease,
> Our frail bark loosened from the shore of
> life.[7]

Sleeping and *Waking* were reproduced as
mezzotints by Thomas Oldham Barlow and
were published by Henry Graves in 1868.
Both works inspired a number of sentimental
variations on the theme of sleeping and waking
children, notably Joseph Clark's *Mother's
Darling* (1884), purchased for the nation by
the Chantrey Bequest in 1885. AS

Figure 20
Sleeping 1865–6
PRIVATE COLLECTION

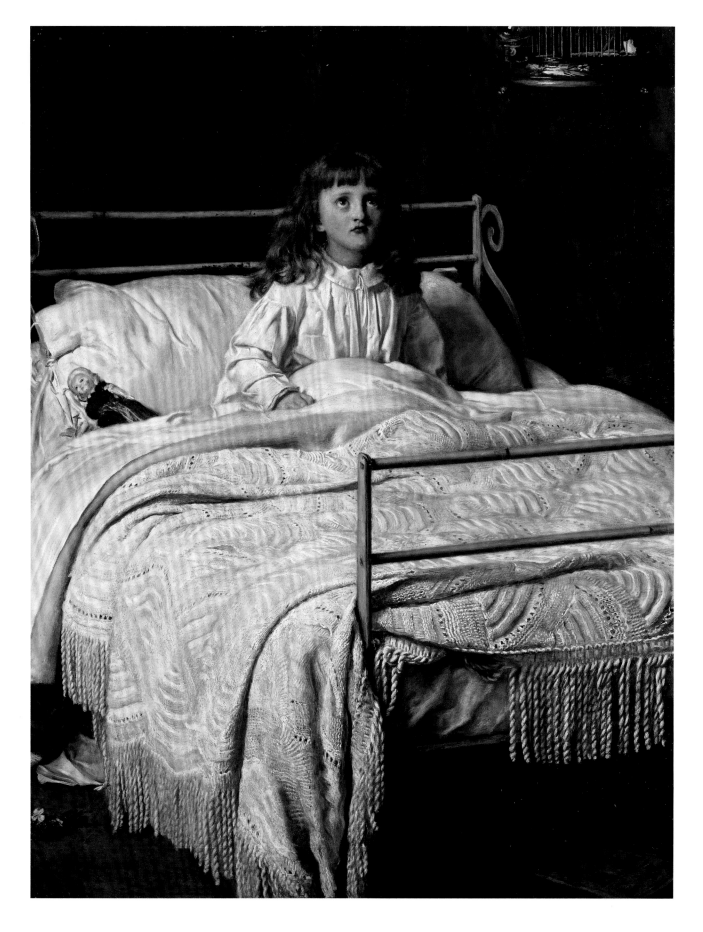

The Minuet 1866
Oil on canvas
110 × 85
Signed and dated in monogram lower right
Elton Hall Collection

Provenance Sir John Kelk, sold Christie's, 11 May 1899 (29),
bt Agnew's; William Proby, 5th Earl of Carysfort; Sir Richard
Proby, Bart., and by descent

Exhibited RA 1867 (628); RSA 1869 (153); FAS 1881 (10);
GG 1886 (119); London 1897 (22); RA 1898 (34); Leggatt
1958 (2); RA and Liverpool 1967 (70)

The Minuet is one of three child pictures Millais
exhibited in 1867 in which he used his
daughters as models (see *Waking*, no.101, and
Sleeping, fig.20). Here Millais's eldest daughter
Effie is shown curtsying to the viewer as she
prepares to dance a minuet, accompanied on
the piano by her aunt Alice Gray.[1] With its
solemn mood, abrupt cropping of the
candelabra and figure on the left, and
representation of two female relatives absorbed
in music, the painting shares affinities with
Whistler's *At the Piano* exh.RA 1860, and then
in the possession of Millais's friend, the artist
John Phillip. This was a work much admired
by Millais.

However, Millais's image differs by
presenting known individuals masquerading
in historical costume. *The Minuet* was in fact
the first of Millais's fancy pictures to present
a child in fancy dress, and one of the artist's
earliest paintings that self-consciously adopts
the stylistic and historical conventions of the
eighteenth century. Effie wears a red dress in
the style of the mid-eighteenth century, with
a white muslin apron, lace ruffles, a floral
corsage and a spray of flowers and pearls
in her hair. The Rococo tapestry of a *fête
champêtre* on the wall enhances Millais's
evocation of the era of *sensibilité*, as does the
china tea-set elegantly perched on the George
III-style chair borrowed from William
Makepeace Thackeray's daughter, the novelist
Anne Isabella Thackeray Ritchie.[2] While
Millais was clearly acknowledging the fancy
portraits of Reynolds in which sitters enacted
roles from the past, the stiffly posed central
figure in *The Minuet* also recalls the Spanish
royal infantas in Diego Velázquez's portraits.
Millais was presumably familiar with the
master's *Las Meninas* c.1656, a copy of which
was produced by John Phillip on his 1860 visit
to Spain, and hung for a while in his studio
before it transferred to the Diploma Rooms at
the Royal Academy.[3] Phillip also made a copy
of Velázquez's *Las Hilanderas* or *Tapestry
Weavers* c.1656, a work Millais's picture also
engages with its conceit of contrasting static
living flesh with 'animate' accessories, the
graceful gesture of the dancing woman on the
right of the wall hanging underscoring the
frozen formality of Effie, who is poised in
emulation of the naturally sophisticated
movements of the dancers reproduced in the
tapestry. A few years earlier, in 1863–4, Millais
had employed a similar tapestry device in his
portrait of *Lilly Noble* (Private Collection),
setting the animated postures of the artificially
woven figures against the self-consciousness
of the girl clutching her doll. In his memoir
J.G. Millais recalled that none of his sisters
enjoyed sitting for their portraits in 1867,
which partly explains the elaborate setting
in all three works. However, while the
contemporary *mise-en-scène* in *Waking* and
Sleeping underpins the 'natural' innocence of
the children, the artificial accoutrements in
The Minuet help compensate for the sitter's
unease in her role.

The success of this new mode of
performative fancy picture encouraged both
Gambart and Agnew's to commission smaller
replicas. Samuel Cousins's mezzotint was
published by Henry Graves in 1868.[4] As

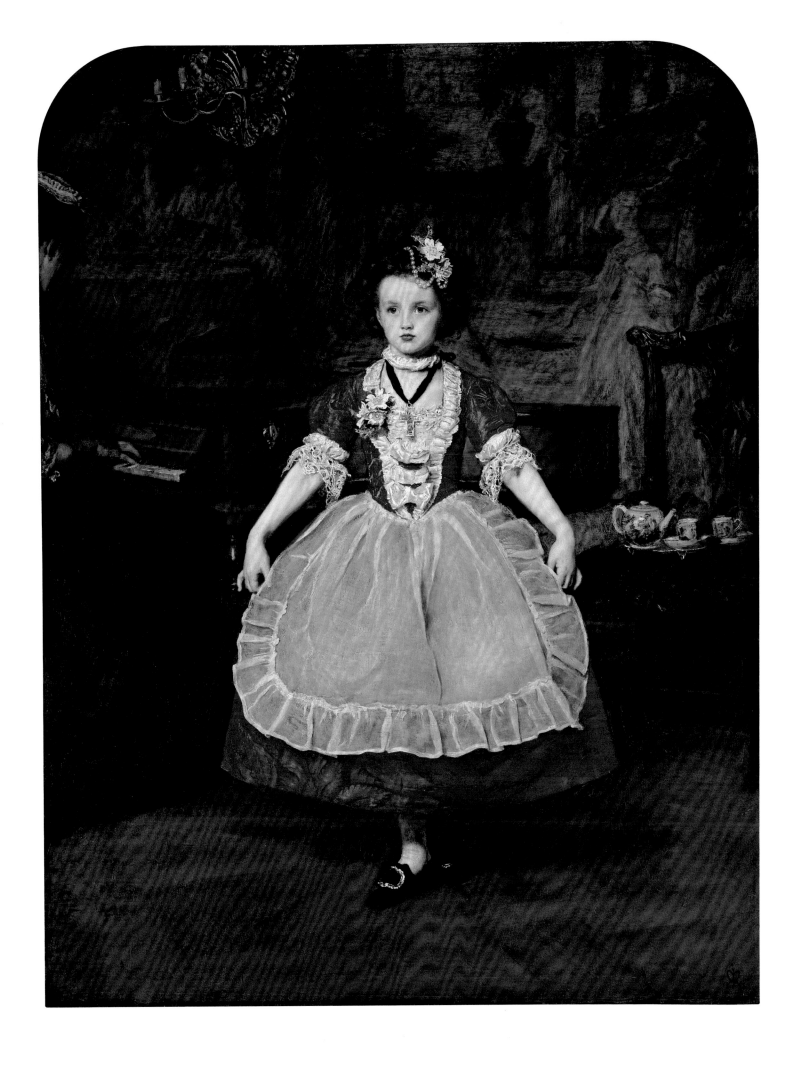

Souvenir of Velasquez. Diploma work deposited in the Academy on his election as an Academician 1868
Oil on canvas, 102.7 × 82.4
Signed and dated in monogram lower right
Royal Academy of Arts, London

Exhibited RA 1868 (632); RA 1898 (123); RA 1901 (101); RA 1939 (24); SLAG 1971 (28); Sotheby's 1971 (238); RA 1982 (57); RA 1982–3 (38); Munich and Madrid 1993 (67); USA 1999–2000 (54)

In 1868 Millais presented *Souvenir of Velasquez* as his Diploma picture to the Royal Academy, five years after his election to full membership.[1] The picture stands as a manifesto for the painterly style he adopted in the late 1860s, a development that was coincident with both public awareness of the art of Velázquez, and the emergence of Impressionism around a group that was coalescing in France. The painting shows a young English girl (modelled from a child who sat by Millais in church one Sunday), seated on a pile of books wearing a dress of Spanish character and holding an orange branch in her hand.[2] Her hair loosely falls into the shape worn by women and children in Velázquez's court portraits. Like *The Minuet* (no.102), the girl is presented in the style and sartorial conventions of the past in the manner of Reynolds's fancy pictures, which could be seen as fitting for a Diploma work, Reynolds being the first president of the Academy. Millais would also have been aware of William Holman Hunt's *The King of Hearts* (fig.21), exhibited at the RA in 1863, a homage to Reynolds's *Master Crewe as Henry VIII* c.1775, and beyond that to Holbein. While Hunt was quoting Reynolds in order to acknowledge Holbein as an appropriate model for the style of realism he espoused, the allusion to Velázquez in Millais's painting can similarly be

seen as a declaration of the free painterly brushwork he now promoted as key to his understanding of what constituted naturalism in art. However, *Souvenir of Velasquez* differs from both Hunt's and Reynolds's conception of a fancy picture in its denial of masquerade. The girl's fancy dress does not belie the reality of her posing for the artist, the books on which she perches being an actual prop Millais used to raise child models higher on the dais in his studio, as can be seen in a number of photographs Rupert Potter took of works in progress. While the girl's quiet, somewhat subdued expression acknowledges the reality of the studio, the loose, almost aggressive treatment of her dress and accessories can be seen as a more self-conscious dramatisation of the act of painting itself. On close inspection the folds of the girl's dress appear as fragmented strokes, but viewed from a distance fuse to suggest the texture of a rich fabric.

Souvenir of Velasquez is on one level a pastiche of Velázquez, in particular the artist's famous study of the Infanta Maria Margarita in the Louvre, which Millais would have seen on his visit to Paris in June 1859. In 1868 the Royal Academy authorised the purchase of John Phillip's copies of Velázquez's *Las Meninas* and portrait of Alonso Cano, which made Millais's choice of Diploma painting all the more timely given the regard with which Velázquez was held by the institution. Millais himself never visited Madrid, although his daughter Carrie did, as the guest of Effie's friend Sir Clare Ford, British Ambassador in the city, in 1890. In a letter to Effie, Ford wrote:

> The moment Carrie cast her eye on the Velazquez's she exclaimed 'How like Papa's style' & I think she is right for to my mind

Sir John has got lots of Velazquez, that Prince of Painters.[3]

Given Millais's debt to the Spanish master, *Souvenir of Velasquez* can also be seen as an attempt to outdo him in bravura brushwork, the *Art Journal* pronouncing Millais's painting to be a manifesto for the broad suggestive style he projected in his exhibits of that year:

> the brush no longer patiently pauses, waits upon form, or feels its way to finish, but dashes furiously at the goal, strikes at once the climax, and hits or misses at a venture.[4]

At a time when many British artists were exploring new ways of making the creative acts of the past relevant to the present day, the painting can further be seen in its broken facture as an attempt to recast in modern form Velázquez's experience of painting the Infanta. In this sense the picture can be described as a re-translation of the art of Velázquez into an English mode of feeling made apparent by the wistful expression of the girl. Millais's play on double identity in *Souvenir of Velasquez* finds a parallel in the experiments made by certain aesthetic painters around 1868. G.F. Watts's *Wife of Pygmalion: A Translation from the Greek*, exhibited at the same Royal Academy exhibition, was a painted recreation of a specific antique bust, and also based on the myth of Pygmalion, whose sculpted creation came to life. While Millais eschewed Watts's interest in formal beauty, his painting similarly focuses on the idea of stylistic correspondence to establish a sense of suspension, both in terms of atemporality and in his presentation of the model, who appears simultaneously real yet an artificial recreation. AS

Figure 21
William Holman Hunt
(1827–1910)
The King of Hearts
1862–3
PRIVATE COLLECTION

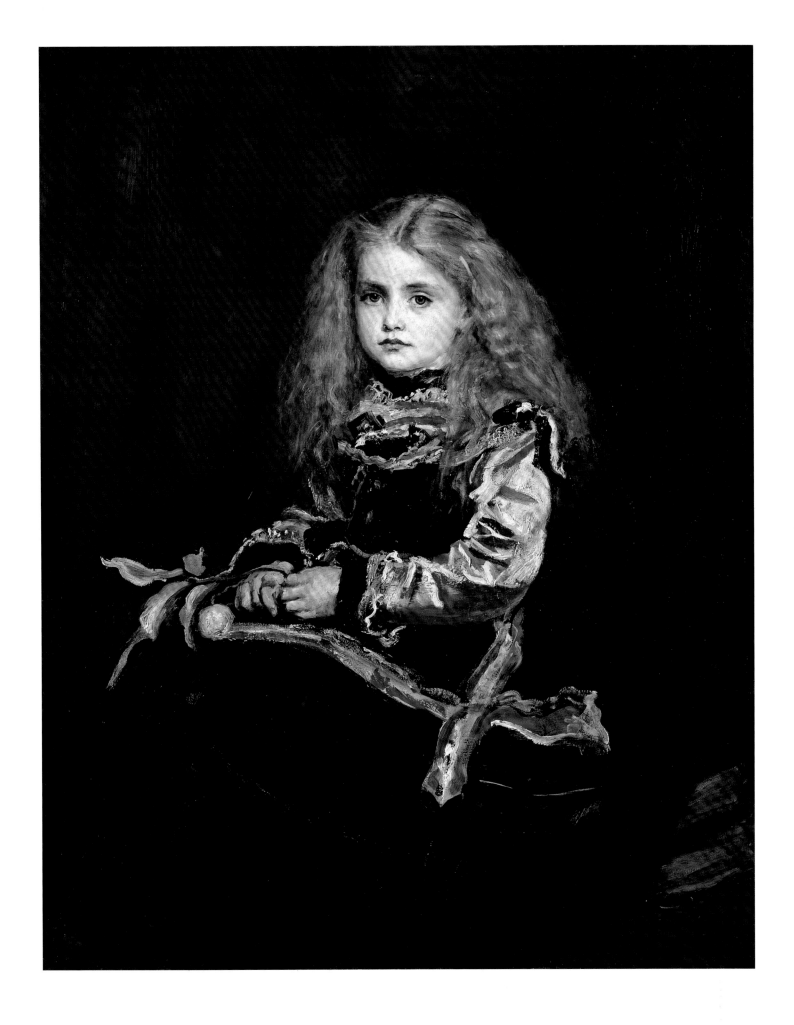

Bright Eyes 1877
Oil on canvas
92 × 71.5
Signed and dated in monogram lower right
Aberdeen Art Gallery & Museums Collections

Provenance Bt by Alexander Macdonald 12 June 1877;
bequeathed by him to Aberdeen Art Gallery 1901

Exhibited GG 1886 (50); RSA 1881 (120); Japan 1993a;
Japan 2000–1 (22)

Bright Eyes is a fresh portrait of a young
woman called Florence Coleridge, who stands
facing the spectator with a direct honest
expression. She wears a bright red Inverness
cape and tucks her hands into its pockets in a
casual confident manner. In the language of
flowers the mistletoe over her head symbolises
obstacles to be overcome, but, given the
informal nature of this portrait, it more likely
alludes to the custom of kissing a desired one
under a mistletoe branch at Christmas, thus
reinforcing the engaging qualities of the sitter.

The painting was not immediately exhibited
but entered the collection of the Aberdeen
granite merchant Alexander Macdonald, an
important patron of the modern Scottish
school who specialised in the circle around
Robert Scott Lauder.[1] The simple blithe nature
of the subject probably appealed to Macdonald
as indicative of Millais's affinities with
contemporary Scottish painters. In 1875
Macdonald had acquired the artist's *The
Convalescent* 1875 (Aberdeen Art Gallery), on
the basis of its charm and vitality, and wrote to
him: 'The picture has given me infinite delight,
so fresh and living in colour and one that we
will live beside with constant pleasure and
always find fresh enjoyment.'[2] Millais stayed
with Macdonald at his home Keppelstone
in Aberdeen during 1880, an occasion that
inspired Macdonald to invite his neighbour
George Reid, Scotland's best-known painter
and later president of the Royal Scottish
Academy, to paint Millais's portrait.[3] Millais's
friendship with Reid is attested by the farewell
letter he sent him shortly before he died: 'Yours
is the only hand I cannot grasp in farewell
before I go. But your dear kind eyes I feel daily
in me. I must send this scrap to say I am quite
happy.'[4] AS

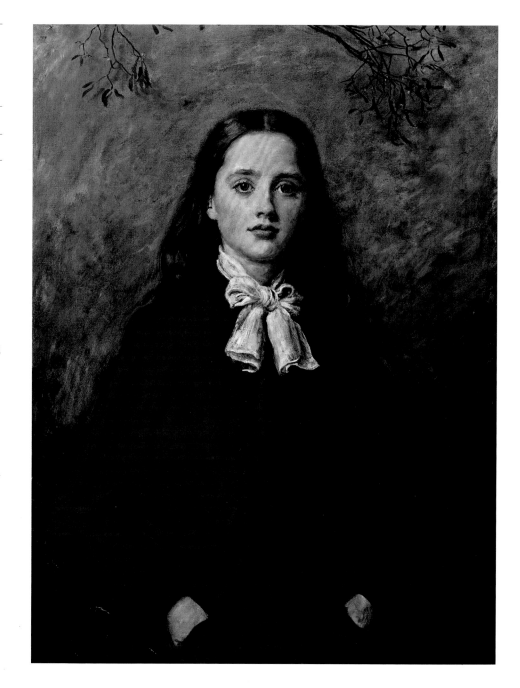

The Captive c.1881–2
Oil on canvas
115.6 × 77.2
Signed and dated in monogram lower left
Art Gallery of New South Wales.
Purchased 1885

Provenance FAS, from whom bt by the Art Gallery of
New South Wales in 1885

Exhibited FAS 1883

Millais first titled this painting *Ruby* after the
sitter, Ruby Streatfield, daughter of his friends
Colonel and Mrs Streatfield of Chiddingstone
Castle, Kent. She later married the 2nd
Viscount Colville of Culross. The title *The
Captive* was most likely suggested by the exotic
costume worn by the girl for the painting, a
rare example of orientalism in Millais's work
(together with *'Oh! that a dream so sweet [...]'*,
no.87), and reminiscent of the fancy pictures
depicting Western women in Eastern dress
popularised by J.F. Lewis. Although the girl's
wistful look relates to her captive status,
indicating a Jewish woman in Babylon or a
white girl in a harem, Millais probably
conceived of the work as an aesthetic statement
downplaying expression in order to focus
attention on the elaborate costume. Spielmann
described the work in aesthetic terms as a
'study in cool colours', and it was also known as
the first subject Millais painted with the aid of
spectacles.[1] In contrast to the broad brushwork
of a work like *Cherry Ripe* (no.106), *The Captive*
is executed with precision, as Beatrix Potter
noted in her diary: 'He took more than usual
trouble with it, keeping it a long time in his
studio.'[2] She also found the face too delicately
coloured and lacking in expression, which
were precisely the characteristics Millais
wished to convey.

 The painting was purchased by the Fine Art
Society who issued a mezzotint by G.H. Every
in 1885. AS

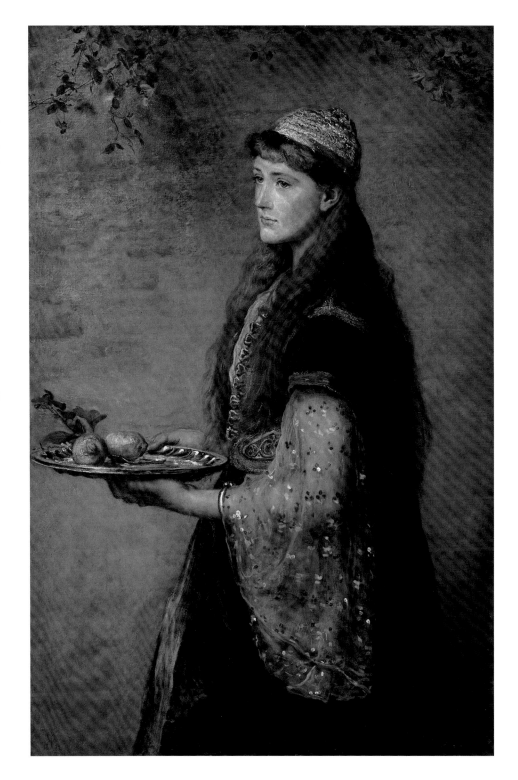

Cherry Ripe 1879
Oil on canvas
134.6 × 88.9
Signed and dated in monogram lower left
Private Collection

Provenance Commissioned by the owners of *The Graphic*;
bt from *The Graphic* by Charles J. Wertheimer; Sir Joseph B.
Robinson, his sale Christie's, 6 July 1923 (90); Joseph Labia
Collection, Channel Islands; Sotheby's, 1 July 2004 (21),
bt present owner

Exhibited Paris 1889 (102); RA 1898 (169); RA 1958 (78);
NGSA 1959 (94); Zurich 1962 (61); Tate 2004–6 (long loan)

Although by 1880 Millais was an acknowledged master of the British school, it was the reproduction and widespread dissemination of *Cherry Ripe* that made him a household name and won him international recognition. It was also the image that led to him being denigrated as an artist who pandered to popular sentiment, as expressed by Max Beerbohm in his satirical cartoon *A Momentary Vision That Once Befell Young Millais,* which shows the Pre-Raphaelite rebel recoiling in horror from an apparition of his mature self bouncing the girl from the picture on his knee.[1]

The title of the painting derives from two well-known poems by the seventeenth-century poets Thomas Campion and Robert Herrick, the latter of which reads as follows:

Cherry-Ripe, ripe, ripe, I cry,
Full and fair ones; come and buy.
If so be you ask me where
They do grow, I answer: There
Where my Julia's lips do smile;
There's the land, or cherry-isle,
Whose plantations fully show
All the year where cherries grow.

The idea that the child is sweet, like a cherry, is suggested by the cherries at her side, and subtly echoed by the foxgloves and honeysuckle in the background, which symbolise respectively youth and sweetness of disposition. Above all, it is Millais's treatment of the figure that characterises the cuteness of his conception: the disproportionate scale of the head in a mob cap in relation to the body, her legs dangling over the log with feet turned inwards, the demure positioning of her hands (resisting the temptation to bite the cherries), and especially the child's coy gaze at the viewer. Although the image has recently been analysed

in terms of its erotic appeal, the borderline between innocence and awareness is very fine in this work and most likely relates to Millais's interest in probing the extent to which little girls consciously affect an attitude when in the company of an adult male.[2]

The painting occupies a significant position in Millais's oeuvre in that, apart from existing as an independent work of art, it was commissioned specifically for graphic reproduction. The existence of a watercolour sketch (Geoffroy Richard Everett Millais Collection) shows how Millais plotted in the main tonal areas in anticipation of the loose facture of the finished picture. According to the story that developed around the image, it was painted from Edie Ramage, the niece of William Luson Thomas, editor of *The Graphic*. In 1879 she attended a fancy-dress ball given by the magazine where she impersonated Reynolds's *Penelope Boothby* (fig.22), and was thought so charming that the next morning she was again dressed in character and whisked off to Millais's studio. Apparently the artist was so delighted with Edie that it was agreed on the spot that he should paint her portrait and that the price should be 1,000 guineas.[3] In 1880 *The Graphic* published a colour lithograph as the centrefold of its Christmas number and sold an astonishing 500,000 copies. According to Thomas the number could easily have doubled had the printing technology been up to the task.[4] Other reproductions soon followed. In 1881 a mezzotint of the picture, engraved by Samuel Cousins, was issued by the print publisher Thomas Mclean, followed in 1882 with the *Illustrated London News*'s engraving of the work, and in 1897 by Pears' Soap, which issued a chromolithographic print for its Christmas annual.[5] It was through such reproductions that *Cherry Ripe* penetrated the furthest reaches of the British Empire, as evinced by the poems and letters of congratulation Millais received from colonial residents in Australia, Canada and South Africa. One copy was even found in a Tartar's hut.[6] The universal appeal of this image of a sweet English girl was heralded by Randolph Caldecott's cover design for *The Graphic* Christmas annual in 1880, which presented the image of *Cherry Ripe* as an icon promoting peace and goodwill across savage and civilised nations (fig.23).

Cherry Ripe's incredible popularity owed

much to Millais's intuitive understanding of the appeal of the fancy picture genre to adult sensibility. Here he was tapping into an existing market for the fancy portraits of Gainsborough and Reynolds that had burgeoned since the 1860s, in the wake of the revival of interest in eighteenth-century fashion and portraiture Millais himself had helped instigate. It was around this time that aristocratic patrons were joined by a new middle-class elite keen to harness its taste for contemporary art with that of the past as part of its assimilation into the upper ranks of British society. The first owner of *Cherry Ripe* after *The Graphic* was the prominent Jewish collector Charles J. Wertheimer, who went on to accumulate a number of works by Millais featuring demure Anglo-Saxon girls. Millais was also aware of the pathetic appeal of Reynolds's *Penelope Boothby*. Then in the collection of the Earl of Dudley, this work was widely known through reproductions and exhibitions (having recently been shown at South Kensington in 1862 and the Royal Academy in 1871), and epitomised the ideal of vulnerable childhood that appealed to Millais's generation. The fragility of Reynolds's child is emphasised by her over-sized mob cap and the white fichu wrapped snugly around her tiny body. Millais would no doubt also have been conscious of the brevity of Boothby's life. She was the only child of Sir Brooke and Lady Boothby but died of fever before reaching her sixth birthday. In Millais's painting the quotation from Reynolds serves to accentuate the viewer's apprehension of the vulnerability of childhood, a feeling further communicated by his image of a girl poised precariously on a log isolated against a dark sinister background.

With *Cherry Ripe* Millais was widely recognised as a painter of sentiment, the success of his image being in the way he used the visual historicisation of childhood to fuel an adult sensibility of loss. The painting has continued to operate on this level of consciousness, hence the ongoing fascination with Edie, who was later to become Madame Francisco de Paula Ossorio. At the time of the 1967 Millais retrospective, one woman reminisced: 'As a child I met its [*Cherry Ripe's*] model. She was a very fat old woman who warned: "I was as slim as you when I was eight."'[7] AS

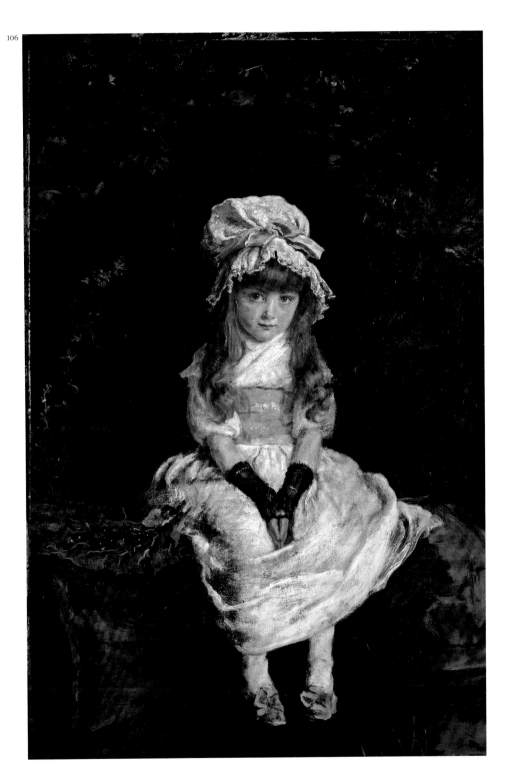

Figure 22
Joshua Reynolds (1723–92)
Penelope Boothby
1788
PRIVATE COLLECTION

Figure 23
The Graphic Christmas number,
1880, cover design by Randolph
Caldecott, featuring *Cherry Ripe*
VICTORIA AND ALBERT MUSEUM,
LONDON

Bubbles 1886
Oil on canvas
107.5 × 77.5
Signed and dated in monogram lower right
Unilever. On long loan to National Museums
Liverpool, Lady Lever Art Gallery

Provenance William Ingram for the ILN, bt from him by
Thomas J. Barratt, 6 April 1886, for A. & F. Pears Ltd., A. & F.
Pears/Elida Gibbs Collection; Unilever PLC

Exhibited A. Tooth and Sons, spring 1886 (118); Paris 1889
(103); Chicago 1893 (337); Grafton 1895 (209); Brussels
1897 (54); RA 1898 (157); RA and Liverpool 1967 (109); Arts
Council 1978 (37); Jersey 1979 (69); USA 1999–2000 (51)

Millais was at the height of his popularity when
he painted *Bubbles*. The previous year he had
become the first artist to be created a baronet,
and in 1886 a large retrospective of his work
was held at the Grosvenor Gallery. *Bubbles* was
not included in this exhibition but was shown
nearby at the gallery of the dealer Arthur Tooth,
who published a mezzotint of the picture by
G.H. Every in 1887. Following his custom of
using family members as models for his fancy
pictures, Millais posed his grandson, Willie
James, then aged four, in a slightly over-sized
costume reminiscent of those worn by boys
in portraits by Gainsborough and Thomas
Lawrence, gazing in awe at a bubble that floats
up from the pipe and bowl in his lap. His
chubby rosy face is reminiscent of that of a
Renaissance putto, and its illumination against
a mundane background lends an ethereal
quality to the image. In order to capture the
iridescent effect of the bubble Millais had a
sphere of crystal made expressly for the
purpose, and to help convey the impression
of spontaneity got Rupert Potter to photograph
the boy in the attitude of cocking his chin at
the ceiling.[1] Although the motif of a child
blowing bubbles alludes to the 'vanitas' genre,
the originally intended title of the painting,
A Child's World, suggests that Millais initially
set out to convey the wonderment of childhood
in the spirit of Reynolds's child portraits.
The accurate depiction of the bubble to
symbolise youthful innocence may also have
been prompted by the ectoplasmic spheres in
Hunt's long-term project *The Triumph of the
Innocents*, the prime version of which was
completed in 1887.

Bubbles was purchased with copyright from
the artist early in 1886 by William Ingram of
the *Illustrated London News* and was published
as a presentation plate in the 1887 Christmas
number of the magazine. Due to Ingram's
reservation that boy subjects were not nearly
as saleable as those depicting young girls, he
opted for a smaller size of reproduction than
had been used for *Cherry Ripe*, which appeared
in 1880 on a scale four times the normal size.

The transformation of the image from one of
childhood enthralment to a means of
identifying the prosaic source of the bubble
came with T.J. Barratt's decision to use it as an
advertisement for Pears' Soap. As chairman of
the company Barratt had long been aware of
the benefits of aggressive marketing, having
devised some highly original publicity schemes
such as getting the actress Lillie Langtry
(no.112) to recommend the soap in
advertisements distributed in the popular
illustrated press. He was perspicacious in
linking the bubble with the transparency of the
particular product he was promoting, as well as
inviting a pattern of association in the viewer's
mind between the child, purity and cleanliness.
Barratt purchased Millais's painting from the
Illustrated London News for £2,200. Although
copyright was included he was legally obliged
to seek Millais's permission before making the
necessary alterations to the design. He visited
the artist with proofs and appeared to have
won him over with the quality of the
chromolithographic reproduction. In February
1889 the company sent Millais some specially
mounted copies of the handbills for approval.[2]
Barratt's great initiative was thus in using art
as advertisement. He retitled the painting,
inserted a bar of transparent soap and the
words 'Pears' Soap' at the top, spent £17,500 in
manufacturing the print and then distributed it
widely as part of a £30,000 publicity campaign
(fig.24). This succeeded both in encouraging
a broad recognition of Pears as a brand name,
and in inviting association between the
product itself and high culture, encouraging
Barratt to branch out further in producing art
prints for the Pears Annual, which was first
published in 1891.

The appropriation of works of art for
promotional purposes soon became a matter
of debate. Those in favour of it argued that it
assisted in the democratisation of art by
educating the masses in the appreciation
of beauty. Those against the development
contended that it compromised artistic
integrity by encouraging self-advertisement
and the production of pot-boilers.[3] The most
trenchant criticism came in 1895 from the
writer Marie Corelli who, in her popular
novel *The Sorrows of Satan*, had one of her
characters say:

I am one of those who think the fame of
Millais as an artist was marred when he
degraded himself to the level of painting the
little green boy blowing bubbles of Pears'
soap. *That was an advertisement*, and that
very incident in his career, trifling as it
seems, will prevent his ever standing on the

dignified height of distinction with such
masters in Art as Romney, Sir Peter Lely,
Gainsborough and Reynolds.[4]

Here Corelli was presumably acknowledging the
connection made by critics between Millais's art
and that of classic English masters in order to
express regret that he was not sufficiently careful
about his reputation.[5]

The question of Millais's complicity in
Barratt's scheme was debated in the press
immediately following his death. In his
biography of his father, J.G. Millais wrote that his
father had 'been furious' when Barratt had called
to show him proofs of the print, a claim Barratt
denied. According to Barratt's testimony Millais
had proclaimed the print to be 'magnificent',
asking for a copy to be hung in his room.[6]
Despite the counter-claim that Millais had
originally conceived of his image as a painting,
not an advertisement, and that Pears alone was
responsible for converting it to the use of a
hoarding, it would seem that the artist himself
was rather candid about the matter.[7] Millais
himself was a firm believer in the broad
dissemination of art and was fascinated by the
latest reproductive technology. For him, a high
standard of replication was enough to preserve
the aura of the original and to prevent it from
being degraded into a merchandising tool. AS

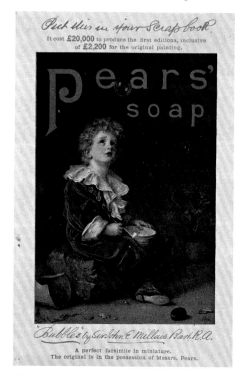

Figure 24
Pears' Soap advertisement of the
exhibition of Millais's original
painting at the World's Columbian
Exhibition, Chicago, 1893
PRIVATE COLLECTION

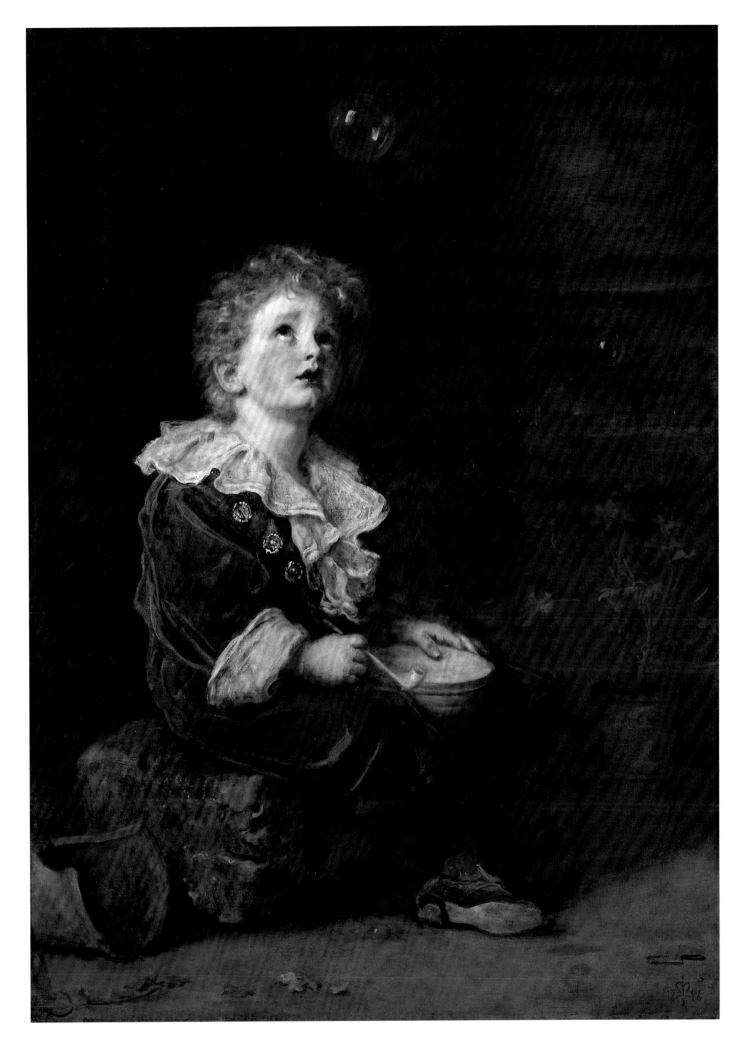

'The Little Speedwell's Darling Blue.'
'In Memoriam', – Tennyson 1891–2
Oil on canvas
98 × 73
Signed and dated lower right
National Museums Liverpool, Lady Lever
Art Gallery

Provenance Bt Agnew's from RA exhibition, 7 April 1892; Sir Julian Goldsmid, 7 Nov. 1895, his sale, Christie's, 13 June 1896 (46), bt Agnew for W.H. Lever (1st Viscount Leverhulme), thence to Lady Lever Art Gallery

Exhibited RA 1892 (256); RA 1898 (43); Port Sunlight 1902a (95); Port Sunlight 1902b (174); Port Sunlight 1948 (153); RA and Liverpool 1967 (115)

The model in this picture was the artist's granddaughter Phyllis (1887–1894), daughter of Effie and Captain William James, and sister of Willie James who posed for *The Ruling Passion* (no.98) and *Bubbles* (no.107). The painting can be seen as the female counterpart to *Bubbles* in that it similarly represents a moment of childhood absorption, although here the girl gazes down rather than up at the object that holds her attention. In both paintings the children are dressed in vaguely eighteenth-century costume, and the light silvery colour in Phyllis's picture complements the warm brown tonality of her brother's portrait.

The Little Speedwell is also a fancy picture. The background, loosely sketched in with dilute oil glazes, is reminiscent of the mature work of Gainsborough, particularly in the treatment of the birch, where paint marks appear detached from the trunk, and in the patch of distant blue glimpsed through veils of silver-grey brushwork. Like the bubble in the earlier painting, the speedwell held by the girl functions as an emblem of the tenderness and ephemerality of youth. According to Spielmann Millais had difficulty in finding an appropriate title for the work, but eventually selected a passage from Tennyson's *In Memoriam* (1850), a poem that had captivated him since his Pre-Raphaelite days and which was still in his mind in the 1890s.[1]

> Bring orchis, bring the foxglove spire,
> The little speedwell's darling blue,
> Deep tulips dash'd with fiery dew,
> Laburnums, dropping-wells of fire.

The stanza comes from section 83 of the poem, which expresses the soul's longing for the regenerative effects of spring. In Millais's painting this feeling is conveyed by the delicate speedwell – one of the first flowers to open at the onset of the season – that attracts the girl's gaze. The child thus personifies the emotion experienced by an adult conscious of the passing of time and burdened by the inevitability of death.

On 17 August 1891 Millais informed Effie that he was expecting Sir Henry James (later Lord James of Hereford) to call to see the painting. By early September James had viewed the work and wrote to Millais:

> As a work of art I think it will be lovely – though as a portrait I should prefer looking into that young person's lovely eyes. I shall be glad to have the picture if I can afford it – so please let me know what price you attach to it.[2]

Whether James was deterred by the downward expression of Phyllis or the price of the work is unknown, but the following spring Millais sold the picture to Agnew's for £1,500 including copyright. Although Agnew's had doubts about reproducing the work due to a slump in the print market, a photogravure was issued later by the dealer.[3] AS

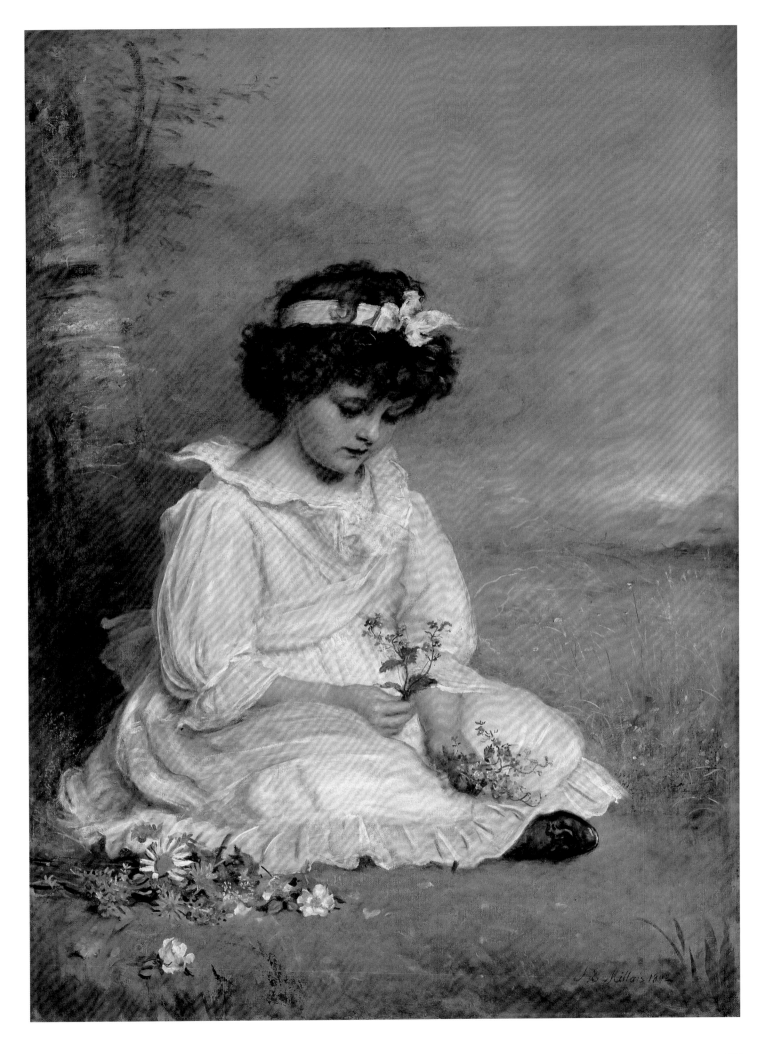

6
Portraits

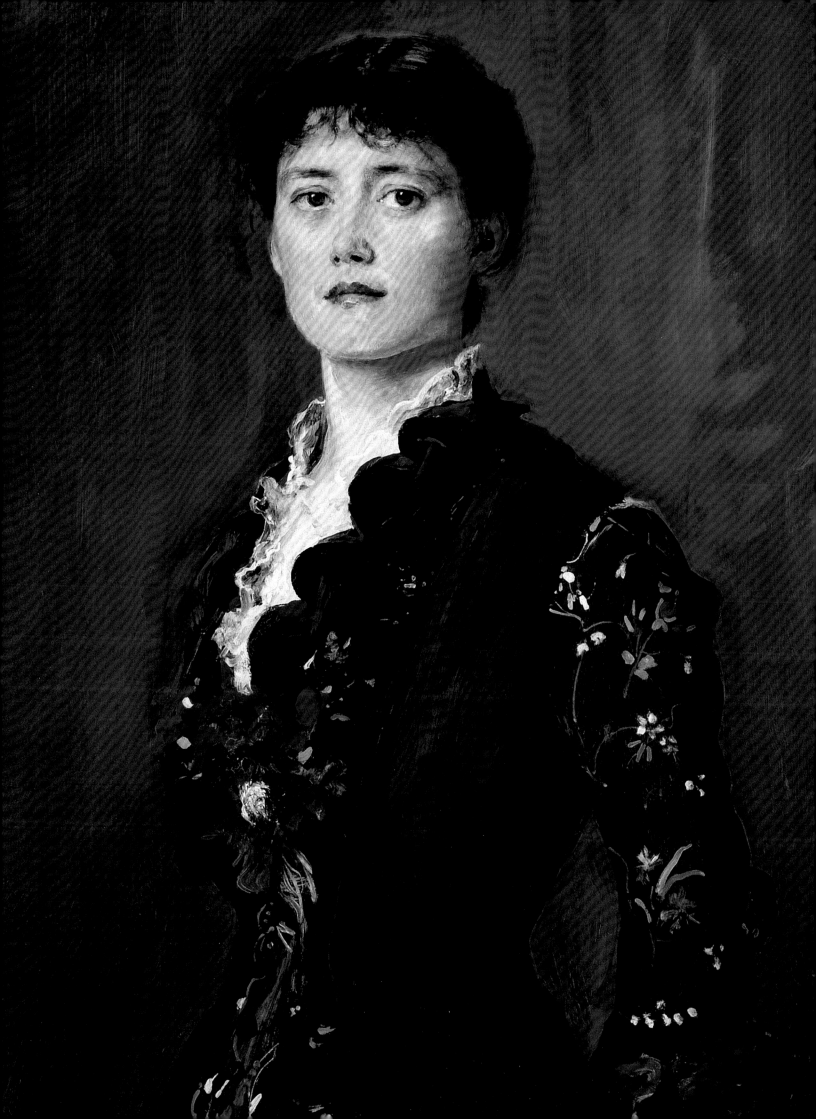

Portraits

IIn August 1880, having missed the opening of the hunting season in Scotland on the 'Glorious Twelfth', Millais wrote to Effie who awaited him at Erigmore House in Birnam, from Palace Gate,[1] in a letter that is exceptional in showing the factory quality of his studio:

> Mrs Otway has just been here with her daughter & I may now be some days later coming North as I have told the girl to come tomorrow to do a sketch of her.[2] I have done with the Barrett children & they go back to the Isle of Wight tomorrow and when I return I can easily finish them.[3] Dr Caird is also finished & Miss Rocker will be complete tomorrow & paid for immediately.[4] The Bishop of Manchester must stand over till my return when I shall be able with a fresh eye to get it to my satisfaction.[5] I have finished the copy of Mr Gladstone for his wife, and sent Miss Schenley away & wrote to Lady Stepney to send for the child.[6] Combe is my difficulty as I can't get him for a last touch, but he may come tomorrow [...][7]
>
> You must arrange with Mr Otway what I am to have for the portrait after it is finished. I am only to make a *sketch* which I daresay will be one of my best. My only inconvenience may be in not being at Erigmore to receive my friends who I have asked [...]
>
> If Johnnie is anything in the Art line he ought to be a *sculptor* as it wd be against him all his life following me & a good English sculptor is sadly wanted.

Johnnie – J.G. Millais – did not follow his father's advice, instead becoming an animal artist and writer, but it is evident that Millais saw portraiture as both the engine of his prosperity and a marker of his artistic success. His productivity was exceptional; in 1881, for example, he showed eight works at the Royal Academy, two at the Grosvenor Gallery, and to add to his exposure, had an exhibition of nineteen works at the Fine Art Society, two of which were shown publicly for the first time. Few artists had gained such exposure.

Lord Ronald Gower, who sat for a portrait in 1876 (Royal Shakespeare Company Collection), described Millais's painting procedure in this period:

> He commenced by covering a fresh canvas with a low tone of Vandyck brown as groundwork, and then worked over this while the ground was still wet, painting in the head without any previous drawing. He works 'con amore', and makes much use of a pier looking-glass. He makes one stand up all the time, and allows but little time for rest. However, he lets one talk and even smoke throughout the sitting.[8]

Millais rarely made preliminary sketches in later life, and never highly finished ones. But he would often have photographs taken of portraits in process, which he would then mark up with chalk or pen as reminders of how he wanted to proceed, and then work directly on the canvas.[9] Millais's portraits of his later career represented people across the broad spectrum of upper-middle class and aristocratic society in Britain. Many of the sitters were clients and friends and, while not every portrait was a classic, sitters were rarely dissatisfied, and the overall quality is exceptional.

Sitters noted that Millais worked quickly, recognising that many of the public figures who posed for him had limited time to sit and, of course, sessions had to be held at Palace Gate during daylight hours. Perhaps the models should be credited to a degree for consenting to sit to such an important painter, although certainly many of their portraits were also painted by merely adequate portraitists such as Frank Holl. But this should be seen as part of a vivid tradition in British culture, stretching back to the time of Hans Holbein, through Joshua Reynolds, and carried on through today, in fact, in work such as Lucian Freud's recent portrait of Queen Elizabeth II (2000–1) or even Johnny Yeo's image of Tony Blair (2001). By comparison, it is inconceivable to think that John Currin or Alex Katz would paint a portrait of George W. Bush—that is a tradition long neglected by significant artists in the United States. While it is true that public figures such as Georges Clemenceau were painted by Édouard Manet

in France, if not officially, in the period, Millais and G.F. Watts performed a broader service, one that was well compensated in the case of Millais, in preserving the images of politicians of the period. One suspects that Millais's thought process went deeper than this. We know that such commissions and, especially, the resultant engravings of the pictures, were a steady source of income for the artist, and allowed him to continue a line of portraiture in reproduction first pursued by Reynolds.[10] For example, the engravings after Millais's pictures of Gladstone 1878–9 (no.121) and Disraeli 1881 (no.122) were sold as a pair.[11] In addition, as a participant in the founding of the National Portrait Gallery in 1856, which until 1969 did not admit images of people not yet dead a decade excepting sovereigns and their spouses, Millais surely had one eye on posterity, producing works that would eventually gain public exposure in perpetuity, even more of a consideration when he helped to secure the gallery a permanent home in 1889. The National Portrait Gallery opened in April 1896, six weeks after Millais became President of the Royal Academy. By that time his portraits of Wilkie Collins 1850 (no.31), John Leech and Carlyle 1877 (no.120) were already in the collection.

Millais's later works have been described as 'brilliantly emblematic without being didactic',[12] and this is a characteristic that is impressive. Meanings arise out of viewer awareness of context. This was the case with *Autumn Leaves* 1855–6 (no.82), continued through *The Eve of St Agnes* 1862–3 (no.88), and remained so until his death with late pictures such as *St Stephen* 1894–5 (no.99). While his portraits do not always function only in this way, they do, in their confluence of fashion sense, drama, lighting, energetic gazes, and evocative technique, represent their period in a way that small photographs and the literary arts could not.

H.C.G. Matthew has written that 'Millais caught the high Victorians as they liked to see themselves, as intellectuals in politics, rather than as politicians *per se*',[13] and perhaps this was the gift of the artist, to satisfy the aspirations of his sitters while rendering them with an immediacy of expression and surface that was unmistakably his own. JR

The Marchioness of Huntly 1870
Oil on canvas
223.5 × 132
Signed and dated in monogram lower right
Private Collection

Provenance Sir William Cunliffe-Brooks, 1st Baronet Cunliffe-Brooks; by descent to Douglas Gordon, 12th Marquess of Huntly; Christie's, 21 March 1969 (78); Sotheby's, 29 Nov. 2001 (22)

Exhibited RA 1870 (989); RSA 1881 (318); Aberdeen Art Gallery 1962–8 (loan); RA and Liverpool 1967 (74)

Amy Cunliffe-Brooks was the daughter of William Cunliffe-Brooks, the Conservative MP for East Cheshire. She married Charles Gordon, 10th Marquess of Huntly, on 14 July 1869. The father of the bride commissioned this picture of her standing in a conservatory. Amy wears a refined and fashionable dress with a gored skirt, formal in its low neckline, lace-trimmed and high waisted, in a transitional moment just prior to the adoption of the bustle. The ensemble is embellished with a choker with pearl pendant and earrings, and she has taken off her glove to reveal a gold bracelet. Her father was a successful banker from Manchester who was an avid sportsman. In 1869 he purchased the estate of Glen Tanar in Aberdeenshire.[1]

Millais knew Cunliffe-Brooks from as early as 1866, when he gave the artist permission to shoot a stag on his Scottish property.[2] In May 1869 Effie attended a party in London that well illustrates the Millais's social network in this period, when they were beginning to advance in society. There she met the future groom Lord Huntly, whom she found very nice and pleasing, 'if boyish'. She and her friends found Lady Fife's daughter Alexina much more entertaining than Amy, Huntly's eventual wife.[3] The Penders were there, owners of three of Millais's pictures (see 'Leisure Hours', no.89),

as well as Madame Leopold Reiss, who would be painted by Millais in 1876. Effie thought the most beautiful guests were Mrs Clarissa Bischoffsheim (no.111) and her sister Miss Lucy Biedermann, who would later marry James Stern and be painted by Millais in 1881–2 (Private Collection). Sir William Harcourt and Arthur Kinnaird were there as well, friends of Millais. Effie observed sharply that Mr Cunliffe-Brooks was out of his element with these people. William Millais sang and Sir Charles Hallé played 'splendidly' with his eventual wife, Madame Wilhelmina Norman-Neruda on violin. Effie recounted that about 120 people heard a fine concert as one would at the Philharmonic, 'with out costing […] a penny'.[4]

Shortly thereafter, Effie wrote to Millais to say that she had sealed a deal with William Cunliffe-Brooks:

> I had an opportunity of speaking to Brooks & it is all settled that you paint Miss Brooks immediately you return for G. [guineas] 2,000 full length a regular Chef D'oeuvre in the Sir Joshua size & either in her Court or Bridal dress. Brooks charmed and very grateful indeed if you will do it thought the price just what you ought to have & said he didn't hesitate a moment between a half length at G. 1,000 or a full length to hand down in the family for 2,000 as he thought it much more important & worth double the money so that is settled.[5]

This is a good example of Effie cannily using social connections and her negotiation skills to secure commissions for her husband, and represents her engagement in his profession.

For a businessman such as Cunliffe-Brooks, marrying his daughter into the Gordon family

was a coup, and he celebrated it with this, Millais's largest portrait. A grandiose 'Sir Joshua size' full-length, it represented Millais's idea of the brightness of earlier painters and is related to the Old Masters in pose and opulence rather than tone. It also showcased his bravura manner, demonstrating his absorption of eighteenth-century portrait conventions. The *Art Journal* spotted such acknowledgements, but also lit on the distinctiveness of Millais:

> one peculiar merit in the painter's achievement is, that it does not remind us of what has been done before; the manner differs from that of either the Italian, the Spanish, or the Flemish school: it is independent and individual.[6]

It is a persistent aspect of Millais's art that inspiration can often be divined, but exact reference is more difficult to perceive. This goes against Reynolds's concept of the grand style or manner, wherein links to earlier masters are but thinly veiled. In Millais's work the veil is thick, and the best pictures indeed appear 'independent and individual'. If Reynolds's type of borrowing is evidence of confidence in an artist, Millais's originality is of a higher order. Despite this, the *Art Journal* concluded by saying that *The Marchioness of Huntly* could not hold its own against the likes of Reynolds and Thomas Gainsborough, as in works such as their *Mrs Thomas Riddell* 1763[7] or *Mrs Grace Dalrymple Elliott* 1778. But for Cunliffe-Brooks the picture was exactly what he desired, and in marrying the tonalities of Aestheticism with the stately grandeur of the Old Masters, Millais created a work of remarkable freshness, both in its active surface and in the depiction of its subject. JR

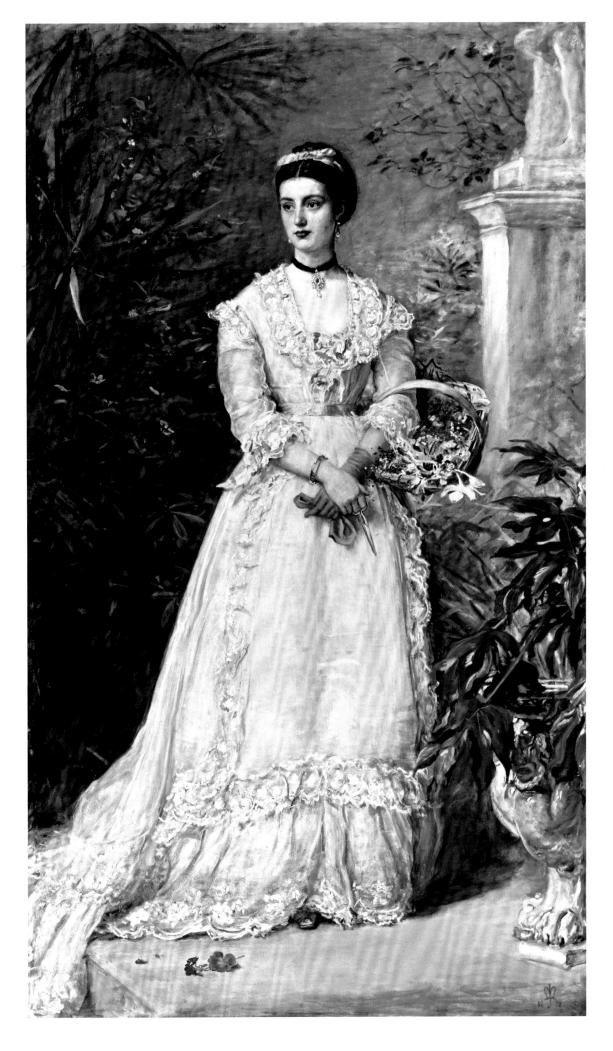

Hearts are Trumps: Portraits of Elizabeth, Diana, and Mary, Daughters of Walter Armstrong, Esq. 1872

Oil on canvas

165.7 × 219.7

Signed and dated in monogram lower left

Tate. Presented by the Trustees of the Chantrey Bequest, 1945

Provenance Walter Armstrong; his bankruptcy sale Christie's, 26 Feb. 1876 (72); bt Agnew's; John Herbert Secker by 1878; Revd Walter Secker to 1945; bt for the Tate Gallery out of the Chantrey Bequest, 1945

Exhibited RA 1872 (223); Paris 1878 (172); Huddersfield 1883 (22); GG 1886 (83); RA 1898 (149); Dublin, National Gallery of Ireland on loan 1904-21; Liverpool 1922 (399); Paris 1938 (94); Glasgow 1938 (421); RA 1949 (307); RA and Liverpool 1967 (78); Tate 1992–3 (63); NPG 1999 (48)

In 1872, the collector and merchant Walter Armstrong commissioned this triple portrait of his daughters playing dummy whist.[1] Armstrong first met Millais in August 1871. He had seen *Sisters* 1868 (no.90) at the London International Exhibition of 1871 and conceived the idea for the portrait, and Millais repeated the concept of three girls in identical dresses with a floral background.[2] However, the age of the Armstrong siblings lent itself to a different meaning, enhanced by the card game they are playing. As with *The Marchioness of Huntly* (no.109), the work is based in the English portrait tradition: the specific reference was Joshua Reynolds's *The Ladies Waldegrave* (1780) hanging at Strawberry Hill in Twickenham. Its owner at the time was Frances, Countess Waldegrave, who frequently hosted members of Millais's family.[3] The reference to Reynolds should be seen in the context of Armstrong's wish to elevate his line

to the level of the eighteenth-century aristocracy. Reynolds's painting showed Horace Walpole's great-nieces winding silk on to a card and making lace, a distinctly mundane occupation and a denial of the ideal, in the sense that they are not shown adorning a herm, or sacrificing to the Graces. In *Hearts are Trumps* Millais approximates an Old Master style, using broad brushwork and impasto, as in the left background which is filled with flora, and the smooth use of paint in the girls' faces. On the right, the forms on the oriental screen include a pagoda rising behind Mary Beatrice's back and vertical joins that demarcate the sisters. She is framed by the decoration of the screen behind Diana in the centre.

Painted only two years after the portrait of the Marchioness of Huntly, Millais shows that the bustle has arrived, but here dresses remain full in the front in the form of voluminous silk satin petticoats (once described as lavender-purple or lilac but now faded) with corsets and trimmed with pink ribbon and lace.[4] This is high fashion for the period. The hairstyle of Elizabeth, in profile on the left, cleverly mimics the style of the clothing, with the bulk braided and moved back. While Millais is thinking about eighteenth-century precedents for art, the dresses are absolutely au courant for 1872. In terms of the game, Mary Beatrice looks conspiratorially towards the viewer, to whom she shows her hand and impressive advantage; she holds the two remaining face cards in hearts. She would marry Rowland Ponsonby Blennerhassett in 1876.[5] The dummy hand in the foreground of the table and the vacant seat also involve the viewer in the scene.

Millais's picture is further related to

Reynolds's in that the title *Hearts are Trumps* refers not just to a suit of cards in the game, but to the hoped-for suitors who would materialise and take these young girls' hearts; such paintings were often commissioned with this in mind, to cause a stir and elicit interest when exhibited in public.[6] There is a far more decorative card table in Millais's picture. To add further to the accumulated aesthetic bric-a-brac in the picture, Millais included a marquetry card table and a ten-sided inlaid table on the left with a blue and white cup and saucer on top. In its eclectic confluence of decorative elements from many different eras and cultures, the picture shows trends in Aestheticist fashion in the period.

Hearts are Trumps continues Millais's debt to Velázquez's technique; by this time he approximated the Spanish painter's brushwork and tone as well as anyone until John Singer Sargent. This was no secret to critics, the *Athenaeum* writing: 'the painting is as brilliant, lucid and forcible as a Velasquez, and as broad as a Reynolds.'[7] The *Illustrated London News* disliked the lack of 'compromise whatever with pictorial conventions, no attempt to unify, or concentrate, or focus. The artist placed his figures in full light, and he painted exactly what he saw.'[8] This claustrophobic effect, experimented with in earlier pictures such as *Sisters*, gives the picture its compositional daring.

In 1875 Walter Armstrong was ruined in a fraud on the London and Westminster Bank and was forced to liquidate his collection. The picture, however, was acquired by John Herbert Secker, by then husband of Diana Secker, pictured in the centre. JR

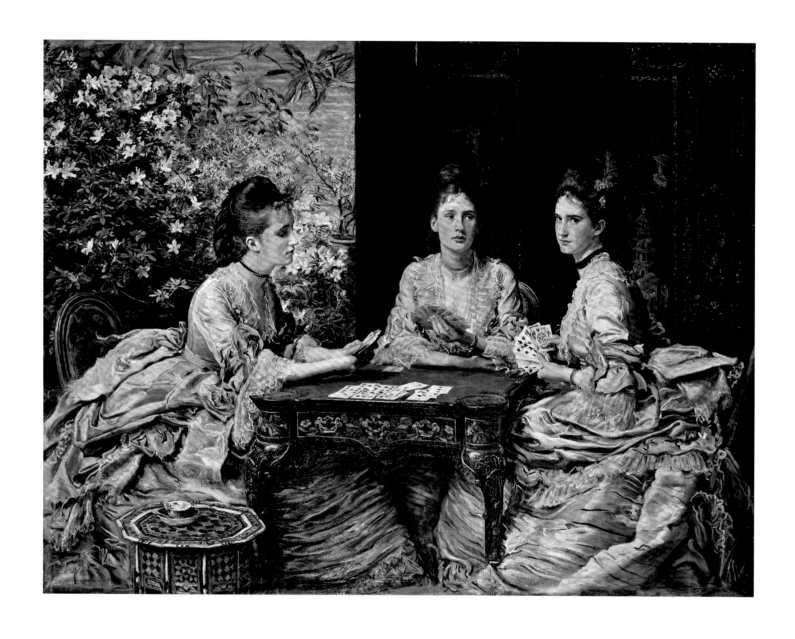

Mrs Bischoffsheim 1872–3
Oil on canvas
136.4 × 91.8
Signed and dated in monogram lower left
Tate. Presented by Lady Fitzgerald, 1944

Provenance Henry Louis Bischoffsheim; by descent to Lady Mildred Fitzgerald, who presented it to the Tate Gallery, 1944

Exhibited RA 1873 (228); Paris 1878 (178); Munich 1879; GG 1886 (95); RA 1898 (113); Whitechapel 1905; Grafton 1910 (36); Liverpool 1910 (1185); Manchester 1911 (243); NGL 1917; London 1924 (W.27); Paris 1938 (95); RA and Liverpool 1967 (81); RA 1968–9 (316); Tate 1992–3 (64); NPG 1999 (49); Leighton House 2000 (loan)

Millais painted two of the seven daughters of Joseph Biedermann, who had been court jeweller to the Hapsburgs in Vienna.[1] Clarissa married Henri Louis Bischoffsheim, whose family had established a bank in Paris. He went to London in 1849 to work in the branch there, and became known as Henry. In 1873 he established his own bank, Bischoffsheim and Goldschmidt.[2] He had married Clarissa in 1856, and they acquired Bute House, 75 South Audley Street in London in 1872, the year Millais began this picture.[3] There they installed a Tiepolo ceiling allegory of Venus and Time now in the National Gallery, London, and decorated the interiors in an eighteenth-century style.[4] His nickname was 'Bisch' and hers 'Mrs Bisch' and, besides being famous hosts, they were connoisseurs of French furniture and art.[5] They were known as exceptionally charitable, and a powerful presence in the London Jewish community. The picture was exhibited in Paris in 1878 and engraved by Charles Waltner.

The sitter is posed in a characteristic dress of the early 1870s, an embroidered two-piece bustle gown with a basque, here with a square neckline and lace frill that may be antique, and extraordinarily deep cuffs with blue piping that matches that on the basque. She also wears an overskirt. It was calculated to tie in with the interior decoration of her house. The pearl drop earrings and massive 'Holbeinesque' pendant are ostentatious and perhaps provide a link to her father's profession.[6] Critics at the time identified her dress as a Dolly Varden, that is, one of muslin with flowers and a calico mauve and green tint. The pineapple pinnacled chair symbolises welcome and may have been part of the family's collection.

The *Athenaeum* detected a certain hauteur in her expression,[7] and perhaps this is unsurprising considering the magnificence of the garment and the role this portrait of one of Millais's many prominent Jewish sitters would play in her sumptuous home and in promoting her role in society. Hence, the *Illustrated London News* described it as 'the beau ideal of a fashionable *grande dame*, with her mature beauty set off by a sumptuous costume of lace and jewels'.[8] Effie Millais described her as the most beautiful woman at a London party she attended in 1869 (see p.192) and here, four years later, Millais was able to convey her attractiveness, if not her personality.[9] JR

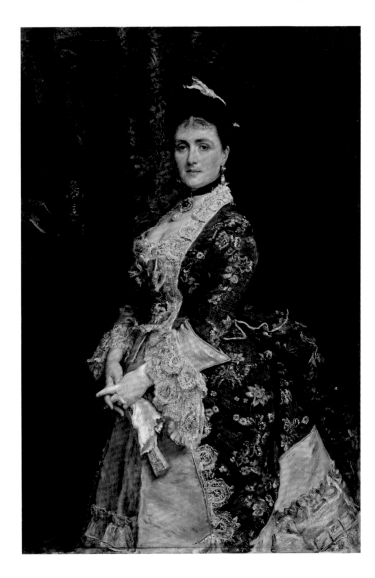

A Jersey Lily 1877–8
Oil on canvas
116 × 85
St Helier (Barreau Le Maistre Gallery)
Jersey Heritage Trust

Provenance Henry Martyn Kennard by 1886 and until at least 1898; Cora, Countess of Strafford; Miss Adele Colgate; Mrs Sidney Smith; Sotheby's, 27 March 1973 (79) to the Jersey Heritage Trust (responsible for the States of Jersey art collection)

Exhibited RA 1878 (307); GG 1886 (23); RA 1898 (90); RA 1923 (651); Jersey 1979 (57); NPG 1999 (52)

With this picture Millais commenced a trio of portraits of beautiful women painted from 1877 to 1880 that represent the high-water mark of his portrait practice, including *Louise Jopling* (no.118) and *Kate Perugini* (no.119). In *A Jersey Lily*, exhibited in the Royal Academy of 1878, Millais painted the rage of the London social scene, Lillie Langtry, who like him had a Jersey connection, having been born there, and had first met Millais at a party given by Sir John and Lady Sebright in 1876. He asked her to let him paint her there and then.[1] Millais kept *A Jersey Lily* in his studio afterwards, as Langtry could not afford it, and he may have used it for the same purpose as Reynolds did his portrait of

The Ladies Waldegrave, to entice commissions from visitors. The painting is perhaps intentionally stiff, calling to mind both classical statuary and a certain shy reserve in its sitter, who was not yet twenty-five. William Michael Rossetti wrote of it in *The Academy*:

> The flower which gives the picture its title is held in the lady's hand: her blush-rose cheeks, blue eyes, and auburn hair, make up almost the type of the 'pretty woman' of modern society – an abstract standard of beauty is not so much in the painter's line: the figure, draped in black silk, has received comparatively little attention from him.[2]

This strand of lily was associated with both the painter and the future actress's home island, and a result of this painting was that it became her nickname.

The Langtry portrait is somewhere between the naiveté of Millais's paintings of children and the maturity of female portraits such as *Louise Jopling*. She wears what may be a black velvet princess dress, with lace collar and cuffs, the mourning outfit she famously wore to her first society party in London. Most

extraordinary are the iridescent green eyes, an effect visible even in black and white photos of Langtry, and well captured here.

While Langtry and the Millais family moved in similar circles in the 1870s and were friends, by the last decade of Millais's life they did not have much contact. Langtry wrote to Millais:

> Dear Sir Everett,
> It was very kind indeed of you to write to me. I couldn't help calling to ask after you when you were so ill & am glad to know you are better again […] Tell Lady Millais I saw her at the private view & couldn't screw up my courage to speak to her. She used to be so kind to me, but she hasn't written to me or asked me to come & see her. I have a little niece I should so much like you to see. I heard someone in the park say as she passed, 'Millais ought to paint her.'[3]

Henry Martyn Kennard, the engineer who was also an amateur archaeologist, antiquary and collector of Egyptian art, owned the work by the late 1880s.[4] In 1881 H. Blair Ansdell published Thomas Oldham Barlow's engraving of the picture. JR

Effie Millais c.1873–4
Oil on canvas
99 × 84
Signed and dated in monogram lower left
Perth Museum & Art Gallery, Perth & Kinross
Council, Scotland

Provenance Millais family; Ralph Millais sale at Christie's,
7 July 1967 (116); bt Sir David Ross; sold by his Executors to
Perth by private treaty through Christie's, 21 April 1977, bt by
Perth Museum and Art Gallery with financial assistance from
the NACF

Exhibited Grafton 1896; RA and Liverpool 1967 (82);
Edinburgh 1991 (38)

Effie was forty-five when Millais began this, his only life-sized formal oil portrait of her. The picture well communicates the independence, scepticism and insouciance evident in her letters.[1] It was the first time he had painted her since *Peace Concluded, 1856* (no.66) and would be his last painted image of her. Their youngest son, John Guille Millais, then around aged eight, originally sat in her lap for the picture. Millais replaced him, appropriately as it turns out, due to his eventual literary career, with the *Cornhill Magazine*, a respected journal identifiable by the four circles in a diamond shape on an orange field, on a cover designed by Godfrey Sykes. Each of these represent images of scenes from the harvest, and Effie points to the lower tondo of a thresher. Effie posed in a red velvet dress and a necklace of agates in gold given to her by Sir Clare Ford who, when an officer in the Dragoons in 1851, had been enraptured by her. At the base of the four agates are 'windows' holding the hair of her four sons. In the directness of her stare, the picture would seem to present a true image of how Millais viewed his wife, and vice versa. She had seen much of life, having had seven of her siblings die in infancy and childhood, two husbands, eight children, one miscarriage, and having perpetually suffered from insomnia. In this sense, the combination of her sharp gaze and pointing to the image of the thresher may be a private joke, representing her role as the manager of Millais's work, and the frequency with which she pushed him to complete pictures and begin new ones. The matter-of-fact quality is the picture's strength and, in this sense, Millais conveys a sense of self-awareness that is remarkable for the period, and largely absent from his commissioned work.

Typical of this period in Millais's career, the picture has an active surface and generous impasto, especially in the background and the heavy curtain in the back left. The pillow behind her is dashed off in a gleaming Gainsborough blue. The bright yellow bow in her hair and olive green paint worked around her head were either meant to cover pentimenti (slight changes to the canvas), or to set off her pale complexion. There is little brushwork as accomplished and as attractive in Victorian art up to this point, and it reveals Millais's continual stylistic experimentation.

The painting was not exhibited in public until the last year of Millais's life, in the Society of Portrait Painters exhibition at the Grafton Galleries. When Millais's body lay in state at Palace Gate in August 1896 the picture overlooked the coffin from above the mantelpiece, in honour of their forty-one years of marriage. Effie died a little over a year later, on 23 December 1897, aged sixty-nine. JR

Portrait of the Painter. Painted by invitation for the Collection of Portraits of Artists painted by themselves in the Uffizi Gallery, Florence 1880
Oil on canvas
86 × 65
Signed and dated in monogram lower left
Galleria degli Uffizi, Collezione degli Autoritratti, Florence

Exhibited RA 1880 (218); FAS 1881 (18); Florence 1971 (86)

This self-portrait, Millais's first in oils since 1847 (no.1), was a commission from the famed Uffizi Gallery in Florence, for their collection of artists' self-images. Now displayed in the Corridoio Vasariano stretching across the Arno River, Millais shares space with contemporaries Lawrence Alma-Tadema, George Frederic Watts, Frederic Leighton, William Holman Hunt, John Singer Sargent and Walter Crane. Joshua Reynolds hangs a little further down the hall. The honour was largely due to the machinations of Leighton, who had put Millais's name to the Uffizi committee in 1879, two years before delivering his own majestic portrait wherein he showed himself in the robes of a Doctor of Oxford University, with the gold medal of the Royal Academy Presidency, backed by a copy of the Panathenaic frieze from the Parthenon.[1] Similarly, Watts, whose self-portrait was painted in the same year as Millais's, positioned himself grandly in front of his painting *Time, Death and Judgement*.[2]

By contrast to Leighton, Millais shows himself at work, with a palette tucked in the nook of his left arm, brushes gripped through the palette's bow, and a metal thinning pot clipped upon the near edge. This is offset, on the left, by a wispy white handkerchief. He wears a brown wool sack jacket or suit, a stand-up collar and black tie, and looks out at the viewer in three-quarter profile, the right side of his face in shadow. The background is simply washes of brown tones. This pared-down presentation is consistent with his larger portrait practice. There is little presumption or excess. Besides a slightly tousled look to his hair, the expression is concentrated and reserved. To paint himself Millais used a looking glass on wheels that was always in the Palace Gate studio.[3] He purportedly completed the painting in two or three days.

Millais had visited the Uffizi Gallery in November 1865 in the company of the painter Henry Nelson O'Neil, who was preparing lectures for the Royal Academy. He had been waylaid in Florence for two weeks due to a cholera epidemic in the south and, according to Effie, enjoyed himself immensely after failing to find much merit in Venice. Sixteen years later his picture would hang there with those of Velázquez, Bernini, and Dürer, an exceptional honour for a living artist.[4] JR

George Gray Millais 1876
Oil on canvas, oval
Oval 58 × 44
Signed and dated in monogram lower right
Geoffroy Richard Everett Millais Collection

Provenance Artist's collection and thence by descent

Exhibited RA 1898 (152); RA and Liverpool 1967 (90); Jersey 1979 (54); Southampton 1996 (30)

This is one of a series of oval portraits Millais made of his children in this period. The others were of Mary, Alice, Everett and Effie, possibly in emulation of Gainsborough's small and casual oval portraits of the offspring of George III in Windsor Castle.[1] George is shown handsomely, in profile, with a dashing red tie.

George was Millais's second son, born on 19 September 1857, and named after his maternal grandfather. George had modelled for *The Wolf's Den* 1862–3 (unlocated) and *The Boyhood of Raleigh* 1869–70 (no.94). He attended Rugby School, where he was a good student, at least compared with his older brother Everett,[2] and then Cambridge University, with the intention of eventually preparing for the Bar. He there contracted typhoid fever. While receiving treatment he went snipe-shooting, showing his reckless nature (he had once been hit by lightning while riding his bicycle).[3] In late 1877 he went with his mother and sister Mary to France. Doctors advised them to go to Switzerland for his health but, on returning to Britain, a chill followed, then consumption, and he died at Bowerswell on 30 August 1878 while on the way to visit his father at Dhivach, a house lent him near Loch Ness and Drumnadrochit by Arthur James Lewis, one well suited for painting as it had a studio.[4] Thomas Oldham Barlow, Millais's friend and longtime engraver of his pictures, wrote to him in sympathy as he had also lost a son.[5] Millais responded:

We have all had a very trying month for George went through great suffering and died *hard*. Wasting away to a skeleton he lived on, maintaining his senses to within a day of his death. He was such a fine character [...] and the family feel they will never know anyone to supplant him. He was so wise, truthful, and straightforward. I have loved and honoured him from his earliest days.[6]

George had been an active type, and was fishing Scottish rivers with his father from an early age. John Guille Millais wrote of the death of his brother that 'it was a terrible blow to my parents – all the heavier as he was now old enough to be a companion to my father during his autumn holiday, and many a happy day had they spent together with rod and gun'.[7]

Millais's grief came out fully in his painting of Loch Ness and Urquhart Castle (*'The tower of strength [...]*, no.132). In October he and Effie went to Paris to receive his medal for works at the Exposition, but the family did not recover much until their eldest daughter Effie was engaged to Major William Christopher James in February of the following year, the first of his children to marry. George is buried in Old Kinnoull churchyard along with his mother. JR

A Penny for her Thoughts 1879
Etching on paper
20.4 × 17 (image)
Illustrated in *A Series of Twenty-One Etchings*,
published for the Etching Club, London 1879
Geoffroy Richard Everett Millais Collection

Provenance Descent from the artist

Exhibited Southampton 1996 (146); Rye 1996 (26)

The model for this work may be the artist's
second daughter, Mary Hunt Millais (1860–
1944),[1] who in 1879 would have been thirty-
nine. The etching was produced in the same
year as his painting *The Bridesmaid* (Geoffroy
Richard Everett Millais Collection), in which
Mary wears the identical hat and adopts the
same demure pose. Both painting and etching
reveal Millais's preoccupation with the
aesthetics of fashion, which can be seen
throughout his society portraiture of the 1870s
and 1880s. The model wears a fashionable day
dress with bustle and train, the white lace ruffle
cuffs and high collar further indications of her
modish attire.[2] In 1877 Millais moved to a new

home in Palace Gate, and the setting may be
the lake called the Long Water in Kensington
Gardens, which was a short distance away. The
gracefulness of the swan complements the
woman's narrow and elegant silhouette.

Millais allows the viewer to construct a
narrative, the etching's title and her downcast
gaze being the only suggestions as to the
subject. Solitary women were a recurring
subject in Millais's illustrative work, their
inflating skirts and elaborate headdresses
often consuming the design. George du
Maurier described Millais's idea of the
Victorian woman as 'alive at every point,
and the most modern of us all. She is also
the most aristocratic person, even if she be
a dressmaker or poor widow with her mite.'[3]

Millais produced a total of eleven etchings
throughout his career, his first in 1850 (*St
Agnes of Intercession*, no.17). Although more
prolific as a designer for wood engravings,
he remained attached to the medium, and
throughout the 1860s and 1870s attended
meetings held by the Etching Club and

contributed towards their publications. In
February 1877 the Club approached the Art-
Union to finance a series of etchings, and at
the meeting in May each member circulated
proofs of the work they intended to contribute
to the volume.[4] The portfolio of prints, which
included *A Penny for her Thoughts,* eventually
came out in an edition of one hundred, with
twenty-one etchings by Club members
including Charles West Cope, Samuel Palmer
and Richard Ansdell, each member receiving
the sum of £343 10s for his design.[5] The
Etching Club allowed artists a freedom over
the choice of subject and, unconstrained by a
publisher or author, Millais produced a delicate
design, carefully creating tonal effects by
using complex hatched and crosshatched lines.

It is thought that this particular impression
was in the collection of the artist Richard
Redgrave, who was also a member of the
Etching Club.[6] A pencil sketch for the subject
survives in the collection of Geoffroy Millais
outlining the figures and the background
setting. HB

Twins 1875–6
Oil on canvas
153.5 × 113.7
Signed and dated in monogram lower left
The Fitzwilliam Museum, Cambridge.
Accepted by HM Government in Lieu
of Inheritance Tax and allocated to
The Fitzwilliam Museum, 2005

Provenance Thomas Rolls Hoare; Kate Gough; Grace
Wynne and by descent; accepted by H.M. Government in
lieu of inheritance tax from the estate of Mrs Jean Wynne,
and allocated to the Fitzwilliam Museum, 2005

Exhibited GG 1878 (22); GG 1886 (48); RA 1898 (124);
NPG 1999 (51)

Thomas Rolls Hoare of the paint and varnish manufacturers Noble and Hoare commissioned this double portrait for 1,500 guineas.[1] His business partner, John Noble, had commissioned Millais to paint his daughter Lilly in 1863.[2] The sitters were Kate Edith and Grace Maud, two of Hoare's fourteen children, and the occasion was their twentieth birthday.[3] The Hoares lived at 49 Ennismore Gardens in London.

The portrait began with the sisters in riding habits but the family objected, so Millais changed their clothes from skirts with double-breasted jackets to dark green walking outfits with bustles, trimmed with a gold and silver metallic ribbon.[4] Millais chose to exhibit this work at the Grosvenor Gallery and not the Royal Academy. The flashy quality of the brushwork suited this alternate exhibition venue, and critical response was enthusiastic. William Michael Rossetti wrote that the ladies were 'as one might expect, extremely alike: the painter has rightly kept up the same likeness, with several minor points of diversity, in the costumes and the general disposal of his sitters',[5] and these include the varied flowers on their lapels, and that Grace holds her 'gray beaver'[6] hat in her leather-gloved hand, its round form repeated in the loop of the dog whip in Kate's grasp.

Henry James wrote ambivalently, as he often did on Millais, that the picture is 'of the sort that is spoken of at present as representing him at his best' and that the sisters were 'stiffly posed and drawn, but very freely painted, and looking out of the canvas as Mr Millais can so often teach his figures to look'.[7] As in the most compelling of Millais's female portraits of this period, the goals were to shun the excessive idealisation of British portraiture and to navigate around the trend of glamorising sitters through spectacle, as seen in Sargent's society works. This is accomplished in the neutral gaze noted by James and so prevalent in photography of the period, and through a collapsing of space that forces the viewer's attention on the figures, as in the crush of background flowers in *Sisters* 1868 (no.90) and the flattening effect of screens in *'Leisure Hours'* 1864 (no.89) and *Hearts are Trumps* 1872 (no.110). Here a stone wall backs the sitters, with a border of a trellis on the left and creepers on the top and right. In 1898 Spielmann described the Hoare sisters as 'typical English maidens, strong and well grown',[8] and the cooperative deerhound as being as in character as the girls.

The military inspired design of their dresses are unintentionally appropriate considering both girls married into naval families. Kate wed the naval Captain Hugh Gough and she owned a remarkable album, now in the collection of the Victoria and Albert Museum and probably by her hand, that includes albumen photographic portraits collaged on to watercolour backgrounds.[9] Grace married Lieutenant Sydney Eardley-Wilmot of the Navy.[10] JR

118

Louise Jopling 1879

Oil on canvas

125.1 × 76.2

Signed and dated in monogram lower left
National Portrait Gallery, London. Purchased
with help from The Art Fund and the Heritage
Lottery Fund, 2002

Provenance Given by the artist to his godson Lindsay
Millais Jopling, son of the sitter; by descent; L.M. Jopling in
1967; Sotheby's, 22 Nov. 1988 (45); bt Roland Walter
Rowland; his widow Josie Rowland; acquired from her after
2001 via Peter Nahum by the Trustees of the NPG with a
contribution from the Art Fund and additional support from
the Heritage Lottery Fund

Exhibited GG 1880 (49); Liverpool 1880 (75); GG 1886 (30);
Glasgow 1888 (271); Liverpool 1894 (1179); Brussels 1897;
RA 1898 (71); RA and Liverpool 1967 (96); Japan 1987 (103);
Bodelwyddan Castle, Denbighshire, North Wales, 2003 (loan);
Washington 2007 (25)

Millais painted this portrait as a belated
christening present for his godson Lindsay
Millais Jopling, the only child of Joseph and
Louise Jopling. Born Louise Goode in 1843, the
fifth of nine children of a Manchester railway
contractor, Jopling studied art in Paris in 1867
and supported her family through painting
and illustration after the collapse of her first
marriage in 1870.[1] She subsequently married
the watercolourist Joseph Jopling, a great
friend of Millais's, and a man who shared
his love for shooting. In the same year as this
portrait, William Burges designed a studio
for her behind her house at 28 Beaufort Street,
Chelsea.[2] Louise Jopling frequently exhibited
works in Paris and London, and in 1887 she
established an art school for women in
Clareville Grove, South Kensington. She was
later a noted suffragette. The painting occupied
Millais for five sittings in the summer of 1879,
seemingly no trouble for Millais in view of his
stamina during this period, but Jopling wrote
that 'the five consecutive days' standing had
really knocked me up', although she later
cheekily claimed that her own experience
painting portraits had made her a better model,

and made his task easier.[3] Millais noted that as
he had neglected to give his godson Lindsay a
cup on his christening as was the tradition, he
had instead given him 'the mug of his mother'.

Louise Jopling was one of Millais's greatest
admirers. She recollected her first meeting with
him at a private view of a Winter Exhibition
of Old Masters at the Royal Academy at
Burlington House in 1871. Jopling came in
with Val Prinsep, who pointed out Millais:

You can imagine my excitement. I stared
with all my eyes. My friend said, 'Good show
of old masters!' 'Old masters be bothered!
I prefer looking at the young mistresses!'
said Millais, with a humorous glance at me
as he walked off. My companion roared with
laughter. 'There is only Johnny Millais who
would dare make a remark like that!'[4]

This well captures Millais's spirit and arch
sense of humour. In her entertaining memoir
of this period, published in 1925, Jopling gives
a warm portrayal of Millais. In turn, Millais
greatly admired her intelligence and wit.

This mutual admiration comes out in the
portrait, which does not represent her as a
traditional paragon of motherhood, as may
have been appropriate for a christening present.
Instead she is a proud individual, standing in
three-quarters profile, with her face turned so
as to be seen nearly head-on. She looks slightly
up and to her left, just beyond the viewer. Her
hands hold a fan and are clasped behind her
back, accentuating the curve of her figure and
the details of her remarkable black Parisian
dress covered with embroidered flowers,
embellished with fresh carnations. The smooth
and slick wash of black paint that cascades
down her torso well captures the sheen and
thinness of the dress material. By the end of the
1870s the bustle had begun to diminish, and
here the jacket is fitted smoothly over the waist
and hips to accentuate the female shape. Its V-

shaped neckline is embellished with lace and
ribbon. She wears no jewellery. Instead, the
viewer must concentrate on her actual beauty,
enhanced by the naturalism of the flowers, as in
A Jersey Lily (no.112). In this way it goes against
the artificial and opulent culturally constructed
ideal of beauty, the ostentation evident in
The Marchioness of Huntly (no.109) and
Mrs Bischoffsheim (no.111). It is a picture of
consummate confidence, from the perspective
of both subject and portraitist, with a tonal
range and vivacity of background that justified
the contemporary comparisons to the likes of
Diego Velázquez,[5] and which gives it a similarity
to Édouard Manet, in his portraits of female
artist friends Eva Gonzales and Berthe Morisot.
The difference is that Millais here has mastered
a painterly broken realist technique in the
service of representation; his brushwork has
become so calculatedly free as to be the extreme
opposite to the meticulous, small touches of
Pre-Raphaelitism, while still convincingly
depicting the material world. This was one of
Gainsborough's great contributions to British
art, and a style Sargent would later adopt.

This painting was first exhibited at the
Grosvenor Gallery in 1880.[6] The vast majority
of those who saw Jopling's portrait admired it,
including Whistler, who was a good friend of the
sitter, and who wrote to Millais of the success of
his pictures at the Fine Art Society's *Millais*
exhibition in 1881, adding that 'the only regret I
had was at the absence of that superb portrait of
Mrs Jopling'.[7] Whistler had painted her in 1877,
but his picture is all style and fashion, and does
not concern itself with innate elements of the
person.[8] Millais gives more of Louise Jopling, in
addition to beauty and intensity, but like
Whistler he does not show her as an artist; she
holds no props redolent of her trade. Instead,
she bears a fan behind her back, a traditional
implement of female engagement in social life,
and wields a firm, exceptionally level
expression. JR

Portrait of Kate Perugini 1880
Oil on canvas
124.5 × 78.7
Signed and dated in monogram lower right
Katherine Woodward Mellon

Provenance Charles Edward and Kate Perugini; Sir Henry
Dickens; his sale, Sotheby's, 15 March 1967 (116), bt Cyril
Dickens; C. Hawksley in 1969; Christopher Wood Gallery;
Richard P. and Katherine Mellon

Exhibited GG 1881 (68); Liverpool 1881; Manchester 1885
(407); RA 1898 (73); Wood 1994 (12); BAC 1996 (35, Yale only);
NPG 1999 (54)

This portrait represents the first time Millais
painted Kate Perugini since she sat for *The Black
Brunswicker* in 1859–60 (no.68).[1] She was the
youngest daughter of Charles Dickens, and wife
of Charles Allston Collins from 1860 until his
death in 1873.[2] She married the painter Charles
Perugini in 1874. They were both intimate
friends of the Millaises. She was a painter and
was close to Louise Jopling (no.118) and also
Sophie Caird (née Gray), Effie's sister, whose
portrait Millais painted in this period. The
painting was a present to Kate's husband, and is
three-quarter length and life-sized, showing the
sitter from the back, in a high-collared black silk
and sheer organdie or chiffon dress, holding a
fan, her left profile visible over her shoulder.[3]
The dress features a wide satin sash and a bustle,
the latter representing by 1880–1 the last gasp
of this version of that element. The sleeves and
shoulders are French-seamed, visible here in the
rear view. The casual hairstyle reflects the overall
informality of the picture; the only accessory is
the small silver earring.

The critic at *The Academy*, Cosmo
Monkhouse, chided Millais for 'showing the
soot-like effect of a lady's skin seen through
black crepe, even though the lady be *Mrs Kate
Perugini* […] and the imitative skill miraculous',[4]
a decidedly minority opinion of this work.
Théodore Duret, a friend of Manet and Whistler,
wrote of it: 'This is only a sketch, it is true, but the
sketch is at least a bold one: viewed from
the back, with her head turned, the model shows
grace and elegance.'[5] It is intriguing that Duret
would view it as a sketch, when Millais saw it
as a finished work, and perhaps calls forward
a divergence of opinion across the Channel in
which definitions of 'finish' were not cut and
dried. As with the portrait of *Louise Jopling*, this
painting has a remarkable informal quality to
it, especially in the sitter's hair, that distances it
from Millais's other pictures. In both works, the
abstract tonal backgrounds heighten the veracity
of the picture. It bears comparison with a
contemporary work painted in Paris, Sargent's
portrait of the same year of Virginie Gautreau,
known as *Madame X*, but *Kate Perugini* was
calculated to sparkle, not to shock. JR

Thomas Carlyle 1877

Oil on canvas

116.8 × 88.3

National Portrait Gallery, London

Provenance Possibly commissioned by James Anthony Froude; left unfinished in the possession of Millais; bt Reginald Cholmondeley of Condover; Christie's, 16 May 1885 (76), bt in; bt from Reginald Cholmondeley, 11 Sept. 1894 through Stephen T. Gooden by George Schaft, Director of NPG; presented to NPG in Dec. 1895

Exhibited GG 1886 (15); RA and Liverpool 1967 (92); Tokyo 1975 (56); NPG 1981–2 (33); Edinburgh 1991; NPG 1999 (39); Bodelwyddan Castle 2006 (loan)

Millais's portrait of Thomas Carlyle (1795–1881) represents both a penetrating likeness of the prominent Scottish writer, historian and social critic, and a response to James McNeill Whistler's abstracted portrait of the sitter of 1873, exhibited as *Arrangement in Grey and Black, No. 2 (Portrait of Thomas Carlyle)* in the Grosvenor Gallery in early May 1877.[1] Millais began his portrait later that same month. It entered the National Portrait Gallery fourteen years after Carlyle had died, just over the ten-year waiting period after a sitter's death for inclusion in the collection. In contrast to Whistler's subjection of Carlyle, as he had done in the famed portrait of his mother in 1871, to an abstract impulse towards surface design and masses of tone, a hallmark of Aestheticism, Millais presented the full face of Carlyle, and an expressive treatment of his hair, which together give an idea of his state of mind in the last few years of his life. He wears a frock coat and leans on his walking stick while sitting bolt upright. The picture is unfinished and gives insight into the artist's working method, proceeding on the canvas without underdrawing but instead outlining with dark strokes of paint, as evident in the hands. Backgrounds would be worked up from scumbled surfaces applied in increasingly dark layers.

Modern audiences, accustomed to abstract art, see such effects as expressive, but at the time it was seen as inert, 'merely the mask; no soul, no spirit behind' by one viewer, who nonetheless noted that it 'looked modern'.[2] Lacking a commission, and perhaps uncertain if he could successfully complete it, Millais abandoned the work. The picture was famously slashed by a suffragette, as part of a wider five-month campaign to garner attention to the cause; on 17 July 1914 Margaret Giggs (alias Ann Hunt) damaged it at the National Portrait Gallery with a 'chopper' across Carlyle's face. At her trial she said that the picture 'will have an added value and be of great historical interest because it has been honoured with the attention of a militant'.[3] JR

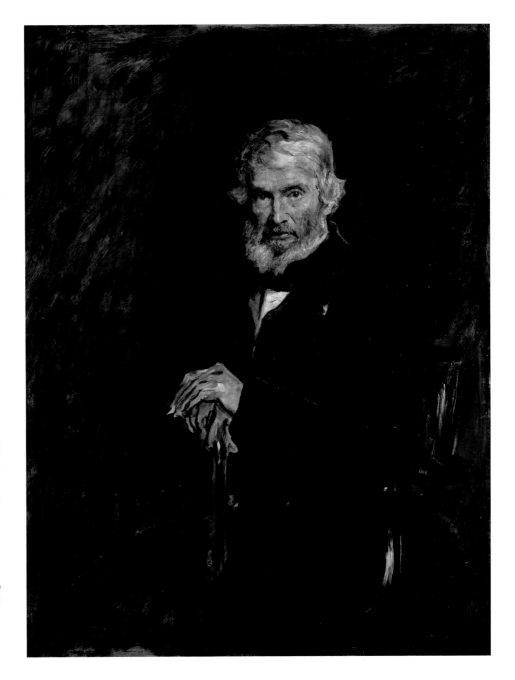

The Right Hon. W. E. Gladstone, M.P.

1878–9
Oil on canvas
125.7 × 91.4
Signed and dated in monogram lower right
National Portrait Gallery, London

Provenance Bt Agnew's including copyright; sold by them to the 1st Duke of Westminster (Hugh Lupus), 1879; bt Agnew's 1886; sold to Sir Charles Tennant, Bt; presented by him to the National Gallery, 1898; transferred to the Tate Gallery, 1955; transferred to the NPG 1957

Exhibited RA 1879 (214); Stonehaven 1881; GG 1886 (97); Manchester 1887 (529); Glasgow Institute 1888; Whitechapel 1889 (26); Paris 1889 (100); RSA 1897 (312); RA 1898 (128); RA and Liverpool 1967 (95); NPG 1999 (40)

Millais's portrait of the Liberal politician William Gladstone (1809–98) shows him, as in that of Disraeli (no.122) and Salisbury 1882 (National Portrait Gallery), without the identifying attributes of office; only the faces convey their identity. H.C.G. Matthew has characterised them as 'undidactic' and 'democratic in their absence of assertion of distinction, save by dignity and force of character: the viewer observes the Prime Minister person-to-person'.[1] Millais presented the politicians without symbolism, with only slight variations in their two-thirds-length poses: Gladstone three-quarter view facing right, hands clasped before him; Disraeli in three-quarter view facing left, arms crossed in front; Salisbury in three-quarter view facing right, arms locked behind him. None look at the viewer, all are against blended brown background, each is almost divinely spotlit.

Millais completed this picture one year before Gladstone would begin his second term as Prime Minister, and the emblematic nature of such a picture benefits from Millais's recognition of the limits of realism and embrace of suggestiveness in a lack of polish. This is evident in the dense dark background, the simplified black suit with plain white cravat, and the standing collar that matches Gladstone's resolution. A button's upper edge is picked out on the jacket, a glint on the third finger of the right hand reads as a wedding ring, but nothing else detracts from the visage.

It is a lesson in refinement and restraint that bled into his female portraiture, most boldly in *Louise Jopling* (no.118) and *Kate Perugini* (no.119).

Gladstone was painted at Millais's own suggestion,[2] and he recalled Millais as the most intense artist he had witnessed. This was a mark of respect from a man famous for his work ethic, whose speeches in the House of Commons were legendary in length, and who 'could do in four hours what it took any other man sixteen to do and that he [nonetheless] worked sixteen hours a day'.[3] Gladstone appreciated that Millais had him sit only a minimal number of times. Two years after Millais's death, Edward Poynter (who followed him as President of the Royal Academy), in a speech described *Gladstone* as 'unrivalled since the days of Rembrandt and Velasquez in its rendering of the mind and the spirit of the man'.[4] For this picture Millais was indeed looking at these artists, as well as Frans Hals, whose work he had first seen in profusion on a trip to Amsterdam, Haarlem and elsewhere in the Netherlands in 1875. In 1880 he visited the Frans Hals Museum in Haarlem with Andrew Gray and William Powell Frith, who later wrote that the seventeenth-century Dutch artist's works 'greatly resemble the style of Millais [...] their value resting – after the splendid dash and brilliancy of the execution – on their absolute truth'.[5]

Gladstone's portrait took five sittings, and would be the first of five Millais would paint of him. The Millais family had known the Gladstones since the 1860s, and Effie at least saw eye-to-eye with his politics. Millais was a frequent visitor to their home, Hawarden Castle, near Chester; they saw each other frequently into the 1890s. In 1887, after Millais had painted him three times from life, Gladstone wrote that he missed the artist's presence that autumn: 'It is so long since I have seen you that I am sure you must have forgotten even my physiognomy.'[6] This was unlikely, of course, but shows the personal terms between the men. That is why it gave Gladstone

pleasure, while Millais was in the middle of painting his, Gladstone's, portrait for the Earl of Rosebery in 1885, to write to inform him with 'satisfaction, both personal and public [...] with the sanction of Her Majesty (and lawfully though at the last gasp) to ask you to accept the honour of hereditary title, and take your place among the Baronets of the United Kingdom'. The postscript was a far less momentous: 'Unless I hear to the contrary I hope to come to sit at twelve tomorrow.'[7] That next day Millais wrote with much more enthusiasm to his daughter Mary who was visiting her uncle in New Zealand:

> Oh Mary, what a time you have lost here. With the Queen's approval Mr Gladstone has made *me* a *Baronet* and the delight of the house is sweet to see, nothing but smiles from the kitchen upwards. Walter I found in the pantry gloating over his hat which was decorated with what he called a *Baron Knights Coomb*. He had been to Heaths and obtained I hope the correct thing which has a *Combe* [...] Carrie has a superior air already, taken into dinner last night by the master of the house as the *Barts* daughter.
>
> It is better than a play to see the efforts the servants make to 'Sir John' & my lady us. Letters are pouring in with every post and I must say they are most kindly. Your Aunt Alice I think on the whole was most excited and evidently had difficulty to restrain herself from seizing every stranger she met and telling the news [...] Give my love to Melville & let me know what *Princes* are proposing for your hand. You know you must return Viscountess Kangaroo at least.[8]

Sir Charles Tennant (1823–1906), the Scottish chemist, industrialist and Liberal MP, who supported the late Victorian revival of interest in English art of the eighteenth century, bought the picture in the 1880s. He also owned Millais's late religious picture, *A Forerunner* (1895–6, Glasgow Museums). He presented *Gladstone* to the nation in 1898, the year of the politician's death. JR

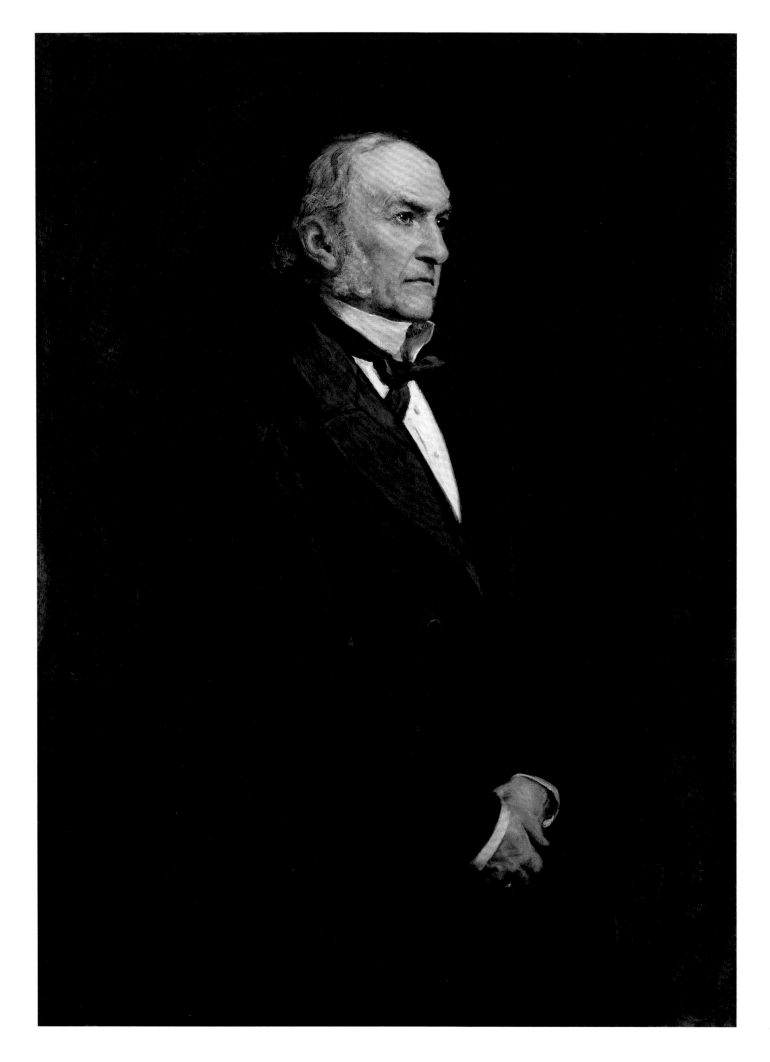

209

Benjamin Disraeli, The Earl of Beaconsfield, K.G. 1881
Oil on canvas
127.6 × 93.1
Signed and dated in monogram lower left
National Portrait Gallery, London

Provenance Bt from JEM by FAS, 6 April 1881; bt from FAS by William Henry Smith, MP for Westminster, 25 May 1881; by descent to his wife, Emily Danvers Smith, 1st Viscountess Hambledon 1891; by descent to William Henry Smith, 3rd Viscount Hambledon, who presented it to the National Portrait Gallery, 21 June 1945

Exhibited RA 1881 (274A); Worcester 1882 (721); GG 1886 (84); New Gallery 1891–2 (132); London 1908 (38); Rome 1911 (58); RA and Liverpool 1967 (100); NPG 1999 (41)

Benjamin Disraeli (1804–81) was the first Conservative politician Millais painted. Lord Ronald Gower convinced him to sit for the artist in March 1881.[1] Disraeli acceded to the request, writing to Millais, 'I am a very bad sitter, but will not easily forego my chance of being known to posterity by your illustrious pencil'.[2] Millais had first met Disraeli at a dinner of Lord John Manners at St Mary's Tower in Birnam in 1874, finding him charming.[3] But only six years later, Disraeli, the 1st Earl of Beaconsfield, whose final government had been ousted by Gladstone in 1880, was already quite ill; he had difficulty climbing the stairs to the studio and could only stand and pose for a moment at a time. By 5 April 1881, Millais wrote to Mary in Perth, 'Poor Ld Beaconsfield, I am afraid will never sit again but I have a capital likeness of him also & I believe the best that has been done of him'.[4] He died a month after posing, the portrait still unfinished. On 27 April, Viscount Barrington sent Millais Disraeli's coat, handkerchief and gloves to assist him in completing the picture,

reminiscing that on one journey from his residence at Curzon Street to Palace Gate, Disraeli had said:

> I suppose it is vanity, which seems absurd at my time of life, with my [...] appearance, but it must be [sensible?] to wish to be painted by the greatest portrait painter in England, & I wish him to have every chance of success with my picture.[5]

The picture was exhibited at the last minute at the Royal Academy in May, draped in black crepe, and hung on a support on the floor in Gallery Three, as seen in William Powell Frith's painting of that year's private view (fig.25). Millais is featured on the far right, looking closely at a painting with a balding gentleman. Gladstone is in the centre, behind Anthony Trollope, who wears a top hat.

Disraeli may be posed 'delicately depicting his personal vanity',[6] but the crossed arms also form a position that might subtly suggest a defensiveness in the wake of political defeat and illness. The emblematic nature of such a picture, showing a fixed former Commander of the Empire without the excessive trappings of imperial ambition that so frequently enfeebled Napoleon's portraits, gives it a presence matched in Gladstone's portrait. It lacks only the animation in the eyes of the latter's picture and in this sense served as a suitable memorial.

There is a reduced copy in the Royal Collection that Millais produced at Queen Victoria's request after she had viewed the uncompleted work at Buckingham Palace. She sent Millais photographs to assist him in making Disraeli's expression less dour. While

Millais's portraits of this period were certainly intended as creative rebukes to the stolidity of contemporary photography, he did use photographs to aid him in the process. They helped him in limiting the time needed for sittings, and in measuring his progress. Often he would mark up such photographs as notations to assist him in reworking elements or bringing pictures to completion. While famous for his bravura technique and the ease and dexterity by which he could work up a picture without underlying sketching, he did not deny his use of the newer medium as a technological aid, and J.G. Millais's biography of his father reproduces many of these photographs.

Hubert Herkomer engraved the work in 1882 for the Fine Art Society, in the same size as Thomas Oldham Barlow's mezzotint of Gladstone, published by Agnew's a year earlier. In 1892 the Beaconsfield Memorial Committee commissioned an exact-size copy of the portrait from William Lockhart Bogle and presented it to the National Portrait Gallery. It was made from the original, then in the Hambledon collection, possibly at Greenlands, Henley-on-Thames, which the bookshop magnate William Henry Smith purchased in 1871.[7] Smith also owned Millais's portrait of the Marquess of Salisbury (1883, National Portrait Gallery). When he bought the picture, he had just served as First Lord of the Admiralty, having previously served as Financial Secretary to the Treasury in Disraeli's government. When he died in 1891, as Lord Warden of the Cinque Ports, his wife was made Viscountess Hambleden in his honour and her grandson gave it to the National Portrait Gallery. JR

Figure 25
William Powell Frith
(1819–1909)
A Private View of the Royal Academy
1881
A POPE FAMILY TRUST, ST HELIER, JERSEY

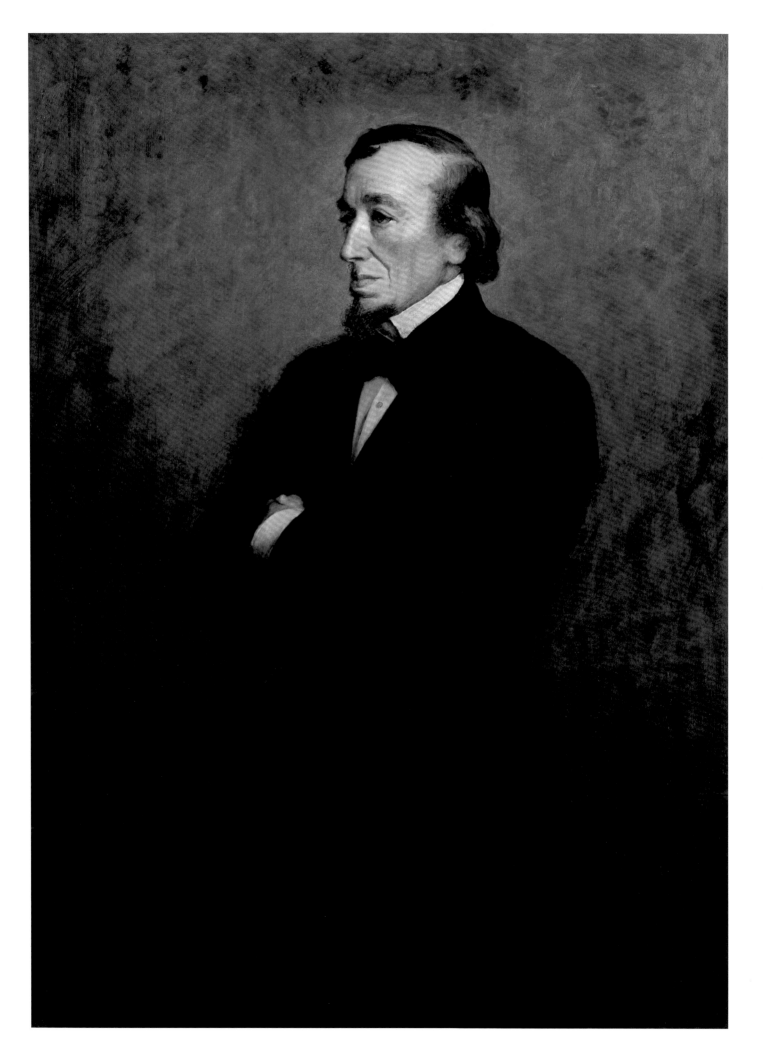

Alfred Tennyson 1881

Oil on canvas

127 × 93

Signed and dated in monogram lower right

National Museums Liverpool, Lady Lever
Art Gallery

Provenance FAS; bt from them by James Thomas Knowles,
11 May 1881; Barbizon House, London, in 1923; bt from them
by William Lever, 1st Viscount Leverhulme, 1923; Lady Lever
Art Gallery

Exhibited FAS 1881 (16); GG 1886 (40); RA 1898 (130); Tate
Gallery c.1910–21/22 (loan); Liverpool 1923–4 (1089); Port
Sunlight 1948 (149); Paris 1951; RA and Liverpool 1967 (101);
NPG 1999 (42)

Millais painted this picture when Alfred Lord
Tennyson (1809–92) was seventy-one. He had
been reading the poet's work all his life, and
producing paintings, drawings and
illustrations from his poems since his early
career, in works such as *Mariana* 1850–1
(no.24), illustrations for the Moxon Tennyson
(nos.71–3), and even in late works like *'The
Little Speedwell's Darling Blue'* 1891–2
(no.108). The Poet Laureate came to sit at
Palace Gate in March and April 1881, and the
work was a commission from the Fine Art
Society, forming the centrepiece of their
exhibition of nineteen works by Millais that
year, a display that drew over 42,000 visitors.[1]
In his notes on the exhibition published by the
Fine Art Society, Andrew Lang made the case
for Millais being at the forefront of artistic
change in Britain over his career, and made the
connection between Tennyson's early poems,
which were strange and distinctive with careful
finish and sentiment and affection for past
times, with Millais's early works, which were
similarly strange, unconventional, ambitious,
minutely finished, and marked by a sentiment
that was often overlooked by the public:

It is unnecessary to lay more stress on this
parallel; to show, for example, how some
of Millais' works – like the 'Cuckoo' of last
year – answer in feeling to Mr Tennyson's
idylls of modern English country life. The
correspondence is near enough to justify
us in asserting for the art of Mr Millais
a position and an influence like those
possessed by the poetry of the Laureate.[2]

H.G.C. Matthew has written that this
direct and unsympathetic portrait of the poet,
along with Millais's four portraits of prime
ministers, reflect 'the caution rather than the
optimism of the age'.[3] This comment may be
reflected in such details as the bags under the
poet's eyes, and his advancing age, but
certainly it is a sober image. Millais portrays
him in the well-known cloak and carrying the
wide-awake hat that had become his calling
card. The hair is quite wild and blends into the
background, as noted by Theodore Watts in an
essay on Tennyson's portraits:

a finer illustration of the importance of not
neglecting the hair could scarcely be found
than that afforded by Sir John Millais'
splendidly-painted portrait at Queen
Anne's Lodge [...] The executive power of
this great painter is, as Rossetti once said
to me, 'paralysing to look upon,' and here
it is seen to perfection. But no painter can
import the Baconian 'strangeness' into a
portrait displaying the pointed beard and
the formal wings of hair that one sees here.[4]

The hair, and its link to Francis Bacon's
'strangeness in proportion' as a route to seeing
the beauty in creation, was not the only

success. In a letter to Millais, the Lord
Justice of Appeal Sir William Milbourne
James wrote:

I think it is the most marvellous portrait
I have ever seen, by any body in any
country & at any time. The impression
of the face quite haunts me, and the hand
is a portrait in itself.[5]

Millais struggled with the painting of hands
the whole of his career. In Tennyson's portrait,
the single hand emerging from inky robes
and holding his hat, in confluence with the
slash of white from under the centre of his
tunic, bears great power.

Hallam Tennyson, the poet's son, wrote to
Millais that the portrait delighted the family,
adding: 'To tell you my secret mind I am very
sorry that it has not been purchased for a
great public gallery of pictures, so that it
might have become a possession for the
nation.' But he was glad that it was being
engraved by Barlow so they could all share
in it.[6] Millais considered it 'first-rate', but
Tennyson, for his part, described it as having
'neither a brain nor a soul and I have both'.[7]
D.S. MacColl later praised 'the living
character so absolutely fixed upon Millais's
canvas.'[8] James Thomas Knowles, an architect
who designed Tennyson's house Aldworth
on Blackdown, editor of *Contemporary
Review* and founder of *Nineteenth Century*,
purchased the picture. After his death in
1908 the National Art Collections Fund
launched an unsuccessful appeal for this
picture, which Knowles priced at £3,000. It
was purchased by William Lever for half that
in 1923. JR

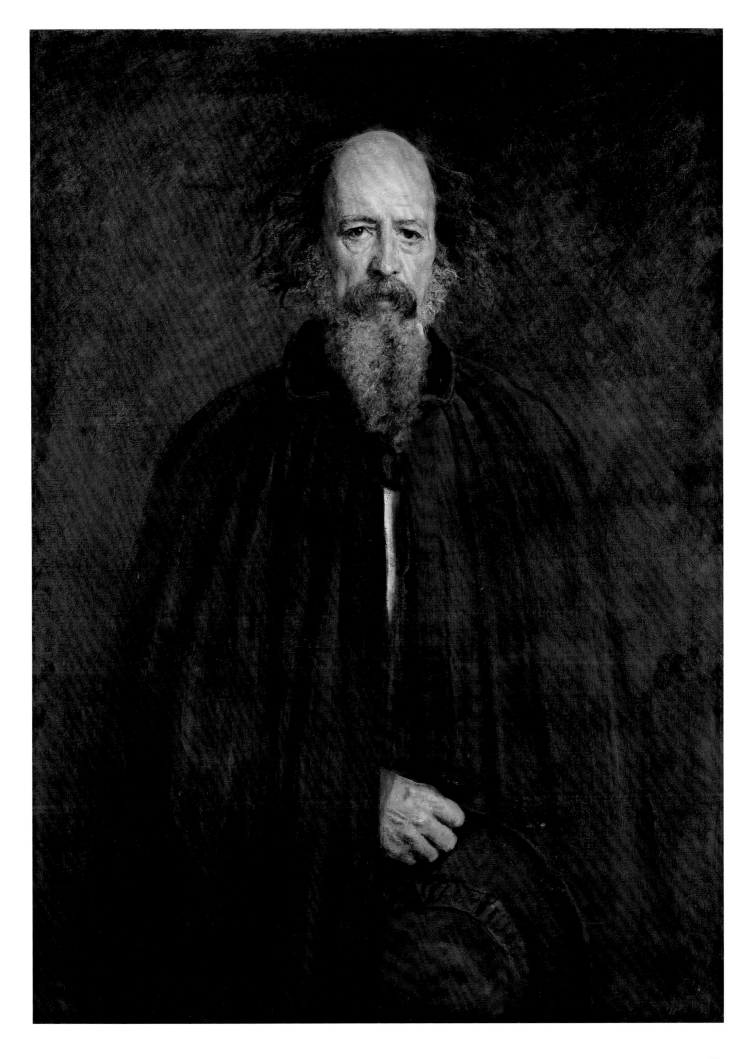

**Henry Irving, Esq. Presented by the Artist
to the Garrick Club** 1883
Oil on canvas
110.5 × 80
Signed and dated in monogram lower left
The Garrick Club

Provenance Presented by the artist to the Garrick Club, 1884

Exhibited RA 1884 (372); GG 1886 (7); Port Sunlight
1949 (147); Tate 1951 (31); RA and Liverpool 1967 (105);
NPG 2005–6

Henry Irving (1838–1905), born John Henry
Brodribb, was arguably the greatest male
Victorian actor. He was also stage manager at
the Lyceum Theatre and a member of the
Garrick Club, to which Millais, a member since
1855, gifted this portrait in 1884. The portrait is
pared down, showing him in strict profile –
unique in Millais's work – and wearing
morning dress and a grey cravat with a gold
pin, his left hand in his trouser pocket. In many
ways the two artists' careers mirrored each
other. Irving served as President of the Actors'
Benevolent Fund, and Millais was a driving
force in the Artists' Benevolent Fund. In 1895
he became the first British actor to be knighted,
just as Millais was the first British artist to gain
a Baronetcy, in 1885. In 1874 Irving became a
member of the Garrick, and they spent many
evenings there together.

The French naturalist painter Jules Bastien-
Lepage began a portrait of Irving in 1880
but did not complete it, possibly because the
sitter did not like the informal nature of it.[1]
When Irving sat for Millais in July 1883, the
English artist delivered this far more refined
representation. From October 1882 to June
1883, before sitting to Millais, he played
Benedick in *Much Ado About Nothing* at the
Lyceum, with Ellen Terry as Beatrice, followed
by a series of revivals through July.[2] But Millais
chose to show him in the role of that theatre's
manager, a post he had held since 1878,
holding his pocket watch and eyeing the lights
to the left.

Irving's grandson Laurence, a designer
and art director on films, offered this
assessment in his biography of his father:

Millais and Irving had much in common in
their characters and predilections and had
become close friends. The painter rarely
missed a first night at the Lyceum and
usually followed up his visits with a letter
to Irving expressing his delights in all he
had seen and occasionally remarking,
with marginal illustrations, on errors or
anachronisms which he had detected in
costumes or weapons […] Unlike Irving,
who neither sought nor enjoyed any
recreation from his work and life in the
theatre, he delighted in abandoning his
studio and the world of fashion for the life
of a country gentleman, which he was able
to lead in some style on the proceeds of
his prodigious industry. Perhaps over-
impressed by the number of banquets and
receptions in Irving's honour which so
recently he had attended, he saw and
painted the immaculate and gracious man
of distinction – the man who – like himself
in the near future – would become the
academic dean of a sister art; he failed
entirely to portray the actor and the abiding
Bohemian. If Irving, perhaps, regarded
his friend's handiwork with sly humour,
Brodribb certainly was well satisfied with
a picture which would display clearly on
the walls of the Garrick Club the intellectual
gentleman of his early ambition.[3]

The picture was engraved in mezzotint
in 1885 by Thomas Oldham Barlow. The next
year Barlow donated the extraordinary carved
wooden frame, which includes the Garrick
Club crest and the motto that reads 'All the
World's a Stage' and surrounds a globe, a
reference to the early membership of the club
being largely actors.[4] Despite the motto, Millais
depicts Irving in profile, with candour and very
much free of vanity. JR

7
The Late Landscapes

The Late Landscapes

In the last twenty-six years of his life, Millais painted twenty-one large-scale landscapes in Scotland.[1] It may seem surprising that, having suffered painting John Ruskin's portrait in the Trossachs' midge-infested glens (no.38), he would so consistently return north to paint out-of-doors. But Millais's landscapes were intricately intertwined with his passion for sport.

The reason he annually found himself in Perthshire between August and January was the shooting and fishing. Painting became an adjunct pursuit, paradoxically one that was as active as angling and hunting were often passive. The weather in Perthshire in the late months of the year was colder than in the Trossachs, and Millais selected more open places to work, as reflected in the panoramic scope and deep distance of so many of these pictures. In choosing, at the age of forty, to establish himself as a major force in Victorian landscape painting, Millais attempted a mastery of a genre that had not been a priority of Diego Velázquez and Rembrandt, his late career heroes, and demonstrated a plurality of subject hardly characteristic of significant figures in British art history. Joshua Reynolds and Thomas Lawrence did not paint landscapes; J.M.W. Turner and John Constable did not paint portraits. Only Thomas Gainsborough essayed the thematic range of Millais, and the art world of his day was not ready to accept his most ambitious, large-scale landscapes. In Millais's time, Frederic Leighton worked brilliantly in landscape but on a small scale, and William Holman Hunt mainly restricted his topographical work to the more intimate medium of watercolour. As with Millais's earlier career, the decision to paint *Chill October* in 1870 (no.125) entailed the risk of critical opprobrium. It was a gambit worthy of celebration. That the landscapes are so rich and varied, such brilliant explorations of a single subject – Scotland – is a testament to the artist's continued singularity of vision and innovative drive.

This exhibition features twelve of these late landscapes, the biggest grouping since the seventeen lent to the memorial exhibition of 1898, and the first time so many have been seen together in one room.[2] The vast Millais exhibition of 1967 in London and Liverpool, which included 397 objects, contained only five. It is time to reassess these works, for they demonstrate not only a dedicated area of Millais's later practice, but also a particular and emotive response to the Highlands, one that moves beyond the picturesque and the melancholy, delighting instead in the intricacies of the autumnal foliage, and in the changing light and mood of the northern landscape in winter. Millais's work as a landscape painter was constructed in the contemporary literature as a masculine endeavour, a conquering of scenery in paint. In their broad expanses, play of detail and breadth, and their employment of a striking, rushing perspective, as well as their reserved tonality (with a few exceptions, such as *The Fringe of the Moor*, no.129), these pictures represent a modern response to the environment that, like Millais's work in other genres, kept him at the forefront of innovation in the period. Despite being clearly based on a passionate appreciation of belief in the beauty of his Scottish subject matter, they are also visible records of the English presence in Victorian Scotland in terms of tourism, and the artist who painted them. They were the result of Millais being a compulsive worker, but also cannily answering the demands of the London art market.[3]

After the late 1870s, Millais's interests in hunting and fishing largely determined his Perthshire rambles along the River Tay. It is difficult to say if the sites he painted had any emotional associations for him, of the kind so crucial to the creative process of an artist of the Romantic era such as Constable. Did an earlier experience on the River Braan, for example, move him to try the scene in paint, twenty years later, in *'The Sound of Many Waters'* (no.130)? He was first there in July 1858, writing to Effie that, on a visit to Loch Freuchie, near Amulree, he 'fished a beautiful little river (the Braan) before breakfast'.[4] While unable to buy his own plot and rights of game due to debts incurred over the building of his house in Palace Gate, he rented various large lodges in the Murthly and Birnam region over the last decades of his life. These he let from landowners who had families with long histories in the region, like Sir Archibald Douglas Stewart, who owned Murthly Castle, or from Englishmen who followed the trend of purchasing recreational plots up north. For those who could not do this, Millais painted Scottish landscapes. To own a Millais landscape became a form of surrogate visual and economic possession, offering a glimpse of the social status that those powerful masculine symbolic acts – stalking, shooting and fishing – offered in Victorian society. For Millais, shooting in Scotland provided recreation and a social milieu that offered regular contact with patrons able to afford such expensive holidays.

But how to read these works? Lately they have come under a critical reappraisal as a few have been more visible, but this exhibition provides an opportunity to study them in depth and in profusion. Tim Barringer has recently described them as 'hauntingly elegiac images exclusively of Scottish scenery such as *Chill October* – a landscape as empty of human life as Millais's London life was teeming with social commitments.'[5] The contrast between the sociality of urban existence, as in the parade of portraits that streamed out of Millais's studios after 1870, and the solitude of Scotland, is pronounced in such works, especially in pictures such as *Winter Fuel* (no.128), *Glen Birnam* (no.138) and

Lingering Autumn (no.134), in which a single figure comes to stand for the human condition, set against the deep thrust of Scottish scenery. This is amplified in the late *'Blow! Blow! Thou Winter Wind'* (no.139), in which isolation is the presiding theme. Julie Codell has perceived them as conveying 'moods and themes of melancholy, the inevitability of death and impermanence', and in their denial of picturesque forms, resisting convention and emphasising 'site-specific, minute observation.'[6] Codell attempts to link them to late Victorian concepts of entropy, in contrast to Millais's own insistence that they were primarily emotive and divorced from science. For Anne Helmreich, the late landscapes represent poetic, elegiac responses, as against critical reaction that saw them as purely descriptive.[7]

Yet to see such pictures as elegiac, melancholy, redolent of mortality, is perhaps to insert one kind of poetry, but to miss the essential elements of the scenes that appealed to the artist, who clearly saw autumn in Scotland as particularly vivid and teeming with life. It a question of interpretations of beauty, a presiding theme in Millais's art, and is reflected in the lines from John Donne chosen to accompany *Lingering Autumn* at the Academy in 1891: 'No spring, nor summer beauty hath such grace/ As I have seen in one autumnal face.' The late landscapes represent a reconceptualising of natural beauty, which is comparable with the radical redefinition of female grandeur in his works of the late 1850s. Critics who saw them as melancholy, then and now, overlook the complexity of his aesthetic.

J.G. Millais wrote that his father 'loved and worshipped Nature rather than painting, and could always find beauty in his own day.'[8] Such an artist did not make an obvious and inevitable connection between autumn and the idea of decline. The majority of critics, in fact, saw the late landscapes as transcriptive and not transcendently elegiac. Spielmann's description of *Scotch Firs* (no.127) as a 'forcible bit of Nature'[9] is incontestable – the poetry of the scene is only obviously elucidated when the Wordsworthian sentiment is attached to the title. Broad landscapes such as *'Over the Hills and Far Away'* 1875 (fig.26), with its evocative rainbow, or the techni-coloured *Fringe of the Moor*, are not melancholy. They

are not as evidently elegiac as Thomas Cole's *Course of Empire* series, or Turner's *Fighting Téméraire* or *Peace, Burial at Sea*, nor do they bear an indisputable religiosity such as in a work by Caspar David Friedrich. Additionally, bleakness in modern art does not necessarily connote desolation. In balancing autumnal foliage with expansive lowering skies and flowing rivers, Millais offered contradictory symbols and figures, in the same way as he and Dante Gabriel Rossetti did in their Pre-Raphaelite pictures. As in so much of Millais's art, this tension elevates these landscapes above insipid sentimentality.

In their combination of atmosphere and detail, Millais succeeded with these landscapes in mastering a mode of painting that Ruskin had encouraged in him from the beginning, the Turnerian. Viewers in the period were perplexed, noting a breadth in his works that represented a continuing evolution away from the meticulousness of Pre-Raphaelitism, while still perceiving botanical intricacies – the product of the artist's decades of looking closely at nature. If Millais's landscapes disavowed the sublimity and the persistence of human agency – no matter how minute in scale – his style mirrored the earlier artist's ability in his historical landscapes to represent the empirical abstractly; *Dew-Drenched Furze* (no.135) and *Lingering Autumn* accomplish this resolutely. By the 1890s Ruskin was unable to see that Millais had become the artist he had always wanted him to be, his fervid imagination consumed by increasingly agonising mental illness. As ever with Millais, in the end it was about paint; not science or sentimentality but, rather, an insistently novel approach to rendering the real, and producing meaning through that method alone. To call the process existentialist is perhaps to get ahead of the game, but in working on such a scale, and in a method viscerally experiential, Millais may well be seen as setting a precedent for mid-twentieth-century abstraction potentially more compelling than landscape painting across the Channel, through a process rooted in romanticism and borne of empiricism. To see Millais in this light might suggest the promise of a more generous, inclusive, and engaged history of modern art that has yet to be written. JR

Figure 26
'Over the Hills and Far Away'
1875
PRIVATE COLLECTION

Figure 27
Photograph of Millais on a hillside
1880s
NATIONAL PORTRAIT GALLERY

Chill October 1870
Oil on canvas
141 × 186.7
Signed and dated in monogram lower left
The Lord Lloyd Webber
[Not exhibited]

Provenance Bt from JEM by Agnew's, 23 Feb. 1871; bt
Samuel Mendel, 10 May 1871, his sale, Christie's, 24 April 1875
(431), bt Agnew's; Lord William Armstrong by 1886, his sale,
Christie's, 24 June 1910 (76) bt Agnew's; Sotheby's, 19 June
1991 (235); The Lord Lloyd Webber

Exhibited RA 1871 (14); RSA 1873 (431); Paris 1878 (171);
FAS 1881 (13); GG 1886 (21); Guildhall 1890 (7); Guildhall
1897 (18); RA 1898 (108); Glasgow 1901 (194); St Louis 1904
(88); RA and Liverpool 1967 (76); Edinburgh 1978 (12.2);
Arts Council 1983 (30); Tate 1984 (140); Newcastle (72);
Perth Museum and Art Gallery to 1991 (loan); Barbican 1992
(75); RA 2003 (28)

Considered Millais's most stirring late
landscape, this was the picture that launched
his career in that genre. Ultimately, it is
perhaps the most traditional in composition
and sentiment of the works he would paint out-
of-doors in Scotland but, in its sweeping span
and perspective, its visual effects of weather,
and exquisite sense of a solitary experience
of nature, it is cardinal in its conception.[1]

The title *Chill October* conveys temperate
and temporal specificity, and was subject to
poetic associations, although it is a pure
landscape in the sense that it did not have any
literary associations, did not form a backdrop
for a scene from history, the Bible or modern
life, and did not aim to communicate directly
a political or ecological meaning. While works
such as *Ferdinand Lured by Ariel* (no.15),
Ophelia (no.37) and *The Proscribed Royalist,
1651* (no.58) were dominated by boldly
envisaged background landscape elements, in
their lack of distance or weather effects within
the pictures and their historical stories they are
far from pure landscape painting, no matter
how meticulously Millais worked at the flora
in them. The idea of pure landscape painting
was not new in British art, although the vast
majority of the landscapes by Gainsborough,
Turner and Constable either included small
figures that gave light to their meanings, or
dealt with areas marked by human
engagement with the land, in a recognisable
and associative topography.

Nonetheless, the picture is not an artificial
conglomeration of landscape features, but a
specific location and view, and one active in its
weather conditions, as opposed to the cloudless
and still scenes of Pre-Raphaelitism. It was
painted on the railway line from Perth to
Dundee, from a spot hugging the left bank of
the River Tay in an area known as Seggieden.
In the centre of the picture is an isthmus that
stretches downstream and is covered with
willow trees, forming the still area of water
between the trees and the rushes on the bank
in the foreground. The picture is remarkable
in conveying a sense of unbound and limitless
nature, as well as solitude, in a region of
Perthshire that was becoming more populated
at the time. Though absent of human presence
or intervention and presided over by only a
flock of flitting swallows, the scene belies the
human engagement in its creation, related in
a letter from the artist of 18 May 1822 once
pasted on the picture's stretcher:

> 'Chill October' was painted from a
> backwater of the Tay just below Kinfauns,
> near Perth. The scene, simple as it is, had
> impressed me for years before I painted it.
> The traveller between Perth and Dundee
> passes the spot where I stood. Danger on
> either side – the tide, which once carried
> away my platform, and the trains, which
> threatened to blow my work into the river.
> I chose the subject for the sentiment it
> always conveyed to my mind, and I am
> happy to think that the transcript touched
> the public in a like manner, although many
> of my friends at the time were at a loss to
> understand what I saw to paint in such a
> scene. I made no sketch for it, but painted
> every touch from Nature, on the canvas
> itself, under irritating trials of wind and
> rain. The only studio work was in
> connection with the effect.[2]

There are a number of important themes
Millais stresses here: a familiar view from the
train going to Dundee, from which point he
and his family often caught the steamer to
London, a vista seen at speed in which the
foreground rushes by in a blur and the
background moves slowly; the perilousness of
such an authentic practice; the importance of
an art of personal meaning; and the recording
of an unimpeded experience of nature, bearing
a sense of immediacy, impression, intimacy and
authenticity that was not the result of ponderous
sketching and organisation but, rather, of
experience and engagement channelled
creatively and authentically. In this statement,
Millais laid out the naturalist aims of his later
landscapes. Finally, it is a painting of a
backwater, an area of stagnant water, but the
term also bears more modern intimations of
peacefulness and isolation, connotations that
work well with the idea of the picture and the
quietude Millais sought in Scotland.

Often read as bleak, such windswept
expanses and crisp atmospherics attracted
Millais and then entranced Vincent van Gogh,
who probably first saw the picture at Christie's
in 1875 (see p.236). Contemporary critics sought
poetic meanings, as in the *Athenaeum* attaching
a quote from William Allingham to it,[3] and this
review from the *Illustrated London News*:

> Materials for a picture could not be simpler;
> yet, apparently without conscious effort,
> without recourse to suggestive means (as
> in pictures such as Daubigny's), by simply
> possessing himself of the broad essential
> facts, and reproducing them with extreme
> fidelity, Mr Millais has produced a work
> which is saturated, as it were, with the sad
> and cold, lonely and foreboding sentiment
> of autumn.[4]

It is precisely this human sentiment that later
writers found banal and trite,[5] but more recently
the pictures have come under more even-
handed analysis, and *Chill October* investigated
for its tonal qualities and innovative pictorial
space.[6]

Owned initially by Samuel Mendel (see also
Jephthah, no.93), it later passed into Lord
Armstrong's collection, and was featured in the
purpose-built drawing-room picture gallery
added to Cragside, his Richard Norman Shaw
mansion in Rothbury, Northumberland. JR

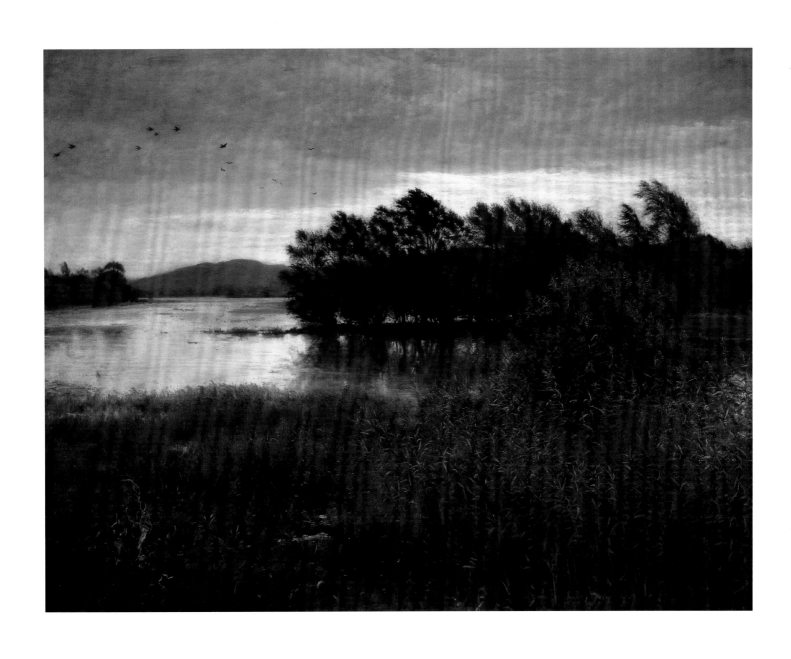

Flowing to the River 1871
Oil on canvas
139.7 × 188
Signed and dated in monogram lower right
Private Collection

Provenance Ernst Leopold Schlesinger Benzon; his sale Christie's, 13 June 1874 (30), bt in ; by descent to Mrs Elizabeth Benzon, her sale, Christie's, 1 May 1880 (57), bt Marsden; Samuel Lewis by 1898; Sotheby's, July 1973 (147)

Exhibited RA 1872 (56); RA 1898 (131); on loan to Tate Britain from 1995

This picture was exhibited at the Royal Academy in 1872 along with a nearly equal size pendant, *Flowing to the Sea* (Southampton City Art Gallery). The latter was made first, and depicted a milkmaid, posed by Alice Gray, talking to a member of the 42nd Highlanders regiment while another soldier sits by the River Tay. It was painted from Waulkmill Ferry, just north of Perth. While the soldiers in that picture reflect the concept of the title *Flowing to the Sea* in terms of Britain's imperial reach, *Flowing to the River* is a more hermetic view of a quaint and traditional British industry. It is a riotous autumn landscape, with a man fishing in the right middle ground and an active flour mill in the rear, painted on a brook near the Stormontfield salmon ponds, a fish-farming operation begun in 1853.[1] It is vigorous, beautifully designed and crisply worked. On the left are nearby tree branches that lead the viewer's eye to the stream that winds to the right and into the background. A half-submerged barrow or wagon in the lower right corner juts towards the centre where, on a slice of land that splits the stream into rapids on the left and a calm pond on the right, a spectral figure stands in white clothing, dusted from the mill flour. Here, Millais shows the older forms of local industry and mode of fishing in preference to the modern fishery nearby. The man wears a red scarf and white hat and ties line to a long rod. In the background the stream turns back to the left and runs past the mill, where people are seen loading a cart. Such elements give it more than a little resemblance to John Constable's *Hay Wain* 1821, with its cart in the river, workmen loading a wain in the far distance, and harmonic relationship between the land and those who work it.[2] *Flowing to the River* has a lovely early autumn feel, with a fine build-up of paint depicting the varied vegetation, and mere flicks of pigment effectively standing for leaves. There is a smooth, brushy wash of colours in the reflective water on the right, but a tighter, less abstract use of paint than in *Winter Fuel* 1873 (no.128), painted two years later. Up close there is still a cohesive surface. Millais's style in this picture retains the mark of close observation with evocative brushwork, almost like a free watercolour sketch opened up into a larger easel painting.

Critics repeatedly described the work as 'picturesque' but ultimately Millais employs a novel mode of vision, moving from the close branches on the left and then to a rapid change of plane to man, brook and mill, with trees ultimately blocking the ability to see into the background. He employs an active surface throughout; a very different approach from the breadth of scenery and dramatic rush into the background of *Chill October* 1870 (no.125). It instead represents a challenge to traditional picturesque compositions. Only the *Spectator* took issue with the detail and perceived a slapdash quality in the picture, calling it but a 'clever sketch' and encouraging Millais to go and look at Turner's prints to see how a truthful landscapist avoids details in favour of masses of form to grip the viewer, interesting in the light of Ruskin's earlier linking of the two artists.[3] But Millais was not seeking such picturesque aspects, and his method is a far cry from the idealised peasant naturalism of contemporary landscape works by George Heming Mason, Frederick Walker and, in France, the later pictures of Jules Bastien-Lepage. Landscape plays a large role in Millais's picture, but it is secondary to the figures and bears little pretence of actuality, instead being consumed by a flowing design. In almost all of Millais's large landscapes, figures are small presences – if they feature at all – and fit elegantly into the scenes. M.H. Spielmann noted an incident in 1898 related to this point:

when a short-sighted lady saw the picture in the artist's studio on 'Show Sunday,' she pointed to the miller's son fishing in the middle of the stream and asked, 'Why does he put a statue there?' Millais, overhearing the criticism and recognising its truth, left the group who were loading him with uncared-for praises, seized his palette and quickly painting in the red scarf that now appears, turned to his young critic and said, with his jovial affectation of egoism – 'There! now you can say that you made Millais alter one of his pictures!'[4]

In mistaking the figure for a statue, and so unwittingly associating this picture with the classical tradition of landscape from the seventeenth-century work of Nicolas Poussin and Claude, this observer reveals the verifiable truth that was more and more expected in the nineteenth century: a rejection of the ideal and the allegorical. Millais had painted the miller's son as he would truly have appeared, relaxing after a day overseeing the mill operations, with a poetry not indebted to the historical, but to the actual. Traditional ways of approaching landscape resisted these new meanings and it was some time before these works found a receptive and comprehending audience.

In the early 1870s the picture was owned by Ernst and Elizabeth Benzon of 10 Kensington Palace Gardens. He was from Germany and a co-founder of Naylor, Benzon and Co., the major British iron and steel merchants, and half-owner and first chairman of Vickers, Sons & Co. Ltd. of Sheffield. He collected art and books, and his sister-in-law would be painted by Millais in 1876.[5] The driving force behind this Aestheticist art collection was probably Elizabeth Benzon, the sister of the painters Henri and Rudolf, and her husband's partner Frederick Lehmann.[6] The Benzons also owned Leighton's *Golden Hours* 1864. The picture was subsequently owned by the moneylender and philanthropist Samuel Lewis,[7] an associate of Benzon. Together they are good examples of the interconnectedness of Millais's social, professional and client circles in the period, as well as Millais's patrons of Jewish ancestry.[8] JR

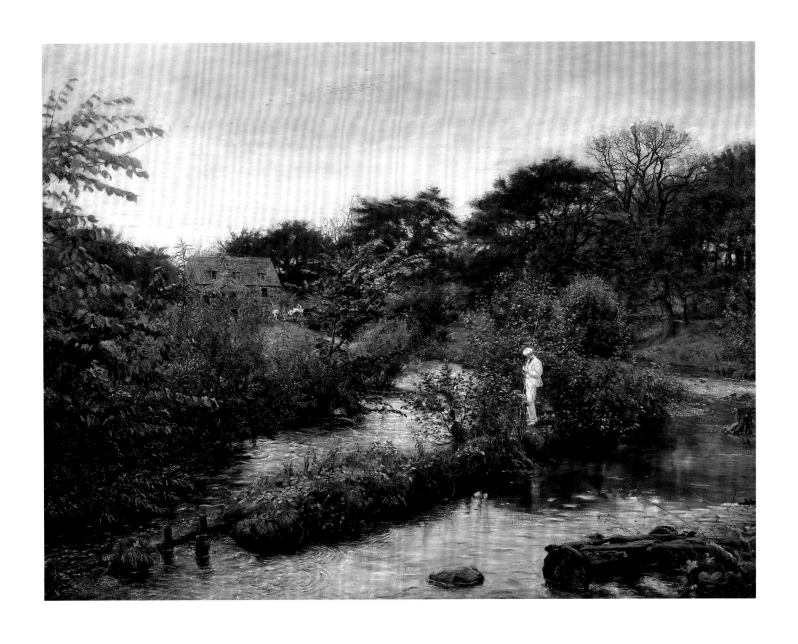

Scotch Firs
'The silence that is in the lonely woods.' –
Wordsworth 1873
Oil on canvas
190.5 × 143.5
Signed and dated in monogram lower right
Private Collection

Provenance Agnew's, sold to Albert Grant in 1874; Christie's, 28 April 1877 (185); bt Agnew's; James Mason by 1886 and thence by descent; Sotheby's, 17 June 1992 (408); Sotheby's Glen Eagles, 26 Aug. 1997 (1182); bt Martyn Gregory Gallery

Exhibited RA 1874 (68); Glasgow 1879 (294); GG 1886 (109); RA 1898 (103)

After painting *Flowing to the River* (no.126), with its intimation of production in the mill, Millais turned to works that avoided more cultivated references to the River Tay by working upstream, in a region associated with non-commercial fishing and tourism. Millais would spend the autumns of the next eighteen years in leased accommodations, in this region and the adjoining towns of Murthly and Rumbling Brig. In 1873 he rented St Mary's Tower, a turreted hunting lodge owned by Lord John Manners, MP, second son of the 5th Duke of Rutland and later 7th Duke. Subsequent landscapes represent a kind of escape from Effie's family and Bowerswell in Perth, the same kind of escape that hunting and fishing throughout Scotland would also provide. Such activities were essential to Millais's life, and increasingly gave him pleasure, as it was in these pursuits that his sons could join him. *Scotch Firs* and *Winter Fuel* (no.128) were two vertically orientated landscapes painted in 1873 around Dunkeld and Birnam, an area that would come to be most prominent in the painter's work of the next two decades. These paintings represent new approaches to

landscape: one through its poetic reference, the other through its unresolved narrative.

Scotch Firs was accompanied in the Royal Academy catalogue for 1874 by the lines 'The silence that is in the lonely woods', attributed to William Wordsworth, although this specific phrase does not appear to be found in his poetry.[1] Nonetheless, the poetic associations of such pictures made them function differently from Millais's designs after Alfred Lord Tennyson, Anthony Trollope or Wilkie Collins; they are suggestive of the texts accompanying them, rather than directly illustrative. The idea of painting such fir trees had been brewing in Millais's thoughts since at least 1865 when he wrote to Effie, 'I would like, if possible, to paint the firs at Kinnoull as a background.'[2] But here background becomes foreground, the six prominent tree trunks amidst the undergrowth transform into almost human presences, spaced out across the canvas and standing in a timeless milieu, forever framing the outline of Birnam Hill in the distance.

This picture builds on the realisation, made in *Chill October* (no.125), that such a subject did not need Shakespearean characters or couples in historical costume to communicate complex emotions, although the Wordsworth connection amplifies the resonance. Despite, or perhaps because of, this lack of human presence and the originality of the upright composition, some critics referred to it as a sketch, a frequent comment in criticism of these landscapes. This was because the dichotomy between on the one hand the darkened trees and undergrowth filling the foreground, and on the other the distant view of blue peaks and spacious periwinkle sky streaked with banks of white cloud, seemed strange to them, an effect commensurate

with contre-jour (a backlighting effect) in photography. In addition, this type of picture lacked the panoramic breadth of contemporary landscape painting in Britain, France, and in the work of the American Hudson River School seen frequently in London, such as that of Frederic Edwin Church. For some reviewers, Millais rendered nature in this picture in such a prosaic manner that it was not inherently poetic. Others reacted to the specifics; the *Art Journal* critic wrote perceptibly of how the vividness of Millais's hues and detail 'brings the actual forms and colours of nature into startling proximity with the eye of the spectator'.[3] Indeed, the lower surface of the picture is remarkably vibrant, a darkened region corresponding to the reduced light levels on the forest floor, and backlit by the bright sky beyond. Multicoloured flecks and dashes of paint represent heather, furze, weeds, stunted oaks, dead needles and leaves, and grasses. The trees appear to tower above the viewer, while the rising landscape recedes into the distant background, an optical effect that simulates being on this hillside above the left bank of the Tay and the town of Dunkeld. Despite the poet's ideal of silence and loneliness, meditation and stillness, the picture is remarkably active: the flicks of brushwork lead one's eyes continuously about the picture, and the build-up of branches and leaves around the top edge and sides of the picture form an active floral frame around the margins of the composition.

Albert Grant purchased *Scotch Firs* from Millais through Agnew's. Born Abraham Gottheimer to a German family in Dublin, he was a financier with his own company in London and would own numerous Millais pictures, including *Winter Fuel*, *The Knight Errant* (Tate), *Victory, O Lord!* (Manchester), and *Jephthah* (no.93).[4] JR

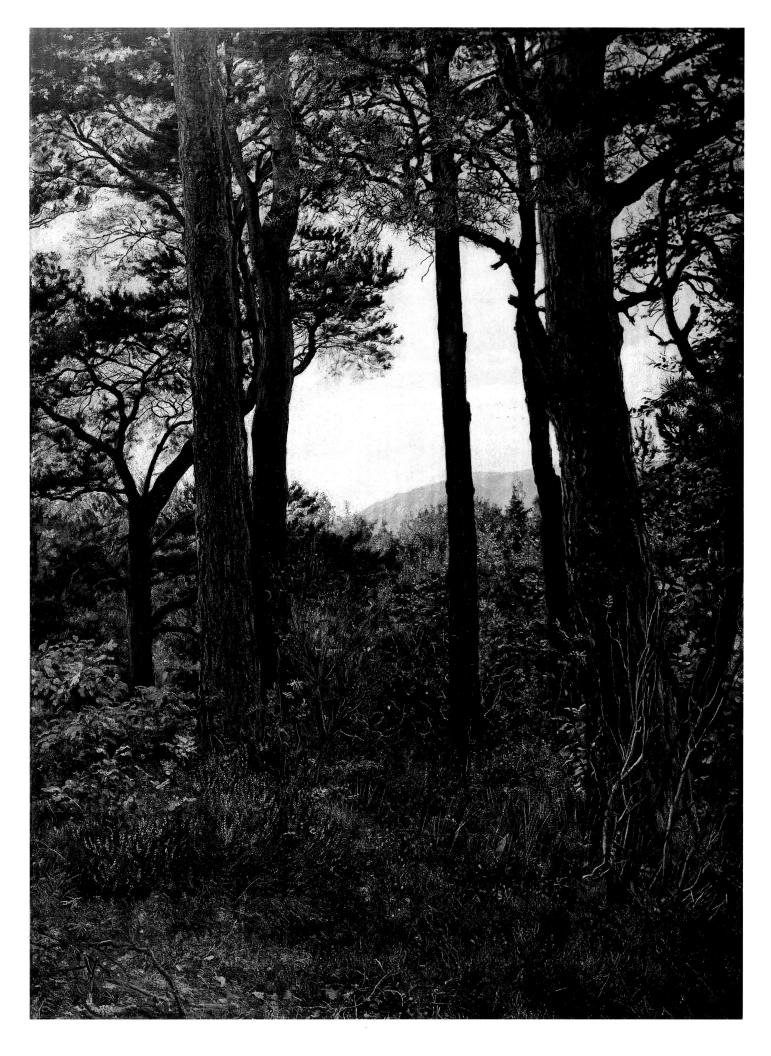

Winter Fuel
'Bare ruined choirs, where once the sweet birds sang' – Shakespeare 1873
Oil on canvas
194.5 × 150
Signed and dated in monogram lower right
Manchester City Galleries. Gift of Gibbon
Bayley Worthington

Provenance Bt Agnew's, 19 Jan. 1874; sold to Albert Grant; Christie's, 28 April 1877 (184), bt Agnew's; Gibbon Bayley Worthington by 1886, who presented it to Manchester, 1897

Exhibited RA 1874 (75); Manchester 1878 (716); GG 1886 (110); Manchester 1887 (506); RA 1901 (100); Manchester 1911 (260); RA and Liverpool 1967 (83); Tate 1984 (145); Barbican 1992 (76); Japan 1993b (39); Japan 2000 (76)

This picture accompanied *Scotch Firs* (no.127) at the Royal Academy in 1874 and was exhibited with a subtitle imperfectly drawn from Shakespeare's Sonnet 73:

> That time of year thou mayst in me behold
> When yellow leaves, or none, or few,
> do hang
> Upon those boughs which shake against
> the cold,
> Bare ruin'd choirs, where late the sweet
> birds sang.
> In me thou see'st the twilight of such day
> As after sunset fadeth in the west;
> Which by and by black night doth take away,
> Death's second self, that seals up all in rest.
> In me thou see'st the glowing of such fire,
> That on the ashes of his youth doth lie,
> As the death-bed whereon it must expire,
> Consum'd with that which it was
> nourish'd by.
> This thou perceiv'st, which makes thy love
> more strong,
> To love that well which thou must leave
> ere long.[1]

The poet's aching words explore the demise of the flesh as perceived by another, while admitting the demise of youthfulness in himself. In the end, there is solace in the recognition that the poet's companion will see this desperation, and love even more fully what will soon be lost: his own youth. On the surface, this seems to have little equivalence to the mysterious narrative in the painting. In a literal sense, the 'bare ruin'd choirs' are the cut birch branches and trunks on the cart in the foreground, transformed from the perch of songbirds to kindling for bodily warmth.[2] *Winter Fuel* forms part of Millais's ongoing meditation on the seasons in his oeuvre, along with *Autumn Leaves* (no.82), *Spring* (no.84), and the later pictures *St Martin's Summer* (no.131) and *Lingering Autumn* (no.134). Again the theme is nostalgia, and a blending in this picture of children and landscape that revisits the themes of the 1850s.

The foreground of the picture is a crush of forms that lead the eye from the centre left to the lower right, where a girl sits on a timber cart loaded with wood, her dog at her feet. They have been distracted by something happening out of the frame on the right. The left side of the picture is devoid of life, dominated only by the now-dead branches. The woodsman has left his work as evidenced by the two-headed axe, crumpled jacket and pail in the right foreground; it is perhaps his actions that have caught their attention, or he is coming to them as they have been waiting for him. But the only slight reaction of the dog, who simply turns his head, cautions against undue alarm. The quietude is amplified by the lack of activity and the slowly drifting smoke in the centre, establishing the mood. What is most interesting is how Millais, unlike in *Autumn Leaves* or *Spring*, avoids showing us the young girl's face, perhaps as a way of setting this picture apart from the fancy pictures of this period, as well as his burgeoning portrait practice. She forms a figure of identification for the viewer, related to the practice in Romantic landscape painting of including one or more people in the foreground of a picture who have their backs to the viewer, so that their faces, and reactions to the scene before them, are not visible. In that sense, the viewer can identify with the imaged person's sense of awe before nature. Millais complicates this to dramatic effect, not allowing us to see what has made her twist round so, in a kind of proto-'problem picture'.

There is a remarkable treatment of nature here, a continuation of the profusion of floral detail found in *Flowing to the River* (no.126). The sky is light on the horizon and cloudier and greyer in the higher atmosphere. The autumnal tree in the right centre is framed by the mountain range and the highest visible crest of Birnam Hill, a natural feature that provides a kind of halo above it. He painted it from the view south from St Mary's Tower. The low range of hills to the left is anchored horizontally by the line of smoke, and above there is a very careful depiction of the varying shades of the slatey hillside. The misty atmospheric perspective of this background and the grassy plain of the middle ground is in stark contrast to the richly described wood-laden cart. Surprisingly, the girl is the least successful part of the composition, her hands being rather crude, a common criticism of the artist. They have little sense of bone or anatomy, and in them rests a most implausible-looking apple. This is opposed to the entangled mix of coloration and brushwork in the smaller branches in the foreground. This is most evident on the left, where Millais used a technique resembling Asian scroll painting and woodblock prints, denoting individual branches with an extremely light touch through diluted paint mixtures applied fluidly in simple lines. It is one of his most scintillating patches of free painting.

The young poet Gerald Manley Hopkins wrote breathlessly and suggestively, in his *Journal* for 1874, in describing *Winter Fuel* as bearing

> almost no sorrow of autumn; a rawness (though I felt this less the second time), unvelvety papery colouring, especially in raw silver and purple birchstems, crude rusty cartwheels, aimless mess or minglemangle of cut underwood in under-your-nose foreground; aimlessly posed truthful child on shaft of cart; but then most masterly Turner-like outline of craggy hill, silver-streaked with birchtrees.[3]

If such a picture does not seek to convey the melancholy of autumn, then what is the role of the Shakespeare quotation? Birnam Hill forms the backdrop for yet another exploration of humankind's experience of time and awareness of nostalgia. In this picture it is complicated further by a scene under a bright sky, with no direct symbolism and no concession to conventions of human beauty. JR

The Fringe of the Moor 1874

Oil on canvas
136 × 216
Signed and dated in monogram lower right
Johannesburg Art Gallery

Provenance Thomas Henry Ismay by 1886; Christie's,
4 April 1908 (52); Christie's, 27 May 1910 (87); bt Sir
Hugh Lane from Agnew's; presented by Sir Julius Charles
Wernher 1910

Exhibited RA 1875 (74); GG 1886 (108); Liverpool 1886
(68); Manchester 1887 (468); RA 1898 (147)

Millais's brightest and most soaring late
landscape, *The Fringe of the Moor* was painted
in the autumn of 1874 when he was again
living at St Mary's Tower, Birnam. He would
hike daily to his painting spot, on a knoll
alongside Kennacoil House with a view looking
roughly west up Strath Braan towards Amulree
and the Glen Quaich Hills. The land here,
associated with the Rohallion estate, was
owned then by a friend of the family, John Bett,
and was famous for its black grouse shooting.
The vista is little changed today, with even one
of the same sycamore trees in the centre still
extant (fig.28).[1] Millais finished the picture in
early November. In a humorous letter to his
daughter Mary, he described the process of
painting it:

> Yes, my labours are all over up the hill, but
> only to begin again down in the Valley [with
> *The Deserted Garden*, unlocated]. Albeit it is
> an Egg in the basket, & I hope a very pretty

chicken will come out of it [...] You will be
delighted to hear that your papa's figure is
even more shadowy than when you left, as
he has been walking eight miles every day,
and on his legs (may I mention them?) the
whole time between, say, half-past ten and
half-past five.[2]

Later in the century, M.H. Spielmann sharply
described it as 'perhaps the best proof of
Millais's wonderful ability in painting the
country without greatly troubling himself
about landscape-composition'.[3] This reprised
Ruskin's critique of the picture upon its first
exhibition, in his *Academy Notes* of 1875, his
first concerted criticism of the Royal Academy
since 1859. Ruskin wrote that

> at still lower level, though deserving some
> position in the Natural History Class for its
> essential, though rude and apparently
> motiveless veracity, must be placed 'The
> Fringe of the Moor.' But why should one
> paint the fringe of the moor, rather than the
> breadth of it, merely for the privilege of
> carrying an ugly wooden fence all across the
> fore-ground. I must leave modern
> sentimentalists and naturalists to explain.

When he saw the picture again at the Millais
exhibition at the Grosvenor Gallery in 1886, he
twisted the knife a bit further: 'The daubed sky
– daubed without patience, even to give unity

of direction to the bristle marks, is without
excuse, even in the rudest haste.'[4] It is interesting
that 'motiveless veracity', truth for truth's sake, a
lauded tenet of Pre-Raphaelitism twenty-five
years earlier, is not construed as a mark of
sentimentality and the scientific motives of
naturalists. But this view is one from green,
cultivated land in the foreground to the more
natural moorland in the distance. And it comes
from Ruskin, who still perceived Millais as a
leader in British art, but whose criticism of the
artist became more and more pointed as he got
older. On a personal level, by this stage, they had
no contact whatsoever, and it is doubtful that
Millais was bothered too much by his negative
criticism, as it had no adverse effect on his
professional success.

The Fringe of the Moor was owned by Thomas
Henry Ismay, founder of the White Star Line
shipping company in Liverpool.[5] From 1884 he
lived at Dawpool in Thurstaston, the Wirral,
Liverpool, designed by Richard Norman Shaw,
and he also owned *Dew-Drenched Furze*
(no.135).[6] Millais exhibited a portrait of him at
the Academy in 1883 (Private Collection). The
work was subsequently purchased from the
dealer Sir Hugh Percy Lane by the mining mogul
Sir Julius Charles Wernher of Wernher, Beit and
Co., and a governor of De Beers.[7] Wernher's
medieval and Renaissance collection is housed
in Ranger's House in Greenwich, but he
presented this work to Johannesburg Art Gallery
as much of his business originated there.[8] JR

Figure 28
Photograph of the site
of *The Fringe of the Moor*,
taken by Jason Rosenfeld,
August 2000

'The Sound of Many Waters' 1876

Oil on canvas

147.5 × 213.5

Signed and dated in monogram lower right
The National Trust for Scotland, Fyvie Castle

Provenance Bt from the artist by David Price; his sale
Christie's, 2 April 1892 (91); bt Tooth; Harry Coghill; his sale
Christie's, 4 April 1908 (127); bt Agnew's for Charles Fairfax
Murray; bt Agnew's, 15 July 1909; Lord Leith; by descent to
Sir Andrew Forbes-Leith of Fyvie Castle; National Trust for
Scotland, acquired with castle, 1984

Exhibited RA 1877 (273); GG 1886 (102); Guildhall 1890
(5); SNPG 1985 (60)

This picture and *St Martin's Summer* (no.131)
were painted from sites very near one another
on the River Braan, a historically significant
tributary of the Tay. The immediate area is just
above the famous Rumbling Brig, long a site of
picturesque associations for travellers through
Scotland, a span illustrated in the Revd William
Gilpin's record of his famous Scottish tour in
1776 and popular in tourist photography
through the later nineteenth century.[1]

The artist lived in Rumbling Brig cottage,
Trochnay, owned by Mr Tomson, only five
minutes by foot from this location, and painted
these pictures over the course of two autumns
and winters, often under difficult conditions.
He avoided any trace of the Rumbling Brig,
painting instead from just off the bridge's
eastern side, above the falls of the Braan. By
shunning the traditional picturesque motif of a
waterfall, he concentrated instead on the more
matter-of-fact scenery looking upstream. In
this sense, *'The Sound of Many Waters'* mirrors
the portrait of Ruskin 1854 (no.38), which was
similarly posed above a rushing torrent and,
instead of crashing water, focused on rocks and
vegetation. But in this picture of more than
twenty years later, Millais conveyed the
technical features of volcanic rock without the
meticulousness and 'slavishness' of Pre-
Raphaelitism. The treatment of the water
varies according to the rapidity of flow; broad
washes in the eddy above the rocks, thick
treatment in churning rapids in the upper left.
As in *Winter Fuel* (no.128), there is quite dry
brushwork in the centre foreground, here
representing the water coursing towards the
sluice. As in *Chill October* (no.125), jutting
branches fill the centre, with red autumn leaves
and wisps of foliage and vegetation in the rocks
and against the stream. In the background a
haze conveys the moist atmosphere above
upper rapids. In its denial of concise and lucid
picturesque vision – lacking a clear focus or

balanced Claudean layout or framing elements
– it is an advanced conception of landscape,
using sound and sight equally, a masterpiece
of observation and large-scale ambition.

The immediate area had long been
connected with the legendary Gaelic bard
Ossian, a partial invention of the writer James
Macpherson in the 1760s. 'Ossian's Cave' and
'The Hermitage' or 'Ossian's Hall' were located
just downstream. Millais completely ignored
these historical connotations, which is what is
interesting about these pictures, along with the
artist's continuing development of landscapes
that are novel in their compositional
organisation, and prosaic scenes. To look at
'The Sound of Many Waters' in particular, one
is struck doubly by the condensation of the
associative and historical into natural scenery
only, and the absence of a picturesque formal
conception. Instead, historical time is literally
imaged in the painting in the striated boulders,
the old red sandstone, and the ceaseless
carving flow of water. Ossianic or human
historical dimensions are absent; only a
solitary heron surveys the scene in the upper
left part of the sky.

The critic M.H. Spielmann wrote of it in
1898, two years after the painter's death:

> There is no great attempt at formal
> composition here, but the picture is
> extremely fine in effect, and would be finer
> still but for the uninteresting white sky
> above, which robs it of proper balance
> and full impressiveness.[2]

Many viewers at the time could not make sense
of Millais's aims. Dramatic picturesque variety
and contrast are absent, as is 'proper balance',
as Spielmann noted above. It was Henry James
who observed that *'The Sound of Many Waters'*
'has the merit of having no expressiveness at
all'.[3] This was an aspect of the picture that
dramatically broke from tradition.

The title is apt, both in sentiment and in
reality, as is consistent with his later
landscapes. It was from a poem, *The Dream
of Gerontius* (1866), by John Henry, Cardinal
Newman, whose portrait Millais would paint
a few years later in 1881 (National Portrait
Gallery):

> My soul is in His hand: I have no fear, –
> In His dear might prepared for weal or woe.
> But hark! a grand, mysterious harmony:

> It floods me like the deep and solemn sound
> Of many waters.[4]

Newman was also thinking of the Book of
Revelation: 'And I heard as it were the voice
of a great multitude, and as the voice of many
waters, and as the voice of mighty thunderings,
saying, Alleluia: for the Lord God omnipotent
reigneth.'[5] These provide the poetic overlay and
innate drama, and the intimation of an aural
art is evident; it is an extraordinarily loud spot.
It is difficult to speak to someone right next to
you and the torrent was appropriately
described in guidebooks as 'a voice of thunder'.[6]
The sheer quantity of water flowing through
this chasm after a rainfall is readily conveyed
in the picture.

However, the gestation of the picture reveals
it to be again about the immediacy of practice
and the specificity of atmosphere, the most
important aspects of Millais's out-of-doors
pictures. Millais painted it from a purpose-
built, partly glazed wooden hut on the river
bed, as he wrote to his daughter Mary in
November 1876:

> I fear that after all I shall have to give my
> work up and finish it next year as there is
> nothing but snow over all, and I have a cold
> as well which makes it horribly dangerous
> my painting out in such cold. However
> we will see what tomorrow brings. It is
> dreadfully dull here when there is nothing
> to do. I have been in my hut this morning
> & I hoped a blink of sun would thaw
> sufficiently the snow on the foreground
> rocks to enable me to get on, but the storm
> is on again, & it is simply ridiculous trying
> to work, as everything is hidden and a
> white sheet. I shot with Bett, & his friends
> yesterday, & it was bitter, & not a very
> pleasant day [...] There is no water in the
> river as well so I cannot even do that [...]
> The madman is still here, & I have had no
> word from Dundee about his family. He
> preaches with naked feet all day to the rocks
> and trees.[7]

The madman is mentioned by J.G. Millais
in his biography of his father. He was under the
influence of a mysterious 'Father P'. The trees
and rocks would not be converted by his
preaching, and neither would the painter, who
had arranged to have the maniac ferried away
by the Dundee Superintendent of Police.[8] The

potential for the primitivism, poetry and sublimity of Ossian was present in the form of the madman, the guidebooks Millais read in his cottage at night, and the crash of the falls just below his painting perch. Millais paid for his toil, writing to Effie that the labour was extraordinarily intense in this picture, and he was sure that 'no sledge-harnessed mariner of Nares' crew has worked harder than I have at this North Pole of a picture.'[9] The reference to Captain George Nares' global expedition on the *Challenger* of 1872–6 reveals Millais's construction of landscape painting as a masculine, exploratory practice, one as much concerned with scientific discovery (in the sense of the truth of nature) as of mapping and

dominating environments.[10] He wrote that he drank 'enough whiskey and water to make an ordinary man quite giddy; but without feeling it'[11] to see him through this trial.

In a sense, his out-of-doors practice in Scotland, in November and December, was heroic. Beset by a madman, plagued by boils, damp, and illness, thwarted by uncooperative weather, he persevered in his labours. The rains inevitably came and, despite Millais's efforts to shore up the area around his rocky ledge, the Braan repeatedly submerged his hut; finally the river completely overran its banks, smashing and sweeping away the painting house. The picture was salvaged at the very last

moment, the weather soon broke and he completed it, returning to his family in Birnam victorious. He wrote to his daughter Mary: 'When I am about finished you may come for me with a Bagpiper and take me home in triumph.'[12]

In January 1877, the wool merchant David Price bought this picture from Millais for £3,000 before it was exhibited at the Royal Academy. He also owned *Spring* (no.84).[13] At Price's death sale in 1892, the dealer Arthur Tooth purchased the picture for 2900 guineas (£3045); by the time of the death sale of the subsequent owner, Harry Coghill in 1908, Agnew's was able to buy it for only 1100 guineas. JR

St Martin's Summer 1878
Oil on canvas
151 × 107
Signed and dated in monogram lower right
Montreal Museum of Fine Arts. Gift of Lord
Strathcona and Family

Provenance William Lee to 1888; Christie's, 26–8 May
1883 (72), bt in; Christie's, 7 May 1887 (85), bt in; his sale,
Christie's, 20–3 June 1888 (412), bt Koekkoek; Sir Donald
Alexander Smith, 1st Baron Strathcona and Mount Royal;
Margaret Charlotte Smith, Baroness Strathcona and Mount
Royal; Donald Sterling Palmer, 3rd Baron Strathcona and
Mount Royal; Montreal Museum of Fine Arts, Gift of Lord
Strathcona and Family, 1927

Exhibited RA 1878 (465); Montreal 1888 (64); Royal
Victorian Hospital, Montreal, 1927–81 (loan); Montreal
1983; Montreal 1989–90 (44); Paris and Montreal
2006–7 (8128)

Despite the travails of the previous year (see
'The Sound of Many Waters', no.130), Millais
evidently liked the vicinity of the River Braan,
as he returned there in 1877 to paint this
picture. He reorientated the picture vertically
but worked with similar rock formations, mere
steps from his prior painting spot and looking
back towards the scene in the foreground of
'The Sound of Many Waters'.[1] This allowed him

some shelter, quiet and privacy, as he distanced
himself from the bridge and the road and
painted from denser underbrush and a tree-
covered bank.

Spielmann described it as 'painted from the
scene close by Dunkeld and Murthly, during
the splendid St Martin's Summer weather
[9 October–11 November] which is supposed
to come at the end of autumn'.[2] In its
unexpectedly warm weather and glow, the
atmosphere of the winter scene bears a
temperate asymmetry offset by the balance
of the composition.

William Michael Rossetti noted that:

At the summit of the picture, the stream
tumbles over rocks; then it ripples resolutely
down to another ledge; and hence it falls in
a straight streak, leaving almost smooth the
water which lies in front, tinged deep
orange-brown in its reflection of the rocks,
and yellow in that of the greenish sky. Here
the leaves of autumn float scatteringly, and a
contorted branch of a tree. All upwards from
the rippled space there is a great amount of
light, and also in front,
but not in the immediate foreground.[3]

The leaves floating in the foreground help to
create space, and the sky remains a bit green,
but has faded somewhat. There is a thick
application of paint on the tree line, and the
active brushwork in the distant waterfall was
added last for the effect of spray rising and the
churning flow of water over rocks. The flecks
of cream-coloured paint that highlight the
branches in the lower right successfully convey
sunlight on the wood, and bear a resemblance
to the evocative treatment of details in Winter
Fuel (no.128).

First owned by William Lee of Downside,
Leatherhead, Surrey, famous for his orchid
collection, St Martin's Summer was later
purchased by the Moray-born Sir Donald
Alexander Smith, later Baron Strathcona,
an eminent businessman and politician in
Canada, and then the largest shareholder in the
Hudson's Bay Company.[4] The picture has been
in Canada since at least 1888, and this is its
first exhibition in London in 129 years. JR

'The tower of strength which stood Four-square to all the winds that blew.' – Tennyson 1878–9

Oil on canvas

91.5 × 135

Signed and dated in monogram lower left

Geoffroy Richard Everett Millais Collection

Provenance James Hall Renton; Christie's, 30 April 1898 (92); bt Capt. McNeil; Mrs A. Vickers to 1972; Christie's, 28 Jan. 1972 (158); bt FAS; bt Sir Ralph Millais 1978 and by family descent

Exhibited RA 1879 (150); GG 1886 (42); RA 1898 (183); Jersey 1979 (58); Southampton 1996 (219)

Following the death of his second son George Gray Millais in 1878 (no.115), Millais retreated to Dhivach house outside Drumnadrochit, owned by his friend Arthur James Lewis. He there produced an expiation of his grief in a painting of Urquhart Castle, Loch Ness, titled solely with lines adapted from Tennyson's lament of 1852, 'Ode on the Death of the Duke of Wellington': 'O fallen at length that tower of strength/ which stood four-square to all the winds that blew!' The picture has often been referred to since as *Urquhart Castle*, a title that dilutes the sense of necessary resilience evident in the poetic original.

Millais would later write to his friend and fellow artist Louise Jopling after her son from her first marriage, Percy Romer, died in 1881:

When George died, I felt grateful for my work. Get you as soon as possible to your easel, as the surest means, not to forget, but to occupy your mind wholesomely and even happily.[1]

The surface of *'The tower of strength'* does not radiate with happiness, but with anguish and despair to match its weather and the wind ripping across the surface of Loch Ness. Both J.G. Millais and Spielmann deemed it a failure,[2] but they were less inclined to accept expressionism and motive paint as symbolic than later generations. Ultimately, it is a most impressive picture and, while the product of personal need, hewed more closely than other landscapes to the theme in his art of that time of reinterpreting British painting of an earlier generation.

As in *Flowing to the River* (no.126), the reference was to the art of Constable, whose *Hadleigh Castle* 1829 similarly represented the expiation of grief, for he painted this image of a blasted castle ruin in the wake of the death of his wife Maria in 1828. Michael Rosenthal has described it as a picture 'charged with an obvious and foreboding intensity, onto which Constable projected the blackness of his own emotions at the time'.[3] Ruins had a powerful meaning in Romantic art, symbolising the vanity of man's worldly ambitions and the ubiquity and power of God and nature. Millais channelled this same idea of the sublime magnified by personal tragedy in *'The tower of strength'*. The surface rises in an immensely thick impasto of white in the illuminated cloudbanks that back and surround the castle and the hill, a grey shape hovering above the turgid loch. There is a remarkable and atypical hard and thick paint application, a kind of visceral treatment of the surface, which may be accounted for by George's recent death.

In addition to the connection with Constable, and the tradition of the imagery of ruins in the Romantic sublime, the rowing figure in the foreground could plausibly be connected with the figure of Charon the boatman from Greek mythology, and a symbolic imagery of death pursued simultaneously by the Swiss painter Arnold Böcklin in his contemporary series of five pictures titled *Island of the Dead* 1880–6. Such a comparison reveals the actuality of Millais's symbolism, with respect to Böcklin's Mediterranean fantasy, but both tap into a similar strain of emotion. In Millais's picture, the castle is barely detailed; only a few windows are visible, the middle one on the right showing sky through its surrounds. On the right, a wing of the structure stretches out and envelops the surrounding landscape, blurring against the sky. Preliminary watercolour sketches for the picture resound with bright blue skies and yellow and light touches on the sides of the castle and the island. All this is swept away in the final oil, in a riot of dark earth tones, a much changed feeling achieved through weather, light, colour and painterly touch. JR

Christmas Eve 1887
Oil on canvas
154.9 × 129.5
Signed and dated in monogram lower left
Private Collection of the late Sir Paul Getty KBE

Provenance Thomas McLean; bt Charles J. Wertheimer; thereafter bt by Sir Joseph Benjamin Robinson; Sotheby's, 17 June 1970 (145); sold by Prince Joseph Labia to the FAS c.1981; Christie's New York, 24 May 1989 (468); Hazlitt, Gooden & Fox; bt Christopher Gibbs

Exhibited McLean's Gallery 1888; Guildhall 1892 (27); RA 1898 (170); FAS 1901; RA 1958 (84); NGSA 1959 (99)

This picture was painted in late 1887 from the west side of Murthly Castle, the seat of Sir Archibald Douglas Stewart, 8th Baronet of Murthly, who would die three years later aged 83, and with him the line. The tower in the painting dates to the fifteenth century. Millais was renting Birnam Hall, often called Dalpowie, a large lodge in the garden of the castle, for the seventh year running.[1] The lodge was about two miles downriver from Dunkeld, and had seven bedrooms, eight servants' bedrooms, public rooms and running water throughout. There was a six-stall stable with a coach house and accommodation, a garden, a lawn-tennis court and kennels. The shootings comprised 6,000 acres of mostly low country. The fishing rights included one mile of the Tay and a further two miles on alternate days. It was a substantial property within an even larger one, and the rent was around £600.[2]

J.G. Millais recalled that there had been a violent snowstorm one evening and it threatened this picture, which Millais had left in his painting hut:

the wet paint turned towards the wall. In great anxiety he waited till the morning, when he hastened to the spot, expecting to find the hut and its contents blown clean away. To his delight, however, there it was, standing four-square to the winds of heaven; and there, too, was the village carpenter who built it, a dear old man who lived four miles away, and, 'fearing for the hoose', had come all the way down at midnight in the blinding gale and made it thoroughly secure![3]

This is another example, as seen in *Chill October* (no.125) and *'The Sound of Many Waters'* (no.130), of the artist in combat with the elements, and pictures saved from certain ruin, that hyperbolically fill J.G. Millais's biography. But it is clear that painting in the outdoors, even in a small hut, in the dead of winter proved a challenge.

There is a stillness to the picture, but a sense of human presence nonetheless, conveyed in various tracks in the snow: a cart, human footprints and possibly those of the person's canine companion. Spielmann's somewhat bizarre assessment of the picture is worth quoting:

This extremely effective, if somewhat theatrical, landscape represents Old Murthly Castle – not to be confounded with the Elizabethan structure which Gillespie Graham designed for Sir A. Douglas Stewart. There is a touch of poetry in the air, as the setting sun lights up the windows of the castle and leaves the snow cool in colour, varied with a hundred tints. But as an example of tree-drawing it is probable that Millais never did anything so bad. There is no care for structure, and the branches look more like waving eels or a gigantic sea-anemone than solid, naturally-developed wood and twig.[4]

The site remains almost exactly the same today, and is notably absent of sea creatures, but Spielmann was correct in finding a poetic quality in the picture, with the cold day clouding over, winter skylight, the deep-set windows of the house reflecting the last golden gleams of the sun, dark firs and yews beyond the garden wall. There are studies for the numerous jackdaws in this picture in the collection of the Royal Academy of Arts,[5] and the presence of these dark birds superficially links the picture to *The Blind Girl* of decades earlier (1854–6, no.62), with its broad view up an expanse of field dotted with dark birds, and distant image of medieval structures.

Thomas McLean published an etching after the work by R.W. Macbeth (1848–1910) in 1889, by which time it had probably entered the Charles Wertheimer collection. Sir Joseph Benjamin Robinson, a wealthy South African mine-owner, purchased this picture and many others from the Wertheimer collection and, at his death, pictures from his collection that had not been dispersed at a sale in 1923 passed to his son of the same name (1887–1954). The paintings were exhibited at the Royal Academy in 1958.[6] JR

Lingering Autumn 1890
**'No spring, nor summer beauty hath such
grace/As I have seen in one autumnal face.'
– Donne.**
Oil on canvas
124.7 × 195.5
Signed and dated lower right
National Museums Liverpool,
Lady Lever Art Gallery

Provenance Arthur Tooth & Sons; George McCulloch by
1893; Christie's, 23–5 May 1913 (78); bt Gooden & Fox for
W.H. Lever; thence to the Lady Lever Art Gallery

Exhibited RA 1891 (293); Chicago 1893 (335); RA 1898
(151); RA 1909 (16); Port Sunlight 1948 (152); RA and
Liverpool 1967 (112); RA 1980 (26)

While most of Millais's Scottish landscapes
were purchased by English collectors,
Lingering Autumn entered the collection
of the Glaswegian mine-owner George
McCulloch, who also owned *Sir Isumbras
(A Dream of the Past)* (fig.5, p.18).[1] *Lingering
Autumn* is more elegiac in reference than most
of the Scottish landscapes, a mood assisted by
the accompanying quote in the Academy
catalogue of 1891 from John Donne's *Elegy 13:
The Autumnall* (pub.1633). The *Athenaeum*
noted that

> the charm the poet found in fair but fading
> human life the painter has recognised in the
> beginning of the year's decay [...] Its subject

is the serene charm, the tender pathos of
incipient decline, more beautiful because
more touching than the earlier splendours
of the year.[2]

The sentiment in the poem, however, is
celebratory. In the painting Millais contrasts
Donne's vision of ageing beauty with the
youthfulness of the pail-wielding child, posed
by Effie Stewart, a Perthshire ploughman's
daughter. As in *Autumn Leaves* (no.82), Millais
used a local working-class model, and the
flowers in her hand are a reminder of the
continued vitality of nature in autumn.

Millais painted *Lingering Autumn* from
the mill stream in Murthly looking south,
with the wide Tay in the background, visible as
intermittent slashes of brilliant white pigment
seen through the trees and underbrush. He
used similarly vibrant brushwork to show
detail in the marshy foreground, with singular
strokes, often choppy with varied width and
thickness, to suggest branches amid pockets
of bright colour. In the lower left there is a wide
swathe of heavy paint and in the top glazes very
delicate, almost ink-like broken lines; Millais
here used a palette knife in the streaks of tan
and white colour where water drains around
a sluice gate. By contrast, the background is
smoothly painted, the far-off hills rendered in
broad washes of violet, pink and blue. The sky

is a deep blue at the top and fades to a cloudy
white towards the horizon, conveying the
changeability of Highland weather. The
remarkable result is that the reflection in the
near water is blue in the foreground and turns
greyish white in the middle ground. Such
touches make this an intricate picture despite
its scale, and it retains, like so many of Millais's
later landscapes, that broad rush back into
space that leads one's eye into the composition,
halts the vision halfway, with the horizontal
line of the bank just before the River Tay,
and then continues back in planar recession,
terminating in the distant range of hills. It
was this same alternating rapid and halting
rush into a panoramic space in *Chill October*
(no.125) that so thrilled a young Vincent van
Gogh and crept into his own art (fig.29). In
such works Millais rejected the photographic
realism so popular in French-inflected
paintings by contemporary artists of the
Newlyn School. Here is just the joy of fine,
confident, brushwork and atmospheric effect.
The painting also completed a loose serious
of works whose titles and natural forms
documented the seasons in Scottish scenery,
including *Autumn Leaves* 1855–6, *Spring*
1856–9 (no.84), *Winter Fuel* 1873 (no.128)
and *St Martin's Summer* 1878 (no.131).

Théophile-Narcisse Chauvel etched the
picture in 1892 for Arthur Tooth & Sons.[3] JR

Figure 29
Vincent van Gogh (1853–90)
Rain
1889
PHILADELPHIA MUSEUM OF ART.
THE HENRY P. MCILHENNY
COLLECTION IN MEMORY OF
FRANCES P. MCILHENNY, 1986

Dew-Drenched Furze 1889–90
Oil on canvas
170.2 × 121.9
Signed and dated in monogram lower left
Geoffroy Richard Everett Millais Collection

Provenance Everett Gray; by 1898 his widow Harriet Grace Mary Gray, after her second marriage, called Mrs John Satterfield Sandars; Christie's, 27 May 1910 (82); bt Obach & Co.; Miss Veronica MacEwen by 1967; Geoffrey Bourne-May; Christie's, 21 July 1978 (159); bt Julian Hartnoll, from whom bt Ralph R. Millais, 1978, and by descent

Exhibited New Gallery 1890 (119); RA 1898 (97); RA and Liverpool 1967 (113); Jersey 1979 (72); Southampton 1996 (237); Tate 1996; Washington 1997 (14); Tate 1997–8 (57)

This is a work that has recently been seen as the pinnacle of the poetic aims of Millais's later art, in a format that appears uncharacteristically abstract. To a degree, this is the result of the subject, which Millais's son described as 'probably never painted before', and one that as he began he feared 'might possibly prove to be unpaintable'.[1] The artist, again, conquered nature in his son's hagiographic telling, but here adulation is warranted, for Millais admirably caught the sun streaming through a clearing of bedewed gorse in the early morning haze. In addition, he productively channelled the art of Constable and Turner in a revival of Romantic landscape painting, mirroring the revival of earlier English art in his portrait and subject pictures. Regardless of the sublimity of such a scene, a poetic element is indicated in the title, another loose citation of a Tennyson work, in this case *In Memoriam* (1850). The year 1889 was no

more remarkable for mourning than any other in the life of Millais, so this picture does not commemorate a single person, but nonetheless continues the elegiac tone of so many of these later landscapes. It is a moving picture: in its narrow format, pervading glow of light, and collapse of space and distance, it bears a distinct human element in its address to the viewer.

When originally exhibited it drew forth comment on its naturalism, being described as

> an autumnal scene in a dense wood, with a fern-crowned vista between trees opening to and ending in a lofty mass of russet oaks, ruddy beeches, and grey larches. The vapour has condensed upon the furze, ferns, leaves and gossamers. In the foreground, embedded among the fern stems, is a hen pheasant, whose mate, with his splendid plumage hidden in the shadow, is close at hand.[2]

J.G. Millais had painted, from a live specimen, a cock pheasant in the right foreground to 'add repose to the scene'. It was posthumously removed, leaving only the nesting hen, hardly visible, rendering the image stark in its depiction of nature consumed in light.[3]

The picture was painted off a road near Murthly, not far from Birnam Hall, which the family had rented since 1881, in a section of forest where the family used to hunt capercailzie, or large wood-grouse, and roe deer.

It is Millais's most composed vertical landscape to date, especially when compared to works such as *Scotch Firs* (no.127), with its scrim of blocking trees. The foreground is worked in a dense skein of tall wispy stalks, overlaid with pigment dabbed on with a dry brush in emulation of what Constable called 'chiaroscuro of nature' effects, derided as 'snow' by critics. Despite traditional framing elements of large trunks on either edge of the composition, the central vista does not lead one's eye to a dramatic point; instead we are left to wander, unseeing and groping, through a gap in the multi-hued surface, with the suffusing efflorescence of a Turner sun. The haze of the growing day spirals up and out of the top of the frame, the colours brightening and more intensely laid in towards the top. Such a work is as sensitive in its depiction of abstracted atmosphere as any pictures by Claude Monet of the coming decade, such as his *Mornings on the Seine* series (from 1896), and more notably unique, against the French artist's seriality, as well as less artificial and more purely naturalistic in its observed tones.

Millais exhibited *Dew-Drenched Furze* at the New Gallery on Regent Street, which by 1890 had inherited the mantle of advanced art from the Grosvenor Gallery, then in its final season. This picture was first owned by Effie's brother, Everett. It has passed twice through the hands of Millais's family and descendants, to Veronica MacEwen, the daughter of Millais's youngest, Sophie, and later to Sir Ralph Regnault Millais, 5th Baronet.[4] JR

Figure 30
Millais photographed against landscape setting in Scotland
c.1890
GEOFFROY RICHARD EVERETT
MILLAIS COLLECTION

Dead Pheasants c.1875
Oil on board
20.3 × 30.5
Signed in monogram lower left
Private Collection

Provenance W.G. Archer, Edgbaston, Birmingham; sold
Christie's, 28 June 1897 (11); sold Phillips, 25 April 1995 (169)

One of Millais's rare still-life paintings, this
should more properly be considered a sketch,
as it does not bear the marks of symbolism
so often associated with that genre. It is
representative of Millais's twin pursuits in
Scotland. Sometimes they juxtaposed
themselves unexpectedly. J.G. Millais relates
the story of his father that, 'one day, while
at work, he noticed a big pack of black game
coming over from the west, and without

moving from his painting-stool he threw down
his palette and killed a blackcock as it flew
overhead'.[1] Apparently this was not the usual
practice, as the artist preferred to shoot at prey
from a fair distance, but the anecdote gives an
indelible image of a man equally comfortable
in both pursuits, and committed to their
spontaneity. The tangible results of such
shooting were rarely committed to canvas.
It may seem an oddity that Millais did not paint
still-lifes, as many of his contemporaries did,
especially in France. But it is not a common
genre in the history of English art, more
associated with preparatory sketches for larger
pictures or proper animal painting, and Millais
was not an artist who made oil sketches or even
preparatory drawings to any great extent in the
latter part of his career.[2] JR

The Last Trek 1895
Electro-etched frontispiece published
in John Guille Millais, *A Breath from
the Veldt*, London
Private Collection

Millais contributed illustrations to three books
written by his son, John Guille (1865–1931).
Growing up on the east coast of Scotland, John
Guille developed a passion for wildlife and, in
particular, ornithology. He gained a reputation
as a traveller, hunter and naturalist, and wrote
more than twenty publications, including *A
Breath from the Veldt* (1895), *British Deer and
their Horns* (1897) and *Far Away up the Nile*
(1924). Unlike his father who never ventured
further than Europe, John Guille travelled
widely, to Iceland, Norway, Africa and North
America. In particular he became fascinated
by South Africa following his first trip there
in 1893.

A Breath from the Veldt, too large to be useful
for any traveller, describes his expedition
through the South African grasslands, shooting
bustards, eagles and springbok, 'the fleetest
antelope in South Africa', and commenting on
the climate, which even in February is 'too hot
for the average Britisher'. It contains a total
of twelve etchings and a large number of
illustrations of the various creatures and
specimens he encountered. Millais's
contribution was the volume's frontispiece,
which relates to a scene John Guille witnessed
in South Africa of 'a white hunter dying in the

wilderness attended by his faithful Zulus'.[1] In
Millais's illustration the hunter's hat has been
cast aside, and the steam from the boiling pot
in the foreground is directed towards a herd
of zebra distracted by a chase in the middle
ground. Millais, who enjoyed hunting and
shooting on his regular trips to Perthshire,
here imagines that role in South Africa, just
four years before the outbreak of the Second
Boer War (1899–1902), which was fought
to expand the British Empire. The title may
refer to the 'Great Trek', which, partly over
discontent with the English colonial
authorities in the mid-1830s for abolishing
the Slave Trade, led to the movement of more
than 10,000 Boers from the Cape Colony to
the north and north-east of the country.

The Last Trek is the only known electro-
etching produced by Millais.[2] Although he
rarely commented on the processes of
printmaking, he remarked in 1879 that:
'After an unusual amount of oil work – life-
size – I find my old eyes damned doing small
drawings for woodcut […] Everybody draws
for the wood so splendidly now, & I feel quite
a duffer.'[3]

Gradually during the 1870s wood engraving
began to be replaced by photo-mechanical
processes, and it became possible to print a
photograph directly on to a block. The final
illustration Millais produced appeared as a
photogravure[4] in John Guille's *The Wildflower
in Scotland* and appeared five years after
the artist's death. HB

Glen Birnam 1890–1

Oil on canvas

145.2 × 101.1

Signed and dated lower right

Manchester City Galleries

Provenance Charles J. Wertheimer;
Mrs Enriqueta Augustina Rylands by 1898;
bequest 1908

Exhibited RA 1891 (432); RA 1898 (82);
Manchester 1911 (234); Japan 1993b (40)

Glen Birnam is one of two wintry landscapes
from the last years of Millais's life. He began it
in late 1890, after a particularly trying summer
of portrait painting. He was looking forward to
returning to Birnam Hall for the tenth straight
season. In August he wrote to Effie, who was
already in Scotland with the family, 'I never
looked forward to a holiday with greater
pleasure as I am tired out. The anxiety of
satisfying people in portraiture is almost
intolerable.'[1] A work such as *Glen Birnam*, with
its white stillness and single solitary figure,
possibly conveys precisely the release the artist
was seeking in Scotland, where he could paint
or hunt in silence, without the chatty social
demands of portrait painting. He preferred
vertically orientated canvases in this period,
including *Dew-Drenched Furze* of the previous
season (no.135) and *Halcyon Weather* (Geoffroy
Richard Everett Millais Collection), which he
would paint the next year. The orientation of
the canvas echoes the form of an old woman on
the right who trudges along a road, stretching
deep into the background and curving gently to
the right, with trees flanking it on either side.
Undisturbed by her surroundings, she wears a
heavy dark cloak, a red scarf on her head, a blue
striped shawl over her frame, and elevates a
basket with her left arm. It is early morning and
a cold light fills the scene, the clouds streaking
diagonally across the sky above the birches and
denuded trees. The road is rutted by wheel
tracks, and the snow is old, many times frozen,
marked by animal tracks that disappear into
the trees on the left. Millais used a dry brush in
the upper branches to bring out the texture of
the canvas – it is very thinly painted in parts –
and to stand for leaves. This wintry scene,
painted near Birnam Hall, well communicates
the commitment of Millais's practice, an
equivalent to the necessary trek of this cold
traveller. There is no moral or narrative, no
evident symbolism. It is a seasonal landscape
without bombast. JR

'Blow, Blow, Thou Winter Wind.' – 'As You Like It,' act. ii. sc. 7 1892

Oil on canvas

108 × 155

Signed and dated lower right

Auckland Art Gallery Toi o Tāmaki, gift of Mr Moss Davis, 1933

Provenance Major James Arthur Joicey by 1898; Arthur Tooth & Co., London; Mr. Moss Davis, Auckland, before 1933; Auckland Art Gallery Toi o Tāmaki, New Zealand, gift of Mr Moss Davis, 1933

Exhibited RA 1892 (211); RA 1898 (78); Australia and New Zealand 2001–2 ; New Zealand 2004–6 (32)

In the autumn of 1891, finding Birnam Hall unavailable, the Millais family took up lodgings in a mansion house called Newmill a few miles upriver from Perth, where he began the meditative *Halcyon Weather* 1891–2 (Geoffroy Richard Everett Millais Collection). But, after a fire that destroyed the house on 10 January 1892, the family moved to Bowerswell, Perth. There Millais began a landscape that, like *Glen Birnam* (no.138), introduced a human presence into a desolate winter scene. But while *Glen Birnam* lacked any significant narrative, *'Blow, Blow, Thou Winter Wind'*, the last large landscape he would paint in Scotland, marked a return to social themes from his work of the mid-1850s.[1] The subsequent two lines from Shakespeare's song within the play, sung by Amiens, one of the Duke's lords, are 'Thou art not so unkind/ As man's ingratitude', and this is what is represented in the image, suggested by a scene the painter witnessed on Corsey Hill in Kinnoull Woods. A young woman sits beside the snow-covered track, nursing her small child and buffeted by the wind. In the middle ground a collie lifts its muzzle to the sky and howls. In the distance a man walks away,

disappearing into the mist. He has abandoned his family, which makes this one of the artist's rare pictures that deals with contemporary social ills, a theme more frequently encountered in his drawings. The two additional lines from *As You Like It* were accidentally omitted from the Academy catalogue, and many viewers were confused as to the meaning. But the inclusion of a concise story was a rarity in Millais's late landscapes.[2]

Millais painted *'Blow, Blow, Thou Winter Wind'* at a bleak and blustery exposed spot near the gamekeeper's house around Kinnoull Hill, where the road in the picture winds south around Corsey Hill to meet the old highway from Perth to Dundee, off which Millais had painted *Chill October* (no.125) more than twenty years before. Aged Scotch firs line the right on the side of Kinnoull Hill, and on the left lies the windswept Hatton Farm. This picture was finished in the studio, but it is uncertain how much was painted indoors or whether it was just a slight amount 'in connection with the effect', as was customary from *Chill October*. Spielmann wrote that

> the chief artistic motive, Sir John added, was the painting of the branches of the fir trees blown back with such violence that they are turned up and the sky is seen through them – 'an extraordinary effect in nature, that, and one which I believe never to have been represented before.'

The critic then continued to discuss 'the sentimental motive' described above, separating the two aspects, and privileging the one that seems to present the sharper

commitment of the painter, representing nature in a novel way.[3] Yet it is the way in which the fir trees manage the incessant violence of the wind, challenging it to 'Blow, blow', and continue to survive, if in a changed form, that presents hope for the abandoned mother.

Later that year, in a letter of November 1892, Millais's friend, the animal painter Briton Rivière, encouraged him to continue to paint such winter landscapes:

> Are we then to place among the other bad things this unpleasant weathered [?] season has brought us the loss of your winter landscape? Do not decide too soon not to do anything. You have been truly successful with even snow & I can just fancy something very charming from your hands even from a 'withered' aspect of nature.[4]

That withered aspect had been well captured in *'Blow, Blow, Thou Winter Wind'*, and the picture had been hung in a place of honour on the north wall of the Academy's showcase Gallery III at Burlington House in May 1892.

Major James Arthur Joicey was the son of Baron Joicey, who owned a colliery in Durham. His father owned *Flowing to the Sea* 1870–1 (Southampton City Art Gallery) and his brother, the future 3rd Lord Joicey, later owned *Little Miss Muffet* 1884 (Private Collection). The family frequently employed Arthur Tooth as their dealer. Later the picture entered the collection of Moss Davis, a Jewish merchant who emigrated to New Zealand and was married to Leah Jacobs. They owned Hancock and Company, a liquor company in Auckland, and in 1910 retired to England.[5] Davis was a great benefactor of the Auckland Art Gallery. JR

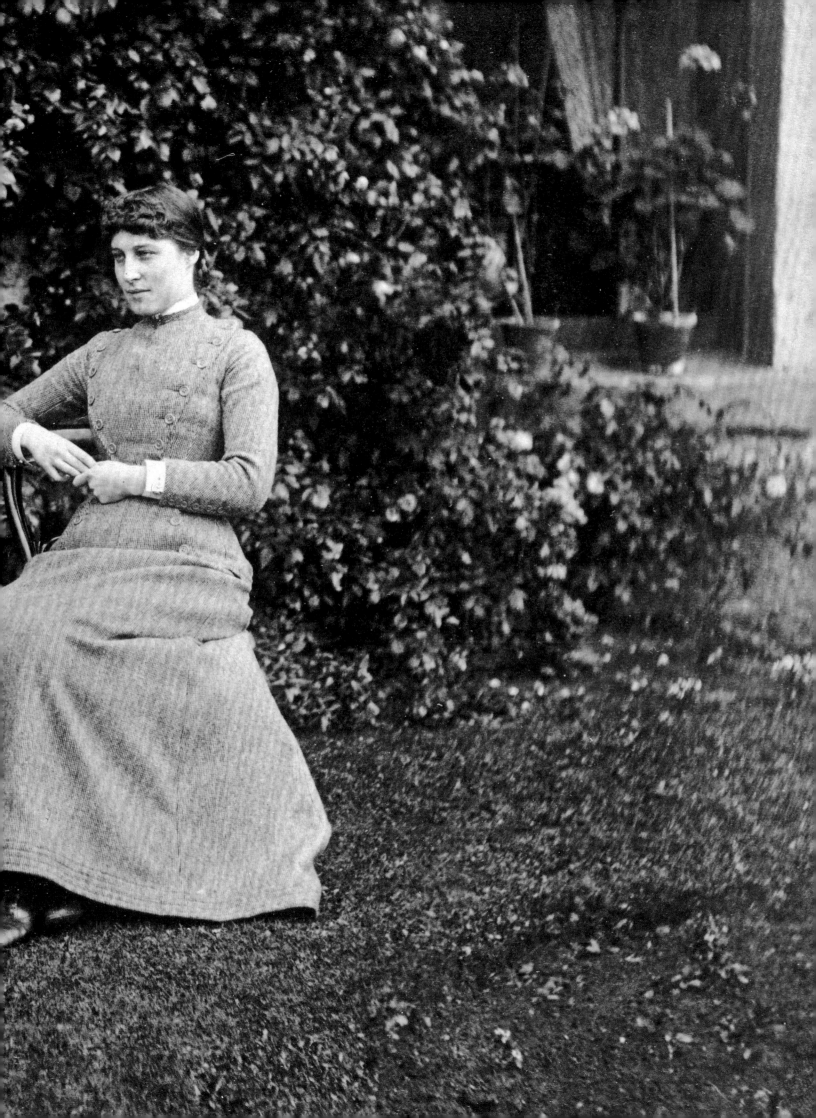

Chronology

1828

7 May: Euphemia (Effie) Chalmers Gray, the first of fifteen children of George Gray (1798–1877), a solicitor, and Sophia Margaret Jameson (1808–1894), daughter of the Sheriff Substitute of Fife, born at Bowerswell House, Kinnoull, Perth.

1829

8 June: John Everett Millais, third child and second son of John William Millais (1800–1870), a minor official and military officer from an old Jersey family, and Mary Emily Hodgkinson, née Evamy (1789–1864), from a family of saddlers, born at No.30 Portland Street in Southampton, his mother's home town.

1831– c.1834

Millais family living in Jersey.

c.1834–1837

Family living in Dinan, Brittany, to improve Mary Emily Millais's health.

1837–1838

Family living near St Helier, Jersey. Millais receives art instruction from Mr Bissel at Hackett Cottage in St Helier, and also receives guidance from a German artist, Edward Henry Wehnert, who had studied in Paris and was living in Jersey during this time.

1838

Family travels to Southampton and then to London.

His mother takes him to meet the President of the Royal Academy of Arts, Sir Martin Archer Shee, who encourages him to enrol at the art academy run by Henry Sass (1788–1844) at No.6 Charlotte Street (now Bloomsbury Street) near the British Museum.

1839

Wins a Silver Isis award for a drawing depicting a scene from the Battle of Bannockburn. Enters for the annual drawing competition for the Society of Arts, Manufactures and Commerce, also known as the Society of Arts.

1840

June: Enters Royal Academy of Arts schools, Trafalgar Square, as a probationer. At the age of eleven Millais is the youngest pupil ever to pass his probationary term. He is entitled to study for ten years in the Royal Academy schools, although he remains for six.

1843

Meets William Holman Hunt (1827–1910) while sketching at the British Museum. Shortly afterwards the sixteen-year-old Hunt is admitted as a probationer to the Royal Academy.

March: John Ruskin publishes *Modern Painters* Vol. I.

10 December: Awarded his first Royal Academy silver medal.

1844–1854

Leases the house at No.83 Gower Street (now No.7), just north of Bedford Square. Millais's studio is at the rear of the ground floor.

1846

April: Ruskin publishes *Modern Painters* Vol. 2.

May–August: *Pizarro* (no.5) exhibited at the Royal Academy.

Summer: Millais makes the first of many annual visits to Oxford to visit his half-brother from his mother's first marriage, Henry Hodgkinson.

1847

Pizarro wins a gold medal at the Society of Arts. *The Tribe of Benjamin Seizing the Daughters of Shiloh in the Vineyard* wins a gold medal for historical painting at the Royal Academy schools. Submits *The Widow's Mite* (in fragments, Christchurch Priory, Hampshire) to the Palace of Westminster competition.

1848

Revolutions take place in many cities throughout Europe; the Chartist demonstration is held on Kennington Common, south London.

10 April: Effie Gray marries John Ruskin at Bowerswell.

April: The Royal Academy hanging committee rejects *Cymon and Iphigenia* (Lady Lever Art Gallery).

September: The Pre-Raphaelite Brotherhood is formed in Millais's studio at Gower Street. Members include Millais, Holman Hunt, the brothers Dante Gabriel Rossetti (1828–82) and William Michael Rossetti (1829–1919), Frederic George Stephens (1828–1907), James Collinson (1825–81) and Thomas Woolner (1825–92).

1849

March: D.G. Rossetti exhibits *The Girlhood of Mary Virgin* (Tate) at the National Institution's *Free Exhibition of Modern Art* at the Chinese Gallery on Hyde Park Corner, the first picture seen in public with the initials 'P.R.B.'

May–September: *Isabella* (no.9) exhibited at the Royal Academy throughout August. *The Art Journal* remarks that it is 'perhaps the most remarkable work in the whole Exhibition'. The painting sells at the opening for the asking price of £150.

1850

March: Produces his first print, the etching *St Agnes of Intercession* (no.17b), intended for the never-published fifth issue of the Pre-Raphaelite circle periodical, *The Germ*.

15 June: Charles Dickens publishes an issue of *Household Words* including his attack on Millais's *Christ in the House of His Parents* (no.20), then on view at the Royal Academy. The painting is removed to Windsor Castle for a day for Queen Victoria to have a private view. Millais writes to Hunt: 'I hope it will not have any bad effects on her mind.'

Tennyson publishes *In Memoriam*.

1851

1 May–15 October: *The Great Exhibition of the Works of Industry of All Nations* opens in Joseph Paxton's Crystal Palace in Hyde Park.

13 May: John Ruskin's letter in defence of the Pre-Raphaelite Brotherhood is published in *The Times*.

June: Meets Ruskin for the first time (Millais and Effie met once before seven years earlier).

June–December: Millais and Hunt live and work in Surrey, on Surbiton Hill, Kingston upon Thames, then with the Barnes family at Worcester Park Farm near Cheam, and paint the backgrounds to *Ophelia* (no.37), *A Huguenot* (no.57), and Hunt's *The Hireling Shepherd* (Manchester City Galleries) and *The Light of the World* (Keble College, Oxford).

August: Ruskin publishes his pamphlet *Pre-Raphaelitism*.

19 December: Death of J.M.W. Turner.

1852

South Kensington Museum opens (known from 1899 as the Victoria and Albert Museum). Publishes his first print, the frontispiece for Wilkie Collins's *Mr Wray's Cash-Box*.

Mid-September: Millais visits Winchelsea in East Sussex with Hunt and Edward Lear.

November: Threatens never to exhibit at the Royal Academy again after Frederick Goodall is chosen over him to become Associate of the Royal Academy. At twenty-three Millais is one year too young.

Wilkie Collins publishes *Basil*.

A Huguenot wins a £50 prize at the Liverpool Academy exhibition.

1853

March: Effie Ruskin sits for *The Order of Release* 1746 (no.39). Following its exhibition *John Bull* writes that Millais is the 'greatest living painter'.

Figure 31
John W. Millais, the artist's father
GEOFFROY RICHARD EVERETT MILLAIS COLLECTION

Figure 32
The young Millais being presented with an award by the Duke of Sussex Print
GEOFFROY RICHARD EVERETT MILLAIS COLLECTION

Figure 33
Mary Emily Millais, the artist's mother
GEOFFROY RICHARD EVERETT MILLAIS COLLECTION

Figure 34
Mary Hodgkinson, wife of Henry Hodgkinson, the artist's half-brother
GEOFFROY RICHARD EVERETT MILLAIS COLLECTION

YOUNG MILLAIS

RECEIVING THE MEDAL AT THE SOCIETY OF ARTS.

Late June: Millais, his brother William Millais, and John and Effie Ruskin depart for Scotland, staying with the Trevelyans at Wallington Hall, Morpeth, then passing through Jedburgh, Edinburgh, Stirling and Dunblane and arriving at the New Trossachs Hotel, Brig o'Turk on 2 July.

9 July: The party move into local schoolmaster Alexander Stewart's family cottage. Millais writes to Hunt describing the Ruskins as 'the most perfect people'. Millais begins to develop a close acquaintance with Effie while teaching her to draw and nicknames her 'Countess'.

27 July: Millais begins Ruskin's portrait, which he completes the following November (no.38).

7 November: Elected Associate of the Royal Academy of Arts.

1854
The Crimean War begins (ends 1856).

13 January: William Holman Hunt leaves London for Egypt and the Holy Land.

25 April: Effie Ruskin leaves her husband.

Early summer: The Millais family leaves Gower Street and moves to South Cottage, Portsmouth Road, Kingston upon Thames, where there is a studio over the stables.

23 May: Millais, with Collins and others, leaves for Glenfinlas in the Trossachs, Scotland, to complete the background of the Ruskin portrait.

15 July: Effie's marriage to Ruskin is annulled in the Commissary Court of Surrey on the grounds that 'the said John Ruskin was incapable of consummating the same by reason of incurable impotency'.

July–August: Stays with the family of his close friend, the illustrator John Leech (1817–1864), at the Peacock Inn, Baslow, Derbyshire, near Chatsworth.

Late August–22 November: Working at Winchelsea near Rye, East Sussex, on *The Blind Girl* (no.62) and *L'Enfant du Régiment* (no.61).

October: Takes a studio at No.4 Langham Chambers, No.1 Langham Place, Regent Street, working there until late 1859.

November–December: Stays with Alfred Tennyson at Farringford House, near Freshwater Bay, Isle of Wight.

1855
Elected to the Garrick Club, seconded by John Leech, William Makepeace Thackeray and Wilkie Collins.

May: Threatens to resign his associateship of the Academy until his painting, *The Rescue* (no.63), is lowered three feet. Ruskin remarks in his Academy Notes, 'It is the only great picture this year, and it is very great'.

15 May–15 November: Three works shown at the Exposition Universelle in Paris, *The Order of Release 1746*, which won a second-class medal, *The Return of the Dove to the Ark* (no.25) and *Ophelia*.

3 July: Millais marries Effie Gray at Bowerswell and they have a month's honeymoon.

6 August: John and Effie move into Annat Lodge, next to Bowerswell, Effie's family home, in Perth, living there until 1857.

Autumn: Millais begins *Autumn Leaves* (no.82) in the rear garden at Annat Lodge.

1856
Millais earns 2,000 guineas from the sale of *The Blind Girl* 1854–6 (no.62), *Peace Concluded, 1856* (no.66), and *Autumn Leaves* at the Royal Academy. Millais participates in the founding of the National Portrait Gallery, London.

30 May: Birth of Everett Millais at Annat Lodge, Effie and John's first of eight children. An authority on dog breeding, he would be 2nd Bt. until his death in 1897. His son, John Everett Millais (1888–1920) becomes 3rd Bt. on Everett's death.

November: Elected a member of the Etching Club.

Submits *Sir Isumbras (A Dream of the Past)* (fig.5, p.18) to the Academy, which he thinks will be the sensation of the year. Ruskin considers it 'not just fall but catastrophe'. Millais continues to make changes to the painting until the 1890s.

1857
5 May–17 October: John Miller lends *Autumn Leaves* to the *Art Treasures of the United Kingdom* exhibition in Manchester.

19 September: George Gray Millais born. Publication of *The Moxon Tennyson* (no.71).

1858
28 November: Effie Gray Millais born (marries Major William Christopher James (1851–94) in 1878 and dies in 1911).

1859
Frederic Leighton (1830–96) returns to London after studying and travelling on the Continent, and starts to exhibit at the Royal Academy.

May: James McNeill Whistler (1834–1903) moves from Paris to London, settling in Chelsea in 1863.

May: Millais exhibits *Spring* (no.84), *The Vale of Rest* (no.85), and *The Love of James the First, of Scotland* (Private Collection) at the Royal Academy, after showing nothing the year before. Disheartened by the reaction of the critics, he begins to take on illustrative work for novels and journals, in particular *Once a Week*, which guarantees a secure income.

8–14 June: Trip to Paris with Effie, staying at the Hôtel du Louvre, and visiting the Sainte Chapelle, Notre Dame, the Louvre, the Salon and the Tuileries Gardens.

1860
13 May: Mary Hunt Millais born (dies 1944). William Holman Hunt is chosen to be her godfather.

May: Millais family moves to No.45 Bedford Square, until the next year, when Millais shares lodgings and a studio at No.130 Piccadilly with Joseph Jopling.

The Black Brunswicker (no.68) is exhibited to great acclaim at the Royal Academy and is sold for 1,000 guineas to Ernest Gambart.

1861
November: The Millais family move into No.7 Cromwell Place, South Kensington, subsequently the residence of Francis Bacon and now home of the Art Fund.

1862
10 April: Alice Sophia Caroline Millais born, called Carrie (marries Charles Beilby Stuart-Wortley, 1851–1926, in 1886 and dies in 1936).

November–December: John and Effie stay at Knole in Sevenoaks, Kent, where he begins *The Eve of St Agnes* (no.88).

Four of Millais's oil paintings (*The Vale of Rest*, *The Return of the Dove to the Ark*, *Autumn Leaves* and *Spring, as Apple Blossoms*) and three prints after his works (*A Huguenot, The Proscribed Royalist, 1651* (no.58) and the Dalziel Illustrations to *The Parables of Our Lord*) shown at the *London International Exhibition*.

Figure 35
Effie Millais, the artist's wife July 1870
GEOFFROY RICHARD EVERETT MILLAIS COLLECTION

Figure 36
John Everett Millais 1850s
NATIONAL PORTRAIT GALLERY

Figure 37
George and Everett Millais, the artist's sons
GEOFFROY RICHARD EVERETT MILLAIS COLLECTION

35

36

37
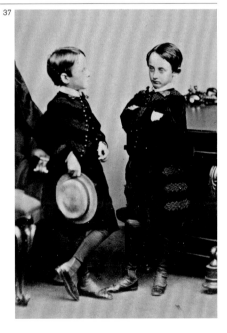

1863
Second trip to Paris.
Good Words publishes twelve illustrations to *The Parables of Our Lord*, engraved by the Dalziel Brothers.
My First Sermon receives positive reviews and a commendation from the Archbishop of Canterbury. Millais becomes London's most sought-after artist, and predicts that he can earn £5,000 over the year.

18 September: Geoffroy William Millais born (marries Madeline Campbell Grace in 1901, and is 4th Bt. from 1920 until his death in 1941).

18 December: Elected a full Royal Academician by one vote over Edward William Cooke, the marine painter.

1864
The Parables of Our Lord, with prints after Millais by the Dalziel brothers, is republished in book form.
Third trip to Paris.

29 October: John Leech dies of angina at the age of forty-six, devastating Millais. He is buried at Kensal Cemetery next to W.M. Thackeray.

1865
24 March 1865: John Guille Millais born (marries Frances Margaret Skipwith in 1894, publishes *The Life and Letters of Sir John Everett Millais* in 1899 and dies in 1931).

August: The Royal Academy rejects *The Parable of the Tares* (no.91), which Millais had submitted as his diploma picture.

October–December: Trip through Europe, with stops in Paris, Geneva, Chamonix, Lake Maggiore, Milan, Verona, Venice, Padua, Bologna, Florence, Pisa, Rome and Genoa.

1867
1 April–31 October: *The Eve of St Agnes*, *The Parable of the Tares*, and *The Romans Leaving Britain*, engravings after *The Black Brunswicker*, *The Order of Release, 1746*, *The Parable of the Lost Piece of Money*, *Ophelia*, and a set of the Dalziels' *Twelve Illustrations of the Parables of Our Lord* are shown at the Exposition Universelle in Paris.

Exhibits four paintings of children including *Sleeping* (fig.20, p.174), *Waking* (no.101) and *The Minuet* (no.102) at the Royal Academy. Their popularity is assured through printed reproductions.

1868
8 April: The Royal Academy accepts *A Souvenir of Velasquez* (no.103) as Millais's diploma picture.

15 June: Eighth and last child Sophia Margaret Jameson Millais born, called Sophie (marries Douglas Lilburn MacEwen in 1891 and dies in 1907).

The Royal Academy moves from Trafalgar Square to Burlington House, Piccadilly.

1870
Kinnoull Parish Church stained-glass window above the altar featuring images after Millais's illustrations to the *Parables of Our Lord* donated by George Gray.

28 January: John William Millais dies. Stays at the Octagon (built 1818), Fore Street, Budleigh Salterton, while working on *The Boyhood of Raleigh* (no.94).

September: Shoots at Braemore, Caithness, Loch Broom in Ross-shire, John Fowler's estate, and then at Loch More by Laing, Sutherlandshire, Lord Westminster's estate.

October: Begins *Chill October* (no.125) on a backwater of the River Tay, his first large-scale Scottish landscape.

1871
As a direct result of his experience in dealing with the estate of John Leech, Millais co-founds the Artists' Orphan Fund with the architect Philip Hardwick.

1873
Chill October exhibited at the Royal Scottish Academy, Edinburgh autumn and winter. Rents St Mary's Tower in Birnam, Perthshire, a turreted hunting lodge owned by Lord John Manners, MP, second son of the 5th Duke of Rutland and later 7th Duke. Paints *Scotch Firs* (no.127) and *Winter Fuel* (no.128).

Three out of the six works he exhibits at the Royal Academy are portraits, and the *Saturday Review* remarks that he is 'the most fertile in resources of any painter now living'.

1874
Autumn and winter: Rents Erigmore House, Birnam, owned by Sir John C. Carden, Bart.; paints *The Fringe of the Moor* (no.129).

Queen Victoria refuses to see Effie on account of her former marriage and divorce from Ruskin (she does not agree to see Effie until 1896).

1875
Trip to the Netherlands, stopping at the Hague, Haarlem, Leiden, Delft, Dordrecht and Amsterdam.

Autumn: Rents Erigmore House, Birnam.

1876
10 May–10 November: *Early Days* is shown at the *Centennial Exhibition* in Philadelphia.

Autumn and winter: Rents Rumbling Brig Cottage, Trochnay, and paints *'The Sound of Many Waters'* (no.130).

1877
January–February 1877: The Millais family moves into No.2 Palace Gate, Kensington, an Italianate red-brick studio house with Portland stone detailing designed by Philip Hardwick on a plot Millais had purchased in 1873.

1 May: Opening of Sir Coutts Lindsay's Grosvenor Gallery, at Nos.135–7 New Bond Street. Exhibits four portraits and a genre picture alongside works by James McNeill Whistler and Edward Burne-Jones, G.F. Watts and Edward Poynter. The *Art Journal* remarks that they are 'by the far best pictures in the Exhibition'. Millais continues to exhibit regularly at the Grosvenor Gallery.

May: Thomas Agnew and Son moves their establishment to No.39 Old Bond Street.

Autumn: Rents St Mary's Tower, Birnam, paints *St Martin's Summer* (no.131) on the River Braan near Rumbling Brig.

Begins his portrait of Lillie Langtry (no.112), exhibited at the Royal Academy the following year.

1878
Trial of Ruskin v. Whistler takes place at the Old Bailey, London.

1 May–10 November: Millais shows ten works at the Paris *Exposition Universelle*. He is awarded the gold Médaille d'Honneur and subsequently made an Officer of the Légion d'Honneur.

30 August: George Gray Millais dies at Bowerswell aged twenty of complications from typhoid fever and consumption.

Autumn: Works on *The Tower of Strength … (no.132)* while staying at Dhivach, a house left him by Arthur James Lewis, near Loch Ness and Drumnadrochit, Inverness-shire.

October: Visit to Paris to accept awards from the Exposition Universelle.

13 November: Following the death of Sir Francis Grant, Frederic Leighton succeeds him as President of the Royal Academy.

1879
Autumn: Millais rents Eastwood, in Dunkeld.

Figure 38
John G. Millais, the artist's son
GEOFFROY RICHARD EVERETT MILLAIS COLLECTION

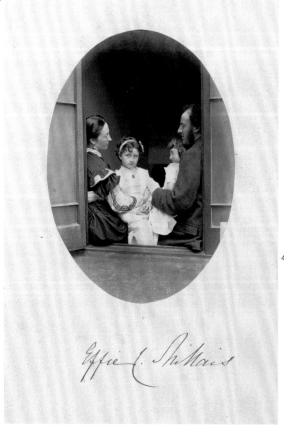

Figure 39
Effie and John Everett Millais with their daughters Mary and Effie
Photograph by Charles Dodgson (Lewis Carroll) at Cromwell Place, 21 July 1865
Signed by Effie Millais
HENRY RANSOM CENTER, UNIVERSITY OF TEXAS

Figure 40
Millais in his studio, 12 June 1887
Photograph by Rupert Potter
NATIONAL PORTRAIT GALLERY, LONDON

1880

May: Visits the Hague, Amsterdam and the Frans Hals Museum in Haarlem with William Powell Frith and Andrew Gray.

Autumn: Stays at Erigmore House.

August: Receives honorary Degree of Doctor of Law from Oxford.

His painting of Edie Ramage, *Cherry Ripe* (no.106), gains enormous popularity through the *Graphic*'s colour reproduction and 500,000 copies are sold.

Invited by the Uffizi Gallery, Florence to paint *Self-Portrait* (no.114).

1881

Autumn: Stays at Birnam Hall, also known as Dalpowie, in Murthly, owned by Sir Archibald Douglas Stewart, laird of Murthly Castle; the family would rent Birnam Hall every autumn until 1890.

The Fine Art Society holds an exhibition of nineteen of Millais's works and offers for sale prints after thirty-five of his works. A total of 42,380 people attend the exhibition.

1882

15 March: Sophie Gray Caird dies after many years of mental illness.

9 April: D.G. Rossetti dies at Westcliff Bungalow, Birchington-on-Sea, Kent.

1885

16 July: Created a baronet by the Liberal Prime Minister, Gladstone. Millais is the first artist since Sir Godfrey Kneller and the first ever native British artist to be given a hereditary title: Baronet of Palace Gate, Kensington, in the county of Middlesex and St Ouen, Jersey, Channel Islands.

1886

The New English Art Club is founded. The Grosvenor Gallery hosts a large exhibition of 159 of Millais's works. The exhibition is very well received, especially by Ruskin, who remarks that it is the most important exhibition of English art yet staged.

Paints *Bubbles* (no.107), showing his grandson, William James, which becomes famous as an advertisement for Pears' Soap. Millais earning in the region of £30,000 per annum.

1888

8 May: Millais exhibits *Forlorn* (Private Collection), *The Last Rose of Summer* (Geoffroy Richard Everett Millais Collection), and *A Typical Bassett Hound* at the newly established gallery on Regent Street, the New Gallery.

Millais publishes an essay titled 'Thoughts on our Art of Today' in the *Magazine of Art*. He defends free brushwork and 'individuality of conception and expression'.

1889

6 May–31 October: Millais has six works at the Paris Exposition Universelle: *The Right Hon. W.F. Gladstone, MP, James Clark Hook* (Private Collection), *Cherry Ripe, Bubbles, The Last Rose of Summer* and *Cinderella* (Lord Lloyd-Webber Collection).

1890

Grosvenor Gallery closes.

Autumn: At Birnam Hall and paints *Glen Birnam* (no.138) and then *Lingering Autumn* (no.134) in Murthly.

1891

Autumn: Finding Birnam Hall unavailable, the Millais family lodges at Newmill, a few miles upriver from Perth.

1892

10 January: Newmill house burns to the ground and the Millais move to Bowerswell; he begins 'Blow, blow, thou winter wind' (no.139) on Corsey Hill in Kinnoull Woods.

Meets the sugar magnate, Henry Tate, and encourages him to open a museum of British art. Millais becomes his most favoured painter.

1893

1 May–30 October: Millais has seven works at the *World's Columbian Exposition* in Chicago, the largest display in the United States in his lifetime: *The Ruling Passion* (no.98), *Halcyon Weather* (Geoffroy Richard Everett Millais Collection), *The Last Rose of Summer*, *Sweet Emma Morland* (Private Collection), *Lingering Autumn*, *Shelling Peas* (Leighton House, London) and *Bubbles*.

1894

February: As one of Europe's most important artists, Millais accepts an invitation from the Mayor of Venice to join the Committee of Patronage for the first Venice Biennale.

April: Millais stays at the Royal Bath Hotel, Bournemouth, for health reasons.

Autumn: At Bowerswell, and paints the background to *St Stephen* (no.99) at an old stone quarry on Kinnoull Hill and begins 'Speak! Speak!' (no.100).

October: Millais stays with the Gladstones at Hawarden Castle, Chester.

1895

Summer: Millais's last visit to Jersey, cruising there on the Palatine.

Autumn: At Bowerswell, painting the background to *A Forerunner* (Glasgow Museums), the last work he does out of doors.

Millais exhibits *The Ruling Passion* and *The Last Rose of Summer* at the first Venice Biennale

1896

25 January: Leighton dies at Leighton House; Millais is a pallbearer at his funeral.

20 February: Elected President of the Royal Academy.

11 May: Emergency tracheotomy delivered by Frederick Treves, famous for having been the physician to Joseph Carey Merrick (1862–90), the 'Elephant Man'.

13 August: Dies at 5.30 pm at Palace Gate of cancer of the larynx from pipe smoking.

20 August: Funeral and burial at St Paul's Cathedral in Painters' Corner. His pallbearers are William Holman Hunt, Philip H. Calderon, RA, Sir George Reid, PRSA, Sir Henry Irving, Lord Rosebery, Lord (Viscount) Wolseley, the Marquess of Granby, the Earl of Carlisle.

1897

7 September 1897, Everett Millais, 2nd Bt., dies of pneumonia.

23 December: Effie dies and is buried in Old Kinnoull churchyard.

The National Gallery of British Art opens on Millbank; almost immediately it became popularly known as the Tate Gallery, which was confirmed as its name officially in 1932.

1898

3 January–12 March: Memorial Exhibition of Millais's works at the Royal Academy featuring 242 works.

1899

20 March: William Henry Millais dies.

John Guille Millais publishes the two-volume biography of his father, *The Life and Letters of Sir John Everett Millais*, 'To the memory of my dear father and mother I dedicate these volumes'.

JR AND HB

42

43

Notes

Please refer to the Bibliography for full publication details of the main literature on Millais that is cited below.

Millais in His Time and Ours pp.10–13

1 It is clear that despite Millais's insistence on his Englishness, he saw his art in the larger context through his connections with the Old Masters and his relations with contemporaries abroad. An unsteady foreign traveller, he was nonetheless adventurous in his artistic wanderings. In this sense he was not provincial but, in the interests of resuscitating him and the Pre-Raphaelites in the 1960s and 1970s, art historians cast him as such, and treated his art both somewhat apologetically and as hermetic.
2 Milan Kundera, '*Die Weltliteratur*: How We Read One Another', *The New Yorker*, trans. Linda Asher, 8 Jan. 2007, pp.28–35.
3 We take this approach for granted in considering Modernism and contemporary art, but it has less often been attempted with art that falls beyond Modernism's narrowly defined projection. For an early exception, see Robert Rosenblum and H.W. Janson, *19th-Century Art*, revised ed. 2004, and more recent publications on British art: Prettejohn 2000; Barlow 2005; Tim Barringer and Elizabeth Prettejohn (eds.), *Frederic Leighton: Antiquity, Renaissance, Modernity*, London and New Haven 1999.
4 *The Complete Letters of Vincent van Gogh: With Reproductions of All the Drawings in the Correspondence*, 3 vols, Boston 1978, vol.1, p.4.
5 In 1883 van Gogh acquired a print of Millais's *Christmas Story-telling*, published in the *Illustrated London News*, 20 Dec. 1862, and mounted it for his collection. See Martin Bailey, *Van Gogh in England: Portrait of the Artist as a Young Man*, exh. cat., Barbican Art Gallery, London, 1992, p.140.
6 *Complete Letters of Vincent van Gogh* 1978, vol.1, p.300.
7 Ibid. p.129. He compared Millais's nobility to that of the fictional John Halifax in Dinah Mulock Craig's novel, *John Halifax, Gentleman* (1856). Van Gogh was living in Brixton and working at Goupil's, his uncle's art firm, when he saw *Chill October* (no.218) at the Samuel Mendel sale at Christie's on 24 April 1875 (431), where it was bought by Agnew's for £3,255. He probably saw '*Over the Hills and Far Away*' (fig.26, p.218) at the Academy in 1876. See *English Influences on Vincent Van Gogh*, exh. cat., University of Nottingham and the Arts Council of Great Britain, 1974, p.19; Barbican 1992, pp.36–43, 136.
8 *Complete Letters of Van Gogh*, 1978, vol.1, p.417, to Theo, n.d. [1882].
9 Ibid. vol.3, p.322 [between 27 May and 1 June 1882].
10 Ibid. p.366.
11 Salvador Dalí, '*Le Surréalisme spectral de l'Éternel Féminin préraphaélite*', *Minotaure*, no.8, 15 June 1936, pp.46–9.
12 In the unlocated *Murthly Moss, Perthshire* of 1887, see Millais 2, 1899, pp.199–201.
13 Harry Quilter, 'The Royal Academy', *Universal Review*, May 1888, pp.66–7.
14 *Paris Daily Messenger*, 14 Aug. 1896, pp.53–5.
15 Walter Richard Sickert, *A Free House! or, The Artist as Craftsman*, ed. Osbert Sitwell, London 1947, pp.148, 349 n.116 (transl.).
16 Spielmann 1898, p.118.
17 Millais 1, 1899, p.422, and *Daily Telegraph*, 14 Aug. 1896.
18 Wolf Jahn and Gilbert & George, 'Naked Human Artists', *Tate Etc.*, spring 2007, p.44.

'The Poetic Image': The Art of John Everett Millais pp.14–19

1 *Art Journal*, 1896, p.319.
2 For example, *The Last Romantics*, exh. cat., Barbican Art Gallery, London, 1989; *Heaven on Earth*, exh. cat., Djanogly Art Gallery, Nottingham, 1994.
3 Corelli to J.E. Millais, 24 Dec. 1894, PML, MA.1485.k.186. www.victorianweb.org/authors/corelli/kuehn6.html; Millais 2, 1899, p.191.
4 'The Lesson of Millais', *Savoy*, 6 Oct. 1896, pp.57–8.
5 Shakespear 1898, p.148; Connors 2006, pp.114, 161. The comparison between Millais and Solomon was implicitly made by Symons in 1896, p.58, and explicitly in 1925. See Funnell in NPG 1999, p.14.
6 Shakespear 1898, p.76; Connors 2006, p.114.
7 See, for instance, Roy Strong, 'Down with Effie', *Spectator*, 20 Jan. 1967.
8 Sickert 1929, p.760.
9 Millais 2, 1899, pp.1–2.
10 Shakespear 1898, p.36; Connors 2006, pp.111–12.
11 Shakespear 1898, pp.75–6.
12 Trans. Alan Turney, London (1965) 1984 ed., pp.102–3.
13 *Daily Graphic*, 14 Aug. 1896.
14 See, for example, Ford Madox Brown's *Take Your Son, Sir!* (1851 and 1856–7), Hunt's *Il Dolce Far Niente* (1859–60) and *Lady of Shalott* (1866–1905). Millais includes the convex mirror in his study for *Mariana* (no.22), but omits this detail in the finished painting.
15 Cook 1898, p.19.
16 'To the Art Student', 29 May 1875, PML, J55.
17 Fried 1980, p.32; Hartley 2005, p.100.
18 *Academy*, 12 May 1877, p.421.
19 Undated poem, PML, MA 1485 J42. (See also J43, J68, J69).
20 Unpublished notes, PML, MA 1485 J39.
21 This theory appears in Hume's *A Treatise of Human Nature* (1739–40) and Smith's *Theory of Moral Sentiments* (1759).
22 Solicari 2007.
23 Lewis 1947, p.22.
24 *The Times*, 1 May 1875.
25 Spielmann 1898, p.118; *Athenaeum*, 2 May 1891, p.574.
26 Ruskin 5, p.205.

1 Pre-Raphaelitism pp.20–69

1 *Self-Portrait*
1 GRE Millais Colln. Repr. in Southampton 1996, p.42.
2 Bennett 1988, p.115.
3 J.E. Millais, Technical Notes (7 Cromwell Place), PML, D19.

2 *Bust of a Greek Warrior*
1 Warner 1985, p.174.
2 See letter from Martin Archer Shee to George Jones, 25 June 1840, quoted Lutyens 1972–4, p.3.
3 PML, J55, 'To the Art Student', 29 May 1875.

3 *The Danes Committing Barbarous Ravages [...]*
1 *Art Union*, April 1843, p.89.
2 Wildman 1995, p.76; Arts Council 1979, p.25.
3 *Art Union*, Nov. 1842, quoted Arts Council 1979, p.6.
4 These were published by the Art-Union in 1844 (Calloway 1975, p.30). See also Vaughan 1979, ch.4.
5 Calloway 1975, pp.33, 72.

5 *Pizarro Seizing the Inca of Peru*
1 Hunt 1, 1913, p.41.
2 Warner 1985, pp.33–4; Hamlyn 1993, p.36.
3 Kestner 1995, p.55.
4 Hunt 1, 1913, p.41.

6 *The Death of Romeo and Juliet*
1 Bennett 1967, p.48, fig.28; Vaughan 1979, pp.153–4, fig.85. In 1846 James Wyatt presented Millais with a copy of Retzsch's *Outlines to Shakespeare* (Leipzig 1836), which had inscribed on the front fly-leaf: 'John Everett Millais/ presented by Mr James Wyatt/ Oxford May 1st 1846' (collection of Stephen Calloway).
2 Hunt 1, 1913, pp.90–1.

7 *The Death of Romeo and Juliet*
1 Hunt 1, 1913, p.111.
2 Sotheby's, 7 June 2005 (2).
3 Millais 1, 1899, p.68.
4 Ibid. pp.120, 163.

9 *Isabella*
1 Hunt 1, 1913, p.122; *Illustrated London News*, 12 May 1849, p.305.
2 For a detailed decoding of the symbolic motifs see Warner in Tate 1984, pp.68–9; Bennett 1988, p.122.
3 Millais's copy of the Beatrix d'Este plate is in the Walker Art Gallery (see Bennett 1988, p.126). See also Spielmann 1898, pp.25, 85; Huntington 1992, p.4. Giovanni Bellini's portrait of *Doge Leonardo Loredan* (acquired by the National Gallery in 1844) could also be cited as another influence for the inscrutable expression, rich brocade and strong colour.
4 Spielmann 1898, p.84; Barlow 2005, p.12.
5 Calloway 1975, p.33.
6 Spielmann 1898, p.85.
7 *Athenaeum*, 2 June 1849, p.575.
8 Tate 1984, p.69; Bennett 1988, pp.122–3.
9 Barlow 2005, p.13; Codell 1991, p.55; Hartley 2005, ch.3.
10 Meier-Graefe 1908, p.190.

10–12 *Isabella (pen and ink); two studies for 'Isabella*
1 Hunt 1886, p.482; Hunt 1, 1913, p.98.
2 Grieve in Parris 1984, p.25.
3 Bennett 1988, p.119, 120 fig.48, p.121 fig.50.
4 The damask hanging that flattens the background was worked up from a carefully squared-up drawing (GRE Millais Colln, illustrated in Southampton 1996, p.86).
5 Wildman 1995, p.102.

13 *Garden Scene*
1 Millais 1, 1899, p.37.
2 Art Gallery of Western Australia, Perth (see Warner 1985, p.281). A related sketch for an etching intended for *The Germ* is in the British Museum. The other drawing in a private collection is reproduced in Arts Council 1979, p.21.
3 Ironside and Gere 1948, p.39.

14 *The Disentombment of Queen Matilda*
1 Strickland 1840, pp.118–20.
2 Arts Council 1979, pp.20–1. Edith, or Margaret of Scotland, not to be confused with Margaret of Flanders, was known for her acts of piety. Alastair Grieve has since suggested that the drawing represents *St Elizabeth Washing the Feet of Pilgrims*, Grieve in Parris 1984, p.26.
3 Thursday 17 May 1849, Fredeman 1975, p.3.
4 Letter dated 16 March 1869, GRE Millais Colln, 1/23.

15 *Ferdinand Lured by Ariel*
1 Nigel Gosling, 'Prodigy in Wonderland', *Observer*, 15 Jan. 1967.
2 Quoted in Tate 1984, p.74; *Art Journal*, June 1850, p.175.
3 Rossetti, 'At the Royal Academy', *The Critic*, 15 July 1850, p.360.
4 Hunt 2, 1913, p.331.
5 *PRB Journal*, 12 Jan. 1850, Fredeman 1975, p.42.

16 *The Eve of St Agnes*
1 Note on the back of the frame by Jeremy Maas.

17 *St Agnes of Intercession*
1 *The Germ* had been re-titled *Art and Poetry: Being Thoughts Towards Nature* after the Feb. issue.
2 Discussing Rossetti's poem *St Agnes of Intercession*, David A. Reide suggests that the woman's soul passes into the work of art as a result of having her portrait painted. See Riede 1992, p.112.
3 Two further impressions of the etching survive in the collections of the Yale Center for British Art and the V&A.
4 Tate 1984, pp.242–3.

18 *Study for 'A Baron Numbering His Vassals'*
1 Arts Council 1979, p.27.
2 Millais 1, 1899, p.59; Birmingham and London 2004, p.57. Letters in BMAG to J.R. Holliday from F.G. Stephens (4 Sept. 1906), Hunt (19 March 1907), and W.M. Rossetti (24 May 1907; 5 May 1911).

19 *Study for 'Christ in the House of His Parents'*
1 These studies, some of which may relate to Rossetti's poem *The Blessed Damozel* (1850), exist in Birmingham, and one is in the National Gallery of Ireland, Dublin. The open window to the left is another shared feature with *Mariana*. See Birmingham and London 2004, p.57 (B27–B29); Arts Council 1979, p.27.
2 Fredeman 1975, p.21.
3 Millais 1, 1899, p.78; Fredeman 1975, pp.30, 38.

20 *Christ in the House of His Parents*
1 *PRB Journal*, 21 July 1850, Fredeman 1975, p.71.
2 Engraved as Part 1 of *Die Vierzig Evangelischen Darstellungen aus dem Neuen Testament*, Vaughan 1979, p.223. There is the further possibility Millais could have seen this image at the Combes' house in Oxford.
3 *PRB Journal*, 29 Dec. 1849, Fredeman 1975, p.38; Hunt 1, 1913, p.142. For a full identification of the models see Warner in Tate 1984, p.78.
4 Millais 1, 1899, p.78; obituary of Noël Humphreys, *The Times*, 13 March 1923, p.16.
5 Hunt 1, 1913, p.142.
6 Nellor 1995, pp.13–15; *Builder*, 1 June 1850, p.256.
7 For a detailed analysis of the symbols see Warner in Tate 1984, p.78; Errington 1984, pp.250–62.
8 *Guardian*, 1 June 1850, p.396. See also letter from Francis E. Powell to the editor of the *Westminster Review*, 26 Sept. 1916.
9 Grieve 1969, pp.294–5; Morris 1970, pp.343–5; Hunt 1, 1913, p.137.
10 Dickens 1850, p.266.
11 *Art Journal*, June 1850, p.169.
12 Ruskin 4, pp.314–32, 'Of the Superhuman Ideal'.
13 *Illustrated London News*, 11 May 1850, p.336; *Punch*, 18 May 1850, p.198.
14 Spielmann 1898, p.101.

21 *Study for 'The Woodman's Daughter'*
1 Fredeman 1975, pp.5, 29.
2 Warner in Tate 1984, p.87.

22 *Study for 'Mariana'*
1 Grieve in Parris 1984, p.40.

23 *The Woodman's Daughter*
1 Hunt 1, 1913, p.137.
2 Fredeman 1975, p.27.
3 Ibid. 7 Dec., p.29.
4 See Polhemus 1994, pp.433–50; Werner 2005, pp.218–20.
5 Staley 2001, p.15.
6 Letter dated 28 Jan. 1851, Millais 1, 1899, p.97.
7 Hunt 1, 1913, p.197.
8 May 1851, Fredeman 1975, p.90.
9 *Guardian*, 14 May 1851, p.354; Patmore letter to F.G. Stephens, 30 Nov. 1885, British Library, quoted by Warner in Tate 1984, p.86.

24 *Mariana*
1 W.M. Rossetti, diary entry, Oct. 1850, Fredeman 1975, p.72.
2 The stained-glass figures were adapted from the window of the Annunciation at Merton College, Oxford.
3 Birmingham and London 2004, p.57, B27–B31.
4 *Art Journal*, June 1851, p.159.
5 Diary entry, 2 May 1851, Fredeman 1975, p.91; *Guardian*, 7 May 1851, p.331.
6 Sotheby's, 13 Dec. 2005 (21).

25 *The Return of the Dove to the Ark*
1 Letter from Millais to Mr Combe, 28 Jan. 1851; letter to Mrs Combe, 10 Feb. 1851, Millais 1, 1899, pp.97, 99.
2 Townsend 2004, p.126.
3 Warner in Tate 1984, pp.88–9; Millais 1, 1899, p.100. The frame was never executed.
4 Letter to Mrs Combe, 22 Nov. 1851, Millais 1, 1899, p.135; Errington 1984, p.291.
5 Fredeman 1975, pp.92–3: 8–10 May, 12 May (for Woolner's explanation that Ruskin's father wanted the picture), 13–15 May 1851; Ruskin 12, pp.325–6; xlviii.
6 Quoted Werner 2005, p.97. See also Gautier 1855, pp.36–7.
7 *Daily News*, 14 Aug. 1896; *People's Friend*, 5 May 1891, p.629.

26 *The Eve of the Deluge*
1 Millais 1, 1899, p.105.
2 Fredeman 1975, p.86; Millais 1, 1899, pp.91, 97.
3 Millais to Mrs Combe 28[?] 1851 in Millais 1, 1899, pp.103–4.
4 Millais 1, 1899, pp.162, p.172; Lutyens 1967, pp.93, 110; quoted Warner in Tate 1984, p.252.

27 *The Bridesmaid*
1 *PRB Journal*, 9 Feb. 1851, Fredeman 1975, p.91.
2 Millais 1, 1899, p.94; Baker 1974, pp.9–10.
3 I am grateful to Carol Jacobi for this suggestion.
4 *Vanity Fair*, 1847 (1920, p.120). The motif of the orange blossom corsage may have been suggested by the brooches Queen Victoria gave her daughters for their weddings, based on her own drawing of the spray (I am grateful to Charlotte Gere for this information). See also Gere and Munn 1989, pp.52–3.

28 *St Agnes' Eve*
1 The sketch for this painting is in the collection of Birmingham Art Gallery, see Goldman 2004, p.58. See also Staley 1995, pp.73–4.
2 Lutyens 1967, pp.147–8.
3 The illustration in *Little Songs for Me to Sing* was probably engraved by Ahyer. Goldman 2005, p.51.

29 *Portrait of a Gentleman [...]*
1 Tate 1984, p.81
2 Spielmann 1898, p.88.
3 Fredeman 1975, p.42.

30 *Mrs James Wyatt Jr and her Daughter Sarah*
1 Warner 1985, p.51.
2 Such parodies exist in Birmingham and Bolton; Ashmolean 1941, p.2.
3 Warner in Tate 1984, p.82.

31 *Wilkie Collins*
1 Hunt 2, 1913, p.143; Birmingham and London 2004, pp.9, 27.
2 2 Sept. 1894, quoted RA and Liverpool 1967, p.29; Hunt 1, 1913, p.220; Hunt 2, 1913, p.143.

32 *Thomas Combe*
1 Ashmolean 1909, p.12; Lane Poole 1912, vol.1, p.198.
2 Letter from Michael Maclagan FSA, College of Arms, to Jon Whiteley, 29 March[?], Ashmolean Museum; Warner in NPG 1999, p.73.

33 *Charles Allston Collins*
1 Hunt 1, 1913, p.192; letter dated '– 28, 1851', Millais 1, 1899, p.103.
2 Hunt 1, 1913, p.220.

34 *Emily Patmore*
1 www.victorianweb.org/authors/patmore/ eron5.html
2 Champneys 1900, vol.2, p.269.
3 Hunt 1, 1913, pp.191–2. There are clear signs of cracking in the background.
4 F.G. Stephens correspondence, Bodleian Library, quoted in NPG 1999, p.78.

35 *William Holman Hunt, John Everett Millais*
1 Hunt 1, 1913, pp.55–6.
2 Lutyens 1967, p.99; Gere and Munn 1989, pp.58, 62.

36 *William Holman Hunt*
1 Millais to Thomas Combe, 26 Dec. 1853, Millais 1, 1899, p.221; letter dated [12] Jan. 1854, ibid. p.226.

37 *Ophelia*
1 Gautier 1855, p.38.
2 Webb 1997, p.15.
3 W.M. Rossetti, quoted in Werner 2005, p.94.
4 Millais 1, 1899, p.123; Webb 1997, p.37. For a detailed explanation of the flower symbolism see Warner in Tate 1984, pp.96–7; Washington 1996, p.68.
5 *Punch*, 22 May 1852, p.216.

2 Romance and Modern Genre pp.70–127
1 Millais 1, 1899, p.148.
2 Collins 1980, 'letter of dedication'.
3 *Athenaeum*, 10 May 1856, pp.589–90.
4 See entries in Ford Madox Brown's diary, 2 and 12 May 1855, Surtees 1981, pp.135–6.
5 Ruskin 12, pp.359–61.

Millais in Scotland
1 For thorough discussions of the portrait and its inception see Lutyens 1967; Staley 2001, pp.57–62; Warner in Tate 1984, pp.115–17; Alastair Grieve, 'Ruskin and Millais at Glenfinlas', *Burlington Magazine*, April 1996; Warner in NPG 1999, pp.83–100; Tate 2004, pp.145–7.

38 *John Ruskin*
1 See RA and Liverpool 1967, pp.36–7; Lutyens 1967; Tate 1984, pp.115–17; NPG 1999, pp.90–1; Prettejohn 2000, pp.168–71; Tate 2000, p.25; Tate 2004, pp.145–6; Mary Lutyens, 'Millais's Portrait of Ruskin', *Apollo*, April 1967, vol.85, no.62, pp.246–53; Alastair Grieve, 'Ruskin and Millais at Glenfinlas', *Burlington*, April 1996, pp.228–34; and Staley 2001, pp.57–63.
2 Quoted by Warner in Tate 1984, p.115.
3 In the collection of the Ruskin Foundation in Lancaster. Warner in NPG 1999, p.83, repr. p.81. Thomas Woolner thought it made Ruskin look somewhat demented.
4 Ruskin was delighted with the likeness in this drawing. Lutyens 1967, p.130.
5 Ibid. p.150.

39 *The Order of Release, 1746*
1 For example, in *'The Love of James the First, of Scotland'* 1859 (Private Collection), *'Charlie is my darling' – Jacobite Song* 1864 (Private Collection), and subjects from Walter Scott, *Effie Deans* 1877 (Private Collection) and *The Bride of Lammermoor* 1877-8 (Bristol Art Gallery).
2 To show unity with Millais's art, Ruskin allowed her to sit for the picture, as it was something more typically outside normal social practice. See Warrell in Tate 2000, p.206.
3 Bowerswell Papers, PML, MA.1338, R.13, Effie to Mrs Gray, dated Herne Hill, 3 May 1853. This was not the first time Effie had been represented at the Royal Academy. Portraits of her by G.F. Watts and by Thomas Richmond commissioned by John James Ruskin were exhibited there in 1851. See Mary Lutyens, 'Portraits of Effie', *Apollo*, March 1968, vol.87, no.73, pp.190-7.
4 Warrell in Tate 2000, p.206; Tromans 2002, p.89.
5 RA and Liverpool 1967, p.35 and Warner in Tate 1984, p.109. Effie was not his first choice; sketches show the model may have been Anne Ryan, who posed for *The Proscribed Royalist, 1651* (no.58).
6 Hubert Wellington (ed.), *The Journal of Eugène Delacroix*, trans. Lucy Norton, Ithaca 1980, p.280.
7 Delacroix was moved by Millais's realism, and may have sensed the limitations of his own Romantic version of *The Death of Ophelia* 1853, with its bare-chested partly submerged heroine clinging awkwardly to a branch. The painting is in the Louvre.
8 It was published in May in an edition of 475 artist's proofs (9-8-0), 25 presentation proofs, 375 proofs before letters (4-4-0), and 75 lettered proofs (2-2-0), with an unspecified number of common prints. Two months later David Thomas White published Thomas Oldham Barlow's engraving after *A Huguenot* with exactly the same number of proofs and with the same price scale. *An Alphabetical List of Engravings Declared at the Office of the Printsellers' Association, London, Since Its Establishment in 1847 to the End of 1891, Compiled by the Secretary, G.W. Friend*, London 1892, p.175.
9 Warner in Tate 1984, pp.108–10. The watercolour of 1863 sold at Christie's, 10 June 1999 (43).

40 *William Henry Millais, Glenfinlas*
1 Millais 1, 1899, p.14.
2 Description from the *Athenaeum*'s review of William Henry Millais's *The Rookery, Worcester Park Farm, Surrey*, exh.RA 1852. 'Royal Academy', *Athenaeum*, 22 May 1852, p.582. It is similar, however, to Millais's smaller oil sketch of *Waterfall at Glenfinlas*, with Effie shown seated stitching on rocks (fig.10, p.74).

41 *Effie Ruskin*
1 Pencil copy (Private Collection, repr. Nahum 2005, p.30). See other images of her in this same linsey-wolsey cloak. See NPG 1999, pp.84–9.
2 At one point Millais planned to send this picture to the Royal Academy as a deposit for a future diploma work submission: 'I discovered at the Council that I can get away the Evil one [*The Parable of the Tares*, no.91] by sending anything as a deposit so I will send yr little portrait sewing the red velvet, & get the picture home.' PML, MA.1485.A, Millais to Effie, dated 7 Cromwell Place, 4 Aug. 1865.

42 *Sketches of 'Natural Ornament'*
1 Reproduced in Lutyens and Warner 1983.
2 Ruskin 7, p.359.
3 HL HH370, quoted Gamon 1991, p.204; letter from Ruskin to his father, 2 Aug. 1853, quoted Lutyens 1967, p.75.
4 Conversation with author, 12 June 2006. See also Lutyens 1972, pp.166, 169; Lutyens 1965, pp.77, 212, 240, 254, 267, 277.
5 HL HH 372, quoted Gamon 1991, pp.210–11.
6 See designs for stained glass windows, Prints and Drawings Collection, Courtauld Institute (repr. in Arts Council 1979, p.12); *Design for a Gothic Window* (repr. RA 2003, p.48); Tate 2000 (86).

43 *Tear Him to Pieces (Foxhunting)*
1 Millais 1, 1899, p.262.
2 Ibid. p.265.
3 Bowerswell Papers, PML, MA. 1338/S.27.
4 Letter from Millais to Leech, 27 Sept.1853, TGA 20027/1.
5 Letter from Millais to Leech, 17 Oct. 1853, TGA 20027/2. For Millais's comic drawings that were reproduced in *Punch*, see Arts Council 1979, p.24 n.27.
6 TGA 20027/12. Leech's son John was born in Aug. 1855.

44 *Awful Protection Against Midges*
1 Lutyens and Warner 1983.
2 Halliday died while Millais was in Budleigh Salterton painting *The Boyhood of Raleigh* (no.94), and he was grieved not to be able to make it back for the funeral.
3 Effie to Rawdon Brown, Annat Lodge, Perth, 18 Nov. [1856], PML, MA.1338.
4 JEM to CAC, Jedboro', Scotland, [?]1 July 1853, PML, MA.1338/S.1.
5 JEM to CAC, Mr Stewart Teacher Brig of Turk Callander Perthshire [*sic*] [17 Aug. 1853], PML, MA.1338/S.15.

45 *My Feet Ought to be Against the Wall*
1 NPG 1999, p.94.
2 PML, MA.1338/S.6, dated 'Mr. Alex Stewart, Teacher Brig of Turk/nr. Callander N.B.'.
3 PML, MA.1338/S.7, dated 'Mr. Alex Stewart/Teacher/Bridge of Turk/near Callander/Sunday 10th July 1853'.
4 Millais 1, 1899, p.91.

Drawings from Modern Life
1 Millais 1, 1899, p.490.

46–48 *Married for Rank [...]*
1 Warner in Tate 1984, p.262.

49 *Accepted*
1 Warner in Tate 1984, p.260.

51 *The Blind Man*
1 Werner 2005, pp.64–5; article signed 'Laura Savage', *The Germ*, no.4. May 1850, (1979) Oxford 1992 ed., p.170.

52 *The Dying Man*
1 Millais 1, 1899, p.340; Warner in Tate 1984, p.263.
2 Letter dated 30 Dec. 1853, Millais 1, 1899, p.225.
3 Letter dated 3 Feb. 1854, ibid. p.226.

53 *The Race Meeting*
1 Houfe 1984, pp.126–7.
2 Millais to Charles Collins, 31 May 1853, PML Bowerswell Papers, MA.1338/R.25.

54 *Sketch for 'The Prisoner's Wife'*
1 Millais 2, 1899, p.490; Millais 1, 1899, p.231.
2 Illustrated in Birmingham and London 2004, p.59 (B78).

55 *A Ghost Appearing at a Wedding Ceremony*
1 For an alternative explanation of the drawing, that it is a symbolic interpretation of Effie Gray's marriage to John Ruskin, see Evans 1950, p.201.

56 *Retribution*
1 Birmingham and London 2004, pp.34, 41.

Romance and Modern Genre
57 *A Huguenot [...]*
1 Millais to Mrs Combe, 22 Nov. 1851, Millais 1, 1899, p.135.
2 C. Jacobi, 'Revealed: British Art's Great Wall of Surrey [...]', *Cornerstone*, vol.26, no.4, 2005, p.17.
3 Hunt 1, 1913, pp.203, 207–10; Millais 1, 1899, pp.136–8. Millais was lucky in having his picture promoted through an anonymous engraving published in the *Illustrated London News* at the same time Meyerbeer's opera was performed in London. See *Illustrated London News*, 8 May 1852, p.368; 15 May 1852, p.398.
4 Millais 1, 1899, pp.130–1, 136–8.

58 *The Proscribed Royalist, 1651*
1 Millais 1, 1899, p.166; www.arborecology.co.uk/article_ancienttree.htm
2 J.F. Boyes, 'The Private Art Collections of London: Sir John Pender's, in Arlington Street', *Art Journal*, June 1892, p.164.
3 Engraved by W.H. Simmons and published jointly by Gambart and Henry Graves in 1858.

59 *Waiting*
1 JEM to CAC, PML, MA.1338, u-v.76.
2 It was called *The Stile* in an article on Joseph Arden's collection in the *Art Journal* 1857, p.310; Spielmann 1898, p.163.
3 Letter from Millais to Effie, 28 July 1854 (GRE Millais Colln), Wortley 1938, vol.3, p.183.

60 *The Violet's Message*
1 Lutyens 1967, p.159.
2 NPG 1999, p.99.
3 Letter dated 10 April, Huntington Library, cited in ibid. p.99.

61 *L'Enfant du Régiment*
1 Barlow 2005, p.59; James 1948, p.204.
2 *Art Journal*, June 1856, p.172; *Athenaeum*, 10 May 1856, pp.589–90.
3 *Athenaeum*, 10 May 1856, pp.589–90.

62 *The Blind Girl*
1 Hunt 1, 1913, p.243.
2 Phythian 1911, p.64.
3 Surtees 1981, p.169; Millais to Charles Collins, 29 April 1856, Millais 1, 1899, p.296.
4 Millais repainted the colours of the complementary rainbow in reverse when the original pattern was declared inaccurate by a correspondent in the *Art Journal*, Aug. 1856, p.236.
5 Rossetti 1867, p.219; Spielmann 1898, p.31. See also Sitwell 1937, p.9.
6 Letters to Effie, PML, 10 April 1856.
7 Sickert 1929, p.758; Herkomer to Millais, 5 April 1893, quoted in Millais 1, 1899, pp.242–3.

63 *The Rescue*
1 Spielmann 1898, p.75; Millais 1, 1899, pp.247–8.
2 'The Fire Brigade of London', *Household Words*, 11 May 1850, pp.145–51.
3 Walker 2004, p.57; Cooper 1986, p.473; Millais 1, 1899, p.248.
4 *Spectator*, 26 May 1855, p.554.
5 Tate 1984, p.133; Warner 1985, p.93 for Thackeray's recommendation that Arden purchase the painting as a pendant to *The Order of Release*.
6 Millais 1, 1899, pp.250–1.
7 Barwell quoted in ibid. p.250; undated letter sold Sotheby's, 19 Dec. 2000 (42).

8 Letter to Hunt dated 22 May 1855, quoted in James 1948, p.247.
9 *Art Journal*, Aug. 1855, p.238; Ruskin 14, p.22; *The Times*, 7 May 1855, p.10; letter signed Chroma, *Art Journal*, July 1855, pp.211–12.

64 *Wandering Thoughts*
1 Diary entry for 6 March 1855, Surtees 1981, p.125.

65 *Only a Lock of Hair*
1 Collins 1980, pp.142–3.

66 *Peace Concluded, 1856*
1 The soldier was described thus in RA 1898, p.9; Millais 1, 1899, p.290.
2 Hancher 1991, pp.504–5.
3 For Millais's reading of *The Newcomes* see Lutyens 1967, p.107; letter from Millais to John Leech, 2 Sept. 1855, TGA.
4 BM 1994, nos.45, 46, pp.72–4. For Millais's references to the Crimean War see Lutyens 1967, pp.89, 90, 173; Millais 1, 1899, p.295.
5 Letter from Millais to John Miller, 1 July 1858, RA Archive.
6 Millais's other Crimean subject *News from Home* exh.RA 1857 (Walters Art Museum, Baltimore), is also a private moment but set in the Crimea itself.
7 Hunt 2, 1913, p.80; Surtees 1981, p.168 (diary entry 11 April 1856).
8 G.F. Watts's drawing of Effie aged eighteen shows her wearing her hair in a similar fashion. The drawing is reproduced as the frontispiece to Millais 2, 1899, and in James 1948 opposite p.66. Significantly Ruskin thought the work surpassed that of Titian, Ruskin 14, pp.56–7.
9 Egg to Miller, 5 April 1856, RA Archive. See also Millais to Effie, 15 April or May 1856, PML, MA.1485/A. Millais to Effie, 8 May 1856, PML, section A. See also Lalumia 1984, pp.94–5; Hichberger 1988, p.137.

67 *The Escape of a Heretic, 1559*
1 Millais 1, 1899, pp.319–20. William Stirling of Keir House, Dunblane, was MP for Perthshire from 1852 to 1868. In 1852 he had published *The Cloistered Life of Charles V*. In 1865 he succeeded his uncle, Sir John Maxwell, Bt., and assumed the additional surname of Maxwell. See Lutyens 1967, p.47n.
2 *Athenaeum*, 9 May 1857, p.603. For similar charges of obscurity and exaggeration see Ruskin 14, pp.110–11; *Art Journal*, June 1857, p.165.
3 Barlow 2005, p.82; Forbes 1975, pp.149–50.

68 *The Black Brunswicker*
1 Letter dated 17 May 1859, quoted in Millais 1, 1899, p.348.
2 Ibid. p.356. According to a letter sent to the Tate Gallery from Margaret Ruston on 5 Aug. 1960, the model for the officer was Sydney Smith, Jr., son of Sydney Smith RA.
3 Letter dated 18 Nov. 1859, ibid. p.350. The sketch in the Ashmolean presenting the figures as they are positioned in *A Huguenot* is reproduced in Bennett 1988, p.147.
4 *Art Journal*, June 1860, p.162. The title is singular in the RA catalogue, but plural in the *Art Journal*.
5 *The Times*, 5 May 1860, p.5.
6 *Art Journal*, June 1860, p.162; *Blackwoods Edinburgh Magazine*, July 1860, p.79; *Illustrated London News*, 12 May 1860, p.458; *The Times*, ibid.
7 Prettejohn 1991 p.108.
8 *Evening Telegraph*, 1874 or 1875, album of press cuttings loosely inserted, GRE Millais Colln.
9 The watercolour copies were made in 1863 and 1867 and are probably those now in the Whitworth and British Museum. Rosenfeld in Staley 1995, p.24.

69 *The Ransom*
1 Millais 1, 1899, p.365; Butler 1922, p.11.
2 Millais 1, 1899, p.365. Letter from Millais to Stirling, in which the artist proposes to visit Keir House to look at some woodcuts in a large book of costume for his picture set in the early sixteenth century. Stirling Maxwell of Pollok Records, Glasgow City Archives and Special Collections T-SK 29/10/151. I am grateful to David Howarth for this reference.
3 *Art Journal*, June 1862, p.129.
4 Barlow 2005, pp.98–100.
5 Letter to Effie, 18 April 1859, Millais 1, 1899, p.340.
6 Accounts book, PML.
7 Letters to Effie: 27 and 28 May 1861, Millais 1, 1899, pp.362–3.

70 *The Young Mother*
1 Millais often portrayed his children in his work, especially in his engravings. *Happy Springtime* may show Effie holding their eldest daughter Effie Gray Millais. Two other etchings produced in 1872, *Going to the Park* and *The Baby House*, are portraits of Millais's third and fourth daughters, Alice Sophia Caroline and Sophia Margaret Jameson. See Goldman 2005, pp.46, 49.
2 Birmingham and London 2004, p.30.
3 NAL, MSL/1998/5/1/11. Millais to Emily P. Hodgkinson dated Annat Lodge Perth NB./June 2.56.
4 For further information on the Etching Club see Chambers 1999.
5 Etching Club Minutes, NAL Ms.
6 The Art-Union was founded in 1837 as a means of securing art patronage from the middle classes. Members were asked to pay annual membership fees to be spent on contemporary art, which was then redistributed among the membership by lot.
7 The book was brought out in an edition of five hundred, the majority of copies being distributed to Art-Union subscribers. The book generated a profit of £524.10s.9d., which was divided among Club members. See Chambers 1999, p.199.

71 *The Moxon Tennyson*
1 Ruskin 15, 1903–12, p.224.
2 Munro 1996, p.3. Ruskin later confirmed Tennyson's fears over the Moxon Tennyson and wrote to him, 'the plates are very noble things, though not, it seems to me, illustrations of your poems.' Ruskin 36, p.264.
3 G.H. Fleming, *That ne'er shall meet again: Rossetti, Millais, Hunt*, London 1971, p.83.
4 Warner 1985, p.130.

72 *A Dream of Fair Women: Cleopatra*
1 The other shows Queen Eleanor sucking the poisoned wound of Edward I.
2 Lewis in Watson 1997, p.179.

73 *Locksley Hall*
1 There are a number of corrected proofs and woodblocks for the Moxon Tennyson in the Harold Hartley (1851–1943) collection at the Museum of Fine Arts, Boston.
2 Dalziel 1901, pp.84–5.

74 *The Bridge of Sighs*
1 The bridge was built between 1811 and 1817.

76 *A Lost Love*
1 Goldman 2005, p.23.
2 Warner 1985, p.96.

77 *Love*
1 Willmott (1809–63), who was ordained priest in 1843, was well known for his literary work, which included *A Journal of Summer-time in the Country* (1849) and *Lives of Sacred Poets* (1834). *Poets* was considered a drawing-room book: 'handsome, proper and edifying', *Blackwood's Magazine*, March 1857, p.316.
2 Rossetti wrote to William Allingham of these drawings: 'How truly glorious are Millais's drawings! – among his very finest doings, I think, and preferable to any I have yet seen by him in the Tennyson!', Millais 1, 1899, p.310.
3 *Blackwood's Edinburgh Magazine*, March 1857, pp.315–16.
4 Warner 1985, p.130.
5 For reference see Goldman 2005, p.49.

78 *The Border Witch*
1 May eventually succumbs to the witch's curse and dies of consumption, leaving Johnston 'heartbroken and repining'.

79 *Orley Farm*
1 High-resolution images of Millais's illustrations for Trollope's *Orley Farm* are accessible on the 'Database of Mid-Victorian Wood-Engraved Illustration', produced by Cardiff University, www.dmvi.cf.ac.uk
2 Sadleir 1961, p.386.
3 For the illustration, 'Was it not a lie', Millais went too far for Trollope's liking, and Trollope wrote to the publisher, George Smith, 'It is such a burlesque on such a situation as might do for *Punch*, only that the execution is too bad to have passed muster for that public,' Pantazi 1976, p.48. However he later admitted to having seen 'the *very pattern of that dress* some time after the picture came out', Hall 1, 1983, p.111.
4 Quoted in Hall 1980, p.27.
5 Often called Julians, Julian Hill was owned by the Trollope Family until it was seized by the bailiffs in April 1834 and the family fled to Bruges.
6 Tate 2004, p.195.
7 Hall 2, 1983, p.856.
8 Millais did, however, later illustrate the frontispiece for his 1882 novel, *Kept in the Dark*.

80 *Guilty, Orley Farm*
1 From 1863, however, it became more common for the Dalziels to transfer the design photographically on to another block, which would then be cut.
2 Lutyens 1972–4, vol.44, p.42.

81 *Parables of Our Lord*
1 Quoted in Lutyens 1975, p.xxi.
2 Dalziel 1901, p.94.
3 *Athenaeum*, no.1867, 26 Dec. 1863, p.882.
4 Lutyens 1975, p.xix.
5 Staley 1995, p.75.

3 Aestheticism pp.128–147

1 See Chronology for details of these works.

82 *Autumn Leaves*
1 The figure is not included in the simplified wood engraving after the picture in the *Illustrated London News* of 30 Aug. 1856, p.230 (Henry Linton after a drawing by J. Beech with Millais providing a sketch of the heads), but does appear in Henry Macbeth-Raeburn's more finished etching of the picture, seen in the *Magazine of Art*, Nov. 1856. Tate 1984, p.141.
2 Quoted in Tate 1984, p.141. Both Mathilda and Isabella posed for *The Blind Girl* (no.62) and the latter for *L'Enfant du Régiment* (no.61).
3 Washington 1996, p.73.
4 Ibid. He also chose not to attach any poetic quotation to *The Blind Girl*. PML, MA.1338/ X-Y-Z/C.2 Millais to Mr. Gray, dated 'Langham Chambers,/ Langham Place/ April 11. 56'.
5 Ibid.

6 'Fine Arts: Royal Academy', *Athenaeum*, 10 May 1856, pp.589–90.
7 PML, MA.1338/X-Y-Z/B.9 dated, Annat Lodge, Perth, N.B./ Sunday [Autumn 1855], see Warner in Parris 1984, pp.137–8.
8 Hunt 1, 1905, p.286.
9 Quoted in Parris 1984, p.128.
10 Suggested in Tate 1973, p.134.
11 Malcolm Warner discusses the idea of nostalgia in Millais's child portraits in NPG 1999, pp.105–25.
12 'Exhibition of the Royal Academy – Private View', *The Times*, 3 May 1856, pp.9–10, quoted from www.engl.duq.edu/servus/PR_Critic/ LT3may56.html
13 Ruskin 14, pp.56–7.
14 PML, MA.1485/C.8, Millais to James Eden, Annat Lodge Perth NB/ May 12, 1856. Miller was an important early patron of the artist, owning *The Kingfisher's Haunt* (destroyed), *Wedding Cards: Jilted* (Private Collection) and *The Blind Girl*. He lent *Autumn Leaves* to the Art Treasures Exhibition in Manchester in 1857, a show of support that Millais much appreciated (Letter to ?William Michael Rossetti, MS. Facs.c.93 folio 94 [photocopy from University of British Columbia], dated Perth, 29 July '57).
15 Surtees 1971, no.343. Leathart had *Autumn Leaves* by 1862, when he loaned it to the *London International Exhibition* at South Kensington. Rossetti painted it at William Bell Scott's house at 14 St Thomas Crescent, Newcastle. Rossetti saw *Autumn Leaves* in Millais's studio and 'was AGHAST with admiration, saying he wd rather have the Autumn leaves than *any picture* he ever saw.' PML, MA.1485 Millais to Effie, dated Langham Chambers Langham Place/ Monday morning [8 April 1856].

83 *Sophie Gray*
1 Peter Nahum and Sally Burgess, *Pre-Raphaelite, Symbolist, Visionary*, London 2001, pp.18–19.
2 The heart and stitched border above it is identical to that on the cuff of the left sleeve in *The Escape of a Heretic, 1559* (no.67) of this same year. Sophie appears to have been the model for the heretic.
3 Private Collection, NPG 1999 (no.37).
4 GRE Millais Colln, NPG 1999 (no.53).
5 Tate 1997 (no.2).
6 Boyce purchased the portrait of Alice for his sister, the painter Joanna Mary Boyce (1831–61).

84 *Spring*
1 They were initially the same size, but canvas was added to the bottom of *Spring* while it was being painted. Bennett 1988, pp.140–1.
2 *Sir Isumbras (A Dream of the Past)* (fig.5, p.18) was begun at the same time and is only slightly larger than *Spring*.
3 Bennett 1988, pp.137–44; Warner in Tate 1984, pp.171–3.
4 Ruskin 14, p.214.
5 'Fine Arts: Royal Academy', *Athenaeum*, 7 May 1859, p.618.
6 Ibid. 30 Apr. 1859, p.586.
7 Millais 1, 1899, p.324.
8 This was adapted in 1861 for *Summer Indolence*, an etching, as an example of the artist's common practice of using designs across media. *Passages from Modern English Poets Illustrated by the Junior Etching Club*, 1862, pl.10, repr. in Suriano 2000, p.162. The pose is also similar to the reclining figure in Millais's illustration to *The Parable of the Ten Virgins* from Dalziel's *Parables*.
9 Warner in Tate 1984, pp.171–2.
10 Millais 1, 1899, p.327. 'Fine Arts: Exhibition of the Royal Academy. II', *Spectator*, 21 May 1859, p.544.

11 This was opposed to the two figures on the far left seen as bearing an 'almost Hottentot repulsiveness' in a racist reference to southern Africans, *The Times*, 30 April 1859, p.12, quoted in Bennett 1988, p.140.
12 Bennett 1988, p.138. See 'Fine Arts: Exhibition of the Royal Academy, II', *Spectator*, 21 May 1859, p.544, a slight defence of Millais against Ruskin's criticism.
13 Exhibited in the Paris Salon of 1865. Sold at Christie's London, 30 Nov. 1984 (93). See Bennett 1988, p.142.
14 Millais 1, 1899, p.323.
15 PML, MA.1485, dated 7 April '59.

85 *The Vale of Rest*
1 See Warner in Tate 1984, pp.175–6, Prettejohn 2000, pp.249–51, and Millais 1, 1899, pp.328–33. According to *The Academy*, 10 April 1886, p.262, this was inspired by 'a scene beheld by the artist, we have been told, as he was driving through France', although Effie said it was prompted by a memory from their honeymoon in Western Scotland, pp.328–9. Effie and John did not visit France together until June 1859.
2 Effie would later be buried there, as well as their second son George. See *Kinnoull: A History of the Parish Cemetery*, Perth, Scotland, 1991.
3 Tate 1984, p.175.
4 See Casteras in Huntington 1992, pp.13–35.
5 Ruskin 14, pp.212–14. In Ruskin's judgement, the apparent crudeness of Millais's execution would have enhanced the meaning of this dire subject if the crudeness had been a result of Millais's intellectual conception of the picture, instead of being 'in apparent consistency of decline from the artist's earlier ways of labour'.
6 Millais 1, 1899, p.342.
7 Lyrics by Johann Ludwig Uhland from *Sechs Lieder*, Opus 59, no.5, [6 Partsongs for mixed voices, 'Im Grünen', 1843]. Millais 1, 1899, p.336 and Tate 1984, p.176. *The Vale of Rest* was also often used as the English title of a song from Act 2 of the Giacomo Meyerbeer opera, *Les Huguenots*: 'Giovin belta su questa riva' (Vale of rest), a piece that was familiar to Millais (*A Huguenot*, no.57).
8 Bennett 1988, p.140, and *From Realism to Symbolism: Whistler and His World*, New York 1971, p.104. See also Alastair Grieve, 'Whistler and the Pre-Raphaelites', *Art Quarterly*, summer 1971, pp.219–28.
9 Spielmann 1898, pp.31–2, 72–4.

86 *Meditation*
1 She was the younger of two sisters who would sit for a number of Millais's pictures in this period, including *Departure of the Crusaders (Crusaders family)* c.1857–8 (Oldham Art Gallery), and possibly *The Bridesmaid*, although this resembles her sister Fannie, 1859 (Private Collection), repr. *Apollo*, Feb. 1948, cover, and 'John Kenneby and Miriam Dockwrath', an illustration to *Orley Farm*, vol.2, 1862.
2 PML, MA.1485, A, dated L[angham] Chambers Friday [Nov. 25, 1859]. See Tom Taylor, 'Cabinet Pictures, Sketches, and Drawings', *The Times*, 24 Nov. 1859, p.9.
3 Millais 1, 1899, p.349. The *Athenaeum* critic mistook the model in *Meditation* for one of the girls in *Autumn Leaves*, revealing how consistent Millais was in developing a new idea of female beauty in his pictures of this period. See George Walter Thornbury [?], 'Fine Arts: The Winter Exhibition', *Athenaeum*, 19 Nov. 1859, pp.672–3.
4 Formerly Forbes Collection, sold Christie's, 19 Feb. 2003 (91).
5 For Sandys's picture see Tate 1984, pp.176–7. For *Bocca Baciata* see Paul Spencer-Longhurst, *The Blue Bower: Rossetti in the 1860s*, exh. cat., London 2000, and Prettejohn 2000, pp.108–9.

87 *'Oh! that a dream so sweet [...]'*
1 Peter Nahum and Sally Burgess, www.leicestergalleries.com/ provenart/ dealer_stock_details.cgi?d_id=253&a_ id=13411. J.G. Millais notes a watercolour *Illustration for Moore's 'Lalla Rookh'* by his father (no date, unlocated), writing 'This is the largest watercolour Millais ever did. Highly finished.' Millais 2, 1899, p.488.
2 In addition to Schumann (1843) and Offenbach (1868), the work was also been arranged by Sir William Sterndale Bennett (opus 42) in 1862, whose portrait Millais exhibited at the same Royal Academy as *'Oh! that a dream so sweet [...]'* (Private Collection).
3 Moore's writings inspired the title of a later image of his closest daughter, Mary, of 1888, *The Last Rose of Summer* (GRE Millais Colln). Hunt had used another of Moore's ballads, 'Oft in the Stilly Night' for the sheet music on the piano in his *The Awakening Conscience* 1854, revealing Pre-Raphaelite awareness of his work.
4 Quotation from 'The Royal Academy Exhibition', *Illustrated London News*, 10 May 1873, p.447. The vegetative design is similar to that on the wife's garment in *Peace Concluded, 1856* (no.66), and is also perhaps a reference to that same Aestheticist device used by Albert Moore in his paintings in lieu of his signature from 1866.
5 Spielmann 1898, p.158.

88 *The Eve of St Agnes*
1 On the furnishings of the King's Room, see Christopher Rowell, 'The King's Bed and its Furniture at Knole', *Apollo*, vol.160, Nov. 2004, pp.58–65.
2 The two other pictures were *My First Sermon* (Guildhall, London) and *The Wolf's Den* (unlocated). PML, Bowerswell Papers, I-J.1, dated 5 Cromwell Place/ 11th March [1863]. Cited in Warner in Tate 1984, p.200.
3 Ibid. p.199.
4 'Des tableaux de Millais, la "Veillée de sainte Agnès" d'un vert argenté si lunaire', J.-K. Huysmans, *À Rebours*, Paris (1884), 1978 ed., p.168.
5 Ernest Chesneau, *The English School of Painting*, trans. Lucy N. Etherington, London 1891, p.219.
6 *Art Journal*, May 1867, p.131.
7 Millais 1, 1899, p.374.
8 It hangs in the living room of Clarence House. There is also a large sketch for the female figure in oil, watercolour and chalk on paper, purchased for the collection in 1977.

89 *'Leisure Hours'*
1 NPG 1999, pp.128–9. See also Young 1980, pp.118–26.
2 Warner in Tate 1984, pp.202–3; NPG 1999, pp.128–9; Macleod 1996, pp.459–60. Anita McConnell, 'Sir John Pender (1816–1896)', *Oxford Dictionary of National Biography*, 2004, vol.43, pp.518–19.
3 Also by Millais at the RA that year were *Harold Heneage Finch-Hatton* (Winchelsea Settled Estate), *Lilly Noble* (Private Collection) and *My Second Sermon* (Guildhall Art Library).
4 NPG 1999, pp.112–13.
5 This title was also used in the poetry collection of Maria Jane Jewsbury, *Lays of Leisure Hours* (1829). It often served as the title for piano duets in sheet-music publications. The phrase was also used by Lady Emmeline Charlotte Elizabeth Stuart-Wortley for a publication of 1838. She was the aunt of Charles Stuart-Wortley, who would eventually marry Millais's daughter Carrie. *Thoughts Redeemed; or, Lays of Leisure Hours* (1854) was a publication of hymns and poems by Margaret Mackay.

6 They wear velvet dresses with short puffed and slashed sleeves, a puffed-up overskirt and underskirts of horizontal rows of small pleats, characteristic elements of formal or party attire in the 1860s.
7 J.F. Boyes, 'The Private Art Collections of London: Sir John Pender's, in Arlington Street', *Art Journal*, June 1892, pp.161–8.

90 *Sisters*
1 Rossetti and Swinburne 1868, p.32.
2 Hunt 2, 1905, p.398.
3 Grosvenor 1886, pp.44–5, and Rossetti and Swinburne 1868, pp.2–3.
4 Rossetti and Swinburne 1868, p.53.
5 In Millais's time expressions of doting and loving fatherhood were masked within ostensibly professional activities. A good comparison is Charles Darwin's *Biographical Sketch of an Infant* (1877), an ostensibly scientific biography of an infant, but one that clearly reveals the evolutionist's pleasure in observing his eldest child, Doddy.
6 Robert Rosenblum and H.W. Janson, *19th-Century Art*, revised ed. 2004, p.393.

4 The Grand Tradition pp.148–169

1 Hamerton 1864, p.259.
2 See the description of Millais's working process in Rossetti 1903, p.331 (diary entry for 16 Oct. 1868); Collier 1903, p.9; Sir John Forbes-Robertson, memoirs from 'A Player Under Three Reigns', *Sunday Times*, 25 Jan. 1925.
3 'Millais and Leighton by one who knew them both', *St James's Gazette*, 17 Aug. 1896.
4 Reproduced in Spielmann 1898, p.13. The article was first published in the *Magazine of Art* in 1888.
5 Watts 1912, vol.3, p.235.
6 J.B. Atkinson, 'The London Art Scene', *Blackwood's Magazine*, Aug. 1869, p.227.
7 *Quarterly Review*, 1873, p.302; Barrington 1882, pp.60–77.

91 *The Parable of the Tares*
1 Millais's *The Parable of the Lost Piece of Money* (destroyed), also developed from an illustration of the same subject in Dalziel's *Parables*, is the only other example of an illustration translated into a painting in the artist's oeuvre.
2 *Illustrated London News*, 6 May 1865, p.439; Quilter 1892, p.52; Spielmann 1898, p.79 (who described the figure as 'Fagin-like'). The element of caricature may explain why the design was parodied by *Punch* on 27 Feb. 1886 and 23 Aug. 1905. Millais's treatment of his subject was defended in *The Times*, 8 May 1865, p.8, and 6 June 1867, p.3, and by Palgrave 1866, pp.93–4.
3 See Wickham 2004, pp.90–1; Wickham 2003 p.10.
4 Sickert 1929, p.756.

92 *Esther*
1 Account Book, PML; Millais 1, 1899, p.384.
2 Massingham 1966, p.35.
3 *Fraser's Magazine*, June 1865, p.747.
4 Spielmann 1898, p.90.
5 See review in the *Illustrated London News*, 6 May 1865, p.439.

93 *Jephthah*
1 Colvin was the art critic at the *Fortnightly Review*, and was also Keeper of Prints at the British Museum. Colvin, 'English Painters and Painting in 1867', *Fortnightly Review*, 1 Oct. 1867, p.471.
2 Edward Wakeling (ed.), *Lewis Carroll's Diaries: The Private Journals of Charles Lutwidge Dodgson (Lewis Carroll)*, Luton 1993, vol.5, p.213, entry of 8 April 1867.
3 Jan Marsh (ed.), *Black Victorians: Black People in British Art 1800–1900*, London 2005, p.149.
4 He was Groom-in-Waiting to Queen Victoria, Lt-Colonel in the Grenadier Guards, and Colonel commanding the St George's Rifles. His daughter, Marion Margaret Violet Lindsay, sat for the nun in Millais's *'Mercy': St Bartholomew's Day, 1572* 1886 (Tate).
5 Marsh 2005, p.149.
6 The remarkable realism of this figure is reminiscent of Diego Velázquez's *Juan de Pareja* 1650, and also John Singleton Copley's studies for the black figure at the apex of his composition *Brook Watson and the Shark* 1778.
7 John Opie, William Blake and Martin Archer Shee also produced works on the theme, and in France, Edgar Degas produced an unfinished painting of 1859–60 on the subject.
8 The connection with Lear is plainly enunciated in Heavysege's poem when Jephthah cries that the Lord should 'lash me into madness'.
9 Richard Ormond, 'Holman Hunt's Egyptian Chairs', *Apollo*, July 1965, pp.55–8.

94 *The Boyhood of Raleigh*
1 The article first appeared in the *Westminster Review* of 1852.
2 Millais 2, 1899, p.17.
3 Reproduced in Birmingham and London 2004, pp.24, 36.

95 *A Somnambulist*
1 Effie had seen an earlier production of the opera with the Ruskins back in 1847 at Her Majesty's Theatre in London. Musgrave 1995, pp.231–2; Lutyens 1972, p.36.
2 *Illustrated London News*, 6 June 1871, p.447.
3 Millais 1, 1899, p.281.
4 The impact this work had on Millais is mentioned by Joanna Hiffernan (the model for *The White Girl*) in a letter to George Lucas of 9 April 1862: 'Some stupid painters don't understand it at all while Millais for instance thinks it spleandid [*sic*] more like Titian and those old swells than anything he [h]as seen.' (Quoted from Tsui 2006, pp.450–1).

96 *The North-West Passage*
1 RA and Liverpool 1967, p.52.
2 NPG, Feb. 1876, p.15; letter to Millais from Admiral Sir George Back, 3 March 1875, GRE Millais Colln, 2/08.
3 *The Times*, 9 Jan. 1886.
4 The print was identified by Rosenfeld in Staley 1995, p.24, n.5.
5 The rejected section, for which John Guille and Alice sat as models, was turned into *Getting Better* 1876 (formerly Schaeffer Collection, Australia). The studies are listed in RA and Liverpool 1967, p.96 (387, 388). See also Millais 2, 1899, pp.52, 83.
6 *Spectator*, 9 May 1874, p.597; *Academy*, 23 May 1874, p.584; Barlow 2005, p.157.

97 *The Princes in the Tower*
1 Ingamells 1986, p.99; Chapel 1982, pp.114–15.
2 Millais 2, 1899, pp.88–91.
3 Spielmann states that Millais painted the princes from the children (a sister and brother) of Mr Dallas Yorke of Walmsgate, Lincolnshire (1898, p.134). This is contradicted by J.G. Millais, who says they were the sons of a professional model (Millais 2, 1899, p.91).

98 *The Ruling Passion*
1 Barlow 2005, p.167.
2 17 Dec. 1884, 'Workers and their Work', GRE Millais Colln.
3 Armstrong 1885, p.28; Millais 2, 1899, p.173. J.G. Millais built up a collection of more than 3,000 birds, which are in their original drawers in the collection of Perth Museum and Art Gallery, Perth, Scotland.
4 The birds are identified in Barlow 2005, p.164, p.216, n.33.
5 Millais 2, 1899, pp.169–70. For Gould see Riding 2006, p.58; Barlow 2005, p.163.
6 Ruskin 14, p.469.
7 Millais 2, 1899, p.174.
8 Letters from J.W. Beck to J.E. and Effie Millais, 9 Nov. 1892–5 Feb. 1894, GRE Millais Colln, 4/228–30, 232–9.

99 *St Stephen*
1 Millais 2, 1899, p.312.
2 Ibid. p.303.
3 Armitage 1883, p.230.
4 *Sunday Express*, 22 Oct. 1933, quoted in M. Postle, 'Leighton's Lost Model: The Rediscovery of Mary Lloyd', *Apollo*, Feb. 1996, p.29 n.5. Lloyd also modelled for Leighton.
5 Letter from Henry Tate to J.E. Millais, 9 June 1894, GRE Millais Colln, 4/258.

100 *'Speak! Speak!'*
1 Spielmann 1898, pp.119–20.
2 Herkomer 1908, GRE Millais Colln.
3 Millais 2, 1899, p.307. The light fitting is most likely a reading light (or candle with a shade) dating from the early nineteenth century. See Leeds 1992, no.46.
4 Spielmann 1898, p.119. For the modernity of the subject see Richmond and Herkomer quoted in Millais 2, 1899, pp.311, 308. The painting also compares in its subject matter with Frank Dicksee's *Reverie* 1895.
5 Quoted in Conrad 1978, p.56.
6 Letters to Millais from Henry T. Wells RA, 2 May 1895, and Fred. A. Eaton, Secretary of the RA, 3 May 1895, GRE Millais Colln, 4/298, 4/299.

5 Fancy Pictures pp.170–187

1 I am grateful to Jason Rosenfeld for this suggestion. No other male painter until Pablo Picasso was so intent on documenting his children in paint. Further comparison can be made with Peter Paul Rubens, who often utilised portrait drawings of his children for subject pictures and, like Millais, projected a persona of fecund contentment.
2 Armitage 1883, p.17.
3 Bowerswell Papers, PML, quoted in full in Parris 1994, p.137.
4 Entry for 28 April 1883, Potter 1989, p.41.
5 'Painting a Big Picture', c.1893, article in Lutyens papers, collection of Rupert Maas.
6 Millais 2, 1899, p.343.
7 *Art Journal*, 1863, p.109.
8 Gallati in New York 2004, p.87.

101 *Waking*
1 Millais 1, 1899, p.395.
2 Christie's sales cat., 11 June 2003, p.70. Letter from Millais to Effie, 27 July 1865, PML, MA1485.
3 *The Times*, 4 May 1867.
4 *Art Journal*, June 1867, p.138.
5 Photograph of drawing room repr. in Pennell 1921, pp.152–3.
6 F.G. Stephens, *Athenaeum*, see Christie's sales cat., 2003, p.70.
7 Poem by W. Poole, Balfern reproduced in S.M.G. scrapbook, Mary Lutyens papers, collection of Rupert Maas.

102 *The Minuet*
1 Millais 1, 1899, p.390.
2 Leggatt 1958, p.6.
3 Melville 2005, pl.37, p.38.
4 Millais 2, 1899, pp.487, 496; letter to Millais from William Agnew, 1868[?], GRE Millais Colln, 1/18.

103 *Souvenir of Velasquez*
1 RA Council minutes, 20 April 1868, pp.422–3, RA Archive.
2 Millais 2, 1899, p.17.
3 Letter dated 5 April 1890, GRE Millais Colln, 4/132.
4 *Art Journal*, June 1868, p.105.

104 *Bright Eyes*
1 Carter n.d.
2 Macdonald to Millais, 21 Aug. 1875, GRE Millais Colln, 2/35.
3 Melville 1997, p.22.
4 Copy of letter from Millais to George Reid, written by Mary Millais, 16 July 1896, PML, MA.1485, 586.

105 *The Captive*
1 Spielmann 1898, p.126.
2 Entry for 28 April 1883, Potter 1989, p.41.

106 *Cherry Ripe*
1 Beerbohm 1922, pl.3. See also Osbert Lancaster's spoof of the painting *Pussey's Going Bye-Byes*, in Lancaster 1973, pp.76–7.
2 Reis 1992, pp.201–5. The confidence of the model is attested to in Millais 2, 1899, p.121.
3 Spielmann 1898, p.139.
4 Thomas, quoted from Bradley 1991, p.79.
5 Beatrix Potter noted in her journal that the *Illustrated London News* made £12,000 from the engraving. Entry for 13 Jan. 1885, Potter 1989, p.126.
6 Millais 2, 1899, pp.122, 52.
7 Barbara Niven, 'Everyone's Grandmother loved this', *Morning Star*, 13 Jan. 1967.

107 *Bubbles*
1 Millais 2, 1899, p.189; Potter 1989, p.161 (entry for 15 Nov. 1885).
2 Pears to Effie Millais, 7 Feb. 1889, GRE Millais Colln, 4/61.
3 See, for example, 'Art and Morals for the Million', *Westminster Gazette*, 21 Aug. 1896.
4 Quoted from RA and Liverpool 1967, p.59.
5 For example, *The Academy* linked Millais's art to that of Reynolds, Gainsborough and Van Dyck (13 March 1886, p.189).
6 'Art and Advertisement', letter to the editor of the *Morning Star* by T.R. Barratt, 1896, GRE Millais Colln.
7 Letter to the editor of the *Westminster Gazette* from the honorary secretary of the Advertisement Regulation Society, 1896, GRE Millais Colln.

108 *The Little Speedwell's Darling Blue*
1 Spielmann 1898, p.93; Millais refers to the poem in a letter to his daughter Mary of c.1890, Millais 2, 1899, p.285.
2 James to Millais, 6 Sept. 1891, GRE Millais Colln, 4/172. See also 4/230.
3 George W. Agnew to Millais, 4 April 1892, GRE Millais Colln, 4/201.

6 Portraits pp.188–215

1 PML, MA.1485, dated 17 Aug. 1880.
2 *Evelyn Otway* 1880 exh.Grosvenor Gallery 1882 (Private Collection), repr. Christie's sales cat., 12 June 1992 (111).
3 *The Children of Octavius Moulton Barrett, Esq.*, 1880–1, exh. Grosvenor Gallery 1882 (unlocated).
4 Respectively *The Rev. John Caird, D.D., Principal and Vice-Chancellor of the University of Glasgow*, 1880, exh.RA 1881 (264) (Hunterian Art Gallery, University of Glasgow) and a portrait of Caroline Rocker as *Diana Vernon*, 1880 (National Gallery of Victoria, Melbourne, Felton Bequest 1914, repr. in Millais 2, 1899, p.167).

5 *The Bishop of Manchester*, 1880, exh. RA 1881 (1366) (Manchester City Art Gallery).
6 Respectively *The Right Hon. W.E. Gladstone, MP* 1880 (Glasgow Art Gallery), *Miss Hermione Schenley* 1879, exh. RA 1880 (430) (unlocated), and *Catherine Muriel Cowell Stepney* 1880, exh. RA 1880 (239) (unlocated; repr. Millais 2, 1899, p.163).
7 *Richard Combe* 1880 (unlocated).
8 Quoted from Lord Ronald Gower, *My Reminiscences*, 1883, p.342 by Warner in NPG 1999, p.163.
9 There are a number of these in the GRE Millais Colln.
10 See Martin Postle (ed.), *Joshua Reynolds: The Creation of Celebrity*, exh. cat., Tate Britain, London 2005.
11 NPG 1999, p.155.
12 Ibid. p.158.
13 Matthew in ibid. p.161.

109 *The Marchioness of Huntly*
1 He also owned a house at 5 Grosvenor Square, London, and Barlow Hall, Chorlton. He inherited the bank, and £2.5m from his father, Samuel. www.invernessfieldclub.btinternet.co.uk /excursions/2002/August.htm
2 Millais/Harcourt Papers, Bodleian, dep.201, fol. 135, Millais to William Holman Hunt, 17 Septr Perth [1866].
3 Lady Alexina Duff (1851–82) and Amy Cunliffe-Brooks may have been rivals. Brooks had known Lord and Lady Fife since the 1850s. Alexina married Henry Aubrey Coventry in 1870.
4 PML, Bowerswell Papers, MA.1338, N-O.5, Effie to Mrs. G., dated 7, Cromwell Place,/ South Kensington./ 14th May /"69".
5 PML, MA.1485, E.1, dated 7, Cromwell Place/ 1, June [1869].
6 'The Royal Academy. One Hundred and Second Exhibition', *Art Journal*, June 1870, p.170.
7 In Reynolds's picture she holds a basket of cut flowers. The resemblance was noted in Sotheby's, 29 Nov. 2001 (22), p.70.

110 *Hearts are Trumps*
1 He was the father of the art critic and museum director of the same name, who would later write articles on Millais. Armstrong 1885. Kenneth Garlick, 'Sir Walter Armstrong (1849–1918)', *Oxford Dictionary of National Biography*, 2004, vol. 2, pp.449–50.
2 NPG 1999, p.203.
3 For Reynolds's picture see Nicholas Penny (ed.), *Reynolds*, exh. cat., Royal Academy of Arts, London, 1986, pp.292–3, and David Mannings, *Sir Joshua Reynolds: A Complete Catalogue of his Paintings*, New Haven and London 2000, pp.456–7. A small copy of Millais's picture hung next to *The Ladies Waldegrave* at Strawberry Hill; Millais 2, 1899, p.40.
4 Millais may have designed the dresses. NPG 1999, p.203.
5 Elizabeth would marry Charles James Tennant Dunlop and Diana would marry John Herbert Secker.
6 Reynolds's picture is about purity and marriageability; the locked drawer plainly visible in the middle symbolises female virginity. Desmond Shawe-Taylor, *The Georgians: Eighteenth-Century Portraiture and Society*, London 1990, p.117.
7 'The Royal Academy', *Athenaeum*, 4 May 1872, p.565.
8 'Exhibition of the Royal Academy', *Illustrated London News*, 11 May 1872, p.466.

111 *Mrs Bischoffsheim*

1 Lucy Biedermann married James Stern and Millais painted her in 1882 (Private Collection). See also Pat Thane, 'Henri Louis Bischoffsheim [Henry Louis] (1829–1908)', *Oxford Dictionary of National Biography*, 2004, vol.5, pp.856–7.
2 See Warner in NPG 1999, p.204, for details of the Bischoffsheim collection.
3 Now the Egyptian Embassy. Information from www.turtlebunbury.com/history/history_family/hist_family_cuffe.htm. For Bute House, see John Cornforth, *London Interiors from the Archives of Country Life*, London 2000, pp.79–103.
4 Illustrated in English Heritage, *Survey of London: Volume 40*, 1980, plates 84a and b. See www.british-history.ac.uk/report.asp?compid=42249
5 www.british-history.ac.uk/report.asp?compid=42154
6 Thanks to Kirche Zeile and Charlotte Gere for comments on the clothing and jewellery.
7 'The Royal Academy', *Athenaeum*, 3 May 1873, p.570.
8 'The Royal Academy Exhibition', *Illustrated London News*, 10 May 1873, p.447.
9 Effie would later write to her mother from Cromwell Place: 'Madame Bischoffsheim is sitting here talking it is so hot in the studio & she is talking so much I must stop', PML, Bowerswell Papers, MA.1338.R.2, 19 June / 1872. The Bischoffsheims had two daughters, Ellen and Amelia. The former would marry William Ulrick O'Connor Cuffe, 4th Earl of Desart in 1881. In 1882 the latter married Sir Maurice Fitzgerald, 20th Knight of Kerry, and the picture was given to the Tate by their granddaughter.

112 *A Jersey Lily*

1 NPG 1999, pp.209–11. Edward Poynter finished his portrait of her first and showed it at the same Academy and it is also owned by the Jersey Museums Service.
2 W.M. Rossetti, 'The Royal Academy Exhibition', *The Academy*, 8 June 1878, p.516.
3 PML, MA.1485.K.459 dated 86, Eaton Square./S.W., Sunday, n.d. [after 1885]
4 He donated antiquities to the British Museum, the Manchester Museum, The Ashmolean Museum and the Pitt-Rivers Museum in Oxford.

113 *Effie Millais*

1 Mary Lutyens, 'Portraits of Effie', in *Apollo*, vol.87, no.73, March 1968, pp.190–7.

114 *Portrait of the Painter*

1 Southampton 1996, p.108; *Frederic Leighton 1830–1896*, exh. cat., Royal Academy of Arts, London, 1996, p.190.
2 Barbara Bryant, *G.F. Watts' Portraits: Fame and Beauty in Victorian Society*, exh. cat., National Portrait Gallery, London, 2004, p.164.
3 Millais 2, 1899, p.127. Visible in W. Hatherley's print of the studio in Oldcastle 1881.
4 There is a copy by an unknown Italian artist in the GRE Millais Colln that was given to Millais by the Uffizi. There is also a copy by Sir Charles Holyrod dated 1897 in the collection of the Garrick Club.

115 *George Gray Millais*

1 All are in the GRE Millais Colln except Mary Hunt Millais, sold Christie's, 27 Nov. 2002 (20) and see the entry for the Gainsborough connection.
2 PML, MA.1445 Millais to Effie, dated Wednesday 29th July/ 1868.
3 PML, Bowerswell Papers, MA.1338 R.2) Effie to Mrs. Gray, dated 7 Cromwell Place, 19 June / 1872.
4 It was leased for a time by the painter John Phillip RA, and had a converted barn for a studio. http://www.dhivach.com/
5 PML, MA.1445, dated Auburn Lodge, / 38A Victoria Road,/ Kensington. W. Sept 3.1878.
6 Dated 6 Sept. 1878, GRE Millais Colln.
7 Millais 2, 1899, p.92.

116 *A Penny for her Thoughts*

1 Birmingham and London 2004, p.50.
2 *The Ladies' Treasury* commented that the replacement of the crinoline with the cuirass bodice in the mid-1870s resulted in skirts being 'so tight that our sitting and walking are seriously inconvenienced'. Vanda Foster, *A Visual History of Costume: The Nineteenth Century*, London 1984, p.14.
3 Munro 1996, p.2.
4 See Etching Club Minutes, NAL Ms. Complete editions of the portfolio are rare.
5 Chambers 1999, p.200.
6 Information supplied by GRE Millais.

117 *Twins*

1 Millais's pricing was consistent: 2,000 guineas for a full-length, single sitter (*The Marchioness of Huntly*, no.109), the same for a triple portrait of half-lengths (*Hearts are Trumps*, no.110), 1,500 guineas for a double portrait 3/4 length such as this.
2 Private Collection, repr. NPG 1999, p.111.
3 Museums, Libraries, and Archives Council, *Acceptance in Lieu Report 2005/06* (London: 2006), pp.71–4. NPG 1999 p.209. The picture may have been painted at Burton Park, Sussex. Information from Mrs Jean Wynne, 16 Aug. 2000.
4 Grosvenor 1886, p.35.
5 W.M. Rossetti, 'The Grosvenor Gallery', *The Academy*, 18 May 1878, p.447.
6 *The Times*, 2 May 1878.
7 [Henry James], 'The London Exhibitions—The Grosvenor Gallery', *Nation*, 23 May 1878, pp.338–9, reprinted in Peter Rawlings (ed.), *Henry James: Essays on Art and Drama*, Aldershot 1996, pp.278–9.
8 Spielmann 1898, p.124.
9 www.vam.ac.uk/vastatic/microsites/photography/ photographerframe.php?photographerid=ph028
10 Sydney Eardley-Wilmot, *An Admiral's Memories: Sixty-Five Years Afloat and Ashore*, London 1927. The picture was offered to the Fitzwilliam in lieu of tax from the estate of Mrs Jean Wynne (*née* Richardson), Grace's granddaughter, and a graduate in Modern Languages of St Hugh's College, Oxford.

118 *Louise Jopling*

1 Meaghan E. Clarke, 'Louise Jane Jopling [*née* Goode; *other married names* Romer, Rowe] (1843–1933)', *Oxford Dictionary of National Biography*, 2004, vol.30, pp.696–7 and Deborah Cherry, *Painting Women: Victorian Women Artists*, 1993.
2 Malcolm Warner, 'Joseph Middleton Jopling (1831–1884)', *Oxford Dictionary of National Biography*, 2004, vol.30, pp.695–6.

3 See Peter Funnell's entry on the picture in *The National Art Collections Fund 2002 Review*, London 2002, p.92, Louise Jopling, *Twenty Years of My Life 1867 to 1887*, London 1925, pp.139–44, and Millais 1, 1899, p.443.
4 Millais 1, 1899, p.443, reprised in Jopling 1925, p.49.
5 Warner in NPG 1999, p.204.
6 At the Grosvenor Gallery, Louise Jopling's *Portrait of A.J.R. Trendell, Esq.* (58) hung in the same room as Millais's of her, as well as her '*Chatty*' (75), a portrait of a child.
7 PML, MA.1485.K.768, dated 28 Wimpole Street [1881].
8 *Harmony in Flesh Colour and Black: Portrait of Mrs. Louise Jopling*, Hunterian Art Gallery, Glasgow.

119 *Portrait of Kate Perugini*

1 NPG 1999, pp.213–14 and Millais 2, 1899, pp.372–5.
2 See Lucinda Hawksley, *Katey: The Life and Loves of Dickens's Artist Daughter*, New York 2006.
3 I am grateful to Kirche Zeile, Assistant Professor of Theatre Arts at Marymount Manhattan College for her assistance in identifying the clothing in this and other Millais portraits.
4 Cosmo Monkhouse, 'The Grosvenor Gallery', *The Academy*, 7 May 1881, p.343.
5 *Gazette des Beaux-Arts*, June 1881, p.552, quoted by Warner in NPG 1999, p.214.

120 *Thomas Carlyle*

1 Warner in NPG 1999, p.164. Whistler's picture is in the Glasgow Art Gallery and had first been exhibited in his one-man show at the Flemish Gallery, 48 Pall Mall, in 1874. See Richard Dorment and Margaret F. MacDonald, *James McNeill Whistler*, New York 1995, pp.143–5. See also RA and Liverpool 1967, p.54.
2 Quoted in NPG 1999, p.164.
3 Richard L. Stein, 'Unstable Foundation: Ruskin and the Costs of Modernity' in Giovanni Cianci and Peter Nichols (eds.), *Ruskin and Modernism*, Basingstoke and New York 2001, pp.1–16, quote from pp.13–14.

121 *The Right Hon. W.E. Gladstone, M.P.*

1 'Portraits of Men: Millais and Victorian Public Life', NPG 1999, pp.149–50.
2 NPG 1999, pp.166–7.
3 James Graham quoted in Roy Jenkins, *Gladstone*, London 1996, p.67.
4 Millais 2, 1899, p.114.
5 NPG 1999, p.167. The first Hals portrait entered the National Gallery in 1876. Frith, Millais and Andrew Gray visited the Frans Hals Museum, Haarlem, on 17 May 1880. See Petra ten-Doesschate Chu, 'Nineteenth-Century Visitors to the Frans Hals Museum', in Gabriel P. Weisberg and Laurinda S. Dixon (eds.), *The Documented Image: Visions in Art History*, New York, 1987, p.136. For Frith quote see William Powell Frith, *My Autobiography and Reminiscences*, 2 vols, New York 1888, vol.1, p.397.
6 PML, MA.1485, K.303, to Birnam Hall, Birnam, Perthshire, fr. William Ewart Gladstone, Sept 25.87.
7 PML, MA.1485.K.301 to Millais at 2 Palace Gate, from William Ewart Gladstone, 10, Downing Street, Whitehall. June 25.85. Watts was offered a baronetcy at the same time but refused.
8 PML, MA.1485, B.32, 26 June 1885.

122 *Benjamin Disraeli*

1 See Warner in NPG 1999, pp.167–8.
2 PML, MA.1485.K.219, dated 19, Curzon Street. W., Mar 2 1881.
3 Millais 1, 1899, p.429.
4 Millais 2, 1899, p.25, dated 5 April 1881.

5 PML, MA.1485, K.52, George William Barrington, 7th Viscount Barrington, to Mrs. Millais at 2PG, 19, Hertford Street, / Mayfair, W. letterhead, April 27/81.
6 H.C.G. Matthew in NPG 1999, p.155.
7 Richard Davenport-Hines, 'William Henry Smith (1825–1891)', *Oxford Dictionary of National Biography*, 2004, vol.51, pp.381–4.

123 *Alfred Tennyson*

1 The show opened in February and the picture was added when Millais completed it; NPG 1999, p.171. The work was commissioned by the Fine Art Society for 1000 guineas including copyright, and they published an engraving by Thomas Oldham Barlow in 1882.
2 FAS 1882, pp.5–6. The other featured picture for sale was *Isabella* (no.9). *Cuckoo* 1880 is in the Johannesburg Art Gallery.
3 NPG 1999, p.158. See also Bennett 1988, p.155 and MacColl 1908, pp.126–8.
4 Theodore Watts, 'The Portraits of Lord Tennyson. – I.', *Magazine of Art*, 16, 1893, p.43.
5 PML, MA.1485.K.444, dated 47, Wimpole Street. W. letterhead, May 16th 1881.
6 PML, MA.1485.K.712, to Millais at Birnam Hall, Birnam, Perthshire, N.B., dated Harringford, / Freshwater, May 17/81.
7 PML, MA.1485.K.768, Millais to Mary at Bowerswell, dated Palace Gate, 5 April 1881. Sir Charles Tennyson, *Alfred Tennyson*, 1949, p.458 quoted by Warner in NPG 1999, p.171.
8 MacColl 1908, p.126.

124 *Henry Irving, Esq.*

1 The picture is in the National Portrait Gallery, NPG 1560. www.npg.org.uk/live/search/portrait.asp?search=ss&sText=irving&LinkID=mp02373&rNo=1&role=sit
2 Austin Brereton, *The Lyceum and Henry Irving*, London 1903, pp.239–42.
3 Laurence Irving, *Henry Irving: The Actor and His World*, New York 1952, p.412.
4 www.garrickclub.co.uk/ librarysearch cataloguenumber.asp?cataloguesearch=G0323 In 1907 the Garrick presented an equal-size copy of the picture by Harry M. Allen (fl. 1907–37), made around 1884, to the National Portrait Gallery. The Club also owns Millais's portrait of the comedian John Hare of 1893.

7 The Late Landscapes pp.216–243

1 The remaining works are *Flowing to the Sea* 1870–1 (Southampton City Art Gallery); '*The Deserted Garden*' 1875 (unlocated); '*Over the Hills and Far Away*' 1875 (fig.26, p.218); *Murthly Moss, Perthshire* 1887 (unlocated); *Murthly Water* 1888 (unlocated); *The Old Garden* 1888 (The Lord Lloyd Webber); '*The Moon is up, and yet it is not night.*' - *Byron* 1890 (Tate); and *Halcyon Weather* 1891–2 (GRE Millais Colln).
2 A distinction should be made here, as these are pure landscapes. As in his Pre-Raphaelite period, Millais often painted backgrounds for figural subjects in the outdoors in Scotland, such as *The Bride of Lammermoor* 1877–8 (Bristol Art Gallery), *St Stephen* (no.99) and *A Forerunner* 1895–6 (Glasgow Museums). And his printed work often included landscape backgrounds devised in Scotland.

3 This was largely via Agnew's, who invested heavily in Millais's work from the 1860s. Typically, works were exhibited in London and remained there. *Chill October*, for one, resided in Cragside, near Rothbury in Northumberland, Richard Norman Shaw's eclectic hill mansion built for William Armstrong in 1870, with a number of the artist's other pictures. There is a photograph of the painting in the massive drawing room, added in 1880 to accommodate pictures of this size. Andrew Saint, *Richard Norman Shaw*, London and New Haven 1976, p.74.

4 Millais 1, 1899, p.327.

5 Tim Barringer, 'Opulence and Anxiety: Landscape Painting and British Culture since 1768', draft of a paper supplied by the author, Jan. 2007.

6 Codell in Mancoff 2001, p.136.

7 Helmreich in Mancoff 2001, pp.149–80.

8 Millais 2, 1899, p.66, quoted in Helmreich in Mancoff 2001, p.155.

9 Spielmann, 1898, p.115, quoted in Helmreich in Mancoff 2001, p.162.

125 *Chill October*

1 See RA and Liverpool 1967, pp.49–50; Tate 1984, p.219; Newcastle 1989, pp.91–2; Royal Academy 2003, 48, 303.

2 Millais 2, 1899, p.29.

3 From Allingham's 'The Wail of the River' in a review that stressed the aural aspects of the picture: 'What saith the river to the rushes grey,/Rushes sadly bending,/River slowly wending?/It is near the closing of the day,/Near the night. Life and light/For ever, ever fled away!'. 'The Royal Academy', *Athenaeum*, 29 April 1871, p.531.

4 'Exhibition of the Royal Academy', *Illustrated London News*, 6 May 1871, p.447.

5 Staley 2001, p.71.

6 Barlow 2005, pp.130–2.

126 *Flowing to the River*

1 Millais 2, 1899, p.39.

2 See Helmreich in Mancoff 2001, pp.159–60.

3 V., 'The Royal Academy', *Spectator*, 4 May 1872, p.561.

4 Spielmann, 1898, pp.126–7.

5 *Mrs Sebastian Schlesinger*, wife of Sebastian Benzon Schlesinger (unlocated). He ran Naylor & Co. in Boston, and unlike his elder brother who at some stage took his mother's maiden name Benzon, kept his given name Schlesinger. I am grateful to Mr Ben Hay of Naylor Benzon and Co. Ltd. for providing extensive information on Benzon.

6 Caroline Dakers, *The Holland Park Circle: Artists and Victorian Society*, New Haven and London 1999, pp.133–4. Millais painted Frederick's daughter Nina twice, once as a child and once grown as Lady Campbell. *Nina Lehmann* 1868–9, sold Sotheby's, 19 June 1984 (73); *Lady Campbell* c.1884, sold Sotheby's, 19 June 1991 (234).

7 Gerry Black, 'Samuel Lewis (1838–1901)', *Oxford Dictionary of National Biography*, 2004, vol.33, pp.647–8.

8 Ernst Benzon's sale was at Christie's, 13 June 1874, and his wife's at Christie's, 1 May 1880.

127 *Scotch Firs*

1 In 1886 it was exhibited at the Grosvenor Gallery as '*The silence that is in the leafy woods*' without the Wordsworth link. It may be conflated from Wordsworth's 'Song at the Feast of Brougham Castle [...]'(1807): 'The silence that is in the starry sky/ The sleep that is among the lonely hills'.

2 Millais 1, 1899, p.389.

3 *Art Journal*, June 1874, p.161, quoted in Sotheby's sales cat., 17 June 1992 (408).

4 See MacLeod 1996, pp.424–5. Thomas Secombe, revised Michael Reed, 'Albert Grant, [*formerly* Abraham Gottheimer], Baron Grant in the Italian nobility (1831–1899)', *Oxford Dictionary of National Biography*, 2004, vol.23, pp.277–8. He also owned pictures by Henry Wallis, William Holman Hunt, Edwin Landseer and E.M. Ward that he bought from the Samuel Mendel collection. These were briefly displayed in Kensington House, designed for him by James Thomas Knowles (see *Alfred Tennyson*, no.123) but demolished in 1883. Its large staircase was salvaged for Madame Tussaud's. There is a photograph in the Millais album at the Aberdeen Art Gallery showing *Jephthah* hanging next to Landseer's *The Otter Speared* 1844 at Kensington House. In the year he bought this picture and *Winter Fuel*, he also restored Leicester Square to a public park and gave it to the Metropolitan Board of Works, bought the *Echo* newspaper, and was caricatured by Ape (Carlo Pellegrini) in the 21 Feb. issue of *Vanity Fair*.

128 *Winter Fuel*

1 Gibbon Bayley Worthington presented it to the Manchester City Art Gallery in 1897, one year after Millais's death, making it his first Scottish landscape to enter a public collection.

2 The title *Winter Fuel* was also possibly inspired by a line from Good King Wenceslaus about hunger, published 1853:
Good King Wenceslas looked out on the feast of Stephen,
When the snow lay round about, deep and crisp and even;
Brightly shone the moon that night, tho' the frost was cruel,
When a poor man came in sight gath'ring winter fuel.

3 *Gerard Manley Hopkins: The Journals and Papers*, 2nd ed., Humphry House, completed by Graham Storey, 1959, pp.244–5.

129 *The Fringe of the Moor*

1 See Millais 2, 1899, p.55. As with so many of these late landscapes, the locations were identified in modern times by W.J. Eggeling of Rumbling Brig, in a talk given to the Dunkeld and Birnam Historical Society in 1982. See Eggeling 1985.

2 PML, MA.1485.B.9 dated St Mary's Tower, Birnam, N.B. 8 Novr 1874 and reprinted in Millais 2, 1899, pp.56–7.

3 Spielmann 1898, p.132.

4 Quoted in Ruskin and Crawford 1886, pp.1–2.

5 J. Gordon Read, 'Thomas Henry Ismay (1837–1899)', *Oxford Dictionary of National Biography*, 2004, vol.29, pp.441–2.

6 Macleod 1996, p.435.

7 I.D. Colvin, revised Maryna Fraser, 'Sir Julius Charles Werner, first baronet (1850–1912)', *Oxford Dictionary of National Biography*, 2004, vol.58, pp.169–71.

8 Michael Stevenson, *Art and Aspirations: The Randlords of South Africa and their Collections*, South Africa 2002.

130 '*The Sound of Many Waters*'

1 The Hermitage had been renamed 'Ossian's Hall' in 1782–3 as a monument to Jacobites. Between the Rumbling Brig and Ossian' Hall was the part natural, part artificial 'Ossian's Cave'. Destroyed through vandalism in 1869, Ossian's Hall was reconstructed in 1884.

2 Spielmann 1898, p.162.

3 Henry James, 'The Picture Season in London', *Galaxy* 24 (July 1877), p.61, reprinted in Peter Rawlings (ed.), *Henry James: Essays on Art and Drama*, Aldershot 1996, p.264.

4 Part the fifth. The Soul is in conversation with the Angel. *The Dream of Gerontius* was suggested by *The Book of Revelation* (19:6) and subsequently put to music by Edward Elgar in 1900.

5 The Revelation of Saint John the Divine (19:6).

6 Malcolm Ferguson, *Black's Picturesque Tourist of Scotland* (1870), p.271. A Hallelulah of Angels. Taylor in the *Graphic* referred to it as 'The Voice of Many Waters', the only critic to come close to noting the reference. 'Royal Academy Exhibition IV', *The Graphic*, 9 June 1877, p.543.

7 PML, MA.1485. B.17, dated Rumbling Brig/ 9th Nov. 1876.

8 Millais 2, 1899, p.84.

9 Ibid.

10 See Julie Codell, 'The Public Image of the Victorian Artist: Family Biographies', *The Journal of Pre-Raphaelite Studies*, 5, Fall 1996, pp.5–24.

11 Millais 2, 1899, p.84.

12 PML, B16, To Mary at Bowerswell, Rumbling Bridge cottage/ 7 Novr 1876.

13 J.F. Boyes, 'The Private Art Collections of London. The Late Mr. David Price's, in Queen Anne Street', *Art Journal*, Nov. 1891, pp.321–8.

131 *St Martin's Summer*

1 Identified in Eggeling 1985, p.10. For further reflections on this picture see Barlow 2005, pp.136–7.

2 Spielmann 1898, p.160.

3 W.M. Rossetti, 'The Royal Academy Exhibition. (Third Notice.)', *The Academy*, 8 June 1878, p.516.

4 A.A. den Otter, 'Donald Alexander Smith, first Baron Strathcona and Mount Royal', *Oxford Dictionary of National Biography*, 2004, vol.51, pp.80–1.

132 '*The tower of strength [...]*'

1 Millais 1, 1899, p.433.

2 Spielmann 1898, p.143 and Millais 2, 1899, p.92.

3 Michael Rosenthal, *Constable: The Painter and his Landscape*, New Haven and London 1983, p.214. See pp.214–18 for a discussion of this picture. Constable's painting was well known from David Lucas's mezzotints, first published in the fifth part of *English Landscape Scenery* (1832) and then a larger version separately in 1849.

133 *Christmas Eve*

1 Dalpowie was pulled down after the Second World War. The Murthly Estate passed into the hands of the Fotheringhams of Co. Forfar, who still own the property. See Eggeling 1985, pp.12–13.

2 From Robert Hall, *The Highland Sportsman*, 1882, pp.407, 441, referenced on www.ambaile.org.uk/en/item/item_page_print.jsp?item_id=19828.

3 Millais 2, 1899, p.199.

4 Spielmann 1898, p.140.

5 Verso is a drawing for *Mrs. Paul Hardy*, exh.RA 1889.

6 D.M. Cregier, 'Sir Joseph Benjamin Robinson, first baronet (1840–1929)', *Oxford Dictionary of National Biography*, 2004, vol.47, pp.378–9. His second daughter, Ida Louise, married Count Natale Labia, Italian Minister to South Africa, and a number of Millais's pictures remain in South Africa in the family's collection.

134 *Lingering Autumn*

1 A few other collectors had Millais works in Scotland. James Clarke Bunten hung *Rosalind and Celia* 1867–8 (unlocated) in Dunalastair, his house overlooking Schehallion and the Valley of the Tummel. See Millais 2, 1899, p.5. For McCulloch see MacLeod 1996 and *The McCulloch Collection of Modern Art*, exh. cat., Royal Academy, London, 1909.

2 *Athenaeum*, 2 May 1891, p.574, quoted in Bennett 1988, p.159, the most complete source on the picture.

3 Published 2 Aug. 1892.

135 *Dew-Drenched Furze*

1 Millais 2, 1899, p.213. See also Helmreich in Washington 1996, pp.75–6 and Christopher Newall in Tate 1997, pp.176–7.

2 Henry Blackburn, *The New Gallery 1890, A Complete Illustrated Catalogue*, London 1890, p.11.

3 Millais 2, 1899, pp.213–14 and Helmreich in Washington 1996, p.76. The cock pheasant is visible in the reproduction in Millais 2, 1899, p.295.

4 Macleod has it in the collection of Thomas Henry Ismay, who also possessed *The Fringe of the Moor* (no.129), but a letter of 31 July 1890 from Millais to Effie mentions that Everett was to pay for the picture in early 1891. PML, MA.1485.A.

136 *Dead Pheasants*

1 Millais 2, 1899, p.74.

2 Millais also painted a similar but larger sketch of his family basset hound, named Model, which is unlocated. Probably Christie's, 25 April 1975 (134) as *Study of a Dog*, repr. See Millais 2, 1899, p.476. The breed was significant, as Millais's eldest son Everett introduced it to England in modern times.

137 *The Last Trek*

1 J.G. Millais and the artist Briton Rivière later urged Millais to produce a painting of *The Last Trek* based on his drawing. Rivière wrote: 'I told him [Millais] how much I had been impressed by his own beautiful frontispiece, 'The Last Trek,' and that I hoped he would paint a large picture of it in the style of his friend Constable. His face lighted up at once, and he said, "I'll do it."' Millais 2, 1899, p.332.

2 Using this technique an electrical charge is passed from an anode attached to a printing plate of the same metal and suspended in a weak acid bath or electrolyte. The metal is etched from the plate where it is not protected by an acid resist. See Rosemary Simmons, *Dictionary of Printmaking Terms*, London 2002.

3 PML, MA2226, Millais to Swain, 10 April 1879.

4 A photogravure is a photographic image produced from an engraving plate.

138 *Glen Birnam*

1 PML, MA.1485. A, dated Palace Gate, 3 Aug. 90.

139 '*Blow, Blow, Thou Winter Wind*'

1 For this picture see Millais 2, 1899, pp.297–8 and Angus Trumble, *Love and Death: Art in the Age of Queen Victoria*, Adelaide 2001, pp.178–9.

2 Millais 2, 1899, p.298.

3 Spielmann 1898, pp.108–10.

4 PML, MA.1485.K.626, dated Flaxley,/ 82 Finchley Rd. N.W., Nov 7/92.

5 Graham W. A. Bush, 'Davis, Ernest Hyam 1872 – 1962'. *Dictionary of New Zealand Biography*, updated 7 April 2006 URL, www.dnzb.govt.nz.

Bibliography

Works are published in London unless otherwise stated

Manuscripts

Ashmolean 1941 Ashmolean Museum, Oxford, sketches by J.E. Millais, Charles Collins and William Holman Hunt from a scrapbook bought at the Combe sale, 1894; arranged and bound 1941

GRE Millais Colln Geoffroy Richard Everett Millais Collection of letters to J.E. Millais, and volumes of press cuttings; transcriptions of Bowerswell papers by Clare Stuart Wortley, 3 vols, 1938

Lutyens Mary Lutyens collection of papers on Millais, Rupert Maas

NAL National Art Library, South Kensington, Special Collections

PML Pierpont Morgan Library, New York, Millais papers and correspondence, Bowerswell Papers

RA Archive Royal Academy of Art, London, council minutes and letters

Stirling Stirling of Keir Papers, Mitchell Library, Glasgow

TGA Tate Gallery Archive, letters from J.E. Millais to John Leech

Publications

Armitage 1883 E. Armitage, *Lectures on Painting*, 1883

Armstrong 1885 W. Armstrong, 'Sir J.E. Millais Bart. President of the Royal Academy: His Life and Work', *The Art Annual*, 1885

Arts Council 1979 M. Warner, *The Drawings of John Everett Millais*, exh. cat., Arts Council of Great Britain, 1979

Ashmolean 1909 Ashmolean Museum, *The Combe Bequest*, Oxford 1909

Baker 1974 M. Baker, *The Folklore and Customs of Love and Marriage*, Aylesbury, 1974

Baldry 1899 A.L. Baldry, *Sir John Everett Millais: His Art and Influence*, 1899

Barlow 2005 P. Barlow, *Time Present and Time Past: The Art of John Everett Millais*, Ashgate 2005

Barrington 1882 E. Barrington, 'Why is Mr. Millais our Popular Painter?' *Fortnightly Review*, Aug. 1882, pp.60–77

Beerbohm 1922 M. Beerbohm, *Rossetti and His Circle*, 1922

Bennett 1967 M. Bennett, 'Footnotes to the Millais Exhibition', *Liverpool Bulletin*, no.12, 1967, pp.32–59

Bennett 1988 M. Bennett, *Artists of the Pre-Raphaelite Circle: The First Generation*, National Museums and Galleries on Merseyside, 1988

Birmingham and London 2004 P. Goldman and T. Sidey, *John Everett Millais: Illustrator and Narrator*, exh. cat., Birmingham Museums and Art Gallery and Leighton House, London, Aldershot 2004

BM 1994 J.A. Gere, *Pre-Raphaelite Drawings in the British Museum*, exh. cat., British Museum, London, 1994

Booth 1951 B.A. Booth (ed.), *The Letters of Anthony Trollope*, 1951

Bradley 1991 L. Bradley, 'From Eden to Empire: John Everett Millais's *Cherry Ripe*', *Victorian Studies*, vol.34, no.2, winter 1991, pp.179–203

Butler 1922 E. Butler, *An Autobiography*, 1922

Calloway 1975 S. Calloway, *Attitudes to the Medieval in English Book Illustration c.1800–1857*, MA report, Courtauld Institute, University of London, 1975

Carter n.d. C. Carter, *Alexander MacDonald 1837–1884: Aberdeen Art Collector*, Aberdeen, nd.

Casteras 1991 S. Casteras (ed.), *Pocket Cathedrals: Pre-Raphaelite Book Illustration*, London and New Haven 1991

Chambers 1999 E. Chambers, *An Indolent and Blundering Art? The Etching Revival and the Redefinition of Etching in England 1838–1892*, Aldershot 1999

Champneys 1900 B. Champneys, *Memoirs and Correspondence of Coventry Patmore*, 2 vols., 1900

Chapel 1982 J. Chapel, *Victorian Taste: The Complete Catalogue of Paintings at the Royal Holloway College*, 1982

Codell 1991 J.F. Codell, 'The Dilemma of the Artist in Millais's *Lorenzo and Isabella*: Phrenology, the Gaze and the Social Discourse', *Art History*, vol.14. no.1, March 1991, pp.51–66

Collier 1903 J. Collier, *A Manual of Oil Painting*, 1903

Collins 1980 W. Collins, *Basil* (1852), New York 1980

Connor and Lambourne 1979 P. Connor and L. Lambourne, *Derby Day 200*, exh. cat. RA of Arts 1979

Connors 2006 P.G. Connors, *Olivia Shakespear and Paterian Aestheticism*, Ph.D, Birkbeck College, University of London, 2006

Conrad 1978 P. Conrad, *The Victorian Treasure-House*, 1978

Cook 1898 E.T. Cook, *A Popular Handbook to the Tate Gallery 'National Gallery of British Art'*, 1898

Cooper 1986 R. Cooper, 'Millais's *The Rescue*: A Painting of a 'Dreadful Interruption of Domestic Peace', *Art History*, vol.9, no.4, 1986, pp.471–86

Corbett and Perry 2000 P. Barlow, 'Millais, Manet, Modernity' in D.P. Corbett and L. Perry (eds.), *English Art 1860–1914: Modern Artists and Identity*, Manchester 2000, pp.49–63

Dalziel 1864 G. and E. Dalziel, *The Parables of our Lord and Saviour Jesus Christ, with pictures by John Everett Millais*, 1864

Dalziel 1901 G. and E. Dalziel, *The Brothers Dalziel: A Record of Fifty Years' Work*, 1901 (reprinted 1978 with an introduction by Graham Reynolds)

Dickens 1850 C. Dickens, 'Old Lamps for New Ones', *Household Words*, 15 June 1850

Eggeling 1985 W.J. Eggeling, *Millais and Dunkeld: The Story of Millais's Landscapes* Perth, 1985 (1994 ed.)

Errington 1984 L. Errington, *Social and Religious Themes in English Art 1840–60*, Ph.D, Courtauld Institute of Art, University of London, 1984

Evans 1950 J. Evans, 'Millais's Drawings of 1853, *Burlington Magazine*, July 1950, pp.199–201

FAS 1882 *Notes on Exhibitions Held by The Fine Art Society*, Fine Art Society, 1882, containing *Notes by Mr. A. Lang on a Collection of Pictures by Mr. J.E. Millais, R.A.*, 1881, pp.5–6

Forbes 1975 C. Forbes, *The Royal Academy Revisited 1837–1901: Victorian Paintings from the Forbes Collection*, New York, 1975

Fredeman 1975 W.E. Fredeman (ed.), *The P.R.B. Journal: William Michael Rossetti's Diary of The Pre-Raphaelite Brotherhood 1849–53*, Oxford 1975

Fredericksen 2002 A. Fredericksen, 'The Etching Club of London', *Nineteenth Century*, Victorian Society in America, vol.22, no.2, Fall 2002, pp.20–6

Fried 1980 M. Fried, *Absorption and Theatricality: Painting and Beholder in the Age of Diderot*, Berkeley, 1980

Gamon 1991 P.B. Gamon, *Millais's Luck: A Pre-Raphaelite's Quest for Success in the Victorian Painting and Print Market 1848–1863*, Ph.D, Stanford University, 1991

Gautier 1855 T. Gautier, *Les Beaux-Arts en Europe IV: MM. Millais–W. Hunt*, Paris 1855

Gere and Munn 1989 C. Gere and G.C. Munn, *Artists' Jewellery: Pre-Raphaelite to Arts and Crafts*, Woodbridge, Suffolk, 1989

Goldman 1994 P. Goldman, *Victorian Illustrated Books 1850–1870: The Heyday of Wood-Engraving*, 1994

Goldman 2005 P. Goldman, *Beyond Decoration: The Illustrations of John Everett Millais*, 2005

Grieve 1969 A. Grieve, 'The Pre-Raphaelite Brotherhood and the Anglican High Church', *Burlington Magazine*, vol.111, May 1969, p.294–5

Grosvenor 1886 *Exhibition of the Works of Sir John E. Millais, Bt (With Notes by F.G. Stephens)*, exh. cat., Grosvenor Gallery, London, 1886

Hall 1980 J.N. Hall, *Trollope and his Illustrators*, 1980

Hall 1, 1983; Hall 2, 1983 J. Hall with N. Burgis, *The Letters of Anthony Trollope*, 2 vols., Stanford 1983

Hamerton 1864 P.G. Hamerton, 'Analysis and Synthesis in Painting' *Fine Arts Quarterly Review*, 2, 1864, pp.236–54

Hamlyn 1993 R. Hamlyn, *Robert Vernon's Gift: British Art for the Nation 1847*, 1993

Hancher 1991 M. Hancher, '"Urgent Private Affairs": Millais's Peace Concluded, 1856', *Burlington Magazine*, vol.133, Aug. 1991, pp.499–506

Hardie 1908 M. Hardie, *Wood Engravings after Sir John Everett Millais in the Victoria and Albert Museum*, 1908

Harrison 2004 C. Harrison, 'An Exhibition at the Oxford Town Hall in 1854', *The Ashmolean*, 47, summer 2004, pp.12–13

Hartley 2005 L. Hartley, *Physiognomy and the Meaning of Expression in Nineteenth-Century Culture*, Cambridge (2001) 2005

Harvey 1973 M. Harvey, 'Ruskin, the Pre-Raphaelites and Photography', *British Journal of Photography*, 6 April 1973

Hichberger 1988 J.W.M. Hichberger, *Images of the Army: The Military in British Art 1815–1914*, Manchester 1988

Houfe 1984 S. Houfe, *John Leech and the Victorian Scene*, 1984

Hunt 1886 W.H. Hunt, 'The Pre-Raphaelite Brotherhood: A Fight for Art', *Contemporary Review*, 49, April 1886, pp.471–88

Hunt 1, 1905; Hunt 2, 1905; Hunt 1, 1913; Hunt 2, 1913 W.H. Hunt, *Pre-Raphaelitism and the Pre-Raphaelite Brotherhood*, 2 vols., London and New York, 1905 and 1913 eds.

Huntington 1992 *The Pre-Raphaelites in Context*, Henry E. Huntington Library and Art Gallery, San Marino, CA, 1992, including M. Warner, 'The Pre-Raphaelites and the National Gallery', pp.1–11; S.P. Casteras, 'Pre-Raphaelite Challenges to Victorian Canons of Beauty', pp.13–35

Ingamells 1986 J. Ingamells, *The Wallace Collection: Catalogue of Pictures II*, 1986

Ironside and Gere 1948 R. Ironside and J. Gere, *Pre-Raphaelite Painters*, 1948

James 1948 W. James (ed.), *The Order of Release*, 1948

Kestner 1995 J.A. Kestner, 'The Pre-Raphaelites and Imperialism: John Everett Millais's *Pizarro Seizing the Inca of Peru, The Boyhood of Raleigh*, and *The North-West Passage*', *Journal of Pre-Raphaelite Studies*, spring 1995, pp.53–6

Lalumia 1984 M.P. Lalumia, *Realism and Politics in Victorian Art of the Crimean War*, Michigan 1984

Lancaster 1973 O. Lancaster, *The Littlehampton Bequest*, 1973

Lane Poole 1912 Mrs R. Lane Poole, *Catalogue of Oxford Portraits*, vol.1, Oxford 1912

Law 2000 G. Law, *Serializing Fiction in the Victorian Press*, Basingstoke 2000

Layard 1893 G.S. Layard, 'Millais and *Once a Week*', *Good Words*, Aug. 1893, pp.552–8

Layard 1894 G.S. Layard, *Tennyson and his Pre-Raphaelite Illustrators*, 1894

Leeds 1992 Leeds City Art Galleries, *Country House Lighting 1660–1890*, Leeds 1992

Leggatt 1958 *Autumn Exhibition in Aid of the Imperial Cancer Research Fund*, Leggatt Bros, London, October 1958

Lewis 1947 C. Day Lewis, *The Poetic Image*, 1947

Life 1976 A.R. Life, 'Periodical Illustrations of John Everett Millais and their Literary Interpretation', *Victorian Periodicals Newsletter*, 9 June 1976, pp.50–68

Lutyens 1965 M. Lutyens (ed.), *Effie in Venice: Unpublished Letters of Mrs John Ruskin Written from Venice Between 1849 and 1852*, 1965

Lutyens 1967 M. Lutyens (ed.), *Millais and the Ruskins*, 1967

Lutyens 1972 M. Lutyens (ed.), *The Ruskins and the Grays*, 1972

Lutyens 1972–4 M. Lutyens (ed.), 'Letters from Sir John Everett Millais, Bart, P.R.A. and William Holman Hunt, O.M. in the Henry E. Huntington Library, San Marino, California', *The Walpole Society*, vol.44, 1972–4, pp.1–93

Lutyens 1975 M. Lutyens, *The Parables of Our Lord and Saviour Jesus Christ with Pictures by John Everett Millais*, New York 1975

Lutyens and Warner 1983 M. Lutyens and M. Warner (eds.), *Rainy Days at Brig O'Turk: The Highland Sketches of John Everett Millais*, Westerham 1983

MacColl 1908 D.S. MacColl, 'Millais's Portrait of Tennyson', *Burlington Magazine*, June 1908, pp.126–8

Macleod 1996 D.S. Macleod, *Art and the Victorian Middle Class: Money and the Making of Cultural Identity*, Cambridge, UK, and New York 1996

Mancoff 2001 D.N. Mancoff (ed.), *John Everett Millais: Beyond the Pre-Raphaelite Brotherhood*, London and New Haven 2001, including J.Codell, 'Empiricism, Naturalism and Science in Millais's Painting'; A. Helmreich, 'Poetry in Nature: Millais's Pure Landscapes', pp.149–80; J.Musson, 'Had a Paint Pot Done All This? The Studio-House of Sir John Everett Millais'

Mason 1978 M.Mason, 'The Way We Look Now: Millais' Illustrations to Trollope', *Art History*, vol.1, no.3, Sept. 1978, pp.309–40

Massingham 1966 B. Massingham, *Miss Jekyll: Portrait of a Great Gardener*, 1966

Meier-Graefe 1908 J. Meier-Graefe, *Modern Art*, 1908

Melville 1997 J. Melville, 'An Album of Photographs Compiled by Sir John Everett Millais', *Studies in Photography*, 1997

Melville 2005 J. Melville, *Phillip of Spain: The Life and Art of John Phillip 1817–1867*, exh. cat. Aberdeen Art Gallery 2005

Millais 1888 J.E. Millais, 'Thoughts on our Art of Today', *Magazine of Art*, 20, 1888

Millais 1, 1899; Millais 2, 1899 J.G. Millais, *The Life and Letters of Sir John Everett Millais*, 2 vols., 1899

Moller 1988 J. Moller (ed.), *Imagination on a Long Rein*, Marburg 1988, including W. Vaughan, 'Incongruous Disciples: The Pre-Raphaelite and the Moxon Tennyson', pp.148–60

Morris 1970 E. Morris, 'The subject of Millais's *Christ in the House of his Parents*', *Journal of the Warburg and Courtauld Institutes*, 33, 1970, pp.343–5

Munro 1996 J. Munro, *Tennyson and Trollope: Book Illustrations by John Everett Millais (1829–1896)*, Cambridge 1996

Musgrave 1995 M. Musgrave, *The Musical Life of the Crystal Palace*, Cambridge, 1995

Nahum 2005 P. Nahum, *The Brotherhood of Ruralists and Pre-Raphaelites*, exh. cat., Leicester Galleries, London, 2005

Nellor 1995 L.M. Nellor, *Honest Truth and Titian Beauty: Red Hair in Pre-Raphaelite Painting 1849–1880*, MA thesis, Courtauld Institute, University of London, 1995

Newcastle 1989 *Pre-Raphaelites: Patrons and Painters in the North East*, exh. cat., Laing Art Gallery, Newcastle upon Tyne, 1989

New York 2004 B. Gallati, *Great Expectations: John Singer Sargent Painting Children*, exh. cat., Brooklyn Museum, New York, 2004

NPG 1999 P. Funnell *et al.*, *Millais's Portraits*, exh. cat., National Portrait Gallery, London, 1999

Oldcastle 1881 J. Oldcastle, 'The Homes of our Artists: Mr Millais' House at Palace Gate', *Magazine of Art*, vol.4, 1881

Palgrave 1866 F.T. Palgrave, *Essays in Art*, 1866

Pantazi 1976 S. Pantazi, 'Author and Illustrator: Images in Confrontation', *Victorian Periodicals Newsletter*, vol.9, no.2, June 1976, pp.39–50

Parris 1984 L. Parris (ed.), *Pre-Raphaelite Papers*, 1984, including A. Grieve, 'Style and content in Pre-Raphaelite Drawings, 1848–50', pp.23–43; M. Warner, 'John Everett Millais's "Autumn Leaves": "A Picture Full of Beauty and Without Subject"', pp.137–8

Pennell 1921 E.R. and J. Pennell, *The Whistler Journal*, Philadelphia, 1921

Phythian 1911 J.E. Phythian, *Millais*, 1911

Polhemus 1994 R.M. Polhemus, 'John Millais's Children: Faith, Erotics, and *The Woodman's Daughter*', *Victorian Studies*, 37, 3, spring 1994, pp.433–50

Potter 1989 B. Potter, *The Journal of Beatrix Potter 1881–1897*, transcribed by Leslie Linder, 1989

Prettejohn 1991 E. Prettejohn, *Images of the Past in Victorian Painting 1855–1871*, Ph.D thesis, Courtauld Institute, University of London, 1991

Prettejohn 2000 E. Prettejohn, *The Art of the Pre-Raphaelites*, Princeton 2000

Quilter 1892 H. Quilter, *Preferences in Art, Life, and Literature*, 1892

RA 2003 *Pre-Raphaelite and Other Masters: The Andrew Lloyd Webber Collection*, exh. cat., Royal Academy of Arts, London, 2003

RA and Liverpool 1967 M. Bennett, *Sir John Everett Millais, Bart., PRB., PRA.*, exh. cat., Royal Academy of Arts, London, and Walker Art Gallery, Liverpool, 1967

Reid 1928 Forrest Reid, *Illustrators of the Sixties*, 1928

Reis 1992 P. Tamarkin Reis, 'Victorian Centerfold: Another look at Millais's *Cherry Ripe*', *Victorian Studies*, vol.35, no.2, winter 1992, pp.201–5

Riding 2006 C. Riding, *John Everett Millais*, 2006

Riede 1992 A. Riede, *Dante Gabriel Rossetti Revisited*, New York 1992

Rossetti 1867 W.M. Rossetti, *Fine Art, Chiefly Contemporary: Notices Reprinted, With Revisions*, 1867

Rossetti 1903 W.M. Rossetti, *Rossetti Papers 1862–1870*, 1903

Rossetti and Swinburne 1868 W.M. Rossetti and A. Swinburne, *Notes on the Royal Academy Exhibition, 1868*, 1868

Ruskin 1–39, 1903–12 *The Works of John Ruskin*, ed. E.T. Cook and A. Wedderburn, 39 vols., 1903–12

Ruskin and Crawford 1886 J. Ruskin and A. Gordon Crawford, *Notes on Some of the Principal Pictures of Sir John Everett Millais, Exhibited at the Grosvenor Gallery, 1886*, 1886

Sadleir 1933 M.T.H. Sadleir, *Trollope: A Commentary*, 1933

Shakespear 1898 O. Shakespear, *Rupert Armstrong*, 1898

Sickert 1929 R. Sickert, 'John Everett Millais' *The Fortnightly Review*, vol.125, 1929, pp.753–62

Sitwell 1937 S. Sitwell, *Narrative Pictures: A Survey of English Genre and its Painters*, 1937

Solicari 2007 S. Solicari, 'Selling Sentiment: The Commodification of Emotion in Victorian Visual Culture' in *Interdisciplinary Studies in the Long Nineteenth Century*, Birkbeck College, on-line journal, March 2007

Soseki 1984 N. Soseki, *The Three-Cornered World*, trans. Alan Turney (1965) 1984

Southampton 1996 C. Donovan and J. Bushnell, *John Everett Millais 1829–1896: A Centenary Exhibition*, exh. cat., Millais Gallery, Southampton Institute, 1996

Spielmann 1898 M.H. Spielmann, *Millais and his Works*, Edinburgh and London 1898

Staley 1995 A. Staley *et al.*, *The Post-Pre-Raphaelite Print: Etching, Illustration, Reproductive Engraving and Photography in England Around the 1860s*, New York 1995

Staley 2001 A. Staley, *The Pre-Raphaelite Landscape* (1973) London and New Haven, 2001.

Stephens 1886 F.G. Stephens, *Exhibition of Works of Sir J.E. Millais*, 1886

Strickland 1840 A. Strickland, *Lives of the Queens of England*, 1840

Sullivan 1984 A. Sullivan, *British Literary Magazines: The Victorian and Edwardian Age 1837–1913*, 1984

Suriano 2000 G.R. Suriano, *The Pre-Raphaelite Illustrators: The Published Graphic Art of the English Pre-Raphaelites and their Associates [...]*, New Castle, Delaware, and London 2000

Surtees 1971 V. Surtees, *The Paintings and Drawings of Dante Gabriel Rossetti (1828–1882): A Catalogue Raisonée*, Oxford 1971

Surtees 1981 V. Surtees (ed.), *The Diary of Ford Madox Brown*, 1981

Symons 1896 A. Symons, 'The Lesson of Millais', *Savoy*, 6, Oct. 1896, pp.57–8

Tate 1973 L. Parris, *Landscape in Britain c.1750–1850*, exh. cat., Tate Gallery, London, 1973

Tate 1984 L. Parris (ed.), *The Pre-Raphaelites*, exh. cat., Tate Gallery, London, 1984 (1994 ed.)

Tate 1997 A. Wilton and R. Upstone (eds.), *The Age of Rossetti, Burne-Jones and Watts: Symbolism in Britain 1860–1910*, exh. cat., Tate Gallery, London, 1997

Tate 2000 R. Hewison, I. Warrell and S. Wildman, *Ruskin Turner and the Pre-Raphaelites*, exh. cat., Tate Gallery, London, 2000

Tate 2004 A. Staley, C. Newall *et al.*, *Pre-Raphaelite Vision: Truth to Nature*, exh. cat., Tate Britain, London, 2004

Thackeray 1920 W.M. Thackeray, *Vanity Fair*, 1920 (1847)

Thomas 2004 J. Thomas, *Pictorial Victorians: The Inscription of Values in Word and Image*, Athens, Ohio, 2004

Townsend 2004 J.H. Townsend, J. Ridge, and S. Hackney, *Pre-Raphaelite Painting Techniques 1848–56*, 2004

Tromans 2002 N. Tromans, *David Wilkie: Painter of Everyday Life*, exh. cat., Dulwich Picture Gallery, London, 2002

Tsui 2006 A. Tsui, 'The Phantasm of Aesthetic Autonomy in Whistler's Work: Titling the *White Girl*', *Art History*, 29, vol.3, June 2006, pp.444–75

Vaughan 1979 W. Vaughan, *German Romanticism and English Art*, 1979

Walker 2004 J.A. Walker, 'The People's Hero: Millais's *The Rescue* and the Image of the Fireman in Nineteenth-Century Art and Media', *Apollo*, 5, 160, Dec. 2004, pp.56–62

Warner 1985 M. Warner, *The Professional Career of John Everett Millais to 1863*, Ph.D thesis, Courtauld Institute of Art, London 1985

Washington 1996 M. Warner, *The Victorians: British Painting 1837–1901*, exh. cat., National Gallery of Art, Washington, 1996

Watson 1997 M. Frederick Watson (ed.), *Collecting the Pre-Raphaelites: The Anglo-American Enchantment*, Aldershot 1997, including B.Wingard Lewis, 'A Conflict of Intentions: Tennyson versus Pre-Raphaelite Illustrators'

Watts 1912 M.S. Watts, *George Frederic Watts: The Annals of an Artist's Life*, 3 vols, 1912

Webb 1997 B.C.L. Webb, *Millais and the Hogsmill River*, New Malden, Surrey, 1997

Werner 2005 M. Werner, *Pre-Raphaelite Painting and Nineteenth-Century Realism*, Cambridge 2005

Wickham 2003 A. Wickham, 'From Prodigy to President: John Everett Millais and the Royal Academy', *PRS*, Pre-Raphaelite Society, vol.11, no.2, autumn 2003

Wickham 2004 A. Wickham, 'Breaking the Rules: The Rejection of Millais's Royal Academy Diploma Work', *The Pre-Raphaelite Ideal*, Leeds Centre Working Papers in Victorian Studies, vol.7, ed. P. Hardwick and M. Hewitt, Leeds 2004, pp.89–99

Wildman 1995 S. Wildman *et al.*, *Visions of Love and Life: Pre-Raphaelite Art from Birmingham Museums and Art Gallery*, Alexandria, Virginia, 1995

Wynne 2001 D. Wynne, *The Sensation Novel and the Victorian Family Magazine*, Basingstoke 2001

Young 1980 P. Young, 'Millais' "Leisure Hours"', *Bulletin of the Detroit Institute of the Arts*, 58, no.3, 1980, pp.118–25

Exhibitions

Exhibitions are listed chronologically. Where the abbreviated form appears in the catalogue entry as, for example, 'FAS 1881', the full details will be listed under '1881', followed by 'FAS'.

1846–1896
Royal Academy of Arts, Trafalgar Square, London, *Annual Exhibitions*, 1846–68
Royal Academy of Arts, Burlington House, Piccadilly, London, *Annual Exhibitions*, 1869–96
Liverpool 1846, 1852, 1855, 1857–8, 1867
Liverpool Academy, *Annual Exhibitions*

1847
Society of Arts Society of Arts, London

1850s–
NLSDM North London School of Drawing and Modelling, Mary's Terrace, Camden Town, London *Christmas Exhibition*
Birmingham 1852 and 1856
Birmingham Society of Artists, *Exhibitions of Modern Works of Art*
RSA 1852, 1853, 1854, 1858, 1859, 1869, 1879, 1881, 1897 Royal Scottish Academy, Edinburgh

1855
Paris Palais des Industries, Paris, *Exposition Universelle*, 15 May–30 November

1857
Manchester Manchester, *Art Treasures of the United Kingdom*, 5 May–17 October
Russell Place 4 Russell Place, Fitzroy Square, London, *Pre-Raphaelite Exhibition*, c.May–late June

1857–9
Langham Chambers Millais Studio, 4 Langham Chambers, 1 Langham Place, Regent Street, London

1858–9
French Gallery French Gallery, 120 Pall Mall, London, *Cabinet Pictures, Sketches & Watercolours*, 25 October 1858–8 January 1859

1859
French Gallery French Gallery, 120 Pall Mall, London, *Cabinet Pictures, Sketches & Watercolours*, 18 November–24 December
New York National Academy of Design, New York, *The Second Exhibition in New York of Paintings, the Contributions of Artists of the French and English Schools*, 12 September–29 October

1861
Liverpool Liverpool Institute, Mount Street, *An Exhibition of Rare and Valuable Works of Art, Paintings, Water-Colour Drawings, &c.*, 30 September–26 October

1862
London Cromwell Road, South Kensington, London, *International Exhibition*, 1 May–1 November

1864
Manchester Manchester, Academy of Fine Arts, *Autumn Exhibition*
Manchester 1864a Manchester Royal Institution

1865
Birmingham Birmingham Society of Artists, *Exhibition of Modern Works of Art*, 28 August–13 December
Dublin Dublin, *International Exhibition of Arts and Manufactures*

1867
Paris Champs de Mars, Paris, *Exposition Universelle*, 1 April–31 October

1868
Leeds Leeds Royal Infirmary, *National Fine Arts Exhibition, Gallery of British Living Painters in Oil*, 19 May–31 October

1871
London South Kensington, London, *International Exhibition*, 1 May–1 October

1872
London South Kensington, London, *International Exhibition*

1877–85, 1887–90
GG Grosvenor Gallery, 135–7 New Bond Street, London, *Annual Summer Exhibitions*

1878
Manchester Royal Manchester Institution, *Exhibition of Art Treasures in Aid of the Fund for Erecting a School of Art*, 16 May–July
Paris Paris, *Exposition Universelle*, 1 May–10 November

1879
Agnew Thos. Agnew's & Sons Galleries, London, February–April
Glasgow Royal Glasgow Institute
Liverpool Thomas Agnew's & Sons Galleries, Liverpool, *Annual Exhibition of Pictures*
Munich Munich, *Exhibition*

1880
Liverpool Walker Art Gallery, Liverpool, *Autumn Exhibition*, 6 September–4 December

1881
FAS Fine Art Society, London, *The Collected Works of John Everett Millais*
Liverpool Walker Art Gallery, Liverpool, *Autumn Exhibition*, 5 September–3 December
Stonehaven Stonehaven, *Kincardineshire Exhibition*

1882
Worcester Worcester, *Worcestershire Exhibition of Fine Arts, Industries, and Historical Objects*, 18 July–17 October

1883
FAS Fine Art Society, London, *Pictures of Children*
Huddersfield Technical Schools and Mechanics' Institute, Huddersfield, *Fine Art and Industrial Exhibition*, 7 July–1 December

1884
FAS Fine Art Society, London, *Alfred Hunt Exhibition*
Liverpool Walker Art Gallery, Liverpool, *Autumn Exhibition*, 1 September–6 December

1885
Manchester Manchester Corporation Art Gallery, *Autumn Exhibition*

1886
GG Grosvenor Gallery, London, *Exhibition of the Works of Sir John E. Millais, Bart., R.A.*, winter
Liverpool Walker Art Gallery, Liverpool, *Grand Loan Exhibition of Pictures*

1887
Manchester Manchester Institution, *Manchester Royal Jubilee Exhibition*, 3 May–10 November

1888
Conway Royal Cambrian Academy, Conway, *Annual Exhibition*
Glasgow Kelvingrove Park, Glasgow, *International Exhibition*, 8 May–10 November
Leeds City Art Gallery, Leeds, *Inaugural Loan Collection*
Montreal Art Association of Montreal, *Loan Exhibition of Oil Paintings and Water Colour Drawings*, 23 November–15 December

1888–9
Melbourne Royal Exhibition Building, Melbourne, *Centennial International Exhibition*, 1 August 1888–1 February 1889

1889
Paris Palais du Champ de Mars (Galerie des Beaux-Arts), Paris, *Exposition Universelle*, 6 May–31 October
Whitechapel St Jude's School House, Commercial Road, Whitechapel, London, *Annual Exhibition*, 9–28 April

1890
Guildhall Corporation of London Art Gallery, *Loan Collection of Pictures*, 12 June–31 August
New Gallery New Gallery, London, *Summer Exhibition*

1891–2
Birmingham Birmingham Museum and City Art Gallery, *The Permanent Collection of Paintings, and a Special Loan Collection of Modern Pictures*, 2 October 1891–1892
New Gallery New Gallery, London, *The Victorian Exhibition, Illustrating Fifty Years of Her Majesty's Reign, 1837–1887*, 2 December 1891–2 April 1892

1892
Guildhall Corporation of London Art Gallery, *Loan Collection of Pictures*, 28 March–30 June

1893
Bristol Bristol, *Industrial and Fine Art Exhibition*
Chicago Chicago, *World's Columbian Exhibition*, 1 May–31 October

1894
Guildhall Corporation of London Art Gallery, *Loan Collection of Pictures*, 2 April–30 June
Liverpool Walker Art Gallery, Liverpool, *Autumn Exhibition*, 12 September–15 December
Whitechapel St Jude's School House, Commercial Road, Whitechapel, London, *Annual Exhibition*, 21 March–8 April

1895
Grafton Grafton Galleries, London, *Fair Children*, May
Guildhall Corporation of London Art Gallery, *Loan Collection of Pictures*, 23 April–21 July
Venice Venice, *Biennale (Prima esposizione internazionale d'arte della citta di Venezia)*

1896
Grafton Grafton Galleries, London, *Society of Portrait Painters*

1897
Brussels Brussels, *Exposition Internationale des Bruxelles*
London Earl's Court, London, *The Victorian Era*
Guildhall Corporation of London Art Gallery, *Loan Collection of Pictures, By Painters of the British School Who Have Flourished During Her Majesty's Reign*, 7 April–14 July
SPP Royal Society of Portrait Painters, London, *Annual Exhibition*
Edinburgh [no details available]

1898
Glasgow People's Palace Museum, Glasgow, *Inaugural Art Exhibition*
RA Royal Academy of Arts, London, *Works by the Late Sir John Everett Millais*
Whitechapel St Jude's School House, Commercial Road, Whitechapel, London, *Annual Exhibition*

1900–1
RA Royal Academy of Arts, London, *Works by British Artists Deceased since 1850*

1901
Glasgow Kelvingrove Park, Glasgow, *International Exhibition*, 2 May–9 November
FAS Fine Art Society, New Bond Street, London, *Pictures, Drawings, and Studies by the late Sir J.E. Millais, P.R.A.*
Whitechapel Whitechapel Art Gallery, London, *Winter Exhibition*

1902
Cork Cork, *International Exhibition*, 1 May–1 November
Port Sunlight 1902a Hulme Hall, Port Sunlight, *Art Exhibition to Celebrate the Coronation*
Port Sunlight 1902b Hulme Hall, Port Sunlight, *Autumn Art Exhibition*

1903
Glasgow Royal Glasgow Institute of the Fine Arts
London Earl's Court, London, *International Fire Exhibition*

1904
Bradford Bradford, *Exhibition of Fine Arts: Works of Art in the Cartwright Memorial Hall*, 4 May–October
Manchester 1904a City Art Gallery, Manchester, *Ruskin Exhibition*, 23 March–14 May
Manchester 1904b Agnew's, Manchester
Newcastle Laing Art Gallery, Newcastle, *Special Inaugural Exhibition of Pictures by British and Foreign Artists*, opened 13 October
St Louis St Louis, Missouri, *Louisiana Purchase Exhibition*, 30 April–1 December

1905
Whitechapel Whitechapel Art Gallery, London, *British Art Fifty Years Ago*

1906
BFAC Burlington Fine Arts Club, London

1906–7
Manchester City Art Gallery, Manchester, *The Collected Works of W. Holman Hunt, O.M., D.C.L.*, 3 December 1906–27 January 1907

1907
Dublin Dublin, *Irish International Exhibition, British and Foreign Artists*, 4 May–19 November
Glasgow Kelvingrove Art Gallery, Glasgow, *Exhibition of Pictures and Drawings by W. Holman Hunt, O.M., D.C.L.*, 15 March–April
Liverpool Walker Art Gallery, Liverpool, *Collective Exhibition of the Art of William Holman Hunt, O.M., D.C.L.*, 2 February–2 March

1908
London Palace of Fine Arts, Shepherds Bush, London, *Franco-British Exhibition*, 14 May–31 October 1908

1909
RA Royal Academy of Arts, London, *The McCulloch Collection of Modern Art*, Winter

1910
Grafton Grafton Galleries, London, *International Society of Sculptors, Painters & Gravers, Third Exhibition of Fair Women*, 26 May–31 July
Liverpool Walker Art Gallery, *Autumn Exhibition*

1911
Carfax Carfax & Co. Gallery, Bury Street, St James's, London, *A Century of Art, 1810–1910*
Manchester City of Manchester Art Gallery, *Loan Exhibition of Works by Ford Madox Brown and the Pre-Raphaelites*, 14 September–late November
Rome British Art Palace, Rome, *Esposizione internazionale di Belle Arti*, opened 28 March

1911–12
Tate Tate Gallery, London, *Works by the English Pre-Raphaelite Painters Lent by the Art Gallery Committee of the Birmingham Corporation*, December 1911–March 1912
Birkenhead [no details available]
BFAC Burlington Fine Arts Club, London

1913
Bath Victoria Art Gallery, Bath, *Autumn Loan Exhibition of Works by Pre-Raphaelite Painters from Collections in Lancashire*, 10 November–6 December
Birmingham Birmingham City Museum and Art Gallery, 'The Collection of Drawings and Studies by Sir E. Burne-Jones . . . etc'
Glasgow Royal Glasgow Institution
Tate Tate Gallery, London, *Works by Pre-Raphaelite Painters from Collections in Lancashire*, July–September

1917
NGL National Gallery, London, *English 19th-Century Art*

1919–20
RA Royal Academy of Arts, London, *Winter Exhibition*

1920
Whitechapel Whitechapel Art Gallery, London, *British Art, 1830–1850*

1921
Liverpool Walker Art Gallery, *Autumn Exhibition*

1922
Liverpool Walker Art Gallery, *Liverpool Jubilee Exhibition*, 23 September–9 December

1923
Tate Tate Gallery, London, *Paintings and Drawings of the 1860s Period*, 27 April–29 July

1923–4
Liverpool Walker Art Gallery, *Liverpool Autumn Exhibition*, 20 October 1923–5 January 1924

1924
London Palace of Arts, Wembley, London, *British Empire Exhibition*, 23 April–31 October

1926
RP Royal Society of Portrait Painters, London

1927
Vienna Vienna, *Meisterwerke Englisher Malerei*

1929
Brussels Musée Moderne, Brussels, *Exposition rétrospective de peinture anglaise (XVIIIe et XIX siècles)*, 12 October–1 December

1930
Bradford City of Bradford Corporation Art Gallery, Cartwright Memorial Hall, *Jubilee Exhibition*

1933
Liverpool Walker Art Gallery, *Autumn Exhibition*, 4 October–13 December

1934
RA Royal Academy of Arts, London, *Exhibition of British Art c.1000–1860*, 6 January–10 March
Venice British Pavilion, Venice, *Esposizione internazionale d'Arte, XIXth Biennale*, May–October

1935–6
Europe Bucharest, Vienna, Prague, *English Drawings and Engravings*

1936
Amsterdam Stedelijk Museum, Amsterdam, *Twee Eeuwen Engelsche Kunst*
Toronto Toronto, Ontario, Canadian National Exhibition: British Painting and Sculpture, 28 August–12 September

1937
RBA Royal Society of British Artists, London, *Coronation Exhibition*, 19 April–5 June

1938
Glasgow Palace of Arts, Bellahouston Park, Glasgow, *Empire Exhibition, Scotland*, 3 May–29 October
Paris Palais du Louvre, Paris, *Chefs-d'oeuvre de la peinture anglaise: XVIIIe et XIXe siècles*, 4 March–c.June

1939
RA Royal Academy of Arts, London, *Diploma Gallery*

1943–4
RSBA Royal Society of British Artists, *Some Victorian and Edwardian Draughtsmen*, 1 December 1943–31 January 1944

1945
Roland, Browse & Delbanco
Roland, Browse and Delbanco, *Reality & Vision in Three Centuries of English Drawing*, March–April

1947
Birmingham City Museums and Art Gallery, Birmingham, *The Pre-Raphaelite Brotherhood*, 7 June–27 July

1948
Manchester City Art Gallery, Manchester, *Pre-Raphaelite Masterpieces, 1848–62*, 14 June–8 August
Port Sunlight Lady Lever Art Gallery, Port Sunlight, *Centenary Exhibition of Works by the Pre-Raphaelites–Their Friends and Followers*, 14 June–29 August
Tate Tate Gallery, London, *The Pre-Raphaelite Brotherhood 1848–1948: A Centenary Exhibition*, September
Whitechapel Whitechapel Art Gallery, London, *The Pre-Raphaelites: A Loan Exhibition of their Paintings and Drawings Held in the Centenary Year of the Foundation of the Brotherhood*, 8 April–12 May

1949
Port Sunlight Lady Lever Art Gallery, Port Sunlight, *Theatre Exhibition*
RA Royal Academy of Arts, London, *Exhibition of the Chantrey Collection*, 8 January–6 March

1950
Arts Council Arts Council of Great Britain, Southern Regional Travelling Exhibition, *English Portraits 1850–1950*, c.May–August

1951
Bournemouth Russell-Cotes Art Gallery, Bournemouth, *Paintings and Drawings by the Pre-Raphaelites and their Followers*, 4 June–7 August
ICA Institute of Contemporary Arts, London, *Ten Decades: A Review of British Taste, 1851–1951*, 10 August–27 September
Tate Tate Gallery, London, *An Exhibition of Theatrical Pictures from the Garrick Club*, 9 August–9 September

1951–2
RA Royal Academy of Arts, London, *The First Hundred Years of the Royal Academy, 1769–1868*, 8 December 1951–9 March 1952

1952
Sheffield Graves Art Gallery, Sheffield, *Some Famous Pre-Raphaelites*

1953
Arts Council Cambridge Arts Council Gallery, Norwich Assembly Rooms, Bristol City Art Gallery, Hatton Gallery, Newcastle upon Tyne, *Pre-Raphaelite Drawings and Watercolours*, 16 May–24 October

1955
Wales National Library of Wales, Aberystwyth, and Glynn Vivian Art Gallery, Swansea, Arts Council of Great Britain, Welsh Committee, *Some Pre-Raphaelite Paintings and Drawings*, July–October

1956–7
USA Museum of Modern Art, New York; City Art Museum, St Louis, Missouri; California Palace of the Legion of Honor, San Francisco, *Masters of British Painting 1800–1950*, 2 October 1956–12 May 1957
RA Royal Academy of Arts, London, *British Portraits*, 24 November 1956–3 March 1957

1958
Leggatt Leggatt Bros, 30 St James's Street, London, *Autumn Exhibition in Aid of the Imperial Cancer Research Fund*, 3–24 October
Kansas University of Kansas Museum of Art, Lawrence, Kansas, *Dante Gabriel Rossetti and his Circle*, 4 November–15 December
Midland Federation *English Eye*
RA Royal Academy of Arts, London, *The Robinson Collection: Paintings from the Collection of the Late Sir J.B. Robinson, Bt., Lent by the Princess Labia*, 2 July–14 September

1959
Hampstead Burgh House, Hampstead, *Treasures from Hampstead Houses*
NGSA National Gallery of South Africa, Cape Town, *The Sir Joseph Robinson Collection, Lent by the Princess Labia*
Nottingham University Art Gallery, Nottingham, and Whitechapel Art Gallery, London, *Victorian Paintings*, 20 January–21 June

1960
Liverpool Walker Art Gallery, Liverpool, *Liverpool Academy 150th Anniversary Exhibition*, 3 June–3 July
Moscow, Leningrad Pushkin Museum, Moscow, and Hermitage Museum, Leningrad, *British Painting 1700–1960 (British Council)*, February–August
SPP Royal Society of Portrait Painters, London, *Annual Exhibition*

1961
Agnew's Agnew's, 43 Old Bond Street, London, *Loan Exhibition of Victorian Painting 1837–1887: In Aid of the Victorian Society*, 22 November–16 December
Whitworth Whitworth Art Gallery, University of Manchester, *Pre-Raphaelite Paintings, Drawings and Book Illustration*, 1 February–19 April

1962
Arts Council Aldeburgh Festival of Music and the Arts, Suffolk; Walker Art Gallery, Liverpool; and Cannon Hall, Barnsley, *Victorian Paintings*, 14 June–1 September
Australia National Gallery of South Australia, Adelaide; Western Australian Art Gallery, Perth; Tasmanian Museum and Art Gallery, Hobart; National Gallery of Victoria, Melbourne; Queensland Art Gallery, Brisbane; Art Gallery of New South Wales, Sydney, *Pre-Raphaelite Art: Paintings, Drawings, Engravings, Sculpture, Chintzes, Wallpapers: An Exhibition Arranged by the State Art Galleries of Australia*, March–October
RA Royal Academy of Arts, London, *Primitives to Picasso: an Exhibition from Municipal and University Collections in Great Britain*, 6 January–7 March
Zürich Kunsthaus, Zürich, *Sammlung Sir Joseph Robinson: Werke europäischer Malerei vom 15. Bis 19.Jahrhundert*, 17 August–16 September

1964
Arts Council Arts Council Gallery, London, *Ruskin and his Circle*, 17 January–15 February
Indianapolis and New York Herron Museum of Art, Indianapolis, Indiana, and Huntington Hartford Gallery of Modern Art, New York, *The Pre-Raphaelites: A Loan Exhibition of Paintings and Drawings by Members of the Pre-Raphaelite Brotherhood and their Associates*, 16 February–31 May

1965
Indianapolis Herron Museum of Art, Indianapolis, *The Romantic Era: Birth and Flowering 1750–1850*, 21 February–11 April
Jacksonville Cummer Gallery of Art, Jacksonville, Florida, *Artists of Victoria's England*, 2 February–14 March
Ottawa National Gallery of Canada, Ottawa, *An Exhibition of Paintings and Drawings by Victorian Artists in England*, March–April

1966
Lyon Musée de Lyon, France, *Peintures et aquarelles Anglaises, 1700–1900, du Musée de Birmingham*, 23 October–20 November

1967
RA and Liverpool Royal Academy of Arts, London, and Walker Art Gallery, Liverpool, *Millais: P.R.B./P.R.A.*, 14 January–5 March (Royal Academy); 15 March–30 April (Walker Art Gallery)

1968
Detroit and Philadelphia Detroit Institute of Arts and Philadelphia Museum of Art, *Romantic Art in Britain: Paintings and Drawings, 1760–1860*, 9 January–21 April
Leger Leger Galleries, London, *Truth to Nature*, 16 October–23 November
Sheffield Mappin Art Gallery, Sheffield, *Victorian Paintings: 1837–1890*, September–November

1968–9
RA Royal Academy of Arts, London, *Bicentenary Exhibition, 1768–1968*, 14 December 1968–2 March 1969

1969
Leicester Galleries Leicester Galleries, London, *The Victorian Romantics*
Liverpool and V&A Walker Art Gallery, Liverpool, and Victoria and Albert Museum, London, *William Holman Hunt*, 25 March–22 June
Devon Fairlynch Museum, Budleigh Salterton, 9 July–12 October
Toronto Art Gallery of Ontario, Toronto, *The Sacred and the Profane in Symbolist Art*, 1–26 November
Turin Galleria Civica d'Arte Moderna, Turin, *Il Sacro e profano nell'arte dei simbolisti*, June–August

1970
Brighton Brighton Museum and Art Gallery, *Death, Heaven and the Victorians*, 6 May–3 August

1971
Florence Pitti Palace, Florence, Italy, *Firenze e l'Inghilterra. Rapporti artistici e culturali dal XVI al XX secolo*, July–September
King's Lynn Fermoy Art Gallery, King's Lynn, *The Pre-Raphaelites as Painters and Draughtsmen, A Loan Exhibition from Two Private Collections*, 24 July–8 August
Sotheby's Sotheby's, London, *Art into Art*, 1971
New York and Philadelphia Wildenstein, 19 East 64th Street, New York, and Philadelphia Museum of Art, *From Realism to Symbolism: Whistler and His World*, 4 March–23 May
Peoria Lakeview Center for the Arts and Sciences, Peoria, Illinois, *The Victorian Rebellion: A Loan Exhibition of Works by the Pre-Raphaelite Brotherhood and their Contemporaries*, 12 September–26 October
SLAG South London Art Gallery, *Mid-Victorian Art: Draughtsmen and Dreamers*, 22 October–10 November

1972
Miami Lowe Art Museum, University of Miami, Coral Gables, Florida, *The Revolt of the Pre-Raphaelites*, 5 March–9 April
Minneapolis Minneapolis Institute of Arts, Minnesota, *The Female Image*, 6 June–29 June
Paris Petit Palais, Paris, *La peinture romantique anglaise et les pré-raphaélites*, 21 January–16 April
Whitechapel Whitechapel Art Gallery, London, *The Pre-Raphaelites*, 16 May–14 June

1972–3
Bucharest and Budapest Muzeul de artâ al Republicii Socialiste România, Bucharest and Budapest, British Council Exhibition, *Portretul Engles*, November 1972–January 1973

1973
Colnaghi P. and D. Colnaghi and Co., London, *English Drawings, Water-colours and Paintings*
Maas Maas Gallery, London, *The Pre-Raphaelite Influence*, 18 June–6 July

1973–4
Baden-Baden Staatliche Kunsthalle, Baden-Baden and Städelsche Kunstinstitut, Frankfurt *Präraffeliten*, 23 November 1973–5 May 1974
Tate Tate Gallery, London, *Landscape in Britain c.1750–1850*, 20 November 1973–3 February 1974

1974
Agnew's Thos. Agnew & Sons Ltd, 43 Old Bond Street, London, *Pre-Raphaelite Paintings from Manchester*, 16 July–9 August
Cambridge and New York Hayden Gallery, Massachusetts Institute of Technology, Cambridge; New York Cultural Center, *19th Century Paintings from the Museo de Arte de Ponce*, May–August
Maas Maas Gallery, London, *Stunners: Paintings and Drawings by the Pre-Raphaelites and Others*, 24 June–12 July

1975
Mitsukoshi Mitsukoshi Co., British Fair and Exhibition, Tokyo, *The Queens of Great Britain*
Tokyo National Museum of Western Art, Tokyo, *English Portraits from Francis Bacon, the Philosopher, to Francis Bacon, the Painter*, 25 October–14 December

1975–6
Rotterdam Museum Boymans-Van Beuningen, Rotterdam, *Symbolism in Europe*

1975–7
US and Paris National Gallery of Art, Washington; Cleveland Museum of Art; Grand Palais, Paris, *The European Vision of America*, 7 December 1975–3 January 1977

1976
Colnaghi P. and D. Colnaghi and Co., London, *English Drawings, Water-colours and Paintings*
Portsmouth City Museum and Art Gallery, Portsmouth, *Pre- Raphaelite Drawings. An Exhibition of drawings by William Holman Hunt, John Everett Millais, Dante Gabriel Rossetti, Ford Madox Brown*, 2 May–20 June
Maas Maas Gallery, London, *Gambart: Prince of the Victorian Art World*, 22 January–12 February
Wilmington Delaware Museum of Art, Wilmington, *The Pre-Raphaelite Era 1848–1914*,12 April–6 June

1977
BAC Yale Center for British Art, New Haven, *50 Beautiful Drawings*, August–October
Brighton Royal Pavilion, Art Gallery and Museums, Brighton, *Royal Children Through the Ages*, 5 July–25 September
FAS Fine Art Society, London, *Victorian Painting*, 15 November–9 December
Maas Maas Gallery, London, *An Exhibition of Pre-Raphaelite and Romantic Paintings, Drawings, Water-colours and Prints*, 31 January–18 February
RA Royal Academy of Arts, London, *'This Brilliant Year': Queen Victoria's Jubilee*, 19 March–10 July

1977–8
V&A Victoria and Albert Museum, London, *The Bible in British Art: 10th to 20th Centuries*, September 1977–January 1978

1978
Arts Council Leeds City Art Gallery; Leicestershire Museum and Art Gallery; City Art Gallery, Bristol; and Royal Academy of Arts, London, *Great Victorian Pictures: Their Paths to Fame*
Edinburgh National Gallery of Scotland, Edinburgh, *The Discovery of Scotland: The Appreciation of Scottish Scenery Through Two Centuries of Painting*
Roy Miles Roy Miles Fine Paintings, 6 Duke Street, St James's, London, *The Victorian Ideal: An Exhibition of Paintings, Drawings and Watercolours*, 14 June–28 July
Melbourne National Gallery of Victoria, Melbourne, *The Pre-Raphaelites and their Circle*

1978–9
Wolverhampton and Sheffield Wolverhampton Art Gallery and Mappin Art Gallery, Sheffield, *'For King or Parliament': Attitudes of 19th Century Painters to the Civil War*, 21 October 1978–7 January 1979

1979
Arts Council Bolton Museum and Art Gallery; Brighton Museum and Art Gallery; Mappin Art Gallery, Sheffield; Fitzwilliam Museum, Cambridge; National Museum of Wales, Cardiff, *The Drawings of John Everett Millais*, 7 July–16 December
Jersey Barreau Art Gallery, Jersey Museum, St Helier, *Sir John Everett Millais, Bart., P.R.A. (1829–1896): An Exhibition Celebrating the 150th Anniversary of Millais's Birth*, 20 August–29 September
RA Royal Academy of Arts, London, *Derby Day 200*, 5 April–1 July

1979–80
Munich Haus der Kunst, Munich, *British Council Exhibition of Two Hundred Years of English Painting, British Art and Europe 1680–1880*, 21 November 1979–27 January 1980

1980
RA Royal Academy of Arts, London, *Lord Leverhulme, Founder of the Lady Lever Art Gallery and Port Sunlight on Merseyside*, 12 April–25 May

1981
Agnew's Thos. Agnew & Sons, London, *Thomas Holloway, the Benevolent Millionaire: A Loan Exhibition of Victorian Pictures from the Royal Holloway College in Aid of the Victorian Society*, 3 November–11 December
BAC Yale Center for British Art, New Haven, *Recent Acquisitions*
Hammersmith Riverside Studios, Hammersmith, London, *Victorian Paintings at Riverside*

1981–2
NPG National Portrait Gallery, London, *Thomas Carlyle 1795–1881*, 25 September 1981–10 January 1982
University of London University of London Institute of Education Art Centre; Graves Art Gallery, Sheffield, *Six Children Draw*

1982
BAC Yale Center for British Art, New Haven, *The Substance or the Shadow: Images of Victorian Womanhood*, 14 April–13 June
RA Royal Academy of Arts, London, *RA Retrospective*
Tate Tate Gallery, London, *Paint and Painting*, 9 June–18 July

1982–4
RA Society of the Four Arts, Palm Beach; Cincinnati Art Museum; National Academy of Design, New York; Seattle Art Museum; New Orleans Museum of Art; San Antonio Museum of Art; Virginia Museum of Fine Arts; Delaware Art Museum, *Paintings from the Royal Academy: Two Centuries of British Art*, 7 January 1982–15 April 1984

1983
FAS Fine Art Society, London and Edinburgh, *Rainy Days at Brig o'Turk*
Arts Council Hayward Gallery, London, Bristol City Museum and Art Gallery, Stoke on Trent City Museum and Art Gallery, and Mappin Art Gallery, Sheffield, *Landscape in Britain, 1850–1950*, 10 February–28 August
Montreal Musée de Beaux-Arts, Montreal, *'Truth of Foreground': Millais' St Martin's Summer, Halcyon Days*, 16 June–18 September

1984
Tate Tate Gallery, London, *The Pre-Raphaelites*, 7 March–28 May
Barbican 1984 Barbican Art Gallery, London, *The City's Pictures: A Selection of Paintings from the Collection of the Corporation of London*, 9 February–28 October
BM British Museum, London, *Master Drawings and Watercolours*
Hong Kong Hong Kong Museum of Art, *Pre-Raphaelite Art from the Birmingham Museums and Art Gallery*, 20 October–2 December

1985
Brighton Brighton Museum, *Treasures from Sussex Houses: Bronzino to Boy George*, 17 September–10 November
Brown University Bell Gallery, List Art Center, Brown University, Providence, Rhode Island, *Ladies of Shalott: A Victorian Masterpiece and its Contexts*, 23 February–23 March
Davis & Langdale Davis & Langdale Company, 746 Madison Avenue, New York, *British Drawings 1760–1825*, 2–31 May
Japan Isetan Museum of Art, Shinjuki, Tokyo; Hamamatsu City Museum, Aichi Prefectural Art Gallery, Daimaru Museum of Art, Osaka; Yamanashi Prefectural Museum of Art, *The Pre-Raphaelites and their Times*, 24 January–23 June
London Museum of London, *The Quiet Conquest: The Huguenots 1685–1985*, 15 May–31 October
SNPG Scottish National Portrait Gallery, Edinburgh, *Treasures of Fyvie*, 4 July–29 September

1986–7
BAC Yale Center for British Art, New Haven, *Acquisitions: The First Decade, 1977–1986*, 19 November 1986–25 January 1987

1987
Japan Isetan Museum of Art, Shinjuki, Tokyo; Museum of Modern Art, Shiga; Daimaru Museum, Osaka, *The Pre-Raphaelites in Oxford*, 9 July–9 November

1987–8
Manchester, Amsterdam and BAC Manchester City Art Gallery; Rijksmuseum, Vincent van Gogh Museum, Amsterdam; Yale Center for British Art, New Haven, *Hard Times: Social Realism in Victorian Art*, 14 November 1987–29 May 1988
Minneapolis Minneapolis Institute of Arts, Minnesota, *Beneath the Surface*, 14 February 1987–17 January 1988

1988
Barbican Barbican Art Gallery, London, *Henry Peach Robinson*

1988–9
BM British Museum, *Treasures for the Nation: Conserving our Heritage*, 27 October 1988–26 February 1999

1989
Fitzwilliam Fitzwilliam Museum, Cambridge, *George Field and his Circle: From Romanticism to the Pre-Raphaelite Brotherhood*, 27 June–3 September
Whitworth Whitworth Art Gallery, University of Manchester; Holburne Museum and Craft Centre, University of Bath; Bankside Gallery, London, *Ruskin and the English Watercolour: From Turner to the Pre-Raphaelites*, 6 April–10 September

1989–90
Montreal Musée de Beaux-Arts, Montreal, *Discerning Tastes: Montreal Collectors, 1880–1920*, 8 December 1989–25 February 1990
Newcastle Laing Art Gallery, Newcastle upon Tyne, *Pre-Raphaelites: Patrons and Painters in the North East*, 14 October 1989–14 January 1990

1990
Colnaghi P. and D. Colnaghi and Co., London, *Whisper of the Muse: The World of Julia Margaret Cameron*, 14 March–12 April

1991
Edinburgh National Gallery of Scotland, Edinburgh, *Saved for Scotland: Works of Art Acquired with the Help of the National Art Collection Fund*, 8 August–29 September

1992
Barbican Barbican Art Gallery, London, *Van Gogh in England: Portrait of the Artist as a Young Man*, 27 February–4 May
Wordsworth Wordsworth Museum, Grasmere, and Usher Art Gallery, Lincoln, *Tennyson: A Centenary Exhibition*

1992–3
Japan Isetan Museum of Art, Tokyo; Museum of Modern Art, Ibarak; Kintetsu Nara Hall; Takamatsu City Museum of Art, *Shakespeare in Western Art*, 29 October 1992–28 March 1993
Tate Tate Gallery, London, *The Swagger Portrait: Grand Manner Portraiture in Britain from Van Dyck to Augustus John, 1630–1930*, 14 October 1992–10 January 1993
Manchester et al. Manchester City Art Gallery; Ferens Art Gallery, Hull; Castle Museum, Nottingham; Kelvingrove Art Gallery and Museum, Glasgow, *Innocence and Experience: Images of Children in British Art from 1600 to the Present*, 19 September 1992–1993

1993
Japan 1993a Isetan Museum of Art, Tokyo; Ishibashi Museum of Art, Kurume; Nara Sogo Museum of Art; Tochigi Prefectural Museum of Art, Utsunomiya, *John Ruskin and Victorian Art*, 25 February–15 August
Japan 1993b Mitsukoshi Museum of Art, Shinjuku, Tokyo; Hokkaido Obihiro Museum of Art, Obihiro; Kure Municipal Museum of Art; Hiratsuka Museum of Art; Takamatsu Museum of Art, Japan, *Masterpieces of the 18th and 19th Centuries' British Paintings from the Manchester City Art Galleries*, 2 April–11 October
Munich and Madrid Neue Pinakothek, Munich, *Victorianische Malerei, von Turner bis Whistler*, and Museo del Prado, Madrid, *Pintura Victoriana: de Turner a Whistler*, 26 February–31 July
Paris Bibliothèque nationale de France, Paris, *Le Printemps des génies: les enfants prodiges*
Phoenix and Indianapolis Phoenix Art Museum and Indianapolis Museum of Art, *The Art of Seeing: John Ruskin and the Victorian Eye*, 6 March–29 August

1994
Wood Christopher Wood Gallery, London, *Elegant Ladies: Images of Women in English and French Art Circa 1830–1930*, 7–31 March

1994–5
BM British Museum, London, *Pre-Raphaelite Drawings in the British Museum*, 23 September 1994–8 January 1995
Liverpool Walker Art Gallery, Liverpool, *Three Centuries of Artists' Self-Portraiture*, 28 October 1994–8 January 1995

1995
NGL National Gallery, London, *Sainsbury's Pictures for Schools*

1995–6
USA and Birmingham Seattle Art Museum; Cleveland Museum of Art; Delaware Art Museum, Wilmington; Museum of Fine Arts, Houston; High Museum of Art, Atlanta, Georgia; and Birmingham Museums and Art Gallery, UK, *Visions of Love and Life: Pre-Raphaelite Art from the Birmingham Collection, England*, 9 March 1995–29 September 1996

1996
BAC Yale Center for British Art, New Haven; Denver Museum of Art; Laing Art Gallery, Newcastle upon Tyne, *The Grosvenor Gallery: A Palace of Art in Victorian England*, 2 March–3 November
Norwich Norwich Castle Museum, *Art as Theatre. Shakespeare and Theatre in British Painting from Hogarth to Sargent*, 3 February–14 April
Southampton Millais Gallery, Southampton Institute, *John Everett Millais 1829–1896: A Centenary Exhibition*, 7 June–4 August
Rye Rye Art Gallery, East Sussex, *Millais's Collected Illustrations* , 31 August–22 October
Tate Tate Gallery, London, *Millais Centenary Display*

1997
Birmingham Birmingham Museums and Art Gallery, *Prints in Focus, Part 1*, 4 October–30 November
Tate Tate Gallery, London, *Henry Tate's Gift: A Centenary Celebration*
Washington National Gallery of Art, Washington, D.C., *The Victorians: British Painting in the Reign of Queen Victoria, 1837–1901*, 16 February–11 May 1997

1997–8
Nottingham and Exeter Djanogly Art Gallery, University of Nottingham Arts Centre and Royal Albert Memorial Museum, Exeter, *The Pursuit of Leisure*, 1 November 1997–21 March 1998
Tate Tate Gallery, London; Haus der Kunst, Munich; Van Gogh Museum, Amsterdam, *The Age of Rossetti, Burne-Jones & Watts: Symbolism in Britain 1860–1910*, 16 October 1997–30 August 1998

1998
Australia Art Gallery of New South Wales, Sydney; Queensland Art Gallery, Brisbane; Art Gallery of South Australia, Adelaide, *This Other Eden: British Paintings from the Paul Mellon Collection at Yale*, 2 May–15 November
Berlin Berlin Altes Nationalgalerie, *Fontane und die bildende Kunst*, 4 September–29 November
Japan Tokyo Metropolitan Art Museum and Hyogo Prefectural Art Museum, Kobe, *Masterpieces of British Art from the Tate Gallery*, 23 January–28 June
RA Royal Academy of Arts, London, *Art Treasures of England: The Regional Collections*, 22 January–13 April

1998–9
New York The Frick Collection, New York, *Victorian Fairy Painting*, 14 October 1998–17 January 1999

1999
NPG National Portrait Gallery, London, *Millais: Portraits*, 16 February–6 June

1999–2000
USA Denver Museum, Denver, Colorado; Frye Art Gallery, Seattle, Washington; Norton Museum, West Palm Beach, Florida; National Academy Museum, New York; Cincinnati Art Museum, Cincinnati, Ohio, *Art in the Age of Queen Victoria: Treasures from the Royal Academy of Arts Permanent Collection*, 15 May 1999–24 September 2000

2000
Japan Museum of Modern Art, Shiga; Seiji Togo Memorial Yasuda Kasai Museum of Art; Ashikaga Museum of Art; Museum of Art, Kintetsu; Koriyama City Museum of Art; Museum of Art, Kochi, Japan, *Pre-Raphaelites Exhibition from Manchester City Art Galleries and other Collections*, 8 April–17 December
Tate Tate Britain, London, *Ruskin, Turner and the Pre-Raphaelites*, 9 March–28 May

2000–1
Devon Fairlynch Art Centre and Museum, Budleigh Salterton, Devon, 15 April–29 October 2000; 26 December–7 January 2001
Japan Nagasaki Prefectural Art Museum; Takashimaya Art Gallery, Nihonbashi, Tokyo; Nara Prefectural Museum of Art; Hamamatsu Municipal Museum of Art, Shizuoka; Takamatsu City Museum of Art, Kagawa; Kariya City Art Museum, Aichi; Shimane Art Museum, Japan, *A Scottish Collection: Treasures from Aberdeen Art Gallery*, 29 June 2000–1 April 2001
PML Pierpont Morgan Library, New York, *Ruskin's Italy, Ruskin's England*, 28 September 2000–7 January 2001

2000–2
USA Cincinnati Art Museum, Ohio; Kimbell Art Gallery, Fort Worth, Texas; Denver Art Museum, Colorado; Portland Art Museum, Oregon, *European Masterpieces: Six Centuries of Paintings from the National Gallery of Victoria, Australia*, 29 October 2000–6 January 2002

2001
Nahum Peter Nahum at the Leicester Galleries, The International Fine Art Fair, 7th Regiment Armory, New York; 5 Ryder Street, London; The Grosvenor House Art and Antiques Fair, London, *Pre-Raphaelite, Symbolist, Visionary*, 11 May–19 June

2001–2
Australia and New Zealand Art Gallery of South Australia; Art Gallery of New South Wales; Queensland Art Gallery, Brisbane; Auckland Art Gallery Toi O Tamaki, *Love and Death: Art in the Age of Queen Victoria*, 7 December 2001–24 November 2002
BAC and Huntington Yale Center for British Art, New Haven and Huntington Library, Art Collections, and Botanical Gardens, San Marino, California, *Great British Paintings from American Collections: Holbein to Hockney*, 27 September 2001–5 May 2002

2002–3
Valencia IVAM Institut Valencià d'Art Modern, Valencia, Spain, *De Form Cerrada: Una biografia del dibujo/ In Closed Form: A Biography of Drawing*, 31 October 2002–12 January 2003

2003
Ferrara and London Palazzo dei Diamanti, Ferrara; Dulwich Picture Gallery, London, *Shakespeare in Art*, 16 February–19 October
RA Royal Academy of Arts, London, *Pre-Raphaelite and Other Masters: The Andrew Lloyd Webber Collection*, 20 September–12 December
Tokyo Bunkamura Museum of Art, Tokyo, Japan, *The Dignity of Humble People: Jean-François Millet and Naturalism in Europe*, 10 April–13 July

2003–4
Hayward Hayward Art Gallery, London, *Saved! 100 Years of the National Art Collections Fund*, 23 October 2003–18 January 2004
Australia and USA Art Gallery of Western Australia; Dunedin Public Art Gallery, New Zealand; Frist Center for the Visual Arts, Nashville, *The Pre-Raphaelite Dream: Paintings and Drawings from the Tate Collection*, 12 July 2003–15 August 2004

2004
Palace Theatre Palace Theatre, London, *The Woman in White*

2004–5
Tate, Berlin, Madrid Tate Britain, London; Altes Nationalgalerie, Berlin; Fundació 'la Caixa', Madrid, *Pre-Raphaelite Vision: Truth to Nature*, 12 February 2004–9 January 2005
Birmingham and London Birmingham Museums and Art Gallery and Leighton House Museum, London, *John Everett Millais: Illustrator and Narrator*, 16 October 2004–1 May 2005

2004–6
New Zealand Auckland Art Gallery and Waikato Museum, Hamilton, New Zealand, *Tale to Tell: Narrative Paintings from the Auckland Art Gallery*, 21 February 2004–15 October 2006

2005
Nahum Peter Nahum at the Leicester Galleries, 5 Ryder Street, London, *The Brotherhood of Ruralists and Pre-Raphaelites*, 29 June–29 August 2005
Oklahoma City Oklahoma City Museum of Art, *Artist as Narrator: Nineteenth Century Narrative Art in England and France*, 8 September–27 November

2005–6
Manchester and Birmingham Manchester Art Gallery and Birmingham Museum and Art Gallery, *Black Victorians: Black People in British Art 1800–1900*, 1 October 2005–2 April 2006
NPG National Portrait Gallery, London, *Sir Henry Irving: A Centenary Display*, 10 September 2005–29 January 2006

2006–7
Paris and Montreal Grand Palais, Paris, and Musée des Beaux-Arts, Montreal, *Once Upon a Time: Walt Disney: The Sources of Inspiration for the Disney Studios*, 16 September 2006–24 June 2007

2007
Washington Smithsonian National Portrait Gallery, Washington, D.C., *Great Britons: Treasures from the National Portrait Gallery, London*, 27 April–3 September

Exhibited works

John Ruskin 1853–4
Oil on canvas, arched top, 78.7 × 68
Signed and dated in monogram
lower left
Private Collection
38

The Dying Man 1853–4
Pen and sepia ink with wash, 19.7 × 24.4
Yale Center for British Art, Paul
Mellon Fund
52

**A Ghost Appearing at a Wedding
Ceremony** 1853–4
Pencil, pen and black and sepia inks,
31.1 × 26
Inscribed 'I don't, I don't'
Victoria and Albert Museum, London
55

**Sketch for 'The Prisoner's Wife':
'Wife Confronting Judge'** c.1853–4
Pen and ink over pencil with touches
of bodycolour, 11.3 × 11.2
Birmingham Museums and Art Gallery
54

St Agnes' Eve 1854
Pen and sepia ink, with green wash,
24.8 × 21
Private Collection
28

William Holman Hunt 1854
Black chalk with brown wash on
cream paper, 22 × 17.5
Signed and dated in monogram
The Ashmolean Museum, Oxford.
Bequeathed by Mrs Thomas Combe,
1893
36

Tear Him to Pieces (Foxhunting)
1854
Pen and ink, 23.2 × 19.5
Signed and dated in monogram
Verso inscribed 'The same, Foxhunting
– 1920 A.D.'
Geoffroy Richard Everett Millais
Collection
43

Retribution 1854
Pen and brown ink, 21.4 × 27.5 (sheet
Signed and dated in monogram
The British Museum, London
56

Waiting 1854
Oil on canvas, arched top, 32.4 × 24.8
Signed and dated in monogram
lower right
Birmingham Museums and Art Gallery
59

The Violet's Message 1854
Oil on panel, 25.4 × 19.7
Signed and dated in monogram
lower left
Private Collection, c/o Christie's,
London
60

L'Enfant du Régiment 1854–5
Oil on prepared paper, laid on canvas,
mounted on board, 46 × 62.2
Signed and dated in monogram
lower right
Yale Center for British Art, Paul
Mellon Fund
61

The Blind Girl 1854–6
Oil on canvas, 82.6 × 62.2
Signed and dated in monogram
lower right
Birmingham Museums and Art Gallery.
Presented by the Rt Hon William
Kendrick, 1892
62

The Rescue 1855
Oil on canvas, arched top, 121.5 × 83.6
Signed and dated in monogram
lower left
National Gallery of Victoria,
Melbourne. Felton Bequest, 1924
63

Wandering Thoughts c.1855
Oil on canvas, 35.2 × 24.9
Signed lower right
Manchester City Galleries
64

The Moxon Tennyson 1855–6
Point of the brush with wash and
penwork in Indian ink with some
scratching out
Five works in one mount, all pen
and black ink
The Ashmolean Museum, Oxford
Mariana 9.6 × 7.9
**The Day-Dream; The Sleeping
Palace** 8.3 × 9.6
The Death of the Old Year 9.7 × 8.4
St Agnes' Eve 9.7 × 7.2
The Lord of Burleigh 8.3 × 9.6
71

Autumn Leaves 1855–6
Oil on canvas , 104.3 × 74
Signed and dated in monogram
lower right
Manchester City Galleries
82

Peace Concluded, 1856 1856
Oil on canvas, arched top, 116.8 × 91.4
Signed and dated in monogram
lower left
The Minneapolis Institute of Arts, the
Putnam Dana McMillan Fund
66

The Young Mother 1856
Etching on paper
Published in *Etchings for the Art-Union
of London by the Etching Club*,
London 1857
Geoffroy Richard Everett Millais
Collection
70

Spring 1856–9
Oil on canvas, 110.5 × 172.7
National Museums Liverpool, Lady
Lever Art Gallery
84

The Escape of a Heretic, 1559 1857
Oil on canvas, arched top, 106.2 × 76.2
Signed and dated in monogram
lower left
Museo de Arte de Ponce, Puerto Rico,
The Luis A. Ferré Foundation, Inc.
67

A Dream of Fair Women: Cleopatra
1857
Pen and India ink with scratching out,
mounted with a proof wood engraving
by William James Linton
Published in *Poems by Alfred Tennyson*,
Edward Moxon, London 1857
Victoria and Albert Museum, London
72

Locksley Hall 1857
Proof engraving and corrected proof
engraving by the Dalziel Brothers
Published in *Poems by Alfred Tennyson*,
Edward Moxon, London 1857
Victoria and Albert Museum, London
73

Sophie Gray 1857
Oil on paper laid on wood, 30 × 23
Signed and dated in monogram
lower left
Private Collection, courtesy of Peter
Nahum at The Leicester Galleries,
London
83

Only a Lock of Hair c.1857–8
Oil on wood, 35.3 × 25
Signed in monogram lower left
Manchester City Galleries. Gift of Mr
James Gresham
65

The Bridge of Sighs 1858
Etching on paper, 17.7 × 12.5
Published in *Passages from the Poems of
Thomas Hood Illustrated by the Junior
Etching Club*, London 1858
Geoffroy Richard Everett Millais
Collection
74

The Vale of Rest 1858
Oil on canvas, 102.9 × 172.7
Signed and dated in monogram
lower left
Tate. Presented by Sir Henry Tate, 1894
85

Meditation 1859
Oil on wood, 30.3 × 25.3
Signed in monogram lower right
The Provost and Scholars of King's
College, Cambridge
86

The Black Brunswicker 1859–60
Oil on canvas, 104 × 68.5
Signed and dated in monogram
lower left
National Museums Liverpool, Lady
Lever Art Gallery
68

A Lost Love c.1860
Watercolour on paper, 10.3 × 8.5
The British Museum, London
76

The Ransom 1860–2
Oil on canvas, 129.5 × 114.3
Signed and dated in monogram
lower left
The J. Paul Getty Museum, Los Angeles
69

Iphis and Anaxarete c.1861
Watercolour and bodycolour, 8.1 × 13.3
The Ashmolean Museum, Oxford
75

The Border Witch 1862
Proof engraving by the Brothers Dalziel,
touched proof on India paper
Published in *London Society*,
August 1862
Victoria and Albert Museum, London
78

Love c.1862
Pen and ink and blue watercolour wash,
12.8 × 9.6
Victoria and Albert Museum, London
77

Orley Farm
Engraving by the Dalziel Brothers,
Illustrations for Anthony Trollope's
Orley Farm
Published by Chapman and Hall,
London, March 1862 (Part 1);
April 1863 (Part 14)
The Trollope Society
79

'Guilty', Orley Farm 1862–3
Corrected proof engraving by the
Brothers Dalziel
Illustration for Anthony Trollope's
Orley Farm
Published by Chapman and Hall,
London 1862–3
Victoria and Albert Museum, London
80

The Eve of St Agnes 1862–3
Oil on canvas, 118.1 × 154.9
Signed and dated in monogram
lower right
Her Majesty The Queen
88

Les Miserables 1863
Book
Private Collection

Esther 1863–5
Oil on canvas, 105.5 × 75
Signed in monogram lower left,
Collection of Robert and Ann Wiggins,
USA
92

Parables of Our Lord 1864
Issued in 1863, dated 1864
a. *The Lost Sheep*, b. *The Prodigal Son*, c.
The Sower, d. *The Hidden Treasure*
Wood engravings by the Brothers
Dalziel
Illustrations from *Parables of Our Lord*
Published by Routledge, London 1864
Tate. Presented by Gilbert Dalziel 1924
81

'Leisure Hours' 1864
Oil on canvas, 88.9 × 118.1
Signed and dated in monogram
lower left
The Detroit Institute of Arts. Founders
Society Purchase, Robert H. Tannahill
Foundation Fund
89

The Parable of the Tares 1865
Oil on canvas, 111.8 × 86
Signed and dated in monogram
lower right
Birmingham Museums and Art Gallery
91

Waking 1865
Oil on canvas, 99 × 84
Signed in monogram lower left
Perth Museums & Art Gallery, Perth
& Kinross Council, Scotland
101

The Minuet 1866
Oil on canvas, 110 × 85
Signed and dated in monogram
lower left
Elton Hall Collection
102

Jephthah 1867
Oil on canvas, 127 × 162.7
Signed and dated in monogram
lower left
National Museum of Wales, Cardiff
93

Sisters 1868
Oil on canvas, 106.7 × 106.7
Signed and dated in monogram
lower left
Private Collection c/o Christie's, London
90

Souvenir of Velasquez 1868
Oil on canvas, 102.7 × 82.4
Signed and dated in monogram
lower left
Royal Academy of Arts, London
103

The Boyhood of Raleigh 1869–70
Oil on canvas, 120.6 × 142.2
Signed in monogram and dated
lower left
Tate. Presented by Amy, Lady Tate in
memory of Sir Henry Tate, 1900
94

The Marchioness of Huntly 1870
Oil on canvas, 223.5 × 132
Signed and dated in monogram
lower right
Private Collection
109

Flowing to the River 1871
Oil on canvas, 139.7 x 188
Signed and dated in monogram
lower right
Private Collection
126

A Somnambulist c.1871
Oil on canvas, 151.8 × 90.9
Signed and dated in monogram
lower left
Bolton Museums & Art Gallery
95

'Oh! that a dream so sweet […]' 1872
Oil on canvas, 127 × 83.9
Signed and dated in monogram
lower left
Private Collection, courtesy of Peter
Nahum at The Leicester Galleries,
London
87

Hearts are Trumps 1872
Oil on canvas
165.7 × 219.7
Signed and dated in monogram
lower left
Tate. Presented by the Trustees of the
Chantrey Bequest, 1945
110

Mrs Bischoffsheim 1872–3
Oil on canvas, 136.4 × 91.8
Signed and dated in monogram
lower left
Tate. Presented by Lady Fitzgerald, 1944
111

Scotch Firs 1873
Oil on canvas, 190.5 × 143.5
Signed and dated in monogram
lower right
Private Collection
127

Winter Fuel 1873
Oil on canvas, 194.5 × 150
Signed and dated in monogram
lower right
Manchester City Galleries. Gift
of Gibbon Bayley Worthington
128

Effie Millais c.1873–4
Oil on canvas, 99 × 84
Signed and dated in monogram
lower left
Perth Museum & Art Gallery, Perth
& Kinross Council, Scotland. Purchased
with the assistance of The Art Fund
113

The North-West Passage 1874
Oil on canvas, 176.5 × 222.2
Signed and dated in monogram
lower right
Tate. Presented by Sir Henry Tate 1894
96

The Fringe of the Moor 1874
Oil on canvas, 136 x 216
Signed and dated in monogram
lower right
Johannesburg Art Gallery
129

Dead Pheasants c.1875
Oil on board, 20.3 x 30.5
Signed in monogram lower left
Private Collection
136

Twins 1875–6
Oil on canvas, 153.5 × 113.7
Signed and dated in monogram
lower left
The Fitzwilliam Museum, Cambridge.
Accepted by HM Government in Lieu
of Inheritance Tax and allocated to
The Fitzwilliam Museum, 2005
117

George Gray Millais 1876
Oil on canvas, oval, 58 × 44
Signed and dated in monogram
lower right
Geoffroy Richard Everett Millais
Collection
115

'The Sound of Many Waters' 1876
Oil on canvas, 147.5 x 213.5
Signed and dated in monogram
lower right
The National Trust for Scotland,
Fyvie Castle
130

Bright Eyes 1877
Oil on canvas, 92 × 71.5
Signed and dated in monogram
lower right
Aberdeen Art Gallery & Museums
Collections
104

Thomas Carlyle 1877
Oil on canvas, 116.8 × 88.3
National Portrait Gallery, London
120

A Jersey Lily 1877–8
Oil on canvas, 116 × 85
St Helier (Barreau Le Maistre Gallery),
Jersey Heritage Trust
112

The Princes in the Tower 1878
Oil on canvas, 147.2 × 91.4
Signed and dated in monogram
lower left
Royal Holloway College, University
of London, Egham
97

St Martin's Summer 1878
Oil on canvas, 151 x 107
Signed and dated in monogram
lower right
Montreal Museum of Fine Arts. Gift
of Lord Strathcona and Family
131

The Right Hon. W. E. Gladstone, M.P.
1878–9
Oil on canvas, 125.7 × 91.4
Signed and dated in monogram
lower right
National Portrait Gallery, London
121

'The tower of strength [...]' 1878–9
Oil on canvas, 91.5 x 135
Signed and dated in monogram
lower left
Geoffroy Richard Everett Millais
Collection
132

Cherry Ripe 1879
Oil on canvas, 134.6 × 88.9
Signed and dated in monogram
lower left
Private Collection
106

A Penny for her Thoughts 1879
Etching on paper, 20.4 × 17 (image)
Illustrated in *A Series of Twenty-One
Etchings*, published for the Etching
Club, London 1879
Geoffroy Richard Everett Millais
Collection
116

Louise Jopling 1879
Oil on canvas, 125.1 × 76.2
Signed and dated in monogram
lower left
National Portrait Gallery, London.
Purchased with help from The Art Fund
and the Heritage Lottery Fund, 2002
118

Portrait of the Painter [...] 1880
Oil on canvas, 85 × 65
Signed and dated in monogram
lower left
Galleria degli Uffizi, Collezione degli
Autoritratti, Florence
114

Portrait of Kate Perugini 1880
Oil on canvas, 124.5 × 78.7
Signed and dated in monogram
lower right
Katherine Woodward Mellon
119

**Benjamin Disraeli, The Earl
of Beaconsfield, K.G** 1881
Oil on canvas, 127.6 × 93.1
Signed and dated in monogram
lower left
National Portrait Gallery, London
122

Alfred Tennyson 1881
Oil on canvas, 127 × 93
Signed and dated in monogram
lower left
National Museums Liverpool,
Lady Lever Art Gallery
123

Rupert Potter (1832–1914)
Cinderella, Miss Buckstone 1881
Photograph
National Portrait Gallery, London
131

The Captive c.1881–2
Oil on canvas, 115.6 × 77.2
Signed and dated in monogram
lower left
Art Gallery of New South Wales.
Purchased 1885
105

Henry Irving, Esq. 1883
Oil on canvas, 110.5 × 80
Signed and dated in monogram
lower left
The Garrick Club
124

Rupert Potter (1832–1914)
Elizabeth Manners 1883
Photograph
National Portrait Gallery, London

The Ruling Passion 1885
Oil on canvas, 160.6 × 215.9
Signed and dated in monogram
lower right
Glasgow City Council (Museums)
98

Bubbles 1886
Oil on canvas, 107.5 × 77.5
Signed and dated in monogram
lower right
Unilever. On long loan to National
Museums Liverpool, Lady Lever Art
Gallery
107

Christmas Eve 1887
Oil on canvas, 154.9 x 129.5
Signed and dated in monogram
lower left
Private Collection of the late Sir Paul
Getty KBE
133

Dew-Drenched Furze 1889–90
Oil on canvas, 170.2 x 121.9
Signed and dated in monogram
lower left
Geoffroy Richard Everett Millais
Collection
135

Lingering Autumn 1890
Oil on canvas, 124.7 x 195.5
Signed and dated lower right
National Museums Liverpool,
Lady Lever Art Gallery
134

**Millais photographed against a
landscape setting in Scotland**
c.1890
Photograph
Geoffroy Richard Everett Millais
Collection

Glen Birnam 1890–1
Oil on canvas, 145.2 x 101.1
Signed and dated lower right
Manchester City Galleries
138

'The Little Speedwell's Darling Blue'
1891–2
Oil on canvas, 98 × 73
Signed and dated lower right
National Museums Liverpool,
Lady Lever Art Gallery
108

'Blow, Blow, Thou Winter Wind.'
1892
Oil on canvas, 108 x 155
Signed and dated lower right
Auckland Art Gallery Toi o Tamaki,
gift of Mr Moss Davis, 1933
139

**Pears' Soap advertisement of the
exhibition of Millais's original
painting at the World's Columbian
Exhibition in Chicago** 1893
Private Collection

St Stephen 1894–5
Oil on canvas, 152.4 × 114.3
Signed and dated in monogram
lower right
Tate. Presented by Sir Henry Tate 1894
99

'Speak! Speak!' 1894–5
Oil on canvas, 167.6 x 210.8
Signed and dated in monogram
lower left
Tate. Presented by the Trustees of
the Chantrey Bequest 1895
100

The Last Trek 1895
Electro-etched frontispiece published
in John Guille Millais, *A Breath from
the Veldt*, London 1895
Private Collection
137

Millais's Palette 19th Century
Geoffroy Richard Everett Millais
Collection

Millais's Brushes and Oils 19th
Century
Geoffroy Richard Everett Millais
Collection

Millais's Easel
Purchased by the artist in 1883
Tate

Millais's Sitter's Chair 18th Century
Carved walnut armchair with shaped
back and arms and cabriolet legs;
drop-in seat covered with needlework
pre-Chippendale period; 102 x 75 x 60
Geoffroy Richard Everett Millais
Collection

Bonnet worn in 'Cherry Ripe'
Mrs Fiona Close

Shoes worn in 'Cherry Ripe'
Mrs Fiona Close

Lenders

Photo credits

Public Collections

Aberdeen Art Gallery & Museums Collections 104
Auckland Art Gallery Toi o Tamaki, New Zealand 139
Birmingham Museums & Art Gallery 4, 6, 11, 12, 17, 18, 54, 59, 62, 91
Bolton Museums & Art Gallery 95
Cambridge, The Fitzwilliam Museum 10, 27, 34, 117
Cardiff, National Museum of Wales 93
Detroit, MI, USA, The Detroit Institute of Arts 89
Florence, Italy, Galleria degli Uffizi, Collezione degli Autoritratti 114
Fyvie Castle, The National Trust for Scotland 130
Glasgow City Council (Museums) 98
Johannesburg Art Gallery, South Africa 129
Liverpool, National Museums Liverpool, Lady Lever Art Gallery 68, 84, 108, 123, 134
Liverpool, National Museums Liverpool, Walker Art Gallery 1, 9
London, The British Museum 26, 48, 56, 76
London, Guildhall Art Gallery 23
London, National Portrait Gallery 31, 118, 120, 121, 122
London, Royal Academy of Arts 103
London, Tate 8, 14, 19, 20, 24, 30, 37, 39, 81, 85, 94, 96, 99, 100, 110, 111
London, Victoria & Albert Museum 5, 22, 55, 72, 73, 77, 78, 80
Los Angeles, CA, USA, The J Paul Getty Museum 69
Manchester City Galleries 7, 64, 65, 82, 128, 138
Melbourne, Australia, National Gallery of Victoria, 63
Minneapolis, The Minneapolis Institute of Arts 66
Montreal Museum of Fine Arts 131
New Haven, CT, USA, Yale Center for British Art 21, 44, 49, 50, 51, 52, 61
Oxford, The Ashmolean Museum 25, 32, 33, 36, 53, 71, 75
Perth Museums & Art Gallery, Perth & Kinross Council, Scotland 101, 113
Ponce, Puerto Rico, Museo de Arte de Ponce 67
St Helier, Jersey, (Barreau Le Maistre Gallery) Jersey Heritage Trust 112
Sydney, Australia, Art Gallery of New South Wales 105
Wightwick Manor (The National Trust) 41

Private Collections

Elton Hall Collection 102
The Garrick Club 124
Her Majesty The Queen 88
The Provost and Scholars of King's College, Cambridge 86
The Lord Lloyd Webber 29, 58, 125
The Maas Gallery, London 16
The Makins Collection 15, 40, 57
Katherine Woodward Mellon 119
Geoffroy Richard Everett Millais Collection 2, 43, 45, 70, 74, 115, 116, 132, 135
Charles Nugent Esq. 3
Royal Holloway College, University of London, Egham 97
The Trollope Society 79
Unilever, on long loan to National Museums Liverpool, Lady Lever Art Gallery 107
Nicolette Wernick 46
Robert and Ann Wiggins 92
Private collection 13, 28, 35, 38, 42, 47, 106, 109, 126, 127, 136, 137
Private collection c/o Christie's 60, 90
Private collections courtesy of Peter Nahum at The Leicester Galleries 83, 87
Private collection of the late Sir John Paul Getty KBE 133

Unless otherwise stated, copyright in the photograph is as given in the caption to each illustration

Catalogue illustrations

Amgueddfa Cenedlaethol Cymru. National Museum of Wales 93
Bolton Museums, Art Gallery and Aquarium, Bolton MBC 95
© Christies Images Limited 2007 60, 90
© 1988 The Detroit Institute of Arts 89
Guildhall Art Gallery, City of London/ The Bridgeman Art Library 23
John Lawrence/Southampton City Art Gallery 115, 132
© The Makins Collection, All Rights Reserved/The Bridgeman Art Library 15, 40, 57
The Montreal Museum of Fine Arts, Denis Farley 131
Museo de Arte de Ponce. The Ferré A. Ferre Foundation, Inc., Ponce, Puerto Rico 67
Erik Rosenthal 46
The Royal Collection © 2006, Her Majesty Queen Elizabeth II 88
Miriam Sterling 105
© NTPL/Derrick E. Witty 41
© 2006, The Provost and Scholars of the King's College of Our Lady and Saint Nicholas, Cambridge 86
Soprintendenza Speciale per il Polo Museale Fiorentino. Gabinetto Fotografico 114
Tate Photography/Andrew Dunkley and Dave Clarke 102
Tate Photography/Marcella Leith 110
Tate Photography/Marcus Leith and Andrew Dunkley 16, 28, 47, 133
Tate Photography/Rodney Tidnam 2, 35, 43, 45, 70, 74, 79, 135, 137
Tate Photography/Rodney Tidnam and David Lambert 13, 42, 124
Reproduced by kind permission of Unilever 107
V&A Images/Victoria and Albert Musuem, London 5, 22, 55, 72, 73, 77, 78, 80
The Whitworth Art Gallery, The University of Manchester 3

Figure illustrations

© British Library Board. All Rights Reserved 1022251.621 fig.7
© Christies Images Limited 2007 fig.20
Prudence Cuming Associates Limited fig.22
© The FORBES Magazine Collection, New York/The Bridgeman Art Libary fig.13
Gernsheim Collection, Harry Ransom Humanities Research Center, The University of Texas at Austin fig.39
Kimbell Art Museum fig.26
© 2007 Museum of Fine Arts, Boston fig.14
© 2007 Board of Trustees, National Gallery of Art, Washington fig.16
Private Collection © Pope Family Trust/The Bridgeman Art Library fig.25
Photo RMN/© Gérard Blot fig.8
SCALA fig.19
Tate Photography/Rodney Tidnam fig.24, 31, 33, 34, 35, 37, 38, 40, 41, 42, 43
The Trustees of the Wallace Collection, London fig.17
© Barry Windsor-Smith. All Rights Reserved fig.3

265

Index

Supporting Tate

Tate relies on a large number of supporters – individuals, foundations, companies and public sector sources – to enable it to deliver its programme of activities, both on and off its gallery sites. This support is essential in order for Tate to acquire works of art for the Collection, run education, outreach and exhibition programmes, care for the Collection in storage and enable art to be displayed, both digitally and physically, inside and outside Tate. Your donation will make a real difference and enable others to enjoy Tate and its Collection both now and in the future. There are a variety of ways in which you can help support Tate and also benefit as a UK or US taxpayer. Please contact us at:
Development Office, Tate, Millbank, London SWIP 4RG
Tel: 020 7887 8945
Fax: 020 7887 8098

American Patrons of Tate, 1285 6th Avenue (35th fl), New York, NY 10019, USA
Tel: 001 212 713 8497
Fax: 001 212 713 8655

Donations
Donations, of whatever size, are gratefully received, either to support particular areas of interest, or to contribute to general activity costs.

Gifts of Shares
We can accept gifts of quoted share and securities. All gifts of shares to Tate are exempt from capital gains tax, and higher rate taxpayers enjoy additional tax efficiencies. For further information please contact the Development Office.

Gift Aid
Through Gift Aid you can increase the value of your donation to Tate as we are able to reclaim the tax on your gift. Gift Aid applies to gifts of any size, whether regular or a one-off gift. Higher rate taxpayers are also able to claim additional personal tax relief. Contact us for further information and to make a Gift Aid Declaration.

Legacies
A legacy to Tate may take the form of a residual share of an estate, a specific cash sum or item of property such as a work of art. Legacies to Tate are free of inheritance tax, and help to secure a strong future for the Collection and galleries.

Offers in lieu of tax
Inheritance Tax can be satisfied by transferring to the Government a work of art of outstanding importance. In this case the amount of tax is reduced, and it can be made a condition of the offer that the work of art is allocated to Tate. Please contact us for details.

Membership Programmes
Tate Members enjoy unlimited free admission throughout the year to all exhibitions at Tate, as well as a number of other benefits such as exclusive use of our Members' Rooms and a free annual subscription to *Tate Etc*. Whilst enjoying the exclusive privileges of membership, you are also helping secure Tate's position at the very heart of British and modern art. Your support actively contributes to new purchases of important art, ensuring that the Tate's Collection continues to be relevant and comprehensive, as well as funding projects in London, Liverpool and St Ives that increase access and understanding for everyone.

Tate Patrons
Tate Patrons share a strong enthusiasm for art and are committed to giving significant financial support to Tate on an annual basis. The Patrons support the acquisition of works across Tate's broad collecting remit, as well as other areas of Tate activity such as conservation, education and research. The scheme provides a forum for Patrons to share their interest in art and to exchange knowledge and information in an enjoyable environment. United States taxpayers who wish to receive full tax exempt status from the IRS under Section 501 (c) (3) are able to support the Patrons through our American office. For more information on the scheme please contact the Patrons office.

Corporate Membership
Corporate Membership at Tate Modern, Tate Liverpool and Tate Britain offers companies opportunities for corporate entertaining and the chance for a wide variety of employee benefits. These include special private views, special access to paying exhibitions, out-of-hours visits and tours, invitations to VIP events and talks at members' offices.

Corporate Investment
Tate has developed a range of imaginative partnerships with the corporate sector, ranging from international interpretation and exhibition programmes to local outreach and staff development programmes. We are particularly known for high-profile business to business marketing initiatives and employee benefit packages. Please contact the Corporate Fundraising team for further details.

Charity Details
The Tate Gallery is an exempt charity; the Museums & Galleries Act 1992 added the Tate Gallery to the list of exempt charities defined in the 1960 Charities Act. Tate Members is a registered charity (number 313021). Tate Foundation is a registered charity (number 1085314).

American Patrons of Tate
American Patrons of Tate is an independent charity based in New York that supports the work of Tate in the United Kingdom. It receives full tax exempt status from the IRS under section 501(c)(3) allowing United States taxpayers to receive tax deductions on gifts towards annual membership programmes, exhibitions, scholarship and capital projects. For more information contact the American Patrons of Tate office.

Tate Foundation Trustees

Tate Foundation Executive
John Botts, CBE
Mrs Carol Galley
Mr Noam Gottesman
Mr Scott Mead
Paul Myners, CBE (Chairman of Tate Foundation)
Mr Anthony Salz
Sir Nicholas Serota
Lord Stevenson of Coddenham, CBE

Tate Foundation non-Executive Trustees
The Hon Mrs Janet Wolfson de Botton CBE
Mrs James Brice
Mrs Susan Burns
Ms Melanie Clore
Sir Harry Djanogly, CBE
Dame Vivien Duffield
Lady Forester de Rothschild
The Rt Hon the Lord Foster of Thames Bank
Lady Foster of Thames Bank

Mr Ronald McAulay
The Hon Mrs Rita McAulay
Mr Mandy Moross
Sir John Ritblat
Lady Ritblat
The Rt Hon Lord Sainsbury of Preston Candover
Lady Sainsbury of Preston Candover
The Rt Hon Sir Timothy Sainsbury
Mr Peter Simon
Mr John Studzinski
Mrs Anita Zabludowicz

Tate Britain Benefactors
Agnew's
Howard and Roberta Ahmanson
The American Fund for the Tate Gallery
Ms Wallis Annenberg and The Annenberg Foundation
The Art Fund
Arts Council England
Lord and Lady Attenborough
The Estate of Tom Bendhem
Alex and Angela Bernstein
Big Lottery Fund
Blackwall Green
The Charlotte Bonham-Carter Charitable Trust
Mr and Mrs Pontus Bonnier
Gilbert and Janet de Botton
Louise Bourgeois
Ivor Braka
Mr and Mrs James Brice
Estrellita and Daniel Brodsky
Melva Bucksbaum and Raymond Learsy
Charities Advisory Trust
John and Tina Chandris
Henry Christensen III
Ella Cisneros
Patricia Phelps de Cisneros
Dr David Cohen CBE
Mr Edwin C Cohen
Ricki and Robert Conway
The Ernest Cook Trust
Mrs Dianne Cummings Halle
DCMS/Wolfson Foundation Museums and Galleries Improvement Fund
DCMS/DfES Strategic Commissioning Programme
The Estate of Dr Vera J Daniel
Dimitris Daskalopoulos
Tiqui Atencio and Ago Demirdjian
The Estate of Andre Deutsch
Sir Harry Djanogly
Brooke Hayward Duchin
The Clore Duffield Foundation
Sir Joseph Duveen
Lord Duveen
Jeanne Donovan Fisher
The Estate of Richard B. Fisher
Mimi Floback
Lynn Forester de Rothschild
Glenn R. Fuhrman
Kathy and Richard S. Fuld Jr
Gabo Trust for Sculpture Conservation
Gapper Charitable Trust

Nanette Gehrig
Liz Gerring and Kirk Radke
The Getty Foundation
The Horace W. Goldsmith Foundation
Marian Goodman
Antony Gormley
Noam and Geraldine Gottesman
Mr and Mrs Jonathan Green
Sarah and Gerard Griffin
Agnes Gund and Daniel Shapiro
Calouste Gulbenkian Foundation
Mimi and Peter Haas
Heritage Lottery Fund
The Hite Foundation
Stanley and Gail Hollander
HSBC Artscard
ICAP plc
The Idelwild Trust
Angeliki Intzides
Lord and Lady Jacobs
The Mary Joy Thomson Bequest
Peter and Maria Kellner
Ellen Kern
C. Richard and Pamela Kramlich
Henry R. Kravis Foundation, Inc.
The Samuel H Kress Foundation
The Kreitman Foundation
The Leche Trust
Robert Lehman Foundation
Mr and Mrs Diamantis M Lemos
The Leverhulme Trust
The Deborah Loeb Brice Foundation
Richard Long
Robert and Mary Looker
William Louis-Dreyfus
John Lyon's Charity
Estate of Sir Edwin Manton
The Andrew W Mellon Foundation
The Paul Mellon Centre for Studies of British Art
The Worshipful Company of Mercers
Mr and Mrs David Mirvish
Lucy Mitchell-Innes
Anthony and Deirdre Montagu
The Henry Moore Foundation
The Dr Mortimer and Theresa Sackler Foundation
The Estate of Father John Munton
Paul and Alison Myners
Guy and Marion Naggar
National Heritage Memorial Fund
Hartley Neel
Richard Neel
Peter and Eileen Norton, The Peter Norton Family Foundation
Public Sector Research Exploitation Fund
Ophiuchus SA
Outset Contemporary Art Fund
William Palmer
Catherine and Michel Pastor
The Stanley Picker Trust
The Honorable Leon B and Mrs Cynthia Polsky

Oliver Prenn
Karen and Eric Pulaski
The Radcliffe Trust
Mr and Mrs James Reed
Julie and Don Reid
Simon and Virginia Robertson
Lynn Forester de Rothschild
Ken Rowe
Keith and Kathy Sachs
Salander O'Reilly Galleries
The Basil Samuel Charitable
 Trust
The Sandra Charitable Trust
Debra and Dennis Scholl
Harvey S. Shipley Miller
Peter Simon
John A. Smith and Vicky Hughes
Pauline Denyer-Smith and Paul
 Smith
The Freda Mary Snadow
 Bequest
Kimberly and Tord Stallvik
The Starr Foundation
Hugh and Catherine Stevenson
SureStart Westminster
Sir Henry Tate
Tate International Council
Tate Members
Tate Patrons
Mr and Mrs A Alfred Taubman
David Teiger
Luiz Augusto Teixeira de Freitas
The Mary Joy Thomson Bequest
The Sir Jules Thorn Charitable
 Trust
Peter Touche and Alicia Keyes
Andreas Waldburg-Wolfegg
Ziba and Pierre de Weck
Angela Westwater and David
 Meitus
Poju and Anita Zabludowicz
Aroldo Zevi
Shirly and Yigal Zilkha
and those who wish to remain
anonymous

Platinum Patrons
Beecroft Charitable Trust
Rory and Elizabeth Brooks
John and Susan Burns
Melanie Clore
Pieter and Olga Dreesmann
Mr and Mrs Charles M. Hale
The Hayden Family Foundation
John A. Smith and Vicky Hughes
Peter and Maria Kellner
Mary Moore
Paul and Alison Myners
Catherine and Franck Petitgas
Mr and Mrs James Reed
Mr David Roberts
Simon and Virginia Robertson
Helen Thorpe
Caroline Wiseman
Mr and Mrs Harry Woolf
Anita Zabludowicz
and those who wish to remain
anonymous

Gold Patrons
Pierre Brahm
Arpad Busson
Sir Trevor Chinn CVO and Lady
 Chinn

Alastair Cookson
Mr Dudley Dodd and Mr Greg
 Walker
Mrs Wendy Fisher
Nanette Gehrig
Deborah Goldman
Sarah Griffin
Lady Hollick
Claire Livingstone
Fiona Mactaggart
Gina Marcou
The Hon David McAlpine
Pilar Ordovás
PRA Limited
Mathew Prichard
Mrs Rosario Saxe-Coburg
Mr and Mrs David M Shalit
Mr and Mrs Michael Wilson
Barbara Yerolemou
and those who wish to remain
anonymous

Silver Patrons
Agnew's
Shane Akeroyd
Helen Alexander
Ryan Allen & Caleb Kramer
Toby and Kate Anstruther
Mrs and Mrs Zeev Aram
Edward Ariowitsch Foundation
Mr Giorgio Armani
Kiran Arora
Edgar Astaire
Daphne Warburg Astor
Mrs Jane Barker
Mr Oliver Barker
Victoria Barnsley
Louise Barton
Jim Bartos
Pamela Morgan Bell
Alex and Angela Bernstein
Madeleine Bessborough
Janice Blackburn
Mr and Mrs Anthony Blee
Mary and George Bloch
Sir Alan Bowness, CBE
Mrs Lena Boyle
Mr and Mrs Floyd H Bradley
Ivor Braka
Simon Alexander Brandon
Viscountess Bridgeman
The Broere Charitable
 Foundation
Dan Brooke
Ben and Louisa Brown
Mr and Mrs John Burke
Michael Burrell
Mrs Marlene Burston
Charles Butter
Elizabeth Capon
Peter Carew
Sir Richard Carew Pole
Francis Carnwath
Lord and Lady Charles Cecil
John and Christina Chandris
Frank Cohen
Mr and Mrs Paul Collins
Terrence Collis
Mr and Mrs Oliver Colman
Carole and Neville Conrad
Giles and Sonia Coode-Adams
Mr and Mrs Paul Cooke
Cynthia Corbett
Sidney and Elizabeth Corob

Mr Pilar Corrias
Mr and Mrs Bertrand Coste
James Curtis
Isobel Dalziel
Virginia Damtsa
Sir Howard Davies
Sir Simon Day
Nicole and John Deckoff
Chantal Defay Sheridan
The de Laszlo Foundation
Mollie Dent-Brocklehurst
Simon C Dickinson Esq
Joanna Drew
Michelle D'Souza
Joan Edlis
Vangel Efthimiadou
Lord and Lady Egremont
John Erle-Drax
Stuart and Margaret Evans
Gerard Faggionato
Tawna Farmer
Mrs Heather Farrar
Mrs Margy Fenwick
Mr Bryan Ferry
Ruth Finch
The Flow Foundation
Joscelyn Fox
Eric and Louise Franck
Elizabeth Freeman
Stephen Friedman
Julia Fuller
Mr and Mrs Albert Fuss
Richard Gapper
Mrs Daniela Gareh
The Hon Mr William Gibson
Mr David Gill and Mr Francis
 Sultana
Mr Mark Glatman
Nicholas and Judith Goodison
Paul and Kay Goswell
Noam Gottesman
Penelope Govett
Andrew Graham
Gavin Graham
Martyn Gregory
Sir Ronald Grierson
Mrs Kate Grimond
Richard and Odile Grogan
Mr Haegy
Louise Hallett
Mrs Sue Hammerson OBE
Samantha Hampshire
Richard Hazlewood
Michael and Morven Heller
Ian Henderson-Russell
Patsy Hickman
Robert Holden
Mr Jonathan Horwich
John Huntingford
Rachel Hutson
Robin Hyman
Mr Michael Johnson
Mr and Mrs Peter Johnson
Mr Chester Jones
Jay Jopling
Tracey Josephs
Mrs Gabrielle Jungels-Winkler
Isabella Kairis
Andrew Kalman
Dr. Martin Kenig
Mr David Ker
Mr and Mrs Simon Keswick
David Killick
Mr and Mrs Paolo Kind

Mr and Mrs James and Clare
 Kirkman
Brian and Lesley Knox
Ms Angeliki Koulakoglou
Kowitz Trust
Patricia Lankester
Simon Lee
Zachary R. Leonard
Mr Gerald Levin
Leonard Lewis
Judith Licht
Ina Lindemann
Miss Laura Lindsay
Claire Livingstone
Anders and Ulla Ljungh
Barbara Lloyd and Dr Judith
 Collins
Mr Gilbert Lloyd
George Loudon
Mark and Liza Loveday
Thomas Loyd
Marillyn Maklouf
Mr and Mrs Eskander Maleki
Robert A Mandell
Mr M J Margulies
Lord Marland of Odstock
Marsh Christian Trust
Janet E Martin
Mr and Mrs Y Martini
Penny Mason
Barbara Meaker
Dr. Rob Melville
Mr Alfred Mignano
Victoria Miro
Jan Mol
Mr Donald Moore
David Moore-Gwyn
Houston Morris
Mrs William Morrison
Mr Stamatis Moskey
Mr The Hon Mrs Guy Naggar
Richard Nagy, London
Warren Neidich
John Nickson and Simon Rew
Michael Nyman
Julian Opie
Desmond Page
Maureen Paley
Dominic Palfreyman
Michael Palin
Stephen and Clare Pardy
Eve and Godfrey Pilkington
Oliver Prenn
Susan Prevezer QC
Valerie Rademacher
Will Ramsay
Mrs Phyllis Rapp
Mr and Mrs Philip Renaud
Sir Tim Rice
Lady Ritblat
Tim Ritchie
David Rocklin
Frankie Rossi
Mr James Roundell
Mr Alex Sainsbury and Ms
 Elinor Jansz
The Hon Michael Samuel
Bryan Sanderson
Cherrill and Ian Scheer
Sylvia Scheuer
Charles Schneer
Carol Sellars
Amir Shariat
Neville Shulman CBE

Andrew Silewicz
Simon and Rebecca Silver
Mr and Mrs David T Smith
Louise Spence
Barbara Spring
Digby Squires Esq.
Mr and Mrs Nicholas Stanley
Mr Timothy and the Hon. Mrs
 Steel
Lady Stevenson
Robert Suss
The Swan Trust
Robert and Patricia Swannell
Mr James Swartz
The Lady Juliet Tadgell
Sir Anthony and Lady Tennant
Christopher and Sally Tennant
Mrs Lucy Thomlinson
Margaret Thornton
Britt-Marie Tidelius
Mrs George Titley
Maureen Turner
TW Research
Melissa Ulfane
Mrs Cecilia Versteegh
Gisela von Sanden
Mr Christopher V Walker
Offer Waterman
Mr and Mrs Mark Weiss
Mr Sean N. Welch
John W Wendler
Miss Cheyenne Westphal
Max Wigram
Manuela and Iwan Wirth
The Cecilia Wong Trust
and those who wish to remain
anonymous

Outset, Frieze Special
Acquisitions Fund
Mr and Mrs Philippe Bonnefoy
Sir Ronald and Lady Cohen
Mr Alastair Cookson
Noelle and Robin Doumar
Yelena Duncan
Mr and Mrs Zak Gertler
Abstract Select Ltd
Mr and Mrs Max Gottschalk
Johannes and Leili Huth
Mr and Mrs Stephen Peel
Laurel and John Rafter
Ramzy and Maya Rasamny
Barrie and Emmanuel Roman
Michael and Melanie Sherwood
 Charitable Foundation
Mr and Mrs R Sousou
Mr and Mrs Yigal Zilkha
and those who wish to remain
anonymous

American Acquisitions
Committee
Alessandra and Jonas Almgren
William and Ronit Berkman
James Chanos
Claudia Cisneros Macaya
Cota Cohen Knobloch
David Feinburg
David B Ford
Glenn R. Fuhrman
Kathy Fuld
Matias and Mariana Garfunkel
Deborah Green
Andrew and Christine Hall

Monica Kalpakian
Daniel S. Loeb and Margaret
 Munzer Loeb
Stavros Merjos
Gregory Miller
Kelly Mitropoulos
Peter Norton
John and Amy Phelan
The Honorable Leon B and Mrs
 Cynthia Polsky
Kirk Radke and Liz Gerring
Michael Sacks
Pamela and Arthur Sanders
Anthony Scaramucci
Kimberly and Tord Stallvik
Steven and Lisa Tananbaum
B.J. Topol and Jon Blum
Bill and Ruth True
Tom and Diane Tuft
Andreas Waldburg
*and those who wish to remain
anonymous*

**Latin American Acquisitions
Committee**
Ghazwa Mayassi Abu-Suud
Robert and Monica Aguirre
Tiqui Atencio Demirdjian and
 Ago Demirdjian
Luis Benshimol
Patricia Beracasa
Estrellita and Daniel Brodsky
Carmen Buquera
Carmen Busquets
Rita Caltagirone
Cesar Cervantes
Paul and Trudy Cejas
Mrs Gustavo Cisneros
Gerard Cohen
Prince Pierre d'Arenberg
Tania Fares
Eva Firmenich
Diane Halle
Anne-Marie and Geoffrey Isaac
Nicole Junkermann
Eskander and Fatima Maleki
Becky Mayer
Solita and Steven Mishaan
Margarita Herdocia and Jaime
 Montealegre
Jorge G. Mora
Isaac and Victoria Oberfeld
Michel and Catherine Pastor
Mrs Sagrario Perez Soto
Catherine Petitgas
Isabella Prata and Idel
 Arcuschin
Luciana Redi
Frances Reynolds
Lilly Scarpeta and Roberto
 Pumarejo
Catherine Shriro
Ricardo and Susana Steinbruch
Luis Augusto Teixeira de Freitas
Britt-Marie Tidelius
Paula Traboulsi
Juan Carlos Verme
Baroness Alin Ryan von Buch
Bina von Stauffenberg
Arnoldo and Tania Wald
Anita Zabludowicz

**Asia Pacific Acquisitions
Committee**
Mrs John Chandris

Mr Pierre Chen
Mrs Maryam Eisler
Mrs Eloisa Haudenschild
Mrs Nicolette Kwok
Mrs Ra Hee Hong Lee
Mr and Mrs Eskander Maleki
Mrs Becky Mayer
Mr Young-Ju Park
Ms Catherine Schriro
Mr David Tang OBE
UCCA Beijing

**International Council
Members**
Doris Ammann
Ms Anne H. Bass
Mr Nicolas Berggruen
Mrs Louise T Blouin MacBain
Mr and Mrs Pontus Bonnier
The Hon Mrs Janet de Botton,
 CBE
Mrs Miel de Botton Aynsley
Mrs Bowes
Mr Brian Boylan
Mr Ivor Braka
Mrs James Brice
Mr and Mrs Eli Broad
Mr Donald L Bryant Jr
Mrs Melva Bucksbaum and Mr
 Raymond Learsy
Mr and Mrs John Chandris
Mrs Patricia Phelps de Cisneros
Mr and Mrs Borja Coca
David Coe
Mr and Mrs Robin Congreve
Mr Douglas S Cramer
Mr and Mrs L Gordon Darling
Mr Dimitris Daskalopoulos
Mr and Mrs Michel David-Weill
Mrs Julia W Dayton
Mr Ago Demirdjian and Mrs
 Tiqui Atencio Demirdijian
Mr and Mrs Joseph Donnelly
Mr Stefan Edlis and Ms Gael
 Neeson
Mr Alan Faena
Mr and Mrs Donald Fisher
Dr Corinne M Flick
Fondation Cartier pour l'art
 contemporain
Mr and Mrs Zak Gertler
Mr Alan Gibbs
Mr and Mrs Noam Gottesman
The Earl of Gowrie
Mr Laurence Graff
Ms Esther Grether
Mr Simon Xavier Guerrand-
 Hermes
Mr and Mrs Pehr
 Gyllenhammar
Mrs Peter E Haas
Mr Joseph Hackmey
Mr and Mrs Paul Hahnloser
Mr and Mrs Andrew Hall
Mr Toshio Hara
Ms Ydessa Hendeles
Mr and Mrs André Hoffmann
Lord and Lady Jacobs
Mr and Mrs Dakis Joannou
Sir Elton John and Mr David
 Furnish
Mr John Kaldor and Ms Naomi
 Milgrom
Ms Alicia Koplowitz

Mr and Mrs Richard Kramlich
Mr and Mrs Pierre Lagrange
Baroness Lambert
The Hon Ronald and Mrs
 Lauder
Mr and Mrs Edward Lee
Mr and Mrs Kun-Hee Lee
Mrs Ann Lewis A.M.
Mr and Mrs Filiep Libeert
Mrs Sylvie Liska
Mr and Mrs Peter Marano
Mr and Mrs Donald B. Marron
Mr Ronald and The Hon Mrs
 McAulay
Mr David Meitus
Mr and Mrs David Mirvish
Mr and Mrs Steven Mishaan
Mr and Mrs Rupert Myer
Mr and Mrs Philip Niarchos
Mr Peter Norton
Mr and Mrs Takeo Obayashi
Mrs Kathrine Palmer and Mr
 Peter Watson
Mrs Sydney Picasso
Mr Jean Pigozzi
Mr and Mrs Agostino Re
 Rebaudengo
Mr John Richardson
Sir John and Lady Ritblat
Mr and Mrs Emmanuel Roman
Mr and Mrs Vidal Sassoon
Dr Uli Sigg
Ms Wendy Stark Morrissey
Dr and Mrs Norman Stone
Mr David Teiger
Mr and Mrs Robert Tomei
Ambassador and Mrs Robert
 Tuttle
Mr and Mrs Guy Ullens
Mr Paulo A.W. Vieira
Ms Diana Widmaier Picasso
Mr and Mrs Poju Zabludowicz

**Tate Britain Corporate
Members 2007**
Accenture
AIG
Apax Partners Worldwide LLP
Aviva plc
Barclays Bank plc
BNP Paribas
City Inn Ltd
Clifford Chance
Credit Suisse
Deutsche Bank
Drivers Jonas
Ernst & Young
Fidelity Investments
 International
Freshfields Bruckhaus Deringer
Friends Provident PLC
GAM
GLG Partners
HSBC Holdings plc
Linklaters
Nomura
Pearson
Reuters
Royal Bank of Scotland
Shearman & Sterling LLP
Sotheby's
Tishman Speyer
UBS

**Tate Britain Corporate
Supporters**

AIG
*Constable: The Great
 Landscapes* (2006)

AXA Art Insurance LTD
*Conservation: Tate AXA Art
 Modern Paints Project*

Barclays PLC
Turner and Venice (2003)

BP
Campaign for the creation of
Tate Britain
(1998–2000)
BP British Art Displays at Tate
Britain
Tate Britain Launch (2000)

The British Land Company PLC
Joseph Wright of Derby (1990)
Ben Nicholson (1993)
Gainsborough (2002)
*Degas, Sickert, Toulouse-
 Lautrec* (2005)
Holbein in England (2006)

BT
Tate Online

Channel 4
The Turner Prize (1991–2003)

The Daily Telegraph
Media Partner for *American
 Sublime* (2002)
Media Partner for *Pre-
 Raphaelite Vision: Truth to
 Nature* (2004)
Media Partner: for *In-A-Gadda-
 Da-Vida* (2004)
Media Partner: for *Constable
 the Great Landscapes* (2006)
Media Partner: for *Howard
 Hodgkin* (2006)

Diesel
Late at Tate Britain (2004)
Art Now (2004, 2005)

Egg Plc
Tate & Egg Live (2003)

Ernst and Young
Picasso: Painter/Sculpture
 (1994)
Cézanne (1996)
Bonnard (1998)
Art of the Garden (2004)
Turner Whistler Monet (2005)

GlaxoSmithKline plc
Turner on the Seine (1999)
William Blake (2000)
*American Sublime: Landscape
 Painting in the United States,
 1820–1880* (2002)

Gordon's gin
Turner Prize (2004, 2005, 2006)

The Guardian
Media Partner for *Intelligence*
 (2000)
Media Partner for *Wolfgang
 Tillmans if one thing matters,
 everything matters* (2003)
Media Partner for *Bridget Riley*
 (2003)
Media Partner for Tate & Egg
 Live Series (2003)
Media Partner for *20 years of
 the Turner Prize* (2003)
Media Partner for *The Turner
 Prize* (2004, 2005, 2006,
 2007)
Media Partner for *How We Are:
 Photographing Britain* (2007)
Media Partner for *The Turner
 Prize: A Retrospective* (2007)

The Independent
Media Partner for *Hogarth*
 (2007)

Tate & Lyle PLC
Tate Members (1991–2000)
Ideas Factory, Tate Britain
Art Trolley, Tate Britain

Tate Members
Exposed: The Victorian Nude
 (2001)
Bridget Riley (2003)
*A Century of Artists' Film in
 Britain* (2003–2004)
In-A-Gadda-Da-Vida (2004)
Art Now: Nigel Cooke (2004)
Gwen John and Augustus John
 (2004)
Michael Landy – Semi Detached
 (2004)
Picture of Britain (2005)
Hogarth (2007)

The Times
Media partner for *Art and the
 60s: This Was Tomorrow*
 (2004)